LEONARDO
The *Last Supper*

LEONARDO
The *Last Supper*

WITH ESSAYS BY
Pinin Brambilla Barcilon AND *Pietro C. Marani*

TRANSLATED BY
Harlow Tighe

THE UNIVERSITY OF CHICAGO PRESS
Chicago and London

Photographs: Antonio Quattrone, Florence

Copyright © 1999 by Electa, Milano
Elemond Editori Associati
The University of Chicago Press, Chicago 60637
The University of Chicago Press, Ltd., London
© 2001 by The University of Chicago
All rights reserved. Published 2001
Printed in the United States of America

10 09 08 07 06 05 04 03 02 01 1 2 3 4 5

ISBN (cloth) 0-226-50427-1

Library of Congress Cataloging-in-Publication Data
Brambilla Barcilon, Pinin.
 [Leonardo. English]
 Leonardo : the last supper / with essays by Pinin Brambilla Barcilon
and Pietro C. Marani ; translated by Harlow Tighe.
 p. cm.
Includes bibliographical references and index.
 ISBN 0-226-50427-1 (alk. paper)
1. Leonardo, da Vinci, 1452–1519. Last Supper. 2. Last Supper in art.
3. Mural painting and decoration—Conservation and
restoration—Italy—Milan. 4. Mural painting and
decoration—Expertising—Italy—Milan. I. Marani, Pietro C. II. Title.
 ND623.L5 A683 1999a
 759.5--dc21
 00-011655

This book is printed on acid-free paper

Contents

Preface to the English-Language Edition

Advances in photographic technology allow us to document the results of important art restorations as never before. The photographs in this volume constitute an indispensable part of the record—the long, controversial record—of one of the great monuments of Western art, Leonardo's *Last Supper*. They are, in addition, quite beautiful and, we hope, will arouse in the reader something akin to the wonder experienced by those fortunate enough to view the actual painting in the refectory of Santa Maria delle Grazie in Milan.

There is a method to this book. An initial essay by art historian Pietro C. Marani traces the material and critical fortunes of the *Last Supper* over the past five centuries. (This essay has been carefully edited for the Anglophone reader who may not be familiar with the history of Milan and Lombardy.) Next, an atlas of illustrations offers, first, a broad view of Leonardo's masterpiece, then closely related parts of the composition, and, finally, a number of details. The "pace" of the photographs then changes abruptly, reproducing images in 1:1 scale, in the same dimensions as the original, interleaved with black pages that enhance the articulation of the various figures, details of facial expression, and the still-life fragments on the table.

This visual record is accompanied by an essay on the recently concluded restoration, authored by Pinin Brambilla Barcilon, chief conservator for the project. In translating this essay, we have retained a number of Barcilon's Italian terms (for example, "stuccature"). Others we have translated literally when the result seems to convey her precise technical meaning (for example, "pictorial film").

Undoubtedly, this most recent intervention has resulted in many discoveries and important insights into how Leonardo worked and the conditions under which he executed his masterpiece. However, art restoration is, by its very nature, a sensitive and controversial subject. The term "restoration" is itself highly charged. And little arouses more controversy and debate than the restoration, recovery, or conservation of canonical works like the *Last Supper*. People ask: At critical junctures in the process, why did the conservator make this choice rather than that one? When should repaint be removed and when should it be allowed to remain? And, how, with such a damaged work, can one presume to recuperate the artist's original vision, since each person's eye is unique, by virtue of culture, training, and intent? What constitutes originality anyway?

The debate continues. The University of Chicago Press endorses no position but believes that all informed voices should be heard. The photographs of the restoration are presented here in visual depth for the first time. Truly their worth cannot be measured, and they constitute an enormously valuable visual document of the surface of the fresco in its current state as well as a record of the twenty-year effort to rescue it. They are also a testament to the unwavering care, diligence, and wisdom that Pinin Brambilla Barcilon brought to bear on her heroic search for what is presented here, today, as the "original" Leonardo.

Foreword

"Only a shadow of the *Last Supper* is left." Thus goes the standard lament that, over the centuries, has surrounded the deterioration of Leonardo's great work. This deterioration, noted as early as the sixteenth century (first in 1517 by Antonio de Beatis, then in 1568 by Vasari, who famously noted, "non si scorge più se non una macchia abbagliata") has inspired many attempts, through the centuries, to remedy the painting's condition; so many repaints, layers of glue, and incoherencies were superimposed on the work as to make any meaningful judgment impossible. Obfuscated and blackened, it was reduced to an almost illegible "holy icon" of art history. The vandalism of French soldiers in the late eighteenth century and the tragic bombing of Santa Maria delle Grazie by Allied troops in the summer of 1943 added to the damage deriving from the technique that Leonardo used and the accumulated effects of humidity, dust, and mildew. The greatest masterwork of one of the geniuses of Italian art seemed, in the late 1960s, a gigantic ruin, hardly worthy of the attention of art historians. Indeed, Cesare Brandi stated in 1954, after the restorer Mauro Pellicioli had completed his work on the painting, that Leonardo's work was considered to be "in great part . . . a forgery."

The extraordinary photographs produced by Antonio Quattrone at the completion of the most recent restoration (an operation that has taken more than twenty years), published in this volume, demonstrate that much more of Leonardo's painting survives than previously thought. Thanks to these photographs, even those of us who were unable to mount the scaffolding to view firsthand the extraordinary operations directed by Pinin Brambilla Barcilon can now share Carlo Bertelli's excitement when he declared (in 1983), "We are living a new experience, which is the reappearance of the *Last Supper* after centuries in which its comprehension was entrusted, not so much to its real presence, as to the possibility of reading it through the copies." It was Carlo Bertelli who had the clarity of mind to envision an extensive recuperation of Leonardo's pictorial text and the courage to transform a conservation operation (begun in 1977 under Franco Russoli's direction and continued under that of Stella Matalon) that concentrated on reattaching small flakes of color that were becoming detached, into the extraordinary intellectual adventure documented in these pages. Here we can take part in the rediscovery of Leonardo's painting five hundred years after its execution. Pinin Brambilla Barcilon's exhaustive and detailed description of her patient, highly delicate work, as well as a historical account of the painting by Pietro C. Marani, a Leonardo scholar and codirector of the operations since 1993, enrich our understanding of this remarkable project.

This volume, together with a forthcoming technical publication on the analyses, research, and operations carried out on the *Last Supper* during the past twenty years (developed in collaboration with the Istituto Centrale per il Restauro), constitutes a thorough record of a complex restoration. Scholars have consistently been kept informed of ongoing results, first by two publications issued with the support of the Società Olivetti, then by specialized articles and workshops, including a Convegno di Studi held in April 1999 at the Accademia dei Lincei. Those who asked to observe the cleaning process firsthand were allowed to do so, and it is a pity for art history that the lively discussions that took place on the scaffolding will remain forever a memory in the minds of those involved. In recent years, thousands of visitors to the refectory of Santa Maria delle Grazie have taken advantage of the infinite patience of Pinin Brambilla Barcilon and been allowed to witness the delicate cleaning operations.

This is not the place to summarize the many contributions to conservation science that came out of the restoration or what the result of it may ultimately mean for students of Leonardo's work. But clearly the benefits are considerable, and future conservation efforts on behalf of Italy's historical and artistic heritage will need to acknowledge them, as will evaluations of late fifteenth-century Italian art.

It is traditionally the task of the writer of a foreword to recall those who have participated in the endeavor. Here the list is long, covering a period of more than twenty years. The restoration began in 1977, when Franco Russoli was Soprintendente per i Beni Artistici e Storici. He was followed in that post by Stella Matalon (1978), Carlo Bertelli (1978–1984), Rosalba Tardito (1985–1991), and Pietro Petraroia (1992–1997).

Various art historians were consulted, but continuity was ensured by the expertise of Pinin Brambilla Barcilon, the restorer, who worked without interruption from 1977 to the

completion of the project. The work was carried out under the general direction of the Istituto Centrale per il Restauro, the leading Italian institution in the conservation field, which also helped with scientific analysis and research. Because it is impossible to acknowledge here everyone who provided scholarly and technical assistance, our heartfelt thanks to the directors of the Istituto, who in recent years have been Umberto Baldini, Michele d'Elia, and Michele Cordaro, will have to do for them all. Until 1982, the restoration was financed exclusively by the Ministero per i Beni Culturali e Ambientali; after that, the Società Olivetti generously financed the project, continuing a tradition of cultural patronage that has contributed to some of the most significant restorations of the 1980s, including those of the Brancacci Chapel in Florence and the Camera degli Sposi in Mantua. Costs for the restoration and architectural rehabilitation of the Santa Maria delle Grazie refectory were entirely underwritten by the Ministero per i Beni Culturali. The projects proposed by Roberto Cecchi and Sylvia Righini Ponticelli were realized under the direction of the Soprintendenza per i Beni Ambientali e Architettonici of Milan, headed by Lucia Gremmo. Many other people should be mentioned here: may they not hold it against me that the limitations of space prevent it.

Bruno Contardi
Soprintendente per i Beni Artistici e Storici, Milan

Introduction

Renzo Zorzi

The Società Olivetti became involved in the restoration of Leonardo's *Last Supper* early in 1982, building on a long tradition of supporting and promoting the artistic heritage of Italy. To mention only a few of their projects, they first became involved with the restoration of the great Gothic-Renaissance cycle of the *Life of Christ* by Martino Spanzotti in the church of San Bernardino at Ivrea, a site not far from the Olivetti factories. (A second restoration of the same work, directed by Giovanni Romano, followed several decades later.) Next came sponsorship of an exhibition of frescoes rescued from the 1966 Florence flood, which had been detached from their original sites and restored under the direction of Umberto Baldini. The resulting exhibition, "The Great Age of Fresco: Giotto to Pontormo," conceived with the encouragement of the Honorable Aldo Moro, then the foreign minister, was intended as a gesture of Italy's gratitude to the countries that had contributed labor and technical and special assistance to a rescue operation known the world over. In its travels from the Metropolitan Museum in New York City to the major museums of Europe, the exhibition united an international cultural community, perhaps for the first time, in an affirmation of solidarity. Two other exhibitions of unusual beauty and enormous success followed: "The Horses of San Marco," which logged 3,200,000 visitors—an attendance unheard of in the past fifty years, perhaps in all time—and "The Treasure of San Marco."

In 1980, when the decision was made to undertake the restoration (again, under the direction of Umberto Baldini) of the frescoes by Masaccio, Masolino, and Filippino Lippi in the Brancacci Chapel in the church of the Carmine in Florence, Olivetti assumed the task of coordinating the technical studies needed for a restoration of such great complexity, one involving inspired works of art suffering from many problems. This project lasted eight years, and among its results was the publication of a book (by Electa) that offers a wealth of detailed illustrations in 1:1 scale. During this time, the Cimabue *Crucifix* from the church of Santa Croce in Florence had been restored and was touring Europe, with a detour to New York City. The presentation of this work at the Royal Academy of Art in London was a memorable event. The restoration of the Cimabue *Crucifix* had required more time than that of the frescoes damaged in the Florence flood, because the wood had absorbed not only water but tars and mud that caused so much damage that its painted surface was believed to be unrecoverable. But the restorers were able to save both the wooden support and the painting in its full pictorial identity and striking expressiveness. It was feared that the wood might undergo further changes, but the innovative techniques used to separate the pictorial portion from its support made it possible to affix the painting to an inert material and simply replace it on the cross, thus making the painting autonomous.

The experience of those years and the network established by those involved in the operations and by scholars in museums, universities, and other institutions throughout the world was put to good use in other initiatives. Preliminary historical studies preceded every project, specialized international conferences were organized, and site investigations and discussions with experts were held to take advantage of a vast array of talent and to encourage collaboration. The discoveries that came out of this effort led to an intensified interest in methods of analysis that rely on direct contact with the materials used for restoration and on comparisons involving close contact with a work of art. It was at this point that the Ministro per i Beni Culturali was invited to assume responsibility for the restoration of Leonardo's *Last Supper* in the church of Santa Maria delle Grazie in Milan. Work had recently begun there, but the project was beset by mounting tension.

Now that the restoration has been completed and the efforts of the many agencies involved have come to an end, this is not the time or place to belabor those vicissitudes, many of which arose from a common concern over the fragile condition of the work and the awareness that its treatment allowed no room for error. Such commentary may eventually find a place in other memoirs written with greater hindsight. For the moment it is enough to recall only a few salient events. Technically, this work falls under the aegis of two organizations that share responsibility for it, including its conservation: the Soprintendenza ai Monumenti, which was primarily concerned with the wall, and the Soprintendenza dei Beni Artistici, which was responsible for what was painted on that wall. The refectory building itself had suffered many tribulations during the centuries following the completion of the *Last Supper,*

including a bombing in 1943 that destroyed the roof but spared the wall bearing the painting, thanks to a providential sandbagging. Still, the wall had been rebuilt, and this meant problems. The Soprintendenza ai Monumenti held that the wall bearing Leonardo's painting should be reinforced and consolidated so as to increase its static strength and stability, but the energetic operations required by such a project were opposed by the Soprintendenza dei Beni Artistici. The latter feared that new damage would be done to the painted surface by potentially risky procedures and by increasing the rigidity of the material support for the painting, which was in a precarious condition and threatening to shed flakes of paint.

It was then decided, by common consent, to proceed with a type of restoration that involved removing from the surface of the work everything (or as much as possible) added during the many preceding restorations, from the seventeenth century to the most recent operations, and reestablishing the integrity of the remaining pictorial text, which had been shown to have serious gaps but which the first tests had begun to bring to light.

The story of the restoration is related in detail in this volume, and there is little point in dwelling on it here. It is enough to say that, early in the process, serious disagreements nearly derailed the project, and for this reason Olivetti was asked not only to assume the entire financial cost of the operation, but also to facilitate a satisfactory solution and get the operation back on track.

It should be mentioned that the Istituto Centrale per il Restauro, operating from Rome, at first paid little heed to the problems of the *Last Supper*. The institute's director, Giovanni Urbani, a solid scholar, expressed doubt that a new attempt to restore the painting (which differed in all respects from preceding efforts) could resuscitate what by then seemed no longer to exist, given the enormous damage that had been done not only by armies and atmospheric agents, but even by the Dominican friars who were its custodians and had enlarged a door beneath the painting, destroying the section that included the sandaled feet of Christ and the lower edges of the tablecloth.

The difficulties—material, psychological, and relational—and the climate of uncertainty perhaps made it imperative to seek outside help if work was to begin again with new vigor.

Olivetti accepted the challenge. Especially in the early years, their participation transcended sponsorship as they assumed a genuine share of responsibility for the project. Moreover, the company had always demonstrated its conviction that in a country as rich in culture as Italy, but with only meager public resources to dedicate to safeguarding it, the entire nation, and particularly the agencies that could best afford it, had a duty to contribute to such an endeavor. In a case as difficult and complex as that of the *Last Supper*, it had already been demonstrated that in-depth studies of the work and its immediate environment were needed, as well as help from institutions both within Italy and beyond its borders. Specific expertise in the fields of chemistry, physics, and computer sciences was required, and it was essential that major figures in art and cultural studies be consulted, both in Italy and abroad. The Ministero per i Beni Culturali participated in these efforts from the start, working closely with Olivetti and the restorer.

I was involved as well, as vice president (together with Giovanni Spadolini) of the Associazione degli Amici di Brera, where the problem of Leonardo's painting was often debated, even before the idea of a new restoration began to take shape. The restoration was first discussed by Franco Russoli when he was Soprintendente per i Beni Artistici e Storici (who died prematurely), then under Stella Matalon, who succeeded Russoli for a short time before her own death. In the few months of her tenure, however, Matalon managed to launch the restoration, entrusting the work to Pinin Brambilla Barcilon, an experienced restorer from the private sector who had participated not only in many projects in northern Italy, but had even worked on the great *Crucifixion* by Giovanni da Montorfano in the same room as the *Last Supper*. Immense trust was put in Brambilla Barcilon, not only because she had a reputation for great professionalism, intelligence, and scrupulous attention to detail, but also because her independent status excepted her from a bureaucratic career and thus from the possibility that she might be removed to another job or forced to retire before the restoration could be completed. When Carlo Bertelli, a scholar of exceptional qualifications and autonomy, succeeded Matalon as superintendent, he inherited primary responsibility for the direction and execution of the work in progress. Once the

preliminary surveys had been taken, it was he who decided on the method to use in the project's first phase. When Bertelli resigned to return to research and university teaching (also because of somewhat difficult relations with government bureaucracy), he was sorely missed by those who worked up on the scaffolding and appreciated his abilities, his vast knowledge of the entire Leonardo story, and his sure judgment. It was during his tenure that a first public exhibition was held in the refectory. This exhibition, sponsored by Olivetti and later taken to the National Gallery in Washington, D.C., then to Toronto and Sydney, presented Leonardo's drawings for the *Last Supper*, now conserved at Windsor Castle and lent by Queen Elizabeth. The exhibition catalog, edited by Carlo Pedretti, included essays by Carlo Bertelli and Kenneth Clark (the last of his lifetime), other studies, as well as documentary and bibliographic information and a chronology by Jane Roberts, director of the Cabinet of Drawings at Windsor Castle and a scholar with whom I have collaborated on several occasions. The entire project was carried out with the blessing of Sir Robin Mackworth-Young, at the time librarian at Windsor Castle. This occasion, a grand and very Milanese celebration, revealed beyond all doubt how much Leonardo's *Last Supper* meant to that city and how great was Milan's need to reclaim and fully appreciate the work.

This was just the beginning. When Umberto Baldini was transferred from Florence to assume direction of the Istituto Centrale per il Restauro, relations with that agency improved. Baldini was quick to establish a spirit of collaboration with other organizations, and his first goal was to preserve the *Last Supper* from further deterioration caused by its immediate environment (dust, gases, humidity worsened by excessive numbers of visitors, etc.). This permitted Olivetti to withdraw from certain responsibilities, though throughout the project the company always operated in a spirit of service; even in moments of extreme difficulty within its organization, it never failed to fulfill the task it had undertaken. In particular, it made every effort to back the restorer, who could not be disturbed by problems unrelated to her work. To be sure, there were stressful moments when work had to be slowed or stopped and when further study and comparisons were necessary. Leonardo's *Last Supper* had a great influence on later art; it also produced a large number of copies, chief among them a large canvas that stands out for its power of suggestion and its impact. This copy, attributed to Giampietrino, is believed to be one of the most faithful, especially regarding the disposition of the figures; it was brought to London, where it was completely restored by Brambilla Barcilon. David Alan Brown, of the National Gallery in Washington, D.C., treated the work to a full analysis, published by Olivetti in collaboration with the Ministero per i Beni Culturali as one of the "Quaderni del restauro" under the title *Giampietrino e una copia cinquecentesca dell'Ultima Cena di Leonardo*. As work on the *Last Supper* progressed, Brambilla Barcilon studied other copies (in fact, all the most significant ones), and she participated in international conferences and lectured in many countries. In two other issues of the "Quaderni del restauro" (*Il Cenacolo di Leonardo in Santa Maria delle Grazie* and *Le lunette di Leonardo nel refettorio delle Grazie*) she reported on the studies that had been made and what the wall was revealing. At the same time, repeated series of photographs were made, indispensable to the satisfactory documentation of ongoing work.

This is not the place to dwell on all that took place during the project—on the sometimes exhausting task of examining details with a microscope; on the fear (fortunately dispelled) that the left-hand portion of the painting would turn out to contain losses too great for recuperation; on the need to rest the eye and the brain frequently or to relieve an obsession that arose from continual, uninterrupted contact with the wall. Twenty years of a lifetime were spent up on the planks of the scaffolding, intent on removing one last millimeter of added color or capturing the shadow left by a lost brush stroke.

I would like to conclude on two notes. First, during the restoration eleven people held the post of Ministero per i Beni Culturali, and there were easily as many under-secretaries. These individuals were responsible (at least, morally) for the results of the restoration, and it was their charge to appoint personnel to carry out the many tasks involved in a project of such vast importance. The general directors of the ministry changed as well, as did the members of the Comitato di Settore, four or five directors of the

Istituto Centrale per il Restauro, and as many directors of the two Soprintendenze. Naturally, given the situation, it was difficult to maintain the same criteria and the same methodology throughout such a long period of time without interruptions, deviations, slow-downs, and discouragement.

If the operation to rescue the *Last Supper* was completed without compromise, it was thanks to the courageous perseverence of the restorer, to the constant support she received, and to the exemplary guidance of some of the superintendents (Pietro Petraroia, for one) and the intellectual passion of some officials (among them, Pietro C. Marani). The highly competent personnel of the Istituto Centrale per il Restauro involved in the project also deserve credit. From the moment they first applied themselves to this project, they never abandoned it. Further thanks go to the Soprintendenza ai Monumenti, which had particular responsibility for refurbishing the refectory. As I, along with the restorer, have been part of this project from the start, I can testify to the dedication of many people (beginning with the restorer's assistants), including scholars who have followed the project closely and the technical experts who have shared their knowledge with us and offered encouragement.

On a second note, let me mention a problem that may seem minor but that is actually extremely important. Except for brief periods when the refectory doors remained closed, work was carried out in the presence of an uninterrupted flow of visitors, an ever-larger public that often proved restless when confronted with lights, scaffolding, and other obstacles. The restoration was conducted amid the bustle and confusion of mass tourism, surrounded by crowds of people who were often inadequately prepared to appreciate the painting, thus making concentration difficult for the restorers. This, it seems to me, is a matter demanding serious consideration. In future restoration operations (all such endeavors have the same problems), personnel should be free from the tyranny of visitors and scheduled visiting hours.

While the Leonardo project was in progress, Olivetti was engaged in other initiatives, some less difficult. For example, the company collaborated in the restoration, directed by Michele Cordaro, of the Camera degli Sposi in the Ducal Palace in Mantua and, also in Mantua, of the Sala dei Cavalli in Palazzo Te. In Rome, Olivetti was involved in the restoration of the painting cycle by Masolino in the Chapel of St. Catherine in the basilica of San Clemente; in the Castello di Manta, near Saluzzo, it funded the restoration of a cycle of paintings in the International Gothic style (with French influences) in the Sala dei Baroni, a project also realized under the direction of Pinin Brambilla Barcilon. Olivetti brought to Venice a stunning ivory, *Bury St. Edmunds Cross,* on loan from The Cloisters in New York City; it collaborated with the British Museum and the Römisch-Germanisches Museum of Cologne to produce an exhibition of Roman glass of the imperial age at the Campidoglio in Rome; and in Washington, D.C., Olivetti sponsored an exhibition dedicated to Michelangelo, draftsman and architect. It enabled three continents to become acquainted with masterpieces from the collection of Gianni Mattioli in an exhibition of early twentieth-century painting curated by Franco Russoli. It organized two memorable exhibitions of pre-Columbian sculpture, "Before Cortés" in New York City and "Prima di Colombo" in Venice, Paris, and Madrid. With Joseph Rykwert, the company prepared the electronic media support for an exhibition on Leon Battista Alberti at Mantua. At the same time it presented an exhibition, curated by Luciano Bellosi, of a group of works by fifteenth-century Tuscan artists under the title "Pittura di luce." It backed the great exhibition of work by Andrea Mantegna in London (for which the queen lent the *Triumphs of Caesar*, which had never before left Hampton Court) and the Paul Gauguin show in Paris. It had a hand in many other events, great and small, including shows of contemporary art such as "Le Corbusier pittore e scultore" in Milan and "Mondrian e De Stijl" in Venice, and exhibitions of the work of Alberto Viani and Pino Castagna, again in Mantua. Olivetti also pursued major publishing ventures through its own Edizioni di Comunità and through Electa. In all these enterprises, it has always seemed to me improper to speak of sponsorship: these were, in truth, genuine acts of cultural and scholarly generosity. The initiatives were often original and innovative, reflecting the lively and direct involvement of the company.

What should perhaps be stressed—and this is particularly true of the *Last Supper*—is that this activity continued even during periods of great difficulty for the Società Olivetti. All promises were fulfilled to the letter and without hesitation.

This was true not only during the years in which Bruno Visentini was president of the company, but also during the tenure of Carlo De Benedetti, who welcomed every proposal with enthusiasm and gave it assiduous attention, and it continued under Roberto Colaninno. Colaninno assumed the directorship of the Gruppo Olivetti at a moment of crisis that required drastic cutbacks and sacrifices. But in the same way that he took on the task of resolving the company's financial difficulties and steering it back on course, he also committed to the *Last Supper* project and saw it through to completion. As I say, I have lived through this entire process, and today I can express my profound satisfaction and offer heartfelt thanks to all those who made the restoration possible.

Archival Abbreviations

ABM = Accademia di Brera, Milano
ACS = Archivio Centrale dello Stato, Roma
ASM = Archivio di Stato, Milano
RV = Raccolta Vinciana, Castello Sforzesco, Milano
SBBAA = Soprintendenza per i Beni Ambientali e Architettonici, Milano
SBBAS = Soprintendenza per i Beni Artistici e Storici, Milano

Leonardo's *Last Supper*

Pietro C. Marani

I. Chronology, Sforzesco Commission, and Dominican Spirituality

In a letter of 29 June 1497, Ludovico Sforza, duke of Milan (1451–1508), instructed his secretary, Marchesino Stanga, "to urge Leonardo the Florentine to finish the work already begun in the Refectory of Santa Maria delle Grazie so that he can then attend to the other wall of the Refectory; and make him sign the contract with his own hand to oblige him to finish within the time to be agreed upon."[1]

A record of a payment for 37 lire and 16.5 *soldi* "for work on a window in the refectory, where Leonardo is painting the Apostles," also from 1497,[2] proves that, in that year, Leonardo da Vinci was still working on the *Last Supper,* or, as it is known in Italian, *Il Cenacolo.* Apart from the record of payment, the letter from Ludovico to Stanga is the only surviving document that explicitly connects the painting of the refectory to a commission from "Il Moro" or "The Moor," as Ludovico was known, referring to his dark complexion and black hair. To date no contract for the commission has been found. Nor can we be sure that the commission issued from Ludovico Sforza himself, even though the duke's coat of arms appears in the central lunette above the mural and he was good friends with Vincenzo Bandello, the prior of Santa Maria delle Grazie. Though lacking supporting evidence, it is also possible that the painting was commissioned directly by the Dominican monks of Santa Maria delle Grazie or that an unknown benefactor of the monastery instigated the commission.[3]

Most likely, though, the *Last Supper* was commissioned by Ludovico, probably around 1493–94, earlier than normally assumed. His letter of 1497 demonstrates that he was well aware of the progress at Santa Maria delle Grazie, and in particular of Leonardo's habitual slowness.[4] Clearly the painting of the *Last Supper* had been protracted and its completion delayed.[5]

We cannot know for certain what compelled Ludovico to commission a Last Supper around 1494, in addition to the five lunettes prominently displaying the ducal arms (three on the wall above the *Last Supper* and two on the long side walls of the refectory).[6] But we have a pretty good idea. "The

Moor" had in effect ruled Milan as regent for his nephew Gian Galeazzo Maria Sforza since the early 1480s but then sought to affirm his position as undisputed ruler. He usurped his nephew, and in 1494 Holy Roman Emperor Maximilian I officially invested Ludovico as duke of Milan. Not surprisingly, around that time Ludovico awarded a number of important artistic and architectural commissions to promote his sovereignty and enhance his prestige. These included Leonardo's recommencement of work on the Sforza equestrian monument, the commission for the Sforza altarpiece, new residential quarters at Santa Maria delle Grazie (reflected in Leonardo's drawings of this period), construction of the monastery's new tribune, as well as an intense drive to complete major building projects in Pavia and Milan. The amount of work begun or urged to completion between 1492 and 1494 is impressive.[7] Presumably Ludovico's commission of the *Last Supper* was yet another opportunity for self-promotion, as the ducal arms above the painting suggest.

Leonardo's famous notes concerning models for the figure of Christ and poses for the apostles in the Forster II Codex cannot be dated with certainty, though they are conventionally assigned to 1495–97 because of their relationship to the mural painting.[8] The first general preparatory studies for the large mural composition planned for the refectory have, however, been dated to around 1493–94.[9] Furthermore, the general studies (particularly Windsor sheet 12542 recto, which will be considered extensively), the dynamic conception of the composition, and the representation of actions and gestures reflect scientific theories—even before artistic ones—that had preoccupied Leonardo at least since 1490–92.[10] (Significant evidence, therefore, points to 1494, possibly even to 1492–93, as the time Leonardo began the preparatory studies for the large composition, the perspective scheme, and the great variety of gestures, poses, and groupings.)

The representation of the composition's subject—the announcement of Judas's betrayal and the institution of the Eucharist—posed a complex problem, and the interplay between the figures and their relationship with the illusory space was a particular challange. Such intricacy suggests that

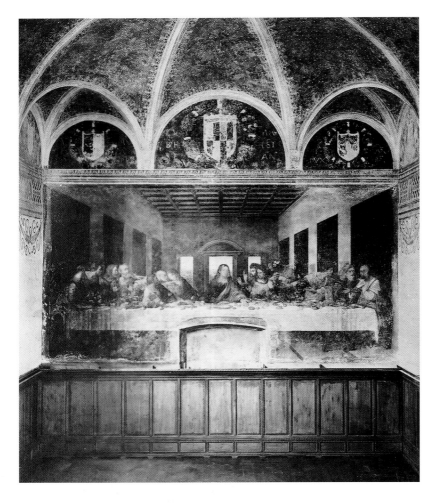

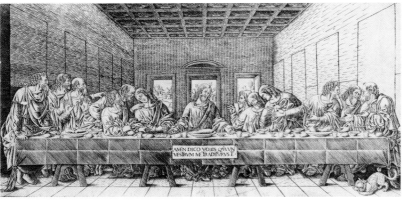

Windsor sheet 12542, generally considered a first working idea for the general composition and its relationship to the space of the refectory, might actually be quite an advanced study. This notion becomes even more convincing when one compares the sketch with the more traditional preparatory study in the collection of the Accademia in Venice (to which we will return later). The scene in the Windsor sheet still recalls Florentine models for the Last Supper, with Judas on the opposite side of the table, but reflects the refectory's architecture, indicated by the four lunettes in the background of the sketch.[11]

The four arches in the drawing denote Leonardo's original plan to fuse the apostles' illusionistic space with the real architecture of the refectory, in a manner similar to Domenico Ghirlandaio's (1449–94) solution for his *Last Supper* at the convent of San Marco in Florence, suggesting a spatial expansion compressed into the painted space. The illusory space was intended to echo and extend the real space. This dualistic plan for the scene's perspective and composition involved a great deal of study and refinement before it could be executed in paint. In fact, the subsequent addition of a coffered ceiling in the mural radically altered the composition, making the painted room seem longer and deeper. Traces of incised lines recently discovered in the plaster, which will be examined shortly, demand a radical reconsideration of Leonardo's method of transferring his perspective scheme to the wall. If Leonardo made other perspective and compositional studies exploring these issues that postdate Windsor sheet 12542, there is even more reason to assign it an earlier date—1493–94, as suggested by Kenneth Clark, rather than 1495–97, as some believe.[12]

The letter of 1497 to his secretary suggests that Ludovico's desire to see the refectory decorated had by then become urgent—an urgency born perhaps from the converging interests of the duke and the Dominican monks. The former "wanted to make the church [his] own mausoleum," and the latter to expand the "now inadequate structure" of the monastery.[13]

The political climate had grown volatile since Ludovico was first confirmed as duke of Milan in 1494, and with the

death of Charles VIII in 1498, France under Louis XII began to prepare a campaign against the duchy.

A new prior, Vincenzo Bandello, had appeared on the scene in 1495, and, in 1496, upon the death of Ludovico's wife, Beatrice, the duke seems to have grown closer to him. Some have credited Vincenzo Bandello with the iconographic and iconological program for the refectory; however, this does not account for the fact that his arrival in 1495 probably corresponded not to the onset of Leonardo's commission but to that of the pictorial execution. The iconographic program had likely been defined and approved by Ludovico well before that date.[14]

All the oldest sources confirm that Ludovico commissioned the *Last Supper*, including Matteo Bandello's *Le Novelle* of 1554 and particularly Luca Pacioli's *De divina proportione,* dedicated to Ludovico on 9 February 1498.[15] According to Pacioli, the duke "had made arrangements" with Leonardo, "with his graceful brush," for that "aforesaid most sacred place, the church de Gratie." Furthermore, Leonardo received a salary from Ludovico during this period, and addressed two letters of complaint to the duke around 1495–97. In one, Leonardo complains that he has not received his salary for the past two years, while having to maintain two skilled workmen "who [are] constantly in my pay and at my cost." In the other, he complains about having six *boche* ("mouths") to feed. Both letters have been construed to refer to interruptions in the execution of the *Last Supper*.[16] But given that, in the draft for the first letter, Leonardo alludes to the project for an equestrian monument to Ludovico's father, Francesco Sforza ("Of the horse I will say nothing because I know the times [are bad]") and that, in the second, he refers to thirty-six months spent feeding "six mouths" while receiving only "50 ducats," it seems likely that the interrupted project was not the *Last Supper* but the monument.[17]

For indeed, Leonardo's method of working on the painting—so well described by Matteo Bandello—was to climb the scaffolding and paint the whole day, forgetting to eat or drink; or leave the Corte Vecchio "where he was at work on that stupendous clay horse," return to Santa Maria delle Grazie, give a brushstroke or two, "suddenly leave and go elsewhere" and not return for "two, three or four days." Given Leonardo's work practices, his moods, and the more leisurely painting technique of working *a secco,* as opposed to *buon fresco,* interrupting work on the *Last Supper* would not have been a problem. The work for which Leonardo complained about not being paid could only have been the Sforza monument. Leonardo would certainly have needed help for the different phases of assembling the mold and the countermold, and for the preparations of the casting process, including setting up the casting pit. Feeding "six mouths" or "two skilled workmen" for three years would be perfectly reasonable for such a vast and challenging operation, one probably even beyond Leonardo's technical capabilities. On the other hand, multiple assistants would have been useless for a pictorial project that crept along by three or four brushstrokes a day. The discoveries of original paint during the recent restoration demonstrate that, with the exception of certain circumscribed areas, Leonardo indeed made carefully measured, delicate progress with the tip of the brush (to be described in section IV).[18] The mere fifty ducats Leonardo received during this period of time could have been compensation for the model of the horse, or for the *Last Supper.* Those fifty ducats might well have been the "fifty scudi" that Ludovico paid Leonardo for the *Last Supper,* according to Gaspare Bugatti's *Historia universale,* published in 1570.[19]

As soon as the *Last Supper* was finished, Pacioli pronounced it and the enormous clay model of the equestrian monument as making the city of Milan "the most worthy place for [Ludovico's] customary residence." Such grandiloquent praise was typical of the writers in Ludovico's court: for example, Bernardo Bellincioni declared Milan a "new Athens," and Giovanni Simonetta rewrote the duchy's recent history to suit Ludovico's own purposes.[20]

There is no evidence that the *Last Supper* was ever recorded as a commission by the Dominicans of Santa Maria delle Grazie or that they ever claimed credit for it. Nevertheless, the refectory was semi-sacred to the Dominicans and the site of a para-liturgical ritual. According to Vincenzo Bandello's description in *Declarationes super diversos passos Constitutionum* of 1505,[21] the monks were required to wash

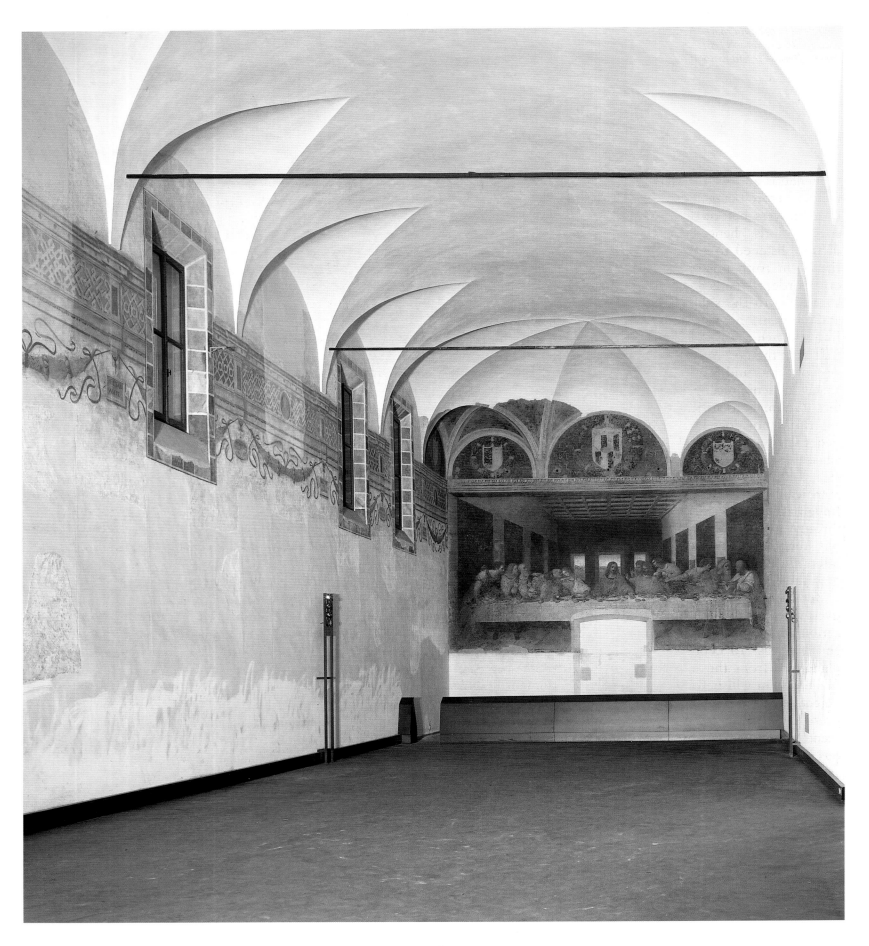

their hands and wait in silence on benches outside the refectory before being allowed to enter. Once inside, they recited prayers before the cross "vel figuram que est supra sedem prioris," hence before they sat down, received a benediction, listened to a reading, and then ate in silence. The ritual—in truth not so different from that prescribed by other orders—lends itself to no other iconographic scheme so well as to the subject of the Lord's Last Supper. Style and content, however, were the choice of the painter. Phrases such as CARNEM VESTRAM DOMATE on the long wall near the *Last Supper* extolling the spiritual life and images of saints and beatified Dominicans are what define the space as Dominican—not Leonardo's representation. In fact, the image does not depend on a specifically Dominican ritual; nor does Leonardo's representation of Christ reflect the ritual recounted by Vincenzo Bandello. Leonardo's Christ does radiate truth and light (although he is represented against the light), but he is no more a "priest and sacrificial victim" than other representations of Christ in Italian Last Suppers painted from the late thirteenth through mid–fifteenth centuries.[22] In traditional iconography, the moment when Christ announces the betrayal and offers the dipped bread or sop to Judas generally prevails over the Institution of the Eucharist.[23]

But one must be cautious about imputing a religious motive to Leonardo in his narrative "history" paintings. Every action and emotion he depicted had to be justified in scientific terms. To Leonardo, everything had a scientific explanation, from the apostles' reactions to Christ's words "One of you will betray me," to the reflections of light on objects and the "lifelike" portrayal of Christ, resigned and prescient at the moment he pronounces the words. That the scene was meant to illustrate that precise moment is obvious from an early engraving after the painting attributed to a Lombard master (Antonio da Monza, Andrea da Brescia, or the Master of the Sforza Book of Hours), who inscribed "AMEN DICO VOBIS QVAM VNUM / VESTRVM ME TRADITVS EST" on the front of the table.[24]

A small drawing on paper of a Sforza coat of arms by Leonardo presumably dates prior to 1494.[25] The drawing (12282 recto), now in the Royal Collection at Windsor Castle, shows a bucrane-shaped (ox skull) coat of arms composed of two intertwining, open-mouthed dragons that coil around two staves in the form of a Saint Andrew's cross. The letters "G" and "M" appear at the sides. The letters could signify Galeazzo Maria Sforza (1444–76), Ludovico's brother, who was assassinated in 1476, or, as suggested by Kenneth Clark, Gian Galeazzo Maria Sforza (1469–94), Ludovico's nephew. In any case, the drawing confirms that Leonardo was responsible for the first version of the Sforza coat of arms revealed by the recent restoration of the central lunette above the *Last Supper.* The charcoal design in the refectory, now fully visible, not only represents the same bucrane shape as the Windsor drawing but also the motif of the open-mouthed dragon. None of Galeazzo Maria's other commissions or emblems display a dragon with an open mouth; therefore, it is probable that Leonardo's original plan was to celebrate Gian Galeazzo Maria Sforza in the central lunette, either because it was he who actually commissioned the *Last Supper* or, more likely, because he had held the title of duke prior to 1494. When Gian Galeazzo Maria Sforza died in 1494, the decoration with his coat of arms, as depicted in Windsor drawing 12282a and revealed by the traces now visible in the central lunette, was evidently already under way. Upon his death, his emblem was modified into a shield-shaped coat of arms composed of alternating rectangular gold and silver fields, with the Sforza dragons painted in blue on the silver ground. It is further embellished with a garland encircled by a palm frond, the initials of Ludovico and Beatrice, and the title "DVX" (*dux,* or "duke").[26]

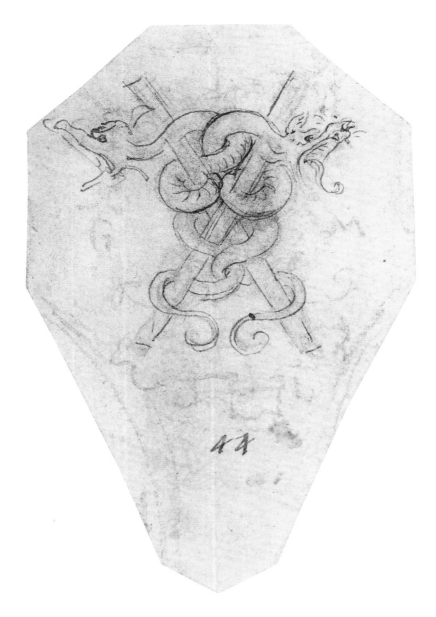

Leonardo, Study for a heraldic device for Gian Galeazzo Maria Sforza. Windsor Castle, Royal Collection (no. 12282a r.).

II. The Preparatory Drawings

In 1827, conservator Agostino Comerio wrote a letter to the Royal Imperial Government of Milan requesting permission to make a copy of the *Last Supper*. Comerio also mentioned a "painting of small dimensions . . . but well conserved in all its parts representing this miraculous supper." He declared that it was executed on

> the finest linen and worked with brush tip in black and white with the greatest precision and patience in the same manner that Leonardo painted his studies, just as Giorgio Vasari recounted in his Lives; the heads all [have] the liveliest expression and presence of relief; the other unclothed parts of the body, especially the feet, [are] drawn with the greatest precision and reveal complete understanding; the simple drapery, logical and exquisitely purposeful, giving certain cause for judging this work the very study Leonardo used for the execution of the large-scale work. . . . What convinces the writer of this opinion are several *pentimenti*, in which one ever admires the supreme wisdom of the great painter, as with the parts of the figures located under the Table—object until now of infinite questions—which are handled in the sublime manner, corresponding to the upper portion. [When I] compared this study and the mysterious remains of the large-scale work, [I] was able to recognize not only the most perfect correspondence with the parts now visible, but also to grasp the significance of those traces scattered here and there, which leave the eye of even the most attentive observer uncertain without such a guide.[1]

The sketch belonging to Comerio does not seem to have survived, but the chance that it might have been an original work by Leonardo is slim in any case. The exact connection between this "study" and Comerio's desire to execute a copy of the *Last Supper* is also unclear. Perhaps his request to the Accademia was merely to tell them that he owned an allegedly original Leonardo, with the veiled hope that it would eventually be acquired for the Pinacoteca di Brera's collection. Nevertheless, what is particularly inter-

esting is Comerio's assumption that Leonardo had prepared a "model" or general study for the *Last Supper*, thus crediting the artist with a typically "academic" method—specifically one used in the modern era.

Did an original drawing for the *Last Supper* ever exist? Thomas Howard, earl of Arundel (1585–1646), mentioned having seen Leonardo's cartoons for the *Last Supper* in 1613 in the collection of Count Galeazzo Arconati in Castellazzo. Louis Doissin, in his volume *Sculpture, Carmen* (1775), also alludes to "original drawing . . . made by Leonardo's hand in coffee-colored watercolor, and with heightening in white and gum, of about six palms in length, and about two and a half in height." According to Doissin, the drawing was owned by Don Giuseppe Casati but entrusted to Domenico Aspari (1745-1831), drawing master at the Accademia di Brera, so that he could engrave it. Despite "some differences between the example and the painting," the drawing was held to be Leonardo's original model for the Milanese *Last Supper*.[2]

Aspari did indeed make an engraving after this "model."[3] (The engraving is now in the Raccolta Bertarelli at Castello Sforzesco. It bears the inscription "LA CENA DI LEONARDO DA VINCI. Disegno originale presso il Nobile sig.r Don Giuseppe Casati Rè d' Arme," and is dated 1780.) Yet, even if Aspari's engraving was made from a "coffee-colored watercolor," this clearly was not the drawing later owned by Agostino Comerio. In Aspari's engraving, the figures are shown only above the table, evidence that the lower part of Leonardo's composition was by that time seriously damaged and virtually illegible.[4] In Comerio's drawing, however, "the parts of the figures under the Table—object until now of infinite questions" were represented. Further cause to discount the source of Aspari's engraving lies in the extreme mediocrity of the image, especially in the dark, neutral treatment of the space behind the figures and in the peculiar expanse of the tablecloth, which is lengthened to cover the feet of Christ and the apostles.

A private Milanese collection possesses another "chiaroscuro" attributed to Leonardo, but it also dates to the end of the eighteenth or beginning of the nineteenth century.[5]

The profusion of these accounts and "chiaroscuro" drawings proves that there circulated in Milan old, possibly even sixteenth-century, prototypes/copies by Leonardo's followers.[6] Because Leonardo's mural was virtually illegible by the end of the eighteenth century—and had been deeply marred by Michelangelo Bellotti's and Giuseppe Mazza's restorations—the circulation of so many alleged originals signals that there existed among erudite Milanese a profound need to return to, or apprehend, Leonardo's original conception of the masterpiece. (Most of these drawings proved to be simply old copies.) Even modern criticism has at times postulated that Leonardo may have produced an original cartoon for the *Last Supper*. Such hypotheses are primarily inspired by the surviving drawings produced by students or followers of Leonardo (to be considered shortly). Because these works do not correspond perfectly to the mural painting, it is often suggested that they were based on cartoons or lost drawings by the master. However, none of the early sources refer to a general *modello* for the *Last Supper*, and postulating its existence seems pointless, unless one supposes that the method Leonardo used in preparing for the *Battle of Anghiari* was first tested in his preparation for the *Last Supper*. We know that Leonardo prepared a small-scale "experimental" panel for the later work.[7] His note on the "fires of Le Gratie" in the well-known *Ligny memorandum* in the Codex Atlanticus (fol. 669 recto, ex 247 recto) from about 1499[8] suggest that the two paintings may have shared a common technique and so perhaps an experimental, small preparatory format as well. The note mentions that braziers were placed in the "Grazie," perhaps to hasten the drying of the wet paint. This may refer to a particular painting technique that Leonardo later used for the *Battle of Anghiari*, which according to reports required braziers to speed drying of the paint. It would have been prudent to "experiment" likewise with a smaller model before proceeding to work on a vast scale. That Leonardo produced a model for the *Last Supper* in the form of a cartoon or a painted sketch is therefore not improbable.[9]

In *Trattato dell'arte della pittura* (published in Milan in 1584 but drafted much earlier), the artist and critic Giovan Paolo Lomazzo (1538–1600) only mentions preparatory drawings done "in pastel . . . excellent and miraculous" for the heads of Christ and the apostles.

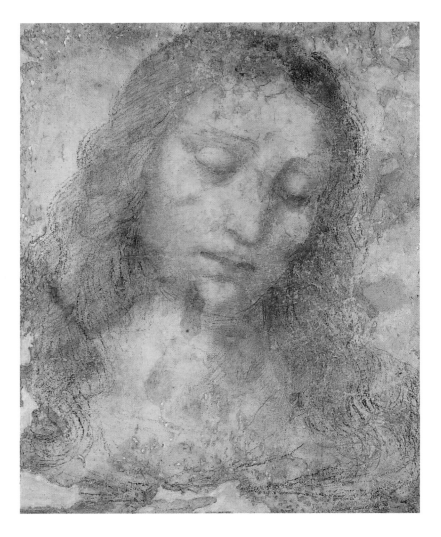

*Leonardo (with later repaints),
Head of Christ.
Milan, Pinacoteca di Brera.*

I will also mention a certain other method of applying color called pastel, which is achieved with pencils made of specially compressed colored powders that everyone can make. It is done on paper, and was much used by Leonardo Vinci, who made the excellent and miraculous heads of Christ and the Apostles in this way, on paper. But as easy as it is to color with this new method, it is just as easy to ruin it.[10]

Lomazzo returns to the importance of these drawings in *Idea del Tempio della Pittura* (published in 1590). He laments the loss of such masterpieces as the *Battle of Anghiari* and the *Last Supper*, which had "detached" from the wall even though painted "in oil." He declared that the *Last Supper* had been

ruined because of the imprimatura [Leonardo] applied underneath. . . . [W]e have much to regret, that such excellent works are lost, only the *disegni* remaining with us, which certainly neither time nor death nor other accident will ever win away from us, but will live eternally to his great praise and glory.[11]

Lomazzo's precise comments on Leonardo's technique for the drawings indicate that he had seen and examined them, perhaps even owned them. That he assigned them great importance is clear, but unfortunately none of Leonardo's surviving drawings for the *Last Supper* at Windsor Castle match Lomazzo's comments on the artist's medium. The only drawing in colored pastels is a heavily damaged and retouched specimen at the Pinacoteca di Brera, representing the head of Christ—and its authenticity is questionable. The overdrawing in charcoal and the numerous retouchings with various materials have impeded the certain identification of Leonardo's hand.[12] The medium—red and black chalk on pale green paper, heightened with white—also recalls the Weimar and Strasbourg cartoons depicting the heads of the apostles. These cartoons must, however, be considered later copies, either executed from the original (as seems the case, for example, with the two sheets from the Weimar series recently attributed to Leonardo's assistant, Giovanni Antonio Boltraffio, and now

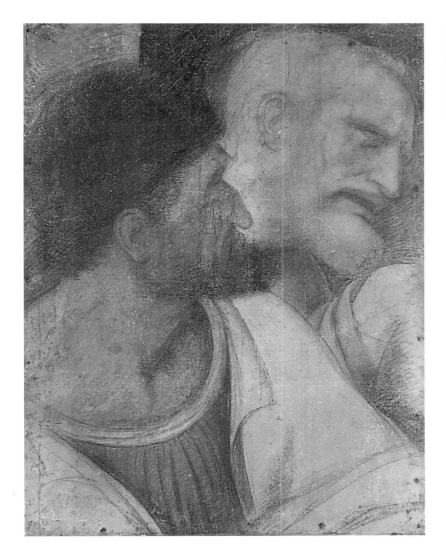 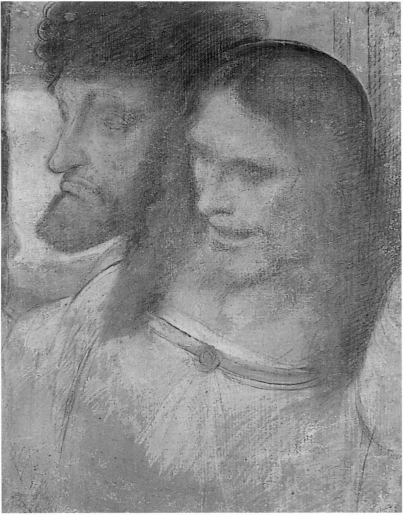

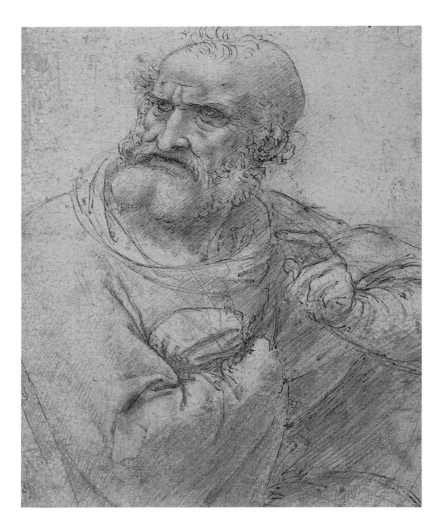

in the Ackland Art Museum at Chapel Hill, North Carolina) or after the first painted copies of the *Last Supper* (as seems the case with the Strasbourg series).[13]

At any rate, Lomazzo's testimony has for some time been viewed in relation to a notation by Leonardo himself in the Codex Atlanticus, fol. 669 recto (ex 247 recto):[14] "Get the method of dry coloring from Jean de Paris." Jean de Paris was identified by Gerolamo Calvi[15] as Jean Perréal (?1450–after 5 April 1530), an artist who followed two French expeditions to Italy in 1494 and 1499 and first introduced *au crayon* drawing there.[16] Leonardo must have been among the first to learn about the technique, as his note of 1494 confirms, and perhaps used it for studies related to the *Last Supper*, as the Pinacoteca di Brera sheet and Lomazzo's recollections suggest.[17]

Lacking indisputable drawings by Leonardo in colored pastels for the *Last Supper*, we should note that in the mid-1490s Leonardo used the Florentine metalpoint technique of drawing on prepared pink or blue paper less and less often.[18] Eventually he abandoned it almost entirely in favor of black or red chalks, which allowed him to achieve greater softness and chiaroscuro effects with heightened atmospheric qualities and *sfumato*. During this period Leonardo did not completely abandon the use of silverpoint, however. Its use is still evident, for example, in the drawing on prepared blue paper of a draped male figure in the Graphische Sammlung Albertina in Vienna, and in the drawing on gray prepared paper of Christ bearing the Cross in the Accademia in Venice.[19] The Vienna drawing has been proposed as a first *idea* for the figure of Peter in the *Last Supper*,[20] as it is technically and stylistically close to other studies dating from the early 1490s, such as the study for the body of a horse (sheet 12289) at Windsor Castle. The Venice drawing, on the other hand, reflects Leonardo's wide-ranging studies of the complex expressions and varied poses that characterize the arrangement of bodies and heads—placed on diagonals and firmly located in space—devised for the *Last Supper*. For that reason, the Venice drawing can be dated to around 1497.[21] Preparatory studies for the *Last Supper*—predominantly pen-and-ink drawings—thus date from the early 1490s to

circa 1497, the chronological extremes represented by these two drawings.

Leonardo must have been fascinated by the idea of a composition with multiple seated figures conversing around a table since he created such studies for the *Adoration of the Magi*, the painting begun for the monks of San Donato at Scopeto but abandoned in 1482, when Leonardo left for Milan. The metalpoint drawing on pink paper at Windsor (12702) and dating from about 1480–81 demonstrates this interest.[22] Such earlier studies must have prompted a point of departure for Leonardo's compositional approach to the *Last Supper*. Windsor drawing 12703 recto, which shows a kneeling figure sketching or drawing a seated figure, is generally accepted as an indication of Leonardo's preferred medium and graphic style when he was beginning studies for the *Last Supper*.[23]

The importance assigned to this drawing has perhaps been exaggerated recently in the effort to reinstate what seems to be a preparatory drawing (inv. 254) at the Accademia in Venice, connected by technique—red chalk—but certainly not by style or evocative power. The Venice drawing at one point belonged to the artist and scholar Giuseppe Bossi, who first presented it as an original work by Leonardo in 1813. Highly controversial, it has been judged a modern forgery by Pietro Estense Selvatico, Carlo Loeser, Anny Popp, Carl Horst, Anna Maria Brizio, Luisa Cogliati Arano and Hans Ost;[24] while Heinrich Bodmer, Kenneth Clark, Arthur Ewart Popham, the Vinciana Commission (Adolfo Venturi), John Shearman, and, more recently, Carlo Pedretti and Martin Clayton accept it as an autograph drawing. Ost, developing an earlier idea of Giorgio Nicodemi, proposed that Bossi forged the drawing himself.[25]

The drawing is universally deemed to be feeble—but the notes identifying the apostles were written in a left hand that appears to belong to Leonardo. Clark's reluctant acceptance of its authenticity reflects the insurmountable difficulties faced by scholars.[26] In Ludwig H. Heydenreich's opinion (1949), the drawing was produced by one of Leonardo's students, who copied the composition from a prototype by Leonardo or from another *Last Supper*. According to this theory, Leonardo would then have added

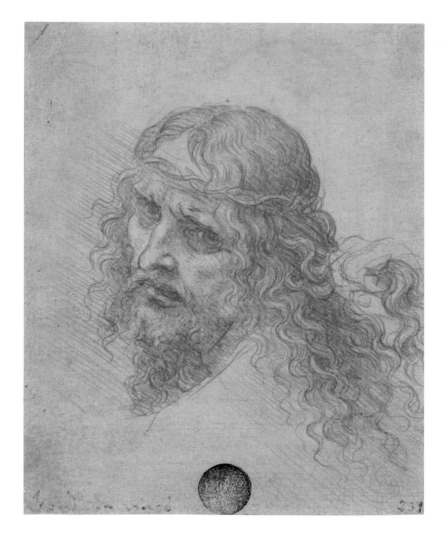

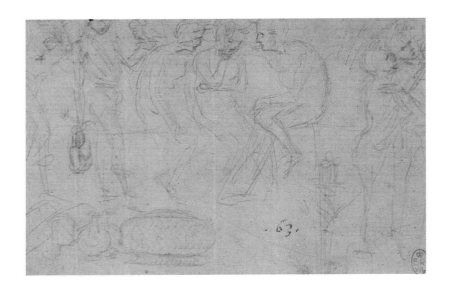

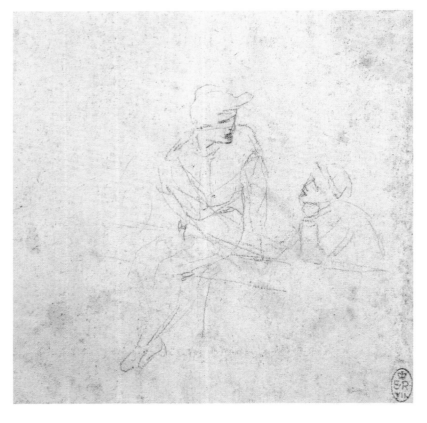

the names of the apostles in his own hand.[27] Pedretti claims to discern a primary faint sketch in Leonardo's hand and, comparing the Venice drawing with Windsor sheet 12703, "the same rapid, light touch of the pencil," which would then have been traced over and altered.[28] Pedretti also questions how a forger in 1813 could have imitated Leonardo's handwriting, faithfully registering the artist's calligraphy and *ductus*. In his opinion, this kind of specific knowledge was impossible in the early nineteenth century, when sheets by Leonardo were not publicly available.[29]

In fact, Bossi possessed a number of Leonardo sheets bearing annotations from the beginning of the 1490s with a *ductus* similar to that of the Venetian sheet depicting the *Last Supper*. Thus we cannot exclude the possibility that he, or some obliging friend, pulled off a deliberate forgery of Leonardo's writing and drawing.[30] Further, the drawing's weakness—completely lacking any of the elements flowing together so harmoniously in the *Last Supper*—should suffice to discredit it. The poorly drawn fingers and inaccurate perspective involved in Judas's placement before the table suggest archaic compositional tastes of the late fifteenth century. Typologies characteristic of Bernardo Zenale (ca. 1450–1526) are apparent, as are elements lifted directly from Ambrogio Bevilacqua's (ca. 1450–1512) paintings, such as the third figure from top right based on an "Eternal Father" replicated many times over by Bevilacqua.

Furthermore, the pastiche at the Accademia in Venice is iconographically weak, involving no revision of local or Florentine traditions. (In the mural, it is clear that Leonardo reconsidered Florentine Last Supper models in his perspective plan and in a few painted details.)

In the end, lacking irrefutable evidence of a cartoon, we must explore the possibility that Leonardo sketched some of his ideas directly on the intonaco of the refectory's north wall. We know this is how he created the retinue in the *Adoration of the Magi,* now at the Uffizi in Florence. The monochromatic but stratified application of paint in the *Adoration* demonstrates that Leonardo could and did alter positions and expressions using his bistre-soaked brush. He had already worked out various solutions in a remarkable series of studies that have luckily survived, unlike the preparatory drawings for the *Last Supper*. Studies for the

Adoration include standing or kneeling figures, skirmishes of intertwining horses and horsemen, a general perspective scheme, anatomical details, and studies for the central group. Absolutely none of the studies is duplicated precisely in the painted version, where everything resembles but also differs from the drawings. The painting itself is a work in progress, a visible rendering of a continuous accumulation of ideas and refinements. An invaluable antecedent to the *Last Supper*, the *Adoration* also represents Leonardo's first application of the innovative principle of transmitting the central event toward the extreme edges of the composition. The *Adoration* is the only precedent that indicates how much has been lost, both of the project and of the studies necessary for Leonardo to confront the complex theme of the *Last Supper*.[31]

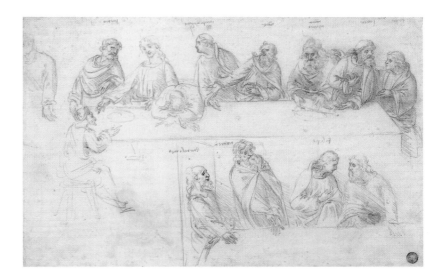

It is likely that Leonardo drew directly on the wall preparation as if he were working on a large panel and that he made a number of sketches and drawings before applying any paint. The recent restoration did, in fact, reveal traces of red chalk laid directly on the intonaco, although in almost imperceptible quantities.[32] The red-earth lines discovered near the figure of Matthew delineate a succession of zigzag lines, perhaps hatching for drapery or the successive emphasis of an outline. Lines incised in the plaster, which advance farther and differ from the successive pictorial application, were revealed when repaint was removed from the upper left part of the wall. The incisions mark the perspective lines of the ceiling and the left wall, as if Leonardo wanted to test directly on the wall the effectiveness of a much more dilated space than he finally adopted.[33] The different arrangement of the coat of arms in the central lunette further confirms that he drew directly on the wall. It follows, then, that Leonardo executed sketches directly on the intonaco and on the preparation layer, and possibly continued to revise all the way up to the final application of paint.

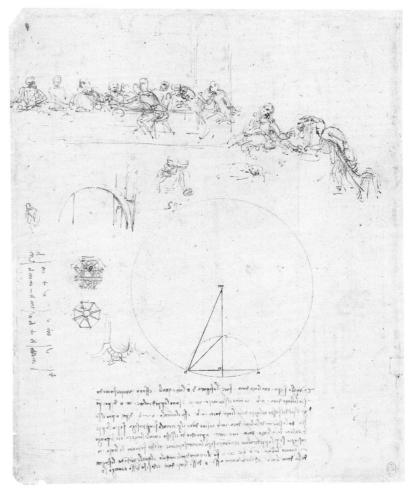

It is just as likely that, excepting the few Leonardo drawings that survive, an entire body of intermediary studies has been lost. Such drawings explain how Leonardo could progress from Windsor drawing 12542, a pen-and-ink study of little more than half the general composition with a few variants, to the head and hand studies for the apos-

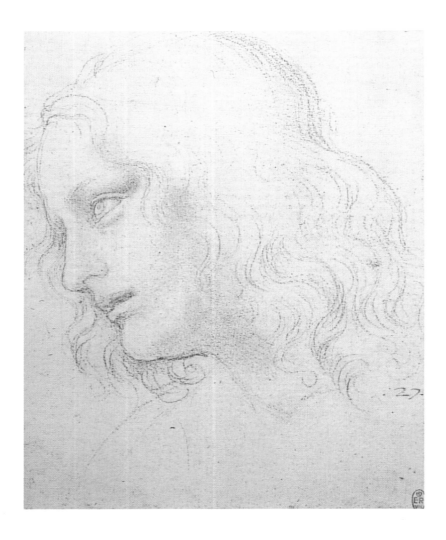

tles, which, though different from the final result, are closer to it.

Still, Windsor drawing 12542 was clearly of capital importance in realizing the *Last Supper*.[34] It includes five figure studies. The largest study at the top shows a grouping of eight or nine apostles with Christ, with Judas seated on the viewer's side of the table. The scene is set against a wall with a row of support arches for a vault. As already noted, the vault must have been conceived as a means of harmonizing the scene with the actual architecture of the refectory. Leonardo's mobile, darting use of pen and ink enlivens the drawing, which is intentionally abbreviated in defining the figures, only barely suggested by a few hatched lines. To the right, the second drawing on the sheet depicts a slightly larger-scale grouping of Christ, John, Peter, and Judas at the moment Christ announces the betrayal and passes the sop to Judas (John 13:21–26). Christ's left arm is represented simultaneously in two different positions like a frame sequence: extended in the act of picking up the bread, and bent in the gesture of handing it to Judas. Judas rises and leans forward to take the bread. The poses of the other two apostles are most unusual: John is almost thrown bodily over the table with Christ's left arm resting on his back; and Peter raises his left hand to his forehead, perhaps incredulous at Christ's revelation. Leonardo manages to give Christ a moving, resigned expression with just a few lines and two or three ink spots. A third figure drawing, just above the circumference of the geometric drawing, tries out the positioning of two embracing apostles, and a fourth figure toward the left margin registers the position of an erect figure in motion as a shorthand sketch.

The rest of the sheet is filled with geometrical and architectural studies. They attest to a coherence in Leonardo's thinking as he set out to illustrate the effect of Christ's words on the apostles, correlating the event to his investigations of mechanics, acoustics, and "reflected" motion. His motion studies ranged from the spread of visual "flares" and sound to the diffusion of waves caused by a pebble dropped in a pond. He had already examined these subjects by the time he wrote MS C of Paris, fol. 16 recto:

> I say that the sound of the echo is reflected to the ear
> from the percussion, just as the shapes of the objects

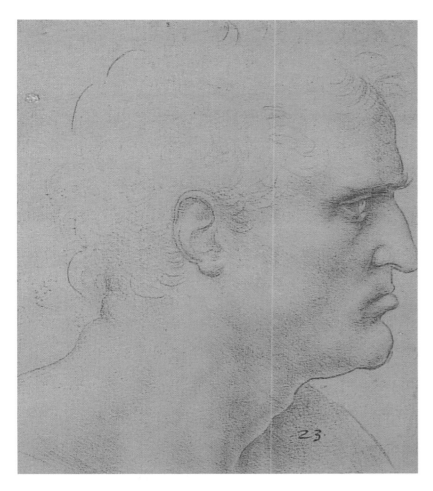

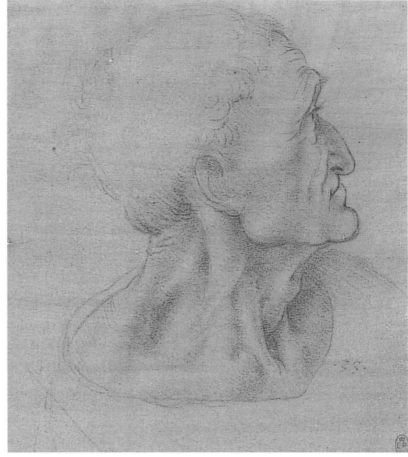

are reflected from the mirror into the eye. And as the likeness is reflected from the object into the mirror and from the mirror to the eye at equal angles, so sound will also fall and be reflected at equal angles as it passes from the original percussion into the concavity and travels out to meet the ear.[35]

The annotations on sheet 1041 of Codex Atlanticus (ex 373 recto b) date from the same time, around 1490: "When a stone hits the surface of the water, it causes circles around itself, which spread until they disappear; and also air, struck by a voice or loud noise, similarly moves out in a circle and disappears, so he who is nearest hears best and he who is far hears nothing." Even better than Leonardo's notes (in the Forster Codex) on the positions of the individual apostles, this text seems to describe both the general meaning of the composition and the first studies on Windsor sheet 12542. Like the painting, the studies on sheet 12542 can be interpreted as the diagrammatic representation of an acoustic phenomenon or a law of mechanics.[36] The series of numbers along the left edge of the sheet has been thought to refer to a system of proportions used by Leonardo in planning the background of the *Last Supper*, but Pedretti has disproved the theory. In fact, it is a record of expenses, common to many other sheets in the Codex Atlanticus during this period.[37]

The value of Windsor drawing 12542, which dates to just before 1495, is manifold. From an iconographic point of view, it documents how Leonardo initially functioned within the fourteenth- and fifteenth-century Italian tradition, and was particularly inspired by the Florentine model. (Other references to Florentine Last Suppers are examined in section IV.) More importantly, it demonstrates that Leonardo considered his artistic studies and "proposals" connected to his scientific inquiry, the ultimate goal of which was the complete understanding of phenomena represented pictorially.

That Leonardo took the strict observation of nature as his starting point in executing the *Last Supper* is confirmed by two other studies in the Royal Library at Windsor Castle. The amazing sheets 12551 and 12552 show preliminary sketches of the heads of Philip and James Major. Indis-

[upper]
Copies of Leonardo, Head of Simon.
Windsor Castle, Royal Collection (nos.
12550 and 12549).

[bottom]
Leonardo, Study for the Hands of John.
Windsor Castle, Royal Collection (no.
12543).

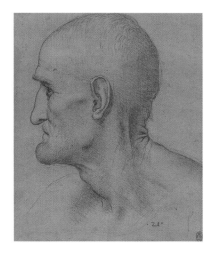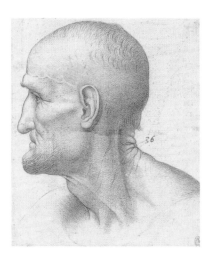

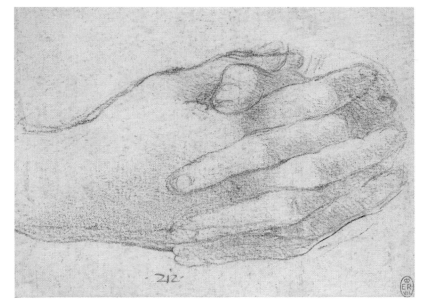

putably authentic,[38] these two drawings do not correspond to the "excellent and miraculous" heads done in colored pastels on paper seen and perhaps owned by Lomazzo. Both were executed on white paper, the first in charcoal, the second in red pencil. The second drawing is flanked by four pen-and-ink architectural studies, perhaps for Castello Sforzesco. Furthermore, the two heads were not precisely transposed to the painted composition. In the painting Philip is represented with foreshortened head, lower forehead, fuller lips, the left temple more exposed to the light, and a broader neck free of the hair almost covering it in the drawing. His expression is more rapt in the drawing, as if overcome by an ecstatic vision (foreshadowing Raphael's typologies and expressions—for example, *Saint Cecilia* now in the Pinacoteca di Bologna; even the "style" anticipates Raphael's late style). In the mural Philip's expression, admirably recovered by Pinin Brambilla Barcilon's recent restoration, is moving and sorrowful.

Even greater disparities exist between the study for the head of James Major and the painted version. The attentive, watchful expression of the figure in the drawing becomes one of great indignation in the painting. A search for more subtle modifications reveals a marked inclination forward in the posture in the drawing, which has been amended to an almost vertical position in the painting. In the drawing the figure lacks a beard and has shorter hair. Although both versions are marked by a strongly plastic sense of form and chiaroscuro (with shadows concentrated in the orbital cavities and the mouth), in the end it is clear that the drawing represents a "state of mind" different from that of the painted figure. In the drawing, the figure also lifts his left hand close to the chest, but does not hold up his garment. The gesture suggests instead a position for playing a stringed instrument. Because it is a left hand, some think it a self-portrait of Leonardo singing and playing.[39] On close examination, however, the marvelously animated head recalls the nervous, lean features of the figure Leonardo painted in *Portrait of a Musician* at the Pinacoteca Ambrosiana. The model was most likely Leonardo's friend Atalante Migliorotti.[40]

Therefore, it seems reasonable that the two Windsor drawings (12551 and 12552) are studies from life, allowing

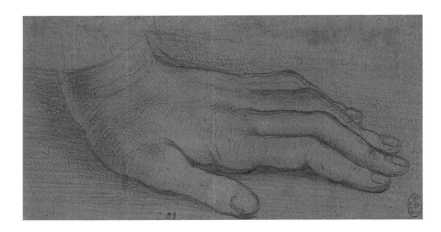

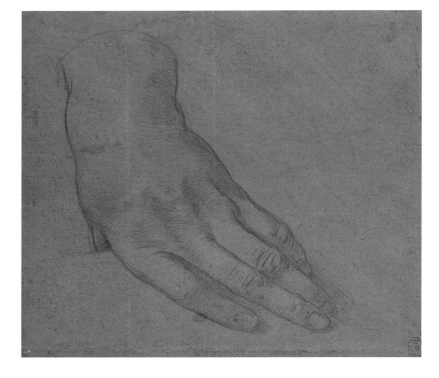

us to speculate that Leonardo executed similar studies for each head and figure in the *Last Supper* and then adapted them as needed to create compelling characterizations of the different apostles. James Major, for example, appears older in the painting than in the Windsor drawing.

The legend that Leonardo left Christ's face incomplete (the recent restoration revealed that it was highly finished) was first recounted by Vasari. Poor condition could have inspired the story, as could the difficulty of finding a sufficiently beautiful and dignified model. Lomazzo, in fact, wrote that Bernardo Zenale reproached Leonardo for making the heads of the two Jameses so handsome and divine that he would be unable to surpass himself in rendering the face of Christ. Vincente Carducho (1576–1638) repeated the story in 1633.[41] In any event, according to his own notes, Leonardo hoped to execute a portrait study of "the young count, the one attached to Cardinal del Mortaro" for the purpose, and wanted to use Alessandro Carissimi of Parma as the model for Christ's hand.[42] Further evidence that the heads of the apostles should be regarded as portraits "from life" comes from Antonio de Beatis, secretary to Cardinal Luigi d'Aragona. Beatis is such an old and reliable source that he may have been quoting Leonardo directly when, in 1517, he stated that the artist had portrayed important members of the Sforza court in the *Last Supper*: "Its figures are portraits from life of several people of very high stature from the Court and Milan of that period."[43] From this we may surmise that a regrettably large amount of preliminary work has been lost.

Nevertheless, to propose that Leonardo was painting actual portraits from life is not entirely correct. The recent restoration revealed Matthew's head to be a profile *all'antica* of idealized and stunning beauty. Should it be considered a portrait? More likely, Leonardo used his studies "from life" as points of departure for the codification of "types" or "genres," which he then applied impartially to subjects as needed. The birth of the caricature and grotesque genres during this period gives added weight to this theory.[44]

The Royal Collection at Windsor Castle holds a group of drawings related to the heads of the apostles in the *Last Supper*. Sheet 12548 shows a head in right profile tradi-

tionally associated with Bartholomew, the first apostle from the left, or sometimes with Matthew. The drawing is executed in red pencil on prepared red paper, with a delicate line that moves from left to right. Richter, Berenson, Clark, Popham, and Brizio judged it original, while recently Pedretti downgraded it to a copy executed in Leonardo's workshop around 1510.[45] Windsor study 12547, previously considered a preparatory study for the head of Judas (or at times an autograph drawing traced over by a student) was likewise downgraded. It, too, is executed in red chalk on prepared red paper, prompting a recent theory that it is by Francesco Melzi, given its hesitancy, anatomical inaccuracies, and affinity to the *Foot* attributed to Melzi in the Resta Codex (now in the Biblioteca Ambrosiana).[46] More recently Martin Clayton reattributed the *Head of Judas* to Leonardo,[47] and I believe the *Head of Bartholomew* (12548) should be likewise reinstated. It cannot belong to the series at Windsor Castle that includes two drawings titled *Head of Simon* (nos. 12550 and 12549), one on prepared red paper and the other on white paper, which are unquestionably copies after a lost original by Leonardo and manifest the typical hand of a copyist. In contrast, Windsor drawing 12548 exhibits a delicate, soft touch very different from Melzi's copies of 1510–11.[48]

Leonardo's privileged medium during this period was black chalk on white paper. There are at least two other autograph studies in the Windsor Castle collections: the *Hands of John*, no. 12543, and the *Right Arm of Peter*, no. 12546. (The *Left Hand of Bartholomew* on sheet 12544 and the *Left Hand of Thomas* on sheet 12545 are both copies. The recent restoration revealed Thomas's left hand in the mural; during an earlier restoration, it had been obscured beneath the painted likeness of a piece of bread.) Leonardo's use of charcoal heightened with lead white allowed him to achieve extraordinarily soft, subtle chiaroscuro passages in the *Right Arm of Peter*, anticipating the later studies for *Saint Anne,* also at Windsor Castle. Here, however, the definition of Peter's right hand shows the same rapid, synthetic stroke already noted in the right hand of the "portrait from life" on sheet 12552 (supposedly a portrait of Atalante Migliorotti used for James Major), seeming to confirm 1495–96 as the date of this drawing.

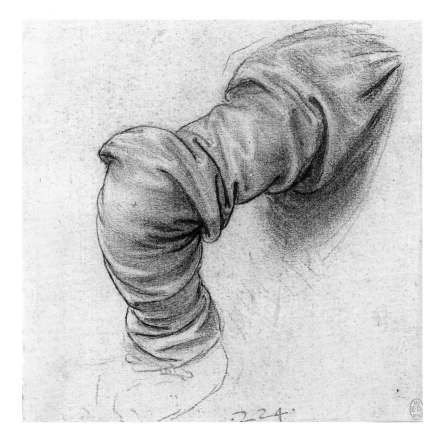

The *Right Foot of Christ,* a final drawing at Windsor (sheet RL12635 recto) allegedly by Leonardo using red chalk on pale rose-colored paper, corresponds to the lower portion of the painting that was lost when the door between the refectory and the kitchen was enlarged in 1652. The drawing is extremely important because it is a study "from life" concerning the anatomical proportions of a seemingly insignificant detail, and because the area below the table has proved to be one of the most damaged areas of the entire painting. (The oldest copies, such as the one now at Magdalen College in Oxford, faithfully reproduce Christ's lost feet.) Leonardo's method of drawing the *Right Foot of Christ* is similar to the drafting system he used to study proportions of the human body during these years, possibly also related to his method for drawing ancient monuments and sculpture.[49]

This study also suggests that other drawings by Leonardo of anatomical details related to the figures in the *Last Supper* once existed. All of the studies for the apostles' feet and almost all of those relating to the hands are missing. It is possible that these anatomical studies were used to train Lombard artists as early as the sixteenth cen-

tury. The practical use of old master drawings may account in part for the loss of many preparatory drawings for the *Last Supper*. At the Accademia di Brera, I recognized the hand of Leonardo's pupil Cesare da Sesto (1477–1523) on a recently rediscovered and unpublished sheet of drawings (kindly shown to me by Francesca Valli). Among other studies of feet, it reproduces a right foot from the identical view as drawing RL12635 at Windsor Castle. Such studies, attributed to Leonardo's best students, in turn were used as study models from the late seventeenth through nineteenth centuries to teach figure drawing at the Accademia di Brera. This practice echoes the method used by Leonardo to teach apprentices in his workshop (which he sometimes referred to, in more high-sounding terms, as the "Achademia Leonardi Vinci"). According to his notes collected in *Trattato della Pittura,* the *putto pittore* (apprentice) setting out to learn the craft should first study "the drawings of good masters" and then copy "from life." It further suggests that, in Milan, a pedagogical continuum extended from Leonardo down through the nineteenth century, accompanied by a continual consumption of drawings "after the master."[50]

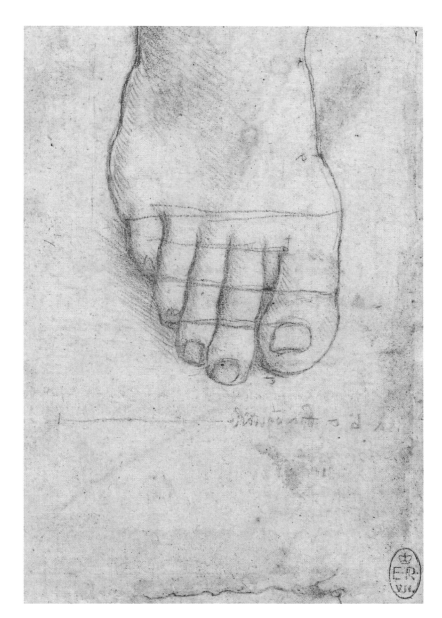

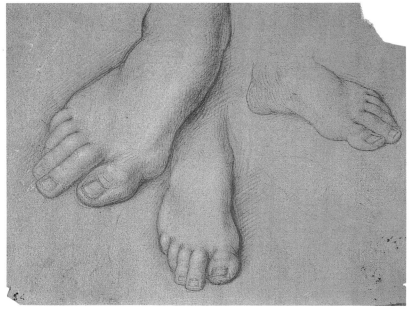

[upper]
Leonardo, presumed to be a Study for the Right Foot of Christ. Windsor Castle, Royal Collection (no. 12635r).

[lower]
Cesare da Sesto, Study of Feet. Milan, Accademia di Brera.

III

Old and Modern Accounts of the Last Supper's Deterioration and Restoration through Pellicioli

Each generation has its own perspective on things of the past; and there is no better example than the *Last Supper* and its many restorations. Each restorer has reclaimed the image differently, each bringing to the task different goals according to his or her own historical moment.

The *Last Supper* has been the subject of eight documented restorations, including the most recent one completed in 1997. There have been a number of undocumented interventions as well. Giuseppe Appiani of Monza allegedly restored the work in 1802 and 1807, although the effects cannot be verified. Two heads were cleaned with disastrous results in 1821, supposedly by two professors from the Accademia di Brera. In addition, several very early interventions were never reported.

Almost every restoration of the *Last Supper* has been undertaken with the purpose of "returning" the painting to its original splendor, "resurrecting" it from certain death, or "saving" it forever and assuring it to posterity by halting its physical deterioration.[1] Such motivations are legitimate and arise from the desire to reach back through the centuries and reclaim Leonardo's masterpiece by "restoring" it or, in the idiom of artist-restorers from the sixteenth to eighteenth centuries, by "repainting it." Since the end of the nineteenth century, even photographers have routinely "updated" the comprehensive image of the *Last Supper* by altering and retouching their plates and negatives. The resulting prints disseminate a distorted image, as retouches to the negatives have added even more layers to the repaints that cover the original work.[2] This false image of the *Last Supper* accounts for much of the public's discomfort with the painting's incompleteness after the recent restoration, which, ironically, has been accused of removing original paint actually lost centuries ago.[3]

Each restoration has been conducted at a unique moment in time. Merely putting the sequence of restorations in chronological order without a context tells us little, except that each generation has been concerned about the mural's

condition. Because restoration is always a critical act, it is fruitful to examine the motivations for the previous interventions on Leonardo's masterpiece according to the tastes, politics, and critical methods of the time.[4]

In *Leonardi Vincii Vita*, published in 1546 but compiled around 1525–27, historian and physician Paolo Giovio (1486–1552) did not mention any sign of deterioration in the painting, though he had probably gathered his information in Milan as early as 1510, or in Rome around 1513–14, when he may even have met Leonardo. (Giovio also refers to the French king Louis XII's intention to remove the painting from the wall and transfer it to France.)[5] And the oldest known copies, one by Marco d'Oggiono at the Girolomini Convent at Castellazzo (but destroyed in 1943) and another attributed to the same artist and now at the Musée de la Renaissance in Écouen, betrayed no particular signs of damage between the first and second decades of the sixteenth century. However, deterioration had certainly commenced by 1517, when Beatis declared that the painting "already begins to spoil."[6]

Vasari, who visited Milan in 1566, wrote that the *Last Supper* had been "reduced to such a condition that there is nothing to be seen but a mass of confusion [una macchia abbagliata]".[7]

And around the time of Vasari's visit, Lomazzo stated flatly that "the painting is completely ruined."[8] Lomazzo went blind in 1570, so the account probably dates to a time when he could have examined the work firsthand, perhaps to 1561 when he was painting a fresco copy of the *Last Supper* in the convent of Santa Maria della Pace. Of course he may have based his pronouncement on the testimony of others, after he lost his sight.

Lomazzo makes even more drastic comments about the painting's condition. Blaming Leonardo's oil technique for the deterioration, he declares it to be already lost, lamenting, "that was one of the marvelous works of painting ever made at any time by any painter, in oil, which was the method of painting used so inventively in that period by Jean de Bruges."[9] And in *Idea del Tempio della Pittura*, published in 1590, Lomazzo calls the figures of the *Last Supper* "ruined because of the imprimatura [Leonardo] applied below."[10]

References to the painting's poor condition increase around the middle of the sixteenth century. Even Giovanni Battisti Armenini, who had seen the *Last Supper* around 1546–47, remembered in 1587 an "oil painting on the wall . . . then half ruined, which nevertheless seemed to me a very great miracle."[11] Paolo Morigia (1525–1604) declared it in 1592 to be "largely ruined."[12]

In his *Musaeum* (1625), Cardinal Federico Borromeo called the painting a "reliquiae fugientes," a statement that confirms the sacrality of those meager remains but also implies that little but fragments remained.[13] Whether the painting survived as remains, traces, or *reliquie*, it was already so compromised by 1612–13 that the good cardinal commissioned Andrea Bianchi, called Il Vespino, to make a copy. The cardinal deemed it important to copy the painting for its historical information,[14] and Il Vespino's copy represents the first attempt to fix the fast-disappearing image in a sort of "freeze frame." The inscription he placed at top left, "RELIQVIAE COENACVLI FVGIENTES HAC TABVLA EXCEPTAE SVNT VT CONSERVARETVR LEONARDI OPVS," indeed perfectly clarifies the copy's purpose: to conserve the unique and unrepeatable "invention" of Leonardo's work.

Cardinal Borromeo's concern for safeguarding the *Last Supper* coincided with a period of cultural reawakening in Milan in the early seventeenth century, with Federico as its architect. Patron, collector, and founder of the Biblioteca Ambrosiana, Federico witnessed not only the climax of a local artistic renaissance but also the recovery of Leonardo's heritage by artists and collectors. The greatest artists of the time—including Giovanni Battista Crespi (called Cerano), Giulio Cesare Procaccini, Caravaggio, and Tanzio da Varallo—turned to Leonardo not only for visual models and motifs but also for theoretical inspiration.[15]

Accounts of the painting's deterioration continued during the first half of the seventeenth century. They included the often-forgotten account by Don Ambrogio Mazenta, circa 1635: "This precious ideal is ruined, because it was painted in oil on a damp wall."[16] Francesco Scannelli in 1657 remarked that the figures were not even recognizable. Agostino Santagostino declared in 1671 that "the passage of time has drained it . . . the eye can enjoy very little of it," and in 1672 Pietro Paolo Bosca blamed the refectory's

excessive humidity for the painting's ruin. In 1674 Carlo Torre provided a moving image—equating the *Last Supper* to "a sun in the last hours of the day, whose falling rays, if they do not appear resplendent, at least give notice of having been the brightest; one still sees vivid expressions, boldly foreshortened figures, resplendent colors, and marvelously well-drawn poses."[17]

The sequence of these testimonies[18] suggests that the painting was not restored between 1517 and 1671, contrary to recent theories.[19] The only artist who had the opportunity before 1570 was Lomazzo, who made the copy for the convent of Santa Maria della Pace in 1561, and to whom Mazenta attributes another copy of the *Last Supper* in the Gerolamini convent at Castellazzo, both now lost.[20] But surely if Lomazzo had intervened there would exist some account of it. Il Vespino's copy of 1612–13 at the Pinacoteca Ambrosiana renders Christ and the apostles only to the waist, as the middle and lower portions were perhaps already too ruined to be copied. Furthermore, his copy displays darkened tones and colors and a table bare of objects, suggesting that the original work's legibility was by then seriously compromised.[21] Torre's comment remains the single exception in an otherwise dismal litany of reports on the painting's condition. After comparing the painting to a setting sun, he still sees "vivid expressions" (illegible to Scanello in 1657) and "resplendent colors" ("una macchia abblagiata" to Vasari in 1566), suggesting that some touching up occurred in the 1670s. At the far left of the composition, heavy oil repaint found on Bartholomew's green mantle could in fact date from this period.

The illustrious masterpiece fell into a period of neglect for more than a century after Cardinal Borromeo's efforts. It was largely ignored by the Milanese[22] until they experienced a jolt of shame when the elder and younger Jonathon Richardsons visited in 1720, and François-Maximilien Misson about the same time. In fact, the first documented restoration was undertaken after these men published reports on the painting's condition in 1722. These visitors are frequently cited in discussions about the painting's poor condition (according to the Richardsons, the painting was a complete loss to the left of Christ, where "only the bare wall is left," while Misson found the painting "so black and

ruined"),[23] but they are never directly credited with spurring the restoration. However, after they complained to the monastery's prior, or perhaps in response to their reports, Father Tommaso Bonaventura Boldi agreed in 1726 to Michelangelo Bellotti's proposal to restore the painting. Bellotti declared that he possessed "a secret to help draw out the eclipsed painting."[24] Nevertheless, his "restoration" was a far cry from a simple repair, and to expert eyes it looked more like a complete pictorial reconstruction. Such was the opinion expressed by Charles-Marie de la Condamine in 1757, by Domenico Pino later, and, in self-defense, by Giuseppe Mazza, the next restorer to work on the painting.

In 1787 Carlo Bianconi declared that the painting had been "certainly washed with corrosives and then repainted, making it seem almost like new." The artist and critic Giuseppe Bossi reached the same conclusion, as did Pinin Brambilla Barcilon when she examined the painting before removing Bellotti's intervention on the three figures to the far right (which Giuseppe Mazza did not repaint in 1770). Nevertheless, Bellotti's unfortunate restoration also had its admirers. The writer Serviliano Latuada praised it,[25] as did Francesco Bartoli, who wrote in 1776,

> This colored mural of such great age was almost lost; which is why the Fathers, no longer heeding it, showed no regard in enlarging the door, in cutting off the feet with the wall, and the legs of the Redeemer's body, located above this door. *Despite this misfortune, the painter Michel'Angelo Bellotti, revived this painting with his special secret, and made it as admirable, as beautiful as it once was.*[26]

The ravages of time and Bellotti's repainting must have convinced academics around the mid–eighteenth century that the "perfection" and "beauty" of Leonardo's painting would remain obscured unless one sought to reclaim it using an approach that was both reconstructive and interpretive. In 1769, Francesco Maria Gallarati set about writing a descriptive essay on the *Last Supper*, now preserved in manuscript in the Biblioteca Ambrosiana. He declared the painting the "ornament and splendor of our city" and called his own "miniature" reconstruction "not how it appears at pre-

sent, being damaged . . . but how it must have been at first." He applied a reconstructive method that betrays a familiarity with the work of the prominent German archaeologist and art historian Johann Joachim Winckelman (1717–68).[27]

Giuseppe Mazza's 1770 restoration of the *Last Supper* should be evaluated within this context and perhaps also in relation to La Condamine's criticisms. Above all, it should be explored in view of the cultural and artistic fervor that had overtaken Milan. The city was enjoying a period of enlightened growth under the Austrians, who had taken control of Milan in 1706.[28] Projects initiated during this time included the Biblioteca Braidense in 1770 and the Accademia di Belle Arti di Brera in 1776, as well as the Teatro alla Scala.[29]

As to the *Last Supper*, Bellotti's repaint had not remedied the deterioration, and the painting had begun to "come apart and seriously suffer." Acting on behalf of the Austrian government, Count Carlo Firmian intervened by asking the monastery's prior, Giacinto Cattaneo, to allow the painter Giuseppe Mazza to "repair" the work. Count Firmian was a prominent figure in Austrian Milan, and an art collector and friend of Winckelmann.

As Bossi relates, Father Cattaneo " obsequiously" complied with the count's request. But, fortunately for the painting, Cattaneo was summoned to Turin to teach theology, and the new prior, Paolo Galloni, examined "the repaired *Last Supper* with a painter's eye" and called a stop to Mazza's work, preventing him from meddling with the figures of Matthew, Thaddeus, and Simon at the far right.[30]

In fact, Mazza had already been criticized by the English painter James Barry. Barry ran into Mazza when he climbed the scaffolding to view the repainting in progress. Mazza confirmed that the work had been done on Count Firmian's orders, adding "that the color of the new work was still faint, and that . . . [he himself] intended to go over it again completely."

Firmian's motivation for promoting a new "restoration" of the *Last Supper* foreshadows the way in which Napoleon and his administrators put the painting to political use thirty years later. To Mazza, and certainly to Firmian, "artistically

restoring" or "repairing" the *Last Supper* meant rescuing the precious painting from Bellotti's repaint. The "civic" value of this operation would further have distinguished not only the Milanese, but Firmian.

A copy of the *Last Supper* made by Giovan Battista Bianchi in 1791[31] should reflect the way Leonardo's composition looked after Mazza's intervention. Bianchi's copy is particularly interesting because of its cool tonality and colors, although possibly he based his copy on a print, perhaps André Dutertre's of 1789.

Napoleon's admiration for the masterpiece testifies to a newfound significance assigned to the *Last Supper*. Giuseppe Bossi wrote in 1810:

> In 1796 when the French army emerged victorious in Lombardy, the young General Bonaparte, who henceforth was striving to build the empire, was attracted by Leonardo's fame and visited the *Last Supper*. He ordered that it be respected and not be used as lodging for troops or damaged in any other way. And he issued it as a decree, which he signed upon his knee before remounting his horse; there were various people present, including Father Porro to whom I owe this account.[32]

When Napoleon visited the refectory in 1796, artistic taste was veering noticeably toward an academic recuperation of classical art. Leonardo's *Last Supper* was certainly already regarded, conserved, and interpreted as one of the greatest accomplishments in Renaissance art and a model for the neoclassical order then in ascendance.[33]

Carlo Giuseppe Gerli launched the idea that Leonardo was the supreme "classical" artist with his engraved "translations" of Leonardo's drawings. Published in Milan in 1784 with an introduction by Carlo Amoretti,[34] their purpose was to glorify Leonardo and Milan, the city that was home to his drawings.[35]

Leonardo's prominence continued to spread as engravings of the *Last Supper* were published, including the one by Domenico Aspari in 1780 (discussed in section II) and another by André Dutertre in 1789.[36] However, the artist's consecration as the supreme representative of classical painting came upon the publication of the Florentine

Francesco Bartolozzi's (1727–1815) extraordinary stipple etchings after Leonardo's drawings in England, which were executed for John Chamberlaine in 1796–97.[37]

Raffaello Morghen, commissioned by Ferdinand III, grand duke of Tuscany, made an engraving in 1797–1800 after a drawing by Teodoro Matteini (1754–1831) of the original painting or possibly of a painted copy.[38] Bossi criticized Morghen's engraving: "[R]egretfully there is no expression of Leonardo's character in this illustrious print." Nevertheless, Morghen's engraving should convey a relatively faithful image of the original's dreadful state after Mazza's intervention, while Aspari's, as noted in section II, is based on an earlier drawing. Both engravings imply that their artists were not able to refer directly to Leonardo's painting and needed an intermediary work—Matteini's drawing or a supposed "original drawing," as in the case of Aspari.

The years 1796–99 were crucial to the birth of the Cisalpine Republic and the destiny of Milan as well as to the critical fortunes of Leonardo's work. The thirteen codices, Leonardo's manuscripts, were removed from the Biblioteca Ambrosiana in 1796 with Napoleon's consent and sent to Paris to be studied by Giovan Battista Venturi (1746–1822). The following year Venturi published *Essai sur les ouvrages physyco-mathématiques de Léonard de Vinci*, a milestone in the study of the manuscripts.[39] It earned the author an audience with Napoleon in Milan that same year and, four years later, a position in the Republic's diplomatic corps.[40]

Enduring further indignities at the hands of occupying French troops (unfortunately the Napoleonic decree of 1796 was not observed), Leonardo's *Last Supper* continued to arouse grave concerns. A little-known account by Antonio Mussi (author of *Discorso sulle arti del disegno*, published in Pavia in 1798, and owner of Leonardo's study for the *Head of Christ*, now at the Pinacoteca di Brera) declared the *Last Supper* in 1798 to be "ruined by time and new brushes."[41] Bossi, who probably examined the work firsthand, related that "the refectory having served as warehouse or haymow, always in military use, even though after Mazza there was no enemy to fear, the *Last Supper* nevertheless continued to be damaged, even by powerful blows from

slabs leaned against the figures, which left traces that are still visible."

The conditions at the church and refectory of Santa Maria delle Grazie were so poor that the painter Giuliano Traballesi complained that "because the painting has in great part separated from the wall, it is barely holding together."[42] His appeal was heard, and the entrance to the refectory was walled up.[43] The Napoleonic government decided to act in order to preserve Leonardo's masterpiece. Andrea Appiani (1754–1817), the leading Lombard neoclassical artist and court painter to Napoleon in Milan, was invited to submit a restoration "proposal" for the *Last Supper*. After a site inspection on 14 August 1802 and fretting over the humidity in the refectory, Appiani wrote:

In response to the invitation received from Honorable Citizen Minister marked 12 July 1802, the first year of the Italian Republic, upon the request of architect Barbigli. Having gone to the former monastery of Santa Maria delle Grazie of Milan to examine the actual state of the *Last Supper*, painted in oil on the wall by the divine Leonardo da Vinci, I was forced to recognize with real regret that this work is quite damaged, as the place was used as barracks for troops, and only slightly or not at all protected from the ravages of time, which has caused not only the loss of color, but also a general cracking, so that the slightest bump causes the precious fragments to rain down. To this situation, we add the effects of vandalistic hands, which have dealt blows with bricks to the above-mentioned painting. In order to prevent [further damage], the entrance of said place was walled up, which means that the many foreigners who continually want to admire such an illustrious example of pictorial art enter by means of a hand ladder, and use the same means to approach and observe the beauties of the work from up close, and consequently lean against the painting, causing continued detriment. As the troops were no longer there, I decided to install a door with the appropriate locks and to order the custodian of the place to remove any kind of ladder; furthermore I ordered him to observe dili-

gently in order to determine the source of the humidity to which [the painting] is subjected. Next, I believe that with much effort and expertise, not only can the actual painting be saved from further ruin, an enormous loss and one damaging to the fine arts and dishonorable to the nation, but its state greatly improved. Because this painting, in my opinion, cannot be transported, it would be best to save the work, and not only to defend the place against the ravages of time, but also to create surroundings worthy of the work, which would demonstrate to all the genius of a government and a nation that knows how to recognize and appreciate the arts, which have always held the most important position in our Italy.[44]

The minister of the interior responded by letter on 23 September 1802:

The glory of the nation demands that the famous Last Supper by Leonardo be conserved if possible, and that every means be employed to impede further damage, as unfortunately until now it has suffered gravely. We would like for you to assume the task of restoring the parts of the painting that are noticeably damaged. In any case, kindly also propose the means you think appropriate to conserve the other, fortunately unharmed, parts. At the same time, please present a project indicating the actual cost, the best way to use the building where the painting is found, so that it serves as the means for admiring such a celebrated work. I invite you at the same time to suggest a decent, simple decoration [of the building].[45]

And so, responsibility for the care and veneration of the masterpiece fell to Appiani, whose profound admiration for Leonardo illustrates how highly Leonardo was regarded in neoclassical circles.[46]

Andrea Appiani proposed that Giuseppe Appiani from Monza be placed in charge of the restoration work. Mention of a restoration by Giuseppe Appiani is again made in a letter dated 27 April 1807 from Eugène Beauharnais, Napoleon's stepson and viceroy of Italy as well as a connoisseur and collector of Leonardo's work. Beauharnais had commissioned Giacomo Raffaelli (in a decree of 24 April 1807) to create a mosaic copy of the *Last Supper*, and in his letter he refers "to less costly measures, which I would devise with Monsieur Appiani for the restoration of this celebrated painting."[47]

A letter dated 2 September of the same year from the minister of the interior to the viceroy gives an account of repairs done in the refectory to accommodate Giuseppe Bossi, a student of Andrea Appiani, who was commissioned to create the preparatory cartoon for the mosaic. It also mentions an inscription planned to celebrate the mosaic's realization and implies that the restoration of the painting was the least of the government's worries: "The daubs of this work still have to be repaired and secured: Monsieur Appiani is seeing to it, and is having it done by the restorer Monsieur Appiani of Monza."[48]

Andrea Appiani's efforts paved the way for Giuseppe Bossi, who, in his book on the *Last Supper*, never mentioned Appiani's role in safeguarding the painting. Bossi was committed to establishing a theoretical language deriving from Leonardo's *Paragone*, and beyond that to collecting historical information on the artist and the *Last Supper*.[49] Bossi was supported in his endeavors by Francesco Melzi d'Eril, a former advisor to Napoleon and descendant of Francesco Melzi, one of Leonardo's most noted students and heirs. Bossi played an essential role in the valorization of Leonardo as the "glory" of Lombard art, even if the *Last Supper*'s preservation and conservation seem a vehicle for his personal ambitions. Bossi turned the execution of a mosaic copy of the *Last Supper* for the viceroy to his own advantage. Once in control of the refectory, Bossi had several windows walled up, had scaffolding built in front of the painting, and had a portion of the wall under the painting—"the remnant of a scarp wall that juts out more than the upper part where said painting is"—removed, refilled, and stabilized. He also had a large heater brought into the room, with easily imagined consequences to the painting.[50] Bossi's reference to a projection clarifies the recent restoration's discovery of the traces of a brick torus molding, recovered below the lower edge of the painting and originally intended to provide a three-dimensional conclusion to the lower part of the composition and enhance the scenographic effect.

Bossi was completely absorbed in creating a full-scale copy of the painting that would be defined today as a "line relief" or "tracing." It was largely based on the copy at the Gerolamini convent at Castellazzo, now, unfortunately, lost, but known from an archive photograph. Bossi, in his proposal of 27 April 1807, seems to have intentionally exaggerated the poor condition of Leonardo's painting in order to demonstrate his ability to "bring back" the lost masterpiece through his own art. Bossi declares that he "will consult every other work that he can find by the artist, with the aim of *restoring* to the best of his knowledge in an analogous style what is *absolutely lost* in the original."[51] Bossi's tracings of the copy at Castellazzo are now in the Weimar Schlossmuseum,[52] and are important because they demonstrate the academic rigidity, typical of the time, imposed on Leonardo's style. Bossi's monumental *Del Cenacolo di Leonardo da Vinci Libri Quattro*, printed in 1810, contains precious observations on Leonardo and on the copies that Bossi examined, but it also reflects that same inflexibility.[53]

Bossi's method of studying and copying the copies in order to reconstruct the damaged masterpiece was harshly criticized by Ugo Foscolo and Carlo Verri. In 1812 Verri questioned the reliability of the copies in principle, maintaining that none had ever managed "to represent the original's style of painting and practical execution; and that is what is mourned as lost." He believed that studying the prints offered insight only into the composition and criticized Bossi for examining the original only after he had formulated a cartoon based on the copies. Leopoldo Cicognara, however, the period's greatest exponent of classical taste, considered Bossi's copy a "very scholarly, careful and correct work." In 1809, Cicognara had given an exaggerated account of the condition of the *Last Supper*, saying that "one can barely see the few spoiled remains of the brutalities and ravages of inferior skill and time."[54]

The French writer Stendhal also owned a copy of Bossi's eminently useful volume. His annotated copy, which is often critical of its author, is now in the Raccolta Vinciana at Milan's Castello Sforzesco.[55] It shows that a visit to Leonardo's *Last Supper* was considered de rigueur for European travelers and that Milan and its culture were held in high esteem. Goethe would make the requisite pilgrimage during the same period.[56]

A vast surge in studies on Leonardo and his *Last Supper* appeared between the last decade of the eighteenth century and the first two decades of the nineteenth century. It was generated by a renewed interest in the High Renaissance and the desire to lay the foundations of a history of Lombard art that would include the masters of the Accademia di Brera. The Accademia, in fact, was the driving force behind this project, with Francesco Albuzio as its self-appointed promoter.[57] Giuseppe Zanoja, who succeeded Bossi as director of the Accademia in 1815, actually located the origins of Milan's Accademia in the imaginary "Achademia Leonardi Vinci."[58] Zanoja's tenure coincided with a period of renewed interest in restoration, which, along with widespread concern over the deterioration of the *Last Supper* following the French occupation, were the driving forces behind Stefano Barezzi's attempt to save the painting between 1819 and 1821.

The arrival of the mosaic copy in Vienna in 1818 aroused the concerns (or ambitions) of Count Saurau, and consequently those of Count Strassoldo, president of the Royal Imperial Government of Lombardy. On 28 October 1819, Strassoldo wrote to the Accademia di Belle Art di Brera:

> The best conservation of Leonardo's *Last Supper* has, from a distance, attracted the concern of the count of Saurau, who advises that a sheet of glass might be of use in protecting the painting. The Accademia will give me its opinion of this expedient and will advise of the requirements it deems most suitable to arrest the deterioration of this masterpiece.[59]

The Accademia was convinced that the wall's humidity was the primary cause of the painting's deterioration (as Appiani had suggested), and therefore considered the suggestion unsuitable. Nevertheless, it resolved to stop the deterioration. The same year, the painter Stefano Barezzi submitted a proposal to transfer the fresco to canvases or panels. Favorable to the idea, the Accademia advised Barezzi to test the method on the frescoes at Santa Maria della Pace,[60] and on 6 September 1819 its painting commission passed a resolution that, should the experiment be

successful, Barezzi might be allowed "to make an attempt on Leonardo's *Last Supper* at [Santa Maria] delle Grazie, which is headed toward ruin."[61]

The same commission drew up the following statement later that year:

[S]aid painting is in the greatest state of deterioration and will be completely lost in a brief period of time. The daubs of old color, distorted by humidity and salts that penetrated the plaster, are only half attached, and are falling off everywhere. It has also been noted that *the last retouches were executed in tempera, as they immediately dissolve when rubbed with a little water*; but it has not been possible to determine whether the first retouches were in oil or tempera, which could only be proved by a test executed by an able restorer on the wall itself. . . . Fortunately, since Signor Barezzi, who was present at this inspection, is available and has on several occasions shown his ability to separate paintings from the wall and transfer them to canvas, he should be entrusted with the task of transferring this painting to canvas, distinguishing the original daubs from later retouches, and saving what little is possible of this venerable skeleton. . . . The Commission was all the more pleased and encouraged to propose this only means of salvation insofar as Signor Barezzi agrees . . . to carry out his first procedure *on two half figures of the same Last Supper*, and if the Accademia decides it inopportune to proceed further, to replace the removed piece in its original place . . .[62]

Barezzi agreed:

After the examination of Leonardo's *Last Supper* with the Painting Commission of this I[mperial] R[egia] Accademia, I consider it my duty to give a written opinion on a work of such importance to the distinguished Accademia. I propose to the I.R. Accademia to detach a pair of figures from the wall of the *Last Supper*, then apply them to panel or canvas, and submit them to the most scrupulous examination; and if this operation for any reason is not approved by the same Accademia, I formally promise to reattach the painting to the wall *exactly as it was before*. What I humbly request, if the

I.R. Accademia honors me with such an honorable task, is that [the Accademia] intervene with the I.R. Government so that I am guaranteed protection from any interference while executing such an important work, as the Accademia itself knows of the complaints made by the custodians of the place where said work exists, as they will lose no small income.[63]

In the event that the Accademia did not approve his procedure, meaning if the *strappo* operation failed, Barezzi made the astonishing claim that he could reapply the painting to the wall "exactly as it was before." Never mind that Leonardo's two figures might be destroyed in the process. Even the Accademia seemed less concerned about the fate of the "two half figures" than about the opportunity to experiment. Count Strassaldo, however, advised of the procedure's risks, wrote to the president of the Accademia on 10 January 1820:

The government has seriously considered your proposals with regard to Barezzi's project to transfer Leonardo's *Last Supper* from wall to canvas.

It would truly be desirable if the precious remains of that illustrious Monument could be saved from the complete ruin by which it is threatened; with this in mind it would be advisable to welcome the project favorably were it not that the interests of the Monument's conservation require the most scrupulous precautions to assure the procedure's success.

For that reason, the government has decided that further tests should first be made . . .

In the corners of the wall across from the *Last Supper*, and next to the Calvary scene painted by Monferato [Montorfano] the government was told that there are two figures painted in the same method as the *Last Supper*, representing Ludovico il Moro and the Duchess, his wife. It is the government's intention, should you find nothing to suggest the contrary, that Barezzi prove his skill on these two figures; detaching them from the wall, and subsequently replacing them after the examination that the Accademia shall make of them.

You will thus have Barezzi execute said procedure,

[and] will then inform us of the I.R. Accademia's opinion of the result.

As regards the compensation proposed for the above-mentioned artist for the experiments executed by him at [the church of Santa Maria] della Pace, before it is set we want to know who owns the wall from which the paintings were detached, and consequently, with whom they must remain.

Pending such verification, however, and pending determinations of the relative payment for the work done at La Pace, you will assure Barezzi that for the two figures he is commissioned to detach and return to their place at Le Grazie, he will soon receive the compensation he is owed, which your excellence will propose.[64]

The painting commission reconvened on 5 February 1820 and the next day expressed some reservations to the government about the efficacy of detaching the two portraits of Il Moro and his wife, attributed to Leonardo, from the wall containing Donato Montorfano's *Crucifixion*. It seemed that "Leonardo painted the portraits of Il Moro and Beatrice on top of an existing painting," while for the *Last Supper* he did not use "a lime arriccio (which is used for fresco painting such as Montorfano's), but his own particular imprimatura, or preparation, composed of gesso, which probably hastened the ruin of his great work." The commission suggested that a "small portion from a less important area . . . a piece of background, painted as tapestry" should be detached from the *Last Supper* itself.

On 16 February 1821, the keys to the refectory were given to Barezzi, and the Accademia's commission examined the painting again. On 6 March it informed the government of the necessity

to precede the detachment with a cleaning. Otherwise, as the wall the *Last Supper* is painted on is covered with as many layers of color as there were painters who in former times tampered with this work, it seems clear that the preparation of material intended to detach the color would detach the first layers, and leave the other most important ones stuck to the wall. . . . The committee that the Accademia delegated to make this new careful examination personally witnessed *a mild clean-*

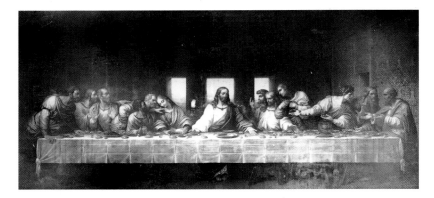

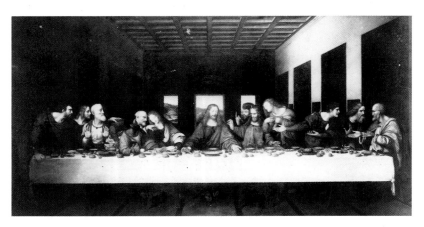

ing test, executed by the Accademia's restorers. They were obliged to conclude that before embarking on the detachment of this masterpiece, prudence advises that the entire work be cleaned, so that the new experiment can remove the dimming and fading, which masks the state of the painting, with diligence and patient work, and thus show more clearly how much remains of the original painting.

The cleaning was carried out by Francesco Fidanza and Antonio de Antoni,[65] but we do not know exactly what part they cleaned. The restorers were ordered to act on the lower part of the figure of Bartholomew. According to the report of 22 March 1821,

> The standing Painting Commission, having gone to the room in Le Grazie where Leonardo's *Last Supper* is found . . . unanimously agreed to have the above-mentioned artist execute an experiment on a less important portion of said work, with the aim of being assured of success in detaching this oil painting. The part of the tablecloth to the left hand located precisely under the figure of Saint Bartholomew has thus been marked; lines circumscribing said piece have been drawn in the manner indicated [on the diagram]. The black marks more or less indicate the damage that currently exists, which has thus been marked, and because of which the lower layer of lime intonaco shows.[66]

On 14 May, Barezzi was ready to show his work to the commission, which drew up a statement on 28 May, requesting Barezzi to "acquaint [them] with the reasons that led him to abandon the first procedure and commence another." Barezzi sent a two-page report, dated 31 May 1821, indicating that he had not followed the Accademia's instructions and had cleaned, stuccoed, and restored another piece, having realized that the *Last Supper* was not an oil painting. He decided to apply his preparation to a part of the tablecloth with a hand:

> Having diligently removed the foreign colors of the stabilized piece, I found that the original [colors] were susceptible to decomposition; I then applied a

cloth with a much weaker solution than normally used to remove paintings to the portion established by I.R. Accademia, and saw with pleasure that the daubs of paint flattened out and fixed to the wall as the canvas dried, which then recovered enough to remove it from the painting; I then felt convinced of the safety of a new attempt, so I took the liberty of choosing a better-conserved piece to offer to the I.R. Accademia's inspection; I then selected a piece of the tablecloth with a hand, to see the approximate result on skin tones as well . . . Seeing it a success, and impatient to transform a few pieces to perfection, I came up with the idea that, instead of restoring it with colors, it would be better in those intersections that remained between the smoothed daubs, to apply a stucco composed for the most part of the same ingredient . . .Those are the reasons, united with fervent desire, that gave me the courage to save such a precious work if possible, [and] that convinced me to carry out different experiments than those laid down for me.[67]

The same 31 May, however, Count Strassoldo demanded that the Accademia explain some new damage to the heads of two apostles. He had personally examined the figures, which were "altered and disfigured by incautious experiments by persons authorized by the Accademia." Clearly he was referring to the figures that Fidanza and De Antoni had cleaned with water in the mistaken belief that the *Last Supper* was an oil painting. Because the paint was tempera, the infamous operation evidently washed it away. The two heads, unidentified in the document, could have been those of Judas and Peter, which during the recent restoration proved to be among the most harshly abraded by old restorations. That episode, along with Barezzi's unbridled experimentation, induced the Accademia to act with greater caution thenceforward, installing two delegates to observe the rest of the operation. Barezzi was held responsible for, among other problems, actual acts of vandalism to the pictorial surface, as he made various deep incisions to delimit the area to be "treated." The still visible deep furrows are concentrated on the table below the

figure of Christ. Various patches of colored wax, used to repair the damage of the failed *strappo,* are also apparent. While Barezzi's procedure was far from successful in removing an image painted *a secco*, it nevertheless proved useful for consolidating the pictorial film and the plaster preparation of traditional frescoes. In 1821–22,[68] he successfully detached the frescoes by Bernardino Luini at Villa Pelucca near Monza,[69] and on 17 February 1823 he submitted a new proposal to restore Leonardo's masterpiece. The Accademia refused to authorize it and, on 8 August, stated that Barezzi's attempt to restore the hand of Christ was "uncertain and defective, that the fingers are swollen and spoiled, that the chiaroscuro is not legible." For the time being, this would suffice to distance Barezzi from the scene.[70]

Artistic tastes were changing. By the 1820s, neoclassicism had been superceded by a preference for historical illustration in a sort of neo-Renaissance manner. In 1809, the Milanese count Giacomo Mellerio had inherited *Portrait of a Young Man*, considered at the time a painting of Leonardo's school, and featuring Leonardo's motto "Vita si scias uti longa est." (It is now attributed to Giovanni Ambrogio de Predis [c. 1455–after 1508] and hangs in the Pinacoteca di Brera.) Mellerio decided it was important to celebrate the *Last Supper*, Leonardo's masterpiece, and commissioned Giuseppe Diotti to create a large painting depicting *Leonardo Presenting the Last Supper Project to Ludovico il Moro*, also known as *The Court of Ludovico il Moro*.[71] The painting was executed in 1823 and exhibited at the Pinacoteca di Brera. Mellerio's commission, along with the "Leonardesque" subjects assigned for Brera competitions,[72] demonstrate that interest continued in Leonardo's mural, perhaps sustained by Barezzi's first restoration proposal to the Accademia di Brera.[73]

Barezzi thus found fertile ground for yet another proposal to consolidate Leonardo's masterpiece. This time the project was approved by the Accademia, resulting in a restoration campaign from 1853 to 1855. The five lunettes representing the Sforza coats of arms within garlands were uncovered above the mural painting. Although the lunettes had been partially visible before the intervention, they had been largely obscured by whitewash and grime.[74] A photograph by Luigi

Sacchi taken in 1857 shows the *Last Supper* with the lunettes as they appeared after Barezzi's consolidation.[75]

The Austrian government followed that project with the request in 1856 to restore the refectory. (Its desire to see the walls and vault "artistically restored" was finally realized by Giuseppe Knoeller in 1872.) The order was included in an unpublished letter, dated 21 May 1857, to the board of directors of the Accademia di Belle Arti, and signed by Perego, governor of the acting Royal Imperial Government of Lombardy. The letter conveys the governor's request that once the "artistic" restoration work was completed, the Accademia should announce a competition for a monument to Leonardo da Vinci and form a commission to that effect:[76]

> To honor the memory of Leonardo da Vinci, His Imperial Majesty would like to order with the above-mentioned sovereign resolution for a statue to be erected in Milan at the expense of the state, and that [the statue] be the subject of a competition announced by the Accademia. . . . His Majesty has fixed the maximum expense at the sum of twenty thousand florins.

The desire to "honor the memory of Leonardo da Vinci" with a public competition following the *Last Supper*'s restoration is particularly interesting. It emphasized Milan's sense of prestige and "civic magnificence" in contrast with the mood during the French occupation, which was undoubtedly blamed for the grave damage suffered by the masterpiece. Not only did the project support the conservation and safeguarding of old works of art but it promoted modern art. The competition took place in 1858, and Pietro Magni executed the winning project. After a long, complex, and divided debate, the monument was placed in Piazza della Scala in September 1872, after the unification of Italy.[77] Its location established a connection between two of the city's greatest glories, Leonardo's *Last Supper* and Teatro alla Scala, and it reflected a flourishing patriotism that had replaced the idea of first Napoleonic and then Austrian "civic magnificence." Because the *Last Supper*'s restoration had been the inspiration for the competition, it was represented in one of the four bas reliefs adorning the base of the statue, the one facing La Scala and located between stat-

ues of Cesare da Sesto and Marco d'Oggiono. At the same time the monument to Leonardo was erected, the problem of another cleaning of the *Last Supper* was proposed and mentioned in documents dating from 1872.[78]

While the restorations conducted in the twentieth century were prompted by legitimate concerns regarding conservation and preservation, they—like those of the eighteenth and nineteenth centuries—involved a range of other motivations as well. For example, the restoration by Luigi Cavenaghi begun in 1903 may have been prompted in part by a conflict between Luca Beltrami, first director of the Ufficio Regionale per la Conservazione dei Monumenti, and the poet Gabriele D'Annunzio. In 1901 D'Annunzio had published his ode "For the Death of a Masterpiece," voicing the general concern that the *Last Supper* was irreparably ruined.

> Weep, O Poets, O Heroes,
> for the light that is no more,
> for the joy that is no more,
> the Universe is humiliated.
> Diminished the pride of the springs.
> A great river is run dry.
> A great poet is lost.
> In people's memory
> the greatness of a name remains
> like the name of a faraway myth,
> of abolished heavens,
> of a god who spoke in the silence of the ages,
> white above the snow
> clothed in his truth.
> O Poets, O heroes, marvelous
> desire of young Earth,
> give your song and cry,
> above the war,
> to the marvel that is no more.[79]

This "death," it should be noted, was quite independent of the mural's actual state of health, and Beltrami reacted to D'Annunzio's poem. Not only was Beltrami a Leonardo scholar and expert in Milanese history, but he had supervised the restoration of the Castello Sforzesco and was an

architect of neo-Renaissance inspiration. (He designed the Banca Commerciale building in Piazza della Scala.) In 1885 he had identified a room in the castle as the "Sala delle Asse," cited in documents of 1498 that mention Leonardo as the author of its decorations. In 1902, the architect Gaetano Moretti, who had succeeded Beltrami as director of the Ufficio Regionale, returned the room, freshly restored and in large part repainted by Ernesto Rusca, to the use of the mayor of Milan. This inspired Beltrami to hail the recovery of the room and its decoration in the pages of *Il Marzocco* in the issue of 11 May 1902, where he mentioned its "rebirth" in refutation of D'Annunzio's "Death of a Masterpiece."[80]

Seemingly in defiance of D'Annunzio's poem, a new restoration of the *Last Supper* was initiated in 1903 (by Cavenaghi), undoubtedly at Beltrami's urging. In 1904 the Raccolta Vinciana was established, also through the efforts of Beltrami, who in the meantime had become a senator. Founded by the communal government of Milan and housed in the civic archives at Castello Sforzesco, the Raccolta's purpose was to collect everything and anything published about Leonardo. The initiative was hailed as an event that would honor Italy and the world, and clearly originated in the polemics surrounding the "death of the masterpiece" and the restoration in progress, which continued until 1908.[81]

Cavenaghi's restoration, conducted in three stages, did not measure up to his usual work,[82] as the photographs taken by Giulio Ferrario in 1908 demonstrate.[83] The hard resins he had used to stabilize the color dried out and caused the detachment of the preparation and the color. A new restoration, by Oreste Silvestri, followed in 1924. As this restoration stabilized and consolidated the precarious flakes of color through the application of soft resins (resin, mastic, and glue), initially it seemed a success, though over time it proved a dismal failure.[84]

At the end of the 1930s, the Milanese government was still closely monitoring the condition of the *Last Supper*. A letter of 1937 reveals that Soprintendente Gaetano Chierici asked Mauro Pellicioli to "conduct a study for the eventual consolidation of the *Last Supper* . . . and to draw up a report." Pellicioli responded that he could not comply

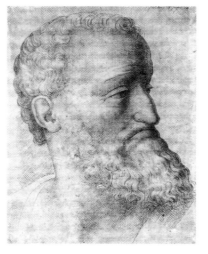
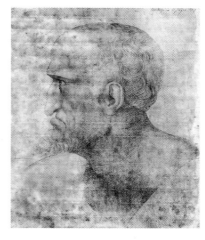
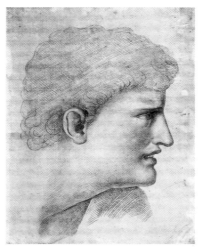
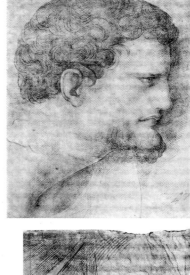
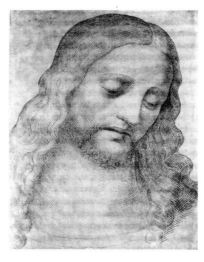
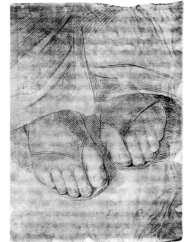

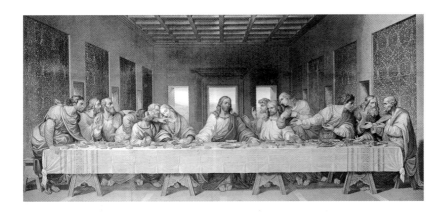

[upper]
Giacomo Raffaelli, mosaic copy of the Last Supper.
Vienna, Minoritenkirche.

[lower]
Copy of The Redeemer by Luigi Ferrari, 1806.
Milan, Museo Nazionale della Scienza e della Tecnica.

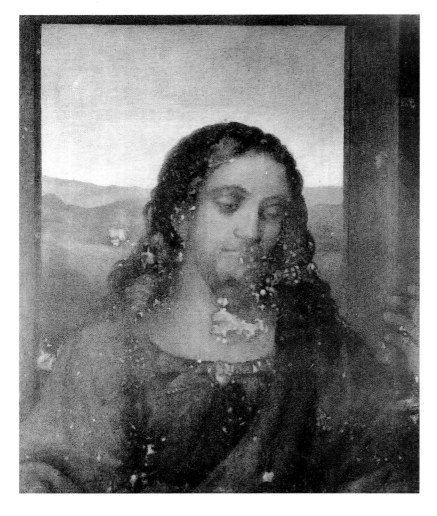

owing to a lack of photographs.[85] Finally, on 8 August 1938, inspector Antonio Morassi submitted a confidential report that thin films of paint had become detached, something that Morassi himself and the restorer Silvestri had failed to observe when they examined the painting in the fall of 1935:

> I was astonished to note, first of all, in some quite extensive areas coinciding in part with the large dark stains caused by humidty in the wall, the particles of color were raised at the edges and gave an impression of roughness I had not noticed previously. In my opinion, this is substantially a phenomenon of very slow disgregation of the films of color from the underlying imprimatura: the edges, which Silvestri already consolidated with apposite adhesive, tend to lift and detach from the underlying layer, along with the small island of color formed by cracking . . . But I made a more serious observation in other areas, and specifically on the chest of the second apostle to the left of Christ, as well as on the shoulder of the penultimate to his right: I noted an empty space, with lifting of the thinnest layer of plaster from the underlying ground as well as a crack with cavities on the second area.[86]

According to the report, the restorer hired by Morassi, a man named Bezzola, discovered analogous damage on other parts of the surface and was of the opinion that Silvestri had treated the restoration "in the encaustic manner." The report concluded with the resolution to order microphotographs, a microscopic examination of suspect areas, and the chemical examination of some particles of color in order to discover "once and for all . . . the elements that compose the color used by Leonardo."[87]

It is dreadfully ironic that soon thereafter, in 1939, as the painting was showing yet new signs of deterioration and arousing the concerns of the Milanese Soprintendenza, Leonardo and his work were openly used to further the cause of Fascism: he was celebrated with a vast exhibition of important loans from around the world at the Palazzo dell'Arte of Milan amid great pomp and display.[88]

Even without the disaster about to befall the *Last Supper*, the painting would have required another consolidation

within a few years, but on 16 August 1943, an Allied bomb hit the refectory of Santa Maria delle Grazie. Exposure to dust and the elements for several years, plus the reconstruction of the east wall and vault of the refectory, caused such a concentration of humidity that the painting quickly faded and became extremely fragile and powdery. The situation had grown so acute by 1947 that Mauro Pellicioli agreed to intervene using wax-free shellac.[89] Pellicioli managed to re-adhere the flakes of the plaster preparation and revive the painting's color.[90]

The situation reached a stalemate in 1951, the fifth centenary of Leonardo's birth, with the national press complaining of the refectory's deterioration and abandonment and the commission established to continue restoration embroiled in a heated debate among competing factions.[91]

In the meantime, Pellicioli had begun a major "pictorial restoration" with the agreement of the Istituto Centrale per il Restauro, as noted by Fernanda Wittgens. When Bernard Berenson climbed the scaffolding in 1953, Pellicioli was still at work, but his restoration was far advanced, to the point that Berenson wrote,

> I felt that the many centuries of restorations had been stripped away in the end, and that I was engrossed in looking at Leonardo's true painting, deteriorated for centuries, but no longer disfigured by incompetent hands. When Professor Pellicioli, with his great skill, has completed this noble enterprise, Leonardo's most famous creation will be visible as it has not been for generations. I wish a new Goethe were among us to write as that genius did 180 years ago, now that the composition can be seen relatively close to the state in which Leonardo must have intended it.[92]

In *Leonardo: Saggi e ricerche*, published in 1954 to celebrate the fifth centenary of the artist's birth, Fernanda Wittgens wrote of the "masterpiece's resurrection,"[93] an event covered by the international press, including *Time* magazine.[94] Like the city of Milan, Leonardo's "true" *Last Supper* was reborn from the war, the destruction, and the bombs. We gather from Wittgens, who referred to the work as a "sacred painting," and, even more, from Berenson, who saluted the restoration as a "noble enterprise," that there

was universal agreement that the newly completed restoration had saved Leonardo's *Last Supper*. Opinion seemed just as unanimous that the results vindicated generations of Milanese (from Lomazzo to Federico Borromeo, from Torre to Traballesi, and from Appiani to Bossi) whose pride had been wounded by the loss of Leonardo's masterpiece.

Today we know that Pellicioli's restoration, though admirable, was not as definitive as Berenson and Wittgens believed. As critics have noted, the Leonardo that appeared could not yet be called "the true Leonardo," because Pellicioli did not remove all of the old repaint.[95] By publishing the photographs made immediately after the most recent restoration, this essay, and the technical report by conservator Pinin Brambilla Barcilon, we hope here to reveal "the true Leonardo" for the first time.

IV

Fragments of Critical Discourse and Fragments of Pictorial Reality

In the sixteenth century Giorgio Vasari praised Leonardo's *Last Supper:*

> He . . . painted in Milan, for the Friars of Saint Dominic, at Santa Maria delle Grazie, a Last Supper, a most beautiful and marvelous thing; and to the heads of the apostles he gave such majesty and beauty, that he left the head of Christ unfinished, not believing that he was able to give it that divine air which is essential to the image of Christ. This work, remaining thus all but finished, has ever been held by the Milanese in the greatest veneration, and also by strangers as well; for Leonardo imagined and succeeded in expressing that anxiety which had seized the apostles in wishing to know who should betray their Master. For which reason in all their faces are seen love, fear, and wrath, or rather, sorrow, at not being able to understand the meaning of Christ; which thing excites no less marvel than the sight, in contrast to it, of obstinancy, hatred, and treachery in Judas; not to mention that every least part of the work displays an incredible diligence, seeing that even in the tablecloth the texture of the stuff is counterfeited in such a manner that linen itself could not seem more real.[1]

Vasari followed with the infamous anecdote concerning the prior who complained to the duke about Leonardo's slowness, and ended up serving as Leonardo's model for Judas. The historian recounted that the *Last Supper* "awoke a desire in the king of France to transport it to his kingdom" and again praised "the nobility of this picture, both because of its design and from its having been wrought with an incomparable diligence."

Now, after five centuries of the painting hovering between life and death, we can at last corroborate Vasari's testimony regarding Leonardo's refinement and "incomparable diligence." We can grasp the love, sorrow, obstinacy, hate, and guilt depicted on the apostles' faces, until now reduced to mere caricatures. Vasari enriched his biographies with notions of the epic, the sacred, and, regarding Leonardo, the "divine." Even drained of hyperbole, Vasari's comments reveal the fully formed conviction—barely sixty years after the painting's completion—that not only did the *Last Supper* inspire pride in the Milanese, it satisfied the city's need to possess a painting judged unique in the world. "Foreigners" considered the painting a treasure belonging to the Milanese, many of whom actually *venerated* it as a divine image.

Carlo Bertelli has examined the affection of the Milanese for Leonardo's mural.[2] After a restoration that lasted more than twenty years, approaching the mural in its current state inevitably inspires in the viewer a measure of trepidation but also the awareness that s/he is standing before an enchanting and fascinating fragment that has survived five centuries. The experience is enriched by the work's renewed balance of composition and color, the refinement of its smallest details ("the nobility of this picture, both because of its design and from its having been wrought with an incomparable diligence"), and by an astonishing series of discoveries and increased technical knowledge. Five centuries of dramatic vicissitudes have left profound traces, and not only *on* the painting, which still conveys a historic breadth related not merely to the many repaints—in places left fully visible—but above all to the material that establishes the composition's significance and to the resulting baggage of descriptions, interpretations, and comments generated over the centuries. Far from being "revived," "brightened up," or—worse—"repainted," the original pictorial matter revealed by this restoration conveys both Leonardo's refined technique and the continuum of time, including its ferocity. Viewing the work makes us aware that we are confronting a five-centuries-old text that is fragmentary and incomplete, but of great quality and beauty.

For five hundred years Leonardo's painting has inspired extraordinary pages of literature and has garnered boundless praise and artistic tributes. Itself an "instrument" of literary and artistic production, the *Last Supper* has generated other works of art that variously retain or reject certain characteristics or details. It has served as the testing

[upper]
Giuseppe Diotti, *The Court of Ludovico il Moro: Leonardo Presents the Project for the Last Supper.*
Lodi, Museo Civico.

[lower]
Pages of the report of 22 March 1821 regarding Stefano Barezzi's proposed restoration, with drawings of the portion to be detached from the wall.
Milan: Accademia di Brera.

ground for historical theories and as the focus of political propaganda and debate involving the "prestige" of the nation and the state. Because the painting comes to us loaded with so many different meanings, it needs to be newly contextualized—for that matter, recontextualized, age by age, moment by moment. First the field should be cleared of certain notions. Obviously the fragmentary image we have inherited is not the one Leonardo consigned to history. The original image and our sense of Leonardo's character have been distorted and altered by time, numerous restorations, and mythologizing literature and art criticism. The images of the masterpiece diffused since the early sixteenth century, from the first painted copies to the eighteenth- and nineteenth-century engravings, have standardized it according to approved academic models, attaching along the way spurious offspring and persistent errors. Photography has not been at all objective but rather has continued to transmit a palatable image familiar to the general public and to critics. The photographic imagery of the *Last Supper* from the nineteenth century through the first half of the twentieth century (but also today) is a subject worthy of in-depth analysis. In fact the relationship of photography to the work of art *in general* should be carefully examined, along with photography's role in generating images intended for "consumption."

While the surviving fragments of the painting can be reunited to form a larger fragment of a whole image—aided by toning down the lacunae—the distorted value of the *Last Supper* is centuries old and rooted in the origin of the painting itself. From the beginning, the *Last Supper* was associated with the splendor of the Sforza court,[3] and it acquired further renown after the visit of the French king François I, who wanted to take it with him to France in 1515. The king visited the refectory accompanied by his chronicler, Pasquier Le Moyne, who in 1520 may have been the first to emphasize the impressive realism of the figures and the still lifes on the table: "The most wonderful thing is the supper that our Lord took with his apostles, painted on the wall of the entrance [sic] to the refectory next to the door where one enters. The painting is a most remarkable thing, because when you see the bread on the table you would say that it is naturally, not artificially made. The

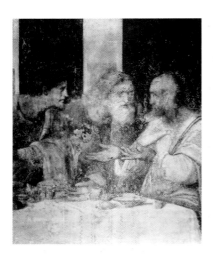
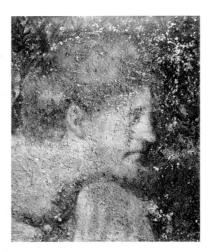
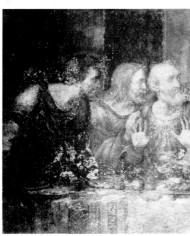

wine, the glasses, the dishes, table and tablecloth with the food are equally realistic, as are the figures. At the other end up high is a crucified Christ, which is not as well done as the supper."[4]

It is worth considering whether or not the *Last Supper* would have become so famous had it lacked the association with the fortunes of the Sforza duchy and with those first royal visits and extraordinary eulogies that undoubtedly resonated throughout the courts of Europe. Subsequent centuries witnessed yet more royal visits. Princes and sovereigns came, drawn to Milan by the condition of the work—forever on the verge of "disappearing"—and by a desire to see the astonishing, endless stream of "pilgrims" visting the "relic".

It is also worth asking whether Leonardo's iconography really deserves its boundless fame in the annals of art history. Art criticism has focused so intensely on the unusual aspects of Leonardo's masterpiece that its relationship to earlier iconographic models has been largely ignored, particularly its relationship to the Florentine Last Suppers.[5] In at least two *Last Supper*s designed by Domenico Ghirlandaio, however, perceptive critics have recently noticed surprising anticipations of Leonardo's treatment of certain problems. The *Last Supper* at the convent of San Marco employs a trompe l'oeil technique of handling the perspective, interpreting the wall as a continuation of the convent's real space, and it pays careful attention to light and reflections in the still lifes. The *Last Supper* at Ognissanti is organized into groupings of three figures each.[6] The figures of some of the apostles in the San Marco *Last Supper* seem to be animated by the same mental *moti* governing the gestures and expressions of the Milanese apostles, though Leonardo handled his figures with more purpose and clarity. Furthermore, in its clear perspective and scenographic illusionism, Leonardo's *Last Supper* develops a simultaneous vision of interior and exterior, which Andrea del Castagno had already ingenuously proposed in the *Last Supper* at the convent of Sant'Apollonia, where even the roofing tiles of the *Last Supper*'s imaginary building appear. The five lunettes above Leonardo's *Last Supper* (four survive) allude explicitly to the interior-exterior concept. The garlands that surround the Sforza coats of arms and inscriptions were

painted on a blue background, simulating real leaf and fruit garlands, and real coats of arms with abundant silver and gold leaf are set against the blue sky. It has been suggested that Leonardo found ample precedent both in the popular custom of decorating streets and palaces for celebrations and ceremonies with living garlands that were "round in the antique style" and in Venetian painting. Mantegna in particular treated garlands and festoons above the principal scenes and on the monochromatic ceiling of the *Camera Picta* at the ducal palace in Mantua with openly illusionistic intent.[7]

The immense fame of Leonardo's *Last Supper* is rooted in nonartistic matters as well. Ancient literary accounts helped amplify its importance as a work of art, but they also suggest something else: that the *Last Supper* was held to be a miraculous image in the sixteenth century. Certainly we know that between the sixteenth and seventeenth centuries, the *Last Supper* was proclaimed to be *miraculous* by Antonio Billi, a *most excellent thing* by Anonimo Gaddiano,[8] and again *miraculous* by Gaspare Bugatti in 1570 and by Francesco Bocchi in 1571.[9] It was declared *miraculous and very famous* by Matteo Bandelli in 1554,[10] a work *venerated* by the Milanese according to Giorgio Vasari and Vincente Carducho, and a *very great miracle* in Giovanni Battisti Armenini's opinion of 1586. At the same time, however, the work was already *confused* and *ruined*, suggesting that an oral tradition had attributed "miraculous" powers to the painting. Given that the work had already begun to deteriorate (as Antonio de Beatis pointed out in 1517) and its survival seemed extraordinary, it was not unreasonable to attribute special properties to the masterpiece.[11]

Certain signs suggest other meanings: the copy of the *Last Supper* attributed to Giampietrino, now at Oxford but originally at La Certosa di Pavia, depicts the apostles with halos, which also appear in the seventeenth-century copy at Ottaviano, Naples, in the church of the Santissimo Rosario. And in this last version, the scene of the Last Supper is set in what appears to be a church.[12] The pilasters in the copy at the church of Saint Germain l'Auxerrois in Paris also suggest a church setting. The recent restoration of Leonardo's *Last Supper* also identified traces of a halo above Bartholomew, the first figure on the left. It could,

however, be a carved motif that was abandoned, as there is no evidence of gold leaf; and other older copies, including the engraved ones, do not show halos (except sometimes around the head of Christ). Furthermore, Leonardo did not include halos in either the Paris or the London version of *Virgin of the Rocks,* defying traditional iconography and contributing to the twenty-six-year controversy with the Franciscans, who commissioned the work, and with the Dominicans, who were called in to settle the dispute. (The halos now visible are eighteenth- or nineteenth-century additions.)[13]

The absence of halos in the composition at Santa Maria delle Grazie contrasts sharply with the *Last Supper*'s "sacred" interpretations and with the character of its location, where the work's purpose was to convey intense spiritual meaning.[14] Instead Leonardo's work emphasizes the "historical" meaning of the event represented. Everything centers on Leonardo's theory of the *moti dell'anima* enlivening the apostles' faces, understood in terms of the "scientific" and objective representation of reality. The scene appears to illustrate a law on the propagation of sound (the apostles' reactions to Christ's words "One of you will betray me") in terms of actions and reactions. Leonardo illustrated the principle as an artist-scientist, using theories on the alternation of colors and studies of the "projection" of luminous rays, colored reflections, and so on.

The *Last Supper* remained the subject of literary and critical scrutiny practically without interruption into the twentieth century, and it enjoyed a moment of extraordinary popularity in the nineteenth century when the "myth" of Leonardo was on the rise and the image of the *Last Supper* had—through engravings and prints—been appropriated by cultures on every continent. Such immense approval compensated at least in part for a period of incomprehension concerning the most "classical" and, at the same time, most "popular" values inherent in the Milanese painting. After receiving the highest praise in the sixteenth and seventeenth centuries, the painting suffered from a lack of appreciation on and off during the eighteenth century, perhaps as a result of its seemingly hopeless deterioration. Before examining the painting as it appears after the recent restoration, it is useful to survey key moments in the work's immense for-

tune and "misfortune," viewing it in light of the judgments of its greatest interpreters. These judgments were not always based on direct observation of the original, however, and often not even on faithful copies. This held true both when the *Last Supper* was seen to represent Leonardo at the height of his power and when it was subjected to the fiercest criticism.

In addition to the tributes already cited, other sixteenth-century admirers included Raffaello Maffei, who in 1516 declared, "Leonardus Vincius XII Apostolos in aede divae genitricis de gratiis, opus praedicatissimum [pinxit]," and Sabba da Castiglione, who praised the *Last Supper* in 1549 as "certainly [a] divine work." Finally, Lomazzo's wretched little quatrain in *Grotteschi* deemed the *Last Supper* superior to every other painting:

Francis King of France sadly cried / When Melzi told him Vinci had died / Who while he lived in Milan did make / The Supper that no other work could take.[15]

Nicolas Poussin illustrated Leonardo's *Trattato della Pittura*, which was translated and published in 1651 in Paris by Raphael Trichet Du Fresne, contributing significantly to Leonardo's fame in France. Seventeenth-century classical taste only slightly clouded the painter's reputation and did not prevent Rubens from admiring the *Last Supper*. In particular Rubens praised the figure of Christ: "His expression is serious, and his arms free and loose to emphasize his grandeur, while on each side the Apostles seem agitated by the vehemence of their anxiety, in which no meanness appears, nor any action contrary to propriety."[16]

Rubens brought something new to understanding the *Last Supper*. Lionello Venturi noted, "A master in the expression of human emotions and in the evocation of material reality, [Rubens] naturally understands Leonardo's exceptional ability to determine the precise character of persons and things. But at the same time, he recognizes the propriety, the power inherent in Leonardo's brush of bringing nobility to everything he touches. And above all, classical *misura*, the artistic parallel of psychological propriety, which he abstracted from the circumstance to achieve the essence, avoiding all trifling aspects of execution, and instead left the completion of the work to the observer's stirred imagination;

Leonardo's *misura* made an exceptional impression on the mind of Rubens."[17]

Unfortunately, Rubens's writings did not have an immediate impact on the taste of the time, as they were published much later—by Roger De Piles, author himself of penetrating observations on Leonardo's color, psychological qualities, and the artist's (presumed) independence from ancient art.[18] Nevertheless, Rubens's observations were probably founded on an already darkened and altered image (as Il Vespino's copy at the Ambrosiana suggests), which prevented him from perceiving details achieved with a brush tip, and in general the "incomparable diligence" noted by Vasari. A generation later, Rubens's remarks were used to bolster the notion that Leonardo had exercised a sort of "disregard" in painting the *Last Supper*. No such sloppiness ever prevailed, of course. The very idea is contradicted by Vasari's powerful observation that "even in the tablecloth the texture . . . is counterfeited in such a manner that linen itself could not seem more real."

By the second half of the seventeenth century, critics such as Francesco Scannelli no longer believed in Leonardo's "perfection," considering him inferior to Raphael, Titian, and Correggio.[19] And the eighteenth century "read" the *Last Supper* with eyes intrinsically prejudiced against its "categories." When the artist Nicolas Cochin traveled to Italy, he found nothing better to say about Leonardo's *Last Supper* than that it was "markedly in the style of Raphael."[20] As Venturi noted, "eighteenth-century French taste ended up unable to bear even the grandiosity and the profundity of psychological life that, despite its ruin, the *Last Supper* still emanated." Charles de Brosses felt obliged "to restate that all the faces are very ugly,"[21] while Lalande noted that "some of the hand and arm gestures [are] a little exaggerated."[22] The eighteenth century largely ignored Leonardo's use of color and evaluated the artist according to Winckelmann and Mengs's neoclassical theories of "chiaroscuro" or according to Lanzi's mistaken conviction that Leonardo had worked in two "manners," one "full of darks that make the opposite lights triumph admirably; the other more placid and achieved with middle tones."[23] Such readings of course obtained in part from the limited legibility of

the *Last Supper*'s color, and from the difficulty of basing judgments on an established catalog of Leonardo's authentic works. Bossi, in fact, shrank from the opportunity to examine the original painting for his project of 1819 and only studied copies and derivations. He privileged abstract problems, such as composition, canons of proportion, and "scientific" content, meaning physiognomy and psychological expression. Bossi also identified certain perceived defects in the *Last Supper*, such as the equal height of the figures, the sharp lines of the tablecloth and table, the uniformity of the groupings and, as Venturi puts it, "other nonsense" of that sort,[24] undoubtedly dictated by the prevailing pseudo-academic fashion as well as by his own boundless presumption.

Compared with Goethe's "ideological" and "psychological" remarks on the *Last Supper*—apparently based on Bossi's prints and book rather than on the painting itself—Stendhal's observations are more penetrating:

> [Leonardo's] drawing had that rare nobility, more striking than in Raphael even, because he did not mix the expression of strength with nobility. He used melancholy, tender colors, abundant with shadows, without harshness in bright colors and triumphant in chiaroscuro, which, had he not existed, would have had to be invented for such a subject.[25]

Theories about Leonardo's use of chiaroscuro in the *Last Supper* proliferated during this period along with ideas about his tender, melancholy coloring, undoubtedly suggested to Stendhal by Bellotti and Mazza's eighteenth-century repainting. Hippolyte Taine tied chiaroscuro to the supposed "immorality" of Leonardo's work,[26] and Leonardo's approach to chiaroscuro dominated John Ruskin's criticism of the painter. Ruskin, in fact, compared the artist with Rembrandt, whose chiaroscuro technique he disliked. He claimed that both artists could not show "local color on the dark side, since . . . it must at last sink into their exaggerated darkness."[27]

Eugène Müntz, in his monumental volume on Leonardo published in 1899, drew parallels between Rembrandt's work and Leonardo's *Portrait of a Musician* in the Pinacoteca Ambrosiana (although at the time not considered an authentic work by Leonardo) and the *Adoration of the Magi* in the Uffizi.[28] Müntz, however, considered the *Last Supper* a miracle of composition, expression, and perspective, which "may be classed with Raphael's cartoons, as a work breathing forth the purest evangelic spirit, a work before which believers of every creed love to meditate and in admiration of which they find a stimulus to faith."[29] Because the painting's poor condition prevented Müntz from analyzing it in detail, he viewed it burdened with theoretical superstructures. Even in the comparison to Raphael, he identified the same generating nucleus of motion and emotion constituted in Christ and his words in the *Last Supper*.

Venturi noted that during the entire nineteenth century—despite Ruskin—Leonardo's art was widely appreciated. It was understood as the "highest revelation of those grandiose, noble characters of expressive power, of synthetic unity of effect, which distinguishes Italian sixteenth-century art from that of the fifteenth century. . . . it is the most common vision, precisely because it is the most traditional . . . [but] therein lies not only its value but also its defect, because . . . Leonardo's own personality disappears, which distinguishes him from the men of his time." This idea, based on Jacob Burckhardt's tenets of neoclassicism, found its highest expression in the criticism of Heinrich Wöfflin. According to Wöfflin, the uniqueness of the *Last Supper*, which he proclaimed "the most popular painting of all Italian art," exists in the intensity of its psychological expression. He declared this is achieved "not as much through form and gesture, as through the art of composition," which manifests itself in Leonardo's choice of the moment to represent—the silence that follows Christ's prophetic words, a pause filled with the dramatic reactions of the apostles.[30]

In the twentieth century, a second period of negative criticism commenced with Bernard Berenson's analysis of Leonardo. Berenson did not like (or understand) Leonardo, crediting him with a following of incompetent and "decorative" artists who obliged the tastes of the court and were easily influenced. Berenson considered Leonardo's faces to be exaggerated, characterized by "his perilous taste for pushing facial expressions to the limits of tolerability."

LA CHIESA DI S.M. DELLE GRAZIE
ED IL CENACOLO VINCIANO

24 TAVOLE

Berenson deemed it incredible that, during his long residence in Milan, Leonardo never found "occasion to teach his greatest gift, dealing with movement," remaining caught up in the "vast conspiracy of the 'decorative.'"[31] Roberto Longhi shared Berenson's opinion; however, in 1952 he confessed that he had a personal "difficulty" in understanding Leonardo, wondering why "from the rapid, multi-faceted flow of the Florentine *Adoration of the Magi,* Leonardo forces himself into the 'magical pyramid' of the *Virgin of the Rocks*, or into the three-by-three regulated scenic progression of the Milanese *Last Supper*. Undoubtedly the old perspective-proportion myth ordains this mystery; and he precedes [Raphael's] *Stanze* by ten years; but with that burden of intrinsic explosive vitality, the reason for the different rule remains uncertain."[32]

Both Berenson and Longhi were undoubtedly reacting to nineteenth-century encomia and to the Romantic "myth" of Leonardo, which cast the artist as a comprehensive, omniscient genius. Once again, however, Berenson's criticism of the *Last Supper*'s sombre color and its reduction to "chiaroscuro" can be attributed to the condition of the painting in 1888.[33] The darkening caused by eighteenth- and nineteenth-century retouches had noticeably muted the painting's high chromatic values. Longhi's suspended judgment of 1952, however, betrays an undeniable revision of his youthful exaggeration; his admission occurred at the same time as Pellicioli's consolidation, by then in its final phase.

Interpretations of the *Last Supper* by Venturi, Kenneth Clark, Ludwig H. Heydenreich, Ernst Gombrich, John Shearman, Leo Steinberg, and Anna Maria Brizio are indispensable to our current view of the masterpiece. The various orientations of contemporary criticism are founded on their work, which remain the most acute analyses of the painting.[34] As I am limited to mentioning only a few abstracts, a passage from Venturi, who is responsible for several successive readings of the *Last Supper,* seems most appropriate. His comments in *La critica e l'arte di Leonardo da Vinci* (1919) represent the culmination of a body of modern Leonardo criticism hinging on the values of "movement" and "chiaroscuro," understood as the instrument for achiev-

ing "relief." His remarks serve as a prelude to our evaluation of the *Last Supper* as it now appears after the most recent restoration:

It is well known that not many years after its completion the painting began to deteriorate, and so its fame was entrusted primarily to the copies and prints. They have truly ruined our eyes: still, despite every effort, we look at the authentic painting through them. And because they reproduced almost everything faithfully, except for the effects of light and shade, which is precisely Leonardo's art, it follows that everything was understood in the *Supper,* except his art. Of course, given the painting's poor condition, it is necessary to turn to external elements in order to reconstruct the painter's creation. However, if these elements are created by different personalities the result is a superimposition of perfectly arbitrary personalities. Therefore, only Leonardo's actual works can constitute these external elements; that is, for everything regarding composition, movement and drama, it is necessary to refer to the *Adoration of the Magi*; and for light effects and execution, to the *Virgin of the Rocks*. Not understanding this has been the reason for all the misunderstandings, underestimations, and overestimations of the *Supper* . . .

Precisely because the *Adoration* was viewed directly and the *Supper* through copies that abolished the light effects and stated Leonardo's "unfinished" pictorial look with false lines and false reliefs, [the copies] emphasized the geometric boundaries of the groups immersed in shadow, filling out the skeleton of the original creation rather than the flesh and blood. . . . The relationship between the figures and the environment is the same in the *Supper* and in the *Virgin of the Rocks*. The room is small, precisely because it has to contain little light; in the end, the windows in the background do not bring any light into the scene, in the same way that the breaks in the grotto make the illuminated space of the open countryside extraneous to the scene. The light is anterior to the images,

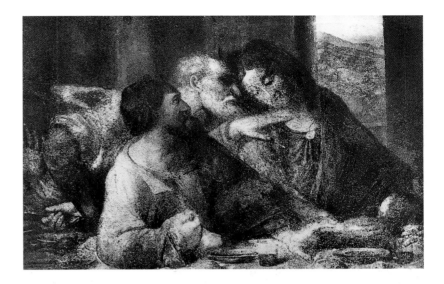

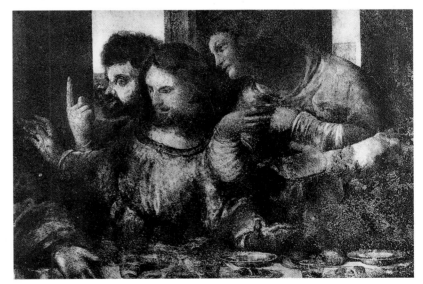

though it is faint, both because the evening is lowering its veil over everything, and because the shadows of the walls reflect on the images. . . .

Concerning the work's finishing touches, copyists amused themselves by representing a lot of meaningless trifles on the table. If you notice how Leonardo represented the bowls in the foreground of the *Virgin of the Rocks*, you will realize that the foodstuffs in the real *Supper* are not trivial but demonstrate his virtuosity in realistic representation. The shadow common to men and things makes both a piece of bread and the shadows under the apostles' eyes communicate meaning. . . .

In the conception of the *Supper*, therefore, there is no theatrical ostentation, no calculation unsurpassed by the imagination, no tumult that is not attenuated in the religious submission of nature at evening, nor cries that dominate the sorrowful rhythm of the composition. The echo of Jesus' words, 'One of you will betray me,' subtly agitates the apostles. Surprise, indignation and love are subtly victorious. Evening falls with inevitable progress. Christ opens his arms, resigned, thoughtful. 'Necessity is nature's theme and inventor, its restraint and eternal rule.' That applies to men and things. It transforms the human drama into a vision of art, because sorrow expands with a rhythm similar to the wave that skims the surface of water, and can be composed into a superior synthesis, which is necessity.

A family in a grotto and a group of men gathered around a table, despite the different emotional situations, translate into the same spiritual activity. And that proves that the spiritual activity is not haphazard: it is Leonardo's true art.[35]

Venturi not only considers the copies and compares the *Last Supper* with previous works but also carefully observes the painting itself. His eye seems to penetrate the thick layers of repaint still covering it in 1919, soon to be worsened by Silvestri's blackish *stuccature*. Venturi's gaze fixes on the vibrant chiaroscuro of Leonardo's original color, on the pieces of bread so realistic that they seem to antici-pate the "painting of reality" ("the flesh and blood"), and on the table's still life painted with a naturalism that presages Caravaggio. In short, Venturi grasped the essence of the work with an acuity that was truly singular in Italian criticism between the two world wars. Later criticism would develop the significance of the *Last Supper* in relation to Leonardo's intellectual and scientific activity and would substantially contextualize the painting, but never achieve such an accurate reading of its "chiaroscuro" and "movement."

Later, Kenneth Clark focused on the values of "unity" and "drama":

The dramatic effect of the "Last Supper" must depend entirely on the disposition and general movement of the figures, and not on the expression of the heads. Those writers who have complained that the heads are forced or monotonous have been belabouring a shadow. There can be no doubt that the details of the fresco are almost entirely the work of a succession of restorers, and the exaggerated grimacing types, with their flavour of Michelangelo's "Last Judgement," suggest that the leading hand was that of a feeble mannerist of the sixteenth century. . . . But in spite of the depressing insistence of these facts, some magic of the original remains, and gives the tragic ruin in Santa Maria delle Grazie a quality lacking in the dark smooth copies of Leonardo's pupils. Luminosity, the feeling for atmosphere, which distinguishes all Leonardo's genuine work from that of his pupils, must have distinguished the "Last Supper" also: and the fresco, perhaps from its very vagueness, has kept a certain atmospheric quality. As we look at them, these ghostly stains upon the wall, "faint as the shadows of autumnal leaves," gradually gain a power over us not due solely to the sentiment of association. Through the mists of repaint and decay we still catch sight of the superhuman forms of the original; and from the drama of their interplay we can appreciate some of the qualities which made the "Last Supper" the keystone of European art.[36]

In his volume on Leonardo, Clark challenges Cavenaghi's report on the restoration he conducted between 1903 and 1908 in which Cavenaghi claims to have found heavy repaint only on the left hand of Christ: since the painting had already been considered a "ruin" in the sixteenth and seventeenth centuries, it could not have survived "more or less intact" to the present day as Cavenaghi declared. Clark believed that Cavenaghi was clearly mistaken and that "what we now see on the wall of the Grazie is largely the work of restorers."

Nevertheless, it proves difficult to find the "Michelangelesque" expressions noted by Clark on the apostles' faces, even in Ferrario's photographs of 1908. Clark's opinion that a "feeble mannerist" was responsible for marring the faces seems even more arbitrary. Such an artist would have had to retouch the painting by the end of the sixteenth century or, at the latest, the early seventeenth century. Even barring the possible culprits (Lomazzo, Figino, or Il Vespino), the idea that the apostles' faces were repainted in the style of Michelangelo is hard to accept. Copies from the period would have recorded the change, but Il Vespino's copy and surviving photographs of Lomazzo's do not reflect this deformation. The so-called "caricatured" expressions are the work of an eighteenth-century painter-restorer, perhaps Michelangelo Bellotti, whose paintings in Gravedona and Busto Arsizio demonstrate a knowledge of Michelangelo, Raphael, and central Italian painting. Clearly, the English scholar's judgment of the painting's physical condition was based on a distorted knowledge of the relevant literature and a visual examination burdened with preconceptions. In the 1959 edition of his book, Clark added a note that the "fresco" had been cleaned by Mauro Pellicioli and that, this time, "early restorations have really been removed and the little that remains seems to have been painted by Leonardo, but it is too faint and discontinuous to give much idea of its original effect."[37]

It is unfortunate that Clark's discerning remarks on the painting's "atmospheric quality" were not based on closer scrutiny of the pictorial matter (if it had been so heavily repainted by a succession of restorers, how could he even detect this?) and that his description of the figures as "superhuman forms" may have been influenced by Pan-Germanic ideals of the 1930s and propaganda about "Italian genius." Indeed, Clark's vision of the *Last Supper,* centered on the composition's "unity and drama," seems to push an ideological reading of the *Last Supper* to an extreme, formal conclusion. The enormous success of his book may help explain the reluctance of Anglo-Saxon scholars to accept that the most recent restoration has actually revealed Leonardo's original painting—and to a greater extent than anticipated.

In the wake of Clark's book, Gombrich ventured some original ideas about the *Last Supper* in *The Story of Art*, first published in 1950: "There is so much order in this variety, and so much variety in this order, that one can never quite exhaust the harmonious interplay of movement and answering movement." Gombrich also made important observations about "reality" and perspective illusionism: "If one forgets the beauty of the composition, one suddenly feels confronted with a piece of reality as convincing and striking as any we saw in the works of Masaccio or Donatello."[38]

This idea was expanded by Sydney Freedberg, who believed that the *Last Supper* resulted from a decade of artistic and scientific maturation by Leonardo and that its "protagonists" possess a stature that is at once moral and dramatic. He comments on "the great increase in the extent and power of Leonardo's reshaping of the evidence of nature. The Apostles, as well as Christ, have been given an extraordinary moral and dramatic stature. . . . What is contained within this frame belongs so evidently to a region of superior existence that the spectator cannot but realize that the picture world, for all its seeming palpable existence, is not meant for him to share as any realistic illusion. The strip of tablecloth across the front plane of the picture makes a boundary between our world and the idea."[39]

Contemporary criticism moves beyond the fiercely contested antithesis between art and science that characterized Vincian criticism during the first decades of the twentieth century and seeks to evaluate the *Last Supper* within the context of Leonardo's intellectual and scientific work (Heydenreich),[40] or it continues to ponder the relationship between "color" and "chiaroscuro" in Leonardo's work (Shearman and Brizio).[41] Brizio recognized the *Last Supper*

as marking the precise moment that Leonardo fully achieved his development and fusion of color, in the sense of "tonal unity." Other approaches to the *Last Supper* range from Steinberg's iconological reading[42] to tracing Leonardo's mechanistic vision of nature[43] to attempting to discover Leonardo's perspective scheme for the painting, or conversely, exploring what some believe to be Leonardo's intentional ambiguity regarding his perspective system.[44] The *Last Supper*'s recent restoration has allowed us to verify certain ideas and has furnished new information important to almost any critical approach.[45]

Albeit in fragments (but of such quality!), the painting has recovered the "plastic" values achieved with chiaroscuro, perhaps for the first time since the early sixteenth century (but well imagined by Stendhal, Venturi, and Gombrich). The figures form an aggregation of solidly constructed, monumental masses freed from the half-light by a more revealing light than ever seen before. Strongly three-dimensional forms, like the figure of Simon at far right, recall Bramante even more than Michelangelo. The newly revealed plastic values particularly affect the unfolding of the animated, agitated composition. The monumental bodies of the apostles, arranged in threes, play out their spatial relationships not only with respect to their own space, but also with that of the figures in their individual groups. Their poses fit together to represent an emotional ripple like a wave spreading out from Christ toward the extremities of the scene. Some figures are set back from the primary plane, and strain forward (Bartholomew, Philip and Thaddeus), while others are placed in the immediate foreground behind the table, and either push back (James Major) or extend even more forward, drawing away from Christ (Judas).

The cleaning recovered the original chromatic values of the apostles' clothing and the flesh tones of their faces, making it possible to reread this interplay of extension and retraction, and light and shade. This interaction governs the apostles' positions, illuminating certain parts in marked contrast with shadowed areas. It also creates juxtapositions of bold and improbable colors, like the turquoise of Judas's sleeve, set directly in front of Peter's ultramarine sleeve, both close to the yellow of Peter's mantle. Gian Pietro Luini

would borrow this sort of contrast for *Sibyls* (in the sanctuary of the Madonna dei Miracoli in Saronno), and seventeenth-century painters like Orazio Gentilleschi would favor the effect as well.

The light that crosses the scene diagonally from the left touches the heads of all the apostles except Judas, who remains in shadow. (For this reason—the absence of white pigment—Judas is also the most damaged.) The apostles' heads are almost always located in planes diagonal to the frontal plane of the painting. Only two heads are perfectly vertical and in pure profile: Bartholomew at far left, and Matthew, third from far right. The other heads all deviate noticeably from profile and frontal views and fold into the scene's depth. The unusual tilt of Peter's head was exactly recovered, while Judas's head is shown in *profil perdu,* like that of Simon at far right, turning toward Christ and thus toward the interior of the room.

Leonardo's brushstroke was discovered on almost every temple, cheekbone, the profile of every nose, and every eyelid bathed with light. It is easy to imagine that these white "highlights" on faces, glass objects, and drapery edges are the brushstroke or two that (according to Bandello) Leonardo chose to apply in a given day, then abandoned, and returned to several days later.

From a general viewpoint, removing thick layers of modern color from the background of the scene at upper left revealed clusters of incised lines with the apparent function of delineating the coffered ceiling. At upper right, a portion of original paint was discovered, allowing Pinin Brambilla Barcilon to reconstruct the original scheme, form and color of the trussing in a diagram published in this volume. Except for this narrow strip, the coffering now visible is an eighteenth-century repaint that was left intact, as no trace of original paint survives below. When the coffering is examined with the newly discovered original line, the structural elements (beams and recessions) of the ceiling prove to have been reversed, changing the number of beams as well as their perspective scheme. The clusters of incised lines confirm this alteration, as they do not correspond with the ceiling currently visible. The incisions commence at the left edge of the wall, and proceed horizontally to the center of the scene. The horizontal incisions are intercepted by at least

four diagonal incised lines, which converge around the vanishing point located near the right eye of Christ, as demonstrated by Brambilla Barcilon's diagram (figure 39). These discoveries indicate that Leonardo had initially planned a perspective view of the room that was considerably shallower than that of the current version. The original plan of the room may even have excluded the foreshortened side walls, like Andrea del Castagno's *Supper* in the convent of Sant'Apollonia in Florence.

The restoration also brought to light the remains of a brick overhang below the painting. It must have served as the link between the real space of the refectory and the illusionistic scene painted above. The plaster used to cover the projection suggests that it was slightly rounded. It could be the element that Bossi had chiseled away in order to place his wooden scaffold in front of the mural.[46] The overhang also would have contributed to the realism of the contiguous painted step, which rises immediately above and constitutes an invitation to the pink and gray floor of the *Last Supper*. Perhaps Leonardo's painted floor, with its pattern of gray stone bands and pink stone slabs, reflected the original floor of the real refectory.[47]

Another discovery during the recent cleaning affects the perception of the overall scene. Scholars, especially those proposing reconstructions of Leonardo's perspective scheme for the *Last Supper*, have long debated the significance of the last section of the painting at far right, compressed between the corner with the refectory's east wall and the edge of the first tapestry on the right. Historians have questioned whether this vertical band should be interpreted as the wall space between one tapestry and the next in Leonardo's painted room, or whether it offers a foreshortened view of part of the molding of the large "window" framing the scene. The second version interprets the band as an ideal continuation of the width of the painted architrave crowning the scene. The lower edge of the architrave is, in fact, represented in perspective. Obviously the two schemes generate different perspective reconstructions. When heavy repaint was removed from the vertical band at right, however, color was revealed as well as grayish brushstrokes identical to those of the wall hung with tapestries. Furthermore, Simon's drapery covers a portion of the band in question,

and the plane of the drapery is clearly in front of the band. Given Simon's spatial disposition, set back from the frontal plane of the wall, the band can only represent a portion of the painted wall that continues beyond the width of the real wall upon which the *Last Supper* is painted. (Among the proposed perspective reconstructions, Martin Kemp's version published in 1981 approaches the true solution.[48]) It follows that Leonardo's painted room is wider than the actual refectory and that his foreshortened walls continue beyond the edges of the real wall.

New discoveries resulting from the restoration of the four lunettes above the *Last Supper* have already been dealt with in Quaderni del restauro 7, published in 1990. That publication also established a relationship between the symbolic meaning of the fruit and plants represented in the lunettes and the Passion of Christ, which commences with the Last Supper.[49] Until the most recent restoration, modern criticism often avoided the lunettes. Leonardo was credited with both the invention of these "screens" lowered to hide the painted coffering's join as well as the conception of the leaf and fruit garlands. Nevertheless, historians usually refrained from taking a stance on whether or not Leonardo actually painted the lunettes himself.[50] Cleaning them provided the opportunity to explore their technique more fully and to formulate new critical opinions. The fruit and leaves in the garlands proved largely repainted, with a compact layer superimposed on a thinner, more delicate surface. The earlier surface, perhaps tempera, is visible where layers of retouching have flaked off.[51] The high quality of the repaint, judged "very old" by Bertelli, suggests that Leonardo himself may have retouched the work. He may have been summoned during the first decade of the sixteenth century to touch up damage to the lunettes dating from 1499, perhaps in *damnatio memoriae* of Ludovico Sforza.[52] The style and handling of the vegetation and fruit seem to confirm this theory. The graceful, elegant clusters of leaves are often sinuous and vibrant, but drawn as though copied from a cartoon. In fact, the same leaf bunches are repeated in the three principal garlands, but vary in sequence, and the bunches in the central lunette are larger. They display corrections, paint thickness, and a method of placing shadows above objects related to the second version of the *Virgin*

of the Rocks (London, National Gallery). We know that Leonardo executed this painting in collaboration with his students between 1493 and 1508 and that the hand of Marco d'Oggiono has been identified in the rocks and in a cluster of white narcisssus.[53] (The fleshy leaves and flowers resemble a narcissus plant in the panel depicting the *Three Archangels* at the Accademia di Brera, executed by d'Oggiono around 1515.) It seems likely that Leonardo— or someone acting on his behalf—may have assigned one of his most talented students the task of retouching the leaves and fruit in the lunettes, perhaps later correcting and refining certain parts himself. This is suggested by the beauty and high quality of some leaves, distinguished by their veining and organic sense, and by the subtle ruffling of some bunches by the wind, especially in the delicate areas of the garland at far right.[54]

An examination of the painted surface after the restoration reveals a general lightening of the color of the two side walls, echoed by the luminous sky behind Christ's head. As a result, the tapestries acquire more clarity. With the coffered ceiling, the tapestries define the structure of the room and establish a sense of depth in the composition. Originally the tapestries must have been painted with a black background, optically and decisively signaling a progressive recession from the foreground—not the pale green with decorative dark pink scrolls that we see now. This clearly eighteenth-century repaint, perhaps attributable to an even earlier restorer than Bellotti, was minimally removed, given that Leonardo's original paint beneath had been almost completely abraded. Traces of black paint and small red petals were found on the first tapestry at right, near Simon's chin, where repaint simulating a beard was removed. At this point in the restoration, Bertelli's theory that Leonardo had painted *millefleurs* tapestries could be only partially confirmed, given that the sole evidence comprised these almost-imperceptible traces and certain old copies, such as the one now at Magdalen College in Oxford. Later, however, several small bunches of flowers on the first tapestry on the left were discovered that fully proved his theory. Leonardo's *millefleurs* tapestries would have resembled the Flemish-made hangings from the last decade of the fifteenth century now conserved at the

Duomo of Monza.[55] Even in the tapestries at left, however, the flowers' fragmentary condition prevented total removal of the repaint and attribution to Leonardo. As details of this sort were absorbed into the large composition, Leonardo might have assigned their execution to his assistants. It seems unlikely that Leonardo would have spent his time tediously filling this vast background with a repetitive pattern of flowers. Furthermore, the perspective scheme of the flowers is inaccurate, with bunches placed flat on the plane of the wall rather than foreshortened along the diagonal of the tapestries' plane.

Leonardo's illusionistic intent and ambition in representing natural "incidentals," however, are confirmed by certain details in these areas. For example, it has already been noted that the pegs that support the tapestries on the right wall—invisible before the recent restoration—throw a faint shadow on the wall. The full recovery of the doors in the left wall and the lower, smaller doors in the right wall introduces a rhythm that echoes the monotony of the tapestries, which are of identical height. The first door on the left, which is open and shown in perspective, proved to be decorated with a sort of patera inscribed in a molded medallion. This decoration is typical of the time and recalls the elements that decorate Bramante's cupola for Santa Maria delle Grazie, further evidence of a continuous exchange of ideas between Leonardo and Bramante. (See Section II, note 9.)

Describing the results of the recent restoration should not of course be reduced to listing specific discoveries and spectacular details. Nevertheless, the overall image of the *Last Supper* is a reunified composition of fragments, aided by the carefully modulated watercolor that evens out the lacunae. In the interest of giving a broad account of the recovery, I shall not linger on the details of the tablecloth—its folds, its embroidered blue decoration, its corners with bulging knots and heavy hems (anticipating the unmade beds in Cerano's interiors); the colored reflections created on the edges of pewter plates by the light as it reflects from the apostles' clothing; the transparency of glasses and cruets; the luminous "flares" that refract light within the plates and illuminate the inner concavity that should be in shadow. These naturalistic details, glimpsed after Pellicioli's restoration, are

today clear and precisely defined: we sense the aromatic fragrance of the bread; the faint shadows cast by objects on the table; the fruit; the well-turned salt-cellars; the reflections of orange sections in the plates.

Rather, I want to address Leonardo's "chiaroscuro" as it emerges in the faces and flesh tones. These are generally the best-preserved parts of the composition, along with the fine drapery passages in the figures of Matthew, Simon, Judas, Peter and Bartholomew.

Christ's face was affected by a loss of color, particularly on the left side. Nevertheless, his face appears highly finished in the conserved areas; even delicate, reddish brushstrokes define the hairs of his beard. The light strikes him from our left, intercepted by his forehead and nose where the rosy flesh tones become paler. Unfortunately, his mass of dark hair has been largely lost but must have originally isolated the face in the white glow of distant sky, creating a shadow area around him from which he emerged. The half-closed mouth, half-lowered eyelids, and inclination to our right imbue him with one of the sweetest, most knowing and moving expressions in Italian Renaissance painting. If we forget for a moment that this face was carefully conceived to represent Christ, we can imagine that Leonardo used a portrait "from life" (perhaps of Alessandro Carissimi of Parma, the model for Christ's hand) to achieve an image of such universal significance. After the restoration, Christ's face does not appear unfinished; the characteristics of the *materia* and the subtlety of its application fully confirm that Leonardo painted the face, which was spared the heavy repaints that long afflicted the heads of Matthew and Philip.

In Philip's face the pictorial rendering follows life so closely with the most subtle passages of tempera color and chiaroscuro as to suggest the figure's "life and breath." Philip's head was probably the most imitated and copied during the sixteenth century because of its expressiveness and intense emotional charge, further enhanced by the apostle's gesture of putting his hands to his chest and the forward motion of his upper torso. Echoes reverberate in paintings by Giorgione, Sebastiano del Piombo, Titian and Palma il Vecchio, artists all clearly struck by the perfect correspondence of pose and expression to *moto mentale,* again

visible after five centuries. Once restored, the face regained an extraordinary plasticity with its marked inclination not only forward, but also diagonally in space. The result rates among the highest achievements of the restoration, immediately appreciable by comparing the recovered image with photographs taken by Ferrario in 1908, in which Philip's face resembles an empty, flat mask. The images published in 1954 in *Saggi e ricerche* after Pellicioli's restoration show the image with only minimal repaint removed.[56]

The head of James Major is more dramatic now that its powerful three-dimensionality has been recovered. We can see that Leonardo achieved the effect through several brushstrokes of white to the side of the nose, the temples and the cheekbones, which contrast with the deep-set eyes and the open mouth. Though fragmentary, the painting communicates the apostle's sense of horror even more successfully than the magnificent drawing at Windsor Castle. The head of Simon, also partially lost, displays Leonardo's virtuoso anatomical skills in the powerful modeling of the neck and nape, also apparent in the study for the head of Judas at Windsor Castle.

The painted head of Judas proved to be largely lost, and it does not achieve the same excellent rendering of the neck's bunched musculature as the head of Simon. The head of Judas may have been one of the most difficult for Leonardo to paint, and he represented it turning toward Christ, extablishing a diagonal within the depth of the painting (and like Simon's head, in *profil perdu*). Judas's head was completely in shadow and turned slightly upward, thus rendering the foreshortening even more difficult, further complicated by the need to concentrate as wicked an expression as possible on his face. Leonardo clearly succeeded: in the second half of the sixteenth century, the distinguished historian Vincenzo Borghini (1515–80) declared Judas's expression the best example of all that was "irascible, cruel, all resentment and rage."[57] (Judas's posture of shrinking back from Christ and leaning his elbow on the table was appropriated by Titian for his *Supper at Emmaus*, now at the Louvre, a painting that betrays a general knowledge of Leonardo's *Last Supper*, Christ included.[58]) At any rate, the absence of white pigment in the *campitura* of Judas's head caused an impover-

ishment of the colors over time (also perhaps affected by old cleanings). The recent restoration revealed that repaints dating from different periods had broadened and excessively expanded the head, transforming it into a pure profile. The restoration revived the head's original outline and reduced its width and foreshortening (but conserved an intermediary repaint).

With the heads of Simon, James Major, Philip and Judas, Leonardo demonstrated his mastery of anatomy studied "from life," of the "passions of the soul" and of physiognomy, taking them to the highest level of artistic expression.[59] With the heads of Christ, Matthew and Bartholomew, however, the scientific study of nature seems to have given way to a process of idealization. The astonishing recovery of Matthew's profile, now free of eighteenth-century repaints, has provoked comparisons with classical relief sculpture. It suggests new insights into Leonardo's relationship to antiquity—that he was familiar with the profiles of Roman emperors carved into the basamento at La Certosa di Pavia and attributed to Giovanni Antonio Amadeo (1447–1522) and the Mantegazza brothers Cristoforo (1464–1482) and Antonio (1472–1495); that he knew the antique models for Tullio Lombardo's (1460–1532) statues for the monument to Doge Andrea Vendramin in Venice; and that he even knew Lombardo's statues themselves.[60] In any event, the restoration of Matthew's head finally exposed not only his noble, classical profile, but also the paint surface, the original "skin" of Leonardo's painting, conserved in almost complete integrity. (The figure also shows significant traces of purple glazing over the transparent blue of the garment's collar.) This "skin," by virtue of its tenuous chiaroscuro and delicate surface, does not translate Leonardo's "classical" ideals into an inert profile, an "academic" head, or a cadaverous, embalmed complexion (to quote Longhi on the figures painted by Leonardo's "students"), but into a face that is at once naturalistic and idealized. If Matthew's head had not been executed in tempera, we might expect to find impressed in its pulsating "skin" the fingerprints of Leonardo, who ultimately handled material in such a way that he achieved an imperceptible vibration and a startling realism in his painting, an effect more commonly obtained using oils.

Matthew's head is certainly idealized but also imbued with an interior life not unlike, though more intense than, those of Leonardo's Milanese portraits, such as *Portrait of a Musician, Lady with an Ermine*, and *La Belle Ferronnière*.

Before leaving this area of the painting, I should mention the left hand of Thomas, resting on the table and visible in all the most faithful copies, but later repainted and transformed into a loaf of bread. Apart from the hand itself, also visible in a student's copy at Windsor Castle, this is the ultimate proof of how Leonardo's original paint layers were long concealed by repaints, until now only minimally removed. Removing the repaint has allowed us, once again, to approach the "true" Leonardo.

The head of Bartholomew, although fragmentary owing to abundant losses of preparation and color, was restored to its original design. The hair had been expanded out of all proportion, to the extent that it covered a large part of the decoration of the door behind the apostle. His garment, serving as counterpoint to Matthew's, turned out to be a luminous blue, and traces of the original emerald green of his mantle appeared in the drapery near the tablecloth (the emerald green—copper acetate—was glazed with lemon yellow—lead-tin yellow—to confer luminosity and transparency). In front of this figure—the only one depicted as standing—a passage of the gray-blue tablecloth was revealed to be intact. Even the metalpoint incisions Leonardo used to define his drawing are visible.

The disfiguring effect of an alteration to Andrew's head, from a three-quarter view to one that was almost frontal, was attenuated. Possibly it was Mazza in the eighteenth century who added the left part of the face and reconfigured the cheekbone and eye. Analogously, the head of Peter, which had been transformed into an erect profile, reacquired its inclination and original foreshortening, although the material and color proved somewhat impoverished. The head of John was also in a fragmentary state, but a portion of his mantle, in delicate pink-violet tones, reappeared after removing the daubs of repaint.

The most important achievement in the Andrew-Judas-Peter-John group, as already noted, was the restored alternation of plastic masses, owing to the discovery of original material defining the limbs and drapery. Now we understand how Peter's right arm serves as the hinge between the figures of Andrew and Judas. The ultramarine blue (lapis lazuli) of his garment, interrupted by the flesh tone of the hand holding a gray-blue knife, which stands out against the yellow of his mantle, allows the arduous transition from the yellow of Andrew's garment to the turquoise of Judas's mantle. It creates a projection toward the viewer in an extremely difficult superimposition of blue lightly heightened with white (for the extending arm) on darker azure (for his side, slightly in shadow). The two blues (ultramarine from lapis lazuli, and turquoise) fade into the blue-violet (almost periwinkle) of John's garment at right. This is coupled with the pink-purple of his mantle, as if to introduce the bright red of Christ's garment, which is in turn intensified through its juxtaposition with the lapis-lazuli blue of Christ's mantle. Matthew's outstretched arms, blue against the red of Philip's garment, serve as the pivot for Peter's arm. All the "tonal" transitions, "direct" our gaze from the center toward the external edge, and vice versa, imparting dynamism and *moti* to the gestures and poses. Every detail of arm or hand received specific attention to achieve this effect, as did the chromatic and tonal values they must have originally exhibited. This achievement elucidates the importance Leonardo assigned to the study of Peter's arm. In the corresponding drawing at Windsor Castle, Leonardo handled the sleeve in a painterly, almost atmospheric manner, foreshadowing the later "painterly" studies for *Saint Anne*, now at Windsor Castle. Undoubtedly, other details must have been studied with the same attention. The hand positions, for example, seem to support the ascending rhythm of the composition from Christ toward the outside, and must have warranted studies. In the painted mural, we can see the care that Leonardo took in painting them. The hands of Simon, Matthew, Philip and James Major at right, and the hands of Peter, Andrew and Bartholomew at left are among the best-conserved parts of the composition. (Unfortunately, John's hands, documented in the drawing at Windsor, are in poor condition.) Outlines are often "reinforced" in black, especially if they stand out against light tones, clearly to make them prominent, creating the effect of space surrounding the various limbs.

Having begun this section with general comments on the restored image, let me end with an equally general remark. The recent restoration seems to allow air to flow around the figures, between them and the painted space and between the painting and the real space of the refectory. The shadowy crevices, the luminous drapery, the plastic power of the faces, the suspended arms and the expressiveness of the hands have been unveiled before our eyes, as if immersed in an atmospheric continuum. We again see the gestures, the gazes, and almost hear the words of Christ resonating in the air. And with the air, the light and shade come alive in these fragments of paint, revitalizing the play of opposites that is the foundation of Leonardo's art.

V

Concerning the Copies

Since the eighteenth century, the *Last Supper* has been routinely studied through copies. The original painting has always been described as being on the catastrophic verge of disappearing, often with exaggerated accounts of its poor condition, justifying the various restorations as well as the execution of copies. Since the sixteenth century the large body of painted copies testify to the ongoing interest of artists and patrons in Leonardo's "modern style" of handling an episode from the Gospels.[1] These copies can be organized into two main groups, with several subgroups.

The first group includes the oldest copies—engraved, painted, or sculpted—dating from the end of the fifteenth century to the early seventeenth century. Leonardo's iconography was deemed new and original, and the main purpose of these works was to convey his "invention," considered excellent and "miraculous" for its artistic values. Not being portable, the painting gave rise to faithful duplications on a smaller scale that could be transported and sold, and to copies on canvas that catered to the desire for same-size versions.

Not surprisingly, the earliest faithful reproduction of the *Last Supper* was a wood engraving, variously attributed to Antonio da Monta, Andrea da Brescia, or the Master of the Sforza Book of Hours. The low cost and vast number of prints that could be pulled from a single plate satisfied the most diverse needs of customers. This print holds an added interest: a scroll appears on the front of the table displaying the quotation from the Gospel of John announcing Christ's betrayal. Undoubtedly this addition was approved by the Dominicans at Santa Maria delle Grazie, who were anxious to review any copy that would disseminate the image and its meaning.

Copies made to "duplicate" Leonardo's *invenzione* include the first known painted copy, by Bramantino (c. 1465–1530), now lost but dating from 1503; the full-scale oil on canvas by Giampietrino from the end of the sixteenth century, originally at La Certosa di Pavia and now at Magdalen College, Oxford; and an oil on canvas from the workshop of Marco d'Oggiono, now at the Musée de la Renaissance at Écouen. (A reduced-scale painted copy on panel, now at the Pinacoteca di Brera, is also attributed to a follower of d'Oggiono.) An oil on canvas copy at the Gerolamini convent at Castellazzo dates to before 1514, while Lomazzo's fresco for the refectory of Santa Maria della Pace dates from the second half of the century (both now destroyed). These large copies were generally done on commission for monastic orders or other religious groups; Bramantino's oil on canvas is an exception as it was commissioned by the ducal treasurer, Antoine Turpin, for the enormous sum of 100 *scudi* (400 imperial lire).[2]

The earliest sculptural versions of the *Last Supper* include an old marble copy attributed to Tullio Lombardo, now at Ca' d'Oro in Venice. Given its considerable age, dating from c. 1510, it might actually reflect a preliminary stage in the *Last Supper*'s composition. Other sculptural versions include the marble copy by Biagio Vairone at La Certosa di Pavia, and the painted wood figures by Andrea da Milano and Alberto da Lodi at the sanctuary of the Madonna dei Miracoli in Saronno,[3] which are important because they capture the *Last Supper*'s plastic, three-dimensional quality. The copies of individual apostles by Bambaia (c.1483–1548) for the tomb of Gaston de Foix at the Castello Sforzesco should also be included in this group.

By the beginning of the sixteenth century, it was popular among the various Lombard monasteries to own a copy of Leonardo's *Last Supper*. Often these copies were not faithful to the original but loosely interpreted Leonardo's composition in light of prevailing religious ideas. Because the artists of these copies made no pretext of documenting the prototype, they often altered the image as a whole, the expressions of the individual figures, and the architectural space, not to mention the meaning. Various fresco copies in northern Italy and in Canton Ticino—the one in the church of San Siro at Lanzo d'Intelvi (Como), for example—emphasize the eucharistic aspects of Leonardo's *Last Supper,* not only because that area was less influenced by alternative imagery for the Last Supper (as in Albrecht Dürer) and resistance to Lutheranism was stronger there, but also because, after the Reformation, the Roman Catholic Church put greater emphasis on the value of the Eucharist.

Leonardo's basic composition was used in this spirit, even though it placed equal stress on the moment of instituting the sacrament and the announcement of Judas's betrayal. Dürer's graphic works and drawings—for example, *The Small Passion* of 1509–11; *The Large Passion* of 1510; the drawing L 579 at the Albertina, Vienna; and the wood engraving from 1523—focus almost exclusively on the mystery of the Eucharist in the Last Supper, as does Gaudenzio Ferrari's *Last Supper* of 1513 on the partition wall at the church of Santa Maria delle Grazie in Varallo.

Along with the oldest, most faithful copies, there are more popular interpretations that also belong in this category. They translate the complexity of Leonardo's painting without absorbing all the relationships among the figures; instead, they disentangle the actors of the drama according to earlier iconographic traditions. The fresco of 1507 by Giovan Pietro da Cemmo, now detached but formerly in the refectory of the Augustine convent of Sant'Agostino in Crema, belongs to this group. Set against a background of monumental vaults, only the figures of Philip and Judas correspond to those in Leonardo's painting. Without the original work's strong, solid structure, this lively and confused composition seems to parody Leonardo's masterpiece.

In Tommaso Aleni's 1508 fresco in the refectory of San Sigismondo in Cremona, only Judas and James Major, and perhaps John and Andrew, retain any of Leonardo's expressiveness. In the fresco attributed to Sigismondo de Magistris, formerly in the church of San Giorgio, now in the parish house of Alzate Brianza (Como), only the figure of Thomas begins to reflect its more prestigious prototype. These more popular versions, especially if they altered the religious content of the *Last Supper*, shed no light on the problem of the painting's original aspect before the substantial modifications of the eighteenth and nineteenth centuries.

Some of the older, small-scale versions may have been private commissions—for example, Bramantino's painting, the oil on panel by Cesare Magni, the one attributed to the workshop of Marco d'Oggiono (both at the Pinacoteca di Brera), and the anonymous oil on canvas currently in the offices of the Soprintendenza ai Beni Ambientali e Architettonici of Milan (Palazzo Reale, Milan). These copies date from the first two decades of the sixteenth century, when Milan was ruled by France and prominent French officials commissioned works by Leonardo and his principal students. Louis de Luxembourg, the count de Ligny, maintained a relationship with Leonardo and Bramantino; Charles d'Amboise also commissioned work by Leonardo; Georges d'Amboise, Charles's brother, was Andrea Solario's patron; Antoine Turpin requested the copy by Bramantino; and Gabriel Goffier, papal prothonotary, commissioned Marco d'Oggiono. These important figures in the French government were fascinated by the "modern" style of Leonardo and his students, and by the *Last Supper* in particular. (There were also Milanese aristocrats, such as Gian Giacomo Trivulzio, whose social and political status required that they conform to the new fashion.) During the first two decades of the century, members of the French government were obviously emulating Louis XII's attention to Leonardo's work. (According to Giovio and Vasari, he was the French king who wanted to transfer the work to France.) After 1515, a similar enthusiasm was spawned by François I's interest in the *Last Supper* and in Leonardo, who eventually followed him to France.[4]

A thorough examination of the *Last Supper*'s influence during the sixteenth century cannot be strictly limited to the copies, which would preclude analyzing Leonardo's impact on a number of highly skilled and intelligent artists. For example, there are many partial copies of the *Last Supper* as well as images that employ Vincian theories of *moti dell'anima,* movements of the soul, to "update" subjects or compositions not always directly related to the *Last Supper*. Sometimes these effects are so camouflaged, however, that it is difficult to create a straightforward list, but echoes of the *Last Supper* can certainly be found in Lombard, Venetian, and central Italian paintings of the sixteenth century, signaling the painting's widespread influence.

The paintings of Giovanni Antonio Boltraffio and Giovanni Agostino da Lodi did much to disseminate the *Last Supper*'s compositional innovations, as did the sculptures of Tullio Lombardo and even some works attributed to Giorgione (showing groups of two or three half-length figures in musical or allegorical scenes, such as the *Three Ages of Man*). Even whole figures from the *Last Supper* were

adapted to different contexts—for example, the altarpiece representing the *Resurrection of Christ with Saints Leonard and Lucy*, attributed to Marco d'Oggiono and Boltraffio. Now in the Berlin Museum, the work was probably completed in 1495 (after a first commission in 1491, reformulated in 1494). The expression of Saint Lucy, attributed to Boltraffio, suggests the artist was familiar with the figure of Philip in the *Last Supper* (indicating either an earlier starting date for the mural by Leonardo or Boltraffio's knowledge of Leonardo's preparatory studies for this figure).

A group of "Leonardesque" painters maintained ties with Venice, and perhaps even moved there between the end of the fifteenth century and the beginning of the sixteenth century. Andrea Solario was certainly in Venice in 1495, and shortly thereafter Giovanni Agostino da Lodi probably arrived as well. His *Saint Peter and Saint John,* now in the Pinacoteca di Brera, seems to reflect the groupings of half-length figures used by Leonardo in the *Last Supper*. In 1498, Marco d'Oggiono was commissioned to paint several canvases for the Scuola di Sant'Ambrogio in Venice, while Francesco Napoletano (Francesco Galli), after accompanying Ambrogio de Predis to Innsbruck in 1494, died in the lagoon city in 1501. The presence of these artists in Venice and works by Marco d'Oggiono sent there extended the influence of the *Last Supper* to this region.

As already noted, in the sixteenth century the most popular figures from the *Last Supper* were those of Judas and James Major, and Philip for his suffering, moving expression. Giorgione's *Portrait of a Young Man* (now in Budapest) executed around 1510 using the "chased and terribly dark, smoky" manner of Leonardo's new style, betrays a familiarity with Philip in the *Last Supper*. Sebastiano del Piombo also seemingly knew the figure and borrowed it for the *Judgement of Solomon* (Bankes Collection, at Kinston Lacy, Dorset). Philip also seems to have inspired a figure in Titian's *Susannah and David* (now in Glasgow), and Titian reworked the figure of Judas into a table companion in *Supper at Emmaus* (Louvre; also translated into a tapestry now in the church of Saint George at Windsor Castle). Leonardo's Philip also seems to have influenced Palma il Vecchio in his treatment of a shepherd in *Adoration of the Shepherds* (Louvre).[5] These examples—and Raphael's cartoons for the Sistine Chapel should figure among them—merely hint at the great importance of the *Last Supper* through the sixteenth century (much more so than copies of the painting, however accurate).

In the seventeenth century, artists began to approach the *Last Supper* with a completely different attitude. Although Rubens and especially Rembrandt (who knew the work only through prints or painted copies) looked to the *Last Supper* for inspiration,[6] the painting's worsened condition led to the idea of reconstituting the image based on copies that faithfully preserved the invention of the "original." This may have been the first application of an archaeological method, anticipating Winckelmann's ideas about the "restitution" of ancient monuments—that is, integrating and completing the surviving vestiges of classical antiquity on the basis of knowledge and external documentation. This may explain the copy that Cardinal Federico Borromeo commissioned in the second decade of the seventeenth century from Il Vespino, as well as all the eighteenth- and nineteenth-century copies.[7] Bossi later showed that this method could also be used for the archaeological "recovery" of the *Last Supper*. His copy (intended as the "model" for the mosaic version of the *Last Supper* executed by Giacomo Raffaelli) was based not on the original but on old textual accounts, on Leonardo's theory of proportions, and on copies, particularly the one at the Gerolamini convent at Castellazzo. Such an approach also led to distortions in André Dutertre's engraving of 1789 and Raffaello Morghen's, finished in 1800. (See section III.)

Given these interpolations, the value of these copies is extremely limited in determining an accurate image of the original, and practically worthless from an artistic point of view. Carlo Verri, criticizing Bossi's method, pointed out how deficient copies were in helping to understand the mural, especially those of the eighteenth and nineteenth centuries. More recently, Venturi made the same argument, calling the copies "the skeleton" as opposed to the spirit of Leonardo's composition.[8]

Leopoldo Cicognara, in contrast, was a great admirer of Bossi's copy, as noted in section III:

The learned and cultured artist, signor Giuseppe Bossi, recently reproduced rather than copied the great work that Leonardo da Vinci painted in the refectory of

[Santa Maria] delle Grazie in Milan. . . . He ingeniously consulted copies made in better times, and analyzed the author's style from as many other works as he could find. He rectified the errors made by all the inaccurate copyists of this admirable work, and through comparisons, hard work, research, diligence and talent, succeeded in recreating a cartoon of the original's exact dimension (the largest ever seen among drawings executed with masterful diligence). He was then able to use it to create his painting with confidence. This work is truly so scholarly, diligent and correct that it would be desirable for [someone of] talent or the commission to reproduce with classical burin these sure traces of such a great work. In comparison, one sees too clearly the fallaciousness and uncertainty with which signor Morghen engraved his much-praised *Supper*. Signor Bossi, a correct draftsman, an inventor rich in fine ideas, a composer full of taste and intelligence, has created other various subjects, making him truly a classical artist.[9]

We have moved far beyond the academic categories of the "correct" and the "classic" that informed Cicognara's remarks, but his comments help us understand the copyists' ambition to surpass the work itself in correctness of design and "diligence." (The same aim may also explain the exaggerated devaluation of the *Last Supper*, considered by then destroyed.) While the academic copies from the early nineteenth century offered distorted and frozen images of the mural, some later prints, especially etchings and lithographs by English, Italian, and German artists, attempted to reproduce the *sfumato* and chiaroscuro values still visible in the *Last Supper*. (Or were these values emphasized by restorers such as Barezzi in 1851–53?) Frederick Christian Lewis the Elder, "engraver of drawings" to Queen Victoria, created an etching around mid-century in which he reproduced the head of Christ in the "Nazarene" style. (A copy is in the Raccolta Bertarelli at the Castello Sforzesco.) In 1852, Michele Fanolli created a lithograph of Christ before the table; Christ, isolated and strongly modeled, seems to emerge from a perspective cube (example in the collection of the Municipio di Cittadella, Padua).[10]

At any rate, the value of the copies cannot be overestimated. The oldest painted copies, such as the oil on canvas attributed to Giampietrino at Oxford and the one attributed to Marco d'Oggiono at Musée de la Renaissance (Écouen), proved useful in the initial phases of the recent restoration, and they have taught us much about the copy methods used by Renaissance artists. Tracings of these copies and the one at Tongerlo Abbey were executed by Pinin Brambilla Barcilon and her team, and they demonstrate how the painters faithfully traced the most important elements of Leonardo's work—the heads, hands, and other principal outlines of the various figures—but then assembled the pieces into complete images that did not always take into account the original intervals between the figures and the painted spaces in the mural.[11]

Because the *Last Supper* was so beloved in the nineteenth century and its image widely disseminated through prints, it commonly figured in popular religious imagery. In the Museo del Folklore in Caltanisetta, one finds a sculptural group of the *Last Supper* intended to be carried in religious processions. Strangely enough, it seems to presuppose knowledge of the sixteenth-century sculptures in the sanctuary at Saronno. The success of the *Last Supper* through prints became an artistic subject in and of itself. Several nineteenth-century genre paintings show one in the background. One example is the delightful *Portrait of Mrs. James Wyatt and Her Daughter Sarah* painted by Sir John Everett Millais (Tate Gallery), where an engraving of the *Last Supper* appears in the background between two engravings after Raphael, alluding to English nostalgia and the myth of Italy.[12]

Painted, sculpted, even embroidered copies, bas reliefs, engravings on crystal, free derivations, and total reinterpretations give a measure of the original work's enormous success over five centuries, even when they border on the ridiculous. "Archaeological" and "academic" copies, prints, engravings and photographs have made its image popular the world over. *Last Supper*s are available on Moroccan rugs and in stained-glass versions in American museum shops. One can even find small three-dimensional versions executed in marble dust compound or stucco by A. Giannetti that echo the copy in Milan's Cimitero Monumentale—most unusual for the way in which they integrate the figures with inventive backdrops of drapery.[13]

During our own time, Leonardo's *Last Supper* continues to inspire new generations of artists—ranging from filmmakers Eisenstein and Buñuel to sculptor Marisol and from painter Ben Willikens, who exhibited his mortuary table at the Pinacoteca di Brera in 1982, to Andy Warhol, who executed a series of mixed-media revisitations in 1986, near the end of his life.[14]

Principal Copies of the *Last Supper*

This list gives leading examples of the more faithful copies of Leonardo's *Last Supper*, divided into three groups: paintings on wood, canvas, or walls; sculptures; and tapestries and embroideries. Drawings and engravings derived from the *Last Supper* are not included. Modern derivations and copies are also not listed, nor are commercial and advertising uses, though indicative of the popularity of the *Last Supper* in our own time.

Paintings

1. Bramantino, oil on canvas, painted in 1503 for Antoine Turpin, ducal treasurer. Lost.
 Bibl.: Janice Shell and Grazioso Sironi, "Documents for Copies of the *Cenacolo* and the *Virgin of the Rocks* by Bramantino, Marco d'Oggiono, Bernardino de' Conti and Cesare Magni," *Raccolta Vinciana* 23 (1989): 103–17.

2. Marco d'Oggiono, oil on wood panel, 1506, approx. 60 cm × 105 cm, commissioned by Gabriel Goffier as part of a predella for a six-part polyptych. Unidentified or lost.
 Bibl.: Shell and Sironi, "Documents" (1989), 105–17.

3. Antonio da Gessate, fresco, 1506, 600 cm × 270 cm. Formerly in the Ospedale Maggiore, Milan; removed after 1915 and placed in the refectory of Santa Maria delle Grazie. Destroyed in 1943.
 Bibl.: Giuseppe Bossi, *Del Cenacolo di Leonardo da Vinci Libri Quattro* (Milan, 1810), 131ff.; Otto Hoerth, *Das Abendmahl des Leonardo da Vinci* (Leipzig: Hiersemann, 1907), 235; Leo Steinberg, "Leonardo's Last Supper," *Art Quarterly* 36, no. 4 (1973): 297–410, esp. p. 402; Shell and Sironi, "Documents" (1989), 104n4.

4. Tommaso Aleni, fresco, 1508, Cremona, San Sigismondo.
 Bibl.: Luisa Vertova, *I Cenacoli fiorentini* (Turin: ERI, 1965), fig. 26; Steinberg, "Leonardo's Last Supper" (1973), 402.

5. Attributed to Andrea Solario, fresco, before 1514. Formerly in the Convento dei Girolomini at Castellazzo. Destroyed in 1943.
 Bibl.: Bossi, *Del Cenacolo* (1810), 134–37; Steinberg, "Leonardo's Last Supper" (1973), 402.

6. Anonymous, fresco, early sixteenth century. Milan, San Lorenzo.
 Bibl.: Francesco Malaguzzi-Valeri, *La corte di Ludovico il Moro*, 4 vols. (Milan: Hoepli, 1913–23), 2:546; Steinberg, "Leonardo's Last Supper" (1973), 402; Marco Rossi and Alessandro Rovetta, *Il Cenacolo di Leonardo: Cultura domenicana, iconografia eucaristica e tradizione lombarda*, Quaderni del restauro, 5 (Ivrea: Olivetti, 1988), 80.

7. Attributed to Marco d'Oggiono, oil on wood panel, 268 cm × 121 cm, ca. 1520. From the church of San Barnaba, Milan. Milan, Pinacoteca di Brera, Reg. Cron. 460.
 Bibl.: Bossi, *Del Cenacolo* (1810), 132–34; Hoerth, *Das Abendmahl* (1907), 237ff.; Carl Horst, "L'Ultima Cena di Leonardo nel riflesso delle copie e delle imitazioni," *Raccolta Vinciana* 14 (1930–34): 118–200, esp. fig. 29; Steinberg, "Leonardo's Last Supper" (1973), 403; Pietro C.

Marani, *Leonardo e i leonardeschi a Brera* (Florence: Cantini, 1987), 176–79; Rossi and Rovetta, *Il Cenacolo* (1988), fig. 45.

8. Attributed to Marco d'Oggiono, oil on canvas, 549 cm × 260 cm, early decades of sixteenth century. Écouen, Musée de la Renaissance. But because the work was commissioned by the Conétable de Montmorency for his chapel in the château at Écouen, built 1540–47, a later date is implied.

Bibl: Horst, "L'Ultima Cena" (1930–34), 126ff.; Steinberg, "Leonardo's Last Supper" (1973), 403; Rossi and Rovetta, *Il Cenacolo* (1988), fig. 44.

9. Giampietrino, oil on canvas, 770 cm × 298 cm, ca. 1515–20, from La Certosa di Pavia (where it could still be found at the end of the sixteenth century). London, Royal Academy of Art; now held in Magdalen College, Oxford. The drawings now in the Strasbourg Museum derive from this work.

Bibl.: Bossi, *Del Cenacolo* (1810), 137–38; Emil Möller, *Das Abendmahl des Leonardo da Vinci* (Baden-Baden: Verlag für Kunst und Wissenschaft, 1952), 139; Steinberg, "Leonardo's Last Supper" (1973), 403; Marani, *Leonardo e i leonardeschi* (1987), 24–28; Rossi and Rovetta, *Il Cenacolo* (1988), fig. 46; Janice Shell, Pinin Brambilla Barcilon, and David Alan Brown, *Giampietrino e una copia cinquecentesca dell'Ultima Cena di Leonardo*, Quaderni del restauro, 4 (Ivrea: Olivetti, 1988).

10. Alessandro Araldi, fresco, ca. 1514, Parma, San Paolo, Camera dell'Araldi.

Bibl.: Corrado Ricci, "La copia del 'Cenacolo' fatta da Alessandro Araldi," *Raccolta Vinciana* 2 (1906): 72–73; Steinberg, "Leonardo's Last Supper" (1973), 402.

11. Gerolamo Bonsignori, oil on canvas, approx. 234 cm × 737 cm, ca. 1513–14. Formerly in the Convento di San Benedetto Po, near Mantua; now in Badia Polesine. An extremely fine sixteenth-century drawing enhanced with gray-blue chiaroscuro in watercolors, gone over with a pen and sepia ink, now in a private collection in Rome, reproduces this copy exactly. It can be identified either as a preparatory sketch by Bonsignori himself or as a *d'après* from his painting.

Bibl.: Bossi, *Del Cenacolo* (1810), 140–41; Malaguzzi-Valeri, *La corte* (1913–23), 2:542, fig. 596; Steinberg, "Leonardo's Last Supper" (1973), 402; Filippo Trevisani, *Restauri nel Polesine: Dipinti, documentazione e conservazione,* catalog of an exhibition (Milan: Electa, 1984), 92–131; Paolo Piva, "Correggio e Bonsignori: La scoperta di un episodio di collaborazione artistica del primo Cinquecento," *Quaderni di Palazzo Te* 4 (January–June 1986): 37–59.

12. Anonymous, copy of Bonsignori's copy, oil on canvas, 76 cm × 122 cm. Munich, Bayerische Staatsgemäldesammlungen.

Bibl.: Piva, "Correggio e Bonsignori" (1986), 38, 40, fig. 4.

13. Attributed to Battista da Vaprio, oil on canvas, first or second decade of sixteenth century. Savona, Seminario Vescovile. This work is considered to reflect the presence of Marco d'Oggiono in Savona during the first decade of the sixteenth century.

Bibl: Carlo Varaldo, "Un'opera leonardesca nella Liguria di Ponente: Il polittico di Marco d'Oggiono e Battista da Vaprio per il San Giovanni di Andora," *Rivista inguana e intemelia* 31–33 (1976–78): 164–71; Rossi and Rovetta, *Il Cenacolo* (1988), fig. 48.

14. Anonymous, sixteenth century, oil on wood panel, 26 cm × 160 cm. Milan, Pinacoteca del Castello Sforzesco, inv. 703.

Bibl.: Malaguzzi-Valeri, *La corte* (1913–23), 2:550; Pietro C. Marani, in *Museo d'arte antica del Castello Sforzesco* (Milan: Electa, 1997), 319.

15. Anonymous sixteenth-century French-Flemish artist, tempera on canvas, 40 cm × 202 cm. Milan, Pinacoteca del Castello Sforzesco, inv. 704.

Bibl.: Malaguzzi-Valeri, *La corte* (1913–23), 2:550; Marani, in *Museo d'arte antica* (1997), 319–20.

16. Cesare Magni, oil on wood panel, 64 cm × 138 cm, ca. 1520–30. Milan, Pinacoteca di Brera, Reg. Cron. 1163. This copy may be connected with the drawing of the heads of Peter and Judas in the Biblioteca Ambrosiana (inv. Cod. F 274 inf. 5).

Bibl.: Hoerth, *Das Abendmahl* (1907), pl. V, fig. 3; Horst, "L'Ultima Cena" (1930–34), fig. 26; Malaguzzi-Valeri, *La corte* (1913–23), 2:363; Steinberg, "Leonardo's Last Supper" (1973), 404; Marani, *Leonardo e i leonardeschi* (1987), 228–31.

17. Anonymous, oil on canvas, before 1540, Château de Gaillon. Lost (given as still in existence in 1550; erroneously connected by Möller with the Tongerlo copy).

Bibl.: Möller, *Das Abendmahl* (1952), 117ff.; Steinberg, "Leonardo's Last Supper" (1973), 404.

18. Anonymous Flemish artist, oil on canvas, 794 cm × 418 cm, 1540s, formerly attributed to Solario. Abbey of Tongerlo (near Antwerp), where it is documented from 1545, when it was acquired from a collector in Antwerp.

Bibl.: Möller, *Das Abendmahl* (1952), 109–27; Albert and Paul Philippot, "La dernière Cène de Tongerlo et sa restauration," in *Het Laatste Avondmaal Tongerlo* (Brussels, n.d.); extracted from *Bulletin* of the Koninklijk Insstituut voor het Kunstpatrimonium, 10 (1967–68); Bernard Berenson, *Italian Pictures of the Renaissance . . . Central and North Italian Schools*, 3 vols. (London: Phaidon, 1968), listed as by Solario; Steinberg, "Leonardo's Last Supper" (1973), 404 (with bibliography); Rossi and Rovetta, *Il Cenacolo* (1988), fig. 42.

19. Anonymous, oil on canvas, 65 cm × 30 cm. Milan, Soprintendenza ai Beni ambientali e architettonici.

Bibl.: Steinberg, "Leonardo's Last Supper" (1973), 404; Marani, *Leonardo e i leonardeschi* (1987), 228.

20. Anonymous, oil on wood panel, first half of sixteenth century. Paris, sacristy of the church of Saint Germain l'Auxerrois. Cited in 1651 by Raphael Du Fresne: *Trattato della Pittura di Lionardo da Vinci nuovamente dato in luce, con la vita dell'istesso autore, scritta da Rafaelle Du Fresne* (Paris, 1651), in French translation by Roland Fréart, Sieur de Chambray, under the title *Traitté de la peinture* (Paris, 1651), 13, copied from a drawing now in Windsor Castle, no. 12541. Traces of a signature (or perhaps of vandalizing graffiti) in the lower right corner read "BURDELOT" (or Burdeloc?) and "DARTTOIS." The painting was seen

by Paul Fréart de Chantelou and by Bernini in 1665; it was damaged in 1831 and subsequently repainted. Engraving by Ryland in 1768: see Richard Hüttel, *Spiegelungen einer Ruine: Leonardos Abendmahl im 19. und 20. Jahrhundert* (Marburg: Jonas Verlag, 1994), 16, fig. 12.

Bibl.: Bossi, *Del Cenacolo* (1810), 139 (Bossi attributes the work to Luini); Steinberg, "Leonardo's Last Supper" (1973), 403–4; Rossi and Rovetta, *Il Cenacolo* (1988), fig. 43; Sandrina Bandera Bistoletti, "Gian Lorenzo Bernini e la copia del Cenacolo di Leonardo a Saint-Germain l'Auxerrois," in *I leonardeschi a Milano: Fortuna e collezionismo*, ed. Maria Teresa Fiorio and Pietro C. Marani (Milan: Electa, 1991), 194–98.

21. Anonymous, oil on canvas, ca. 1540, formerly in the Convento dei Girolomini at Castellazzo (owned by Carli in Bossi's time). Copy of fresco copy in that monastery. Lost.

Bibl.: Bossi, *Il Cenacolo* (1810), 143; Steinberg, "Leonardo's Last Supper" (1973), 404.

22. Anonymous, oil on canvas transferred from wood panel, 132 cm × 77 cm, second half or end of the sixteenth century. Saint Petersburg, Hermitage.

Bibl.: Steinberg, "Leonardo's Last Supper" (1973), 404; Tatyana K. Kustodieva, *The Hermitage Catalogue of Western European Painting: Italian Painting, Thirteenth to Sixteenth Centuries* (Florence: Giunti, and Moscow, 1994), 229–30.

23. Attributed to school of Paris Bordone, oil on wood panel, 74 cm × 27 cm. Strasbourg, Musée des Beaux-Arts.

Bibl.: Horst, "L'Ultima Cena" (1930–34), 146, fig. 32; Steinberg, "Leonardo's Last Supper" (1973), 404.

24. Giovan Paolo Lomazzo, fresco, 1561. Milan, refectory of Santa Maria della Pace. Removed in the 1880s and placed in the refectory of Santa Maria delle Grazie. Curious variant in the walls of the room shows long horizontal windows set into thick walls, with an effect that recalls the surreal architectural constructions of Bramantino. Destroyed in 1943.

Bibl.: Bossi, *Del Cenacolo* (1810), 145–46; Malaguzzi-Valeri, *La corte* (1913–23), vol. 2, fig. 604; Möller, *Das Abendmahl* (1952), fig. 103; Steinberg, "Leonardo's Last Supper" (1973), 403; Pietro C. Marani, "Il Cenacolo di Leonardo e i suoi restauri nella Milano fra il XV e il XX secolo fra arte e fede, propaganda politica e magnificenza civile," in *I Tatti Studies: Essays in the Renaissance*, vol. 7 (Florence: Leo S. Olschki, 1998), 191–229, esp. p. 202.

25. Anonymous, ca. 1565–67. Ponte Capriasca (Lugano), church. Considered important because the names of the apostles are inscribed on it, although there is some doubt concerning their identification. Also attributed to Giampietrino, ca. 1520, or to an anonymous artist, ca. 1547.

Bibl.: Bossi, *Del Cenacolo* (1810), 146–50; Gustavo Frizzoni, "L'Affresco del cenacolo di Ponte Capriasca," *Archivio Storico dell'Arte* 3 (1890): 187–91; Möller, *Das Abendmahl* (1952), 54ff.; Steinberg, "Leonardo's Last Supper" (1973), 407–9 (and attendant bibliography).

26. Anonymous, fresco, ca. 1570. Milan, Monastery of San Vincenzo.
Bibl.: Bossi, *Del Cenacolo* (1810), 151–52.

27. Giovan Battista Tarillo, fresco, 1581, base 632 cm. Sesto Calende, Abbazia di San Donato.

Bibl.: Bossi, *Del Cenacolo* (1810), 152–53; Malaguzzi-Valeri, *La corte* (1913–23), 2: 550, fig. 609; Horst, "L'Ultima Cena" (1930–34), fig. 28; Steinberg, "Leonardo's Last Supper" (1973), 403.

28. Anonymous, fresco, end of sixteenth century. Lanzo d'Intelvi (Como), church of San Siro.

Bibl.: Malaguzzi-Valeri, *La corte* (1913–23), 2:550; Rossi and Rovetta, *Il Cenacolo* (1988), fig. 49.

29. Anonymous, fresco, sixteenth century. Novazzano (Canton Ticino), former oratory.

Bibl.: Rossi and Rovetta, *Il Cenacolo* (1988), fig. 51.

30. Andrea Bianchi, called Il Vespino, oil on canvas, 835 cm × 118 cm. Milan, Pinacoteca Ambrosiana. Commissioned in 1612 by Cardinal Federico Borromeo.

Bibl.: Bossi, *Del Cenacolo* (1810), 153–56; Horst, "L'Ultima Cena" (1930–34), fig. 36; Möller, *Das Abendmahl* (1952), figs. 105, 106; Steinberg, "Leonardo's Last Supper" (1973), 406; Pamela M. Jones, *Federico Borromeo and the Ambrosiana: Art Patronage and Reform in Seventeenth-Century Milan* (Cambridge: Cambridge University Press, 1993), in Italian trans. under the title *Federico Borromeo e l'Ambrosiana: Arte e riforma cattolica nel XVII secolo a Milano* (Milan: Vita e Pensiero, 1997), 250; Marani, "Il Cenacolo di Leonardo" (1997/98), 199–205, figs. 9–15.

31. Anonymous Lombard (?) painter, oil on canvas, 183 cm × 260 cm, 1615. Guamo (Capannori).

Bibl.: Carlo Pedretti, in *Leonardo e la pulzella di Camaiore* (Florence: Giunti, 1998), 41.

32. Attributed to Anthony van Dyck, oil on canvas, 1618. Private collection, Madrid.

Bibl.: Hüttel, *Spiegelungen* (1994), 16, fig. 11.

33. Giovanni Mauro della Rovere, called Il Fiammenghino, detached fresco, approx. 500 cm × 800 cm, dated 1626. Formerly in the refectory of the Convento dei Frati Disciplini attached to the church of San Michele alla Chiusa, Milan; in private hands after the Napoleonic suppression of monastic institutions. Acquired by the Amministrazione Provinciale di Milano from the Vallardi Borgomaneri family in 1957 and placed with the Museo Nazionale della Scienza e della Tecnica, Milan.

Bibl.: Borgomaneri, *Il Cenacolo del Fiammenghino* (Genoa, n.p., 1940).

34. Anonymous, oil on canvas, seventeenth century. Ottaviano (Naples), church of the SS. Rosario.

Bibl.: Marani, *Il Cenacolo* (1998), 198, fig. 15.

35. Giacinto and Agostino Santagostino, oil on canvas, ca. 1675. Milan, refectory of San Pietro in Gessate.

Bibl.: Bossi, *Del Cenacolo* (1810), 157–58.

36. Giuseppe Romagnoli da Marolta, oil on canvas, early eighteenth century. Castro di Valle di Blenio (Lugano), church of San Giorgio.

37. Giovan Battista Bianchi, oil on wood panel, 50 cm × 75 cm, signed and dated 1791. Milan, private collection.

Bibl.: Marani, "Il Cenacolo di Leonardo" (1997/98), 210, fig. 16.

38. Simon Göser, fresco, 1805. Freiburg in Breisgau, Heiliggeist-Kapelle.

Bibl.: Hüttel, *Spiegelungen* (1994), 36, fig. 28.

39. Luigi Ferrari, oil on canvas, limited to a *Head of Christ*, 1806. Milan, Museo Nazionale della Scienze e della Tecnica.

40. Giovanni Bossi, oil on canvas, 1807. Formerly at the Brera, then at the Castello Sforzesco in Milan. Done on commission from Eugène de Beauharnais as a pattern for the mosaic executed by Giacomo Raffaelli. Based on the Castellazzo copy. Destroyed in 1943. See sections III and IV.

Bibl.: Bossi, *Del Cenacolo* (1810), 168–201; Hüttel, *Spiegelungen* (1994), 29, fig. 26; Marani, "Il Cenacolo di Leonardo" (1997/98), 214–15, fig. 20.

41. Francesco Gagna, oil on wood panel, 1821–31. Turin, cathedral. Based on the engraving by Morghen and done on commission for Carlo Felice.

Bibl.: Malaguzzi-Valeri, *La corte* (1913–23), 2:fig. 608; Steinberg, "Leonardo's Last Supper" (1973), 407.

42. Thomas Driendl, oil on canvas, 1858. Elsfleth-Weser, Nikolaikirche.

Bibl.: Hüttel, *Spiegelungen* (1994), 37 fig. 29.

Sculpture and Mosaics

43. Circle of Tullio Lombardo, marble, 85 cm × 189 cm × 11 cm, ca. 1510. Venice, Ca'd'Oro. A free and fragmentary copy (the right part is missing) that may reflect an early stage of Leonardo's project.

Bibl.: Steinberg, "Leonardo's Last Supper" (1973), 405 (and attendant bibliography); Rossi and Rovetta, *Il Cenacolo* (1988), fig. 47; Maria Teresa Fiorio, no. 86, in *Leonardo & Venezia*, ed. Giovanna Nepi Sciré and Pietro C. Marani (Milan: Bompiani, 1922), 390–91 (with bibliography).

44. Giovanni della Robbia, glazed terracotta, 55.9 cm × 162.6 cm. London, Victoria and Albert Museum. Free copy, with the apostles in different positions, inverted in respect to the original.

Bibl.: Steinberg, "Leonardo's Last Supper" (1973), 405; Rossi and Rovetta, *Il Cenacolo* (1988), fig. 61.

45. Biagio da Vairone, marble. La Certosa di Pavia.

Bibl.: Malaguzzi-Valeri, *La corte* (1913–23), 2: fig. 622; Steinberg, "Leonardo's Last Supper" (1973), 405; Rossi and Rovetta, *Il Cenacolo* (1988), fig. 56.

46. Andrea da Milano and Alberto da Lodi, thirteen life-size figures in painted wood, 1528–32. Saronno, Sanctuary of the Madonna dei Miracoli.

Bibl.: Bossi, *Del Cenacolo* (1810), 165; Horst, "L'Ultima Cena" (1930–34), 16, fig. 34; Steinberg, "Leonardo's Last Supper" (1973), 406 (where the piece is given as school of Gaudenzio Ferrari); Rossi and Rovetta, *Il Cenacolo* (1988), fig. 59; Pietro C. Marani, "The Restoration of a Last Supper in 3-D," *Achademia Leonardi Vinci: Journal of Leonardo Studies and Bibliography of Vinciana* 8 (1995): 237–38; Pietro C. Marani, "Pittura e decorazione dalle origini al 1534," in *Il Santuario della Beata Vergine dei Miracoli a Saronno*, ed. Maria Luisa Gatti Perer (Milan: Istituto di Storia dell'Arte Lombarda, 1997), 137–84; Marco Rossi, "Fra decorazione e teatralità: Andrea da Milano e Gaudenzio Ferrari e dintorni," in *Il Santuario della Beata Vergine dei Miracoli a Saronno* (1997), 195–234.

47. Francesco Biancardi, thirteen life-size statues in painted plaster (?), late nineteenth century. Caltanissetta, Museo del Folklore.

Bibl.: Giuseppe Quatriglio, "Divine rappresentazioni" *Arrivederci*, Year 10, no. 107 (Bergamo: January 1999): 28–29.

48. Giacomo Raffaelli, mosaic (from a cartoon and copy by Bossi), 1807–11. Vienna, Minoritenkirche. For archival documentation of this work and the relevant bibliography, see section III.

Bibl.: Hüttel, *Spiegelungen* (1994), 29, fig. 27.

Tapestries and Embroideries

49. Made in Brussels, marked "F.P.," ca. 1530. Vatican City, Vatican Museums (in the Vatican Apartments).

Bibl.: Anna Maria Brizio, "The Painter," in *The Unknown Leonardo*, ed. Ladislao Reti (New York: McGraw-Hill, 1974), 20–55, esp. pp. 32–33; Rossi and Rovetta, *Il Cenacolo* (1988), fig. 58; Steinberg, "Leonardo's Last Supper" (1973).

50. Embroidered altar frontal, Milanese, eighteenth century. Milan, church of Santa Maria della Passione.

[upper] *Attributed to Andrea Solario, copy of the Last Supper.*
Formerly at Castellazzo, now destroyed.

[middle] *Anonymous, copy of the Last Supper.*
Milan, Basilica of San Lorenzo.

[lower, two illustrations] *Giampietrino, copy of the Last Supper, details.*
Oxford, Magdalen College.

I. Chronology, Sforza Commissions, and Dominican Spirituality

1. ASM, *Registro delle missive*, 206 bis; Luca Belrami, ed., *Documenti e memorie riguardanti la vita e le opere di Leonardo da Vinci* (Milan: Fratelli Treves, 1919), doc. 76, pp. 43–44; Edoardo Villata, in Pietro C. Marani, *Leonardo: Una carriera di pittore* (Milan: Federico Motta, 1999). The letter states, "as the expedition of these things lies close to my heart, I would be most pleased to see results as soon as possible; I charge you to act with all dispatch and necessary means so that I will be satisfied." The tasks are laid out in an accompanying list. The first item is "to have the ducal coat of arms in marble and bearing his initials placed at the Ludovica gate, near which insignia should be placed ten bronze medals with the head of the Lord Duke." With the exception of Castello Sforzesco, all other state buildings were to receive the same treatment. Stanga was then to request Cristoforo Solario, called Il Gobbo, "The Hunchback" (c. 1468/70–1524), to execute "in addition to the sepulchre"—meaning the funeral monument for Ludovico and his wife Beatrice d'Este (1475–97)—"part of the altar within the present year." The altar for the duke and his wife's funeral chapel, located in the apse of Santa Maria delle Grazie, would require the purchase of marble in Venice or Carrara. Il Gobbo should be pressed "to work on the cover and to attend to all other requirements." The fifth task was the one related to Leonardo's commission. A reminder follows to summon all the experts "to meet at the architectural [site] to inspect it and make a model for the facade of Santa Maria delle Grazie . . . in proportion to the large chapel." Perhaps concerned about the increasingly unfavorable political climate in Milan and the threat of a French invasion, Ludovico seems to have been anxious to see his coat of arms placed on state buildings and to complete the church and its annexes, including the wall where his tomb and mausoleum were to be installed. See Evelyn S. Welch, *Art and Authority in Renaissance Milan* (New Haven: Yale University Press, 1995); Carlo Pedretti, *Leonardo architetto* (Milan: Electa, 1978), trans. Sue Brill under the title *Leonardo, Architect* (New York: Rizzoli, 1985).

2. The original document has been lost, but it was transcribed by Domenico Pino in 1796. Domenico Pino, *Storia genuina del Cenacolo insigne dipinto da Leonardo da Vinci nel Refettorio de' padri domenicani di Santa Maria delle Grazie di Milano* (Milan, 1796), 15; Beltrami, *Documenti e memorie* (1919), doc. 77, p. 45; Villata, in Marani, *Leonardo: Una carriera* (1999). Payment was not made to Leonardo but to someone else working in the refectory, under the orders of Ludovico il Moro, at the same time as Leonardo. It seems likely that if Ludovico was paying for a window to be installed in the refectory, he also had something to do with the pictorial decoration of the hall.

3. Important works of art had, however, been commissioned by Gaspare Vimercati, benefactor and founder of the Dominican monastery. Vimercati bequeathed his library to the monastery in 1467 and was probably the patron behind an important polyptych painted sometime after 1482 by Bernadino Butinone (c. 1450 to before 6 November 1510). Today only the central panel remains, but, when Carlo Torre wrote *Il Ritratto di Milano* in 1674, the extant work was still located on the half wall of the choir at Santa Maria delle Grazie. The painting is in the Gallarati Scotti collection: see Mauro Natale, in *Zenale e Leonardo: Tradizione e rinnovamento della pittura lombarda* (Milan: Electa, 1982), 52; Marco Magnifico, in *Pinacoteca di Brera: Scuole lombarda e piemontese 1300–1535* (Milan: Electa, 1988), 144.

Butinone also worked on a vast decorative fresco campaign in the church after 1482 (the year the roof was completed; according to Father G. Gattico, probably between 1487 and 1490). See G. Gattico, *Descrizione succinta e vera delle cose spettanti alla chiesa e convento di S. Maria delle Grazie e di S. Maria della Rosa*, in ASM, *Fondo Religione*, p.a., cart. 1397, c. 26.

Interestingly, the artist Bernardo Zenale (c. 1436–1526) assisted Butinone on this project. According to various sources, including Leonardo's own manuscripts, Leonardo asked Zenale for advice on how to finish the head of Christ in the *Last Supper*.

The following well-known passage appears in Giovan Paolo Lomazzo, *Scritti sulle arti*, ed. Roberto Paolo Ciardi, 2 vols. (Florence: Marchi & Bertolli, 1973–74), 2:53: "Having painted all the Apostles, he did James Major and James

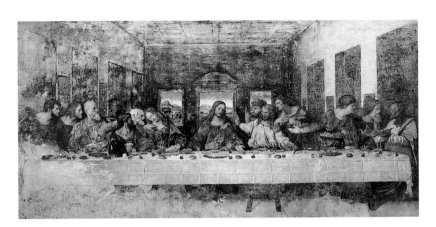

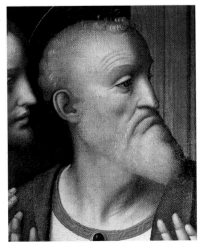

*[top] Anonymous, Flemish, copy of the Last Supper.
Near Antwerp, Tongerlo Abbey.*

*[middle] Anonymous, copy of the Last Supper.
Milan, Soprintendenza per i Beni Ambientali e
Architettonici.*

*[bottom] Anonymous, copy of the Last Supper.
Paris, Church of Saint-Germain l'Auxerrois, sacristy.*

*[top] Anonymous, copy of the Last Supper, detail of the graffiti
signatures.
Paris, Church of Saint-Germain l'Auxerrois, sacristy.*

*[middle] Copy of the Last Supper.
Windsor Castle, Royal Collection (no. 12541).*

*[bottom] Gerolamo Bonsignori (?), drawing of the Last Supper.
Rome, private collection.*

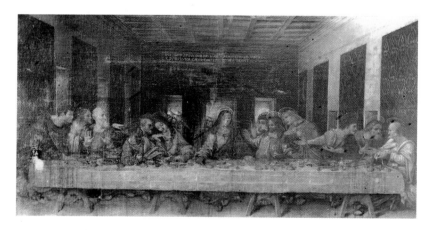

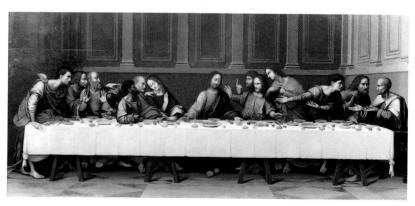

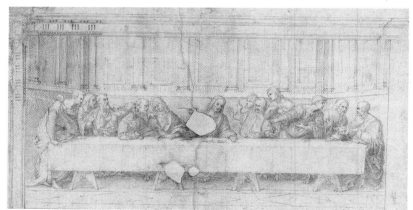

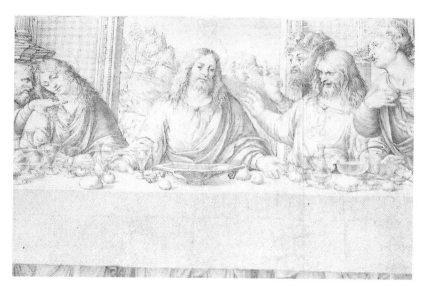

[upper]
Anonymous, copy of the Last Supper.
Ponte Capriasca (Lugano), parish church.

[lower]
Anonymous, copy of the Last Supper.
Novazzano (Canton Ticino), old oratory.

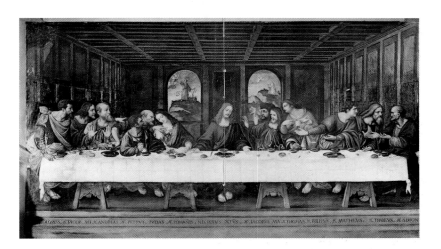

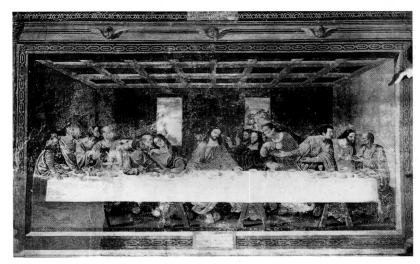

Minor with so much beauty and majesty that when he then came to do Christ, he could never bring that holy face to completion and perfection, because it is so very unique. Desperate, and unable to do anything else, he sought out the counsel of Bernardo Zenale, who encouraged him by saying: O Leonardo, you have made such a terrible error that only God can remedy it. Since it is not in your power, nor in that of anyone else, to give any greater divinity and beauty to a figure than you have given to James Major and James Minor, the better course would be to leave Christ imperfect, because next to those Apostles you cannot do him as Christ. And that was what Leonardo did." See also ibid., 2:463, where Lomazzo repeats what Vasari had said about Leonardo. See also Leonardo's mention of Bernardo Zenale's advice in Windsor 19076, on which, see Leonardo da Vinci, *Scritti scelti*, ed. Anna Maria Brizio (Turin: UTET, 1952), new ed. (1968), 673. On the frescoes of Butinone and Zenale in the church of Santa Maria delle Grazie, see S. Buganza in *Pittura a Milano: Rinascimento e manierismo*, ed. Mina Gregori (Milan: Cassa di Risparmio delle provincie lombarde, 1998), 203–4.

4. In fact, Ludovico commissioned Leonardo to paint the other wall of the refectory—meaning the complete or partial decoration of the opposite wall or perhaps the portrait of Ludovico and his family inserted in the *Crucifixion* by Donato Montorfano (c 1440-1504?)—but he required Leonardo to sign a contract obliging him to finish by a deadline as yet unspecified. On Montorfano's fresco, see Pietro C. Marani, in *Pittura a Milano* (1998), 215.

There is no need to rehash Leonardo's legendary slowness in executing commissioned paintings. Suffice it to recall the case of the *Virgin of the Rocks*, commissioned by the Confraternità della Concezione in the church of San Francesco in April of 1483. Leonardo was supposed to finish it within two years, but it was delivered more than twenty years later, between 1506 and 1508, even if a first version seems to have been completed by 1490. On the *Virgin of the Rocks* and the dating of the first version, see Marani, *Leonardo: Una carriera* (1999), chap. 3, "La Vergine delle rocce: sfortuna di un'invenzione e fortuna del modello."

5. The following year, Leonardo promised on 21 April 1498 to finish decorating the *Camera grande*, or large room,

of the Castello Sforzesco by September, while at the same time rushing to complete the *saletta negra,* or black room. ASM, *Autografi*, cart. 102, fasc. 34; Beltrami, *Documenti e memorie* (1919), doc. 86, p. 50. A document written by the duke's secretary in June 1496 reports, "The painter who is working on the *Camerini* today caused a decided scandal, after which he left," which led Il Moro to seek out Pietro Perugino (c.1445–1523) to finish the job. ASM, *Autografi*, cart. 101, fasc. 16; Beltrami, *Documenti e memorie* (1919), doc. 70, p. 40.

If the 1496 document refers to the same rooms, Leonardo's promise in 1498 appears to resolve a two-year controversy. In light of that project's duration, the date Leonardo began the *Last Supper* should be pushed back by at least two if not three years, to around 1494. All the documents regarding Leonardo's artistic activities have been gathered by Edoardo Villata in Marani, *Leonardo: Una carriera* (1999).

6. Possibly Leonardo received the commission to paint the *Last Supper* at the same time that Donato Montorfano began to paint the *Crucifixion* on the opposite wall. If Montorfano duly executed his work in the *buon fresco* technique, he would have finished it by 1495.

7. See Luisa Giordano, in *"Ludovicius Dux,"* ed. Luisa Giordano (Vigevano: Diakronia, 1995), 94–117.

8. I refer to annotations on fol. 3 recto (on "Giovan Conte" for the figure of Christ), fol. 6 recto (on Alessandro Carissimi of Parma "for Christ's hand"), and fol. 63 verso and fol. 63 recto (on positions and gestures for the apostles). On the dating of the Forster Codex (now in the Victoria and Albert Museum) and on Leonardo's notes, see Augusto Marinoni, "I manoscritti di Leonardo da Vinci e le loro edizioni," in *Leonardo: Saggi e ricerche*, ed. Achille Marazza (Rome: Istituto Poligrafico dello Stato, 1954), 229–74; and Carlo Pedretti, *Leonardo: Studi per il Cenacolo dalla Biblioteca Reale nel Castello di Windsor* (Milan: Electa, 1983) for all passages. See also the recent edition of the Forster Codices: *Leonardo da Vinci: I Codici Forster del Victoria and Albert Museum*, diplomatic and critical transcription by Augusto Marinoni, 3 vols. (Florence: Giunti Barbèra, 1992).

9. Pedretti, *Leonardo: Studi* (1983), 33ff.

10. Pietro C. Marani, *Il Cenacolo di Leonardo* (1986), 11ff.

11. See Pedretti, *Leonardo: Studi* (1983), 71. Pedretti proposes that the mural was originally destined for one of the refectory's long walls. He thinks that four additional lunettes should be added to the four indicated by Leonardo in his sketch, Windsor 12542, thus making eight lunettes to correspond to the eight arches along the side walls of the refectory. The composition would have been gigantic and the figures enormous, but the notion is negated by the limited width of the refectory itself and by the fact that spectators, necessarily placed too close to the wall, could not have grasped the scene as a whole. Another argument against an original plan to locate Leonardo's painting on the east wall is that there were windows there. For the original aspect of the side walls of the hall, see Gisberto

Martelli, "Il Refettorio di Santa Maria delle Grazie a Milano e il restauro di Luca Beltrami nell'ultimo decennio dell'Ottocento," *Bollettino d'arte* 8 (1980): 55–72; and Martelli, "Ulteriori precisazioni sui lavori di restauro di Luca Beltrami nel refettorio di Santa Maria delle Grazie," *Raccolta Vinciana* 21 (1982): 161–75. Windows were not included when the wall was reconstructed after 1946.

12. This is the date proposed in Kenneth Clark, *The Drawings of Leonardo da Vinci in the Collection of Her Majesty the Queen at Windsor Castle*, 2d ed., revised with the assistance of Carlo Pedretti, 3 vols. (London: Phaidon, 1968–69), 1:99–100. Martin Kemp has suggested instead the date 1495–96: Martin Kemp and Jane Roberts with Philip Steadman, introduction by E. H. Gombrich, *Leonardo da*

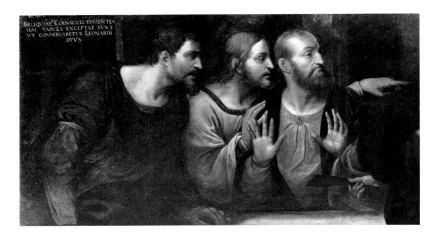

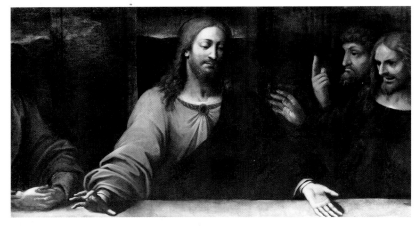

first) seem to refer to a period after 1493 when Leonardo had "recommenced" the "great horse," which would bring us up to 1496. In the second letter, in fact, Leonardo says, "It vexes me greatly that having to earn my living has forced me to interrupt the work and to attend to small matters, instead of following up the work which your Lordship entrusted to me. But I hope in a short time to have earned so much that I may carry it out quietly to the satisfaction of your Excellency, to whom I commend myself; and if your Lordship thought that I had money, your Lordship was deceived, because I had to feed six men [*boche*] for thirty-six months, and had [received] 50 ducats." Richter, nos. 1344 and 1345. Leonardo must have accepted payment between 1495 and 1497 for other commissions, interrupting work that Ludovico had already commissioned and that Leonardo proposed to recommence shortly. He had briskly recommenced work on the monument after 1493 and perhaps protracted it until around 1496 (as shown by the file attached to the Madrid Codex 8936).

18. In 1572 (a rather late date), Antonio Mini stated that Leonardo had "with his own hand begun, prosecuted, and finished" the *Last Supper*. In no way can this statement be taken as evidence that the *Last Supper* was left unfinished, as Carlo Pedretti claims in his *Leonardo: Studi* (1983), 38. Further, the statement contradicts Pedretti's hypothesis that in the execution of the mural Leonardo was assisted by two *maestri*. Leonardo certainly might have used assistants; he had some at the time, and we even know who they were—among others, Marco d'Oggiono and Giovan Antonio Boltraffio (on whom, see Pietro C. Marani, *Leonardo e i leonardeschi a Brera* [Florence: Cantini, 1987], 11–13). On the other hand, there is no evidence, stylistic or documentary, that the painting of the *Last Supper* should not be attributed to Leonardo's hand. Pedretti cites Lomazzo, who, writ-

ing a good deal later in his *Libro dei sogni*, has Leonardo say: "Thus I hope to say that in movement and design (*disegno*) I was so expert in religious matters that many people were moved to take heart from the figures that I had already drawn, and even more from the paintings I did later, which they were looking at, and among which were those of the Last Supper in the refectory of the friars of Santa Maria delle Grazie in Milan that are so divinely varied in their order and with such pained faces, each in his own way, that it is not, I think, granted to a painter to do more; and the same could be said for many other figures in France and elsewhere" (see Lomazzo, *Scritti sulle arti*, ed. Ciardi [1973], 87). Pedretti (*Leonardo: Studi* [1983], 45) interprets this passage to mean that Leonardo made the drawings for his paintings and then had others carry them out, notably in the *Last Supper*. However, the example of the *Last Supper* that Lomazzo puts into the mouth of Leonardo does not support the idea of works *dissegnate* (drawn, designed, projected) by Leonardo and painted by others, but rather the idea (which is the point of the passage) of Leonardo's perfection in portraying "religious matters" (*cose di religione*) and the fact that, thanks to his skill, many people took "heart from the figures." It made no sense for Lomazzo, speaking through Leonardo, to cite the example of the *Last Supper* as the best proof of this if the scene had not been not painted by him. Ciardi, editor of Lomazzo's *Libro dei sogni*, explains (*Scritti sulle arti* [1973–74], 87n20) that Lomazzo used the term *dissegnate* to mean *fatte* (done; made) and that (ibid., 87n21) everyone in sixteenth-century cultural circles, Vasari included, understood the term *disegno* as a synonym for *invenzione*; as the creative phase, more important than the actual execution. Ciardi was thus warning that it is not appropriate to think Lomazzo's observations mean that students of Leonardo's helped paint his works. Lomazzo's discourse should be understood to mean that the power of Leonardo's religious figures was so strong that even painted copies of what he had "created" could arouse the emotions that he had "designed" (that is, "invented"; "created"). For the possible participation of Leonardo's students in the execution of the outer and secondary portions of the *Last Supper* and the lunettes, however, see section IV. See Pietro C. Marani, "Il

Vinci (New Haven: Yale University Press in association with the South Bank Centre, 1989), 60.

13. Marco Rossi, in Rossi and Rovetta, *Il Cenacolo di Leonardo* (1988), 67.

14. This had already been suggested: see Pietro C. Marani, "Prospettiva, botanica e simbolo nelle ghirlande 'tonde a l'antiche' di Leonardo," in Pinin Brambilla Barcilon and Pietro C. Marani, *Le lunette di Leonardo nel Refettorio delle Grazie*, Quaderni del restauro, 7 (Milan, 1990), 1–34, esp. pp. 31–32n30; ASM, *Descrizione*, c. 34; Marco Rossi and Alessandro Rovetta, *Il Cenacolo di Leonardo: Cultura domenicana, iconografia eucaristica e tradizione lombarda*, Quaderni del restauro, 5 (Ivrea: Olivetti, 1988), 70. On the various phases of construction of the refectory, see Roberto Cecchi, "La chiesa e il convento di Santa Maria delle Grazie dalla fondazione all'intervento bramantesco," in Pietro C. Marani, Roberto Cec-

chi, and Germano Mulazzani, *Il Cenacolo e Santa Maria delle Grazie* (Milan: Elemond, 1986), 33–64; Sylvia Righini Ponticelli, "La nascita del convento," in *Santa Maria delle Grazie* (Milan, 1998), 48–117.

15. See Beltrami, *Documenti e memorie* (1919), docs. 79, 82.

16. Drafts of these letters are found in the Codex Atlanticus, fols. 914 recto (ex 335 v-a) and 867 recto (ex 315 v-a). See Pedretti, *Leonardo: Studi* (1983), 34–38. See Jean Paul Richter, ed., *The Literary Works of Leonardo da Vinci*, 3d ed., 2 vols. (London: Phaidon, 1970).

17. On the chronology of the Sforza monument, see Maria Vittoria Brugnoli, "Il Cavallo," in *The Unknown Leonardo*, ed. Ladislao Reti (New York: McGraw-Hill, 1974), 86–109; and Pietro C. Marani, in Marani, Marco Rossi, and Alessandro Rovetta, *L'Ambrosiana e Leonardo* (Novara: Interlinea, 1998), 40–43. The two letters (and certainly the

Giovan Mauro della Rovere, called Il Fiammenghino, copy of the Last Supper, with details.
Milan, Museo Nazionale della Scienza e della Tecnica.

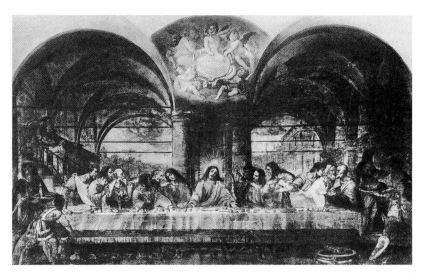

problema della 'bottega' di Leonardo: La 'praticha' e la trasmissione delle idee di Leonardo sull'arte e la pittura," in *I leonardeschi: L'eredità di Leonardo in Lombardia* (Milan: Skira, 1998), 12.

19. Beltrami, *Documenti e memorie* (1919), doc. 262.

20. See Anna Maria Brizio, "Il Cenacolo," in *Leonardo: La pittura* (Florence: Giunti, 1977), 93–114; 2d ed. (1985), 75–89; Gary Ianziti, "The First Edition of Giovanni Simonetta's *De rebus Gestis Francisci Sfortiae Commentarii*: Questions of Chronology and Interpretation," *Bibliothèque d'Humanisme et Renaissance* 44 (1982): 137–47; Ianziti, "The *Commentaries* of Giovanni Simonetta: History and Propaganda in Sforza Milan (1450–1490)," in *Altro Polo: A Volume of Italian Renaissance Studies*, ed. Conal Condred and Roslyn Pesman Cooper (Sidney: Frederick May Foundation for Italian Studies, University of Sidney, 1982), 79–98; Giordano, in *"Ludovicus Dux"* (1995).

21. See Rossi and Rovetta, *Il Cenacolo di Leonardo* (1988), 72.

22. Alessandro Rovetta, "La tradizione iconografica dell'Ultima Cena," in Rossi and Rovetta, *Il Cenacolo di Leonardo* (1988), 28–48.

23. On the eucharistic significance of the Last Supper, see, in particular, Leo Steinberg, "Leonardo's Last Supper," *Art Quarterly* 36, no. 4 (1973): 297–410; Rossi and Rovetta, *Il Cenacolo di Leonardo* (1988). See also Marani, *Il Cenacolo di Leonardo* (1986), 17, which discusses the earlier proposals and the doubts that other scholars have raised regarding them.

24. On this engraving, see David Alan Brown, *Leonardo's Last Supper: Precedents and Reflections* (Washington, D.C.: National Gallery of Art, 1983), no. 16.

25. See Kenneth Clark, *The Drawings of Leonardo da Vinci* (1968–69), 1:9. Carlo Pedretti, in *Studi per il Cenacolo* (1983), 88–89, concurs that it is possible that this drawing, if it has a connection with the *Last Supper*, would help to advance to 1493 the date at which the painting of the mural was begun. But he also relates it to Galeazzo Maria Sforza, whose daughter, Bianca Maria, was to marry Maximilian I in 1493, thus suggesting that the emblem might be an allusion to Leonardo's new patronage relationship with the Habsburgs through Galeazzo's daughter. See also Martin Clayton, *Leonardo da Vinci: A Singular Vision:*

Drawings from the Collection of Her Majesty the Queen (New York: Abrams, 1996), 55. Clayton dates the folio to about 1495 (on the basis of relationships between the sketches on the verso and those of a folio of the Codex Atlanticus, 318v-a, dated 2 January 1496), and he compares it to an emblem of Galeazzo Maria Sforza created for commemorative purposes. This idea seems unlikely, given Ludovico il Moro's ongoing efforts to cancel the memory of a brother whom he himself very probably had assassinated.

26. That Leonardo was working on a bucrane-shaped emblem is proven by a small heraldic drawing located in the second notebook of MS H of Paris, fol. 49 verso (H2, fol. 1 verso). It shows a dragon signifying "prudence" facing a lion signifying "strength" in front of a palm tree signifying "Victory." The notebook also contains a note on purchases dated 29 January 1494, but proves contemporary with the third notebook of MS H, which includes a bookkeeping note from 1493 (MS H3, fol. 106 verso). Notes on other Sforza "projects" appear in the same manuscript, including the well-known comment on fol. 98 recto, "Ermine with mud. Galeazzo between tranquil time and the flight of fortune"—motifs to accompany emblematic images.

Regarding the dating of MS H and its subsequent history, see "Il Manoscritto H" in *Leonardo da Vinci: I manoscritti dell'Institut de France*, diplomatic and critical transcription by Augusto Marinoni (Florence: Giunti, 1986), viii, 52, 98. See also Pedretti, *Leonardo: Studi* (1983), 90, where the caption to fol. 49v is in error, referring to fols 98v–99r. The drawing in MS H fol. 49v seems very similar to the caduceus visible in a coat of arms in the Castello Sforzesco: see the illustration in Giordano, *"Ludovicus Dux"* (1995), 115. On the deeds of the Sforza, see Pier Luigi Mulas, in ibid., 118–25. On the ermine, which was Ludovico's emblem but also used by Leonardo to allude to the *moderanza* of Cecilia Gallerani in the painting now in Cracow, see *Leonardo: La dama con l'ermellino*, ed. Barbara Fabjan and Pietro C. Marani (Cinisello Balsamo: Silvana, 1998).

II. The Preparatory Drawings

1. ABM, Carpi, A VI 19, received 22 June 1827, dated at the top 27 June 1827. The letter is unpublished. Comerio was conservator of the altarpiece by Ambro-

gio Bergognone (c. 1453–1523) at La Certosa di Pavia and assistant professor of Elementi di Figura at the Accademia di Brera.

2. David Howarth, *Lord Arundel and His Circle* (New Haven: Yale University Press, 1985), 217; Carlo Pedretti, "A 'modello' for the 'Last Supper'?" *Achademia Leonardi Vinci: Journal of Leonardo Studies and Bibliography of Vinciana* 3 (1990): 148. See also Ludovico Doissin, *Sculpture, Carmen*, trans. Anton Luigi de Carli (Milan, 1775–77), pp. 154–55.

3. Milan, Raccolta Bertarelli, Art. g. 16-8, on which see Clelia Alberici and Mariateresa Chirico De Biasi, eds., *Leonardo e l'incisione: Stampe derivate da Leonardo e Bramante dal XV al XIX secolo* (Milan: Electa, 1984), no. 43, p. 63.

4. See Pietro C. Marani, "Il Cenacolo di Leonardo e i suoi restauri nella Milano fra il XV e il XX secolo fra arte e fede, propaganda politica e magnificenza civile," *I Tatti Studies: Essays in the Renaissance* 7 (1998), 191–229, esp. p. 212.

5. Milan, Degli Occhi collection. (My thanks to Luisa Cogliati Arano for kindly bringing this to my attention.)

6. Other artists, such as Bernardino Lanino (1512–83), merely imitated Leonardo's compositional style in their own versions of the Last Supper. Lanino's *Last Supper* is now at the Pinoteca di

[upper and middle]
Anonymous, copy of the Last Supper; detail.
Ottaviano, Naples, church of the Santissimo Rosario.

[lower]
Giovanni della Robbia, copy of the Last Supper.
London, Victoria and Albert Museum.

[upper]
Giuseppe Romagnoli da Marolta, copy of the Last Supper.
Castro di Valle di Blenio (Lugano), church of San Giorgio.

[middle]
Giovan Battista Bianchi, copy of the Last Supper.
Milan, private collection.

[lower]
Andrea da Milano and Alberto da Lodi, two sculptural figures copied from the Last Supper. Saronno, Sanctuary of the Madonna dei Miracoli.

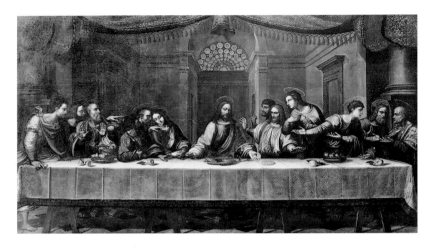

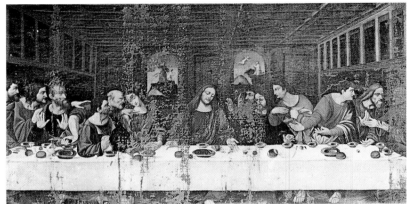

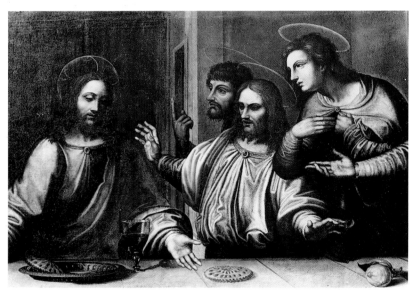

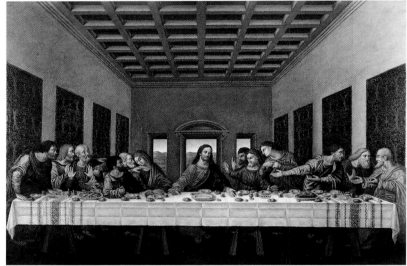

66

Brera. On which, see Daniele Pescarmona, in *Disegni lombardi del Cinque e Seicento della Pinacoteca di Brera e dell'Arcivescovado di Milano* (Florence: Cantini, 1986), 48–50.

7. We know the *Battle of Anghieri* mainly through the grisaille by Rubens that is based on an engraving by Lorenzo Zacchia the Younger (1524–87). On Zacchia's engraving with the inscription "EX TABELLA PROPRIA LEONARDI VINCI MANV PICTA," dated 1558, see Carlo Pedretti, *Leonardo: A Study in Chronology and Style* (Berkeley: University of California Press, 1973), 84.

8. On this *memorandum*, see Carlo Pedretti, *The Codex Atlanticus of Leonardo da Vinci: A Catalogue of Its Newly Restored Sheets*, part 2, vols. 7–12 (New York: Johnson Reprint; Harcourt Brace Jovanovich, 1979), 66. See also Pedretti, *Leonardo: Studi* (1983), 49.

9. It is unlikely that Leonardo ever worked with a wax model, even though Carlo Pedretti has devoted much energy to the theory. Excluding the hypothesis of a cartoon (Pedretti, *Leonardo: Studi* [1983], 49), he launched this idea on the basis of the practices of Giulio Romano and Michelangelo. See also Carlo Pedretti, "Le 'belle cose' di Leonardo a Milano in un 'sogno' di Benvenuto Cellini a Firenze" (paper read at the "Attorno a Leonardo pittore" meeting, Florence, Palazzo Pitti, 20 January 1999, and published in part in *Il Sole 24 ore*, 31 January 1999, no. 30, p. 35). In this article Pedretti refers to Cellini's mention of Leonardo together with great artists such as Masaccio and Michelangelo who used the *lucerna* (lantern) of sculpture as a guide for their works. Leaving aside the indisputable sculptural power of Leonardo's composition, especially as we see it now after its recent restoration, the hypothesis that Leonardo used wax models for the figures of the apostles does not seem to be supported by any sources. To the contrary, the figures seem so monumental and three-dimensional in the painting that they suggest Leonardo's great familiarity with Bramante and with ancient sculpture, which means that this hypothesis should be treated with extreme caution. Might Cellini have been referring (if anything) to the Sforza Monument, for which it is much more probable that wax models might have been made? Leonardo's activities as a sculptor are recorded in the sources, for example, by Lomazzo: see Barbara and Giovanni

Agosti, *Le tavole del Lomazzo (per i 70 anni di Paola Barocchi)* (Brescia: L'Obliquo, 1997). It is more likely that Cellini was alluding to this.

10. See Lomazzo, *Scritti sulle arti*, ed. Ciardi (1973–74), 2:170.

11. Ibid., 1:286. See also Pedretti, *Leonardo: Studi* (1983), 53, who nonetheless interprets this extraordinary statement of Lomazzo's to mean that if paintings perish, the *disegno* remains (and he uses the term *disegno* to mean the essence of the painting, as Lomazzo himself says further on). It seems to me more probable that in this case these words should be taken literally, and that Lomazzo had in mind Leonardo's drawings (if for no other reason than that he had already recalled them and described them in the passage previously cited). That such drawings should survive painting is easy to explain, given the high consideration in which they were already held by artists and collectors, who treasured them.

12. Regarding this drawing, see Pietro C. Marani, in *Disegni lombardi del Cinque e del Seicento* (1986), 27–31, for the latest thought on the question. The drawing, which was thought to be Leonardo's by Richter (1883), Müntz (1899), and Sirén (1916), was later rejected, for example, by Adolfo Venturi (1899) and held by scholars to be the work of the school of Leonardo. Pedretti has recently stated (in *Leonardo: Studi* [1983], 32) that "Leonardo had nothing to do with them," but further analysis has shown the existence of red chalk marks, made with the left hand, on the chin: see Marani, in *Disegni lombardi* (1986), 30. This means that the drawing may have originated as a fleeting autograph sketch: see Brown, *Leonardo's Last Supper* (1983), no. 5. It has also been suggested that Antonio Mussi, the former owner of the drawing, made the sketch himself: see Pietro C. Marani, "Una precisazione sulla provenienza del disegno leonardesco di Brera e un giudizio settecentesco sul Cenacolo 'restaurato,'" *Raccolta Vinciana* 22 (1987): 265–70.

13. On these two series, see Carl Horst, "L'Ultima Cena di Leonardo nel riflesso delle copie e delle imitazioni," *Raccolta Vinciana* 14 (1930–34): 118–200 (especially for the Weimar series, now dispersed in various collections, among them the Ackland Art Museum in Chapel Hill and the National Gallery of Victoria in Melbourne); and Cristina Geddo, "Disegni leonardeschi dal Cenacolo: Un nuovo

nome per le teste di Strasburgo," in *"Tutte queste opere non son per istancarmi": Raccolta di scritti per i settant'anni di Carlo Pedretti*, ed. Fabio Frosini (Rome: Edizioni Associate, 1998), 159–88, both with bibliography. These drawings cannot be attributed to Giampietrino, however, as Geddo states, but must remain anonymous. Francesco Malaguzzi-Valeri thought the Strasbourg cartoons "broad and sure in their making, but a bit weak": Francesco Malaguzzi-Valeri, *Bramante e Leonardo*, vol. 2 (1915) of *La corte di Ludovico il Moro*, 4 vols. (Milan: Hoepli, 1913–23), 546 n. 2. Osvald Sirén, to the contrary, thought they were derived from a supposed cartoon of Leonardo's: Osvald Sirén, *Léonard de Vinci: L'artiste et l'homme*, trans. Jean Buhot (Paris: G. van Oest, 1928), 88–90, a notion with which Horst agreed: "L'Ultima Cena di Leonardo" (1930–34), 176–86. Alain Roy thinks they were derived from hypothetical cartoons prepared by Leonardo: Alain Roy and Paula Goldenberg, *Les peintures italiennes du Musée des Beaux-arts, XVIe XVIIe et XVIIIe siècles* (Strasbourg: Editions Les Musées de la ville de Strasbourg, Musée des Beaux-Arts, 1996), 22–23. The attribution to Boltraffio of the two sheets in the Ackland Art Museum (Chapel Hill) has recently been seconded by David Alan Brown: *Leonardo's Last Supper: The Restoration* (Washington, D.C.: National Gallery of Art, 1983), nos. 6 and 7; and by Maria Teresa Fiorio: "Leonardo, Boltraffio e Jean Perréal," *Raccolta Vinciana* 27 (1997): 325–55, fig. 9. Fiorio nonetheless attributes a part of the Strasbourg series to Boltraffio as well, despite Geddo's attribution of them (see above) to Giampietrino. The Strasbourg series actually derives from the copy of the *Last Supper* belonging to the Royal Academy of Art in London (but now on loan to Magdalen College, Oxford) attributed to Giampietrino. On this question, see Janice Shell, Pinin Brambille Barcilon, and David Alan Brown, *Giampietrino e una copia cinquecentesca dell'Ultima Cena di Leonardo*, Quaderni del restauro, 4 (1988).

14. See Carlo Pedretti, *Commentary*, vol. 3 of *The Literary Works of Leonardo da Vinci*, Compiled and Edited from the Original Manuscripts by Jean Paul Richter (Oxford: Phaidon, 1977), 359–60.

15. See Gerolamo Calvi, *I manoscritti di Leonardo dal punto di vista cronologico storico e biografico* (Bologna: Nicola Zanichelli, 1925), 25.

16. On the relationship between Leonardo and Jean Perréal, see Léon Dorez, "Léonard de Vinci et Jean Perréal," *Nouvelle Revue d'Italie* (1919): 67–86; Fiorio, "Leonardo, Boltraffio e Jean Perréal" (1997), 325–55.

17. Leonardo's assistant Giovanni Antonio Boltraffio used the technique widely, as demonstrated by his two large pastel portraits in the Biblioteca Ambrosiana in Milan. Boltraffio was working in Leonardo's studio by 1490, and in 1494 he and another assistant, Marco d'Oggiono, were finishing the *Resurrection of Christ with Saints Leonard and Lucy* under Leonardo's supervision, now in the Berlin Museum. On the Boltraffio drawing, see Marani, Rossi, and Rovetta, *L'Ambrosiana e Leonardo* (1998), 100–3 and the attendant bibliography. On the Berlin painting, see Janice Shell and Grazioso Sironi, "Giovanni Antonio Boltraffio and Marco d'Oggiono: The Berlin Resurrection of Christ with Sts. Leonard and Lucy," *Raccolta Vinciana* 23 (1989): 119–54.

18. On the evolution of Leonardo's drawing style and, in particular, on the techniques he adopted in the 1490s, see Clark, *The Drawings of Leonardo da Vinci* (1968–69), 1:xxvi–xxvii.

19. For the Albertina drawing, see Bernard Berenson, *The Drawings of the Florentine Painters*, new ed., enl., 3 vols. (Chicago: University of Chicago Press, 1938), p. 124, no. 1113; Arthur Ewart Popham, *The Drawings of Leonardo da Vinci* (London: Jonathan Cape, 1946), no. 164; rev. ed. with a new introductory essay by Martin Kemp (London: Pimlico, 1994), 137; Pedretti, *Leonardo: Studi* (1983), 39–40. For the Venice drawing, see Pedretti, *Leonardo: Studi* (1983), 39–40; and Pietro C. Marani, in *Leonardo & Venezia*, ed. Giovanna Nepi Sciré and Pietro C. Marani (Milan: Bompiani, 1992), 344–47. Clark thinks the techniques that were used make the two drawings of Vienna and Venice rather unusual: see Clark, *The Drawings of Leonardo da Vinci* (1968–69), 1:xxvi n. 2.

20. This thesis is put forth by, among others, Popham and Pedretti (see the preceding note), but although the drawing shows undeniable affinities with that of the apostles of the *Last Supper*, it appears to be somewhat older. In the Vienna drawing, the light seems to come from the right, whereas the apostles in the *Last Supper* are lit from the left, limiting the likelihood of a precise connection with the mural.

21. The drawing might be dated a few years earlier, to c. 1494–95, but the increased pathos of the expression of Christ in *Christ Bearing the Cross* and the complexity of his position (which anticipates Giorgione's "over the shoulder" portraits) seem to indicate that Leonardo was already moving beyond the *Last Supper*.

22. See Pedretti, *Leonardo: Studi* (1983), 56–59.

23. Ibid., 60–62. Kenneth Clark says of this drawing (*The Drawings of Leonardo da Vinci* [1968–69], 1:180) that "there is no reason why it should have anything to do with the Last Supper," and he dates it to the early 1490s. In the catalog of the exhibition of the Windsor Castle collection (Carlo Pedretti, *Leonardo: Studi* [1983]), Pedretti brought together twenty of the Windsor drawings, only six of which, he claims, can be taken as studies by Leonardo for the *Last Supper*, the others being drawings by Leonardo that have no specific relation to the *Last Supper* or copies or derivations by students. See below for a discussion of the two drawings (studies for the heads of Bartholomew and Judas) that Pedretti considers copies.

24. See Hans Ost, *Das Leonardo—Porträt in der Kgl. Bibliothek Turin und andere Fälschungen des Giuseppe Bossi* (Berlin: Mann, 1975), 71ff., fig. 23. Ost published a drawing by Bossi from the Civiche Raccolte di Milano (75, fig. 24) that is a portrait by Cristoforo Solario with an inscription written with the left hand in imitation of Leonardo's handwriting and with left-handed hatching, elements that in part justify the charge that the Venice drawing is not genuine.

25. On this drawing, see, among others, Anna Maria Brizio, "Lo studio degli Apostoli della Cena dell'Accademia di Venezia," *Raccolta Vinciana* 18 (1960): 45–52; Brizio, review of John Shearman, "Leonardo's Colour and Chiaroscuro," *Raccolta Vinciana* 20 (1964): 412–14; Luisa Cogliati Arano, *Leonardo: Disegni di Leonardo e della sua cerchia alle Gallerie dell'Accademia di Venezia* (Milan: Arcadia/Electa, 1980), 56–57; Martin Clayton, in *Leonardo & Venezia*, ed. Giovanna Nepi Sciré and Pietro C. Marani (Milan: Bompiani, 1992), 232–33. Selvatico (1854), Loeser (1903), and Popp (1928) did not consider the drawing genuine, but Adolfo Venturi included it in the fifth volume of Leonardo drawings published by the Commissione Vinciana (1939).

26. Kenneth Clark, introduction to Pedretti, *Leonardo: Studi* (1983), 20: "This is one of the most problematic pieces Leonardo has left us. It is a poor drawing: Christ's right arm and hand might be a child's drawing, and despite the pretended animation of the figures, the drawing lacks the dazzling inner life that shines out even [in] Leonardo's most negligent scribbles. The figures are rigid, almost archaic. For this reason, some of the best critics have questioned its authenticity; the words written above the figures with the same red pencil seem authentic, however."

27. Ludwig H. Heydenreich, *Invito a Leonardo: L'Ultima Cena*, trans. Filippo Grandi (Milan: Rusconi, 1982), 43: Heydenreich states that its "authenticity . . . is disputed, but it was unquestionably produced in his studio." Ludwig H. Heydenreich, *Leonardo: The Last Supper* (London: Allen Lane, 1974), 41.

28. See Pedretti, *Leonardo: Studi* (1983), 62.

29. See Pedretti, *Leonardo da Vinci inedito* (1968), n. 127; Pedretti, *Commentary*, vol. 3 of Richter, *Literary Works of Leonardo* (1977), 381.

30. In reality Giuseppe Bossi was aware of Leonardo's writing hand of the 1490s, although he may not have realized that his *ductus* changed later. In his monumental *Del Cenacolo di Leonardo da Vinci Libri Quattro* (Milan, 1810) Bossi reproduced some of Leonardo's drawings from the early 1490s (engraved by Rosaspina, Benaglia, and Longhi) that bear writings. Among these is the famous *Uomo vitruviano* (which appears in Bossi's volume without the inscriptions above and beneath the figure) and the sheet with studies of proportions of the bust and head of a man seen in profile, drawings that Bossi had acquired as a group from De Pagave (see ibid., 204) and that are now in the Accademia at Venice (inv. 228; inv. 236r and v). Here Bossi faithfully copied and then engraved Leonardo's notations (see ibid., plates between pp. 204 and 205). Bossi himself states (ibid., 260 n. 24): "I am giving the writing of Leonardo, departing from his spelling in order not to create difficulty for those not familiar with it. Anyone who might want a sample of it may read in a mirror what is written on the two prints that represent the same head, in which I have exactly imitated the original writing." Bossi was thus skillful enough to "exactly imitate" Leonardo's hand,

and although he was well able to reproduce it, this was the only specific variety of that hand that he knew. It might be objected that two other sheets in Venice (inv. 215 Av and 215v) present texts by Leonardo on mechanics and on falling bodies usually dated c.1503–4, hence at the time of the studies for the *Battle of Anghiari*, which are sketched on the recto of those sheets; see Giovanna Nepi Sciré, in *Leonardo & Venezia* (1992), 258–62. It should be noted, however, that this type of writing and its *ductus* seem even more similar to those that appear on the sheet with the study for the *Last Supper* under discussion. The annotations reproduced on the plates preceding p. 205 of *Del Cenacolo* are, in turn, singularly alike in their *ductus*, which is more dilated and slightly more ornamental than Leonardo's handwriting, to judge by the writing of the names of the apostles on the drawing of the *Last Supper*. Moreover, a slight inattention by Bossi in reproducing the texts that accompany the drawings of proportions in Venice might be taken to support Bossi's responsibility for the execution of the written portions on the drawing of the *Last Supper* itself and on the drawing of the same subject now in Venice (where the false left-handed hatching is similar to that in the so-called self-portrait by Cristoforo Solario, mentioned in note 24 of this section and actually the work of Bossi). In the engraving of the drawing, Venice inv. 236 (plate following p. 204 in Bossi, *Del Cenacolo*), in which the red chalk drawings of the horsemen and the horse have been omitted, the second line of writing from the top, which begins with the words *del labro chol mento*, the *l* in the preposition *chol* (that is, *col*, "with the") lacks the curl at the upper end visible in the autograph, where a horizontal tail to the letter turns back over the letters *cho*. This is the same way of rendering the letter *l* that appears in the word *filipo* (Philip) in the Venice drawing of the *Last Supper*. Thus Bossi may have written the names of the apostles on that disputed sheet, which is also done on paper noticeably different from the papers that Leonardo usually used, as Anna Maria Brizio has remarked.

31. For a discussion of the preparatory studies for the *Adoration of the Magi* in the Uffizi, and the reasons that work should be viewed as an indispensable antecedent to the *Last Supper*, see Marani, *Leonardo: Una carriera* (1999).

32. See Pinin Brambilla Barcilon, *Il Ce-*

nacolo di Leonardo in Santa Maria delle Grazie: Storia, condizioni, problemi, Quaderni del restauro, 2 (Milan: Olivetti, 1984), 97, fig. 32.

33. I shall return to this question in section III.

34. On this study, see Martin Kemp, catalog entries in Kemp and Roberts, *Leonardo da Vinci* (1989), 60–61.

35. Richter, ed., *The Literary Works of Leonardo da Vinci*, 2:232 (II 30 B).

36. See Marani, *Il Cenacolo di Leonardo* (1986), 9ff.

37. See Thomas Brachert, "A Musical Canon of Proportion in Leonardo da Vinci's *Last Supper*," *Art Bulletin* 53 (1971); Martin Kemp, *Leonardo da Vinci: The Marvelous Works of Nature and Man* (London: Dent; Cambridge: Harvard University Press, 1981), 194–99; Pedretti, *Leonardo: Studi* (1983), 67–68. For other theories regarding Leonardo's methods of treating perspective, see section III.

38. On these two studies, see Clark, *Drawings of Leonardo da Vinci* (1968–69), 1:102, and bibliography. Clark observes that no. 12551 seems to anticipate "Leonardo's later style," perhaps thus implying some reservations regarding its relationship with the *Last Supper*. The Richardsons, who saw this drawing before Michelangelo Bellotti's 1720 restoration of the *Last Supper*, remarked that "that [figure] which is next but one to the *Christ* is the best preserved, (he that crosses his Hands upon his Breast) and has a marvellous Expression, much stronger than I have seen in any of the Drawings." Jonathan Richardson the Elder and Jonathan Richardson the Younger, *An Account of Some of the Statues, Bas-Reliefs, Drawings, and Pictures, & c., in Italy, with remarks* (London: Printed for J. Knapton at the Crown in St. Paul's Church-Yard, 1722), 23. Barbara Fabjan has noted that the drawing to which the Richardsons allude might have been the one now at Windsor (12551), which was already in the royal collections in 1722. Barbara Fabjan, "Il Cenacolo nuovamente restaurato," in *Leonardo: La pittura*, 2d ed., ed. Pietro C. Marani (Florence: Martello-Giunti, 1985), 92 . On this and other studies (such as Windsor 12547, *Head of Judas*, and 12546, *Right arm of Peter*), see also Clayton, *Leonardo da Vinci: A Singular Vision: Drawings from the Collection of Her Majesty the Queen* (1996), 56–59.

39. Pedretti, *Leonardo: Studi* (1983), 100.

40. On this identification, see Marani, *Leonardo: Una carriera* (1999).

41. See section I, note 3. On Carducho, see Pedretti, *Leonardo: Studi* (1983), 30. Carducho states: "I went to Milan to see that masterwork as much praised by connoisseurs as it is venerated by the Milanese. . . . The face of the Savior is lacking; I do not know why the painter has left it so." Petretti interprets this observation literally, and wonders if "the current restoration will be able to ascertain whether the face of Christ is a later addition." It is hard to see how that could be possible, given that all the older copies of the painting, from the one now at Magdalen College, Oxford, to the ones in Écouen and the one by Il Vespino, fairly faithfully reproduce the head of Christ just as it was revealed after the recent cleaning: the head proved to be quite well preserved and completely finished. Another hypothesis is that, in 1633, the mural was in such a sorry state of preservation that the head of Christ was either whitewashed or so blurred that it might have appeared to be unfinished. Vasari, who after visiting Milan in 1566, in fact wrote: ". . . having seen Leonardo's original reduced to such a condition that there is nothing to be seen but *una macchia abbligiata*"; see section IV. (The term "macchia abbligiata" is variously interpreted as "dazzling stain," implying that some of its original brilliance continued to show through when Vasari visited the refectory in 1566; as "dazzled stain"; and as "mass of confusion," for example, in Gaston du C. de Vere's translation in ten volumes published in 1912–14 (see vol. 8, p. 42, "Benvenuto Garofalo and Girolamo da Carpi").

42. See section I, note 8.

43. See Pedretti, *Leonardo: Studi* (1983), 32. David Alan Brown has recently read Leonardo's models in this key: see David Alan Brown, "Leonardo's 'Head of an Old Man' in Turin: Portrait or Self-Portrait?" in *Studi di Storia dell'arte in onore di Mina Gregori*, ed. Miklos Boskovits (Milan: Silvana, 1994), 75–78. He suggests, however, that the Turin drawing was made at the time of the *Last Supper* and may be a study related to it.

44. On caricatures and grotesques, see Ernst H. Gombrich, "Leonardo's Grotesque Heads: Prolegomena to Their Study," in *Leonardo: Saggi e ricerche*, ed. Achille Marazza (Rome: Istituto Poligrafico dello Stato, 1954), 197–220; and Luisa Cogliati

Arano, in *Leonardo & Venezia* (1992), 308–27; Marco Rossi, in Pietro C. Marani, Marco Rossi, and Alessandro Rovetta, *L'Ambrosiana e Leonardo* (Novara: Interlinea, 1998), 80–98.

45. Pedretti, *Leonardo: Studi* (1983), 106 and bibliography. Kenneth Clark (*Drawings of Leonardo da Vinci* [1968–69], 1:101) considered it authentic and from the time of the *Last Supper*, signaling the existence of a copy by Cesare da Sesto in a private collection in Basel. Anna Maria Brizio calls it "superb": Brizio, "Il Cenacolo" (1977), 104.

46. See Pedretti, *Leonardo: Studi* (1983), 110. On the Resta Codex, *Foot*, see Rossi, in Marani, Rossi, and Rovetta, *L'Ambrosiana e Leonardo* (1998), 78. The relationship between the two drawings is more seeming than real: the Resta *Foot* is frozen and academic, it bears no pentimenti, and the prepared paper is of a different color (pinkish red). The redone outlines of the *Head of Judas* indicate that it is not a copy but a first *retracto di naturale* with subsequent corrections.

47. Clayton, *Leonardo da Vinci: A Singular Vision: Drawings from the Collection of Her Majesty the Queen* (1996), 56–59.

48. According to Pedretti (*Leonardo: Studi* [1983], 94, 106), the chief reason for not attributing to Leonardo the *Head of Bartholomew* and the *Head of Judas* lies in the belief that Leonardo used the technique of pencil or red chalk on red prepared paper only later in his work, around 1502–6 (on which, see Clark, *Drawings of Leonardo da Vinci* [1968–69], 1:xxviii). In fact, the use of red chalk can be ascertained a good deal earlier than that; it goes back at least to MS H (c.1493–94) and to the sketches for casting the Sforza horse in the dossier dated 1493, Biblioteca Nacional, Madrid, 8936. It does not seem impossible that Leonardo might have applied this technique to red prepared paper in the period of the studies for the *Last Supper*, nor does this constitute an insurmountable difficulty. A copy of Windsor 12550 (*Head of Simon*) is in the Cabinet des Dessins of the Louvre, no. 2581: see Pedretti, *Leonardo: Studi* (1983), 91, fig. 72.

49. On the measurement of ancient monuments and sculptures and comparing them to the proportions of the human body, see Marani, *Leonardo: Una carriera* (1999), chap. 4.

50. On the possibility of a pedagogical continuity from Leonardo to the Accade-

mia dell'Ambrosiana (founded by Federico Borromeo) and then to the Accademia di Belle Arti di Brera (whose statutes explicitly state the desire to establish a connection with the "Achademia Leonardi Vinci"), see Marani, "Il problema della 'bottega' di Leonardo" (1998), 9–37. Cesare da Sesto's drawing *Study of Feet*, rediscovered in the Scuola degli Elementi di Figura of the Accademia di Brera, bears no signature and has no inventory number. It measures 255 mm ? 215 mm, and is rendered in red chalk on red prepared paper, as were some of Leonardo's drawings for the *Last Supper* and the drawings of Cesare da Sesto now in the Accademia in Venice.

III. Old and Modern Accounts of the *Last Supper's* Deterioration and Restoration through Pellicioli

1. See Fabjan, "Il Cenacolo nuovamente restaurato" (1985), 90–94.

2. See Barbara Fabjan, *Leonardo a Milano: Fotografia del Cenacolo* (Milan: Sicof Sezione Culturale, 1983), 120–22; Pietro C. Marani, "Fotografia e restauri del Cenacolo," in *Sviluppi non premeditati: La fotografia immediata fra tecnologia e arte* (Rome: Carte Segrete, 1991), 139–50.

3. For a survey based exclusively on contemporary newspaper articles, see E. Bonatti, "Il Cenacolo Vinciano: I fatti e le opinione (1979–1994)," *ANAΓKH: Cultura, storia e tecniche della conservazione* 6 (June 1994): 58–60, which follows an article by Jürgen Becker on the restoration of the vault of the Sistine Chapel and an interview with the painter Enrico Baj on the restoration of the *Last Supper*. Unfortunately the articles ignore all of the recent scholarly bibliography on the topic (on which, see section IV, note 45).

4. See Marani, "Il Cenacolo di Leonardo" (1997/98), 191–229, in which I considered certain issues from this broader perspective (the only suitable one, in my opinion).

5. Beltrami, *Documenti e memorie* (1919), doc. 258; Carlo Vecce, *Leonardo* (Rome: Salerno, 1998), 356. The king of France may not have been Louis XII but François I, who, as Michelangelo Biondo reports, visited the *Last Supper* in the company of Pasquier Le Moyne in 1515

(on Le Moyne's appreciation of the painting, see section IV, note 4). On the Anonimo Gaddiano as a source for Leonardo biography, see Beltrami, *Documenti e memorie* (1919), doc. 254. Giovio states that the *Last Supper* was "in admirationem, tamen est Mediolani in pariete Christus cum discipulis discumbens" [however, the wall-painting at Milan of Christ at Supper with His disciples is greatly admired]. For Giovio, see Paolo Giovio, *Scritti d'arte*, ed. S. Maffei (Pisa, 1999), 234–45; also Giovio, "Leonardi Vincii Vita" in *Scritti d'arte del Cinquecento*, edited by Paola Barocchi, vol. 1, pp. 7–9.

6. Beltrami, *Documenti e memorie* (1919), doc. 238.

7. Vasari makes this statement in the *Life* of Benvenuto Garofalo and Girolamo da Carpi; see Giorgio Vasari, *Le vite de' più eccellenti pittori scultori ed architetti*, ed. Rosanna Bettarini and Paola Barocchi, vol. 5 (Florence: SPES, 1976), 424. In English see Vasari, *Lives of the Most Eminent Painters, Sculptors and Architects,* translated by Gaston du C. de Vere, vol. 8, p. 42. See also Bossi, *Del Cenacolo* (1810), 140–41. Regarding Vasari, we cannot exclude the possibility that he may have harbored an anti-Leonardo sentiment in favor of the preeminent position he assigned to Michelangelo.

8. Beltrami, *Documenti e memorie* (1919), doc. 263/19b; Lomazzo, *Scritti sulle arti*, ed. Ciardi (1973–74), 1:53. See also section I, note 6.

9. Beltrami, *Documenti e memorie* (1919), doc. 263/19d; Lomazzo, *Scritti sulle arti* (1973–74), 2:100. On the copy made by Lomazzo and destroyed during World War II, see Bossi, *Del Cenacolo* (1810), 145–46; Steinberg, "Leonardo's Last Supper" (1973), note 9, fig. 36.

10. Lomazzo, *Scritti sulle arti* (1973–74), 2:125. On this and later reports on the state of conservation of the *Last Supper*, see Brambilla Barcilon, *Il Cenacolo di Leonardo in Santa Maria delle Grazie*(1984), esp. pp. 69–70. Another little-known sixteenth-century source, Don Serafino Razzi, whose *Diario di viaggio di un ricercatore* (1572) has recently been discussed by Giovanni Agosti, reports that the *Last Supper* was *mezzo guasto e scalcinato* (half ruined and peeling), but that it was recognizable, thanks to prints of it: see Giovanni Agosti, "Scrittori che parlano di artisti, tra Quattro e Cinquecento in Lombardia," in Barbara Agosti, Giovanni Agosti, Carl Brandon Strehlke,

and Marco Tanzi, *Quattro pezzi lombardi (per Maria Teresa Binaghi)*, ed. Sandro Lombardi (Brescia: L'Obliquo, 1998), 39–93. On Serafino Razzi, who was the brother of Don Silvano Razzi and a correspondent of Vasari's, see ibid., 87. Serafino Razzi's *Diario* was edited by Guglielmo Di Agresti and published in *Memorie domenicane*, n.s., 2 ([1971]). For another discussion of Razzi's account of the *Last Supper*, see Marco Rossi, "Problemi di conservazione del Cenacolo nei secoli XVI e XVII," *Arte lombarda* 62 (1982): 58–65, esp. p. 60.

11. See Giovanni Battista Armenini, *De' veri precetti della pittura* (Ravenna, 1587), bk. 3, p. 172; Bossi, *Del Cenacolo* (1810), 40; Brambilla Barcilon, *Il Cenacolo di Leonardo in Santa Maria delle Grazie* (1984), 69.

12. See Paolo Morigia, *Historia dell'antichità di Milano, Libri quattro* (Venice, 1592); reprint (Bologna: Forni, 1967), 168.

13. See Federico Borromeo, *Musaeum* (Milan, 1625), trans. Luigi Grasselli as *Il Museo* (Milan, 1909), 26ff. On Borromeo's high opinion of Leonardo as a "historical" painter, see Pamela M. Jones, *Federico Borromeo and the Ambrosiana: Art Patronage and Reform in Seventeenth-Century Milan* (Cambridge: Cambridge University Press, 1997), in Italian translation as *Federico Borromeo e l'Ambrosiana: Arte e riforma cattolica nel XVII secolo a Milano* (Milan: Vita e Pensiero, 1997), esp. pp. 84, 89, 137.

14. On Il Vespino's copy, see Angela Ottino Della Chiesa, *L'opera completa di Leonardo pittore* (Milan: Rizzoli, 1967), 98; Heydenreich, *Invito a Leonardo* (1982), 102; Rossi and Rovetta, *Il Cenacolo di Leonardo* (1988), 13, fig. 8; Jones, *Federico Borromeo* (1993), Italian trans. (1997), 250. On Federico Borromeo's characterization of the *Last Supper* as "fleeting relics" (*reliquiae fugientes*), see also Giovanni Testori, "Reliquiae Fugientes," in *Leonardo e Milano*, ed. Gian Alberto Dell'Acqua (Milan: Banca Popolare di Milano, 1982), 11–15; reprinted in Testori, *La realtà della pittura: Scritti di storia e critica d'arte dal Quattrocento al Settecento*, ed. Pietro C. Marani (Milan: Longanesi, 1995), 124–28. See also Pietro C. Marani, "Giovanni Testori e le reliquiae fugientes di Leonardo," *Raccolta Vinciana* 25 (1993): 455–61.

15. See Alessandro Morandotti, "Il revival Leonardesco nell'età di Federico Borromeo," in *I leonardeschi a Milano* (1991), 166–82; Jones, *Federico Borromeo* (1993); Pietro C. Marani, "Una natura morta di Leonardo nella Milano di fine Cinquecento," in *La natura morta al tempo di Caravaggio*, ed. Alberto Cottino (Naples: Electa Napoli, 1995), 26–34; 2d ed. (Naples, 1996). See also Pietro C. Marani, "Nota su Tanzio da Varallo e su alcune sue possibili fonti lombarde," in *Il Seicento lombardo: Giornata di studi*, ed. Mina Gregori and Marco Rosci (Milan: Artemia, 1996), 5–10; Filippo Maria Ferro, "Novità e precisazioni su Tanzio da Varallo," in *Il Seicento lombardo* (1996), 11–20. Works held to be by Leonardo and a copy of the *Last Supper* on canvas also figured in the collection of Cardinal Cesare Monti at the archdiocesan offices from 1635 to 1650: see *Le Stanze del Cardinal Monti 1635–1650: La collezione ricomposta* (Milan: Leonardo arte, 1994). These works included a *Madonna and Child*, now in the Brera, assigned to Leonardo but now attributed to Giampietrino (137–38); two chiaroscuro drawings attributed to Leonardo but actually by Andrea del Sarto (243–44); and a copy of the *Last Supper* attributed to Marco d'Oggiono in the 1650 inventory but actually by an anonymous Milanese painter of the sixteenth century (247). Gregorio Pagani in Florence and Giulio Cesare Procaccini in Milan owned, among other works, copies of Leonardo's *Trattato della Pittura*: see Leonardo da Vinci, *Libro di Pittura*, ed. Carlo Pedretti and Carlo Vecce (Florence: Giunti, 1995), 1:47, 56.

16. See *Le Memorie su Leonardo da Vinci, di Don Ambrogio Mazenta, ripubblicate ed illustrate da D. Luigi Gramatica* (Milan: Alfieri & Lacroix, 1919), 47. Mazenta erroneously attributes the Castellazzo copy to Lomazzo.

17. See Carlo Torre, *Il Ritratto di Milano* (Milan, 1674); reprint (Bologna: Forni, 1973), 154.

18. For other sixteenth-century accounts, see Bossi, *Del Cenacolo* (1810), 157ff.; Brambilla Barcilon, *Il Cenacolo di Leonardo in Santa Maria delle Grazie* (1984); Richard Turner, *Inventing Leonardo* (Berkeley and Los Angeles: University of California Press, 1994), 76ff.

19. See Fernanda Wittgens, "Il restauro in corso del Cenacolo di Leonardo," in *Atti del Convegno di studi vinciani* (Florence: L. S. Olschki, 1954), 39–50; and Wittgens, "Restauro del Cenacolo," in *Leonardo: Saggi e ricerche* (1954), 1–12. Wittgens attributes to Lomazzo the blackish "sixteenth-century" (?) plaster on the figure of St. Bartholomew, the first figure from the left in the composition, as well as other reddish plaster work. See also Brambilla Barcilon, *Il Cenacolo di Leonardo in Santa Maria delle Grazie* (1984), 24: "It is impossible to recognize in this superimposition of *stuccature* the hypothetical work of Lomazzo remembered by Wittgens." The results of the chemical analyses of these plasters by Antonietta Gallone and by the Istituto Centrale per il Restauro will be published in a forthcoming volume provisionally titled *Richerche sulla conservazione e il restauro del Cenadolo di Leonardo*.

20. Bossi, *De Cenacolo* (1810), 134–37, 145–46.

21. On this point, see Pietro C. Marani, "Le alterazioni dell'immagine dell'Ultima Cena di Leonardo dopo le più recenti analisi," *Kérmes: Arte e tecnica del restauro*, year 3, n. 7 (1990): 64–67.

22. In the meantime the painting was praised in France by Roland Fréart Sieur de Chambray (1651) and by André Félibien (1667). See Turner, *Inventing Leonardo* (1994), 76–78.

23. Misson's work appeared in French, and the Richardsons' publication in English, although a French edition of the latter appeared in 1728. See Richardson and Richardson, *An Account* (1722), 23: "In the Refectory over a very high Door, is the famous Picture of the Last Supper, Figures as big as Life; it is excessively ruin'd, and all the Apostles on the Right-hand of the Christ are entirely defaced; the Christ and those on his Left hand appear pretty plain, but the Colours are quite faded, and in several Places only the bare Wall is left." See Gisberto Martelli, "Restauri al 'Cenacolo Vinciano' dal 1978: Richiamo di testimonianze vecchie e nuove," *Raccolta Vinciana* 23 (1989): 17–25. Some doubts might legitimately be raised concerning the Richardsons' account—not so much because direct observation of the surface to the right of Christ now allows us to see that the original paint survives in vast portions of the painting, but rather because we might entertain second thoughts about their culture and their good faith: when the Richardsons went to Rome later in the same trip and viewed Michelangelo's *Last Judgment*, they called him "the Luther of the Reformation of painting" and expressed their astonishment that no pope had ordered the entire fresco destroyed. Richardson and Richardson, *An Account* (1722), 492. See also Romeo De Maio, *Michelangelo e la controriforma* (Florence: Sansoni, 1990), 29, 37. Bossi, *Del Cenacolo* (1810), 61, quotes the Richardsons' opinion of the *Last Supper* as well, as does Brambilla Barcilon (*Il Cenacolo di Leonardo in Santa Maria delle Grazie* [1984], 70–71). It is not immediately clear in which part of the composition, according to the Richardsons, the figures were illegible. "On the Right-hand of the Christ" seems to refer to the left-hand side of the composition as the viewer sees it; but when they state that "only the bare Wall is left" in connection with "those on his Left-hand," they seem to be speaking of the apostles on the right-hand part of the mural. Their report is perhaps not totally trustworthy, not only because of this confusion, but also because it is contradicted by recent discoveries on the right-hand side of the mural, under Bellotti's overpainting. See also Carlo Bianconi, *Nuova guida di Milano per gli amanti delle Belle Arti e delle sacre, e profane antichità* (Milan, 1787), 328. On Misson's comments, see François-Maximilien Misson, *Voyage d'Italie* (Utrecht, 1722), 18ff. See Bossi, *Del Cenacolo* (1810), 63, for La Condamine's statement on Misson's opinion. See also Brambilla Barcilon, *Il Cenacolo di Leonardo in Santa Maria delle Grazie* (1984), 29.

24. Pino, *Storia genuina del Cenacolo* (1796), 42. See also Brambilla Barcilon, *Il Cenacolo di Leonardo in Santa Maria delle Grazie* (1984), 29, 72. Little is known about Michelangelo Bellotti, but the church of San Vincenzo at Gravedona has two large paintings of his, one of which is signed and dated 1735. Both works are reminiscent of Renaissance compositions, in particular a *Martyrdom of St. Vincent*, modeled on a fresco by Aurelio Luini now in the Brera: see Marco Bona Castellotti, ed., *La pittura lombarda del Settecento* (Milan: Longanesi, 1986), figs. 49, 50. Michelangelo Bellotti also painted two frescoes in the mortuary chapel of the basilica of San Giovanni Battista in Busto Arsizio that are good examples of neo-sixteenth-century, Michelangelesque painting. Documents regarding Bellotti's work on the *Last Supper* have been conserved in ASM: see *Ludovico il Moro: La sua città e la sua corte (1480–1499)*, catalog of an exhibition (Milan: Archivio di stato di Milano, 1983), no. 11; Fabjan, "Il Cenacolo nuovamente restaurato" (1985), 93. When Bellotti was working on the *Last Supper*, perhaps using a potassium or a

soda solution to clean the surface, he may have used tempera or gouache to fill in the blank spaces and enhance the remaining original portions. The Bellotti of whom Carlo Verri speaks in negative terms in his Gaetano *o elementare sul disegno della figura umana* (Milan, 1814), recently reprinted in Fernando Mazzocca, *Scritti d'arte del primo Ottocento* (Milan: Ricciardi, 1998), 281ff., is probably not Michelangelo Bellotti but the better-known Biagio Bellotti, a rococo painter who also worked at Busto Arsizio (where he did the frescoes in the choir of the basilica of San Giovanni, for example) and in the Varese region. Verri recalls him together with Magatti (a painter also from around Varese) and Ferdinando Porta as baroque painters in Lombardy.

25. Serviliano Latuada, *Descrizione di Milano* (Milan, 1738), 4:384, states: "The Refectory must be judged to be noteworthy and supremely distinguished for the excellent painting of the Last Supper, represented marvelously by the prominent Architect and Painter Leonardo da Vinci, which, although with the passing years it has lost much of its former liveliness from the ravages of time, was nonetheless once again brought back to perfection with consummate care and patience, nor is it too unlike the [painting] as it appeared when such an excellent brush had just finished it." See also Brambilla Barcilon, *Il Cenacolo di Leonardo in Santa Maria delle Grazie* (1984), 29.

26. Francesco Bartoli, *Notizia delle pitture, sculture ed architetture . . . d'Italia* (Venice, 1776), 192. (Italics added.)

27. On Gallarati's attempted reconstruction of the *Last Supper*, see Carlo Bertelli, in Pedretti, *Leonardo: Studi* (1983), 11–15, esp. p. 12. See also Brambilla Barcilon, *Il Cenacolo di Leonardo in Santa Maria delle Grazie* (1984), 72, for Gallarati's discussion of moisture on the surface of the mural; and Johann Joachim Winckelmann, *Monumenti antichi inediti spiegati e illustrati*, 2 vols. (Rome, 1767).

28. Regarding Mazza's work on the mural, see the documents in ASM published in *Ludovico il Moro* (1983), docs. 12, 13. See also Emilio Motta, "Il restauro del Cenacolo nel secolo XVII e l'auto-difesa del pittore Mazza," *Raccolta Vinciana* 3 (1907): 127–38; Heydenreich, *Invito a Leonardo* (1982), 29; Brambilla Barcilon, *Il Cenacolo di Leonardo in Santa Maria delle Grazie* (1984), 35–57; Fabjan, "Il Cenacolo nuovamente restaurato" (1985), 93. Mazzi completely restored the

figures of the first three apostles on the left-hand side of the mural and made some tests on the next four figures; he cleaned with *mordace detersivo* (probably a potassium or a soda solution, possibly something more caustic) and used a scraper to remove earlier repainting; he used an *impasto a olio* (oil-based mixture) to complete the figure of Bartholomew and, to a lesser extent, those of James and Andrew.

29. For a survey of the architecture and urban planning of the period, see *L'idea della magnificenza civile: Architettura a Milano 1770–1848* (Milan: Electa, 1978); Aurora Scott, *Brera 1776–1815: Nascita e sviluppo di una istituzione culturale milanese*, Quaderni di Brera, 5 (Florence: Centro Di, 1979); and Scotti, *Lo stato e la città: Architetture, istituzioni e funzionari nella Lombardia illuminista* (Milan: F. Angeli, 1984). See also the excellent essay, Anna Maria Brizio, "L'Accademia di Brera nei suoi rapporti con la città di Milano, 1776–1814," in *Mostra dei Maestri di Brera* (Milan, 1975), 13–22.

30. Firmian's personal involvement in establishing the Accademia di Belle Arti often conflicted with the restrictive provisions imposed on the Milanese from Vienna by the powerful Wenzel Anton von Kaunitz, later chancellor of Austria. Bossi, *Del Cenacolo* (1810), 199–200. On Firmian, see Scotti, "L'Accademia di Brera" (1975), 31; on Firmian as a collector, see Giulio Melzi d'Eril, *La Galleria Melzi e il collezionismo milanese del tardo Settecento* (Milan: Virgilio, 1973). For Firmian's relations with Winckelmann, see Johann Joachim Winckelmann, *Lettere italiane*, ed. Giorgio Zampa (Milan: Feltrinelli, 1961), 212ff. In a letter to Anton Raphael Mengs dated 19 October 1762, Winckelmann states that he had asked Count Firmian for a copy of the Leonardo manuscript now conserved in the Ambrosiana.

Pietro Frattini defended Mazza's restoration, declaring in a letter to Count Firmian, "After examining the entire work, [Mazza] realized that nothing original remained by the author, and that other than the frame, it was largely ruined—the trussing of the ceiling poorly corrected and inaccurate according to the legitimate rules of perspective; the tapestries forming a background next to the table completely dark and lost. He discovered that the colors of the drapery and the complexions of all the apostles were mostly altered, as well as the struc-

ture of the table itself. So with singular expert skills and the diligence of the art, he gradually cleaned the drapery, revealing the original painting below."

31. Milan, private collection, oil on wood panel, 50 cm × 75 cm: see Marani, "Il Cenacolo di Leonardo" (1997/98), fig. 16.

32. Bossi, *Del Cenacolo* (1810), 200.

33. Scotti, *Brera 1776–1815* (1979), 43. By the time of Napoleon's visit, Milan's Accademia di Belle Arti had developed into a center for new ideas in the arts. Benefiting from the support of Leopold II and from a faculty of illustrious teachers, it began to train a new class of artists. The teaching program drawn up in 1791 by Giuseppe Parini stressed the "elucidation of nature and of art's purpose" and the perfection of art governed by "absolute rules of simplicity, unity, proportion, order, arrangement, expression," the tenets of neoclassicism.

34. Carlo Giuseppe Gerli, *Disegni di Leonardo da Vinci incisi e pubblicati . . . con un ragionamento intorno ai disegni di Leonardo da Vinci compresi in questo volume*, the latter by Carlo Amoretti (Milan, 1784).

35. Ibid., 174; Aurora Scotti, "La collezione De Pagave," in B. Gorni, A. Papale, and Aurora Scotti, *La collezione De Pagave: Le stampe dell'Archivio di Stato di Novara* (Novara, 1976), 7, 12; Pietro C. Marani, in *Disegni e dipinti leonardeschi dalle collezioni milanesi* (Milan: Electa, 1987), 45. The drawings had been owned by Cardinal Cesare Monti, thereafter by Don Venanzio de Pagave, and then by Giuseppe Bossi. At Bossi's death, they passed into the collection of the Accademia in Venice.

36. On Dutertre's engraving, see Heydenreich, *Invito a Leonardo* (1982), 40, fig.; Brown, *Leonardo's Last Supper*, no. 21; Aurora Scotti, "Carlo Bianconi, Luigi Dagoty e un tentativo di incisione a colori del Cenacolo Leonardesco," *Almanacco Italiano* 80 (1979): 148–57. For the other engravings, see Alberici and Chirico De Biasi, *Leonardo e l'incisione* (1984), 51, 63–65, catalog nos. 43 (Aspari).

37. John Chamberlaine, *Imitations of Original Designs by Leonardo da Vinci* (London, 1796), with seventeen plates (on which, see Clark, *Drawings of Leonardo da Vinci* [1968–69], 1:xiv. John Chamberlaine later published an enlarged edition under the title *Original Designs of the Most Celebrated Masters of the Bolognese, Roman, Florentine and Venetian Schools* (London, 1812).

38. For Morghen, see De Biasi, catalog no. 44 (Morghen); Brown, *Leonardo's Last Supper* (1983), catalog no. 22 (Morghen).

39. See Marinoni, "I manoscritti di Leonardo da Vinci" (1954), 229–74; Nando De Toni, "Giovan Battista Venturi e i manoscritti dell'Ambrosiana a Parigi nel 1797," *Commentari dell'Ateneo di Brescia per il 1974* (1974): offprint, 1–7

40. Turner, *Inventing Leonardo* (1994), 86–87.

41. See Antonio Mussi, *Poesie pittoriche* (Pavia, 1798), 32. On Mussi, see Marani, "Una Precisazione sulla provenienza" (1987), 265–70.

42. See Pier Luigi De Vecchi and Aurora Scotti, "'Artefici di numi': Gli artisti e le istituzioni," in *I cannoni al Sempione: Milano e la 'Grande Nation' (1796–1814)* (Milan: Casse di Risparmio delle provincie lombarde, 1986), 103–212, esp. p. 107.

43. Bossi, *Del Cenacolo* (1810), 200–1.

44. ASM, Fondo Auotografi, cart. 103, fasc. 1: see *Le vicende del Cenacolo di Leonardo da Vinci nel secolo XIX* (Milan: Ufficio Regionale per la conservazione dei Monumenti della Lombardia, 1906), 15–16; Sandra Sicoli, "I restauratori nella Regia Pinacoteca di Brera: Le origini di una professione della Milano napoleonica," in *Giovanni Secco Suardo: La cultura del restauro tra tutela e conservazione dell'opera d'arte*, supplement to *Bolletino d'arte*, ser. 6, vol. 81, no. 98 (1998), 45, doc. 8. On Appiani's report, see Heydenreich, *Invito a Leonardo* (1983), 30, 96–97. On Appiani as commissioner of fine arts in the Napoleonic government, see Roberto Paolo Ciardi, "Andrea Appiani commissario per le 'Arti Belle,'" *Prospettiva* 33–36 (1985); Sandra Sicoli, "La politica di tutela in Lombardia nel periodo napoleonico: La formazione della Pinacoteca di Brera: Il ruolo di Andrea Appiani e Giuseppe Bossi," *Ricerche di Storia dell'arte* 38 (1990): 71–90.

45. ASM, Fondo Autografi, cart. 103, fasc. 1. See *Vicende del Cenacolo* (1906), 16; Sicoli, "I restauratori nella Regia Pinacoteca di Brera" (1998), 45, doc. 7.

46. Appiano affirmed, "I place Leonardo after nature." As a painter and proponent of the official taste of the period, Appiani represented the high esteem of Leonardo's art in Milanese neoclassical painting, while Giovanni Antonio Antolini's (1753–1841) great urban projects for the Foro Buonaparte suggested the possibility of a true Renaissance based on ancient architecture and catering to Jacobin ideals. On Appiani

and his appreciation of Leonardo, see Giovanni Battista Sannazzaro, "Motivi leonardeschi nell'Appiani," *Raccolta Vinciana* 26 (1995): 255–85. For the artistic and architectural climate of the times, see Aurora Scotti, *Il Foro Bonaparte: Un'utopia giacobina a Milano*, intro. Werner Oechslin (Milan: Ricci, 1989). Antolini's designs for the Foro Bonaparte date from 1801, but Pietro Canonica's project was chosen (1809). On collecting in Milan at the time, see also Alessandro Morandotti, "Le stampe di traduzione come fonti per la storia del collezionismo: Il caso di Milano fra età napoleonica e restaurazione," in *Il Lombardo-Veneto 1814–1859: Storia e cultura*, ed. Nicoletta Dacrema, Proceedings: Università degli studi di Pavia (Udine: Campanotto, 1996), 193–237.

47. *Vicende del Cenacolo* (1906), 17.

48. Ibid., 21, which also gives the text of the inscription commemorating the event, which still existed on the side door of the refectory. On the mosaic copy of the *Last Supper* and its transfer to Vienna, see ABM, Scuola di Mosaico, 1811–1836, TEA G IV 5, in which an entire dossier is devoted to the "Gran quadro di Leonardo." The first files in this dossier refer to the request to use the pieces left over from the mosaic copy of the *Last Supper* for pavings in the royal residence of Racconigi. See also Ottino Della Chiesa, *Opera completa di Leonardo pittore* (1967), 98; Steinberg, "Leonardo's Last Supper" (1973), no. 42 and bibliography; Alberici and Chirico De Biasi, *Leonardo e l'incisione* (1984), 67. On Eugène de Beauharnais as a collector and on his relations with Bossi, see Gabriella Ferri Piccaluga, "Eugenio di Beauharnais collezionista e conoscitore di dipinti leonardeschi," in *I leonardeschi a Milano* (1991), 221–23, 227 n. 43; Morandotti, "Le stampe di traduzione" (1996), 213–14 n. 31.

49. See Scotti, *Brera 1776–1815* (1979), 52.

50. *Vicende del Cenacolo* (1906), 18–19.

51. Ibid., 20.

52. On the Weimar drawings, see Heydenreich, *Invito a Leonardo* (1982), 30–31; Rosalba Antonelli, "Gli studi preparatori della copia del Cenacolo di Giuseppe Bossi allo Schlossmuseum di Weimar," *Raccolta Vinciana* 26 (1995): 287–327.

53. On Bossi, see also Giulio Bora, "Giuseppe Bossi segretario e professore di Brera," in *Mostra dei Maestri di Brera* (1975), 31–35. On Bossi and his activity

as an artist, see *Milano e Brera nella Repubblica Cisalpina*, Atti del Convegno, Milan, Accademia di Brera, 4–5 February 1997, ed. Roberto Cassanelli and Matteo Ceriana (Milan, 1999), in particular, the papers by Fernando Mazzocca, Dario Trento, and Pietro C. Marani.

54. Carlo Verri, *Osservazioni sul volume intitolato Del Cenacolo di Leonardo da Vinci, Libri Quattro, di Giuseppe Bossi pittore, scritte per lume de' giovani studiosi del disegno e della pittura* (Milan, 1812), 73–74. On Verri, see Alessandro Conti, *Storia del restauro e della conservazione delle opere d'arte* (Milan: Electa, 1988), 192. Bossi himself responded to Verri's criticism with a volume titled *Postille alle Osservazioni sul volume intitolato Del Cenacolo di Leonardo da Vinci Libri Quattro* (Milan, 1812), new ed. (1912). The Raccolta Vinciana of the Castello Sforzesco contains two copies of Bossi's *Postille*, one of which bears annotations by Carlo Verri (ERV, A.II.22; H.II.22). For Ugo Foscolo's criticisms, see his *Hypercalypseos* (1815). Foscolo reproached Bossi for painting Christ with black hair instead of the reddish hair that Leonardo had given him. On Foscolo, see Pedretti, *Leonardo: Studi* (1983), 32. For Goethe's comments on Bossi's *Del Cenacolo*, see note 56, below, and section IV. For the Bossi-Verri polemic, see Mazzocca, *Scritti d'arte del primo Ottocento* (1998), 849–50. For Leopoldo Cicognara's favorable opinion of Bossi's copy of the *Last Supper* (given in section V) and for his sharp criticism of the work's state of preservation and the restorations it had undergone ("bruttura . . . e ingiuria di pessim'arte" [ugly stuff, an insult of the worst kind of art]), see Leopoldo Cicognara, *Dello stato delle Belle Arti nel Regno italico* (1809), reprinted in Paola Barocchi, *Dai neoclassici ai puristi 1780–1861*, vol. 1 of Barocchi, *Storia moderna dell'arte in Italia: Manifesti, polemiche, documenti* (Turin: Giulio Einaudi, 1998), 108.

55. See Pietro C. Marani, "Stendhal e il Cenacolo di Leonardo," *L'Esopo* 3 (1979): 51–55; Pierluigi De Vecchi, "Stendhal e Leonardo: Il Cenacolo di Santa Maria delle Grazie," in *Stendhal e Milano* (Florence: Leo S. Olschki, 1982), 2:729–37, both with bibliography. Stendhal was no more gentle with Bossi than were other critics, scribbling insulting marginalia in his copy of Bossi's book, now in the Raccolta Vinciana, Castello Sforzesco, Milan, RVA Inf. 10.

56. See Johann Wolfgang von Goethe, "Joseph Bossi über Leonardos da Vinci Abendmahl zu Mailand" (Weimar, 1817); *Leonardo da Vinci: Das Abendmahl, herausg. von Emil Schäffer, mit einer Einleitung von Goethe* (Berlin: J. Bard, 1914). See also Lavinia Mazzucchetti, ed., *Goethe e il Cenacolo di Leonardo* (Milan: U. Hoepli, 1939); Emmy Rosenfeld, "Goethe und der Mailänder Naturforscher Giuseppe de Cristoforis," *Literaturwissenschaftliches Jahrbuch*, n.s. 20 (1979): 107–38; Luisa Cogliati Arano, *Von Leonardo zu Goethe* (Milan, n.d.). See also Kate Steinitz Trauman, "Goethe and Leonardo's Treatise on Painting," *Raccolta Vinciana* 18 (1960): 104–11. For the success of the *Last Supper* throughout Europe and its reflections in nineteenth-century painting, see Richard Hüttel, *Spiegelungen einer Ruine: Leonardos Abendmahl im 19. und 20. Jahrhundert* (Marburg: Jonas Verlag, 1994). For further commentary, see section IV.

57. Aside from Albuzio's work on Lombard painters, Carlo Amoretti should be mentioned in the context of Leonardo studies. After his introductory essay to Gerli's engravings (Gerli, *Disegni di Leonardo da Vinci*, 1784), he published *Memorie storiche su la vita, gli studi et le opere di Leonardo da Vinci* (Milan, 1804). See also Ignazio Fumagalli, *Scuola di Leonardo da Vinci in Lombardia* (Milan, 1811).

58. See Scotti, *Brera 1776–1815* (1979), 69.

59. ABM, Carpi, A VI 19; *Vicende del Cenacolo* (1906), 22–23.

60. On Barezzi's first and unsuccessful attempt at "restoration" (a proposal to detach the painting) and on his work on the mural in 1853–55, see ASM, *Studi*, p.m., cart. 357; RV, *Stefano Barezzi: Carteggi*, E.V.26; *Vicende del Cenacolo* (1906), 23ff.; Brambilla Barcilon, *Il Cenacolo di Leonardo in Santa Maria delle Grazie* (1984), 39–41; Fabjan, "Il Cenacolo nuovamente restaurato" (1985), 93. On the Barezzi restoration, see also Emilio Seletti, *Commemorazione del pittore Stefano Barezzi da Busseto* (Milan, 1859), and Seletti, *Appendice documentata alla Commemorazione del pittore Stefano Barezzi da Busseto* (Milan, 1859). For a contrasting viewpoint, see Giuseppe Mongeri, "Sulla conservazione del Cenacolo di Leonardo da Vinci," *La Perseveranza* (1861), 15ff.: "It was he who, toward the end of 1819, presented himself to the Accademia, offering to detach the Last

Supper from the wall and affix it to wood or canvas. The offer was accompanied by [a promise] to first conduct an experiment on two figures, and if the experiment were not [deemed a success by the committee], to return to the wall the figures he had removed. Given the ruined state of the painting and that little was known about the imprimatura, his proposal seemed a miracle of daring, if it was not (as indeed it was) presumptuous and perhaps also a snare. . . . Barezzi was assigned, for his experiment, to detach a square portion, 1.2 meters × 1.2 meters, at the lower edge of the painting, to the viewer's left. Like Bellotti (of inauspicious memory), Barezzi shut himself in. We can imagine the astonishment of the supervisory commission when they discovered two months later that, instead of attempting to detach the portion assigned to him, Barezzi had, of his own volition, attempted to restore—rather, to re-do—a central portion of the painting with plaster and colored pastes! After its visit, the commission immediately suspended work, and the Last Supper was saved from the third and gravest misfortune to which it had been subjected." Mongeri goes on to describe Barezzi's second attempt to restore the work in 1852.

61. ABM, Carpi, A VI 19; *Vicende del Cenacolo* (1906), 25.

62. Ibid., 25–27.

63. Ibid.; the document is given in part in *Vicende del Cenacolo* (1906), 27.

64. AMB, Carpi, A VI 19, letter no. 34164, C. 4455; an extract from this document is transcribed in *Vicende del Cenacolo* (1906), 27.

65. *Vicende del Cenacolo* (1906), 29–30.

66. ABM, Carpi, A VI 19; the report was signed by Mazzola, Domenico Aspari, Giacinto Cattaneo, Longhi, Serangeli, and Ignazio Fumagalli. Only one sentence of the document is given in *Vicende del Cenacolo* (1906), 30–31, which omits the important note summarizing the damage in this dark-colored zone (a part of the mural that is still very deteriorated). Above all, *Vicende del Cenacolo* does not publish the extremely interesting black pencil sketch, poorly retraced in pen and ink in the copy on the sheet that follows, both of which are reproduced in this volume.

67 ABM, Carpi, A VI 19; *Vicende del Cenacolo* (1906), 31–32, transcribed only in part.

68. See Maria Teresa Binaghi Olivari,

in *Pinacoteca di Brera: Scuole lombarda e piemontese 1300–1535*, ed. Federico Zeri (Milan: Electa, 1988), 268–76.

69. See Conti, *Storia del restauro* (1988), 227. Barezzi's clumsy attempt at restoration was also criticized by Secco Suardo and, on 24 August 1824, by the English painter William Brockerdon: see Heydenreich, *Invito a Leonardo* (1982), 97.

70. In a report dated 3 April 1823, the Accademia declared that the restoration of the *Last Supper* "is in itself a thorny problem" and that " in proposing himself as restorer of the *Last Supper*, Signor Barezzi either is not afraid of encountering similar problems or believes himself sufficiently skilled to overcome them; but the commission would never take responsibility for his procedures, desiring to avoid further disagreeable complaints from the government or the public." *Vicende del Cenacolo* (1906), 32–36.

71. On this painting, see Renzo Mangili, *Giuseppe Diotti nell'Accademia tra Neoclassicismo e Romanticismo storico* (Milan: Mazzotta, 1991), 82, cat. no. 98. On the Giovanni Ambrogio de Predis painting, inherited by Mellerio and containing the Leonardo motto (on which, see Marani, *Leonardo e i leonardeschi* [1987], 72–74), see Germano Mulazzani, "Giacomo Mellerio collezionista e mecenate," in *Palazzo Mellerio: Una dimora nobiliare nella Milano neoclassica* (Cinisello Balsamo: Silvana, 1996), 117–18.

72. For example, in 1811 a prize was offered for a representation of "The Death of Leonardo in the Arms of the King of France." The competition was won by the Pisan painter Sante Soldaini, the only candidate, who took inspiration from an earlier (1781) canvas of François Guillaume Ménageot on the same theme. Artists Jean Charles Vasseur and Giuseppe Cades, among others, had treated the same subject, and it was taken up again by Ingres in 1818. On the 1811 contest and Soldaini's cartoon, see Antonio Musiari, in *Pinacoteca di Brera: Dipinti dell'Ottocento e del Novecento: Collezioni della Pinacoteca e dell'Accademia*, ed. Federico Zeri (Milan: Elemond, 1994) 2:627–29. Another episode in Leonardo's life was treated by Giambattista Gigola in a miniature (c. 1815, Milan, Pinacoteca Ambrosiana) titled *The Farewell of Ludovico il Moro at the Tomb of Beatrice d'Este*, a scene set in the convent of Santa Maria delle Grazie with Leonardo shown as present. On this painting, see Fernando Mazzocca, *Neoclassico e troubadour nelle miniature di Giambattista Gigola* (Florence: Centro Di, 1978), 154.

73. The middle of the nineteenth century also saw a burgeoning interest in pictures "revisiting" Leonardo's life. In 1845, Francesco Gonin, who illustrated Alessandro Manzoni's novel *I Promessi Sposi* [The Betrothed], created a pictorial reconstruction of the Renaissance environment depicting an encounter between Leonardo and Ludovico Sforza in the refectory of Santa Maria delle Grazie, with a glimpse of the right section of the *Last Supper*. Cherubino Cornienti explored the same theme around 1850. In 1852 Raffaello Casnedi won the Mylius prize with a fresco project for the Accademia di Brera portico representing "The School of Leonardo da Vinci," considered particularly appropriate for the Accademia. Casnedi's project was never realized—although Pietro Magni's sculptural monument to Leonardo treats the same subject—but it recognized the contributions of Leonardo's followers to the "glories" of Lombard art. On these works and this commission, see Roberto Paolo Ciardi, "Leonardo illustrato: Genio e morigeratezza," in *L'immagine di Leonardo: Testimonianze figurative dal XVI al XIX secolo*, catalog of an exhibition at Vinci (Florence: Giusti, 1997), 17–60. Gonin's painting (Milan, private collection, on which see Fernando Mazzocca, "Il modello accademico e la pittura di storia," in *La pittura in Italia: L'Ottocento*, ed. Enrico Castelnuovo [Milan: Electa, 1991], 2:609, fig. 859) was engraved in 1845 by D. Gandini; the painting by Cherubino Cornienti (Milan, Galleria d'Arte Moderna, inv. 6441), which shows the left-hand side of the *Last Supper*, was engraved in 1846 by G. Ripamonti: see Alberici and Chirico De Biasi, *Leonardo e l'incisione* (1984), 123 n. 176, 124 n. 177. Both paintings and the related engravings clearly show the left-hand and right-hand sections of the *Last Supper* in the state in which Barezzi's first attempted restoration had left it, which makes them of extreme interest to scholars. On how the *Last Supper* and Leonardo's biography influenced the formation of neo-Renaissance taste in nineteenth-century Milan, see also Fernando Mazzocca, "The Renaissance Repertoire in the History Painting of Nineteenth-Century Milan," in *Reviving the Renaissance: The Use and Abuse of the Past in Nineteenth-Century Italian Art and Decoration*, ed. Rosanna Pavoni (Cambridge: Cambridge University Press, 1997), 239–67. Regarding the "fortune" of Leonardo's students around the middle of the nineteenth century, which peaked in Pietro Magni's monument to Leonardo (see below), it is important to recall the rich offerings of the antiquarian market in that period, as evidenced by collections that were being gathered and dissolved with extraordinary rapidity. On this topic, see Marani, *Leonardo e i leonardeschi* (1987), 61–65, and the records of works offered for sale to the Pinacoteca di Brera: see Rosalba Tardito, "Dipinti leonardeschi offerti alla Pinacoteca di Brera nell'Ottocento," in *I leonardeschi a Milano* (1991), 253–54.

74. On Barezzi's removal of the whitewash covering the lunettes, see Brambilla Barcilon and Marani, *Le lunette di Leonardo* (1990). On Barezzi's second round of work on the mural, see Brambilla Barcilon, *Il Cenacolo di Leonardo in Santa Maria delle Grazie* (1984),43–45; Fabjan, "Il Cenacolo restaurato" (1985), 93. See also Mongeri, "Sulla conservazione" (1861), 17–18: "Barezzi . . . was confronted with the unilateral opposition of a Commission of the Accademia, and he received permission for only one operation, the overall consolidation of the crust, with the aid of a glue particular to him, an operation that excluded all artistic means or exercise, and that, conducted under the assiduous surveillance of the Commission itself, was successfully concluded, with commendable results, in 1855."

75. On the photographer Luigi Sacchi, see Robert Cassanelli, *La cultura fotografica a Milano alla vigilia dell'Unità: Luigi Sacchi e L'Artista (1859)* (Cinisello Balsamo: Silvana, 1998). The photograph, 53 cm × 83 cm, is extremely rare and is printed on salt paper.

76. SBBAS, Archivio Corrente, 13/31, file of old documents regarding the Barezzi restoration, published for the first time in Marani, "Il Cenacolo di Leonardo" (1997/98), 221–22. The file also contains documentation of later payments to Knoeller for his "artistic restoration." See below, however, and note 78. Excerpts from Perego's letter of 21 May 1857:

The board of directors is kindly requested to give its carefully considered proposals for the execution and supervision of the required work, with regard to the work done concerning the celebrated painting, or remaining to be done . . . [and] at the same time also report on the result of the restoration of the *Last Supper* carried out by Stefano Bareggi [Barezzi].

To honor the memory of Leonardo da Vinci, His Imperial Majesty would like to order with the above-mentioned sovereign resolution for a statue to be erected in Milan at the expense of the state, and that [the statue] be the subject of a competition announced by the Accademia.

The resolution of the project for the ordered competition, particularly regarding the statue's material and its location, should be determined by a special committee of experts, whose proposals will then be subject to the supreme decision of His Majesty, whose decision must be requested concerning the outcome of the competition before the prize is awarded, and before the contract is written.

His Majesty has fixed the maximum expense at the sum of twenty thousand florins.

77. See *La città di Brera: Due secoli di scultura* (Milan: Fabbri, 1995), 81 and the bibliography at 84 nn. 2 and 3. See also Ciardi, "Leonardo illustrato" (1997).

78. ACS, busta 482, fasc. 503: "Milano. Convento delle Gracie. Cenacolo di Leonardo da Vinci, 1872–1876," which contains three bundles, the first of which is labeled "Ripulitura dell'affresco. 1872." I have not been able to consult these documents in the original, but I think they must concern Knoeller's work on the mural, on which documentation also exists in the archives of the Soprintendenze in Milan. In any event, see Matteo Musacchio, ed., *L'archivio della Direzione generale delle antichità e belle arti (1860–1890)*, Pubblicazioni degli archivi di Stato, Strumenti 120 (Rome: Ministero per i Beni Culturali e Ambientali, Ufficio Centrale per i Beni Archivistici, 1994), 851.

79. The ode was published in *Illustrazione italiana* 28 (1901) as a lament for Leonardo's *Last Supper*, and it was originally accompanied by a note of explanation: "This ode was conceived by the poet during a recent visit to Santa Maria delle Grazie, before the irreparable ruin of the Last Supper of Leonardo." It elicited an immediate and enormous response, but also severe criticism.

80. See Luca Beltrami, "La Novella opera di Leonardo da Vinci," *Il Marzocco*, 11 May 1902, on which, see the comments in Marco Rosci, "La Sala delle Asse," in *Leonardo: La pittura* (1977), 115. Beltrami stated that the work could never die because "the inspiration from which it germinated will remain pure and fertile, like a natural force." Luca Beltrami, "A proposito dell'*Ode* per la morte

di un capolavoro," *Rassegna d'arte* 1 (1901): 20–24. Beltrami soon renewed his polemic with D'Annunzio: after Cavenaghi had completed his restoration of the *Last Supper*, Beltrami claimed that the gist of D'Annunzio's poem was actually "in disaccord with the title, or, more precisely, with the expectation aroused by the title, which gives one to think that the work of art is now completely lost." Luca Beltrami, *Vicende del Cenacolo Vinciano dall'anno MCCCCXC all'anno MCMVIII* (Milan: Allegretti, 1908), 40. The ode continued to have its admirers, however, and it was often republished, even in art history texts: see Mario Salmi, *Il "Cenacolo" di Leonardo da Vinci e la chiesa delle Grazie a Milano* (Milan: Fratelli Treves, 1927), xxxvi–xxxvii. On D'Annunzio, the ode, and decadentism in Europe, see Sandra Migliore, *Tra Hermes e Promoteo: Il mito di Leonardo nel decadentismo europeo* (Florence: L. S. Olschki, 1994), esp. pp. 155–93.

81. See *Raccolta Vinciana* 1 (1905): 7.

82. On the Cavenaghi restoration, see SBBAA, *Cenacolo. 1903–4* and *1906–8*; ABM, Ornato pubblico, Carpi, A VI 13; *Vicende del Cenacolo* (1906), 60–69; Beltrami, "Relazione del Prof. Luigi Cavenaghi sur restauro del Cenacolo vinciano," in Beltrami, *Il Cenacolo di Leonardo da Vinci* (1908), 49–53; Luigi Cavenaghi, "Cenacolo Vinciano," *Bollettino d'arte* (1908): 321–23, reprinted in Luca Beltrami, "La relazione del prof. Luigi Cavenaghi sul consolidamento del Cenacolo e la medagli d'oro a lui dedicata," *Raccolta Vinciana* 5 (1909): 95–103; Brambilla Barcilon, *Il Cenacolo di Leonardo in Santa Maria delle Grazie* (1984), 47–53; Fabjan, "Il Cenacolo nuovamente restaurato" (1985), 93; Conti, *Storia del restauro* (1988), 326. Cavenaghi also worked as a fresco painter, often taking inspiration, in his technique and his style, from the Quattrocento and Cinquecento masters. Frescoes of the sort (often actual imitations of the older Lombard paintings) are in Palazzo Bagatti Valsecchi (on which, see, for example, Rosanna Pavoni, *Museo Bagatti Valsecchi a Milano* [Milan, 1994], 20–21) and in the church of Santa Maria di Piazza in Busto Arsizio. On technical aspects of these works, see M. Barbaduomo, "Gli affreschi del Cavenaghi in Santa Maria di Piazza a Busto Arsizio: Tecnica e restauro," in *Restauro e valorizzazione degli affreschi nella Provincia di Varese*, ed. Pietro C. Marani (Varese, 1997), 101–5.

83. As in the past, studies on Leonardo, poetry, artistic literature, and the *Last Supper*'s restoration became intertwined, but with greater frequency in Milan in the new century. Another distinguished scholar of Milanese studies, Francesco Malaguzzi-Valeri, published from 1913 to 1923 his monumental *Corte di Ludovico il Moro*, a work in four volumes that revived the pictorial achievements of the romantic school through a literary reconstruction of the environment. See Malaguzzi-Valeri, *Bramante e Leonardo*, vol. 2 of *La corte di Ludovico il Moro* (1915). Other major studies appeared on the fourth centennial of the death of Leonardo in 1919: aside from Luca Beltrami's *Documenti e memorie* (1919), see, in particular, Lionello Venturi, *La critica e l'arte di Leonardo da Vinci* (Bologna: Zanichelli, 1919); Giovanni Poggi, *Leonardo da Vinci: La vita di Giorgio Vasari nuovamente commentata e illustrata* (Florence, Pampaloni, 1919); Wilhelm Suida, "Leonardo und seine Schule in Mailand," *Monatshefte für Kunstwissenschaft* 12 (1919).

84. On the Silvestri restoration, see SBBAA, *Milano. Cenacolo. 1924*; RV, miscellany of articles cataloged as F.IV.5; *Raccolta Vinciana* 12 (1926): 181–82; Brambilla Barcilon, *Il Cenacolo di Leonardo in Santa Maria delle Grazie* (1984), 54–59; Fabjan, "Il Cenacolo nuovamente restaurato" (1985), 93. Whereas Cavenaghi used hard resins as a sealant (which soon dried, causing new flaking), Silvestri used soft resins, leveling the surface with hot iron rollers and anchoring the borders of the flakes with a blackish-gray plaster; he signed his work at the center of the wall: see Brambilla Barcilon, *Il Cenacolo di Leonardo in Santa Maria delle Grazie* (1984), 59, fig. 21.

85. Gaetano Chierici's letter of 10 July 1937 was discovered in the archives of the Soprintendenza per i Beni Ambientali e Architettonici. See Brambilla Barcilon, *Il Cenacolo di Leonardo in Santa Maria delle Grazie* (1984), 61.

86. SBBAS, Archivio vecchio, prat. 4/16.

87. Ibid.: "To consolidate the color particles he used a mixture of about one part wax, two parts resin mastic, and ten parts petroleum spirits, at times using a syringe, at times a heating roller. . . . Knowledge of these facts is highly important, because any future restorer of the Vincian masterpiece must take them into account."

88. Heydenreich, *Invito a Leonardo* (1982), 159–69.

89. The wax-free shellac was invented by the English and was relatively effective in countering the enormous damage wrought by Allied bombs. See "The True Last Supper," *Time*, 4 October 1954, 40.

90. On the Pellicioli restoration, see SBBAA, Archivio corrente, prat. 13/31, *Milano. Cenacolo. 1947–49* and *1952–54*; Wittgens, "Il restauro in corso del Cenacolo" (1954), 39–50; Wittgens, "Restauro del Cenacolo," in *Leonardo: Saggi e ricerche* (1954), 1–12. For the first phase of the stabilization of the fragments, see Brambilla Barcilon, *Il Cenacolo di Leonardo in Santa Maria delle Grazie* (1984), 61–63.

91. The situation led to the resignation of several members of the commission, Edoardo Arslan in particular, and to Cesare Brandi's opposition to restoration beyond stabilization. For the letters of Arslan and Brandi expressing their reservations about the wisdom of continuing the restoration, see *L'Europeo*, no. 448, 16 May 1954.

92. Bernard Berenson, "Il restauro del Cenacolo," *Proporzioni* (November 1953), reprinted in *Corriere della Sera*, 20 December 1953, and in Bernard Berenson, *Valutazioni 1945–1956*, ed. M. Loria (Milan: Electa, 1957), 81–87. Berenson makes it clear that he did not consider himself to be qualified to plunge into a discussion of technical and physical details of Leonardo's mural, even though this was certainly not his only visit to the *Last Supper*. His first visit was on 10 September 1888, as we know from a letter in which he praises the hands of the apostles, which "said so much" and formed "such beautiful lines." See Ernest Samuels, *Bernard Berenson: The Making of a Connoisseur* (Cambridge, Mass.: Belknap Press, 1979), 81. The question, however, deserves further analysis.

93. Wittgens, "Restauro del Cenacolo" (1954), 12.

94. See the *Time* article, "The True Last Supper," cited above, note 89. See also R. A. La Joie, "The Great Restoration," *Home Messenger* (August 1954): 8–9; La Joie, "The Last Supper Survives," *Catholic Digest* (September 1954): 39–42 (which mentions Brandi's doubts). *Time* reported the initial phases of the restoration in its issue of 4 May 1953.

95. See Brambilla Barcilon, *Il Cenacolo di Leonardo in Santa Maria delle Grazie* (1984), 66. Pellicioli removed some plas-

ter work (on which, see Wittgens, "Il restauro in corse del Cenacolo" [1954], 47), but he failed to remove the overpainting on the flesh portions, the coffered ceiling, the still life, the tapestries, the apostles' robes, the under parts of the table, and more.

IV. Fragments of Critical Discourse and Fragments of Pictorial Reality

1. Giorgio Vasari, *Le vite de' più eccellenti pittori scultori ed architettori* (Florence, 1550; 1568); ed. Gaetano Milanesi (Florence, 1881), 4:34ff.; English translation by Gaston du C. de Vere, *Lives of the Painters, Sculptors and Architects*, 4:96; Beltrami, *Documenti e memorie* (1919), doc. 260; Giorgio Vasari, *Le vite dei più eccellenti pittori, scultori ed architettori nelle redazioni del 1550 e 1568*, ed. Rosanna Bettarini and Paola Barocchi, vol. 4, *Testo* (Florence: SPES, 1976), 25–27. The episode of the head of Judas and the prior's complaints appears only in the second edition of the *Vite* (1568). On Vasari's "Life of Leonardo," see also Paul Rubin, "What Man Saw: Vasari's Life of Leonardo da Vinci and the Image of Renaissance Artists," in *Nine Lectures on Leonardo da Vinci*, ed. Francis Ames-Lewis and Anka Bednarek (London: Department of History of Art, Birkbeck College, University of London, 1990), 96–108.

2. See Carlo Bertelli, in Carlo Pedretti, *Leonardo: Studi* (1983), 15.

3. See section I.

4. For the text of Michelangelo Biondo referring to François I's desire to take the painting away with him, see Beltrami, *Documenti e memorie* (1919), doc. 259: (". . . nevertheless, he could not satisfy his desire, since the thing was painted on the wall"). Biondo, however, attributes the *Last Supper* to Mantegna. See also Vasari, *Le vite*, ed. Bettarini and Barocchi, 4:27. For Pasquier Le Moyne, *Le couronnement du roy Francois Premier de ce nom voyage et conqueste de la duche de Millan* (Paris, 1520), 205, but unnumbered, see Luca Beltrami, "Notizie sconsciute sulle città di Pavia e Milano al principio del secolo XVI," *Archivio Storico Lombardo*, ser. 2, vol. 7, year 17 (1890): 408–24; Joanne Snow-Smith, "Pasquier Le Moyne's 1515 Account of Art and War in Northern Italy," *Studies in Iconography* 5 (1979): 173–234; Pedretti, *Leonardo: Studi* (1983),

43, 146 (where one can read, though with difficulty, directly from the reproduction of the pages of the sixteenth-century publication). In the two unnumbered pages that follow, the same text speaks of the refectory of the monastery of Sant'Angelo alle Fosse as a "refectoir pour les malades tres honeste ou est la cene . . . au bout painct en plat bien singulierement" [refectory for the very worthy sick persons, where the Last Supper is . . . painted most singularly on the flat at the end]. See also Rossi and Rovetta, *Il Cenacolo di Leonardo* (1988), 76; Giovanni Agosti, "Scrittori che parlano di artisti," in Agosti, Agosti, and Tanzi, *Quattro pezzi lombardi* (1998), 78–79. The latter also provides Le Moyne's description of a "nostre seigneur en tombeau" in Santa Maria delle Grazie that, rather than being a part of the tomb of Ludovico il Moro by Cristoforo Solario, can be identified as a *Compainto di Cristo* given to the church in 1503 (on which, see Luisa Giordano, in *"Ludovicus Dux,"* [1995], 183–85).

5. See, for example, Heydenreich, *Invito a Leonardo* (1982), 41ff.; Brizio, "Il Cenacolo" (1977), 7; Clark, in Pedretti, *Leonardo: Studi* (1983), 19.

6. See Luisa Vertova, *I Cenacoli fiorentini* (Turin: ERI, 1965); Rossi and Rovetta, *Il Cenacolo di Leonardo* (1988), 15; Eve Borsook, *The Mural Painters of Tuscany: From Cimabue to Andrea del Sarto*, 2d ed., rev. and enl. (Oxford: Clarendon Press; New York: Oxford University Press, 1980), 116; Giorgio Bonsanti, "Il Cenacolo del Ghirlandaio," in *La chiesa e il convento di San Marco a Firenze*, 2 vols. (Florence: Giunti, 1990), 2:173.

7. See Marani, "Prospettiva, botanica e simbolo" (1990), 1–34.

8. Beltrami, *Documenti e memorie* (1919), doc. 254. On these accounts, see also Carlo Vecce, *Leonardo* (Rome: Salerno), 358–62; Villata, in Marani, *Leonardo: Una carriera* (1999).

9. Beltrami, *Documenti e memorie* (1919), doc. 262.

10. See Matteo Bandello, *Le novelle*, ed. Gioachino Brognoligo, 5 vols. (Bari: Laterza, 1910), 2:283ff.; Beltrami, *Documenti e memorie* (1919), doc. 79; Brizio, "Il Cenacolo" (1977), 93–114. For other statements of praise during the sixteenth century, see Bossi, *Del Cenacolo* (1810), 18ff.

11. On usage of the term *miracoloso* in artistic literature and in the Italian language in the sixteenth century, see

Marani, "Il Cenacolo di Leonardo" (1997/98), 197–200. For Dante, *miracoloso* signified something "che è o che sembra frutto di un miracolo" [that is or that seems the result of a miracle]. For Tommaseo (n. 2275), the term *miracoloso* meant "A prodigy; portent; a thing admired because its cause is unknown." On usage of the term in the early sixteenth century, see Manlio Cortelazzo and Paolo Zoli, *Dizionario etimologico della lingua italiana*, s.v. "miracolo" (vol. 3, Milan, 1983, p. 760), which cites Leonardo's usage and explains the adjective *miracoloso* (from *miraculum, mirari*, "to be surprised") as "meraviglioso, portentoso, prodigioso, che suscita stupore, pertanto l'ammirazione non disgiunta dalle *venerazione tremebonda* per il 'completamente altro da noi' della cui potenza quel fatto è manifestazione" [marvelous, portentous, prodigious, which elicits stupor, and for that reason admiration connected with trembling veneration for what is completely other than ourselves, of whose power that event is a manifestation]. In a 1594 text Francesco Panigarola explicitly uses the adjective as something "that does miracles" (*che fa miracoli*).

12. On the Royal Academy version of the *Last Supper*, see Bossi, *Del Cenacolo* (1810), 137–38; Shell, Brambilla Barcilon, and Brown, *Giampietrino* (1988). The Ottaviano version is not normally included in studies of copies of the *Last Supper*: see Horst, "L'Ultima Cena di Leonardo" (1930–34), 118–200; Steinberg, "Leonardo's Last Supper" (1973), 297–410.

13. On this important point, see Marani, *Leonardo: Una carriera* (1999), chap. 3.

14. See Rossi and Rovetta, *Il Cenacolo* (1988), and section I.

15. See Giovan Paolo Lomazzo, *Grottesche* (Milan, 1587), book II. On these opinions, see Bossi, *Del Cenacolo* (1810), 18, 24–25, 145. For an overview of the authors, texts, and themes of the literature of art in the sixteenth century, see Paola Barocchi, ed., *Scritti d'arte del Cinquecento*, 3 vols. (Milan and Naples: Ricciardi, 1971–72).

16. *Trattato della Pittura di Lionardo da Vinci nuovamente dato in luce, con la vita dell'istesso autore, scritta da Rafaelle Du Fresne* (Paris, 1651), immediately translated into French by Roland Fréart, Sieur de Chambray, under the title *Traité de la peinture de Léonard de Vinci* (Paris, 1651). On the Poussin drawings that ac-

company this work, see *I disegni leonardeschi della Contessa De Béhague*, ed. Alessandro Vezzosi (Florence, 1978); Pietro C. Marani, "Leonardo, Rubens e Poussin a confronto," *Almanacco Italiano* 81 (1980): 136–41.

17. See Lionello Venturi, *La critica e l'arte di Leonardo da Vinci* (1919), 125.

18. See Roger de Piles, *Abrégé de la vie des Peintres* (Paris, 1699), 165ff.

19. Francesco Scannelli, *Il Microcosmo della Pittura* (Cesena, 1657), 40ff.

20. Charles Nicolas Cochin, *Voyage d'Italie* (Paris, 1758), 41–42.

21. Charles de Brosses, *Lettres historiques et critiques sur l'Italie* (Paris, 1799), letter 3 (1738).

22. See Joseph-Joseph Jérôme Le Français de Lalande, *Voyage d'un françois en Italie dans les années 1765 et 1766*, 8 vols. (Yverdon, 1769), 1:265.

23. See Venturi, *La critica e l'arte di Leonardo da Vinci* (1919), 129ff. On Lanzi, see Luigi Antonio Lanzi, *Storia pittorica della Italia dal risorgimento delle Belle Arti, fin presso al fine del XVIII secolo* (1789), 4th ed., ed. G. Fiorillo, 6 vols. (Bassano, 1818), 1:120 and 4:189–90. For art criticism on Leonardo in the neoclassical age, see Mazzocca, *Scritti d'arte del primo Ottocento* (1998), *ad incidem*.

24. See Venturi, *La critica e l'arte di Leonardo da Vinci* (1919), 131.

25. See Stendhal, *Histoire de la Peinture en Italie*, 2 vols. (Paris, 1817), new ed. (Paris, 1892), 140, quoted in Venturi, *La critica e l'arte di Leonardo da Vinci* (1919), 133. For references on Goethe, see section III, note 56. See also Johann Wolfgang von Goethe, *Schriften zur Kunst*, in Goethe, *Gedenkausgabe der Werke, Briefe und Gespräche*, ed. Ernst Beutler (Zurich: Artemis-Verlag, 1954), 13: 744–78. Goethe's short work on the *Last Supper* (in reality, a review of Bossi's *Del Cenacolo*, published in Weimar in 1817) is given in Italian translation in Heydenreich, *Invito a Leonardo* (1982), 123–26. Heydenreich also quotes a letter of Goethe's to Duke Karl August of Weimar dated 23 May 1788, which Goethe had written immediately after he had seen the *Last Supper*. Goethe writes: "Leonardo's *Last Supper* is truly a key-work in the sphere of artistic conceptions. It is quite unique and there is nothing that can be compared to it": Heydenreich, *Leonardo: The Last Supper* (1974), 85. Some of Goethe's remarks on the coloring of the shadows seem to have been dictated by an awareness of

Leonardo's notes, and perhaps of his *Treatise on Painting*. See Johann Wolfgang von Goethe, *La teoria dei colori*, ed. Renato Troncon, intro., Giulio Carlo Argan (Milan: Il Saggiatore, 1993), esp. xviii. On Goethe's interpretation of the *Last Supper*, see also Hüttel, *Spiegelungen einer Ruine* (1994), 31–35.

26. Hippolyte Taine, *Voyage en Italie* (Paris, 1897), 2:409ff. Taine went to Italy in 1864.

27. John Ruskin, "Of Turnerian Light," *Modern Painters*, 5 vols. (London, 1843–60), 4:45. For a new critical edition of Ruskin's *Modern Painters* in Italian translation, see Ruskin, *Pittori moderni*, ed. G. Leoni with A. Guazzi, intro., Giuseppe Leonelli, 2 vols. (Turin: Einaudi, 1998). Ruskin refers to the *Last Supper* in *Modern Painters*, part 3, section 2, chap. 5, paragraph 7: "Leonardi has I think done best . . . that Cenacolo is still the finest in existence"; and part 4, chap. 3, paragraph 5: "The habitual choice of sacred subjects, such as the Nativity, Transfiguration, Crucifixion (if the choice be sincere), implies that the painter has a natural disposition to dwell on the highest thoughts of which humanity is capable; it constitutes him so far forth a painter of the highest order, as, for instance, Leonardo, in his painting of the Last Supper." In part 9, chap. 6, paragraph 5, Ruskin states that whereas the Venetians are at their best in representing sacred subjects, Flemish and Dutch painters "are always languid unless they are profane. Leonardo is only to be seen in the Cena...."

28. See Eugène Müntz, *Léonard de Vinci: L'artiste, le penseur, le savant* (Paris, 1899), 71, 173–76, 194, 392; in English translation as *Leonardo da Vinci: Artist, Thinker and Man of Science* (Boston, 1899), 61–88, 209.

29. Müntz, *Léonard de Vinci* (1899), 183, 192.

30. Venturi, *La critica e l'arte di Leonardo da Vinci* (1919), 151ff. For the quotation from Wölfflin, see Heinrich Wölfflin, *Die Klassische Kunst: Eine Einfürung in die italienische Renaissance* (Munich: F. Bruckmann, 1924), 26–32; in the more recent edition (Basel and Stuttgart: Schwabe, 1968), 40.

31. See Bernard Berenson, *The Florentine Painters of the Renaissance*, 3d ed., rev. and enl. (London and New York: G. Putnam's Sons, 1909); in Italian translation as *I Pittori italiani del Rinascimento* (Florence: Sansoni, 1954), reprint of the

4th ed.(Florence: Sansoni, 1974), 260. Berenson had even worse things to say in *The Study and Criticism of Italian Art* (London: G. Bell, 1916), 1ff., where he nonetheless admits that in his expression of the apostles' horror and indignation Leonardo remained within the limits of art in the *Last Supper*. For other comments on Berenson's negative reaction to Leonardo, see Venturi, *La critica e l'arte di Leonardo da Vinci* (1919), 153–57. Judging Leonardo's art on the basis of his influence on his followers does little to clarify the problems connected with Leonardo's own painting. Although critical attitudes regarding Leonardo's "school" oscillated, they found a more reasonable basis for evaluation in Wilhelm Suida, *Leonardo und sein Kreis* (Munich: Bruckmann, 1929). For contemporary critics' reservations and the continuing debate on Leonardo's "students," see *I leonardeschi: L'eredità di Leonardo* (1998).

32. See Roberto Longhi, "Le Due Lise," *La Voce*, January 1914, reprinted in Longhi, *Opere complete di Roberto Longhi*, vol. 1, *Scritti giovanili, 1912–1922* (Florence: Sansoni, 1961); and Longhi, "Difficultà di Leonardo," *Paragone*, 29 May 1952, 10–12, reprinted in *Opere complete di Roberto Longhi*, vol. 8, pt. 2, *Cinquecento classico e Cinquecento manieristico* (Florence: Sansoni, 1974), 1–3.

33. Berenson first visited Leonardo's *Last Supper* in that same year; he did so again in 1953, when he demonstrated little comprehension of Pellicioli's efforts. On Berenson's 1888 visit, see Samuels, *Bernard Berenson* (1979), 81; on his 1953 visit, see Marani, "Il Cenacolo di Leonardo" (1997/98), 228–29. On the latter occasion Berenson was persuaded that he was seeing the mural stripped of the disfiguring additions accumulated over the centuries. This was perhaps what Pellicioli or Wittgens told him, but in reality it was far from true, as Pinin Brambilla Barcilon demonstrates in this volume.

34. These scholars will be cited extensively in the following notes.

35. See Venturi, *La critica e l'arte di Leonardo da Vinci* (1919), 191–95. On Venturi's critical stance, see the comments in Benedetto Croce, *La Critica e la storia delle arti figurative: Questioni di metodo* (1934), 2d ed., enl. (Bari: Laterza, 1946), 183ff.; Giorgio Castelfranco, "Momenti della recente critica vinciana," in *Leonardo: Saggi e ricerche,*

ed. Achille Marazza (Rome: Istituto Poligrafico dello Stato, 1954), 415–68, esp. pp. 427–31, which give an appreciation of Lionello Venturi's contribution to Leonardo studies.

36. See Kenneth Clark, *Leonardo da Vinci: An Account of His Development as an Artist* (Cambridge: Cambridge University Press, 1939), with several subsequent editions, including that edited, with an introduction, by Martin Kemp (London: Viking, 1988). Quotations are taken from the new edition of the latter (London, 1989), 147–49. On Clark, see also Pedretti, *Leonardo: Studi* (1983), 17–22.

37. Clark, *Leonardo da Vinci* (1989), 147 n. 9. See the note added by Martin Kemp that refers to David Alan Brown's discussion of the recent restoration by Pinin Brambilla Barcilon.

38. Ernst H. Gombrich, *The Story of Art* (1950), 16th ed., revised, expanded, and redesigned (London: Phaidon, 1995), 298. Gombrich's study was followed two years later by Emil Möller, *Das Abendmahl des Leonardo da Vinci* (Baden-Baden: Verlag für Kunst und Wissenschaft, 1952).

39. Sydney Joseph Freedberg, *Painting in Italy: 1500 to 1600* (1971), Pelican History of Art (Baltimore: Penguin, 1975), 10.

40. See Ludwig H. Heydenreich, *Leonardo* (Berlin: Rembrandt-Verlag, 1943; 2d ed. 1944); Heydenreich, *Arte e scienza in Leonardo* (Milan: E. Bestetti, 1945); Heydenreich, *Leonardo da Vinci: An Exhibition of His Scientific Achievements and a General Survey of His Art* (Los Angeles: Panold Masters, 1949); and, of course, Heydenreich, *Leonardo da Vinci: Das Abendmahl* (Stuttgart: Reclam, 1958); and Heydenreich, *The Last Supper* (London: Allen Lane; New York: Viking, 1974), in Italian translation under the title *Invito a Leonardo: L'Ultima Cena*, trans. Filippo Grandi (Milan: Rusconi, 1982).

41. See John Shearman, "Leonardo's Colour and Chiaroscuro," *Zeitschrift für Kunstgeschichte* 25, no. 1 (1962): 13–47; Brizio, review of Shearman, "Leonardo's Colour and Chiaroscuro," (1964), 412–14. See also Anna Maria Brizio, "The Painter," in *The Unknown Leonardo* (1974), 20–55; Brizio, "Il Cenacolo" (1977), in *Leonardo: La pittura* (1977), 93–114, reprinted separately in 1982, and reprinted again in the second edition of *Leonardo: La pittura* (Florence: Giunti, 1985), 75–89.

42. Steinberg, "Leonardo's Last Supper" (1973). For more recent iconological interpretations, see Rossi and Rovetta, *Il Cenacolo di Leonardo* (1988). I withhold comment on the more recent astrological, zodiacal, and musical interpretations of the *Last Supper*, although some interesting ideas are put forth in Georg Eichholz, *Das Abendmahl Leonardo da Vincis: Eine systematische Bildmonographie* (Munich: Scaneg, 1998), where the method used to discuss the *Last Supper* combines structuralist, psychological, and philosophical techniques.

43. See Ernst H. Gombrich, "The Form of Movement in Water and Air," in *Leonardo's Legacy: An International Symposium*, ed. Charles Donald O'Malley (Berkeley: University of California Press, 1969), 131–201, reprinted in Gombrich, *The Heritage of Apelles: Studies in the Art of the Renaissance* (Ithaca: Cornell University Press, 1976), in Italian translation under the title "La forma del movimento nell'acqua e nell'aria," in Gombrich, *L'eredità di Apelle: Studi sull'arte del Rinascimento* (Turin: Einaudi, 1986), 51–79 (see pp. 70–71 for an analysis of the *Last Supper* as the result of Leonardo's study of the dynamics of impulse and reaction, thus as a consequence of his studies of applied mechanics). See also Cecil Gould, *Leonardo: The Artist and the Non-Artist* (London: Wiedenfeld & Nicolson; Boston: New York Graphic Society, 1975); Kemp, *Leonardo da Vinci: The Marvellous Works* (1981); *Leonardo da Vinci: Le mirabili operazioni* (1982), 174–83; Marani, *Il Cenacolo di Leonardo* (1986). For other recent interpretations of the *Last Supper*, see Carlo Pedretti, *Leonardo: A Study in Chronology and Style* (Berkeley: University of California Press, 1973), 68–72, which focuses on the perspective aspects of the composition but disappoints for its scanty references to Leonardo criticism because Pedretti believed that "the greater part of the enormous Leonardo literature is useless" (175). See also Jack Wasserman, *Leonardo da Vinci* (Milan: Garzanti, 1982), 124–35 (originally published in English under the title *Leonardo: Leonardo da Vinci* [New York: H. N. Abrams, 1975]); Marco Rosci, *The Hidden Leonardo* (Oxford: Phaidon, 1978), 108–12, published in Italian translation under the title *Leonardo* (Milan: Mondadori, 1979).

44. On attempts to reconstruct the perspective scheme of the *Last Supper*, see, in particular Giovanni Degl'Inno-

centi, in Carlo Pedretti, *Leonardo architetto* (Milan: Electa, 1978), 286–89 (2d ed. 1988); Francis M. Naumann, "The 'Costruzione legittima' in the Reconstruction of Leonardo da Vinci's 'Last Supper,'" *Arte Lombarda* 52 (1979): 63–89; Marichia Arese, Aldo Bonomi, Claudio Cavalieri, and Claudio Fronza, "L'impostazione prospettica della 'Cena' di Leonardo do Vinci: Un'ipotesi interpretativa," and Joseph Polzer, "The Perspective of Leonardo Considered as a Painter," in *La Prospettiva rinascimentale: Codificazioni e trasgressioni*, ed. Marisa Dalai Emiliani (Florence: Centro Di, 1980), 1:249–59 and 233–47, respectively; Kemp, *Leonardo da Vinci: The Marvelous Works* (1981; trans. under the title *Leonardo da Vinci: Le mirabili operazioni* [1982], 179–83); Kemp, *The Science of Art: Optical Themes in Western Art from Brunelleschi to Seurat* (New Haven: Yale University Press, 1990), 47–52. See also Rolf Dragstra, "The Vitruvian Proportions for Leonardo's Construction of the 'Last Supper,'" *Raccolta Vinciana* 27 (1997): 83–101. Both Kemp (*Leonardo da Vinci: The Marvelous Works* [1981] and Marani (*Il Cenacolo*, 1986) have stressed the ambiguities of the perspective scheme of the *Last Supper* and the fact that Leonardo concealed the key points of the scene that would have permitted the viewer to discover his method. Personally, I am still persuaded that, while Leonardo applied principles of perspective in the *Last Supper*, he subordinated them to the representation of the figures and their intended meanings, so much so that it is a mistake to view Leonardo's perspective as a central theme of the work. The perspective adopted—which we can term "accelerated"—has the function of making not only Christ and the apostles but also the actions and the drama taking place tip forward out of the flat wall, thus engaging the spectator to the utmost. The plane of the table, which is also strongly tilted toward the viewer—I have already had occasion to indicate analogous examples in northern European painting, in particular, in a *Supper at Emmaus* by Dieric Bouts in the Berlin Museum (on which, see Marani, in *Pittura a Milano* [1998], 216–17)—seems about to spill its contents on us. The painter is taking understandable liberties here: if normal perspective had been used, spectators in the refectory would not be able to see the upper surface of the table but would, in fact, be looking at its

undersurface. One might raise the objection, however, that Leonardo placed the viewing point about four meters above the pavement of the hall, and that it thus cannot coincide with the spectators' eyes. This means that this is yet another artifice aimed precisely at enhancing the presence of the apostles as they loom out at us over the table.

45. Scholars have reported on the latest restoration as work progressed from top to bottom and from right to left: see Carlo Bertelli and Barbara Fabjan, "Il Cenacolo di Leonardo," *Brera: Notizie della Pinacoteca* (autumn and winter, 1981–82): 1–3; Bertelli, "Verso il vero Leonardo," in *Leonardo e Milano*, ed. Gian Alberto Dell'Acqua (Milan: Banco Popolare di Milano, 1982), 83–88; Bertelli, "Conservazione e restauro dopo Pellicioli," in Heydenreich, *Invito a Leonardo* 1982, 127–56; Bertelli, "Il Cenacolo vinciano," in *Santa Maria delle Grazie in Milano* (Milan: Banca Popolare di Milano, 1983), 188–95; Brown, *Leonardo's Last Supper: The Restoration* (1983); Brambilla Barcilon, *Il Cenacolo di Leonardo in Santa Maria delle Grazie* (1984); Fabjan, "Il Cenacolo nuovamente restaurato" (1985), 90–94; Carlo Bertelli, "Leonardo e l'Ultima Cena (ca. 1495–97)," in *Tecnica e stile: Esempi di pittura murale del Rinascimento italiano*, ed. Eve Borsook and Fiorella Superbi Gioffredi, Villa I Tatti Studies, 9, 2 vols. (Milan: Silvana, 1986), 1:31–42.; Marani, *Il Cenacolo di Leonardo* (1986); Marani, "Leonardo's Last Supper: Some Problems of the Restoration and New Light on Leonardo's Art," in *Nine Lectures on Leonardo da Vinci*, ed. Francis Ames-Lewis and Anka Bednarek (London: Department of History of Art, Birkbeck College, University of London, 1990), 45–52; Marani, "Le alterazioni dell'immagine dell'Ultima Cena" (1990), 64–67; Tardito, "Il Cenacolo di Leonardo" (1989), 3–16; Brambilla Barcilon and Marani, *Le lunette di Leonardo* (1990). For an account of the first concerted effort to photograph the right-hand part of the composition (including the figure of Christ) after the recent restoration, see Pietro C. Marani, *Leonardo* (Milan: Electa, 1994). Analyses conducted during the restoration allow us to identify the technique that Leonardo adopted: he painted in tempera (perhaps mixed with oil) over two preparatory layers, a first rougher layer of calcium carbonate and a second finer layer with a white lead base to help the paint adhere.

See Mauro Matteini and Arcangelo Moles, "A Preliminary Investigation of the Unusual Technique of Leonardo's Mural 'The Last Supper,'" *Studies in Conservation* 24 (1979): 125–33; H. Travers Newton, "Leonardo da Vinci as Mural Painter: Some Observations on His Materials and Working Methods," *Arte Lombarda* 66 (1983): 71–88; Hermann Kühn, "Bericht über die Naturwissenschftliche Untersuchungen der Malerei des Mailander Abendmahls," *Maltechnik* 4 (1985): 24–51. An account of the most important analyses, physical and chemical examinations, and precautions taken for the conservation of the painting is available in a volume edited by Giuseppe Basile and Maurizio Marabelli (Milan: Electa, 1999). The restoration just completed, which began with experimental cleaning in 1977 (on which, see the essay by Pinin Brambilla Barcilon in this volume), has elicited comments and even some dissent. For the most serious negative opinion, see Martin Kemp, "Looking at Leonardo's Last Supper," in *Appearance, Opinion, Change: Evaluating the Look of Paintings* (London: United Kingdom Institute for Conservation, 1990); and Kemp, "Authentically Dirty Pictures," *Times Literary Supplement*, 17 May 1991. In essence, Kemp states that subordination to the demands of the sponsors on the part of some restorers (though this is not the case with the *Last Supper*) makes it difficult to perceive the composition in its unity, that too much philological attention paid to particulars generates the impression that we are in the presence of an "archaeological map" for which the general public has insufficient preparation, that the refectory has been turned into a museum, and more. For Pietro C. Marani's response to Kemp, see Marani, "Lettera a Martin Kemp (sul restauro del Cenacolo)," *Raccolta Vinciana* 25 (1993): 463–67; see also Kemp's rejoinder, "Letter to Pietro Marani (on the Restoration of the Last Supper)," *Raccolta Vinciana* 26 (1995): 359–66. Other criticisms advanced in the international press object to the removal of the old repaintings, even though they covered Leonardo's original. On these, see E. Bonatti, "Il Cenacolo Vinciano: I fatti e le opinioni (1979–1994)" (1994): 58–60; Jacques Franck, "The Last Supper, 1497–1997: The Moment of Truth," *Achademia Leonardi Vinci: Journal of Leonardo Studies and Bibliography of Vinciana* 10 (1997): 165–82. In an introduction to the latter ("Justissimus dolor," in

ibid., 163–64), Carlo Pedretti calls the current restoration "questionable and perplexing." Recalling a visit he made to the scaffolding in the company of Carlo Bertelli and Pinin Brambilla Barcilon in 1983, Pedretti notes that he predicted that at the completion of the restoration (which occurred in 1997, fifteen years later), Leonardo's painting would be "somewhat like a large mosaic as reconstructed for didactic purposes in archaeological museums." He wonders aloud, echoing Kemp, whether "we are prepared to approach Leonardo as archaeologists." This seems a strange attitude, given that Pedretti has spent a lifetime operating like an archaeologist, publishing philological studies of the "fragments" of Leonardo—the *disiecta membra*, both graphic and literary, of his legacy—and attempting to fit them into a unified intellectual framework: see Carlo Pedretti, *Leonardo da Vinci: Fragments at Windsor Castle from the Codex Atlanticus* (London: Phaidon, 1957). Why should we not take a similar approach to the pictorial fragments of the *Last Supper*? It is clear, however, that there is a neo-Ruskinian tendency to retain the eighteenth- and nineteenth-century aspect of the painting rather than return to the original, judged too difficult to appreciate or to "exploit" because it is fragmented. Such critics forget that vast zones of "historical" repainting were maintained, as we shall see later. Even less pertinent are the objections put forth by Franck in the same volume: he compares the general effect of the painting, thanks to the use of watercolor in the lacunae in the background, to the style of Seurat: "At the risk of excessive purism, it would have been better to leave the missing sections visible; no anachronism would now trouble our eye when reading the few beautiful vestiges of the martyrised work which can still be discerned"(179). The same criticism might be made of any effort to restore a painting through "chromatic selection," a universal method. Worse, however, Franck has not understood (since he never closely examined the painting during the restoration) that the "missing sections" are perfectly visible and discernible, in part because they lie on a lower plane than the original preparation and the original colors. For the restoration methodology of the *Last Supper*, see also Giorgio Bonsanti, "Aperto per restauri," *Il Giornale dell'arte* 134 (June 1995): 18; Bonsanti, "Diffamare gli italiani rende: Non rischi niente e si

parla tanto di te," *Il Giornale dell'arte* 174 (February 1999): 63; Pietro Petraroia and Pietro C. Marani, in *TEMA: Tempo, materia, architettura* 4 (1998, published in 1999); and the interview with Giovanni Romano published in the supplement to *Il Giornale dell'arte* 176 (April 1999), 1. Romano declares the *Last Supper* project to be "the most unsettling restoration of recent years." He adds, "It has the positive sense of something that comes to an end, a great restoration, done calmly, in which nothing in the reconstruction is irreversible. Perhaps we will get used to seeing a different Leonardo. I would be satisfied with a restoration of this sort every year." The results of the ongoing restoration were presented in a series of international conferences led by Pinin Brambilla Barcilon and Pietro C. Marani, in particular, "The Great Age of the Fresco from Masaccio to Titian," Metropolitan Museum, New York, 11 March 1989. Other conferences were held at the Istituto Italiano di Cultura of London, 21 March 1989; at Georgetown University, Washington, D.C., 23 February 1991; at the Biblioteca Hertziana, Rome, 15 February 1995; and at the Harvard University Center for Italian Renaissance Studies at Villa I Tatti, Florence, 10 October 1996. In January 1998 an international seminar on the restoration of the *Last Supper* was held in Palazzo delle Stelline in Milan under the sponsorship of the Soprintendenza per i Beni Artistici e Storici. Participants included the present authors and, among others, Giuseppe Basile (Rome), Giorgio Bonsanti, Eve Borsook (Florence), Jill Dunkerton, Caroline Elam (London), Eudal Guillaermet (Barcelona), Théo Hérmanes (Geneva), Madeleine Masschlein Kleiner (Brussels), Renato Pancella (Lausanne), Pietro Petraroia, Sylvia Righini Ponticelli (Milan), Andreas Rothe (Los Angeles), Mirella Simonetti (Bologna), and other conservators and art historians (including two representatives of Art Watch International). Another workshop, organized by the Expert Center pour la Conservation du Patrimoine Bâti,was conducted on 1 October 1998 at the École Fédérale Polytechnique at Lausanne with an introductory presentation by Mauro Natale of the Université de Lausanne. Finally, a preview of the restoration and the results of related scientific studies was held at the Accademia Nazionale dei Lincei on 27 April 1999, opening with a *prolusione* by Giovanni Melandri, Ministro per i Beni e le Attività

Culturali. Among the scholars and friends who have visited the work site of the *Last Supper* in recent years, the following deserve particular mention and thanks: Alessandro Ballarin, Fabio Bisogni, David Alan Brown, Giorgio Bonsanti, Marco Chiarini, Roberto Paolo Ciardi, Marisa Dalai Emiliani, Walter Kaiser, Martin Kemp, Laura Mora, Earl A. Powell III, Leo Steinberg, Jack Wasserman, Bruno Zanardi, and Federico Zeri.

46. Capomastro Cristoforo Aimetti was responsible for the repair work on the walls of the refectory for Bossi's restoration. See section III.

47. The space between the gray stripes on the pavement to the right and to the left of the door that was opened in 1652 make it difficult to imagine that another stone strip was painted under the feet of Christ at the precise center of the *Last Supper*, as proposed in Steinberg, "Leonardo's Last Supper" (1973), 329. This lack of room runs counter to Steinberg's thesis that Christ's feet rested on that painted strip, creating a resemblance to the Crucifixion with the obvious allusion to his sacrifice. The bands painted on the pavement close to the area that was later destroyed must have been two, not one, as they are shown in the copy by Giampietrino now at Magdalen College, Oxford, and the copy by Cesare Magni, now in the Brera, among others.

48. See Kemp, *Leonardo da Vinci: The Marvelous Works* (1981); *Leonardo da Vinci: Le mirabili operazioni* (1982), 181, fig. 47. The dilemma is stated in Brizio, "Il Cenacolo" (1977), 102 (1985 edition, 81). This means that the graphic schemes given in Steinberg, "Leonardo's Last Supper" (1973), figs. 33 and 34, are in error, also because he confuses the rise of the step painted at the very front of the mural with the perspective view of the thickness of the wall. In 1997 I had an opportunity to show Leo Steinberg the new results of the restoration, and he stated his intention to bring his essay up to date and to reconsider these schemes as a consequence of his visit. Among the various graphic reconstructions available, the scheme published in Pedretti, *Leonardo architetto* (1978), 287, is also inaccurate.

49. See Brambilla Barcilon and Marani, *Le lunette di Leonardo* (1990).

50. On the discovery of the lunettes and the subsequent critical discussion, see ibid. See also Angela Ottino Della Chiesa, *L'opera completa di Leonardo pittore* (Milan: Rizzoli, 1967), 99: "Direct reference to Leonardo is nearly unanimous." See also Pedretti, *Leonardo: A Study* (1973), 69; Brizio, "The Painter" (1974), 32: "The crescent-shaped lunettes above the fresco correspond to a Vincian conception, but they are too badly preserved for us to judge whether he actually painted them." See also Brizio, "Il Cenacolo" (1977), 106: "Not because [the lunettes] are autograph works—a question that in the state of ruin and repaintings in which the three lunettes find themselves cannot even be raised—but for the genial way in which the problem of the transition was solved, I have no doubt that at least the idea and the design of the three lunettes are due to Leonardo."

51. See Bertelli, "Conservazione e restauro" (1982), 12; Brown, *Leonardo's Last Supper: The Restoration* (1983).

52. See Marani, *Il Cenacolo di Leonardo* (1986), 17–20; Marani, "Prospettiva, botanica e simbolo" (1990), 8–9.

53. See Marani, *Leonardo: Una carriera* (1999), chap. 3.

54. It is nonetheless generally admitted that Leonardo personally designed and sketched, and perhaps also painted, the first version of the coats of arms and the garlands (*tonde a l'anticha*). This is demonstrated by the brush sketch, executed with the left hand, visible in the coat of arms in the center lunette.

55. See Nello Forti Grazzini, "Gli Arazzi," in *Monza: Il Duomo e i suoi tesori* (Milan: Electa; Credito Artigiano, 1988), 111–14.

56. See Fernanda Wittgens, "Restauro del Cenacolo," in *Leonardo: Saggi e ricerche* (1954), 1–12, esp. pl. 8.

57. See Vincenzo Borghini, "Da una selva di notizie," manuscript, Kunsthistorisches Institut, Florence, K 783 (16), inv. 60765, reprinted in *Pittura e scultura nel Cinquecento: Benedetto Varchi, Vincenzo Borghini,* ed. Paola Barocchi (Livorno: Siballe, 1998), 112. The letter that contains the passage quoted, which concerns the relationship between sculpture and the other arts, bears the marginal notation, "il Giuda di Lionardo da Vinci." On what Borghini knew of Leonardo's writings and theories, see Marco Rosci, "Leonardo 'filosofo': Lomazzo e Borghini 1584: Due linee di tradizione dei pensieri e precetti di Leonardo sull'arte," in *Fra Rinascimento, Manierismo e Realtà: Scritti di Storia dell'arte in memoria di Anna Maria Brizio,*

ed. Pietro C. Marani (Florence: Giunti Barbèra, 1984), 53–78.

58. On this painting (c. 1528–30), see the catalog entry by Jean Habert in *Le siècle de Titien: L'âge d'or de la peinture à Venise* (Paris: Réunion des Musées nationaux, 1993), 567–69; see also the bibliography therein on the influence of Leonardo's *Last Supper*. See section V on the later fortunes of this painting.

59. This question has been analyzed with particular attention in Flavio Caroli, *Leonardo: Studi di fisiognomica* (Milan: Leonardo, 1991). See also *L'anima e il volto: Ritratto e fisiognomica da Leonardo a Bacon,* exhibition catalog, ed. Flavio Caroli (Milan: Electa, 1998), and the sections by Carlo Pedretti, Franco Moro, and Pietro C. Marani. For later developments in Lombardy in the study of physiognomy and the *teste grottesche* that resulted in great part from Leonardo's studies during the time he was working on the *Last Supper*, see also the exhibition catalog, *Rabisch: Il grottesco nell'arte: L'Accademia della Val di Blenio: Lomazzo e l'ambiente milanese* (Milan: Skira, 1998).

60. On these relationships, see Pietro C. Marani, "The 'Hammer Lecture' (1994): Tivoli, Hadrian and Antinous: New Evidence of Leonardo's Relation to the Antique," *Achademia Leonardi Vinci: Journal of Leonardo Studies and Bibliography of Vinciana* 7 (1995): 207–25. For an analysis of the connections between Leonardo and sculpture, both ancient and modern, and in particular, with Tullio Lombardo's sculpture in Venice, see Marani, *Leonardo: Una carriera* (1999), chap. 5. A relief attributed to Lombardo's *bottega*, now in Ca' d'Oro (and given in the list of principal copies, which precedes these notes) reproduces Leonardo's *Last Supper*. On the sculptures on the base of the facade of La Certosa di Pavia, see the bibliography in the texts cited here, but particularly Andrew Burnett and Richard Schofield, "The Medallions of the *Basamento* of the Certosa di Pavia: Sources and Influences," *Arte Lombarda* 120 (1997): 5–27.

V. Concerning the Copies

1. On copies of the *Last Supper*, see, in particular, Bossi, *Del Cenacolo* (1810), 127–67; Otto Hoerth, *Das Abendmahl des Leonardo da Vinci* (Leipzig: Hiersemann, 1907), 17ff., 235ff.; Malaguzzi-Va-

leri, *La corte di Ludovico il Moro* (1913–23), vol. 2 (1915), 534ff.; Horst, "L'Ultima Cena di Leonardo nel riflesso delle copie" (1930–34), 118–20; Möller, *Das Abendmahl des Leonardo da Vinci* (1952), 109ff.; Steinberg, "Leonardo's Last Supper" (1973), 402–10; Marani, *Leonardo e i leonardeschi* (1987); Rossi and Rovetta, *Il Cenacolo di Leonardo* (1988), 76–95. On engraved copies, see Alberici and Chirico De Biasi, eds., *Leonardo e l'incisione* (1984), updated in Clelia Alberici, "Leonardo e l'incisione: Qualche aggiunta," *Raccolta Vinciana* 24 (1992): 9–53, and in Hüttel, *Spiegelungen einer Ruine* (1994), 18–22.

2. On which, see Janice Shell and Grazioso Sironi, "Documents for Copies of the *Cenacolo* and the *Virgin of the Rocks* by Bramantino, Marco d'Oggiono, Bernardino de' Conti and Cesare Magni," *Raccolta Vinciana* 23 (1989): 103–17. This study discusses a six-panel polyptych with a three-part predella that Gabriel Goffier, Apostolic Pronotary, commissioned from Marco d'Oggiono. One portion of the predella is supposed to have been copied from the *Last Supper* in Santa Maria delle Grazie, but Leonardo's name is never mentioned in the documents as the author of the painting.

3. This version, sculpted in wood and painted (mentioned in Bossi, *Del Cenacolo* [1810]) has elicited great interest after its recent restoration: see Pietro C. Marani, "The Restoration of a Last Supper in 3-D," *Achademia Leonardi Vinci: Journal of Leonardo Studies and Bibliography of Vinciana* 8 (1995): 237–38; Marani, "Pittura e decorazione dalle origini al 1534," in *Il Santuario della Beata Vergine dei Miracoli a Saronno,* ed. Maria Luisa Gatti Perer (Milan: Istituto di Storia dell'Arte Lombarda, 1997), 137–84, esp. pp. 169–80; Marco Rossi, "Fra decorazione e teatralità: Andrea da Milano e Gaudenzio Ferrari e dintorni," in *Il Santuario della Beata Vergine dei Miracoli* (1997), 195–234. For references to Tullio Lombardo's work in Venice, see note 5 below and Section IV, note 60.

4. The anonymous tempera copy (inv. 704) at Castello Sforzesco, in fact, appears to have been created by a Franco-Flemish painter. See in this volume "Principal Copies," number 15.

5. On the complex relationships between the *Last Supper* and Venetian painting, see in particular David Alan Brown, "Il Cenacolo di Leonardo: La prima eco a Venezia," in *Leonardo &*

Venezia, ed. Giovanna Nepi Sciré and Pietro C. Marani (Milan: Bompiani, 1992), 85–96; Brown, "Il Cenacolo a Venezia," in *Leonardo & Venezia* (1992), 335–43; and Maria Teresa Fiorio, "Tra Milano e Venezia: Il ruolo della scultura," in *Leonardo & Venezia* (1992), 137–52. For the paintings of Giorgione, Sebastiano del Piombo, Titian, and Palma il Vecchio, see the studies of Mauro Lucco and Alessandro Ballarin, in particular, Mauro Lucco, *Le "Tre età dell'uomo" della Galleria Palatina: Firenze, Palazzo Pitti* (Florence: Centro Di, 1989); Alessandro Ballarin, Luisa Attardi, and Alessandra Pattanaro, in *Le siècle de Titien* (1993), 309–13, 324–29, 348, 379–91, and 431–33 and bibliography. On Leonardo's followers in Venice, see Janice Shell, "Marco d'Oggiono a Venezia," in *Leonardo & Venezia* (1992), 360–61; Giulio Bora, "I leonardeschi a Venezia verso la 'maniera moderna,'" in *Leonardo & Venezia* (1992), 358; Peter Humphrey, "Giovanni Agostino da Lodi," in *Leonardo & Venezia* (1992), 358–59 and the bibliography therein.

6. For Rubens's attitude toward the *Last Supper*, see section IV. For his drawings, see the catalog items signed "A.K.W.," nos. 11–14, in Brown, *Leonardo's Last Supper: Precedents and Reflections* (1983); Zygmunt Wazbinski, "Pieter Paul Rubens e il suo studio dell'Ultima Cena di Leonardo da Vinci: Un contributo alla storia del tenebrismo in Italia intorno al 1600," in *I leonardeschi a Milano* (1991), 199–205 (where Wazbinski discusses Rubens's drawing of Diogenes, now in the Musée Manguin). The Rubens painting of the *Last Supper* from the church of St. Rambaud in Malines, obtained by the Brera in an exchange with the Louvre, although not a direct citation (Rubens changes both the position of the table, which he presents from the side, and the viewpoint), is nonetheless evidently inspired by Leonardo's masterpiece, whose chiaroscuro and dramatic animation Rubens understood. The theme of the painting, however, is the institution of the Eucharist. On this painting, see Caterina Limentani Virdis, in *Pinacoteca di Brera: Scuole straniere*, ed. Federico Zeri and Carlo Pirovano (Milan: Electa, 1995), 69–72. On Rembrandt's drawings, see the fundamental study, Otto Benesch, *A Catalogue of Rembrandt's Selected Drawings* (Oxford and London: Phaidon; New York: Oxford University Press, 1947), vol. 2, catalog nos. 45 (the copy of the *Last Supper* formerly in the collection of Emperor Friedrich August II and now in Berlin) and 46 (dated 1635, also in Berlin, Kupferstichkabinett) and vol. 1, p. 19. For the Berlin drawing, see also Gianni Carlo Sciolla, *Rembrandt: Disegni scelti e annotati* (Florence: La Nuova Italia, 1976). See also "A.K.W." in Brown, *Leonardo's Last Supper* (1983), catalog item no. 17 (the Berlin drawing) and fig. 2 (drawing in the British Museum, London).

7. This also applies to the copy proposed by Francesco Maria Gallarati in 1769 (not surviving or perhaps never executed).

8. For Venturi's comments, see section IV. Venturi's metaphor recalls Ann-Claude Philippe de Caylus' engraving from 1730, which only outlines figures, one of the first eighteenth-century "archaeological" prints, however meager and approximate.

9. See Leopoldo Cicognara, *Dello stato delle Belle Arti nel Regno italico* (a letter accompanying this report is dated 9 December 1809), reprinted in Paola Barocchi, *Storia moderna dell'arte in Italia* (1998), 1:108.

10. Lewis died in 1856, but Fanolli became a professor of lithography at the Accademia di Brera in 1860. With their strong chiaroscuro interpretations of the *Last Supper*, Lewis and Fanolli explored parallel paths, even ahead of Ruskin's and Müntz's criticism, which would lead to comparisons of Leonardo and Rembrandt.

11. Even the two most famous series of surviving "cartoons" of the *Last Supper*, one formerly in Weimar and the other in Strasbourg, were likely executed after the original or, as I believe for the Strasbourg series, after a tracing of the version now at Magdalen College, Oxford (rather than from preparatory drawings). Regarding these series of sketches, see section II. I am pleased to add a drawing from a private collection in Sassari, Sardinia, to the list of these ancient "cartoons." Excellently made and, I believe, dating from the end of the eighteenth century, this drawing anticipates and surpasses in quality Bossi's tracings (now in the Weimar Schlossmuseum). I thank L. Paolillo, who kindly brought it to my attention in 1986. Regarding Bossi's copies of the *Last Supper*, see sections II and III.

12. On John Everett Millais, *Portrait of Mrs James Wyatt and her Daughter Sarah* (London, Tate Gallery, inv. TO3858, oil on masonite), painted at Oxford in 1850, see *John Everett Millais*, catalog of an exhibition, Liverpool, 1967. The engraving of the *Last Supper*, which may be the one by Morghen, is shown on the wall in the background, between engravings of Raphael's *Madonna della seggiola* and his *Madonna Alba*. For other nineteenth-century paintings that show domestic scenes with engravings of Leonardo's *Last Supper* as part of the decor, see Hüttel, *Spiegelungen einer Ruine* (1994).

13. For a sampling of these derivative versions of the *Last Supper* (which are often commercial gimcrackery), see Hüttel, *Spiegelungen einer Ruine* (1994), 52–68.

14. Of the Warhol series, a dozen monumental paintings, a group of smaller canvases, and numerous works on paper were first exhibited in Milan in 1987, across the street from Santa Maria delle Grazie. For the interpretations of Andy Warhol and other contemporary artists, see Hüttel, *Spiegelungen einer Ruine* (1994), 95ff. See also *Ben Willikens Abendmahl*, catalog of an exhibition, Stuttgart, Münster, and Milan (Stuttgart, 1982). For the use of the composition of the *Last Supper* in the cinema, see Constantine C. Pepinashvili, "The 'Last Supper': A Cine-montage Breakdown," *Achademia Leonardi Vinci: Journal of Leonardo Studies and Bibliography of Vinciana* 2 (1989): 117–20; Hüttel, *Spiegelungen einer Ruine* (1994), 100–8.

The Last Supper

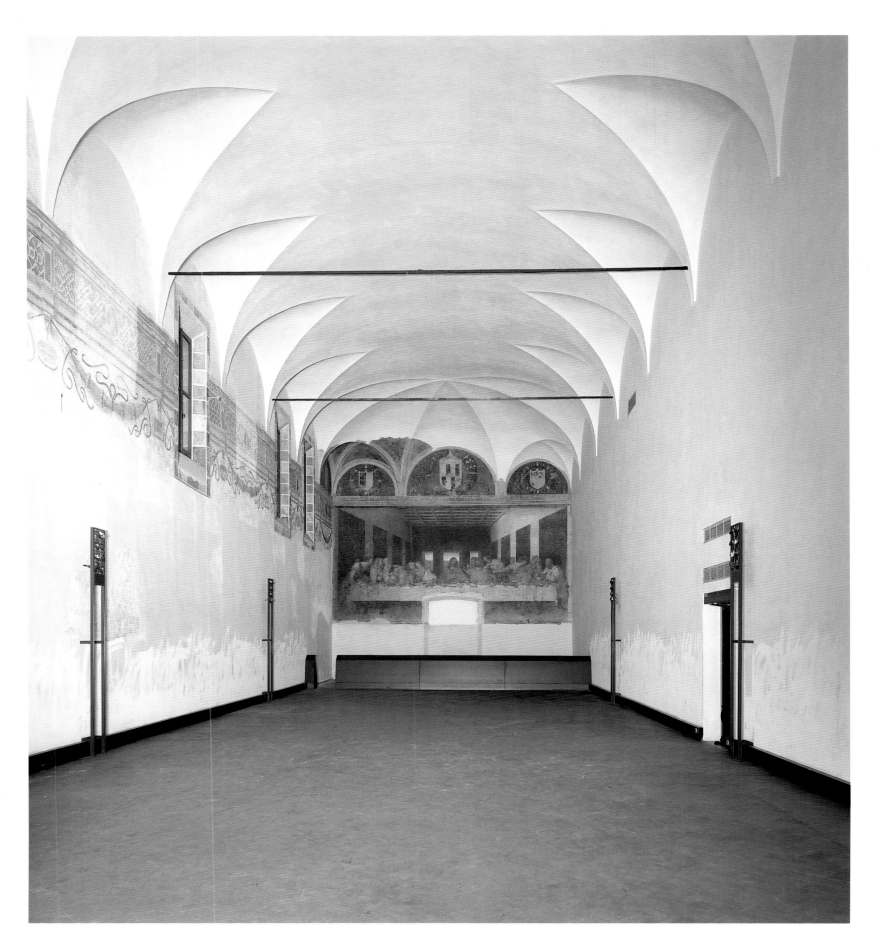

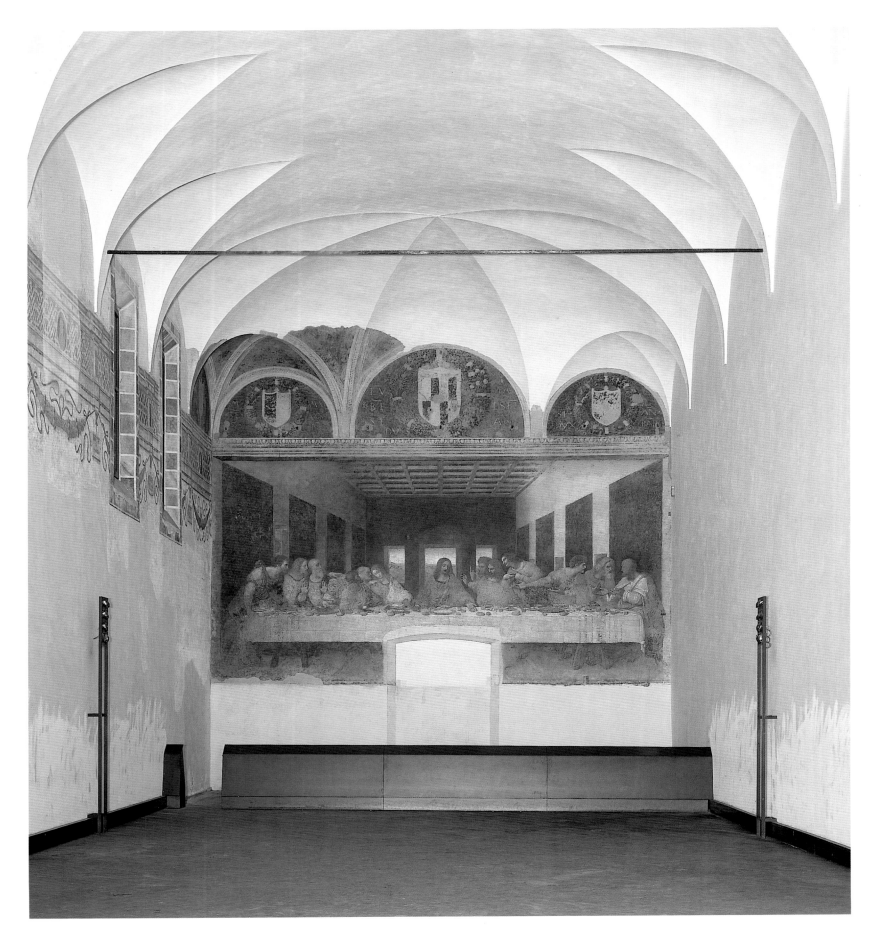

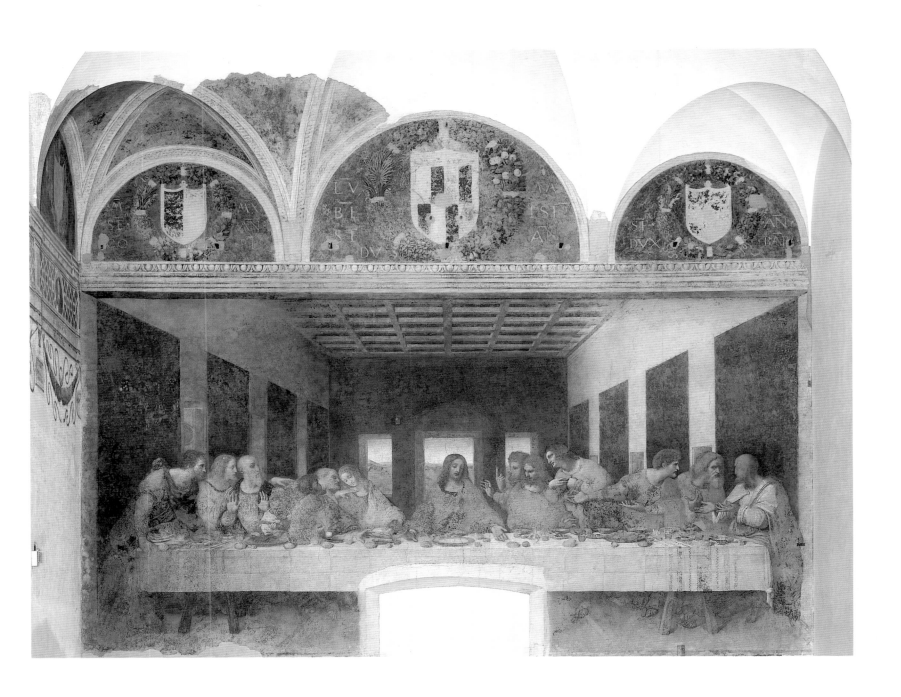

Central lunette with an inscription alluding to Ludovico Sforza and Beatrice d'Este.

88

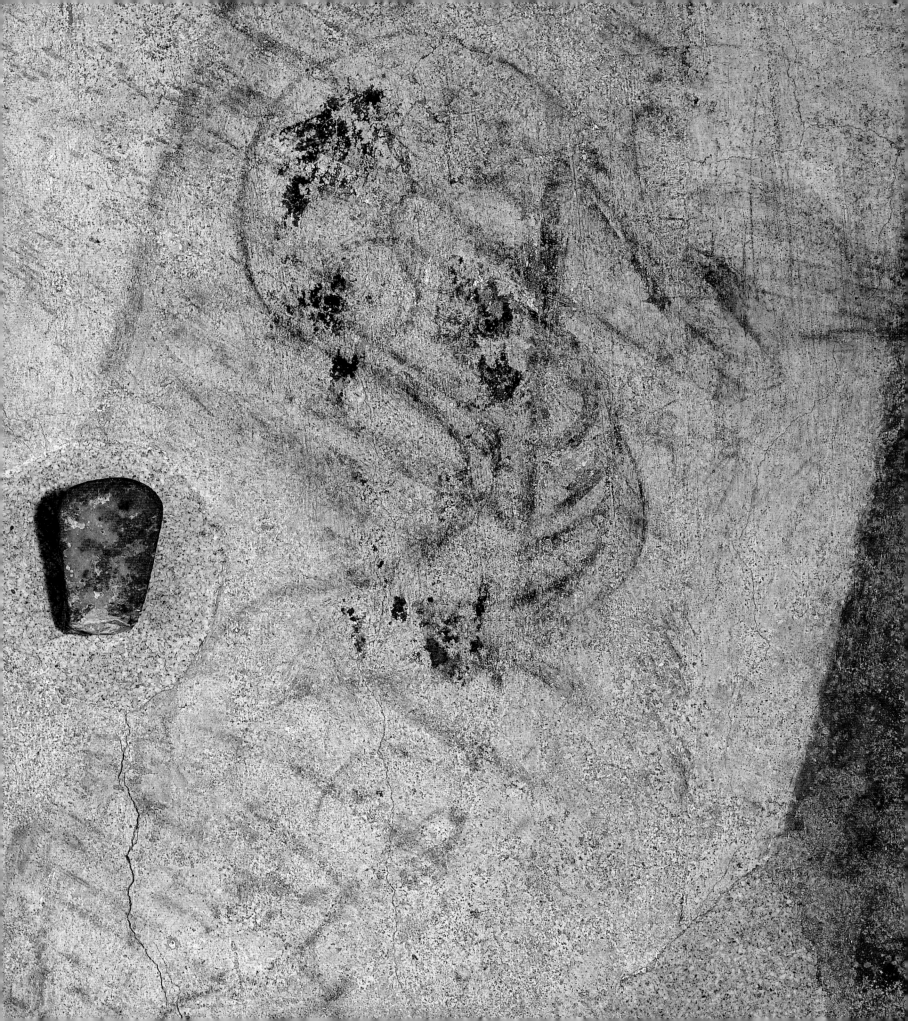

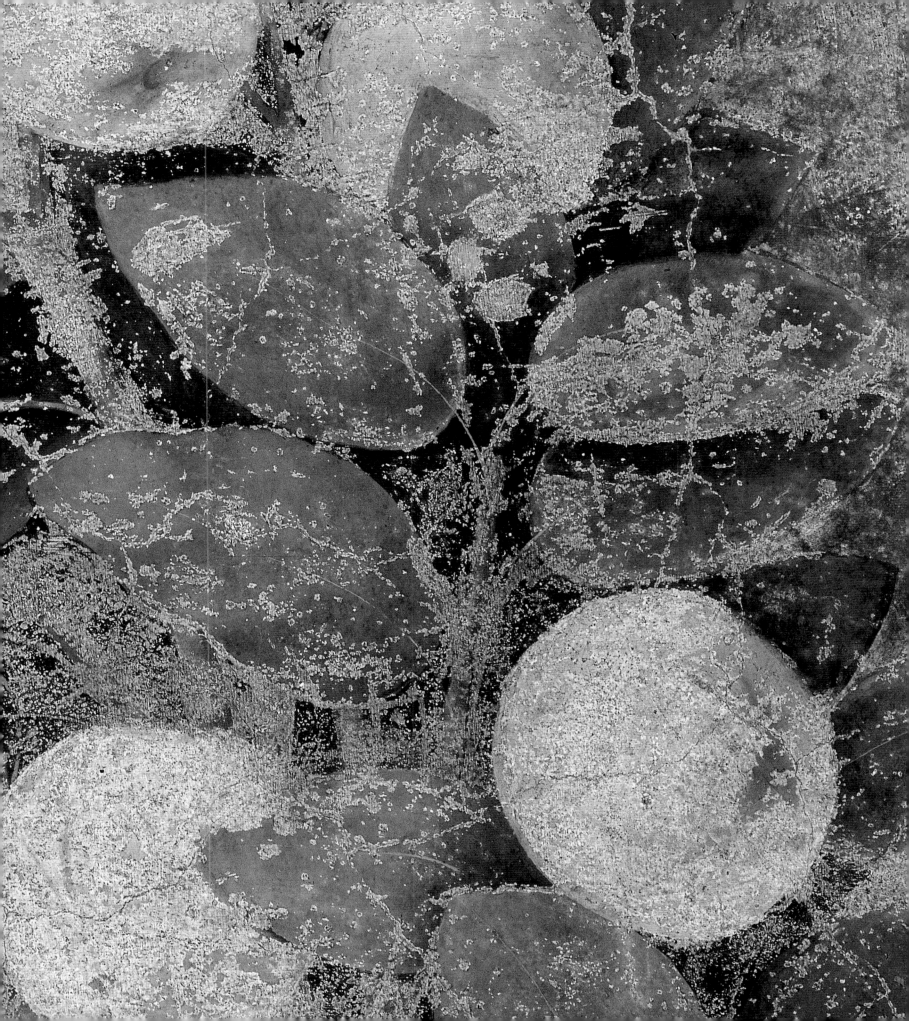

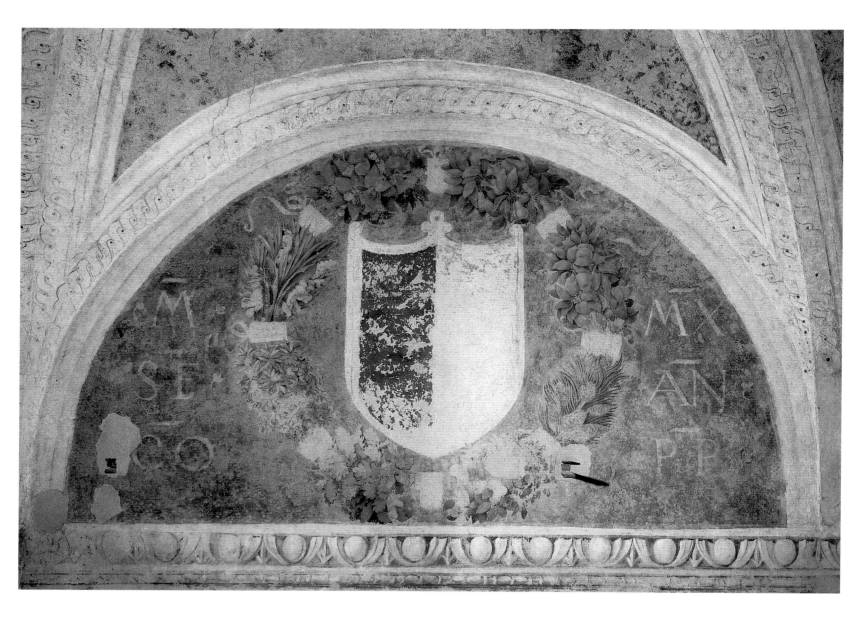

Left-hand lateral lunette with inscription alluding to Massimiliano Sforza.

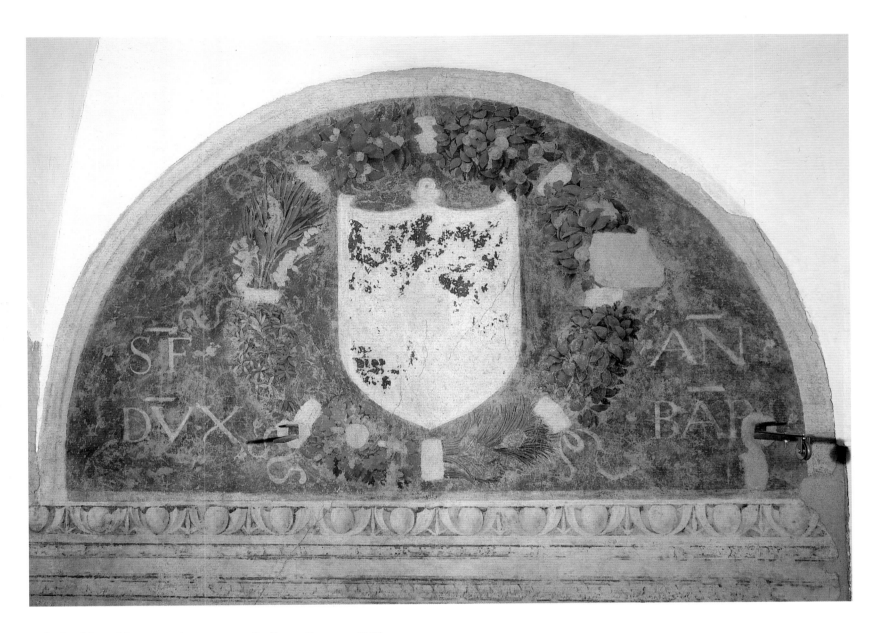

Right-hand lateral lunette with inscription alluding to Francesco II Sforza.

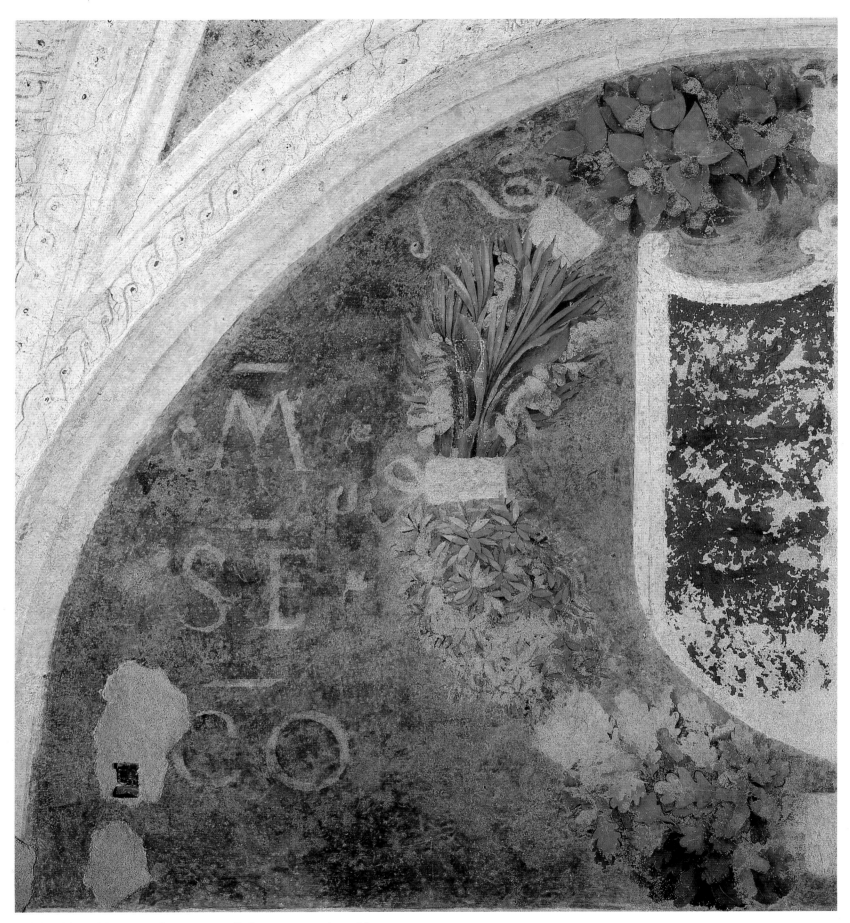

Left-hand lateral lunette with inscription alluding to Massimiliano Sforza.

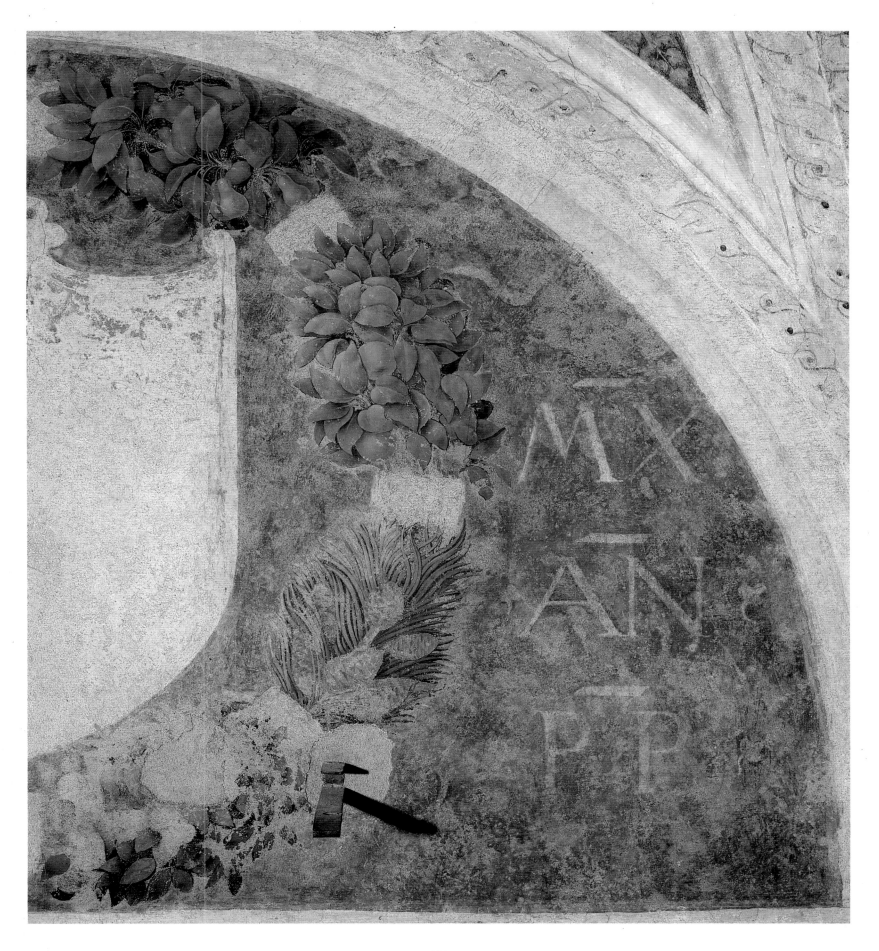

Right-hand lateral lunette with inscription alluding to Francesco II Sforza.

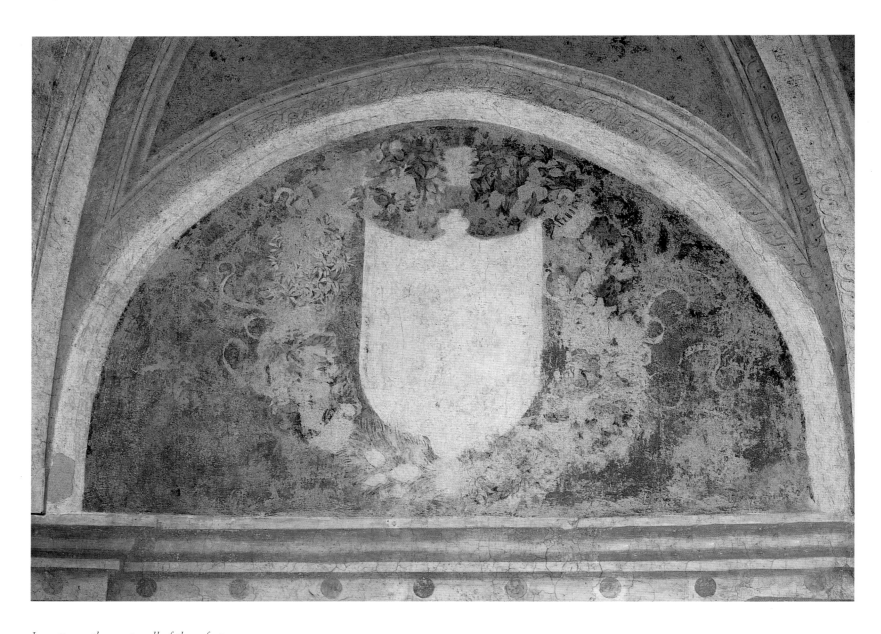

Lunette on the west wall of the refectory.

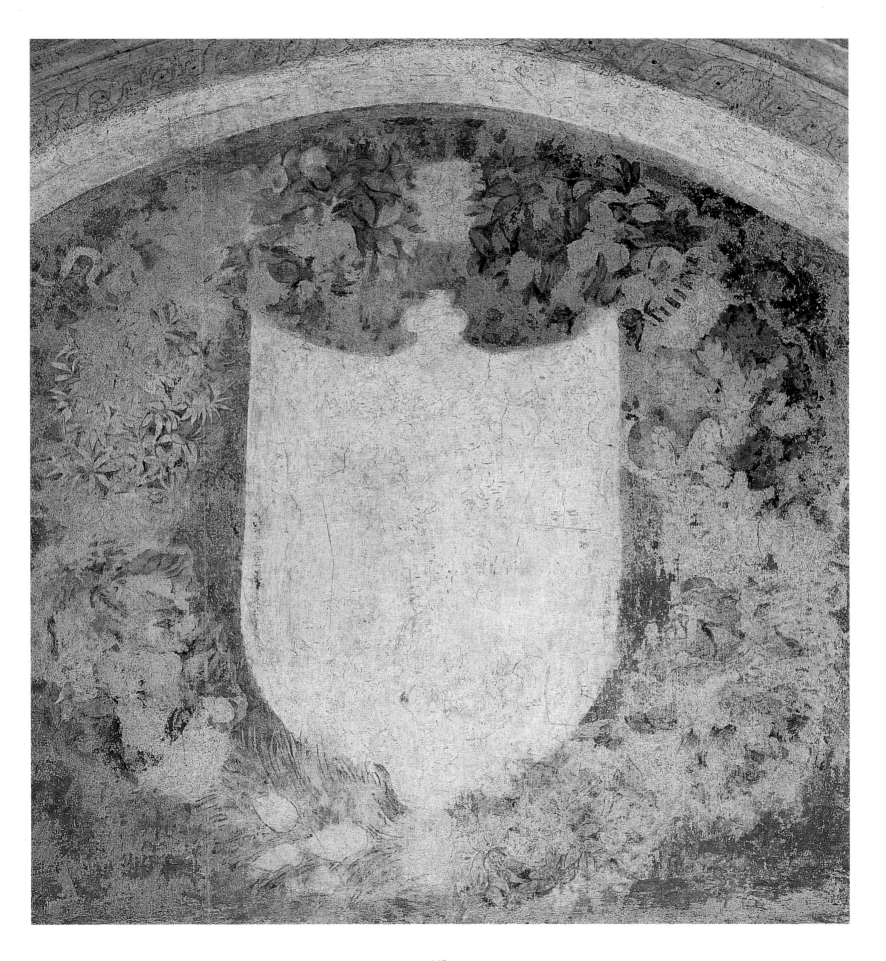

The Last Supper

Tempera and oil over two layers of preparation; 460 cm × 880 cm

The mural painting is executed with a technique different from the one used in the lunettes above it. In order to obtain an extremely smooth, almost polished surface, Leonardo spread a first layer of calcium carbonate on the intonaco, following it with a second, thinner, layer of white lead that covers only the central band of the painting. The colors were applied in superimposed layers over this complex preparation, as was the shading in oils and the gold touches on the clothing.

Christ is presented at the center of the composition, surrounded by the apostles. At his right hand is the group of John, Peter, and Judas, followed by Andrew, James Minor, and Bartholomew.

On Christ's left is the dramatic group of Thomas, James Major, and Philip, then, at the extreme right-hand side of the painting, Matthew, Thaddeus, and Simon.

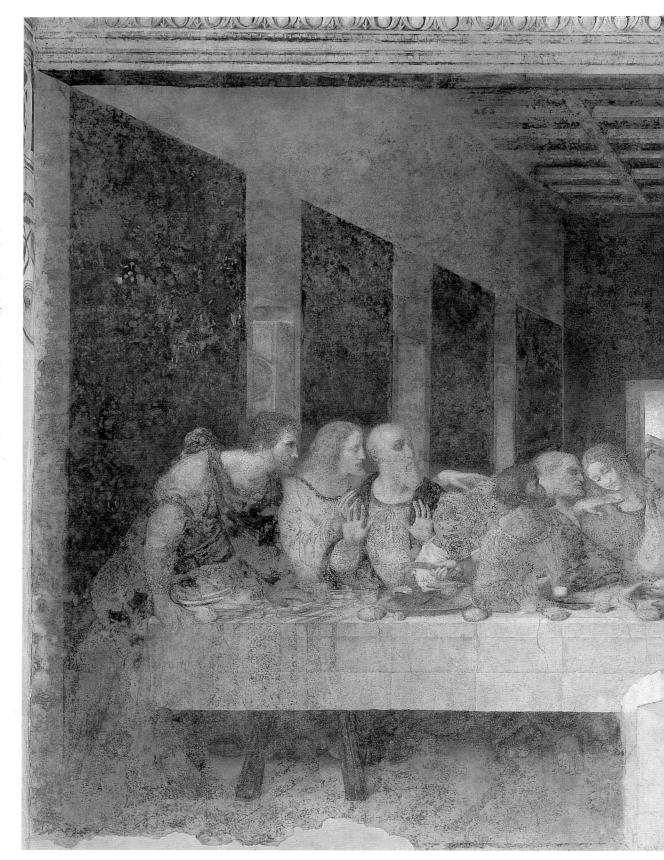

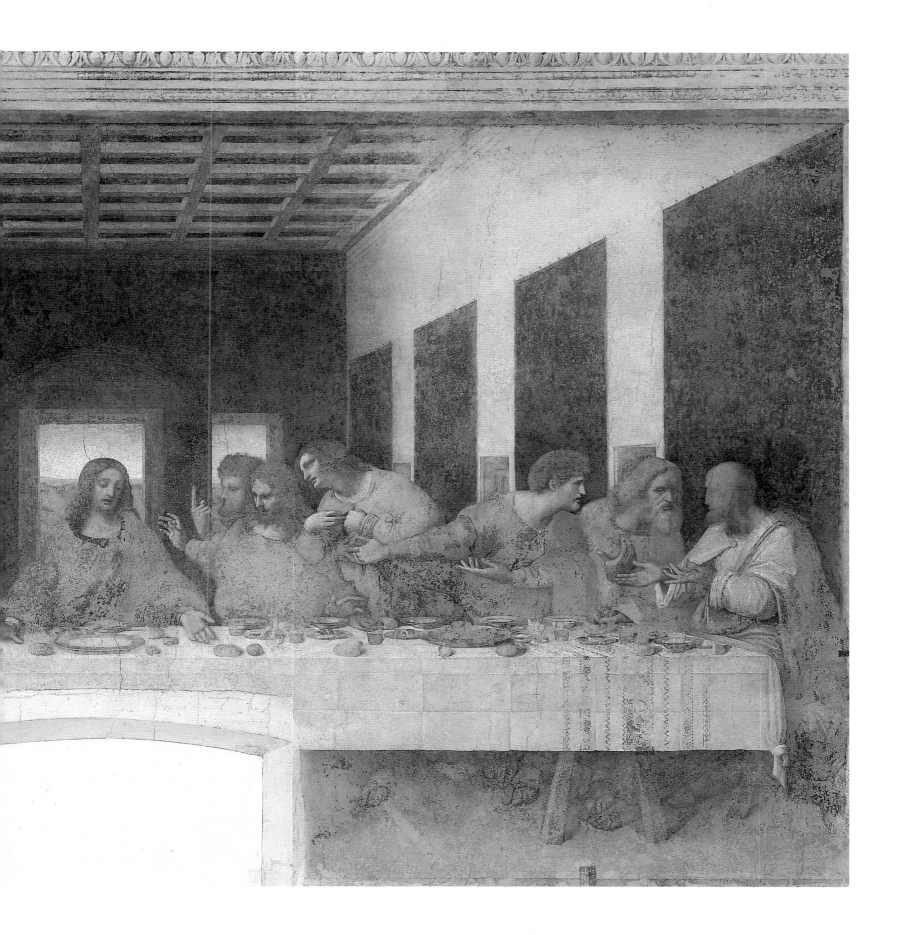

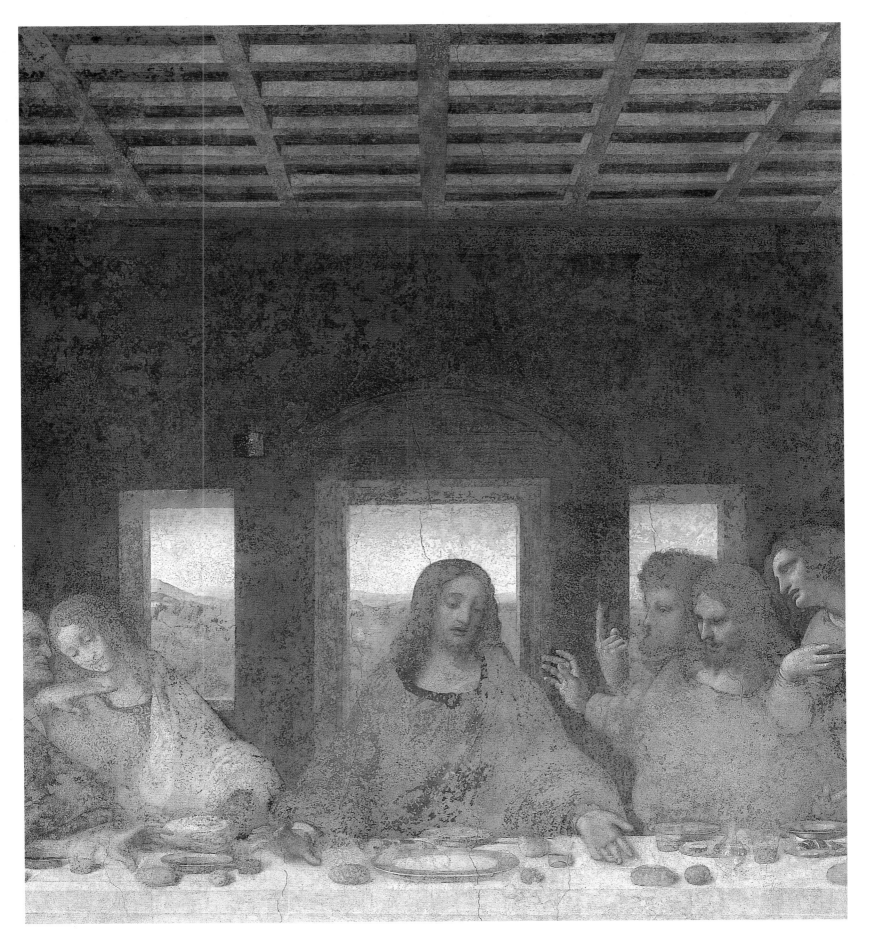

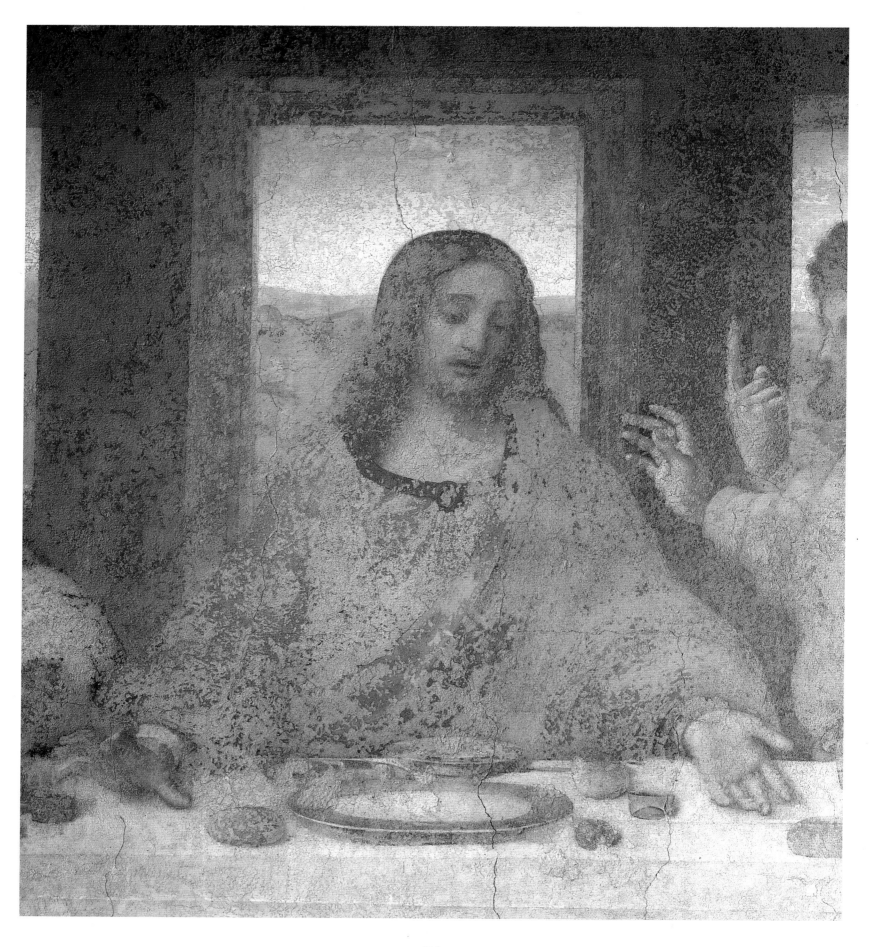

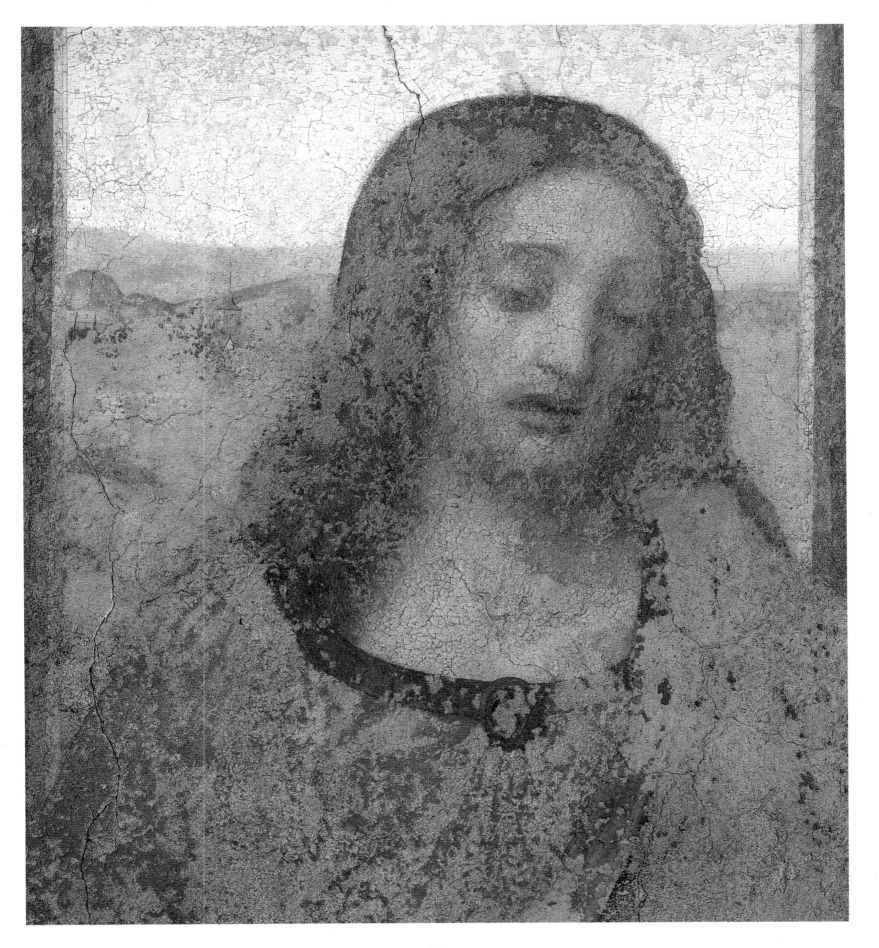

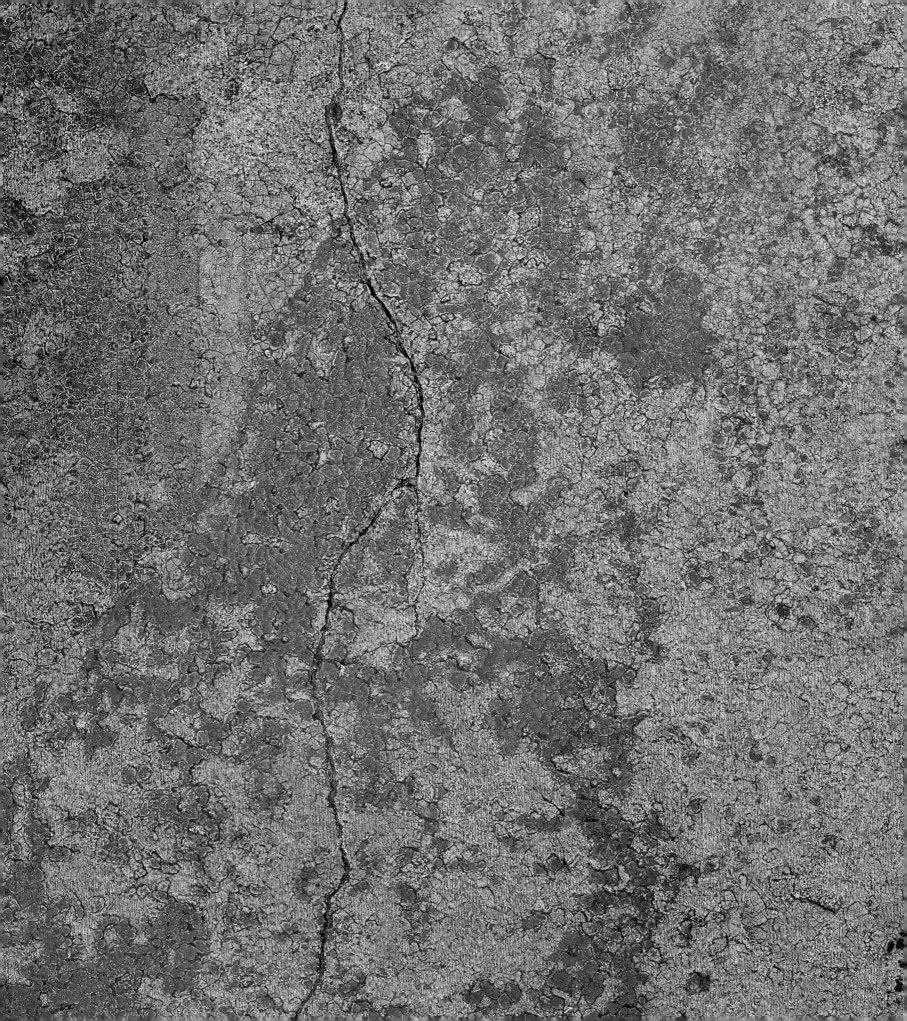

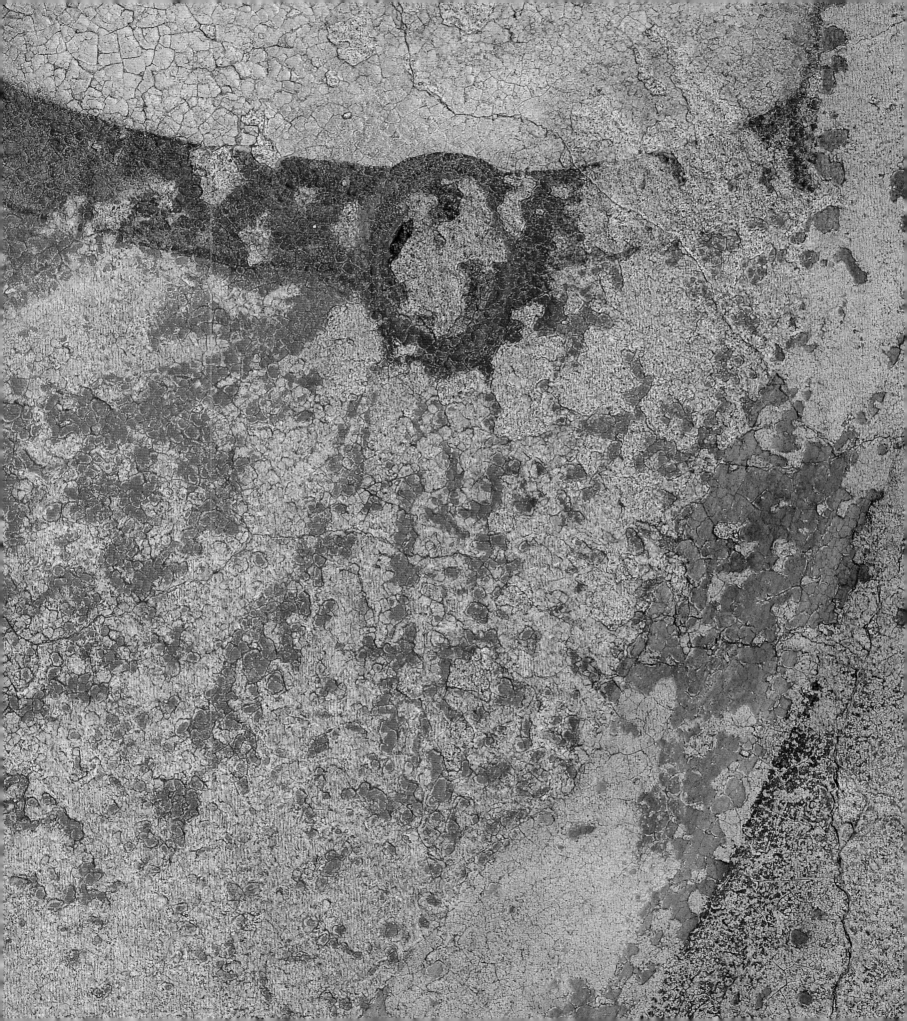

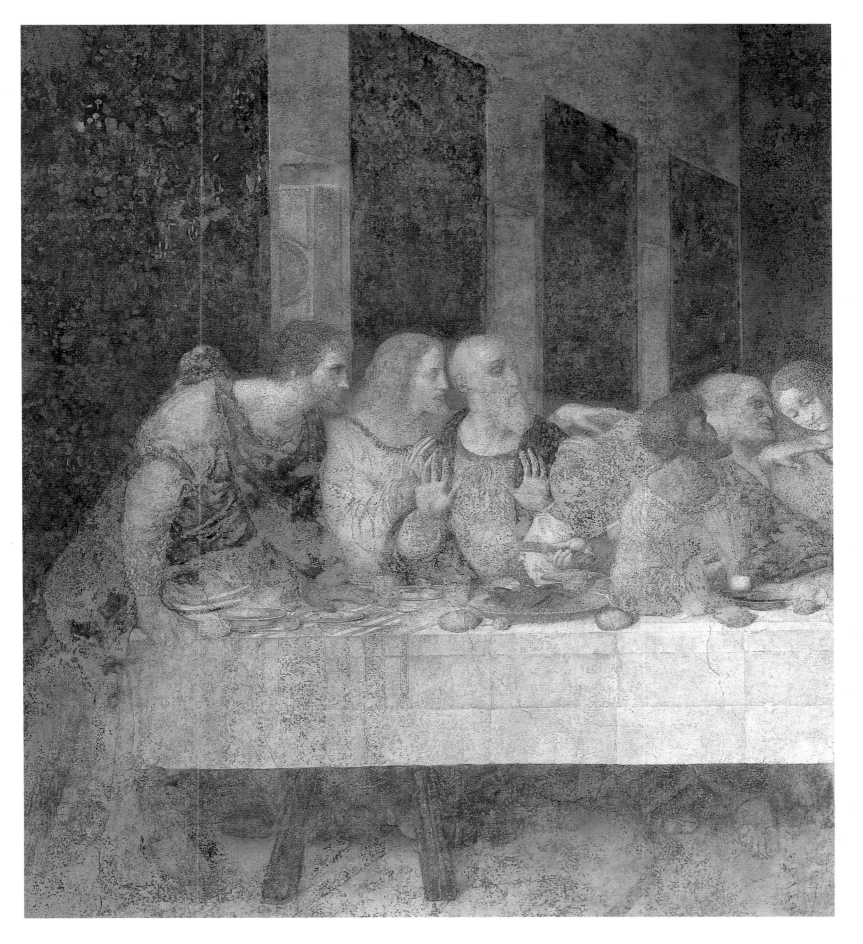

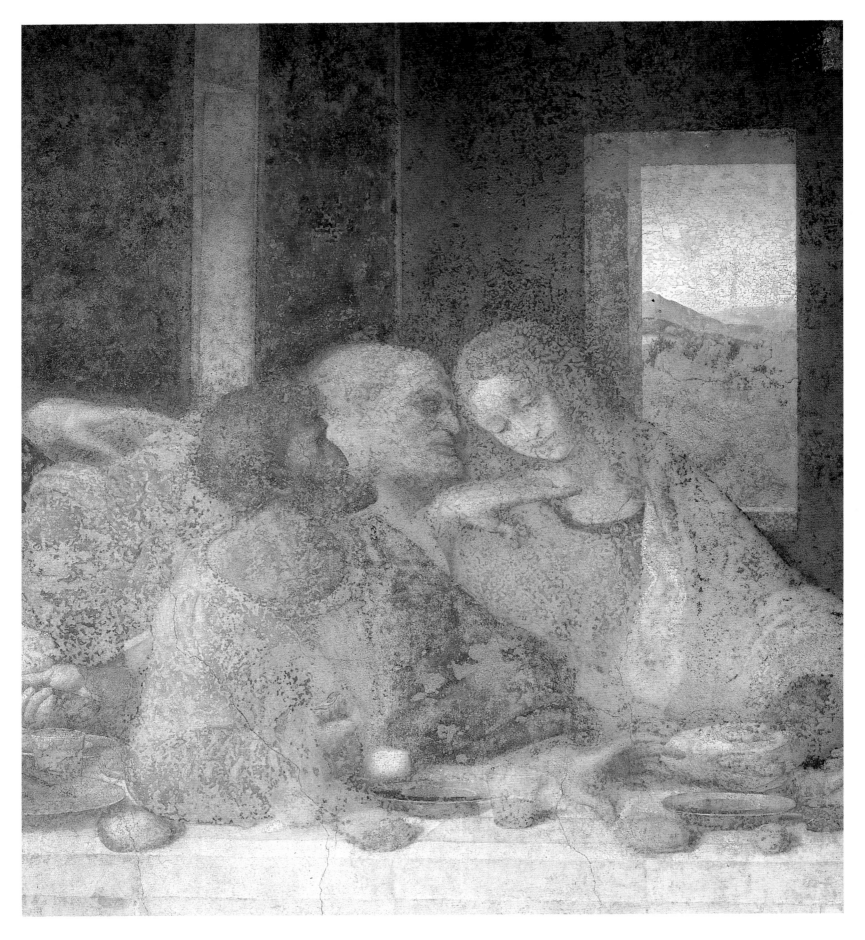

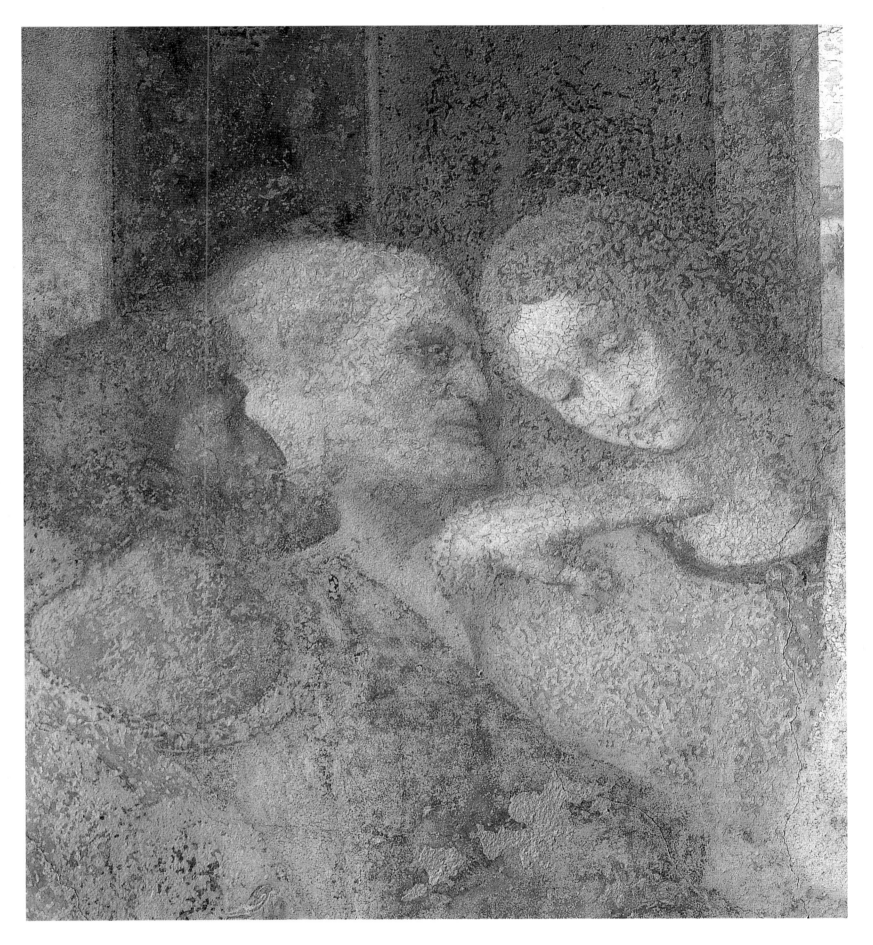

181

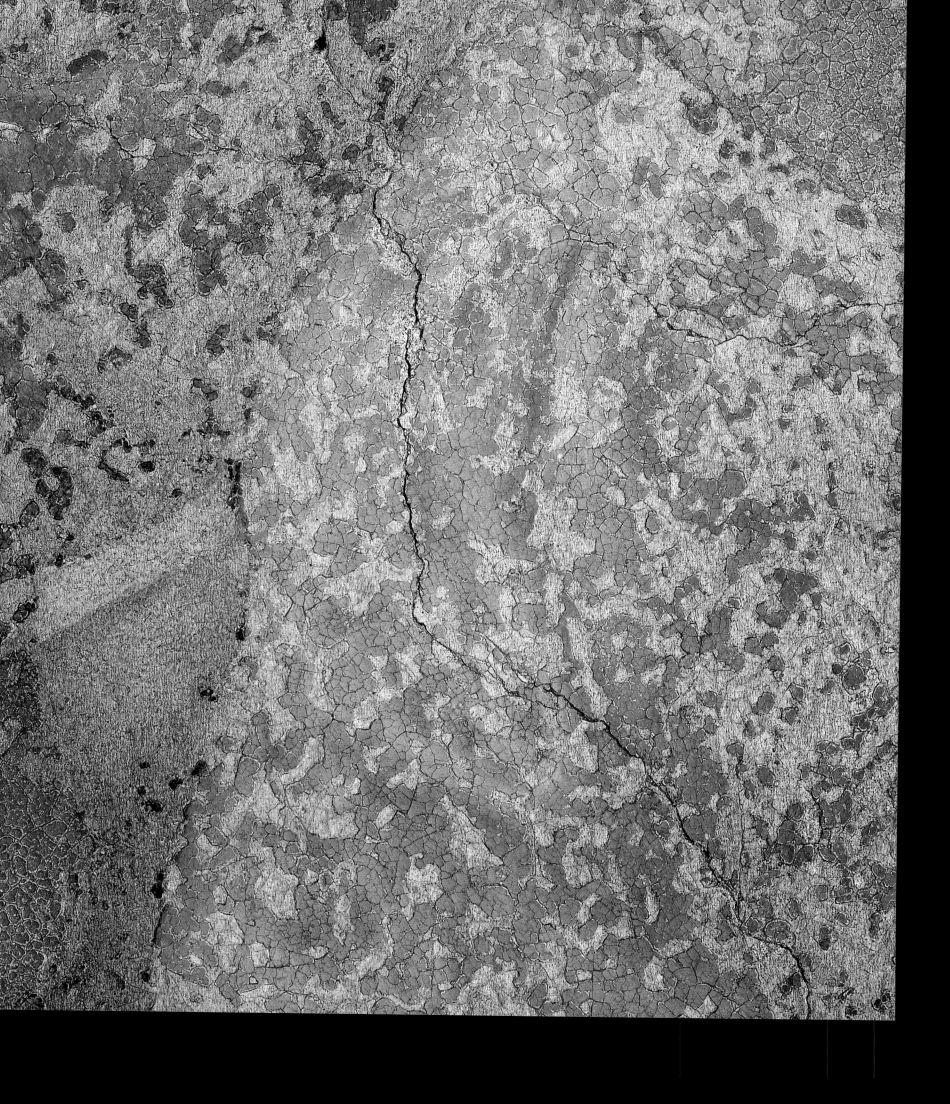

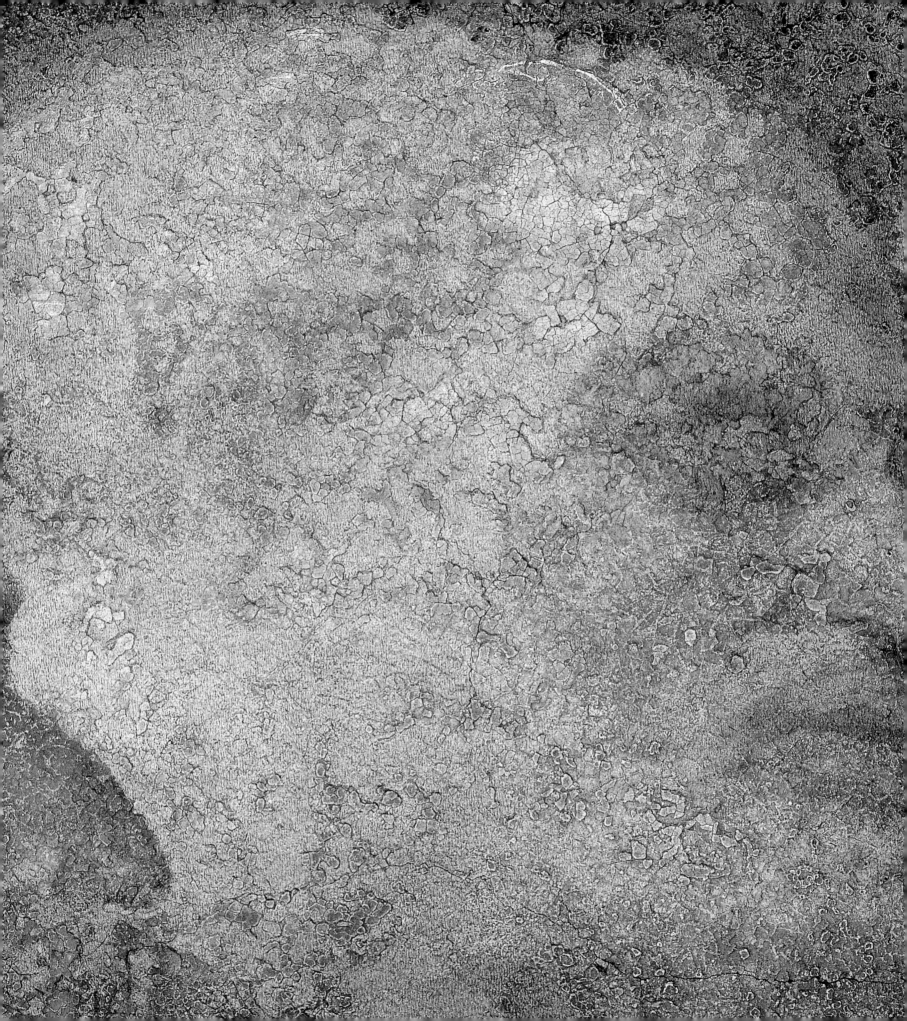

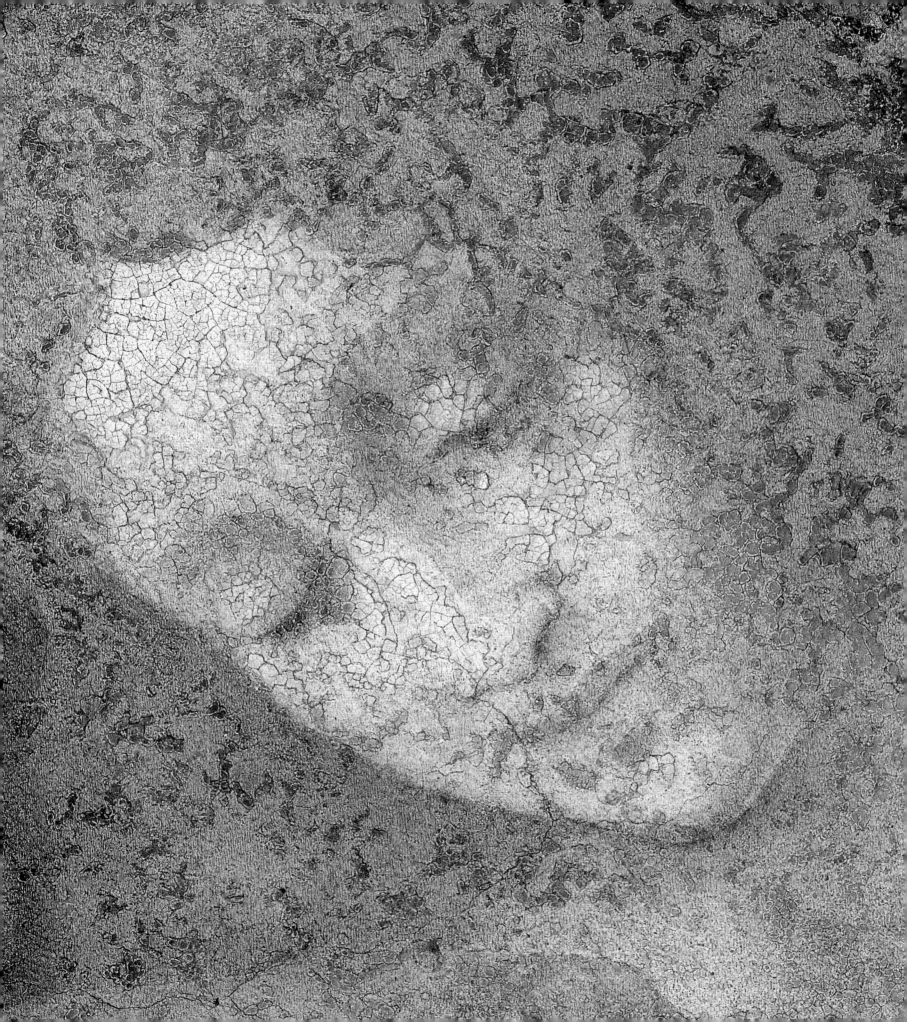

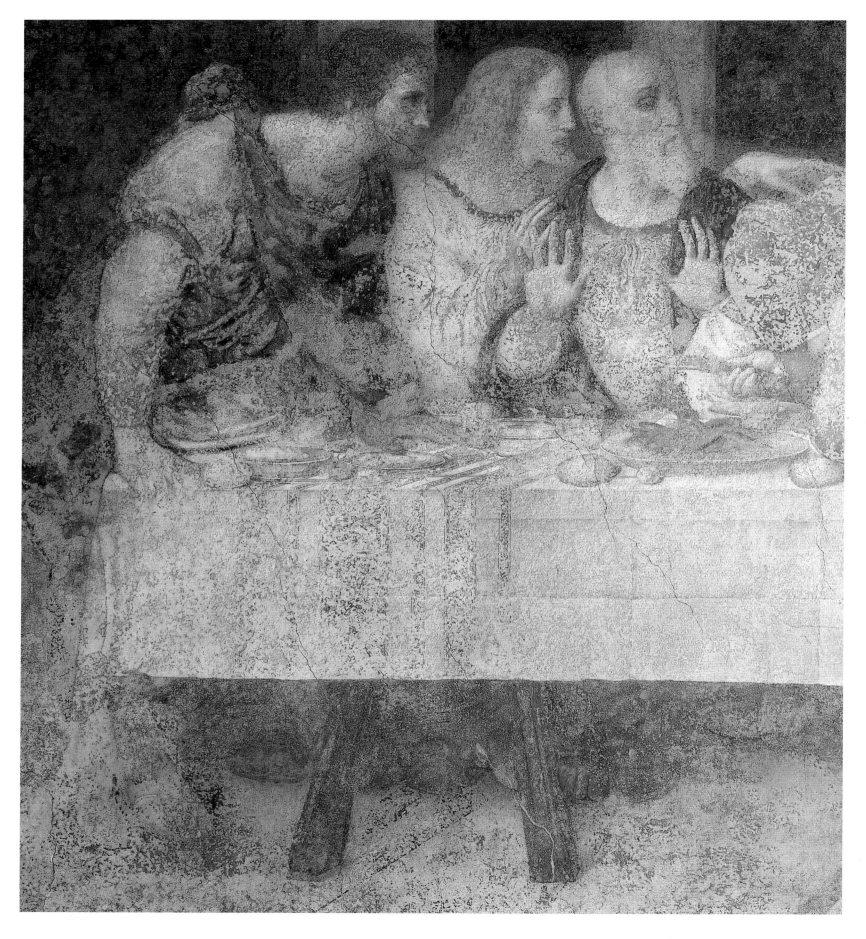

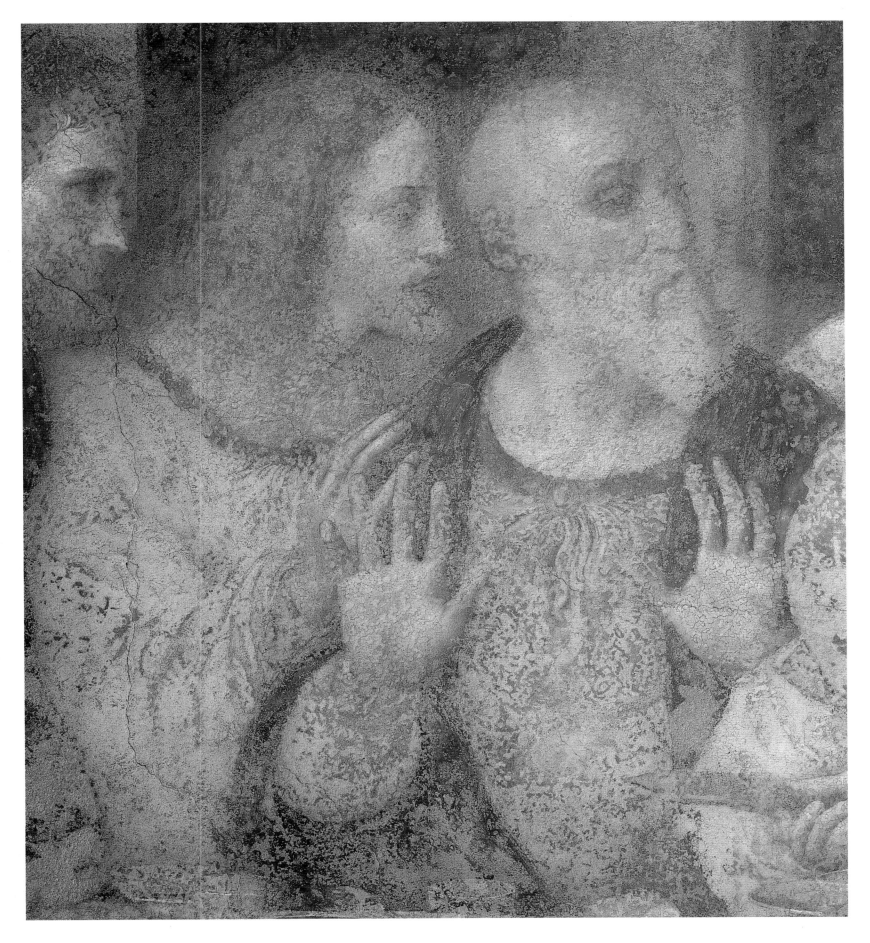

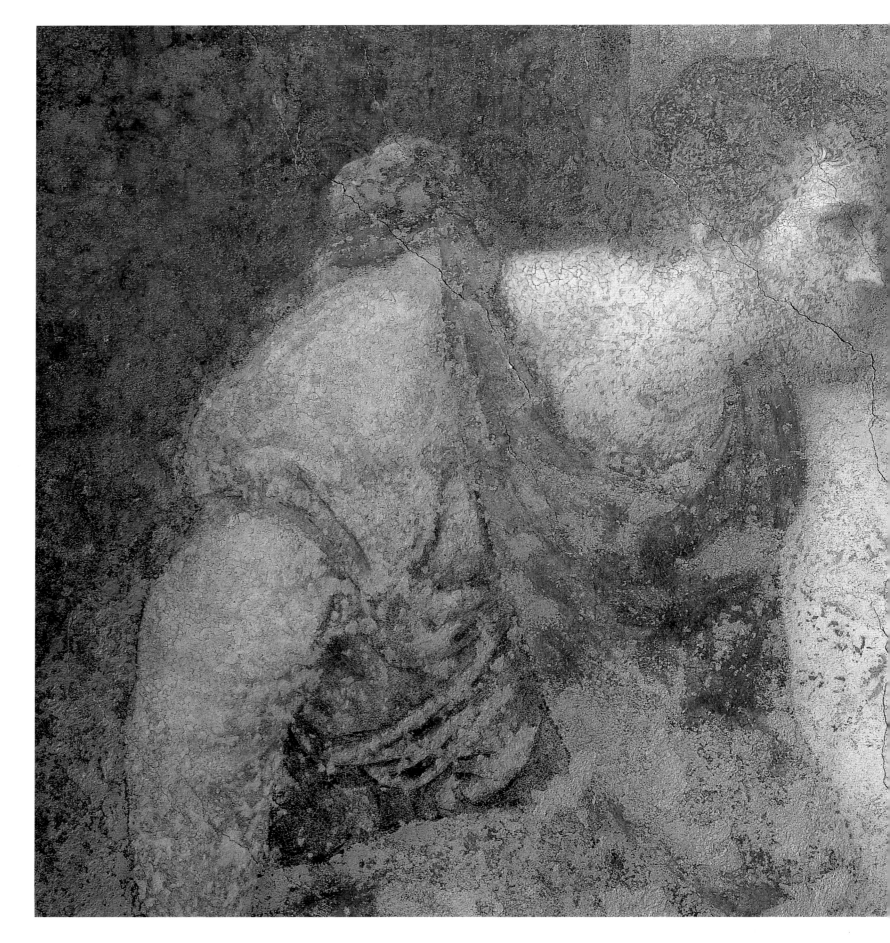

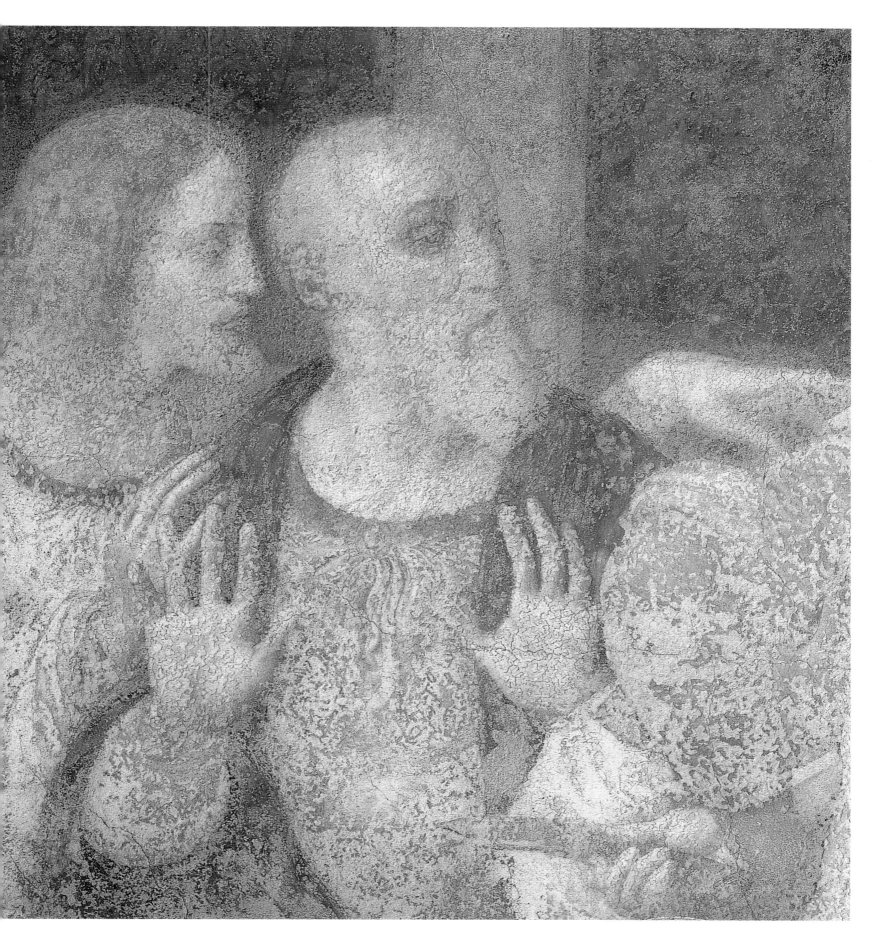

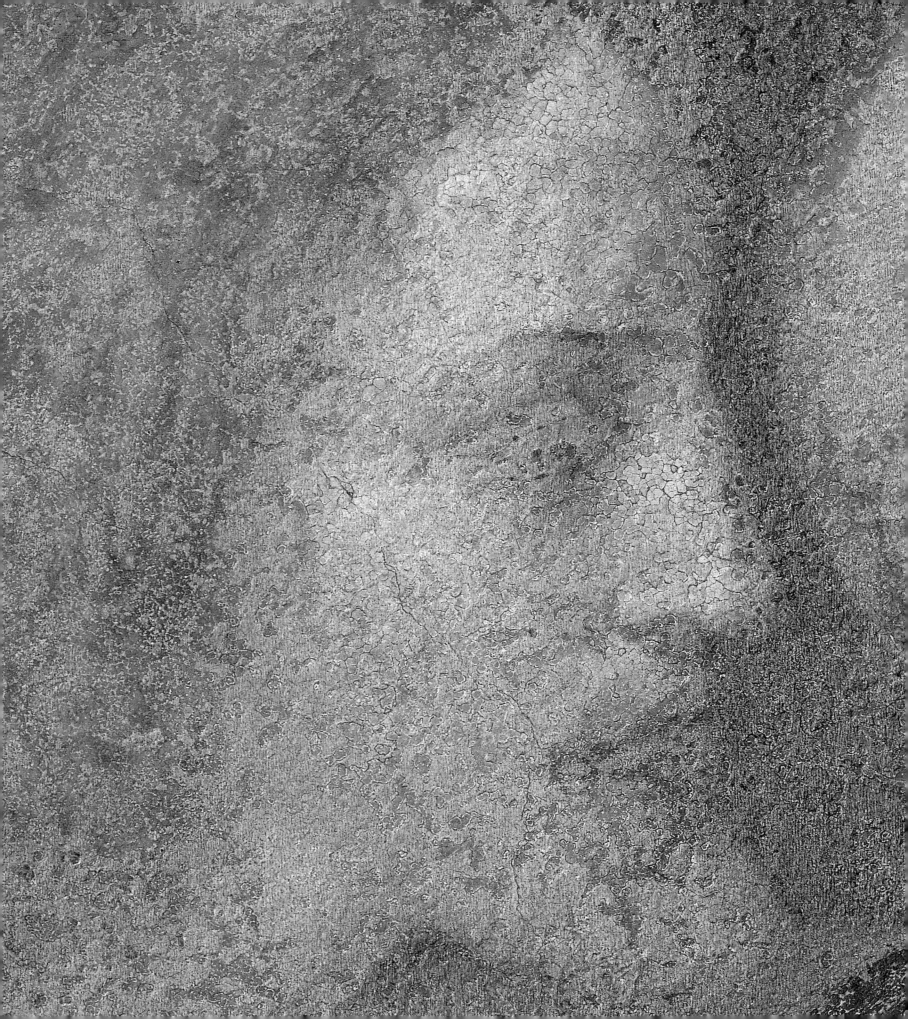

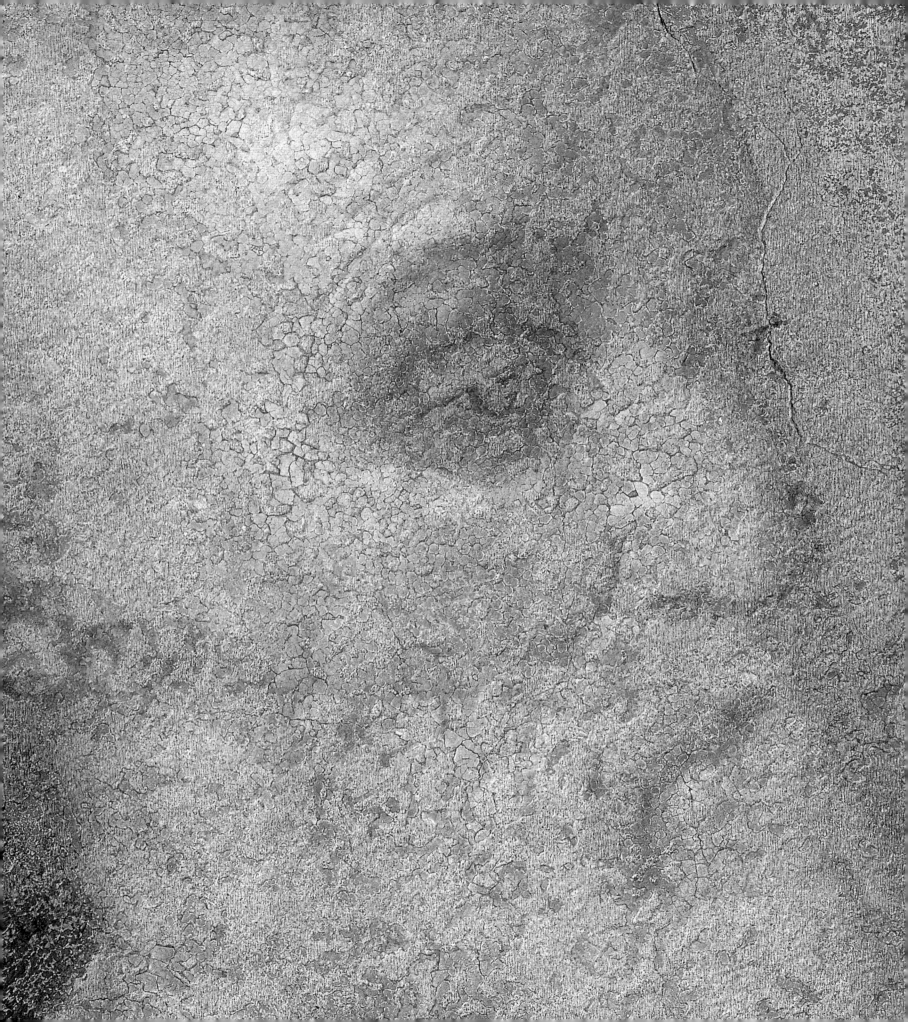

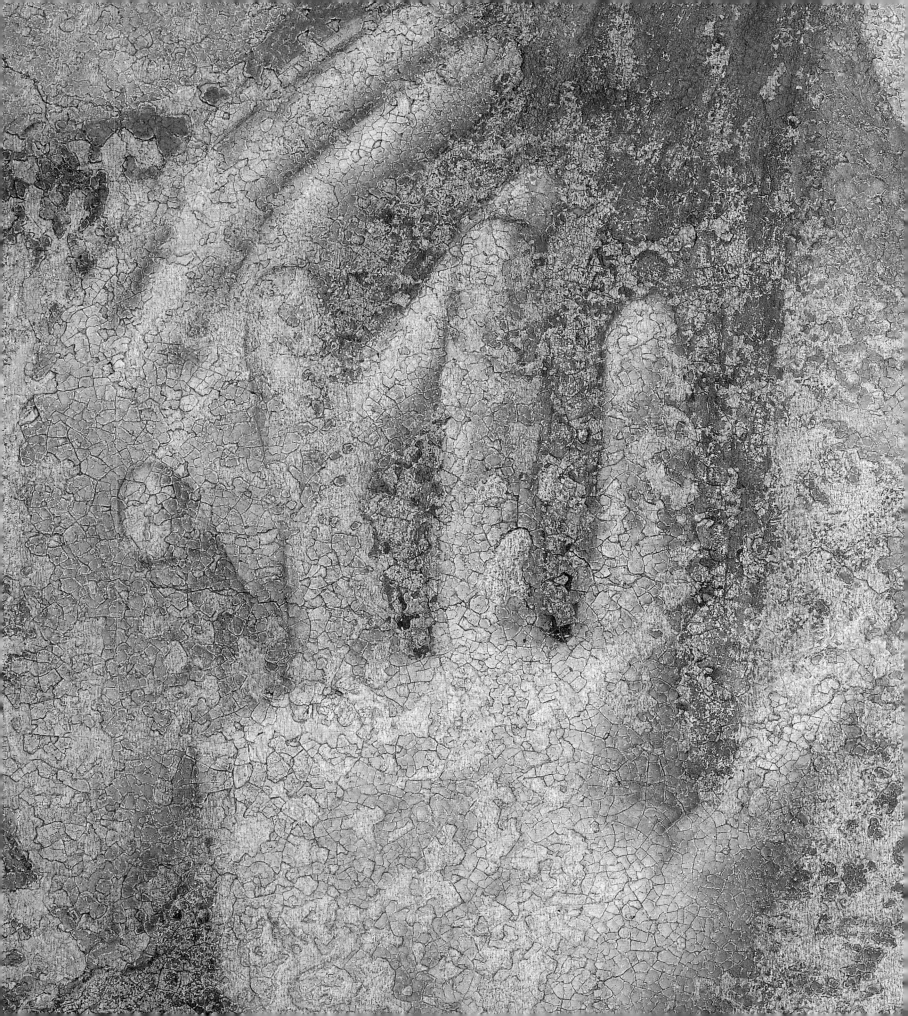

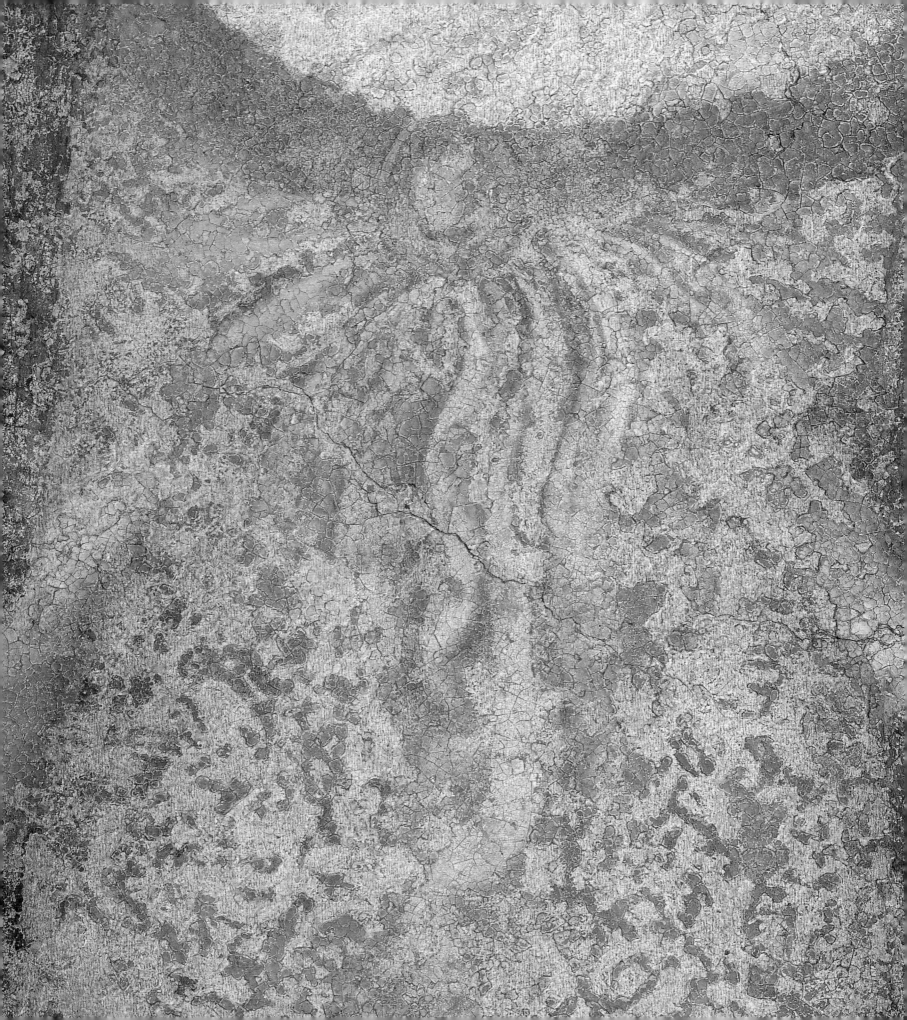

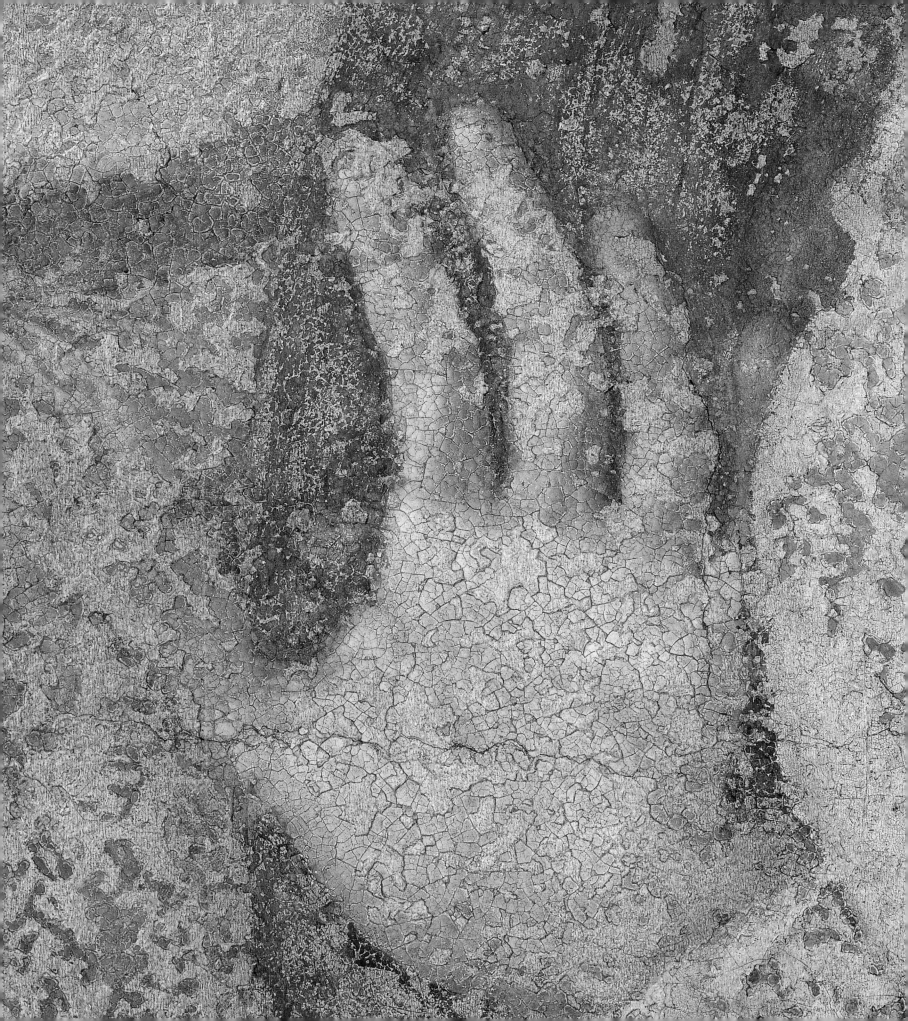

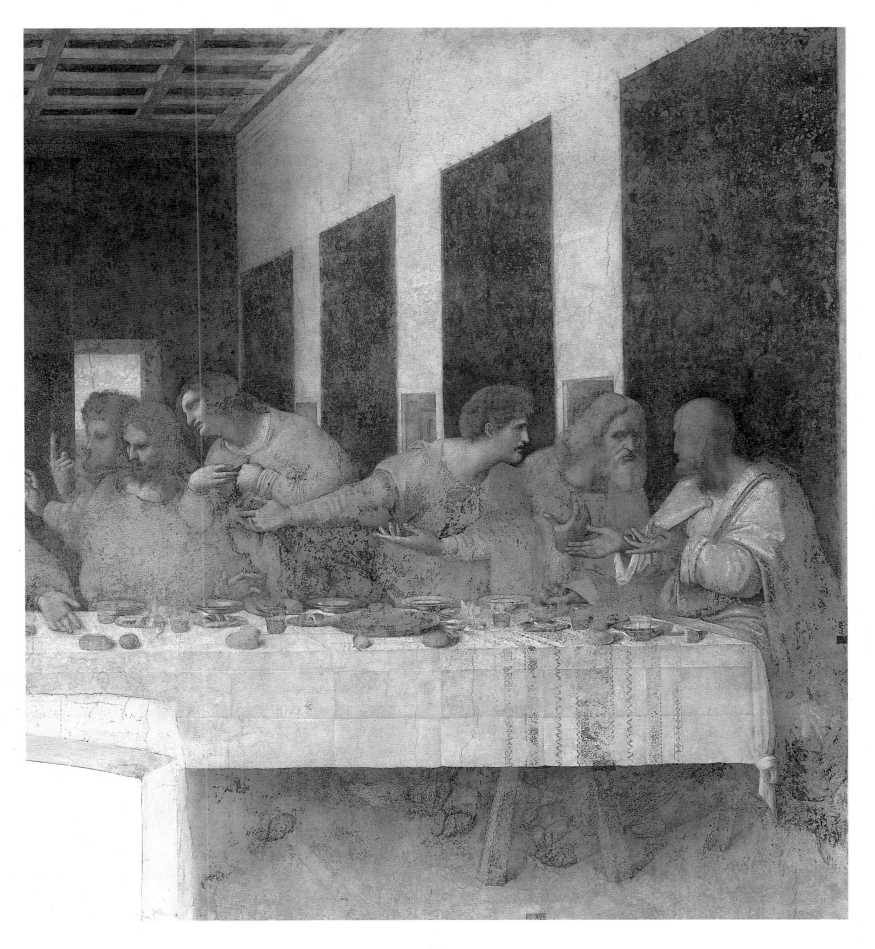

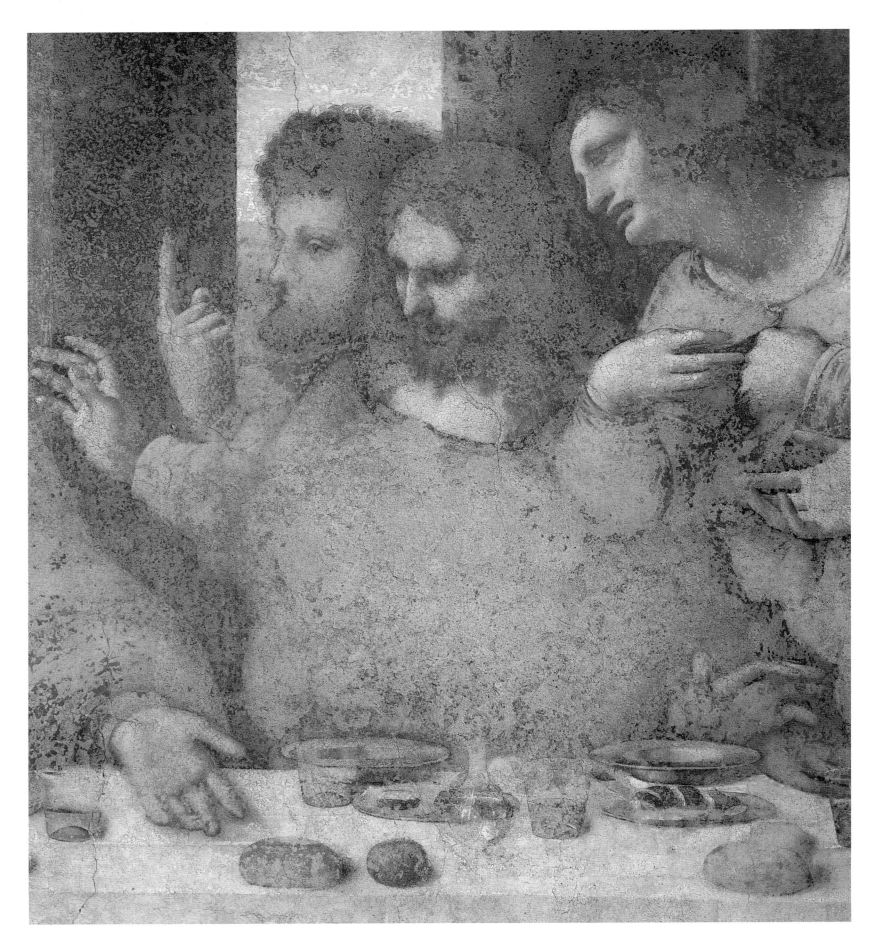

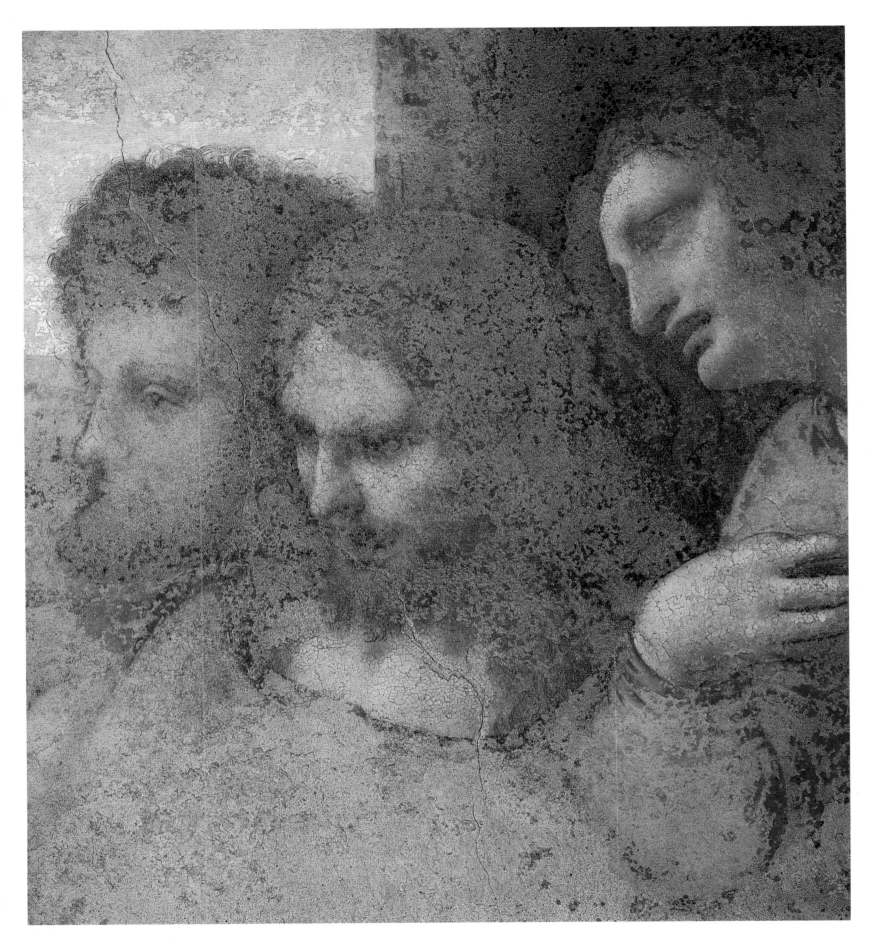

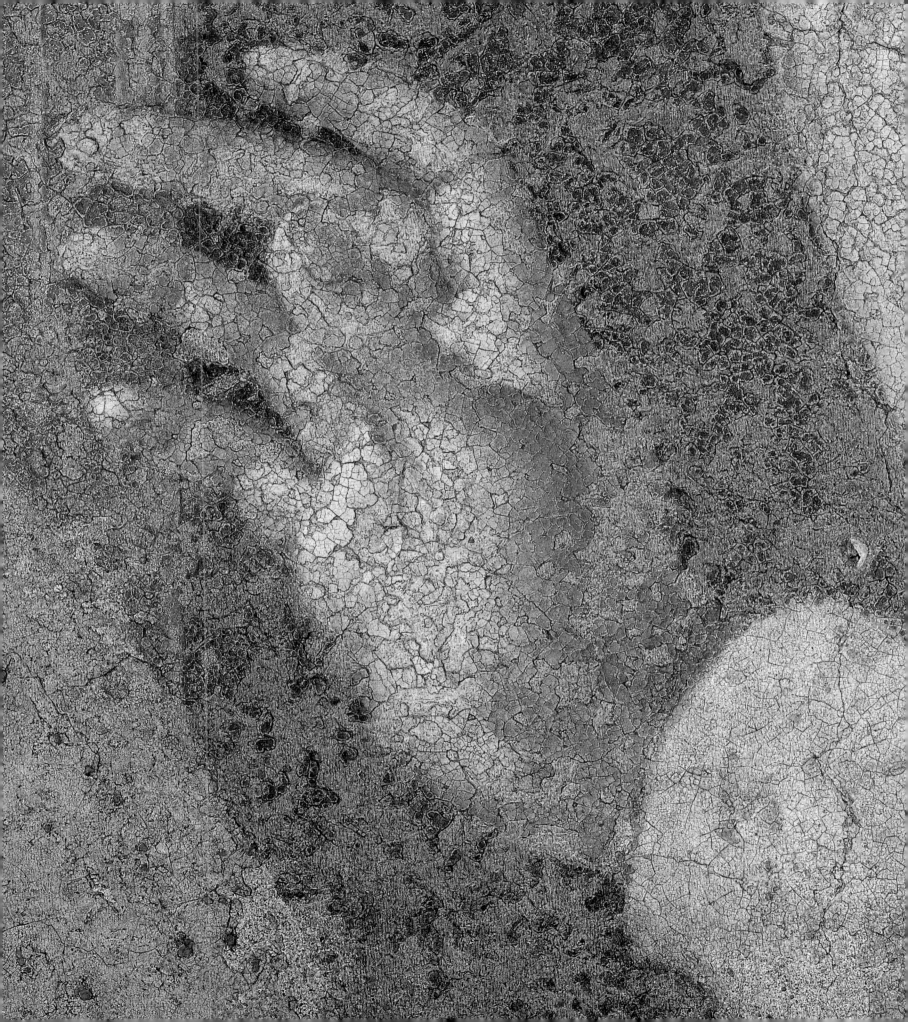

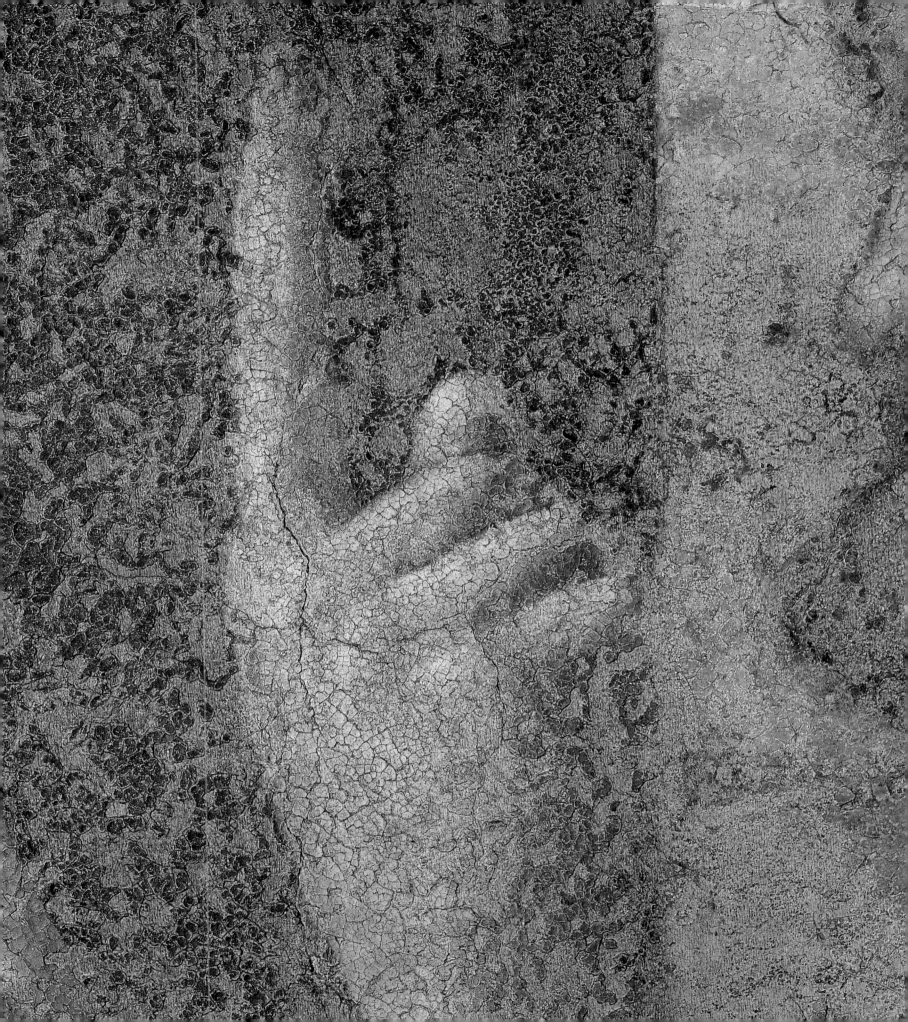

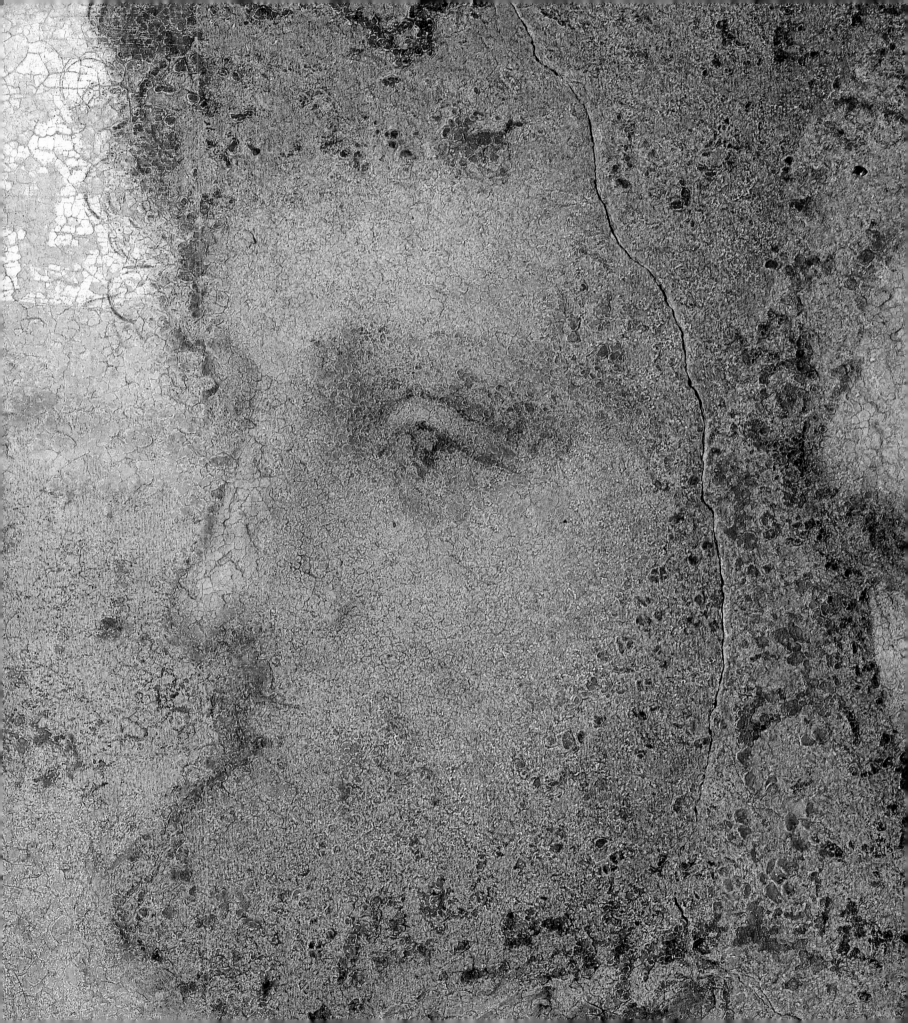

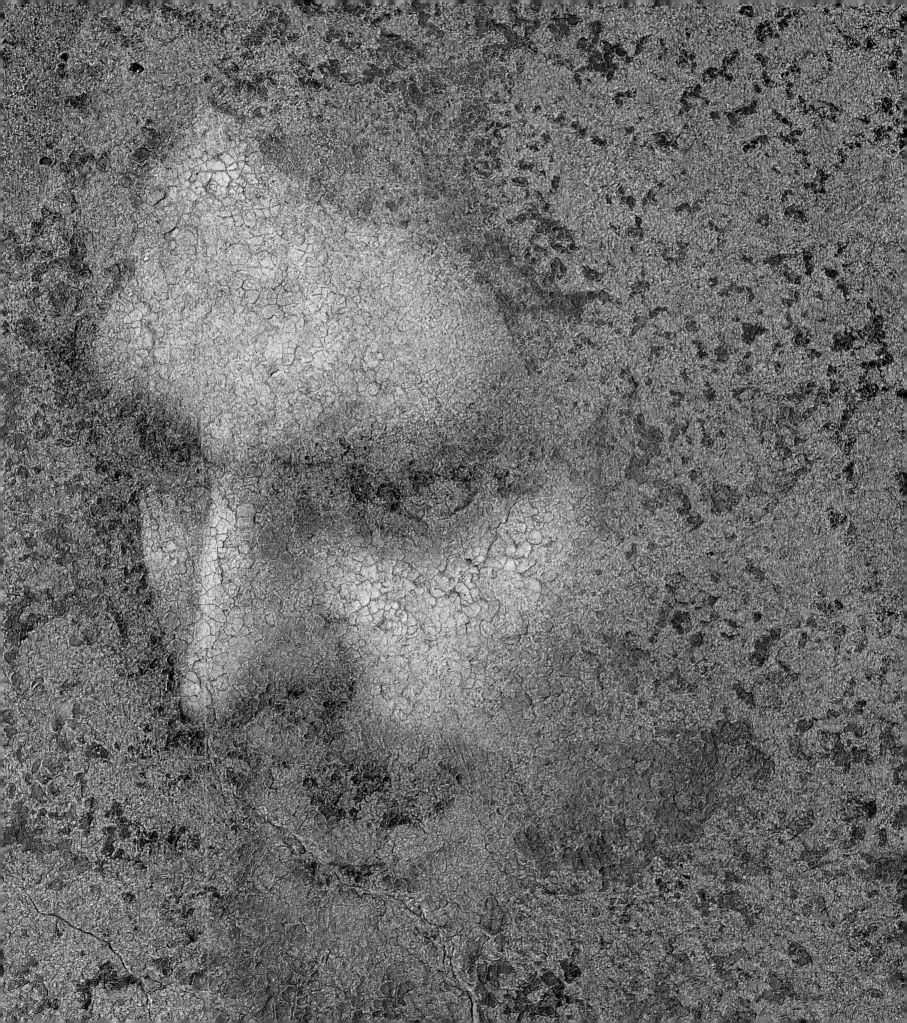

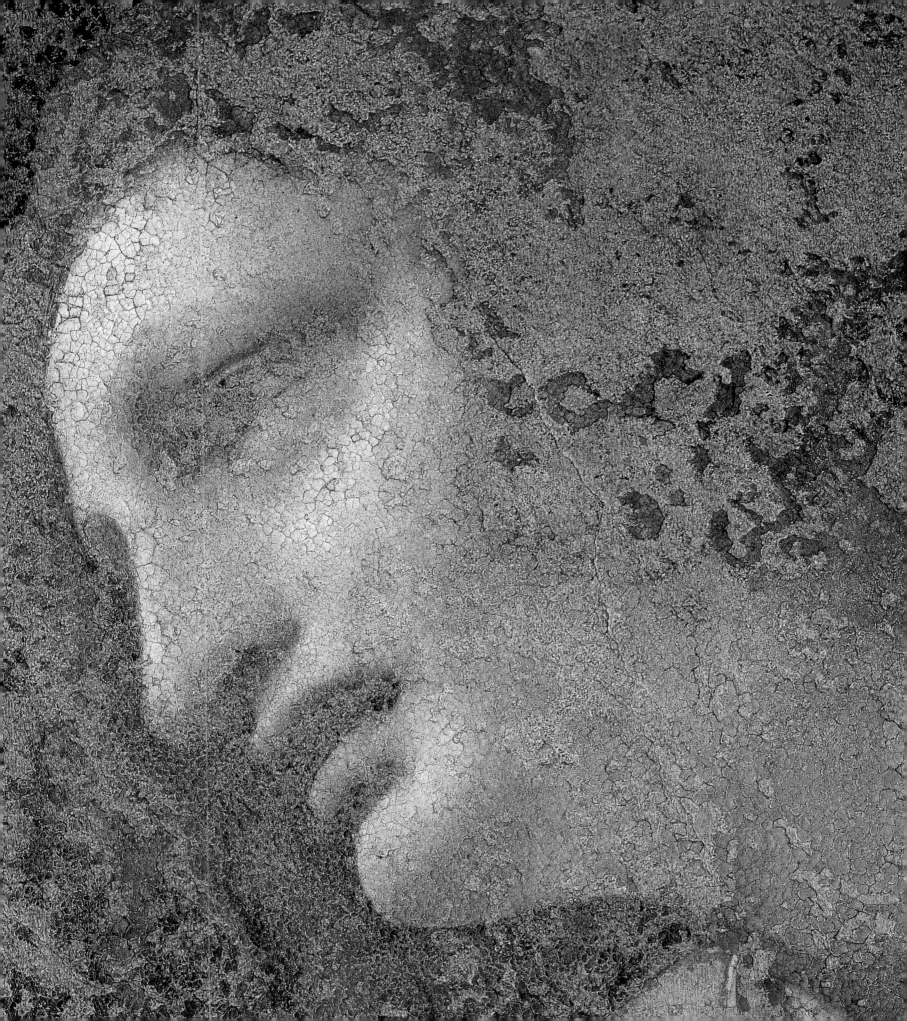

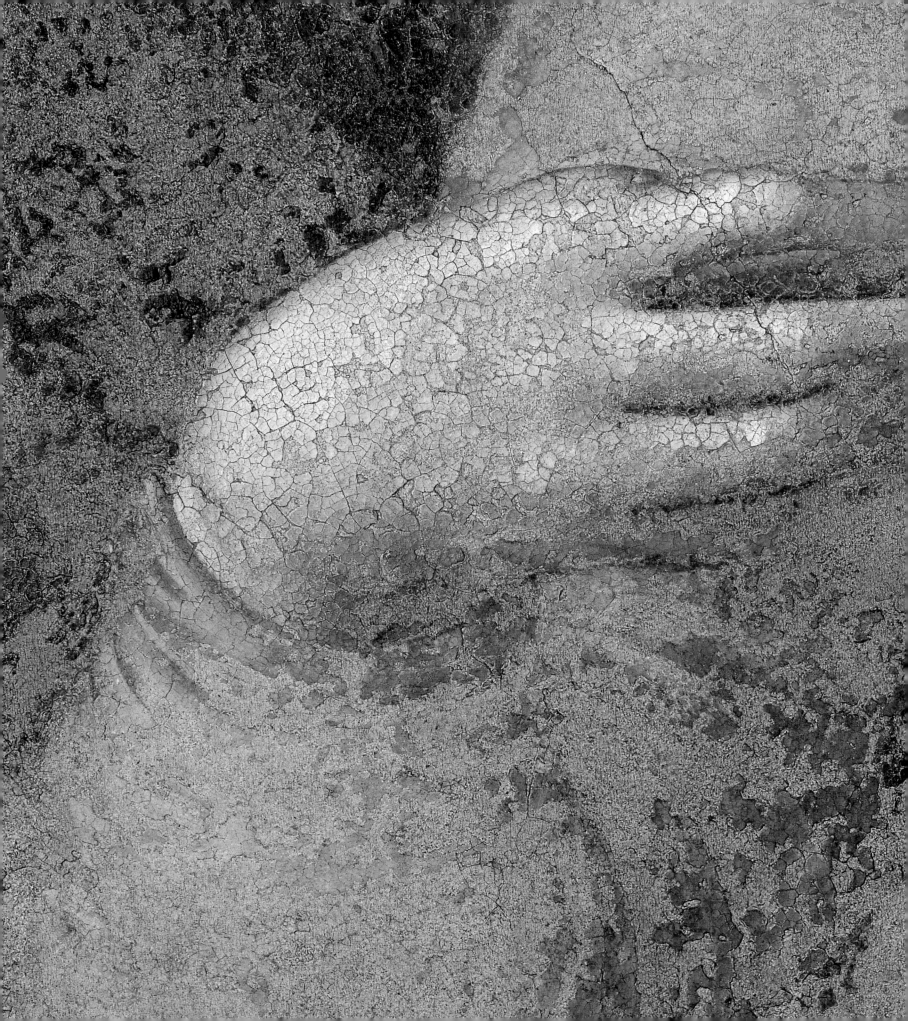

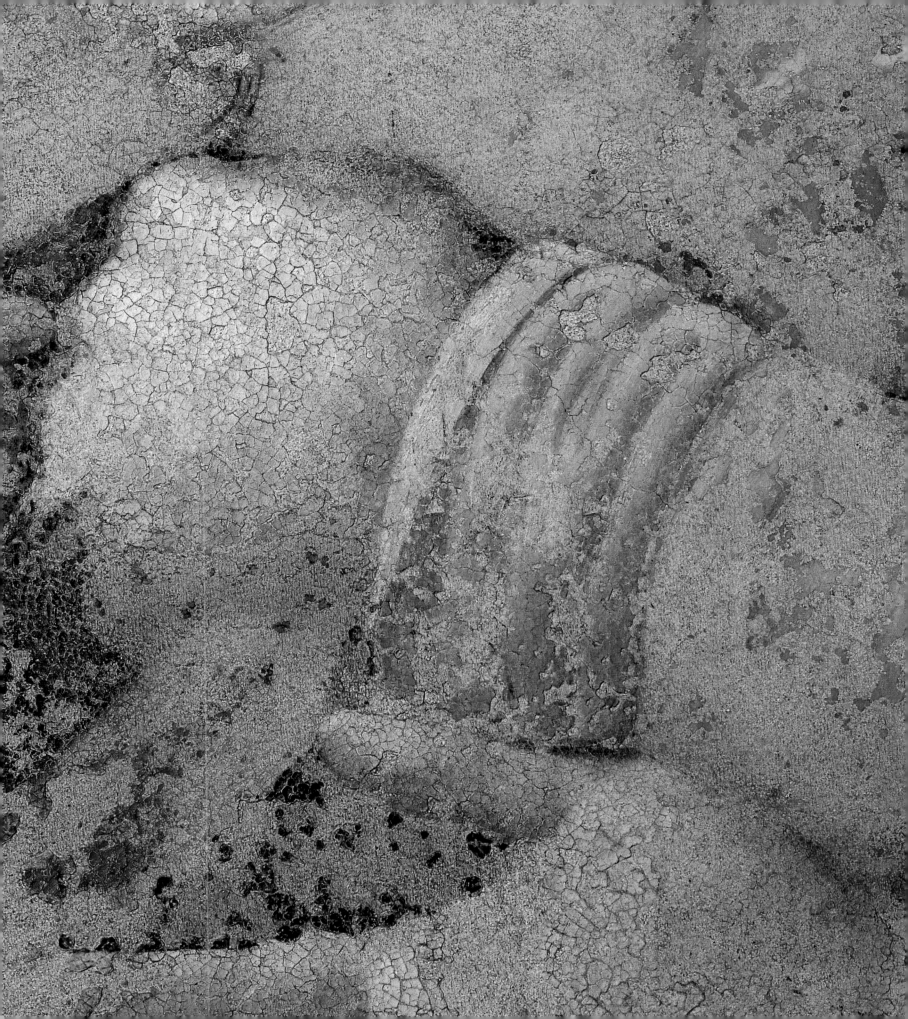

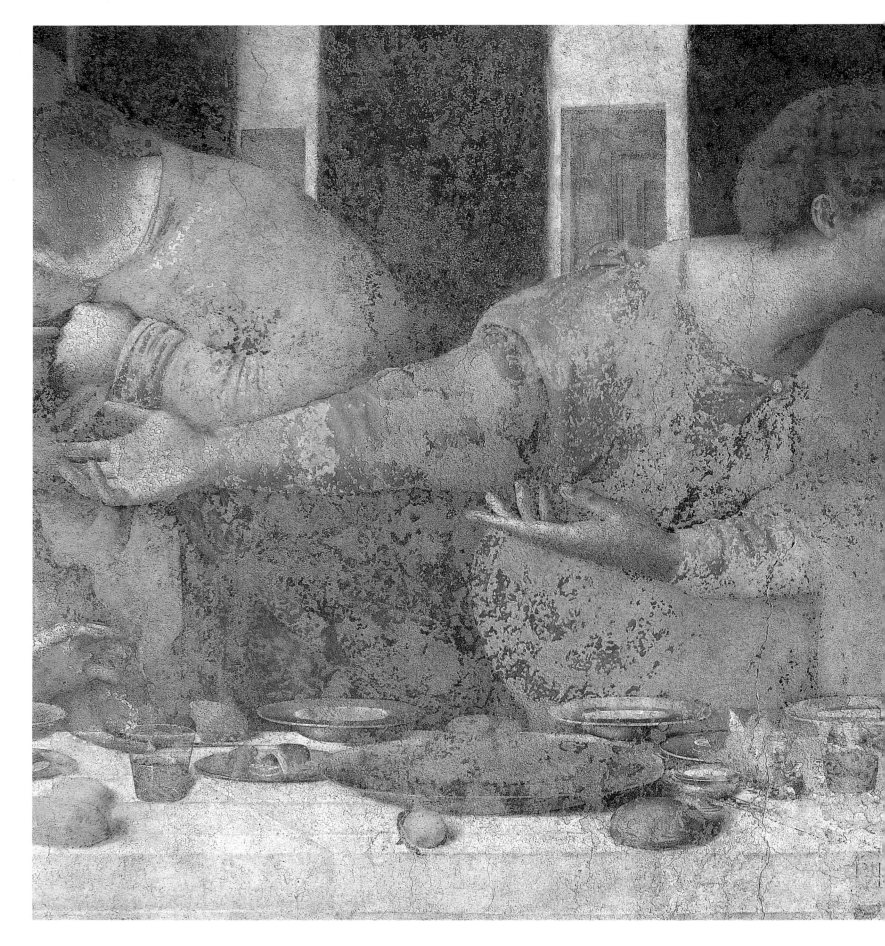

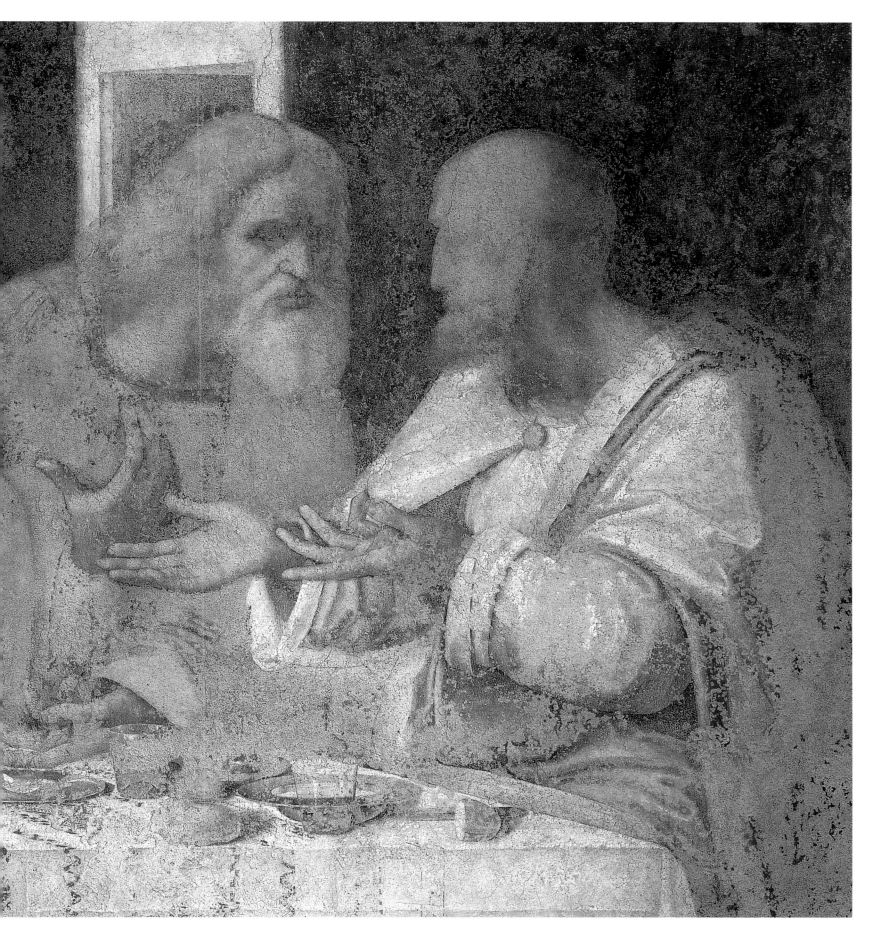

249

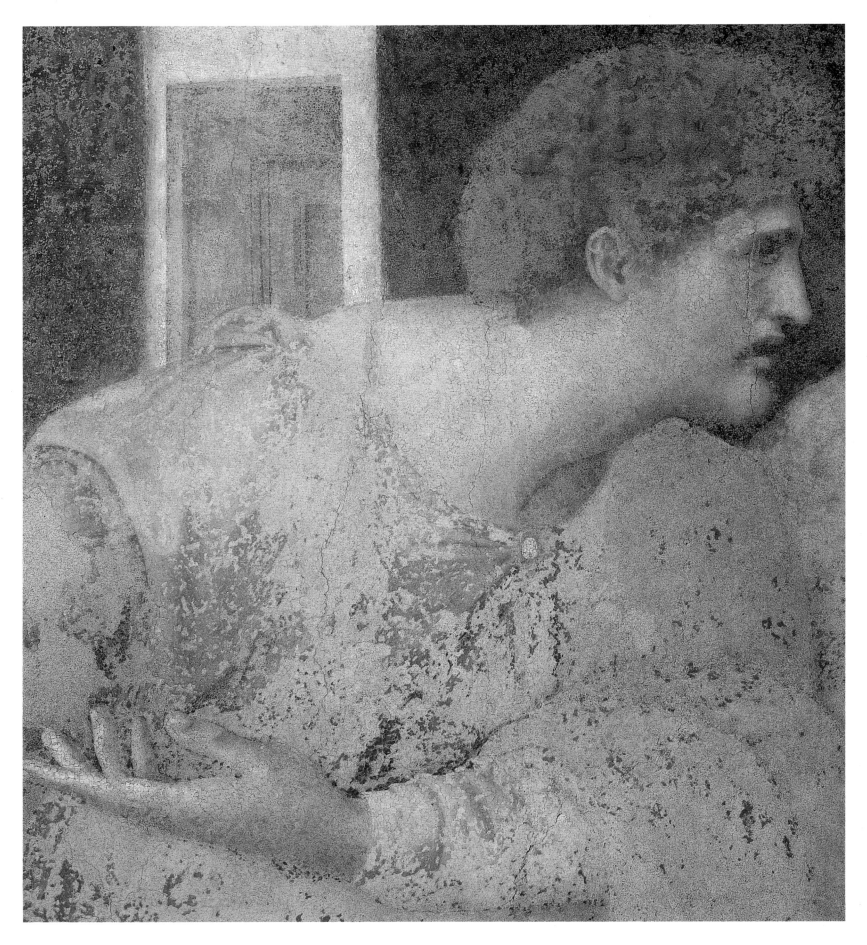

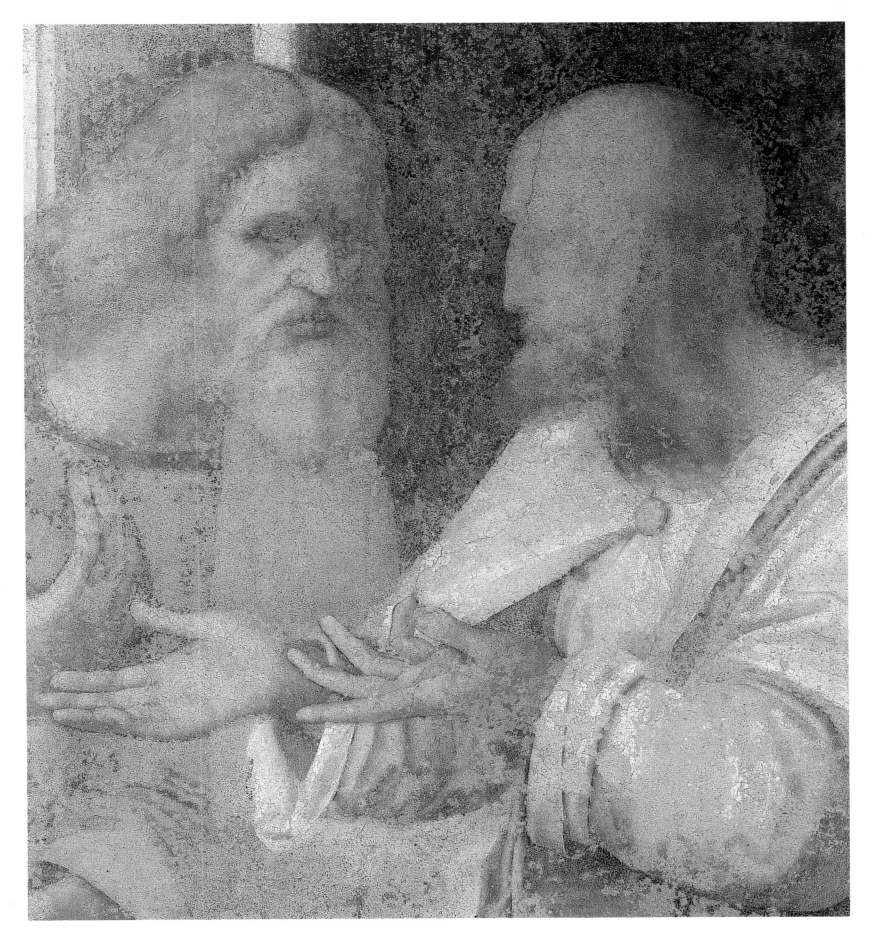

251

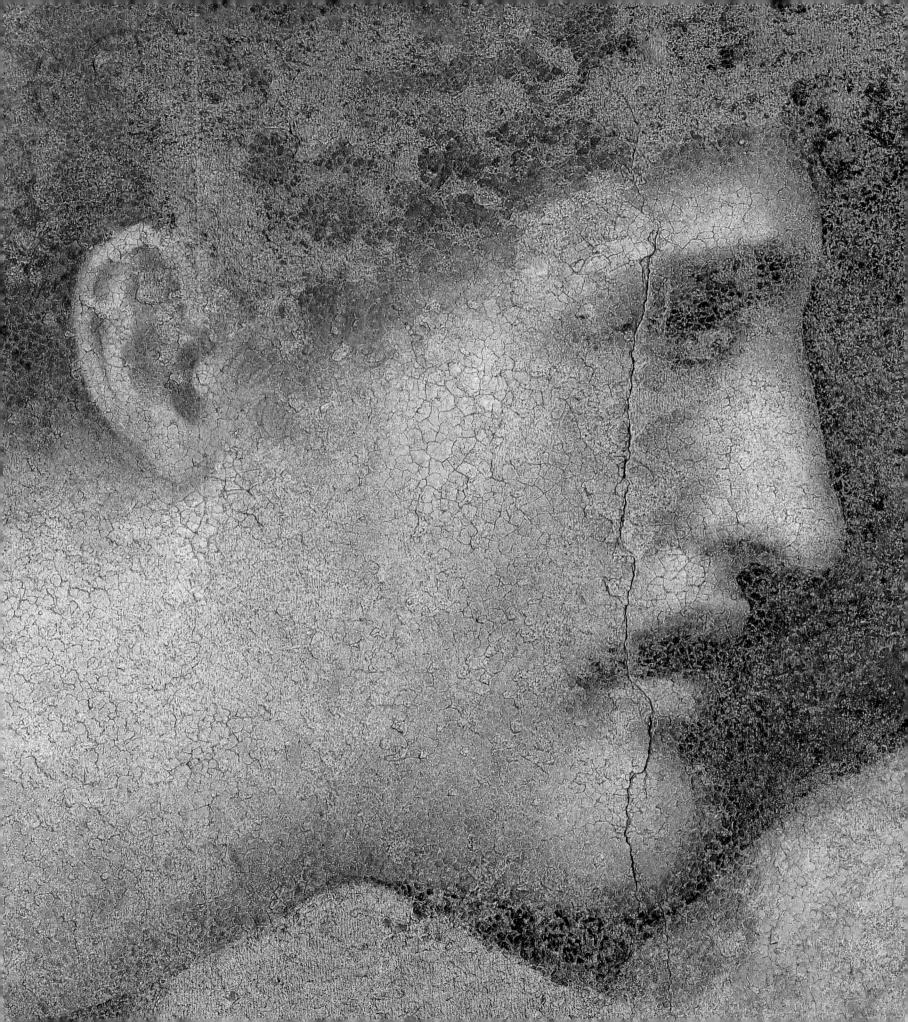

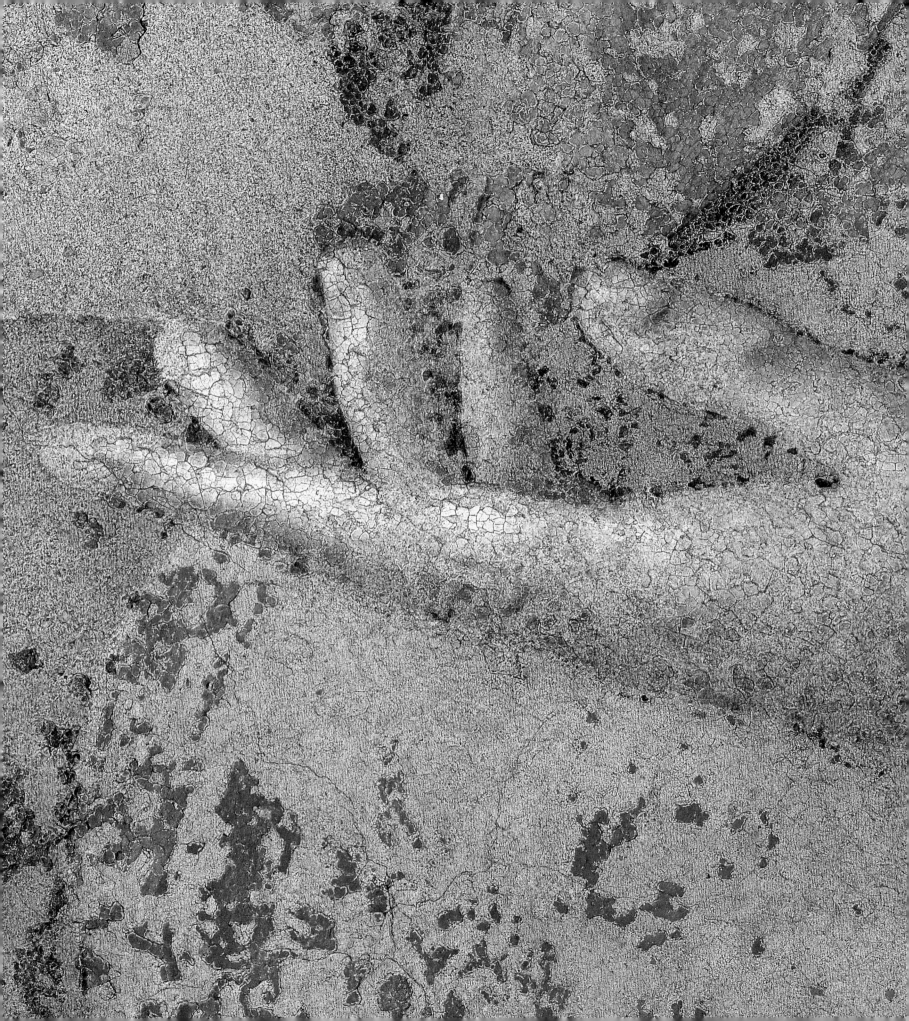

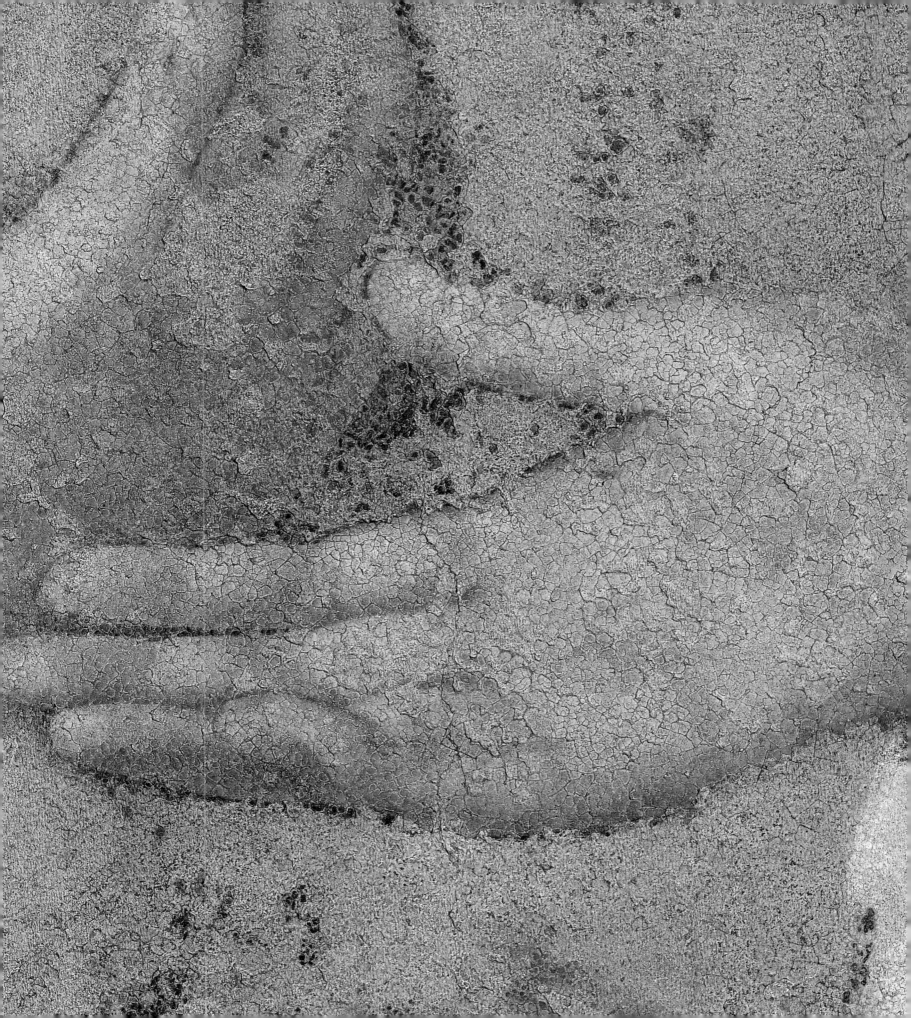

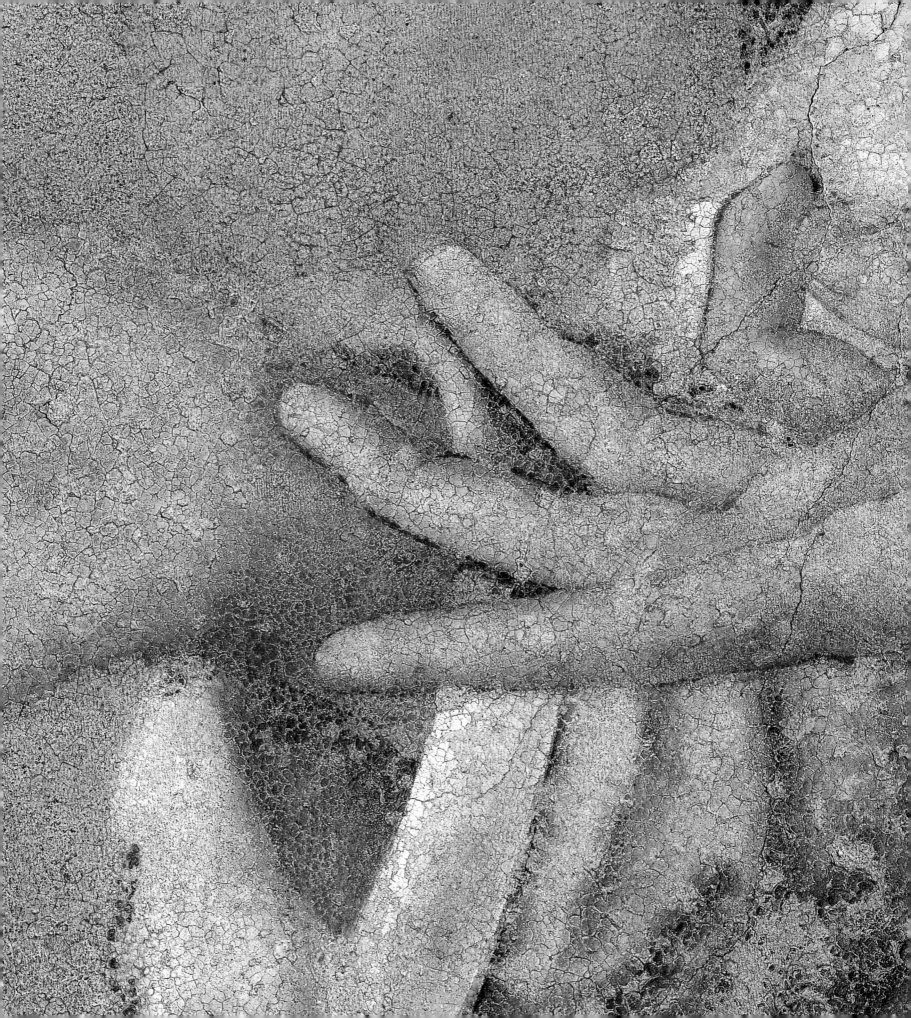

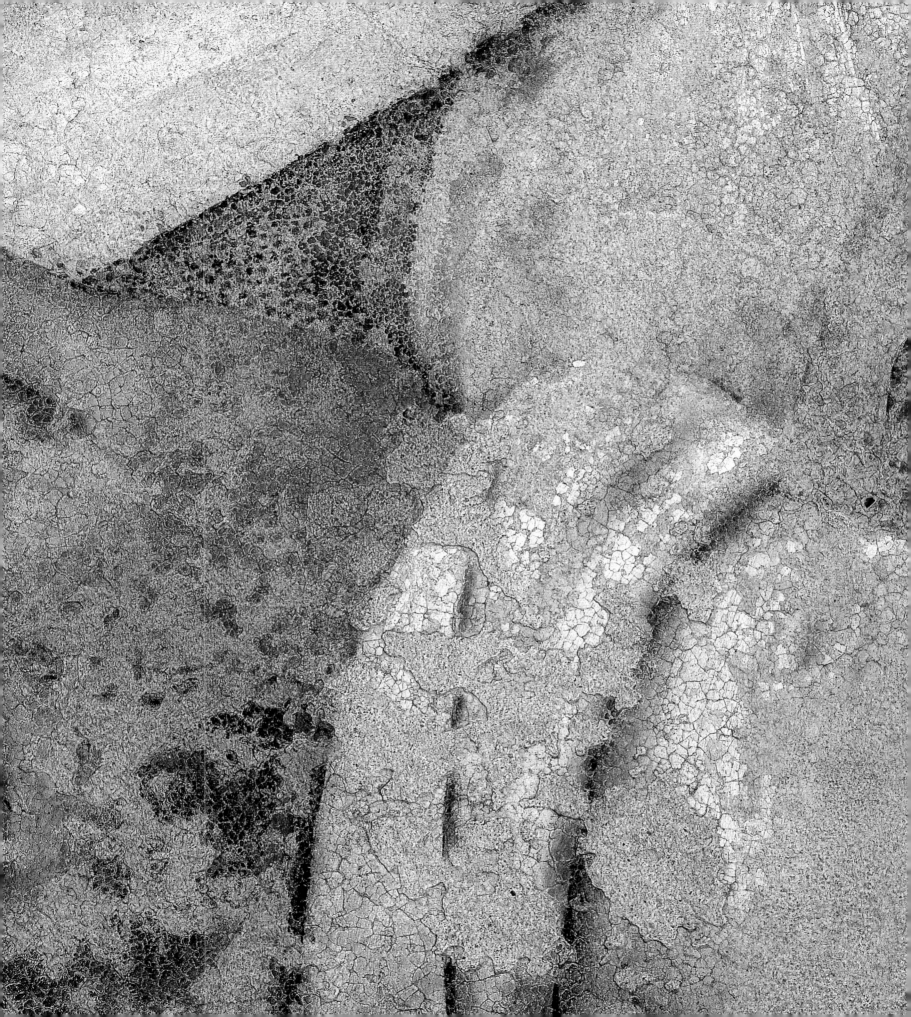

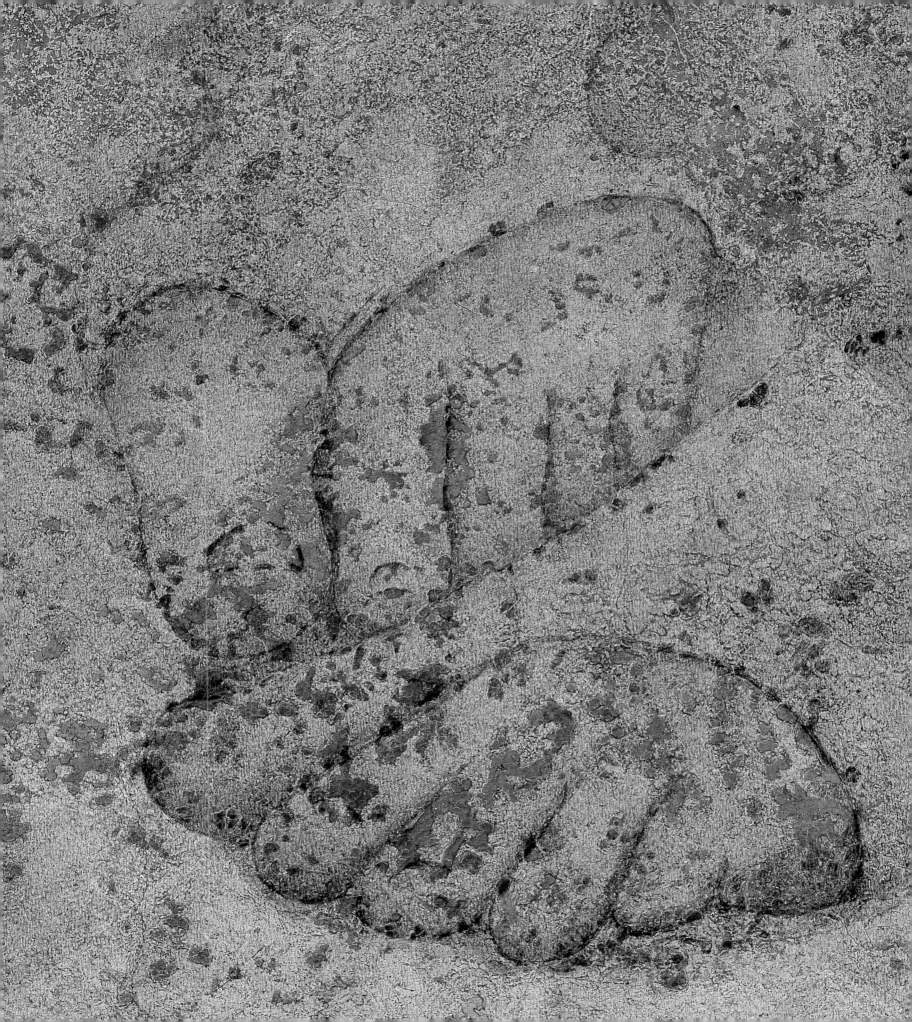

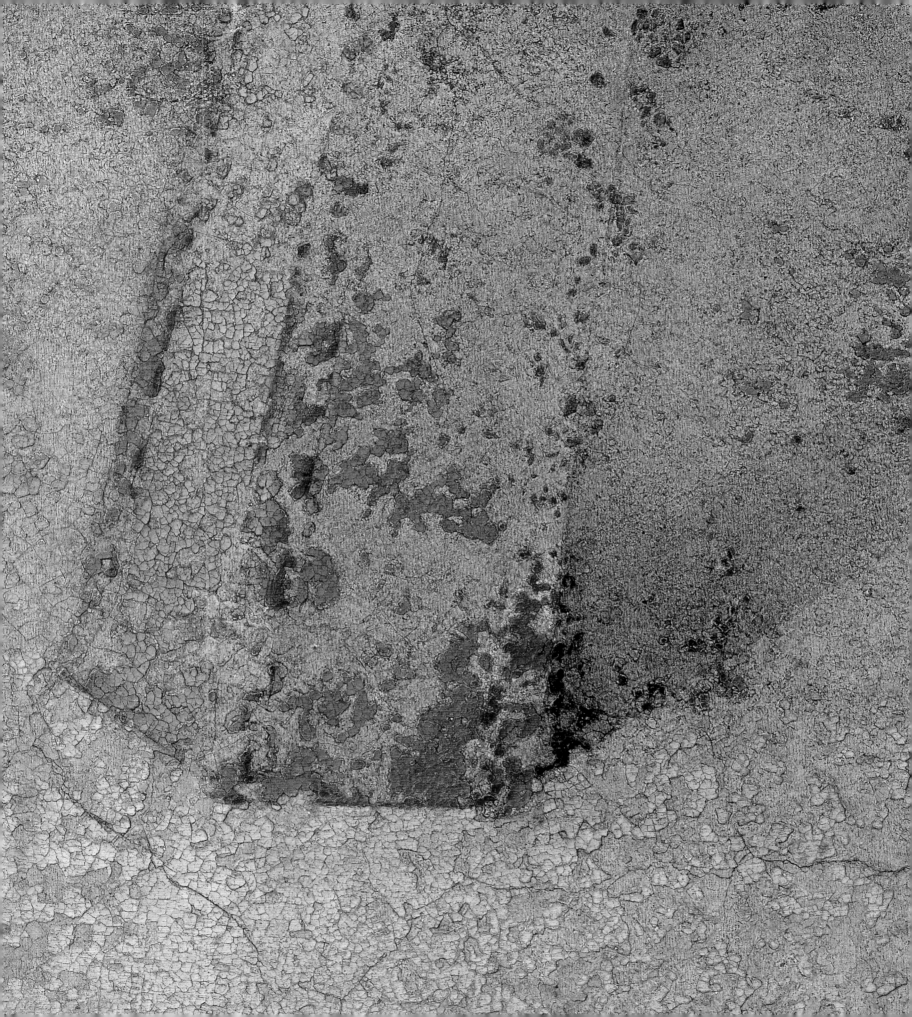

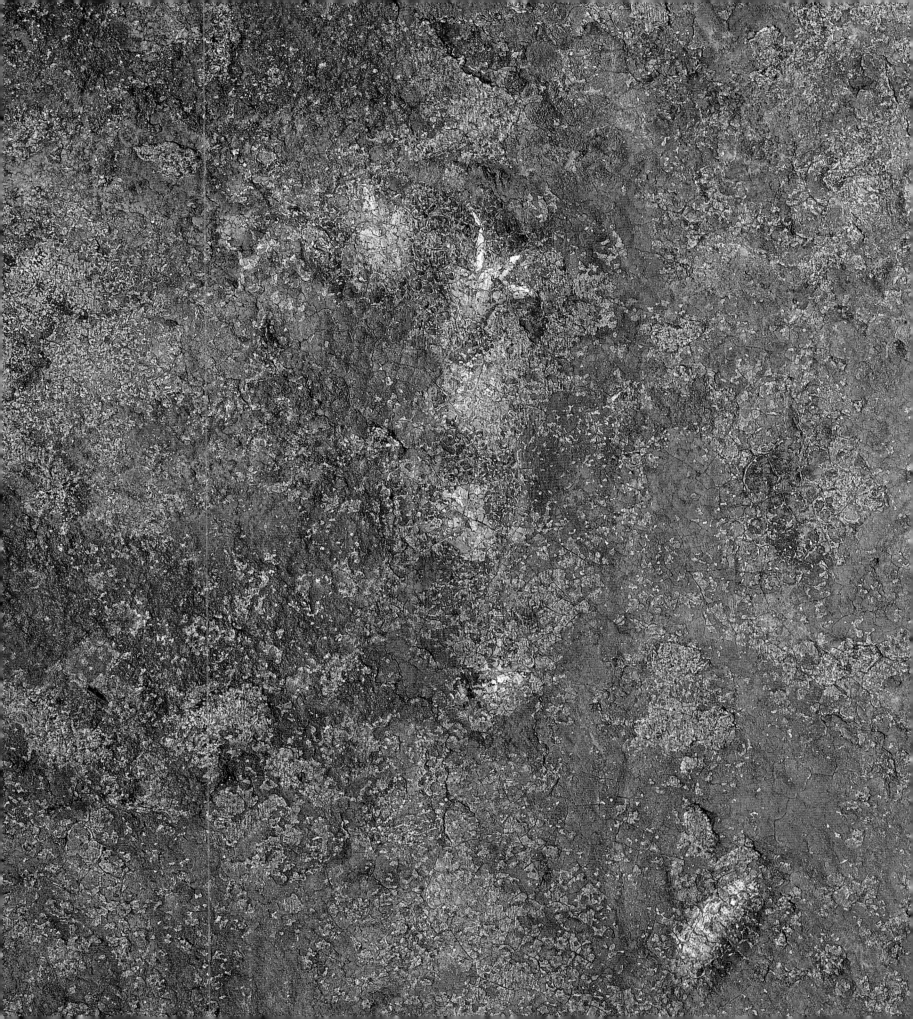

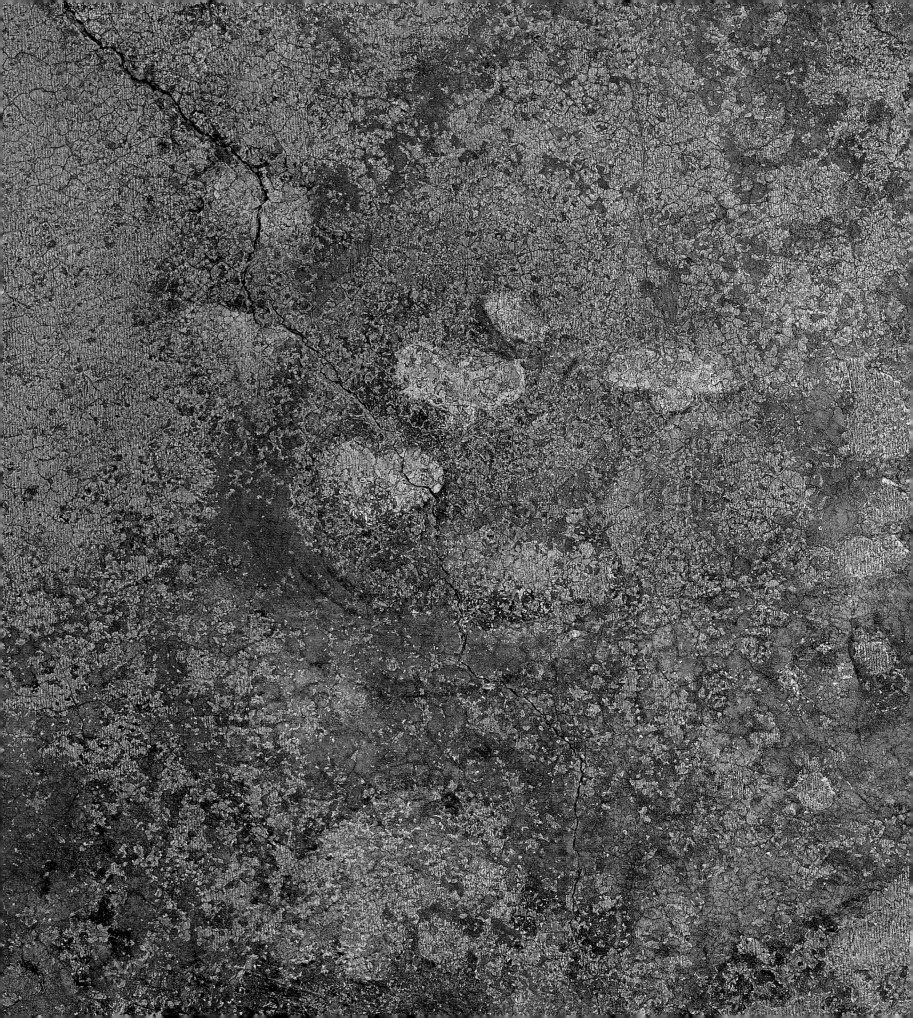

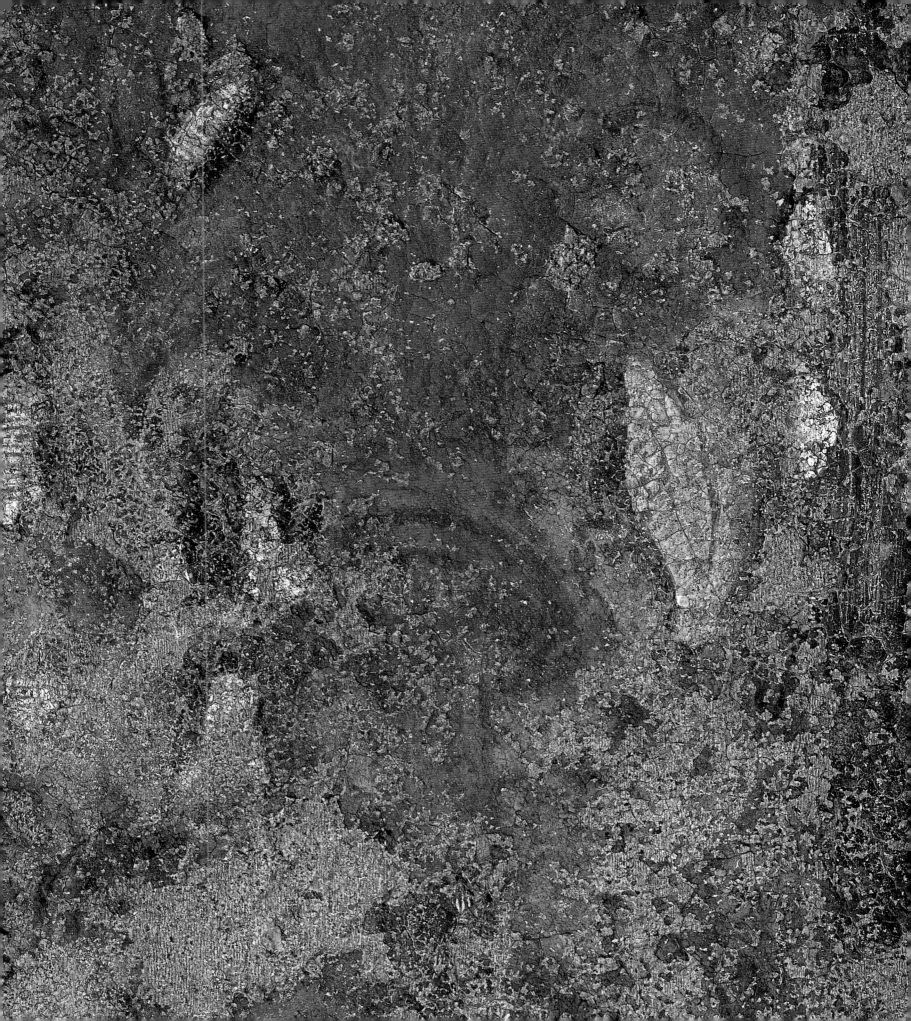

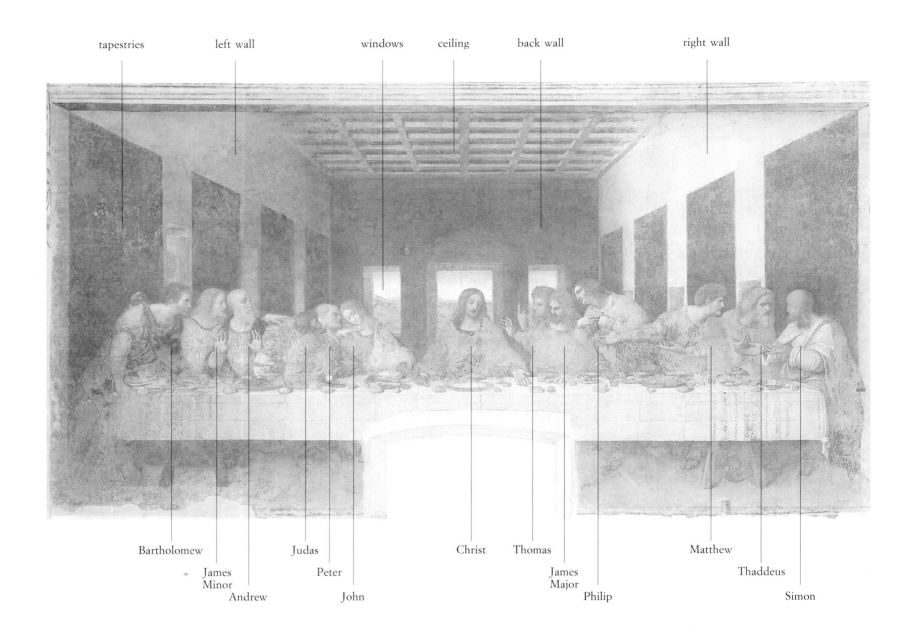

tapestries left wall windows ceiling back wall right wall

Bartholomew Judas Christ Thomas Matthew

James Minor Peter James Major Thaddeus

Andrew John Philip Simon

The Restoration

Pinin Brambilla Barcilon

with the collaboration of
Licinia Antonielli
Laura Bellani
Pierangela Formaggini

Introduction

For centuries our grasp of the *Last Supper* has been hazy, obscured by myth and rather mystifying beliefs arising from the work's universal appeal. This, as well as the painting's profoundly innovative realism, has bequeathed to us an *idea* of the original work. The story of the *Last Supper* is well known: the various copies and the copies of copies that over the centuries tried to reconstruct the famous work. Publications and eyewitness accounts have documented the condition of the *Last Supper* again and again, like a dramatic chronology that measures the slow, progressive death of the masterpiece. Finally, there have been many restorations, some of which exhibit what is probably the temptation—conscious or otherwise—to substitute oneself for Leonardo's genius.

The tragic fortunes of the commission, born—literally—under the emblem of Ludovico Sforza, hardly allowed time to glorify Il Moro's greatness: "The duke lost his state and possessions, and no work was finished for him." Advised to "extinguish the fires at Le Grazie," Leonardo left Milan at the end of 1499.[1]

One can only wonder: how many people actually had the opportunity to see the *Last Supper* in an unspoiled state, and for how long? Leonardo was still alive when his masterpiece began its inexorable decline. Nevertheless, Vasari's words ("non si scorge più se non una macchia abbagliata") manage to convey the magical luminosity and the ethereal atmospheric quality that still emanate from the work and that

we continue to seek in the parts that survive.

When today's restorers approach the *Last Supper*, they treat it as if it were a great invalid undergoing consultation, thanks to advanced technology, developments in Leonardo studies, and the discovery of previously unknown accounts. Filarete (Antonio Averlino), the fifteenth-century Florentine sculptor, architect, and art critic, declared, "I will show you that buildings are just like living men, and you will see that they need nourishment in order to live, just like men; they get sick and die, and often can be healed when sick through the offices of a good doctor." As everyone knows, the *Last Supper* "became ill" only a few years after its completion. Old accounts speak of at least six restorations, which can now be identified, analyzed, and evaluated on the tortured, altered surface of the painting.[2]

While prior restorations were based on the scientific and technical information then available, they were also guided by fluctuating and evolving theories of taste and culture. Up to and throughout the nineteenth century, the concept of restoration was identified with repainting. Conscious respect for the original work did not arise until the beginning of the twentieth century, when restoration became an act of conservation and "historical intelligence."[3]

The *Last Supper* has miraculously endured until our time, but with few certainties and endless mysteries. The responsibilities and conservation challenges presented by such a work often went hand in hand with frustration over the countless baby steps involved

in the effort. Working scientifically on the *Last Supper* was a privilege that involved rigorous and exacting discipline. Each day proved a new and engrossing experience, but one inevitably grounded in caution and reflection, confirmation and consultation. The daily work journal we kept detailing each operation provides a collection of data and information highly valuable for further study.

The "patient" has been undergoing treatment for more than twenty years. There are no quick cures. While the restoration has produced positive results, it has also forced us to confront the painful truth that much of Leonardo's original work is irrevocably lost. We take comfort, however, in the many discoveries that have emerged from our patient, painstaking labors. The most important of these is the restitution of a more accurate pictorial text, resulting from the kind of care usually reserved for panel paintings.

I want to thank Renzo Zorzi, who has always supported me during this long odyssey; and Stella Matalon, Carlo Bertelli, Rosalba Tardito, Pietro Petraroia, Bruno Contardi, Giuseppe Basile, Lidia Rissotto, and Pietro Marani, all of whom supported me during the final and most complex phase of the project.

Past Restorations

The *Last Supper*'s age-old woes, which began only a few decades after its completion, and the fear of losing such a universally prized work of art prompted two responses: the production of

copies and the execution of restorations. The *Last Supper*'s fame and its immediate influence in the art world contributed to the creation of a mythic aura that must inevitably have induced a sort of reverential awe in restorers entrusted with the job of "touching up" the masterpiece.

It was no easy task to distinguish the various restorations on the painting's muddled, darkened surface, even though a study of historical and literary accounts accompanied direct examination of the work.[4] The ravages of time, including condensation, a physiological phenomenon whose damaging effects were augmented by the work's component materials, proved no less serious than the havoc wreaked by restorers, who in some cases showed precious little respect for the original image. The various attempts to save the *Last Supper* often layered damage upon damage by superimposing one incompatible material on another. These range from corrosive detergents used to clean the surface to varnishes and oils used to revive the dulled surface, and from adhesives used at the beginning of the twentieth century to stabilize the work to a refined shellac diluted in alcohol used to consolidate it in 1953. Solvents, resins, waxes, and animal glues were used at various times in the ongoing attempt to save the painting. The most serious alterations occurred during the two massive eighteenth-century restorations, which were actually repaints billed as "aesthetic maintenance" for the masterpiece.

No documentation survives regarding restorations before the eighteen cen-

5. Diagram 1. Cracks running
across the surface of the painting;
from a contact plotting in 1:1
scale.

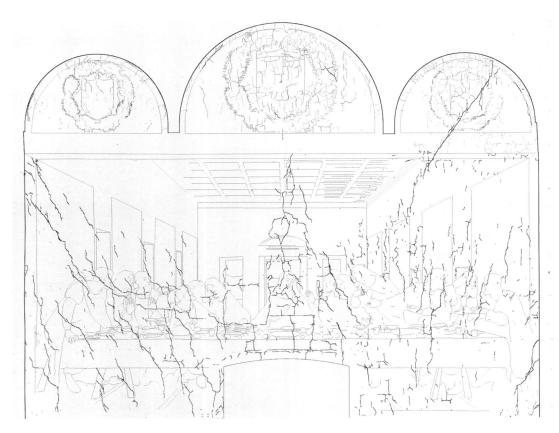

tury, even though earlier accounts of the work's deterioration do exist. While historical sources date the first restoration to 1725, older interventions came to light during the recent restoration. These earlier operations were probably intended to remove dust bound to the surface by water condensation. The construction of a door in the middle of the wall in 1652, as well as other tampering, probably occasioned further interventions.

Certain theories posited during our initial examination of the painting were, by the end of the restoration, proven to be true. Although the many restorations show significant differences in working methods and materials, it is difficult to

date them accurately because the tonality in certain areas may be attributable to color changes in the repaint, to the restorer's imitation of previously darkened tones in contiguous areas, or to the prevailing taste of the period.

The application of a dark paint of a thick, granular quality perhaps dates to the last decades of the sixteenth century. Its purpose was probably to remedy the large lacuna in the upper part of the ceiling, which had appeared because the colored preparation failed to adhere to the smooth intonaco. Two later coats of opaque gray paint completely distorted both the composition and its original colors (see fig. 1).

Some restorations were stylistically

faithful to the original image and were undoubtedly based on direct accounts. For example, the repainted green mantles of Bartholomew and Andrew and the two finely restored fingers of Andrew's left hand betray the skill of a consummate restorer. Here the losses were subtly concealed by imitating the surrounding original color. This careful intervention also repaired all the losses of green paint in the mantles of Judas and Thaddeus and in James's robe. Probably executed during the second half of the seventeenth century, this restoration shows dense cracking, but not the physical color loss typical of the eighteenth-century interventions. It was partially executed on a black base, with a pigment composed of green, copper, and antimony yellow, and an oily binding material.[5] In some areas it had been applied over red *stuccature* (plaster or mortar-based material used to fill lacunae) and covered the only surviving passages of original green pigment. Leonardo's original green pigment was not found beneath the other areas with green repaint and had undoubtedly been removed during prior restorations.

Stuccatura composed of white, large-grained mortar seems to be the primary material used to patch the large lacunae in Christ's blue mantle (see fig. 70) and in James's robe, which may have been ruined soon after it was painted and subsequently concealed under three repaints. The black *stuccatura* appear to be the work of eighteenth-century restorers.

In 1725, the restorer Michelangelo Bellotti worked on the *Last Supper*,

most likely damaging the entire surface, which was already fragile and weakened by humidity. He cleaned the surface with soda or caustic potash and then varnished the painting with oil to attenuate the opacity caused by the solvent's corrosive action.[6] Bellotti dealt with the problem of missing areas by trying to reestablish a logical continuity, heavily coating the work with an opaque, dull color, deposits of which remain in the spaces between the flakes of original color. He restored the painting with hurried, simplistic facility, broadening the outlines of the apostles' faces, sketching in Thaddeus's eyes with a single dark diagonal stroke, and giving Matthew a beard (see fig. 84).

We do not know Bellotti's reason for employing different techniques in different areas of the painting. He added casein to the gray pigment used for the floor and the left wall and to the light-blue pigment used for garments, tablecloth, and landscape, causing his repaint to adhere tenaciously to the surface. The same pigments used in other areas, such as the tapestries, were easier to remove, suggesting that casein was not added for those sections. Bellotti's repaint is easy to identify, because a half century later the restorer Giuseppe Mazza stopped working at the third group of apostles, leaving the three figures to the far right untouched. This allowed us to compare the techniques of the two eighteenth-century restorers.

When Giuseppe Mazza repainted the *Last Supper,* he preserved the previous restoration, but his approach was more descriptive and detailed, as is apparent

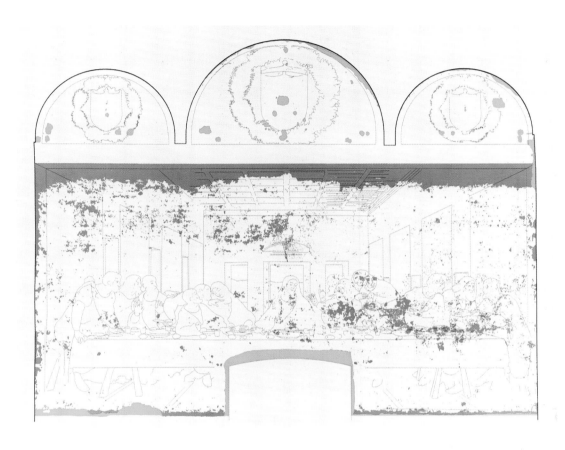

in the head of Judas. Mazza's retouching was not limited to the lacunae, but extended to the painting's composition. The effect contrasted sharply with that of the earlier restoration, because Mazza used broad brushstrokes loaded with color, which later altered significantly (see fig. 3). He applied the material thickly, and it took on an almost glossy look owing to the superimposed oils and varnishes.[7]

Stefano Barezzi's intervention of 1821 is clearly distinguishable and well documented. His task was to evaluate the feasibility of performing a *strappo*, meaning the complete transfer of the work to canvas, by conducting a sam-

ple test. He carried out his test on the right hand of Christ, which still exhibits the minute fragmentation typically caused by *strappo* operations.[8] Furthermore, Barezzi defaced a part of the tablecloth below the figure of Christ, making incisions for either a *strappo* or a restoration test. He filled the lacunae in this area with wax, which yellowed, and covered it with a layer of tempera color. In some areas this treatment looks transparent because of subsequent cleanings (see fig. 170).

Past restorations are not limited to the ones just cited. Materials and methods have been detected that are not compatible with the episodes de-

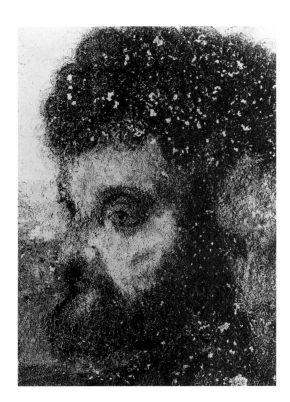

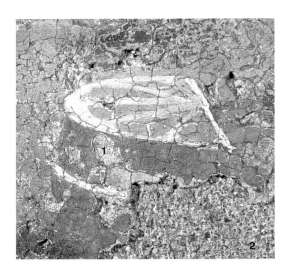

scribed, generating new conjectures about the painting's history. For example, intriguing color residues were discovered at scattered points under the oldest white *stuccature* applications, which lie directly on the intonaco layer, suggesting that the repaint was applied exclusively in lacunae. This restoration was evidently removed during the eighteenth century. The reconstruction of one of Andrew's eyes and one of Peter's eyes does not correspond to either Bellotti's or Mazza's restoration. Coarsely repainted over a layer of brown *stuccatura*, its different workmanship denotes another restorer. Other hands can also be discerned in two cursory repaints of the tablecloth's ornamental motif, the first executed in a green granular color, and the second in an intense blue mixed with casein.

The endless restorations to the painting's tortured surface, up to and including the one in 1953, were not limited to consolidation treatments or repairing lacunae. They also removed areas of prior repaints, hindering the formation of uniform strata, which would have made it possible to identify the individual restorations. Furthermore, because many of the restorers left no written records, lingering doubts necessarily surround surviving testimonies.

In the three documented restorations of the twentieth century—performed by Luigi Cavenaghi (1903–8), Oreste Silvestri (1924), and Mauro Pellicioli (1947–54)—the prevailing concern was to conserve the surviving material. The first remarks on the work's condition appear in the archives during this time and were increasingly at-

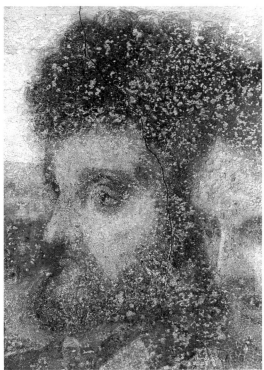

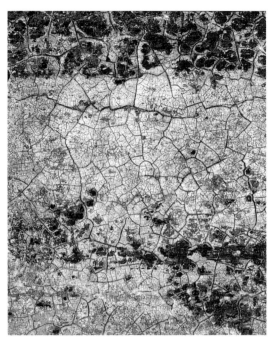

11. Photograph shows damage from compression of the pictorial film by a spatula: there are fractures at several points, and in places the original flakes of color have slipped from one point to another on the surface of the painting.

12. Detail of the left side wall showing large cracks in the preparation layer and finer cracks on the imprimatura.

13. Detail showing dirt covering the surface of the painting and adhering to rough spots. There are also cobwebs.

tentive and detailed, although they shed little light on the materials employed for consolidation and cleaning treatments. It is easier to identify Luigi Cavenaghi's watercolors, which he used in lighter tones than the original color, to restore the lacunae, for example on Philip's light-blue sleeve. Called in to remove the glues used by his predecessor, Cavenaghi declared that he only intervened pictorially in the areas with lacunae.[9]

Oreste Silvestri and Mauro Pellicioli seem to have interpreted the concept of reintegration differently. They both used "neutral" (*neutro*) temperas, in both cool and warm tones. Before the pictorial integration, Silvestri consolidated the color with injections of a fixative composed of "an adhesive resin dissolved in mineral oil and added to wax." He concluded the operation by "ironing" the surface with hot iron

rollers, and finally with a rubber roller. Even if extremely difficult and risky, this treatment seems to have conferred new consistency and vivacity to the color.[10] In 1947 Pellicioli partially removed prior restorations, working principally on the flesh tones with turpentine, alcohol, and scalpels. He skillfully succeeded in maintaining a balanced appearance for the entire work.[11]

It should be noted that in the nineteenth century, an "antiquarian" tradition of restoration was popular. This consisted of intensely cleaning only the light and lighted areas, with the aim of "making them resonate" in contrast to the dark areas, which were ignored by the restorer. While one cannot tell from past restorations the intentions of individual restorers, they do allow us to trace the history of taste and restoration criteria as well as the technical achievements of the time.

1977: State of Conservation

Initially the *Last Supper* seemed scarcely legible due to an overall, uniform darkening. The painting's uneven, rough surface was covered by dust and altered repaints, which had been layered over the lacunae and the original, but thin and abused color. Within the refectory, the wall of the *Last Supper* endured the most mistreatment—the victim of events Giuseppe Bossi defined as "the *Last Supper*'s misadventures."[12]

The most worrisome problem was one of statics. The thrust exerted on the wall by the vault, which had been reconstructed after the damage incurred during World War II, was not counterbalanced. It was further modified by the force exerted by the adjacent buildings, whose original positions had been altered. This perhaps caused the first splitting, mostly on the rear of the wall, and distorted its unusually narrow

14. *Deposits of dust, accumulated along the upper edge of the color scales where they meet gaps in the painted surface.*

structure, which was not scarfed with the east wall, also reconstructed after the war. In fact, a noticeable disjunction is visible along the edge of the joint between the two walls, and a crack still runs in the northeast corner from the right lunette to the central lunette.[13] Not all the lesions affect only the back of the wall, as some follow a different course and involve the painted facade.

Actual mutilations predated the statics problems. Around 1652, the door in the center of the wall was created, destroying the area representing Christ's legs and further impairing the wall structure. The person or persons who ordered the construction work may have considered the *Last Supper* irreparably compromised, if not already lost.[14]

The intonaco supporting the scene of the Last Supper differs from that of the lunettes. The former is rough and characterized by large granules, while the latter is smooth (see fig. 190, diagram 12). Moderate loss of adhesion was detected between the intonaco and the wall support along the edges of the fissures. The painted surface was crisscrossed by a web of vertical and horizontal cracks, appearing as black marks where dust had been absorbed—almost invariably affecting the preparation, even undermining the intonaco.

In certain areas the cracks correspond to cracks in the wall structure, but then break off and recommence in different directions. The bombing of 1943 caused the cracks to widen, as a comparison with prewar photographs demonstrates (see figs. 7–8, with regard to the figure of Thomas). Some diagonal fissures are localized at the

[left]
16. Materials used to reattach the paint are clearly visible on these pinkish flakes and in the lacunae.

[middle]
17. Detail of the tapestry showing superimposed layers of black and red patching.

[right]
18. The same detail, after the patches were removed, showing underlying wax stopping up a nail hole.

lower left, while above the door a large horizontal crack crosses the bust of Christ in a broken line. On the right side the cracks are more numerous near the lunettes (see fig. 5, diagram 1).

The entire surface contained numerous small holes caused by the insertion of nails.[15] The preparation layer, spread about 100/200 microns thick over the intonaco, was characterized by a slightly yellowish cast, caused predominantly by the infiltration of various restoration materials. As the preparation is very porous by nature, it is particularly sensitive to humidity, which encourages progressive detachment, making the preparation layer the painting's "weak point."

The primary cause of the *Last Supper*'s dramatic condition is its defective adhesion. The material detached without lifting, as can be seen by the rapid absorption of any liquid that is applied to the color. Cracks formed because of contractions involving the entire structure, most noticeable on the surface, but there were also cracks beneath it. The cracks appear in broader web patterns in the upper part of the work. Material losses were manifested in different ways, in fragments involving all the layers or sometimes only the final one.

The entire surface exhibits numerous losses. The most obvious problems involve the upper band where the preparation was applied in very thin layers over extremely smooth intonaco, which provided a poor surface for the adhesion of successive layers. Particularly interesting are the losses that, taken together, form a discontinuous band across the right part of the painting horizontally at the height of the figures. This is visible in the figure of James Major, whose robe has been completely lost. Losses caused by perforations, in addition to those cited, are indicated in diagram 2 (see fig. 6, diagram 2).

The depth of the white imprimatura, spread over the entire surface between the preparation and the color layer, varies from 10 to 30 microns. Generally its fate was the same as that of the preparation, and it is exposed along the edges of the flakes of color. It is particularly fragile and unstable, and characterized by very fine cracking.

The original color and the superimposed repaints must be considered separately. Only a few years after the com-

[upper left]
19. Oreste Silvestri signed his name to this stuccatura during his restoration in 1924.

[lower left]
20. A stratigraphic view showing three separate, superimposed layers of plaster of different colors.

[right]
21 Some fragments of the original bright blue are covered by a compact layer of plaster.

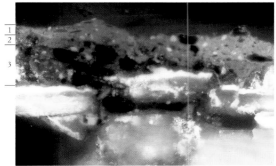

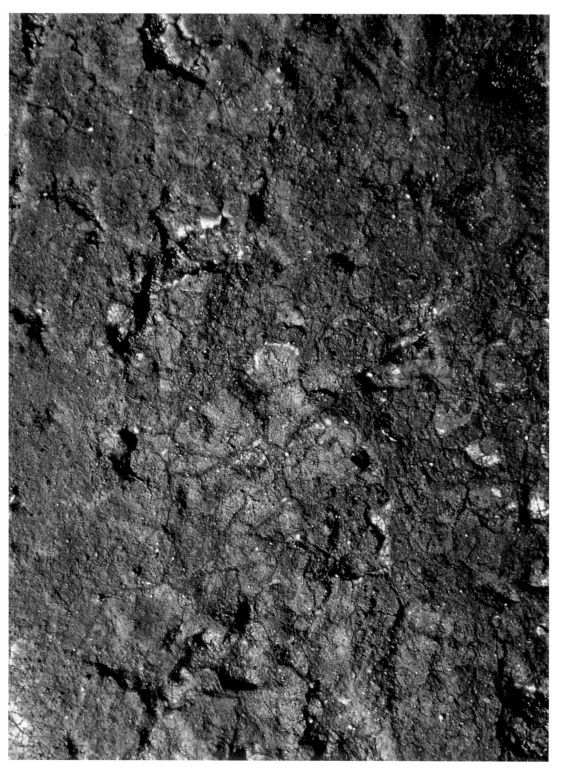

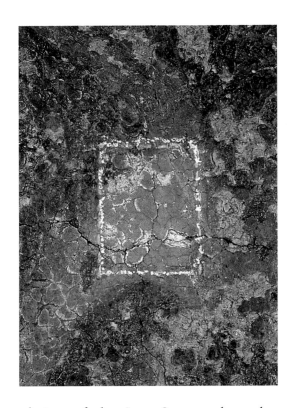

pletion of the *Last Supper*, the color displayed considerable lifting and paint losses.[16] Humidity caused particles of color to separate from the underlying layers, at times lifting and pulling away the imprimatura and the preparation (see fig. 9). The greatest losses are concentrated in the dark, shadowed areas of the painting, which were built up via many coats of paint. Attempted remedies only aggravated the situation, as the traction exerted on the original color by glues and adhesives caused further damage, especially in the repainted areas.

Francesco Maria Gallarati witnessed the results of the final, ill-fated attempt to repair the damage caused by humidity.[17] Intense, uneven pressure was exerted over the entire swollen surface by means of repeated "ironings," in-tended to dry the condensation and prevent the color from flaking. Initially the treatment caused the pictorial film and imprimatura to form furrows in the preparation. Then the paint flakes detached from the wall, leaving an imprint of their form, still visible today (see fig. 10).

The damage caused by compressing the pictorial film using spatulas and other mechanical means is characterized in different areas by the fracturing of flakes of original color and their shifting positions on the surface (see fig. 11). A magnified view shows that some flakes of color are now superimposed or have shifted over different color areas or lacunae. This forced consolidation method also abraded the edges of flakes. The damage, visible even to the naked eye, is corroborated by the exposed imprimatura. Not all abrasions exhibited the same degree of damage, and some lesions were limited to certain strata and so did not compromise the recovery of underlying color. More often, however, the damage was so extensive that the yellowish preparation is exposed.

In general, the painting exhibits a complex and irregular network of cracks caused by contractions of the preparation layer, and can be divided into two types. The cracks that cross the entire pictorial layer are broad and irregular, while those affecting the imprimatura are very fine (see fig. 12).

As early as 1517 Antonio de Beatis blamed humidity for the painting's deterioration. The humidity was largely caused by the wall's location, and Leonardo's pictorial technique proved

338

particularly vulnerable to the dampness. According to Fernanda Wittgens, in the seventeenth century both the environment and Leonardo's technique were seen as dual sources of the mural's ills.[18]

Simple observation verified the presence of an unthinkable amount of material superimposed over the original pictorial surface and penetrating the interstices of the flakes of color. A more obvious, superficial layer of dust, exacerbated by recent environmental pollution, had darkened the painting, making it cloudy and illegible (see fig. 15). Below the dust, an even thicker layer of grime had been consolidated by prior interventions. Analyzed under the microscope, it took the form of dark deposits in the center of the flakes of color. Dust had infiltrated deep into

cracks or was deposited thickly on the upper edges of areas of original color bordering lacunae (see fig. 14). Trapped by fixatives and solvents, the dust conspicuously outlined the cracks. Microscopic examination and analyses also identified the growth of various kinds of mycelia on the pictorial surface.[19]

The various materials used to stabilize the surface were of different thick-nesses and each altered the color dissimularly (see fig. 16). The shellac used by Pellicioli and the Istituto Centrale per il Restauro after the war had yellowed slightly, but without damaging the color. Sometimes the superimposed residues of earlier glues had caused a *strappo*-like action on the underlying paint fragments. In the zone of Christ's hands, wax was discovered that had been used both as a fixative and to fill lacunae.

Stuccature had been applied widely and often, in areas lacking color and as a consolidant along the edges of precarious flakes of color. The densest concentrations were found on the architectural background, while the most visible appeared in a large area of Bartholomew's robe, where five super-

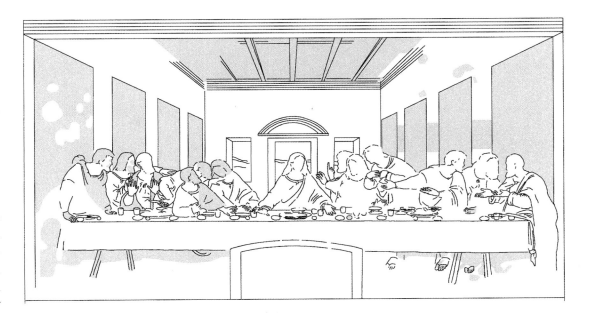

imposed layers of different colored *stuccature* (black, red, brown, gray, and white) were identified (see fig. 161, diagram 9). The dark sleeve of Matthew's robe was the recipient of another conspicuous *stuccature* treatment. Among the numerous and varied restorations, the only *stuccatura* that was unquestionably identified was applied by Silvestri, who carved his name and date, 1924, into its surface (see fig. 19).

Original color could sometimes be identified under the materials that had deposited in the lacunae. It was difficult to read the painting as a whole, however, because the images seemed flattened by the many layers of dark, or at least opaque, extraneous materials. Where conserved, the variations of tone and timbre used by Leonardo to represent volume and articulate depth were no longer legible. The dark, opaque areas lacked transparency and depth, the chromatic contrasts were diminished and even completely erased, and the composition was deprived of meaning and detail.[20]

Methodology

Information generated by a range of specialized examinations, along with historical evidence, was used to determine the best course of action for dealing with the *Last Supper*'s problems. The principle objective of the examinations was to evaluate the painting's condition, which appeared distressed and varied, and to identify the original material and distinguish it from the stratified substances of numerous restorations.

The methods chosen were based on the work's various levels of conservation.

That process distinguished areas that called for the preservation of repaint as historic testimony of significant events, other areas that could be partially cleaned, and others still that promised certain recovery of original color. Ultimately, the restoration had to guarantee the recovery of expressive values in the best-conserved details, as well as a coherent vision of the work as a whole.

Interventions

Adhesion

The surface of the *Last Supper* was carefully examined through a surgical binocular microscope, a procedure crucial to the initial phases of the restoration. Next, limited cleaning tests were conducted to evaluate how many times, and where, the original work had been repainted. Repaints related to loss of original color were immediately identified so that they would not be removed.

It was determined that the pictorial film had suffered greatly in terms of adhesion to the wall support. The entire, uneven surface was composed of endless small islands of color, which had become deformed and concave. The edges had lifted where superimposed substances—such as glues and varnishes applied during prior restorations—had thickened and exacerbated the cleaning of the original surface.

The first task was to analyze and document this lifting of the paint layers concentrated in the upper region of the painting. To re-adhere the fragments, we used wax-free shellac in alcohol, the same adhesive Pellicioli applied during his intervention of 1947.[21]

Removal of Restoration Varnishes and Altered Repaints

It was difficult to identify the original pictorial film, as it was buried under numerous layers that had condensed into a sort of thin skin, mainly com-

posed of filmlike substances. We first attempted to clean the work near the figure of Simon, in areas where the original color was believed to be largely intact. The solvent's action was monitored under the microscope.[22]

Varnishes and layers of repaint were removed in a nearly uniform manner. The solvent was applied to the surface with small pieces of Japanese paper and was adjusted after trial tests, allowing us to control its action according to the length of application.[23] The substances were removed as they dissolved (see figs. 22–24), and the treatment was repeated at intervals until the original material was uncovered. In places where oleo-proteinaceous substances had accumulated because of the concave form of the flakes, the solution was applied with a brush tip and removed manually (see fig. 26).

Repaints of different consistencies were noted during the operation. Some dissolved and were easily removed (see fig. 25), while those associated with older interventions proved exceedingly tenacious and invasive, and quite difficult to remove given their casein base (see fig. 27). In such cases as the mantles of Christ, Matthew, and Philip, the repaint had been applied in areas with lacunae and had been partially absorbed by the preparation, making it impossible to remove completely.

That different fixatives had been used during the various restorations presented considerable difficulties, because they had deposited along the edges of the lacunae or in the lacunae themselves. Layers of dust had adhered to the substances, proving more tenacious than the flakes of color on which

they rested. Some fixatives were absorbed by the preparation, turning it an intense yellow (see figs. 28–30). A layer of wax beneath the figure of Christ was removed mechanically,[24] along with the abundant *stuccature* overflowing from the lacunae and clinging tenaciously to the original pictorial film. Cleaning the left half of the painting was even more difficult. It had been densely and coarsely consolidated with *beveroni*, or swills of organic, oily adhesives that covered the small, fragmented flakes of the pictorial film.

The recovery of surviving original paint was particularly difficult in areas of the painting weakened by interventions more damaging than reparative, resulting in a slow, arduous conquest, centimeter by centimeter. As the work progressed, original passages with intense color values often contrasted with stratified repaints that had turned brown or yellow. Despite the difficulties and problems, the cleaning yielded singularly important discoveries and exciting results, especially in the details. In many cases, the cleaning recaptured the volume and expressive intensity of the figures, believed to have been irrevocably lost.

Reintegration

Achieving a balanced coherence for the entire image represented a formidable challenge. From a purely visual standpoint, the color losses, the lacunae, the pictorial surface's irregularities, and the conspicuously yellowed preparation and white intonaco added up to a problematic and complex situation.

Where the pictorial film was missing, the initial procedure was to reintegrate

the image based on neutral tonal reduction (*neutro*), intended to create an ideal background of homogeneous color for the original fragments. In the interest of achieving greater legibility and unity, a method of reintegration that approximated the surrounding color was adopted later. Executed in watercolor, the reintegration was particularly laborious and delicate because the surface absorbed the color unevenly, requiring repeated applications and a gradual buildup of tonal intensity.

Portions of the painting had been irretrievably lost. But these were counterbalanced by the recoveries, discoveries, and information gained by the restoration, along with the restitution of a more reliable image. Not only was the original color recovered, but also the clarity of the architectural structure, the perspective devices, and the physiognomies. The faces, burdened with grotesque features from so many restorations, again manifest a genuine expressiveness, opening new paths in art historical research. Now the faces of the apostles seem to genuinely participate in the drama of the moment, and evoke the gamut of emotional responses intended by Leonardo to Christ's revelation. The image of the *Last Supper* today is far removed from the stereotype to which we are accustomed.

Documentation

An important part of the restoration program was to generate extensive graphic and photographic documentation using different methods. Black-and-white photographs and color slides prove that the pictorial surface was carefully monitored before, during, and after the restoration. Each image presents a portion of the painting that was photographed at different stages of the process. The smallest details were documented in raking light and, when necessary, using macrophotography.[25] As much information as possible was recorded and organized graphically in order to clearly identify the surviving original material, and the extent and severity of the effects of time.

Precise visual maps were developed from plots traced on acetate sheets. This technique revealed the outline of the images, the damage and holes caused by nails, the extent of missing preparation and pictorial film, and the exposed intonaco. All the tracings were then compared with photographs, scanned, vectored, and stored in a computer database.[26] Other plots document the numerous *stuccature* applied at different times to various areas of the *Last Supper*, as well as the incisions Leonardo made in the plaster to define the painted environment's pictorial space.

The hypothetical diagrams reconstructing missing areas proved useful in identifying the original composition, which had been altered by the many restorations. In particular, our hypotheses dealt with the design and color of the wall tapestries, the tablecloth's decoration, and the different vessels and their arrangement on the table.

The original perspective solution was also reconstructed, revealing a discrepancy between it and the coffering that now articulates the ceiling of the *Last Supper*'s spatial environment. The room's original proportions proved quite different from what we have always believed, based on repaints now revealed as arbitrary and unfaithful.

The Architectural Space The architectural space of the *Last Supper* frames the dramatic moment in which Jesus prophesies, "One of you will betray me." The setting is at once simple and complex. The "action" unfolds in a room with three walls: the right wall, which is the lightest, is illuminated by a light originating from the opposite side; the left wall is darker, as if in shadow; while the back wall, the darkest, is tempered by a central trabeated portal and two lateral windows. The ceiling is coffered. Four rectangular panels decorated with a red and green damask motif are located on each of the side walls. Doors that open slightly in the direction outside the room occupy the wall space between the panels and behind the apostles.

The complexity of the architectural space was evaluated, section by section, both prior to commencing the restoration and upon its conclusion.

Right Lateral Wall

Concentrated on the right lateral wall, heavy repaints had unified the pictorial material into one muffled, smoky field of dark color. The entire surface bore the signs of treatments with consolidants, giving it a translucent appearance.

In the upper portion, a strip measuring about twenty-five centimeters clearly showed an almost total loss of pictorial matter, caused by lack of adherence between the preparation and the underlying smooth intonaco (see fig. 6, diagram

[upper]
34. A sample block untouched by cleaning shows the state of conservation of the surface before the current restoration.

[lower]
35. In the portions of the wall painted between the tapestries, a higher chromatic density shows a perspective line converging on Christ. It is symmetrical with the architraves of the painted doors on the left wall.

2). Traces of a disjointed restoration in this area had been covered with a transparent glaze, probably during a twentieth-century restoration. Nails hammered into this area had caused further damage. Both walls suffered from widespread microscopic losses in the form of minute flaking. This problem had persisted without solution until Pellicioli's restoration.

The lightest area of the right wall revealed two overlapping restorations. The most recent and superficial one, distinguished by its heavy, opaque appearance, was easily removed. The older one proved more tenacious and had been executed in lime-based colors. Given the painting's general condition, the older restoration was preserved in the areas with lacunae, because removing it would have emphasized the yellowed preparation, creating a harsh chromatic incoherence. Once the repaint on the far left of this wall had been removed, a shadow appeared on a vertical strip measuring about thirty centimeters, at the point where the side wall meets the back wall. It had been painted with a *sfumato* effect graduating from light blue-gray to white. The *sfumato* shadow effect repeats on the coffered ceiling, where traces of darker gray were found under the painted architrave. Lines discovered on the right wall between the tapestries are also particularly interesting. Distinguished by greater color saturation, they are laid out according to a perspective line that converges toward Christ. In fact, the lines prove to be symmetrical with the doors painted on the left wall (see fig. 35).

The pictorial restoration tried to attenuate the abundantly visible yellowish preparation with a glazing of cool tonality that harmonized with the surviving original color. The final result was enhanced by the discovery of a pale, luminous color that made the spaces between the tapestries, where three molded wood doors open slightly behind the figures of the apostles, more legible.

Left Lateral Wall

The left wall is cast in shadow and has the same characteristics as the right wall, but before the restoration the darker tonality and numerous repaints had obscured the three painted doors. Their presence is documented by the oldest copies of the *Last Supper*, such as those at Tongerlo Abbey near Antwerp and Magdalen College in Oxford.[27]

The cleaning removed two layers of opaque color that had virtually flattened a surface that is actually quite uneven owing to its many losses. In the upper area of the painting, an intriguing series of close-set incised perspective lines were uncovered that do not correspond to Leonardo's final plan. Etched into the surface with a sharp instrument, three groups of nine or ten transverse parallel lines begin at the dark gray band of the architrave and, like the more intense bands of color revealed on the right wall, are directed toward the figure of Christ, where the vanishing point for the entire composition falls. Traces of five other groups of incisions, each composed of ten or eleven lines, cross the entire wall hori-

[upper]
36. *Detail of the left wall in the painting before restoration. Repaints had obliterated the three doors painted between the tapestries.*

[lower]
37. *The same after restoration.*

zontally and appear below the tapestries where the preparation shows through (see figs. 38 and 39, diagram 4).

The spatial plan defined by this incised grid seems to refer to an early compositional idea, which called for the coffered ceiling to occupy all of the upper area of the scene. The lines therefore disclose an initial project characterized by a perspective plan with less depth of field and a shallower space. The pictorial surface was also manipulated more here than in other areas.

The cleaning confirmed the presence of doors between the panels of damask fabric as well as significant passages of Leonardo's original tapestries as they appear in the oldest copies. The search proved difficult, however, because the area below the superficial layer of gray tempera repaint was barely legible. It had been largely erased by old, lime-based dark gray or brown repaint, discovered in other areas of the painting as well. The restoration material's tenacious grip on the flakes of fragmented color, as well as the spaces between the flakes, made it difficult to eliminate.

The first door on the left was recuperated, which opens outward and is lighter and more luminous than its counterpart in the right wall. The door's decorative molding, which probably simulated different wood grains, is embellished at the center by a clypeus motif in light tones ranging from rose to burnt browns. The inner surface of the upper part of the doorway also reemerged during restoration, illuminated by a light source from the left.

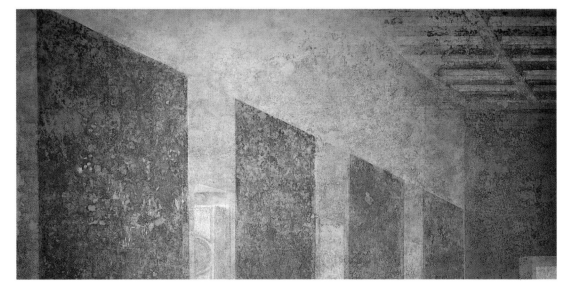

All these details are faithfully reproduced in the copy at Tongerlo Abbey.

Another surprising discovery in the lower part of the door was the incision outlining Bartholomew's halo, composed of a fragmented, delicate gold line applied with a brush. Results relating to the two other doors in the left wall were less significant, as their condition was poor. Sporadic microscopic flakes of original color appear on both doors, but differ from them, suggesting the presence of molding.

The fragility of the dark color used as the base for the tapestries' decoration perhaps contributed to their compro-

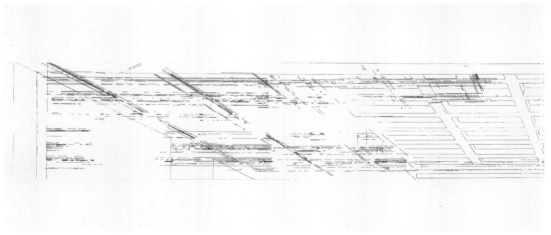

mised condition. Above the nonoriginal pictorial film, close examination revealed a heavy layer of particulate matter and a shiny film composed of glue and fixatives, which had induced localized flaking of the paint layer.

Microscopic flaking continued uninterrupted until this restoration, and was concentrated in the upper areas. The prior restorations had treated the small-scale, widespread color losses using materials of unmodulated color. The first tapestry on the left exhibited obvious, small applications of *stuccature* in dark gray and red, as well as other older, more extensive treatments composed of white mortar.

Leonardo's original design and color for the tapestries had been profoundly altered over time.

In 1725 Bellotti removed almost all the original paint, perhaps in the belief that the decoration was of secondary importance, and repainted the tapestries according to his own taste, borrowing a damask decoration from the second half of the sixteenth century (see figs. 40 and 43, diagram 5).[28]

Mazza's modifications of 1775 clashed with Bellotti's repaint, and he ended up interpreting the hangings as tapestries set into the wall.

What little remained of Leonardo's tapestries were ephemeral traces around the heads of the apostles and Christ, but a bit more survives in the first tapestry on the left.

The surface cleaning was limited to eliminating adhesive residues and lightening recent restorations. This revealed, on the right wall, rings and support hooks for the tapestries, as well as a

short fringe on the textiles' edges, a precise black-gray line painted on the white background with brush tip (figs. 41–42). The fragments that emerged in the area between the faces of Simon and Thaddeus proved even more significant. Although the flakes of color were abraded along the edges from numerous cleanings and consolidations, two small groups of red and blue flowers stand out against the black background.

More color was found under the layered repaints and *stuccature* on the left wall, the right edge of which was outlined by a dark band of uncertain origin. A deeper cleaning of the first tapestry on the left revealed bunches of flowers arranged in patterns on a black, threadbare ground. The rich variety of flowers, perhaps each chosen for its symbolic meaning, range from sky blue to vivid light-blue flowers, red and pink flowers with rounded and star-shaped petals, and clusters of white and black flowers in the lower area. In a few cases, traces survive of stems and leaves in green shades similar to the shoots depicted in the lunettes.

This decorative floral motif served as a rich background for the figures of the apostles. The copies in Tongerlo and Oxford, considered the most faithful, reproduce brightly hued fabrics that actually correspond to the traces of original paint found under the repaints (see fig. 44, diagram 6).[29] Black probably served as the background for the tapestry decorations. The particular composition of the blue pigment caused it to fade within a short time. The tapestries depicted in the copy of the *Last Supper* at the Vatican Museum are of particular interest for their elegant and freely interpreted floral decorations (see fig. 46).[30]

When the cleaning was completed, the repaints that had beset the tapestries over the centuries contrasted sharply with the rest of the room, which had recuperated its original luminosity. The small lacunae dotting the surface were integrated by darkening them.

Pilasters

Before our restoration, the dark bands at the sides of the *Last Supper* had been interpreted as shadowed pilasters that

43. Diagram 5. Reconstruction of
the eighteenth-century damask
decorative pattern.

44. Diagram 6. Reconstruction of
the tapestry in the copy of the
Last Supper at Tongerlo Abbey.

supported the bearing architrave for the lunettes' imposts. This would have formed an open space separating the real Last Supper (the Eucharist) in the refectory from the painted *Last Supper*.[31]

Ancient, heavy repaints in these areas contributed to a lack of interest in them. For example, the restorer Cavenaghi "did not clean or stabilize the two long, external lateral strips as much as the painting." Successive restorations adopted the same attitude, until the recent cleaning uncovered the original, lighter color on the right side. Traces of gray, similar to marbling, emerged in some areas between the support and the figure of Simon.

Five transverse lines and one vertical line appeared at the lower left. Even though their direction does not correspond with the rest of the perspective plan, they nevertheless suggest the sketch of a design for the base of a narrow pilaster, set against the wall.

It seems unlikely that any protruding architectural elements were depicted in the *Last Supper* and, therefore, that any visual impediment existed between the real environment and the painted one where the sacred drama unfolds, creating an ideal continuity between spectator and scene.

Back Wall

The entire painted surface of the back wall was almost completely repainted as well, probably with the aim of reconstructing a uniform whole. The uppermost of the two eighteenth-century restorations used a tempera mixture that concealed both the lacunae and the paint film, while indentations

48. *Detail of the back wall: (1)
cleaning trial showing previous re-
storations; (2) rectangle left by
Pellicioli showing the condition of
the painting before his restoration;
and (3) the area as it appears after
the most recent restoration.*

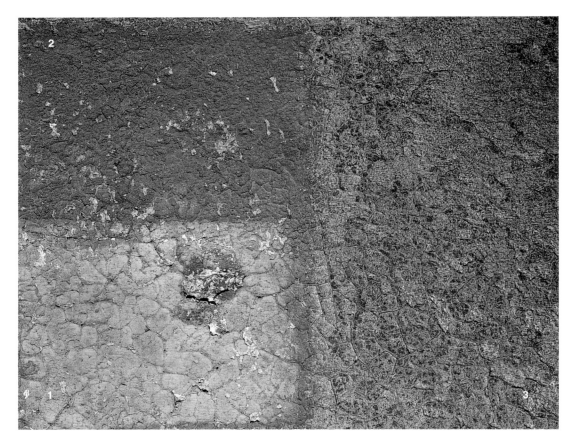

caused by fallen flakes of color and
preparation were patched with thick
stuccature. The earlier eighteenth-cen-
tury restoration, warmer in tone, cov-
ered the portions of color in part and
the lacunae completely, suggesting that
a subsequent attempt had been made
to remove this layer. The heaviest re-
paints were concentrated above the
figure of Thomas, which had perhaps
already been afflicted at an early stage
with serious cohesion problems. The
entire wall, however, was characterized
by the widespread loss of color. For
example, significant losses resulted
from the insertion of nails around the

figure of Christ. The circular arrange-
ment of the holes suggests that the
nails might have been inserted to pro-
tect the figure of Christ, perhaps to se-
cure a protective canvas over the fig-
ure during the irreverent military
occupation of the refectory in the late
eighteenth century.

Once the superficial repaint had been
removed, it was clear that we had to
press on with cleaning in order to
achieve some sort of visual coherence
between the back wall and the side
walls. The right wall was touched by
light, while the left wall was shadowy
and suggestive. The rediscovered prepa-

ration, even if dotted by fragments of
original color, was so abraded that the
pictorial film seemed to have been in-
tentionally removed.

Leonardo's palette discovered in this
area is consistent with a dark, cool gray
applied over lead white imprimatura,
with a final coat of intense black. Re-
covering the central opening's tympa-
num, though not complete, allowed us
to recuperate the molding and lovely
range of grays in the architectural de-
tails. Cleaning also revived the bands
that form the jambs around the win-
dows, which previous restorers had ar-
bitrarily modified, not realizing that
they represented openings. The yellow-
brown elements that appeared after the
cleaning should probably be inter-
preted as open wooden doors, which
correspond to the oldest copies.

Pictorial integration meant that the
wall had to be restored using coats of
dark-toned watercolor to define the
shadows. Obviously the flakes of orig-
inal color remain completely visible (see
fig. 48).

Lateral Windows

The shadowy back wall opens onto a
landscape through two side windows
and a central door, which silhouettes
the figure of Christ. A thick coat of
grayish, granular material tenaciously
adhered to the ground in areas with la-
cunae, obscuring part of the sky and
giving the impression of pale streaks
similar to clouds amid the light blue. In
some areas the surface was already
somewhat free of repaint and revealed
original color, probably thanks to Pel-
licioli's restoration.

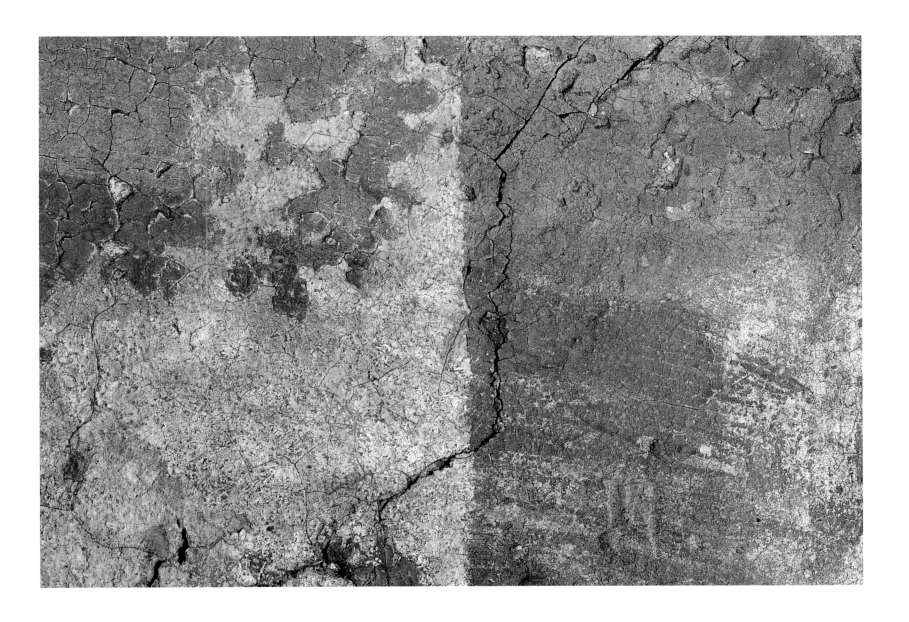

351

precarious edges of color, and at one time the shape of one such treatment had been mistaken for a figure in the landscape (see fig. 54). The restoration allowed a more comprehensive reading of the two mountain chains, which delineate the landscape in two light-blue tones under the horizon line.

The lower part of the landscape emerged with an entirely different range of values, not rich in pigments. The purity and meticulous attention to the details of branches and the fragments of a cuspidate building with a bell tower typical of Northern architecture, confirm Leonardo's attention to Flemish painting. By the nineteenth century, Bossi interpreted the landscape as follows: "On the horizon, neither trees nor buildings are clearly visible. Everything breathes the tranquility that reigned over Zion."[32]

Ceiling

The state of conservation of the coffered ceiling in the painting had been seriously compromised. The ceiling's deterioration and the various restorations have over time generated much confusion regarding its condition. In the eighteenth century the restorer Mazza realized that "the trussing of the ceiling was poorly adjusted and the correct rules of perspective ignored."[33] Later Giulio Carotti noted that, according to Cavenaghi, who was responsible for the restoration of 1904, the ceiling was almost intact "with its skillful and exact perspective, which confers a distinct effect of vastness and depth of environmental space to the entire scene."[34]

By eliminating the repaint, we unexpectedly managed to recover elements of the original composition, particularly Leonardo's uniform, limpid sky. Executed in two tonalities, the sky was composed of a thin layer of lapis lazuli superimposed over a uniform base of azurite. Interrupted by a horizontal loss of material above the head of Thomas, and a circular loss beside Christ, the sky delicately shades from dark to light hues, and light-blue tones to whites.

The continuity of the light-blue pigment merits special attention. Originally more extensive, it was reduced, as if in a *pentimento* (change of mind), and replaced with a pale gray border that overlaps it, framing the upper edge of the windows (see fig. 208). Before the current restoration, the windows opened onto a landscape that had been repainted in a confused and heavy manner. In the lower area, the repaint was denser where a material with large granules unified the lacunae of the original color, while a lighter, greenish tone was used in the upper area.

Removing the repaints was already a delicate operation because the original color was so fragile, and it was further complicated by the consistency and tenacity of the repaints, which had been mixed with casein. It took three months to free the surface of the greenish brushstrokes on the left window, as they had solidly attached to the lead white imprimatura (see fig. 49). Numerous dark *stuccature* had been applied to the

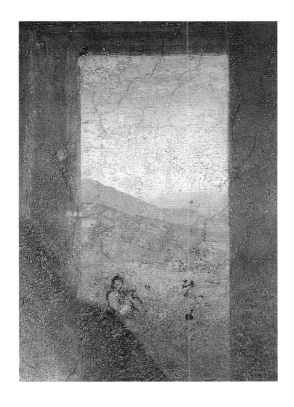

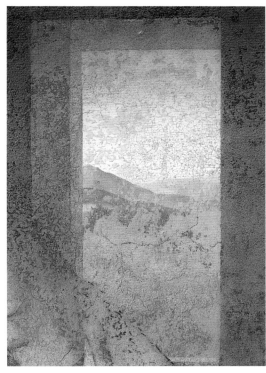

It is actually quite difficult to make out the original structure of the ceiling. Removing the superficial layer, which had altered and darkened, revealed layers of repaint. In the upper area, the uneven layers of coarse repaint seem to have been applied directly on the smooth intonaco, and in the lower area, the original preparation still partially exists. On the left side, some old attempts at very deep cleaning had seriously damaged the first beam, which was not reconstructed in the recent restoration but simply painted in a gray tone that matched its surroundings.

Through patient investigation, we were able to verify the existence of an older intervention under the two eighteenth-century repaintings. The modifi-

cations to the coffered ceiling with the deviation and reduction of the beams to the position visible today date from this earlier intervention. Fragments of Leonardo's original color appear under this old reconstruction, which was carried out using large-grained pigments in tempera that easily crumble to powder. It is likely that much of the ceiling was lost almost immediately after Leonardo completed the painting, especially in the upper zone, because of the failure of the color preparation to adhere to the plaster. By the beginning of the sixteenth century, the few surviving traces were already barely legible.

While the eighteenth-century re-paintings did not respect Leonardo's "taste" and rhythm, the sixteenth-cen-

tury chromatic modulation appears fairly faithful to the original, at least according to the copy at Tongerlo Abbey. The current restoration furnishes crucial information regarding the original perspective of the room, one of the most difficult and intriguing problems for Leonardo scholars. This information is significant, because, along with providing a reliable image of the rich and varied color of the original—far from the current monotonous, artificial darkness—it reveals Leonardo's intended proportion for the space.

Along the left edge of the ceiling, the cleaning revealed a fascia of original color that is somewhat abraded but legible within the structure. The newly dis-

covered passages of color suggest that
the beams were originally grayer in
tone, decorated with brown wood
molding with narrow red borders, and
coffers with a blue background. Like
the ceiling, the outer frame was sub-
jected to numerous modifications that
impoverished and simplified its original
decoration.

Because little of the original paint
layers survive, we did not remove all the
repaint on the ceiling. Enough of the
original remains, however, to propose
that a dark tone defined its shadowy
areas, leaving only a small portion to
the right touched by light. Once again,
the Tongerlo copy corroborates this hy-
pothesis.

The cleaning also revealed the ceil-
ing's structural grid. A compact series
of deep incisions made in the almost-
dry preparation extended over the en-
tire upper part of the painting and
served as guidelines for the perspective
scheme. A line designated by small nail
holes vertically marks the center of the
Last Supper, and is also visible in the
lower part of Christ's garment. Paired
horizontal lines were recovered that

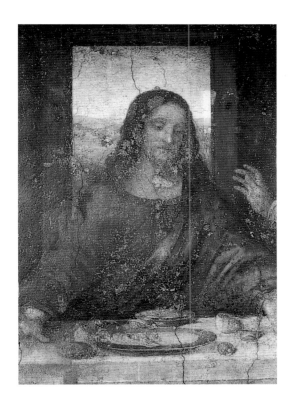

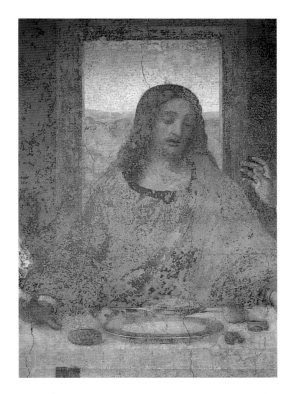

gave rhythm to the coffers' design, and indicated the red outline (fig. 57, diagram 7).

The outline for the architectural elements, composed of compact, well-defined incisions, continues on the wall. The unrealized preparatory scheme revealed by the cleaning operation testifies to Leonardo's habit of reworking his ideas, and provides further information in the complex search for the "true" *Last Supper*.

Christ

The focal point of the *Last Supper* is the figure of Christ. Seated at the center of the table, framed by the open portal in the background, he bows slightly, arms open and outstretched, hands resting on the laid table. The back lighting of the crepuscular landscape distinctly silhouettes his head, long chestnut hair reaching to his shoulders. The tranquil, resigned, and gentle face is that of one detached, beyond the pathos of the apostles. His red tunic is embellished at the neckline by a border with a green gem at the center, and the blue mantle falls from his left shoulder, according to traditional iconography.

Both Christ's face and his hair had been largely repainted. Much of the hair was the product of a restoration that had summarily compensated for serious losses of original color by evening out the locks in a uniform dark brown blanket of color, which merged at some points with the landscape. The face was similarly restored with a heavy, opaque repaint that had turned brownish-yellow over time. Touches of dark color reinforced the eyes, nose, and profile, and the hands were completely repainted.

The condition of the right hand was particularly compromised. During the first quarter of the nineteenth century, in all probability it was subjected to an unthinkable attempt to detach it and transfer it from the wall to canvas. The operation caused obvious trauma and irreparably shattered the layers of preparation and color. The left hand also appeared to have been repainted and was seriously compromised. In a restoration its missing portions had been reconstructed over a layer of wax, which covered both the lacunae and the original fragments.[35]

The clothing appeared to have been

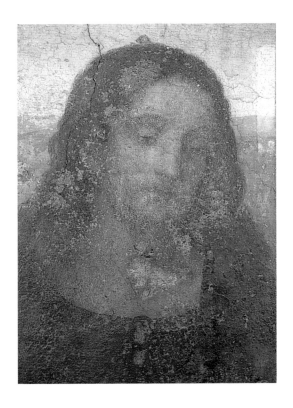

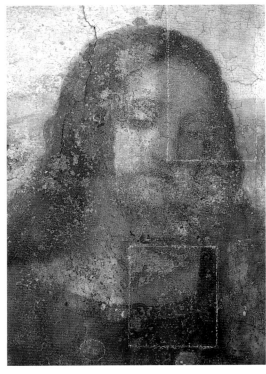

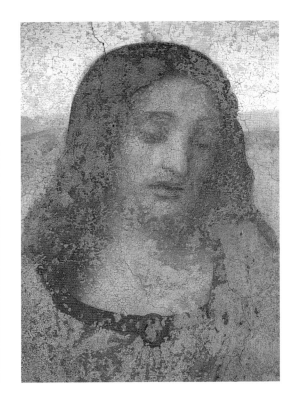

completely reconstructed with layers of dense color that recreated both the drapery's basic background color and the modeling of its folds, probably inspired by copies. The tunic had been repainted in a heavy red tone, and the folds of the sleeve outlined in a brownish color. The wrinkles caused by the gem's clasp were left virtually undefined. In addition to the thick layer of superimposed color, the entire area had been massively doused with a great brew of yellowish-brown animal glue, which had deposited in the lacunae and become translucent and opalescent.

The blue mantle had suffered a similar fate. It had been covered with an opaque mixture in two different tones:

dull light blue for the light areas, and dark gray to define the shadows. The stylized folds had been handled in a rigid, mediocre manner, similar to the repainting of Matthew's mantle. An examination in raking light attested to immense losses in the area, but traces of original paint were recovered along the mantle's border on Christ's chest.

Another restoration, executed *a neutro* directly on the intonaco, had attenuated the disturbing effects of some of the losses of color to the hair, neck, and central part of the figure. In the 1950s Pellicioli tried to lighten the darkened areas, but only achieved a heterogeneous and mottled effect.[36]

Serious and numerous cracks have damaged the area around Christ. One

begins in the sky area above the figure and descends toward the right part of the head to the eye; a second crack progresses from the chest toward the table; and a third runs all along the right arm, through the wrist, and to the fingers. Another vertical crack affects the right arm.

Around 1652 the Dominican monks requested that a door be cut into the wall of the refectory just below the image of Christ. Undoubtedly this constitutes the primary cause for the structural weakening in the central area of the wall. Sometime after this damage occurred, the wall was consolidated several times with injections of material to fill areas where the paint had detached from the wall. On these occa-

[left]
64. *The right hand of Christ
before restoration, showing loss of
paint.*

[right]
65. *The same detail after
restoration.*

sions numerous holes were created, which are still visible today.

The entire figure of Christ revealed microscopic flaking of fragments of color. As the clothing had been completely repainted, it was impossible to verify the extent of abrasions to the original material. The losses to the pictorial film, however, were clearly visible in the flesh areas, especially on the right hand, the lower part of the face, and the mouth. Examination in raking light suggested that *stuccature* had been applied and coarsely leveled near the large lacunae along the edge of the blue mantle, adjacent to the tablecloth.

The cleaning operation was studied at length, and the option to eliminate the ancient restorations carefully evaluated. We were in fact able to restore the original coloring to Christ's head. Christ's face, unlike the apostles' faces, had been reconstructed in a manner more faithful to the original physiognomy, with semitransparent glazes of pinkish beige in the flesh areas, which had darkened owing to the application of consolidants. After the superimposed materials were removed, its condition proved quite compromised, with particularly serious damage and loss to the hair and face. The flakes of color had been worn down, and the glazes that conferred light and shade worn away. On the right temple, brown *stuccature* merged with the surrounding paint, concealing a hole that proved to be the focal point of the composition's perspective. Unfortunately, only limited traces remained of the mustache and dark beard. The areas around the neck and the edge of the garment were better conserved.

The mantle had been repainted with erroneous colors that betrayed no reliance whatsoever on copies contemporaneous with the *Last Supper*. The original flow of the drapery, which had even been partially legible at the time it was restored, had also been arbitrarily altered. Its elimination revealed two layers of repaint, which corresponded to two different restorations. The most recent restoration had been realized in two shades of dull light blue, while the older one utilized a darker, more brilliant tone for the deepest shadows, such as the areas next to the turned-up border of the mantle (figs. 70–71). On the part of the mantle near the sleeve, a third repaint in tempera emerged, which had been applied so thickly that it filled the lacunae between the flakes of color. Traces of red heightened with white were discovered under this last repaint, perhaps the remains of a glass cruet, which early restorers had incorporated into the blue mantle.

There were many *stuccature*, some-

times partially removed, on the chest and the lower part of the mantle. They were composed of a granular mortar with a lime base, which made it so difficult to remove that some layers had to be reduced mechanically. *Stuccature* of different colors and materials, polished brown or tenacious red, had also been added. Next to the hair, where blue pigment had flaked off, the cleaning also revealed a differentiated join in the preparation layer, similar to the border of a *giornata*, or the area of prepared surface that could be frescoed in one day.

Like the mantle, Christ's robe also required the removal of extensive repaint, as the heavy red tone detracted noticeably from the lovely original vermilion passages. The thick adhesives made the removal particularly difficult, so it progressed with the re-

peated application of compresses, which managed to dissolve the film of glue completely. The cleaning redefined the original articulation of the folds, both at the neckline and at the sleeve cuff. The cuff, which had been covered by the mantle's repaint, now revealed beautiful violet flakes, composed of a blue base glazed with a crimson lake to define the shadow area.

Other noteworthy recoveries included the border of the robe's neckline, where a geometric decoration executed with minute brush strokes are now visible, along with the central gem. With the exception of a serious lacuna near the wrist, the left hand was in good condition, despite the fragmentation and losses to the final coats of pigment. Leonardo's masterful chiaroscuro modulation is still visible, and even some *pentimenti* can be identified where the four fingers were shortened to accentuate their contraction. The wax that Barezzi applied over the lacunae and original color in this area was also eliminated. Serious lesions affected the right hand, where all the original flakes of color had been harshly abraded and reduced to minute fragments.

The goal of the pictorial integration was to achieve sufficient legibility of gesture, pose, and modeling. A method of approximating the surrounding color was adopted for the face and right hand, which consolidated the image appreciably, even though some particularly significant details, such as the mustache and beard, are missing.

70. Detail: Christ's blue mantle
before cleaning.

71. The same detail after
restoration.

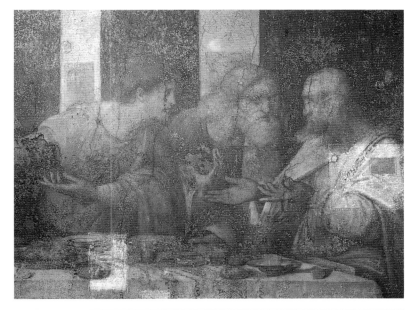

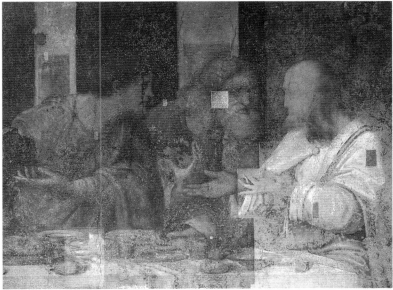

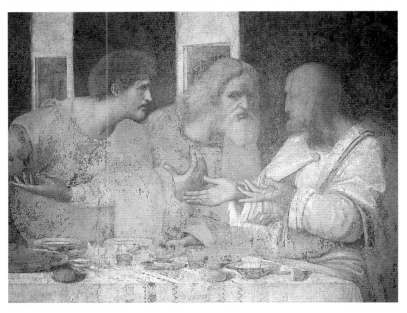

Simon

The figure on the far right is the apostle Simon, represented as an elderly bald man who turns to Thaddeus and lifts his open hands in a gesture of astonishment. Clothed in a gray robe with a warm-toned mantle on the shoulders, the figure is characterized by an imposing, stern bearing. The current restoration of the *Last Supper* actually commenced with this figure. This first approach evaluated the recovery possibilities and established the restoration methodology.

Mazza's restoration of 1775 appears not to have intervened on the portion of the painting with Simon and the adjacent two figures. The apostle's heavy, comprehensive restoration thus seems attributable to Bellotti's treatment of 1725. The samples cleaned by Barezzi in 1850 and Cavenaghi in 1904, ordered by the delegated commissions, were also identified.[37]

In 1954 Fernanda Wittgens described Pellicioli's restoration as "the recovery of a very delicate rosy peach . . . in the robe of the apostle Simon."[38] The evidence that he partially cleaned the mantle in the area next to the table remained in the form of a dark patch. Bossi had already noted that "the color of this pallium tends toward yellow in the illuminated parts, and toward a reddish color in the shadowy tints."[39]

Our preliminary examination revealed profound alterations to the figure and differing states of conservation. The head was very abraded, and its profile appeared to have been repainted and coarsely delineated by a dark brushstroke, which emphasized the

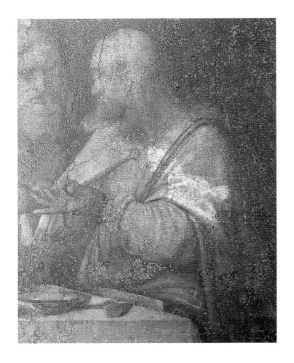

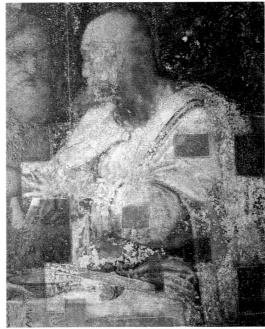

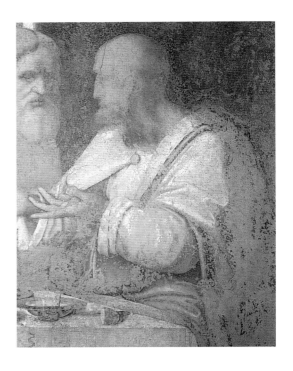

outlines and weighed down the expressive features. The details of the face (eye, ear, and lips) were illegible, while the upper part of the head was not anatomically correct. The nape was no longer well defined, and the neck and mantle had fused into a single indistinct tone. The beard also appeared to have been lengthened, and the modeling of the front part of the neck was somewhat muddled.

Even though the face of Simon had undergone partial but intensive cleanings, the treatments did not eliminate the repaints that deformed the profile. The eye, now lost, had been summarily redrawn with short dark hatching. The nose had been shortened, the beard enlarged, and the back part of the neck and nape broadened with a black emphatic line that merged with the tapes-try behind the figure. The repaint on the temple and left cheek had not been completely removed.

The pictorial interventions on the hands were also massive and reconstructive. Some of the fingers of the left hand had been hastily redrawn, and the right hand, although better conserved, had been completely repainted. No modeling could be identified in the folds of the mantle's drapery, while all the shadows in the robe's left sleeve had been reinforced. In some areas the repaint was so dense that it filled the lacunae in the preparation and covered the numerous layers of fixative, altering the image and giving it a dark, smoky look.

Even before the current cleaning, an examination of the surface in raking light showed significant damage. In the central part of the robe and on the cuff of the left sleeve, there were losses to the preparation layers. Considerable lacunae marked the overall surface, and the only surviving pictorial film, concentrated in the shadowed area of the mantle, displayed missing areas. Finally, all the illuminated portions of the face and head were abraded and worn.

Three long vertical cracks partially damaged the wall, involving the background and stopping in the upper area of the face. Two other closely aligned cracks snaked across the part of the mantle covering the figure's chest, crossed the hand, and ended at the lower part of the garment. The few interventions utilized *stuccature*, and most of them were brown and of modest size.

362

The current removal and cleaning operation reached Leonardo's paint surface, revealing that the original version was substantially different. The head's features were characterized by greater severity and a furrowed brow, and the profile of the nose and the puckering of the lower lip acquired new legibility. In general the rediscovered features now display an appreciable affinity to the preparatory drawing at Windsor Castle.

The back of the head and neck are the best-conserved parts and enhance the twisting movement of the head, which is marked by a delicate outline, creases at the nape, and a strongly shadowed throat. The head's rotation is consistent with the face's recovered position, which is not in profile, but rather in three-quarters. The left hand

was also freed of the thick pinkish repaint that filled the immense lacunae on the back of the hand, the palm, and the thumb.

The cleaning and removal operation on the gray robe revealed two layers of repaint superimposed over the original pigment. The oldest layer was grayish in tone and predominantly reconstructive; the more neutral second layer served to fill the earlier layer's small lacunae. A yellowish haze caused by a uniform layer of organic adhesive covered the repaint.

The layers were not uniform, because previous cleanings had "lightened" some parts of the figure. Their removal made many details lighter and more distinct, such as the contour of the neckline. The lovely material of the sleeves and lower part of the robe

emerged as soft folds with very defined contrasts, which shade from white highlights to various modulations of silver gray, and dark gray in the most intense shadows. A delicate, elegant black brushstroke enhances the chromatic relationships and accentuates the luminous effects.

The cleaning also disclosed different pictorial effects in the wide pallium. It now passes from rosy white in the illuminated areas to delicate gray in the half-shadowed area along the edge of the cuff, with an intense crescendo of deep red and violet shading for the dark tones that define the shadows, which had been partially lost in the thinnest layers. The entire area of the mantle had been glazed with a vermilion lake. Other interventions then concealed it under yellowed consolidants

and a material that turned an improbable and arbitrary dark brown.

The rediscovered pictorial film under the repaints revealed an extraordinarily beautiful movement in the drapery, embellished by lake whose intensity is still very strong, emphasizing the texture of the fabric where illuminated. This precise clarification of the means of realizing two types of fabric is unique to the painting: the soft, heavy quality of the gray robe and the vibrant, silky texture of the mantle (see fig. 81).

Unfortunately the lower part of the figure below the table is lost, and few traces of the feet remain, either of the flesh areas or the blue-turquoise footwear. Initially the pictorial integration utilized neutral hatching, which was later matched to the surrounding original color in the small lacunae. The dissonance caused by color losses was reduced, and considerable details were recovered in the clothing. A significant conquest of the volumetric and plastic values of the figure of the apostle resulted.

Thaddeus

To the left of Simon is the apostle Thaddeus, depicted at an advanced age and with long hair and a thick beard. The position of his head is almost frontal, his right hand is lifted toward Simon, and his left hand rests on the table. He wears an ocher-colored tunic, and a mantle that was originally green covers the left shoulder. His position is set back, almost in the middle ground with respect to the apostles next to him.

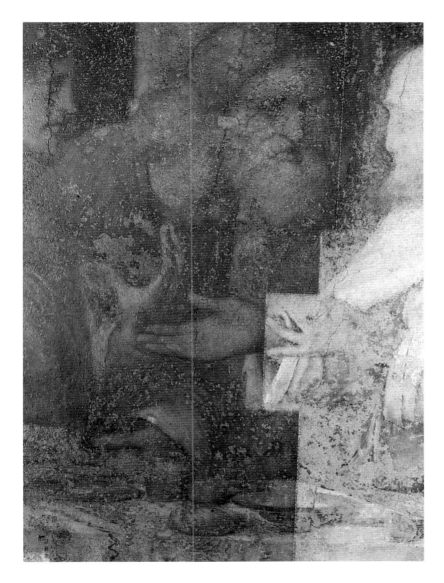

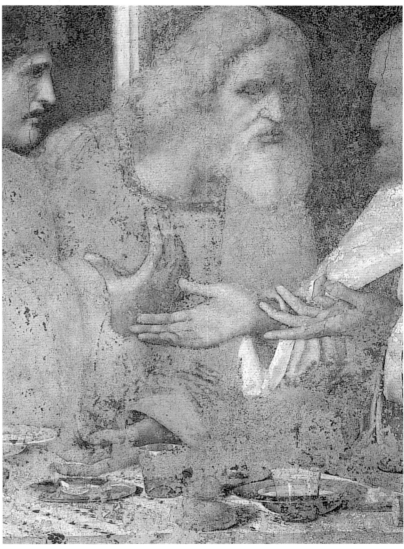

Before the latest restoration, the figure generally appeared dark, and the facial features were undefined. A dark diagonal stroke roughly designated the eye. The hair blended in with the gray field of the wall behind the figure, and the almost indistinct volume of the hair was flattened in an abbreviated mass. The hands had been subjected to a mediocre reconstruction, and the first phalanx of the thumb and the index and middle fingers of the right hand had been repainted. The hand lying on the table displayed an even worse reconstructive manipulation, with original color limited to the thumb and fragments of the other fingers.

The ocher tunic had also been completely and thickly repainted, significantly blunting the articulation of the folds and the volume of the drapery. Such a comprehensive repaint suggested that the condition of the original color was seriously compromised, confirmed by Bossi's statement of 1810, "now almost no feature is visible that

[left]
84. Detail: head of Thaddeus before restoration. The face has been lengthened arbitrarily and dark brush strokes emphasize the position of the eyes.

[middle]
85. The same, during cleaning.

[right]
86. The same, after restoration, with the apostle's face returned to its original aspect.

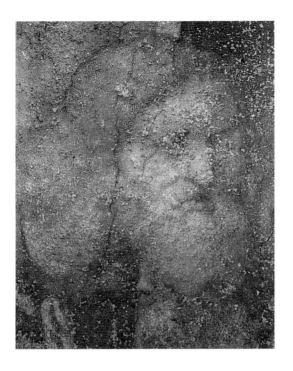

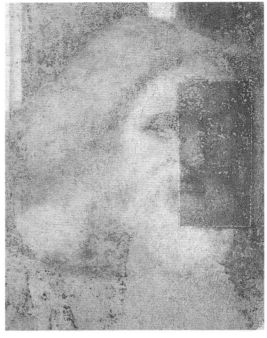

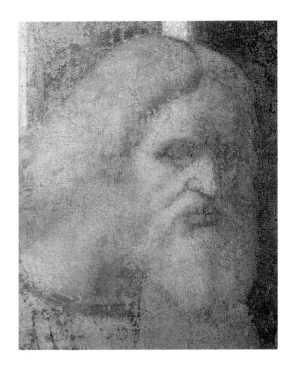

can be considered original, even if Mazza's brush did not reach it."[40]

Microscopic flaking from the preparation layer was generally visible. The details of the eyes were among the most damaged, with paint missing between the eyebrows and cheekbones. Where limited original pictorial film emerged, there were losses within the strata of the various layers.

A faint crack crosses the head of the apostle to the neckline; a second thinner one descends from the chest to Simon's outstretched hand; and a third almost hairline crack runs across the cuff of the left arm's sleeve. Dark *stuccature* had been applied sporadically to the clothing. The lacunae were partially filled. Near the fingers of the lifted hand two kinds of brown and gray *stuccature* were noted.

The process of removing the repaint was time-consuming and delicate. Like other parts of the *Last Supper*, the thick layers of casein pigments proved extensive, and the layers of adhesive tenacious. Numerous and unexpected recoveries of original material emerged from beneath the blanket of repaint, especially in the face and hair. The hair reacquired its initial volume, modulated by wavy locks threaded with subtle highlights and delicate white brushstrokes, while a soft gray glaze skillfully emphasized the hairline. The facial features proved leaner and purer, even on a chromatic level.

Once the two diagonal marks that poorly designated the depth of the eye sockets had been eliminated, part of the pupils, the *sfumato* outline of the brow, and the subtle network of wrinkles on

the temple reappeared. The apostle's expression proved different from Bossi's description, who declared that the saint had been represented "turning somewhat towards the adjacent brother, gesturing with his right [hand] and posing the left, and turning the eyes in a different direction than the head."[41]

The restoration also recovered significant portions of the lips, and the profile of the nose and chin, which had been hidden under the repainted beard. Leonardo had originally conceived the beard divided in two halves, whose ends curled like his hair, with light highlights and *sfumato* shadows. The back of the right hand and most of its fingers were rediscovered, while only meager amounts of original color survived on the left hand, concentrated

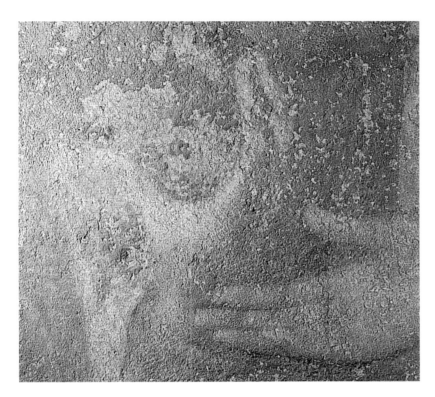
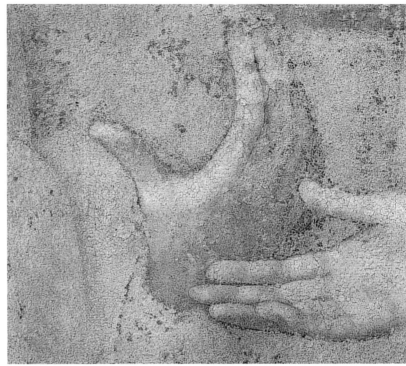

around the thumb. Part of the ancient repaint was preserved, although its reconstruction of the hand was reduced to a barely legible suggestion.

In the area of the clothing, recoveries proved scarce, and serious lacunae exposed large areas of preparation. Some significant details remain, however, such as the neckline, embellished with traces of a geometric design with a braided ribbon motif, perhaps an embroidered border, painted with black hatch marks. On the shoulder, original luminous yellow chiaroscuro intonations stand out strikingly, and on the left sleeve, even if abraded, one can see the chiaroscuro of its folds, as well as the shadowy depths from which the hand emerges.

The meager traces of original color suggest that the garment varied on the chest from yellow to brown. The mantle draped on the left shoulder is completely lost, and the green fragments superimposed on Simon's light right sleeve are the only evidence of its intense color. Nevertheless, the cleaning revealed the bright red of the right sleeve's cuff.

Here the pictorial reintegration—which was achieved in the dense network of minute lacunae in the face and head with the usual technique of hatch marks—was instead accomplished with the use of hues intended to enhance the intensity of the remaining particles of original color rather than to match that color.

Matthew

Younger than the other apostles, Matthew is represented in profile turning toward Simon. Elegant in demeanor, he wears a refined tunic and a mantle in the antique style, held in place by a pin.

The pictorial interventions carried out in the past also proved misleading for this figure. The hair had been reduced by a muddy repaint to a uniform mass of dark brown, and the outline of the head was lost in the tapestry background, which had also been repainted. The expressiveness of the face had been drastically altered. *Stuccature* had been applied to the large crack that split the profile, a black brushstroke reduced the eye socket to a dark stain, and the

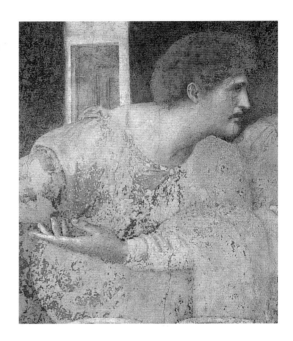

lines of the mouth had become bitter and vulgar. An abbreviated short beard merged with the outlines of the mantle, and a black line delineated the neck, altering its proportions.

The index and middle fingers of the right hand had been coarsely reconstructed. The left hand was in better condition, despite the dark mark delineating the external profile of the finger and the back of the hand, and the presence of a thick pinkish material applied over the original color to fill the lacunae.

The mantle had likewise been completely covered with a blue-green, opaque tempera. The tunic had been repainted in brown on the chest, and gray-blue on the right shoulder. Among the various repaints (chest and right arm), the fragments of the oldest restorations to the chest and right arm were characterized by an unusually fine

cracking. The figure's condition seemed emblematic of the severe problems of material detaching over time. The arm especially served as a veritable survey of the progressive deterioration and successive restorations intended to halt losses of preparation and color. At least three kinds of *stuccatura* with different pigmentation had been applied along the borders of the pictorial layers in the attempt to check the losses. *Stuccature* also compensated for other small losses, such as the dark, disfiguring plaster that filled small nail holes near the temple.

Three vertical cracks of varying dimensions and lengths affect the figure. The deepest crack commences at the head, crosses the face, cuts off the eye and mouth, reaches the mantle, and ends at the table at the height of the plate holding an orange. The second crack, parallel to the first but thinner,

descends from the nape to the chest, while the third begins above the shoulder, descends in correspondence with the other two, and turns left at the hand.

An initial cleaning liberated the surface of the deposits of organic fixatives and superficial sediments of shellac, present in small whitish lumps. Our intervention verified that, in 1954, Pellicioli had already removed some of the grime and repaint sedimentation. The photograph taken by Ferrarro in 1908 shows the presence of extensive prior repaints. (see fig. 92).

Removing the repaint revealed passages of Leonardo's paint in the fundamental details of the figurative structure, quite legible even though undermined by vast lacunae. The elimination of arbitrary elements especially enhanced the face. The repainted beard, which resulted from an erro-

[upper left]
92. *Head of Matthew, photograph by Ferrario (1908) taken after the Luigi Cavenaghi restoration.*

[lower left]
93. *The same, early cleaning trials.*

[upper right]
94. *The same, after cleaning.*

[lower right]
95. *The same, after restoration.*

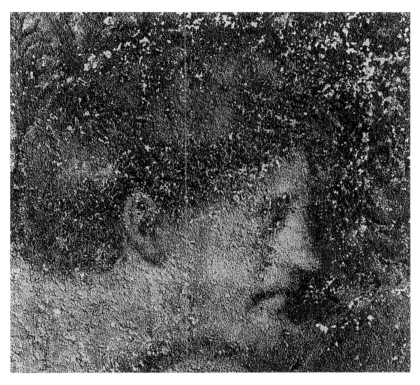

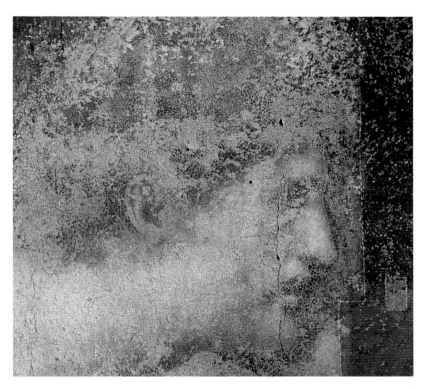

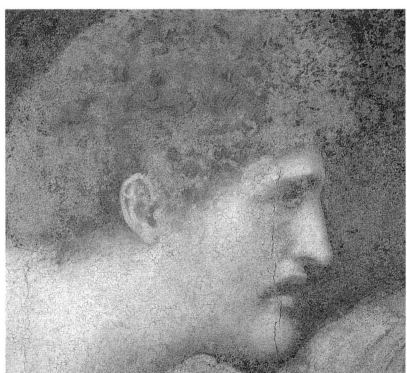

Second group of apostles: Philip, James Major, and Thomas.

[upper left]
96. Photograph with light cast along the plane of the picture to show the rough surface.

[lower left]
97. The second group of apostles with early cleaning samples.

[upper right]
98. The same group during restoration.

[lower right]
99. The same group, after restoration.

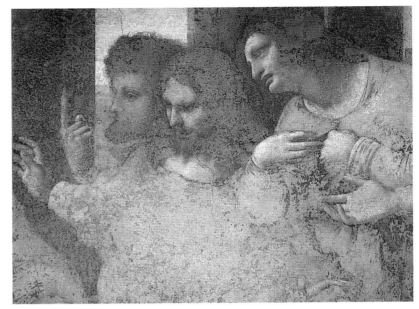

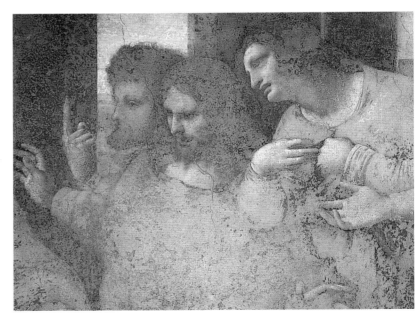

[left]
100. *The figure of Philip before restoration.*

[middle]
101. *The same, detail with early cleaning trials.*

[right]
102. *The same, after restoration.*

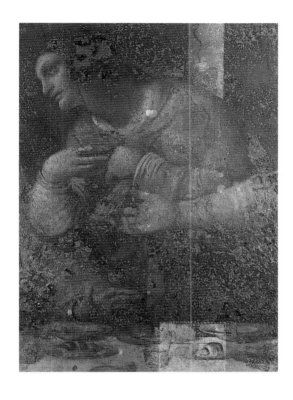

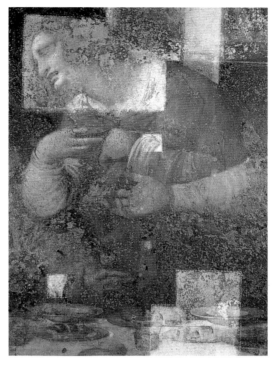

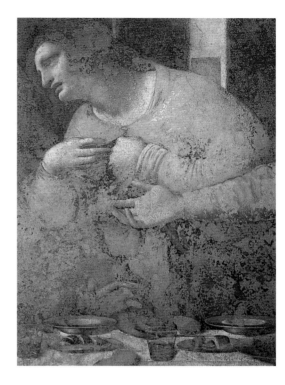

neous interpretation of the chin's shadow, was removed. The mouth reacquired legibility, revealing the soft, fleshy lips just opened in amazement at the announcement of the betrayal. The classical, youthful profile of the nose was almost completely recovered. The reduced proportions and anatomical definition of the ear were also rediscovered, as well as the vivacity of the gaze and the original line of the neck and throat.

The subtle modulations of shadows on the flesh of the cheek and neck are now appreciable, and the curls of the apostle's hair reacquired their vibrant tones, from chestnut to golden blond. The left hand is modeled delicately and sensitively, and the lifted thumb and the pads of the middle and fourth fingers

are precisely highlighted. The phalanxes of the right hand's index, middle, and ring fingers are absent, but passages of exceptional quality are still visible, standing out against the background of Philip's tunic with the plasticity and softness characteristic of Leonardo's *sfumato*.

From the first trial cleaning to the final stage of the restoration, which left the preparation visible, the repaints on Matthew's shoulder and the lower part of his mantle were removed very gradually. The heavy yellow repaint concealed the robe's original border, composed of a red lake glaze over the light-blue base of the robe, whose original color was embellished with highlights and delicate chiaroscuro. The ocher-colored clasp, painted to imitate

gold, and the precious white stone at its center stand out against the neckline.

After the cleaning, the lacunae initially received a neutral tint, which became slightly bluish upon contact with the original preparation. This was later balanced. The restoration of the figure of Matthew was particularly successful. The original color was revived and the facial features recuperated. Today Matthew's authentic emotional state, as intended by Leonardo, seems to emanate from the figure.

Philip

The apostle Philip turns toward Christ with hands raised to his chest and a moving expression on his face. A light source from the left strikes the figure, creating strong chiaroscuro contrasts.

[left]
103. Head of Philip, photograph by Ferrario (1908) taken after the Luigi Cavenaghi restoration.

[middle]
104. The same, an early cleaning trial.

[right]
105. The same, after restoration.

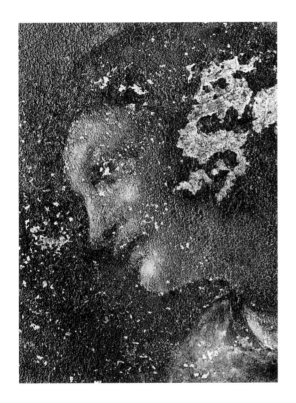 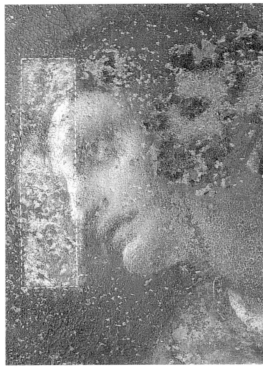 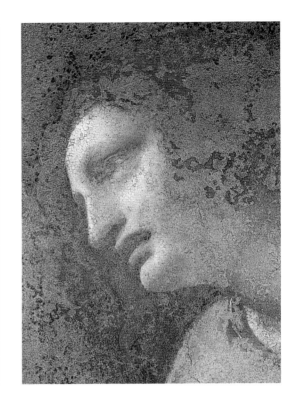

The different restorations of the past resulted in heterogeneous states of conservation. In a photograph taken in 1908 after Cavenaghi's restoration, the apostle's face appears static, the neck heavily repainted, the mouth shut, and the gaze fixed. The full dark hair seems to merge with the background. Another archival photograph documented Pellicioli's cleaning operation, which Fernanda Wittgens has fully described.[42] Pellicioli left untouched the dark outlining that altered Philip's face, the thick layer that covered his straightened hair, and the extensive loss around the ear and in the hair, which had been filled in with neutral tones but had been modified at the edges by a highly colored *stuccatura*. The face had been completely repainted with a pinkish gray color, applied indiscriminately over the lacunae and the original flakes. The eye had been reconfigured, with the iris repainted with blackish strokes, and the mouth distorted by red repaint on the upper lip.

The left hand was in better condition, even though damaged by layers of dust that had deposited on the shell-shaped flakes of color, and by sediments of a granular, bright pink material in the lacunae. Prior restorations did not eliminate the repaint that had excessively elongated the little finger and obliterated the last phalanges of the ring and index fingers. A heavy touch-up had reinforced all the fingers' shadows. The right hand exhibited similar characteristics, including the obvious, arbitrary reconfiguration of the little finger in the form of a hook.

The apostle is wrapped in a full, dark orange mantle, which is held at the neck by a gem, now lost, and by the left hand, creating a succession of modulated folds. Sporadic original fragments can be glimpsed below the conspicuous, comprehensive repaint, which reinvented all the drapery. The repaint is even heavier in the lower part, with increasingly darker tones. Alterations to the robe proved less serious, and a semitransparent glaze patched the lacunae and emphasized the folds.

The density of the repaint could not conceal the partial abrasions around the edges of the flecks of original color,

[left]
106. Philip, detail of hands before the restoration. Note the addition of the little finger of the left hand and the lengthening of the fingers of the right hand.

[right]
107. The same, after restoration, with recuperation of the original position of the fingers.

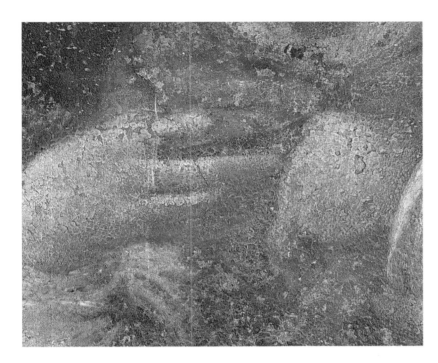

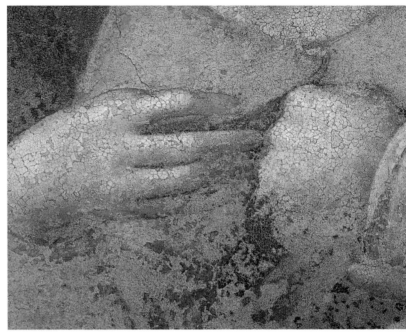

probably resulting from a stabilization operation that compressed the pictorial film. *Stuccatura* treatments vary from one area to the next, and hairline cracks are also visible. A minute crack begins in the architectural background and crosses the apostle's face; a second crack starts on the shoulder and proceeds diagonally to the hand; a third, slight crack appears on the right shoulder.

The current intervention achieved surprising results, especially in the flesh areas. It recovered the face's *sfumato* and the neck's original coloring in the passages between illuminated and shadowed areas. The shape of the mouth and chin reacquired a subtle *sfumatura,* as well as its delicate features.

The pale, rosy areas and the gray half-lights now animate the face with decided clarity. The face looked static,

partially because the pupil had been incorrectly positioned. Now the apostle's face evokes an emotional engagement of great beauty with Christ's drama. To the left of his face, the locks and curls of hair regained their original vibrant copper-brown tones, framing Philip's face against the dark background. The newly legible features of the hands also display great charm. Our discoveries regarding the clothing were more significant in terms of quality than quantity. Heterogeneous treatments and repaints concealed the poor condition of the upper areas of the clothing, but the phrasing of the complex drapery pattern emerged nevertheless.

As with the other figures, the blue pigment used on this apostle was in good condition. The robe's sleeves, for example, retained passages that were

practically complete, such as the wrist, which made it possible to study Leonardo's *sfumato* technique. Unlike the other apostles' mantles, Philip's cloak had no border at the neckline, but only a green gem. The tonalities used for the mantle are unusual and quite refined. They progress from warm, rosy hues in the illuminated areas—almost wavering at the neckline—to more intense variations for the middle tones, and deeper colors for the shadows, created with glazes of green lake, visible under the microscope.

Discontinuities in the mantle presented a particularly complicated and laborious challenge. As a result, in the second phase of restoration, we decided to avoid transforming the completely visible lacunae into something "figurative" and the imagined form of

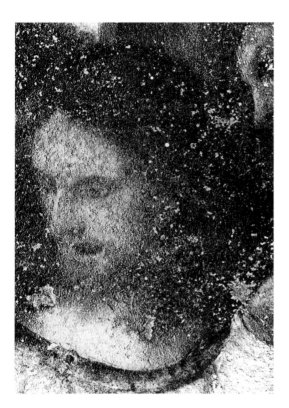

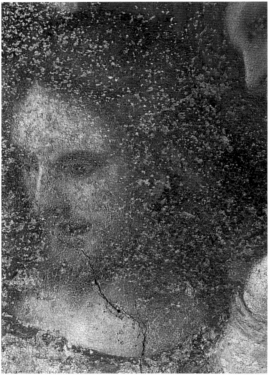

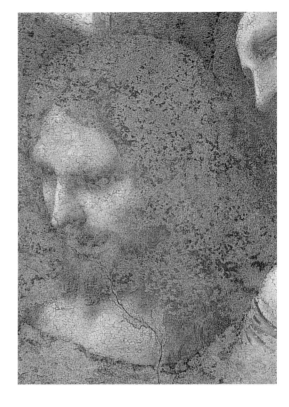

Philip behind it into "background." Therefore, with the approval of the Istituto Centrale per il Restauro, a slight tonal compensation was added and extended to the large lacunae.

James Major

Unus vestrum me traditurus est. Christ's words seem to strike the chest of the apostle James, who lifts his arms, incredulous and intensely disturbed.

The various restorations and ancient repaints had reduced the face to a caricature, and Leonardo's penetrating psychological study of the apostle's reaction emerged only with great effort. The hair and beard had become dark, opaque clouds, the modeling of the facial features altered, and the eyes and mouth heavily emphasized. The hands,

expressive bearers of the moment's drama, showed different states of conservation. The outlines of the right hand had been coarsely redone, and the left hand had been plagued by losses, *stuccatura* applications, and massive reconfigurations.

Of all the figures, this was the one most severely affected by losses in the preparatory layer. The condition of the clothing was highly compromised, especially in the central parts, where the intonaco ground was exposed. In general, the figure looked chaotic and confused. The detachment of color was clearly visible on the arm and left shoulder.

To check the lacunae, *stuccatura* composed of various materials and colors had been applied during various interventions. The oldest had employed

abundant quantities of a white, granular material. Others that were gray or brown had been added to protect the edges, and all had been toned in an improbable gray-blue color. Careless treatments had been carried out sporadically, some to attenuate the effects of the *stuccature*, others to compensate for the color losses with heavy brushstrokes in various shades of green. A general touch-up in olive green was visible on the sleeves, along with a mild attempt to reconstruct the folds at the wrist and along the neck.

The figure also suffered from cracks. The most significant one penetrates the area between the nose and beard, becoming deeper on the neck and halting at the edge of the table. A second crack, originating on the near figure of

111. Pellicioli photograph (1954) showing many places where paint became detached from James's clothing.

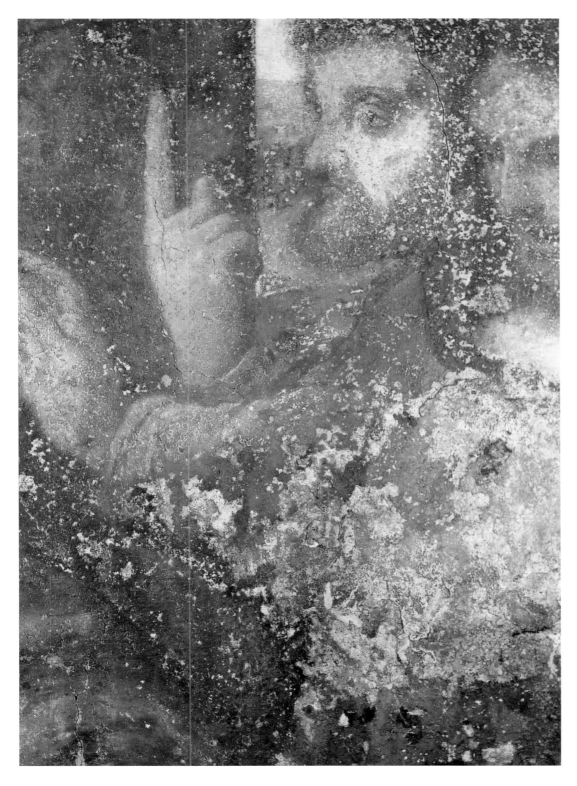

111. Pellicioli photograph (1954) showing many places where paint became detached from James's clothing.

Thomas, affects the hair and the neck. A third crack is visible between the left sleeve, and a fourth less visible crack runs across the wrist.

Such extensive losses dictated that we exercise extreme caution. Once the repaint had been removed, the most important recovery involved the face area. A rediscovered lock of hair in delicately modulated shades of copper-blond falls in carefully articulated filaments on the flesh of the neckline. The pale, downy hairs of the mustache reappeared, as did those of the short beard.

To achieve greater legibility for the face, toned glazes were used. Apart from a portion of the forehead, the face regained its original flesh-tone, which was discovered in the profile of the nose in different layers. Now even Leonardo's outline of the mouth, rosy color of the lips, and gray *sfumatura* of the eye cavities are visible. Nevertheless, irreparable losses diminish the saint's original emotional intensity, suggested by the oldest copies of the *Last Supper.*

The apostle's right hand is one of the best-conserved areas. The plastic subtlety and refinement of its modeling emerged in an almost intact state from the dense, misguided repaints. The left hand, however, was largely lost, missing some of its phalanges. Thomas's hand lies almost on top of James's hand, causing ancient viewers to believe that James had a double little finger.[43]

The repaint and *stuccature* on the robe were almost totally eliminated. The mortar repair was particularly irksome, as its consistency was very hard and it had attached firmly to both the intonaco and the preparation. It was gradually eliminated, its layers worn down a

little at a time.[44] Almost all the greenish repaint was removed, but some of the higher quality glazes were intentionally left in the area of the clothing next to the table, on part of the sleeves, and on the figure's back. The neckline proved to be the best-conserved area of the garment, and traces of the clasp were also recovered. On the left shoulder, original but abraded color also reappeared under yellow layers that must have defined a lock of blond hair.

The restoration also confirmed the structure of the intonaco, which was exposed owing to immense losses of preparation. An examination in raking light revealed that the plaster composition is particularly rough, with traces impressed by a trowel.

Thomas

Thomas, positioned next to Christ, is set back farther than the rest of the apostles on the right side of the composition. The back lighting sharply silhouettes his profile against the background landscape framed by the window. Thomas's hand, the index finger pointing up in Leonardo's trademark gesture, next to James's open hand, completes the dynamic interplay of gestures and expressions indicating the apostles' states of mind on the right side of the painting.

Before the current restoration, Thomas's heavily repainted head had lost all expression. The mass of hair had been repainted a dark brown, allowing only glimpses of original color fragments to show through. Only a few curly locks on the top of the head stood out against the sky in the background.

The facial features and flesh tones had been generally repainted. The deepest lacunae in the flesh areas betrayed the application of bright pink paint during a prior intervention. Past restorations had also altered the eye, creating an unnaturally immobile, stunned expression. The contours of the mouth had been redrawn with dark marks that turned down. The lips had no definition and were covered by a brown stain. The back of the right hand and the fingers had been flattened with an overpowering deep pink with no chiaroscuro modulations. Part of the sleeve cuff, glimpsed behind James's shoulder, had been treated with an ill-defined dark color, while another portion, under the arm of the same apostle, had been covered with a thick, oily material.

The intonaco and pictorial film are crisscrossed by cracks. A clearly visible one runs from the window across the head of the apostle, and ends at the base of his neck. Two others on the right hand are almost hairline cracks.

[left]
114. Detail: the figures of James
Major and Thomas after
restoration.

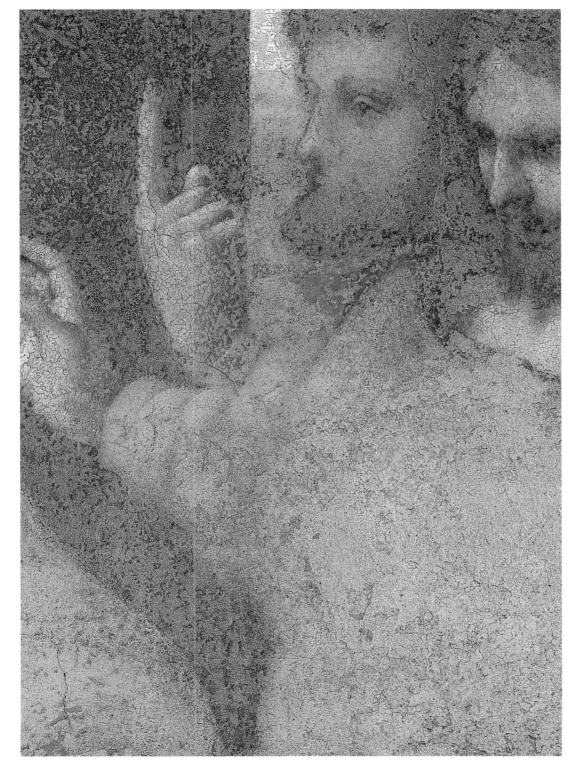

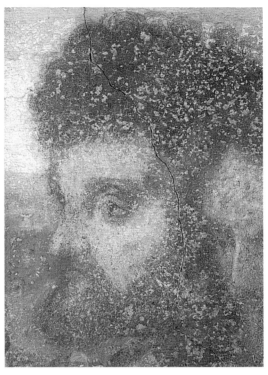

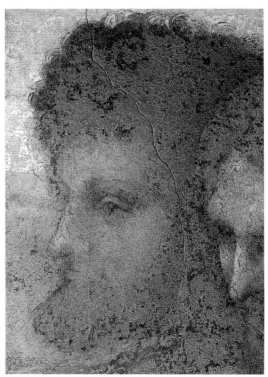

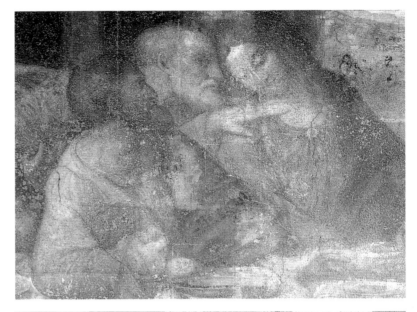

The gradual elimination of the prior restorations' various layers proved particularly beneficial in this case. The original material defines the head of Thomas with poetic effect and dramatic power. His thick mass of curls, full of airy brushstrokes, stand out against the light blue of the sky in the background. The rest of his hair, except for a few original fragments, is lost. The beard, too, is mostly lost, with only sporadic traces left around the line of the chin, the rest being full of lacunae.

The apostle's left hand, placed on the table, afforded a discovery of great importance that confirmed the faithfulness of the oldest copies. Located between James Major and Philip, the hand had been transformed by an unfortunate restoration into a loaf of bread on a plate.[45] The cleaning brought to light two fingers holding a knife, which can also be seen through a transparent glass. The removal of the right hand's restoration caused particular difficulties, because the repaint was extremely thick and the preparation very fragile. The completed cleaning confirmed its reasonably good condition, even if worse than James's nearby hand.

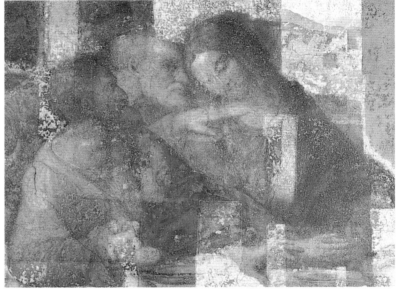

Just below the beard in an area that initially seemed part of the landscape, a few fragments of the light-blue robe were recovered, which match the original light-blue flakes found above the plate, next to the apostle's left hand. The awkward red repaint that indicated the apostle's mantle covered and erased a puff of the garment's sleeve. To enhance the legibility of the apostle's physiognomy, toned glazes were employed.

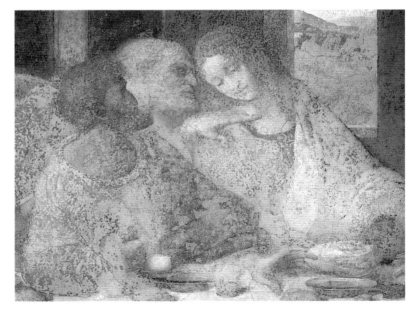

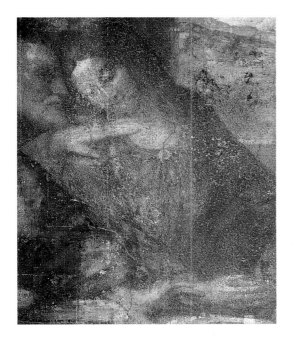

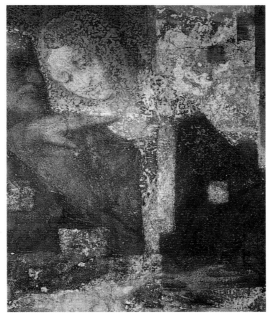

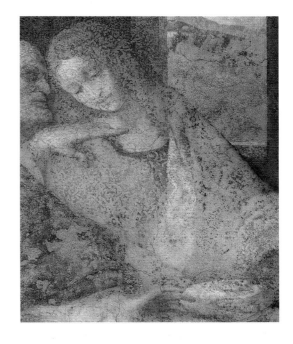

John

John sits to Christ's immediate right, and his calmness contrasts dramatically with the dynamic agitation of the other apostles. With his hands folded on the table, John inclines his head slightly toward Peter, who calls on him to ask the Lord for the answer to the question on everyone's lips, the identity of the traitor. John's effeminate facial features are framed by long hair, and his complexion, despite the many restorations, is very pale. The brown border at the neckline of the light-blue robe is ornamented with a gray gem, and the full folds of the reddish mantle drape over the left shoulder and arm.

The head was discontinuous, and the hair had been heavily repainted. Unlike the figures to the apostle's left, John's face had not been globally reconstructed. Nevertheless, the facial features seemed poorly drawn and in cer-

tain cases (nostrils and mouth) reduced to small dark lines. In all probability, a summary cleaning carried out during a previous restoration had partially removed the repaint, revealing areas of original color.

A preliminary examination revealed that the painting was in precarious condition, with notable losses in the lower area of the face. The hands had also been repainted and partially cleaned, although for the most part the extraneous material had only been eliminated from the illuminated areas. The pictorial quality of the restoration was mediocre and displayed gross chromatic alterations. The many lacunae had been crudely patched, and the outlines of the right hand had been reinforced, while the back of the left hand had been erased by a uniform brown coat of repaint. The partial cleaning had abraded the final layer of the flesh

tones, wearing down the edges of the surviving flakes of original material and revealing the pinkish background color on the face and the hands.

Both the robe and the mantle had been massively reworked. The heaviness of the mantle's repaint in particular, similar to the manner in which James Minor was restored, did not allow any fragments of original color to be identified. The greenish tonality of the repaint to the robe partially invaded the background color, and contrasted with the original light-blue color.

Even a general examination of the painted surface revealed that the dense applications of organic adhesives had experienced serious alteration. Three cracks damage the figure: the deepest begins at the table, runs along the entire figure, and ends in the distant landscape behind him; the finest crack branches off from the face; and the

third crosses the lower portion of the figure horizontally. Beyond the immense and widespread losses of long ago, in recent times continued flaking has provoked microscopic losses, despite the pictorial restorations. The left shoulder of the apostle was predominantly affected, while other intermittent losses were localized on the light-blue tunic and the hair.

Because historical sources describe the serious damage that protracted rainwater infiltration caused to this area of the painting, it was cleaned with particular care. Initial cleanings revealed a particularly critical situation in certain background areas, including, for example, the entire mantle. Broad areas were afflicted with lacunae in the half tones and in the shadowed areas. Attention was therefore was focused on the still-conserved illuminated areas, whose luminosity and coloring contrasted with the heavy repaint, entailing a total, deep cleaning. The rediscovered original tonality resembles Simon's mantle, with the same silky, iridescent effects ranging from white to intense crimson and black.

The light-blue robe had been densely repainted, with particularly thick layers in the lacunae. Small portions of the original pictorial film were visible in some places, but they were almost always abraded at the edges of the flakes, exposing the lead white imprimatura. This damage resulted from the decidedly inappropriate use of pressure to stabilize the surface. During the cleaning, two distinct pictorial interventions came to light, both carried out with casein colors. The oldest and most fragmentary restoration's violet tone had deposited almost exclusively on the original color. The second operation covered both the color and the lacunae. Almost insoluble and extremely tenacious, both restorations resisted removal. As solvents proved ineffective, the overlying layers were gradually thinned out with almost exclusively mechanical means.

The hair had been reduced to a shapeless blanket of brown color with some improbable pink highlights, which was completely removed as we believed that sufficient original color lay below the repaint. The original passages emerged in a warm reddish chestnut color.

The cleaning and retouching phases of the flesh areas were also approached with extreme care. Two different pictorial interventions were selectively and cautiously removed from the already seriously impoverished face. The most recent restoration had been executed on the entire face with heavy, dense brushstrokes in a greenish tone. Intermittent bright pink traces of the older underlying intervention were identified in the area between the mouth and the nose. The brown lines that distinguish the nostrils and the lips correspond to this older intervention, and were partially conserved in order to retain at least some of the descriptive information of the facial features.

The same kind of repaint was also eliminated from the hands, revealing a critical situation. Only some groups of flakes representing highlights remained on the back of the hand and the fingers. The absence of anatomical features and shadows made it impossible to read the interlaced fingers.

A further, patient cleaning phase required that we repeatedly extract massive deposits of glue that had impregnated the preparatory layers. These deposits gradually surfaced as the repaint was eliminated, and they caused considerable yellowing that interfered with the image's pictorial coherence. Such copious amounts of glue can be ascribed to repeated attempts to halt the detachment and weakening of the preparation layers, caused by humidity.

Nine-tenths of the original pictorial film in the flesh areas had been lost, and the recovery of the remaining material was extremely difficult and challenging. With a careful, gradual effort, unexpected results were obtained. The recovered facial expression resulted in an image that is less static and confused, and more coherent with the other heads. Likewise, the position of the hands proved to be slightly more foreshortened than the old restorers' reworked design.

The most remarkable result proved to be the recovery of the light-blue robe. Like the other rediscovered examples of this color in the *Last Supper*, it revealed a surprisingly rich tonality. The neckline was also well conserved, showing full portions of the gem's color. With the exception of the cuff, however, the pinkish mantle unfortunately retained very few surviving passages of original paint.

Judas

In terms of spatial organization, the figure of Judas is the most complex of all the apostles. A twisting of the upper torso makes him lean his upper right arm practically on the front edge of the

[left]
124. The figure of Judas, before the restoration.

[middle]
125. The same, detail with cleaning trials.

[right]
126. The same, after restoration.

table, and focuses on him the breaking point and the center of the intense emotional wave disrupting the other apostles.

His robe lacks the mounted gem at the neckline of the other apostles' robes. Once again, his right hand conspicuously grips the bag containing the thirty coins that, according to tradition, was the price of his betrayal. The left arm reaches toward Christ. His head, which is in shadow and hence characterized by a dark complexion, is represented almost in profile directly in front of Peter.

Although at first the figure seemed fully integrated, in fact it had been completely repainted. A prior intervention had reworked the black hair, the beard, the flesh tones, and the facial features. Close examination determined that almost all the original color had been lost. The layer of repaint appeared compact and generalized, with no visible flakes of original material, except in the illuminated area of the neck. Unlike the neck, the head's poor legibility suggested that it had not been cleaned as often and was thus less damaged by ancient cleanings. One of the causes of its deterioration undoubtedly lies in the fragile nature of Leonardo's dark pigments, which were lost early in the painting's history.

While the hands had not been repainted, they were nevertheless completely obscured by layers of glue and grime. The right hand was well conserved, especially in the shadowed area, despite abrasions at the edges of the flakes. In addition to abrasions, the left hand showed losses in a large area on the back of the hand, as well as on the upper part of the index and little fingers.

The fabric of Judas's clothing exhibited a particularly varied chromatic range. Over a violet robe, he wears a two-colored mantle, light blue on the right shoulder and green on the left. Keen observation reveals a delicate, fragmentary gold decoration applied by brush on the illuminated part of the mantle's cuff at the neck. Fernanda Wittgens thought it was Kufic writing, but its identification remains uncertain, given its condition.

Prior restorations of the clothing varied distinctly from area to area. On the right side, repainting was limited to areas with lacunae, prevalently localized in shadowed areas, such as the light-blue sleeve. The attenuation of some lacunae and *neutro* infilling could be attributed to Pellicioli. In the illuminated areas, the flakes of original color were visible and largely intact.

The condition of the left shoulder and arm was entirely different. They had been altered by a crude and ex-

[upper left]
127. *Detail: the head of Judas, before restoration.*

[upper middle]
128. *Detail: head of Judas, during cleaning.*

[upper right]
129. *Detail: head of Judas, after restoration.*

[lower]
130. *Detail: Judas's arm, during restoration. Clear signs of black repaint in the zone of contact with the table.*

tensive gray-green repainting, scattered with numerous black and brown *stuccature*. The same intervention had reworked the drapery folds, beginning at the wrist and ending at the elbow. This was one of the most confused and oxidized areas of the *Last Supper*, and unfortunately no flakes of original color were found. The purple robe had also been completely repainted, but owing to the lack of original material, it was adjusted and maintained.

The cracks that affected the figure were mostly hairlines. One descends from the face to the chest; another wider crack cuts the arms and right wrist transversally and continues to the tablecloth; and a third crosses the bust horizontally. A final crack descends from Peter's hand, branches out toward the right side, cuts the wrist of Judas, and crosses the tablecloth.

The method used to clean the figure

was adapted to variations in its condition and to the amount of old repaint that could be eliminated. The original flesh tones were retrieved where possible, such as in the illuminated areas of the neck and on the hands. For the face, the half of the neck in shadow, and the hair, however, the oldest restoration was maintained, but obviously freed of the heavy strata of repaint, adhesives, and the darkening caused by particle deposits.

The cleaning of the mantle also had to be adapted to variations in its condition. Part of the ancient repaint on the green left side was maintained as a pictorial basis, since the original material was completely lost. The invasive *stuccatura*, however, was removed. Deep cleaning was carried out on the right shoulder and arm. The old restoration material was removed, but

particular attention was paid to the conservation of the gold fibers, which were freed from the usual, tenacious casein-based interventions always encountered on the blue and light-blue painted backgrounds. The ancient restoration was also almost completely preserved on the front of the violet robe in order to save the articulation of the crinkled drapery folds.

Integrating this figure with the rest of the painting was particularly difficult because of the diverse and gradual nature of the cleanings, which were conducted with the goal of maintaining a balance between this figure and the others and with the composition of the *Last Supper* as a whole. Still, the effort proved a success even though the dark tones of the image of Judas had become extremely fragile over time. The recovery of the light-blue mantle, with the

beautiful azurite turquoise gradations of light and dark tones, adds a remarkable chromatic effect. The gold decoration of the cloak is now much more legible and, despite its wear and fragmentary state, is a precious iconographic and pictorial find. Finally, the discovery of the bag held tightly in the right hand is noteworthy. The integral color makes it again possible to appreciate the puckering of the purse held between the fingers, which is described with refined virtuosity.

Peter

Leonardo painted the figure of Peter straining forward, with foreshortened profile, his left hand extended toward Christ. The accentuated forward thrust of the apostle's complicated position is further heightened by the twisting of the right arm and hand that grips a knife.

[upper] 134. The face of Peter before the restoration.

[middle] 135. The same detail during cleaning. The stuccatura at the eye and some of the reconstruction of the mouth have not been removed.

[lower] 136. The same, after restoration.

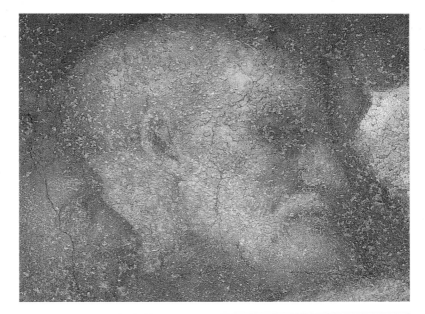

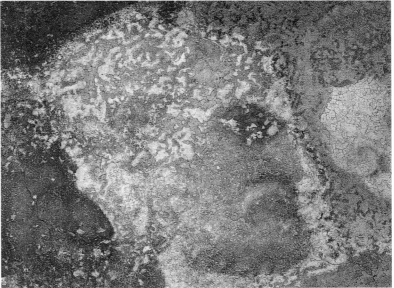

The unusual, exaggerated position constitutes a stylistic forerunner for the successive period's pictorial canons. Peter has the characteristics of a man advanced in years. Even though he is partially hidden behind Judas, parts of Peter's blue robe and rose-colored mantle, draped at the hip, are still visible.

Like all the heads to the figure's left, Peter's facial features also show extensive, reconstructive restoration, which superficially suggests a certain completeness. Raking light reveals that in reality, few areas of the face, namely the forehead and cheekbones, are conserved.

Although relatively well done, the old repaints had yellowed and taken on dark tonalities, such as the flesh tones of the hands, which had become quite brown. Under raking light, the surface of the hands betrayed the presence of animal glues that gave the material a translucent, gummy look. The reconstruction of the hands accentuated the contours and the shading with a thick blanket of brown or black. The right hand lacked parts of some fingers, while the lower outline of the left hand had been reinforced. Despite the heavy restoration, there was general abrasion to the remaining original flakes, for example on the palm of the right hand and the index finger of the left hand. The knife and handle displayed the effects of the same restoration that had reinforced the outlines and filled the lacunae.

The original color of the blue robe was almost completely covered by the repaint, which had taken on a grayish tint. The restoration color had particularly settled in the lacunae, so only the deepest folds were visible.

[left]
137. Detail: Peter's bright blue robe, before restoration.

[middle]
138. The same, during cleaning.

[right]
139. The same, after restoration.

[left]
137. Detail: Peter's bright blue robe, before restoration.

[middle]
138. The same, during cleaning.

[right]
139. The same, after restoration.

Further, numerous losses dating from earlier periods had been attenuated by a localized intervention *a neutro*. The left arm had been covered by the addition of drapery in a gray-blue tone. This repaint was opaque and characterized by a particularly thin, worn surface. The ancient restorer's intent was to recreate not merely the sleeve for the robe, but drapery for the mantle. The cleaning allowed the exact identity of this detail to be obtained.

An orthogonal web of cracks that follow the direction of the underlying bricks damaged the apostle's entire right arm. Two other longitudinal cracks cross the face and the left hand, while a hairline crack cuts the lower edge of the beard horizontally.

Few *stuccature* had been used, and

then primarily to fill lacunae in the lower part of the blue robe. The area of the robe corresponding to the inner elbow displayed an extensive black portion left untreated during Pellicioli's stabilization, as well as a rather oxidized pictorial surface.

Inevitably, our cleaning operation had to be selective. After first removing adhesives and dust, we decided to maintain the lower part of the face, which otherwise would have been completely missing. This repaint, however, was lightened as much as possible to match the original color, which had been completely recovered on the forehead and hair.

The eye socket proved to be composed of dark *stuccatura*, which initially seemed to imitate the morphology and

color of the original. However, and most unfortunately, the details of the eye had not been realized pictorially. The repainting of the ear also proved imprecise and anatomically incorrect. In the lower part of the face, the beard's repaint was restored and, after the grime and adhesives were eliminated, proved to be a tone similar to the few flakes of surviving original color.

In the areas where the cleaning could be pushed to the point of completely removing the repaint, considerable amounts of Leonardo's color were rediscovered. For example, even though the blue robe exhibited lacunae and abraded flakes of color, it regained an intense, prominent tonality. The right hand grasping the fisher's knife was also successfully recovered, and subtle, re-

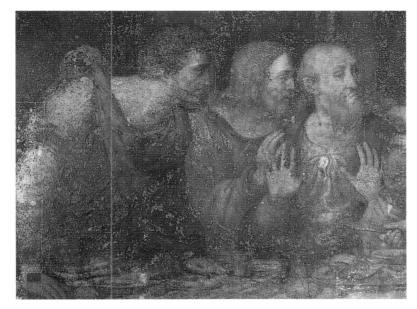

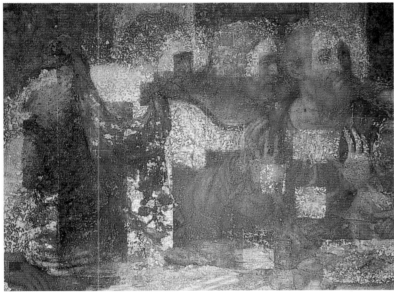

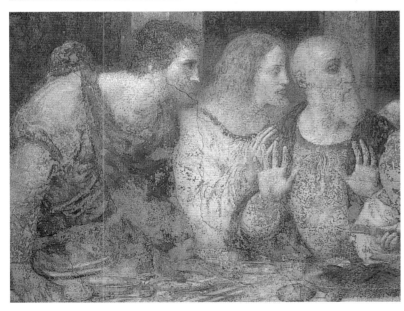

fined light blue-gray highlights reappeared on the handle. The knife blade's condition was poor, but still perfectly legible.

The pale mantle was in worse condition, but the small rediscovered passages nevertheless disclosed that the original color was not the pinkish color of the ancient repaint, but rather a changeable yellow-orange. It proved much more luminous, and the master had painted it as if it were being struck by a radiant natural light source from the left. The belt at Peter's waist was only partially recovered. The upper part of the belt is almost complete, but the lower part is totally lost.

The left hand proved very compromised, both in the flesh areas and in the blue robe's cuff. The progressive cleaning of this area, however, showed that the thumb had been significantly repositioned from its original distended arrangement to a downward curve. The cleaning was responsible for bringing that *pentimento* to light.

The reintegration of Peter's figure of was particularly laborious because the repainted portions of the face had to be harmonized with areas where much original paint was uncovered

Andrew

Elderly, balding, and with a thick gray beard, Andrew turns his head toward the Savior and raises his hands in a gesture of heartfelt innocence as he hears the charge of betrayal. He wears a brown tunic highlighted with pale folds that gather at the neckline, and a dark green mantle over his shoulders.

The apostle's facial expression appeared weighed down by the dense

143. The figure of Andrew, before restoration.

144. The same, detail, with early cleaning trials.

145. The same, after restoration.

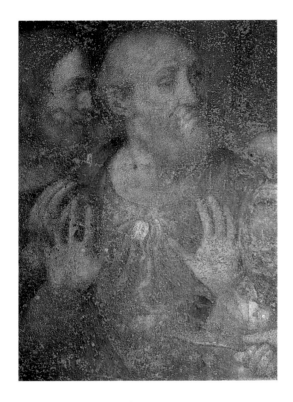 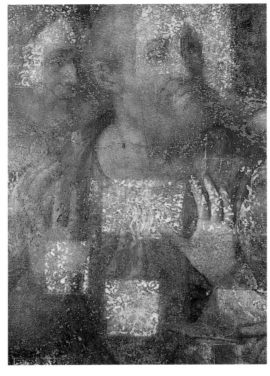 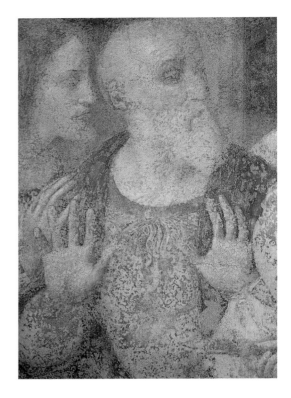

brushstrokes that had almost completely redrawn the eyes and ears. The gray beard and cropped hair were the product of a single, uniform coat that covered both the lacunae and the fragments of original color. Rose-colored flesh tone repaint had been partially removed in areas, revealing flakes of original color. In areas most struck by light, such as the temple and left part of the neck, the repaint had been removed from the lacunae. A brownish layer of adhesives and superficial grime remained exposed.

The repainting of the shadowed area of the face was heavy and unfaithful. The outline of the head and the repainted eye had been abbreviated and enlarged. Near the upper part of the left eye and above the nose, *stuccature*

composed of an unusual bright green material were visible. Brown stucco had also been heavily applied below the apostle's left hand.

Two reconstructive interventions of the past were clearly distinguishable. On the robe, the reintegration primarily covered the lacunae, while also concealing numerous fragments of original color, which fortunately remained intact. The repainting of the mantle was of a different nature—total and invasive. The compact, dense character of the color actually took on a layered consistency. The restoration was similar to the ancient background repaint of Bartholomew's mantle.

Next to the right hand, animal glue had been applied that was so shiny and conspicuous it looked like a

glaze. The repaint on the hands had already been removed, and consequently their restorations seemed less invasive, only partially filling the lacunae in the illuminated areas. Repaints were manifestly visible, however, in some of the shadowed flesh tone areas, such as the right wrist. The thumbs were completely missing from both hands, and the little finger of the right hand appeared seriously compromised, having been reconfigured by the same worker who intervened on the mantle.

Longitudinal hairline cracks were identified on the head. One grazes the external outline of the left temple, and another branches out on the right cheek and the neck. Two other horizontal, parallel cracks span the neck

[upper left]
146. Detail: head of Andrew, during trial cleaning.

[lower left]
147. Detail: Andrew's and James's hands, before restoration.

[upper middle]
148. Head of Andrew: a more advanced stage in the cleaning showing an arbitrary reconstruction of the left eye.

[lower]
149. Detail: Andrew's and James's hands, during cleaning.

[upper right]
150. Head of Andrew, after restoration, showing recuperation of the original physiognomy.

[lower right]
151. Detail: Andrew's and James's hands, after restoration.

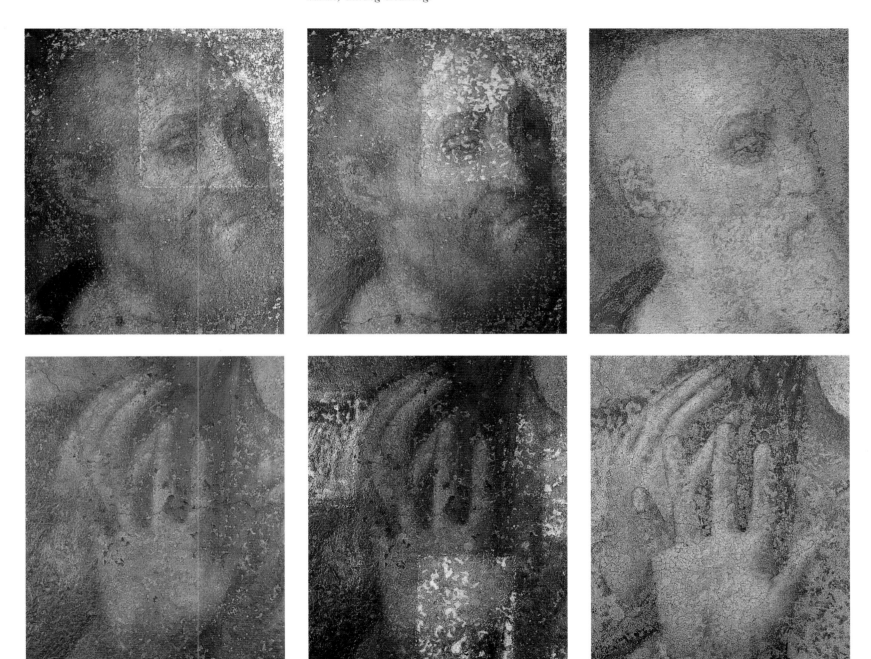

[left]
152. The figure of James Minor, before restoration.

[middle]
153. Detail of the same, showing first cleaning trials.

[right]
154. The same, after restoration.

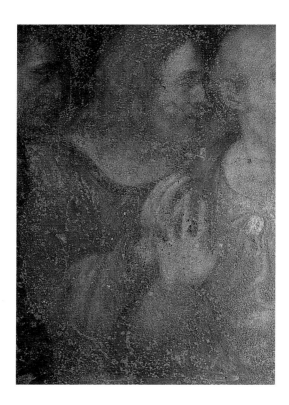

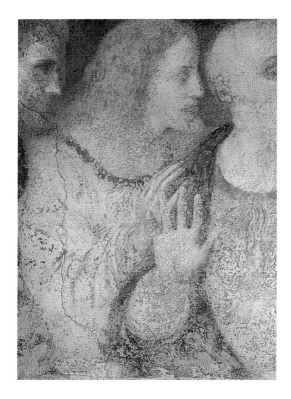

and chest, while a third, smaller one traverses the center of the robe. Finally a lesion caused by the settling of the wall cuts across the right elbow.

The flesh tones and robe were brought back to light and freed of the clearly distinguishable consecutive interventions. Like the robe of James Minor, Andrew's yellow tunic had been comprehensively repainted in an opaque color. Some of the modeling and the play of the close-set gathers at the neckline had been reinforced. After the cleaning, the robe partially reacquired the original brilliant tonality of the yellow ocher fabric, and the modeling of the drapery in gradations of brown to golden yellow.

The neckline of the tunic is trimmed with a decorative border with the same tonalities as the fabric, and embellished at the center by an oval, light blue-gray gem in a gold setting. The lower area is marked by an unusual relief formation in the preparation layer that seems to provide a material emphasis to the pattern of the folds.

The mantle was freed of dust and adhesives, revealing an extremely resistant type of repaint in a bright green tonality, which had been applied with thick brushstrokes over the preparation and surviving fragments of original color. Like the repaint on the figure of Bartholomew, it was thinned in some points to attenuate the dissonance between the original surface and the repaint. Its preservation was dictated by

the decision to conserve such an old intervention. Brilliant green fragments of original color were also recuperated.

Removing the repaints from the left side of Andrew's face meant that his head was returned to its proper size and proportions, but it was also returned to the artist's original perception, a very foreshortened pose in which the left eye is reduced to little more than a point, thanks to a sharp viewing angle.

The elimination of the repaints made the remaining and quite fragmentary paint film stand out as inconsistent with the rest. The pictorial matter—intact from the cranium to the nose, on the nape, the ear, and on the lower part of the head to the neckline—contrasted

[left]
155. Detail: head of James Minor, before the restoration.

[middle]
156. The same, during cleaning and after partial removal of repaints.

[right]
157. The same, after restoration.

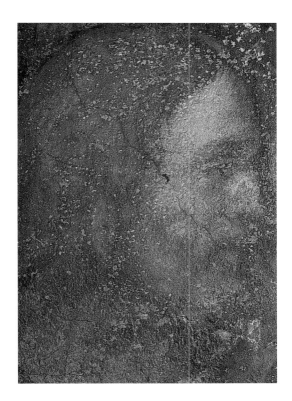

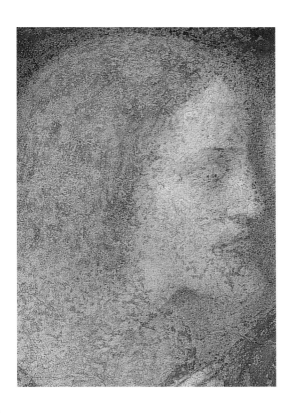

with the conspicuous lacunae. Even though the lines delineating the ear were not original, they enhanced the legibility of the position of the head, and were consequently maintained.

Andrew's hands, as suggested by the initial examination, were in good condition with the exception of the last phalanges of two of the fingers of the left hand, which had been redrawn at the same time that the apostle's mantle had been restored. Despite the partial cleaning, heavy sedimentation of pigmented material in the lacunae between the fragments of the original pictorial film were discovered, characterized by a tenacious casein binding material.

The recovered coloring of the flesh areas is particularly vivid. Because of the acute fragmentation of the pictorial film, the restoration of the face proved more effective for the generalized characteristics than the physiognomic details, as with the head of Simon. The reintegration strove to respect the refined drapery composition, especially in the upper part of the tunic. A comparison of Andrew's flesh tones with the other apostles confirms Leonardo's consummate, subtle attention to the chromatic differentiation of the figures' faces.

James Minor

James Minor, the second apostle from the left, turns his head toward Christ and his body toward the viewer. His outstretched left arm behind Andrew's shoulders seems to bind the group of three apostles together and create a connection with the other figures. The left hand just barely touches the figure of Peter, while the right hand, lifted in a gesture of surprise, is almost interwoven with Andrew's hand. The youthful, well-defined face is framed by long, dark-blond hair.

The beard and hair had been repainted, and the flesh tones appeared delicate and uneven because of the partial cleaning carried out long ago to emphasize the illuminated parts of the forehead and temple. The same type of intervention was discovered on other heads, such as Bartholomew and John. The those of facial features had been completely reworked. The eye and nose

had been redrawn, and a heavy black brushstroke opened the mouth.

The lacunae at the neck and throat had been completely repainted. The hands displayed differing states of conservation. Ample amounts of original material had survived on the right hand. In the left hand, fragments of original color were left only in the highlights on the thumb and index finger, while the lacunae in the parts of the hand in the shadow were summarily traced in a brownish tone.

The tunic had been completely repainted with a heavy application of red color, which carelessly reworked the gathers at the neckline and the modeling of the drapery. The light-blue cuffs of a shirt emerged from the tunic's full, draping sleeves, but only a small portion of the light blue was visible, as a blackish color that was absolutely different from the original tone had been used to fill the lacunae. The left cuff was almost indistinguishable from the background. Although the neckline of the tunic had been repainted, traces of a subtle yellow trim imitating gold were visible.

The red repaint of the tunic uniformly covered the exposed preparation, visible in raking light, and the areas where only intonaco remained. It did not succeed, however, in homogenizing the extremely discontinuous surface. Gummy materials had settled in the interstices of the lacunae, forming translucent, yellowed strata.

On the temple, near a crack that transversally crosses the apostle's head, black *stuccatura* filled a lacuna in the intonaco. A beige-colored mixture, which clearly contrasted with the surrounding surface, had been used to fill a longitudinal crack that runs across the right shoulder, the arm, and the tablecloth. Minute but widespread recent losses were noted, as well as older significant repairs made *a neutro*. *Stuccature* mixed with black pigment patched the small lacunae.

The cleaning operation began with the head. Exploratory tests revealed that the original pictorial film of the hair was in extremely poor condition, and almost completely lost with the exception of sporadic reddish flakes. As a result, we decided to maintain at least partially the preexisting repaints, while thinning out the thickest layers and eliminating the most mediocre parts of the prior restorations. The head's real profile was thus recovered.

Once the heavy, altered repaints on the flesh areas of the face and neck had been removed, we decided to maintain the layers covering the lower area of the nostrils, the lips, and the bearded chin, while the eye was freed of the superimposed layers of adhesive. The original color on the right hand was successfully recovered. The cleaning of the left hand proved more difficult, because the residual color was extremely fragile and fragmented into small, concave flecks that detached easily from the preparation layers. In the flesh areas, traces of a tenacious bright pink repaint applied with thick brushstrokes were discovered between the flakes of original material.

In the first phase of cleaning the red robe, we removed the superficial layers of dense fixative. The opaque repaint was easily removed, but the blue background paint was composed of a particularly resistant substance. On the robe's neckline near Bartholomew's beard, the greenish pigment with yellow decoration proved false. On almost the entire width of the neckline, the cleaning revealed a refined geometric design painted by brush tip with lead white and yellow pigment. A delicate oval constituted the setting for a green gem.

Removing the extensive tempera repaint on the tunic was simpler. As a result, scattered groups of flakes emerged, located mostly on the illuminated areas of the sleeve. The original color is a pale pink-orange tone. As usual, Leonardo employed lakes for the shadow areas.

The reintegration took into account James's withdrawn position with respect to the adjacent apostles. The green tone of the neighboring apostles' mantles seemed more accentuated, so a slightly darker tone than usual was employed on James's garment to revive the correct tonal relationships with the other figures. Notable results included the apostle's recovered left wrist position, which now appears decidedly bent compared with its former erratic, horizontal arrangement. Another particularly interesting detail is the smooth, compact preparation at the illuminated points of the drapery folds. Finally, more than any other area of the work, the lead white imprimatura, exposed because of the losses to the pictorial film, exhibits close-set, minute reticular cracking, which is different than the cracking of the preparation or color layers.

[upper left]
158. The figure of Bartholomew, before restoration.

[upper right]
159. The same, during cleaning.

[lower left]
160. The same, after restoration.

[lower right]
161. Diagram 9. The same. The various colors show stuccature applied to lacunae at different epochs.

Bartholomew

Bartholomew is depicted at the far left of the *Last Supper* in the act of rising with his hands on the table, as though pushing himself up in incredulous, pained indignation. The profiled head and elongated neck accentuate the apostle's movement as he stretches toward Christ. Bartholomew's mantle, worn in the antique style, is held on one shoulder and falls to the hem of the tablecloth, leaving his right arm free.

A translucent, yellowish patina totally covered the figure, creating a varnishlike effect. An adhesive of organic origin had been applied in such thick, copious quantities that it had impregnated the pictorial layers and formed a compact superficial film. *Stuccature* had been applied liberally to the mantle and robe and were clearly visible because of their color and polish, which contrasted sharply with the irregularity and tone of the surrounding pictorial film. Even though *stuccature* had been removed during a previous restoration,[46] the number, in differing tones, on this figure proved greater than that found elsewhere (see fig. 161, diagram 9).

The head merged visually with the background, and the hair had been completely repainted with a uniform dark brown pigment. The flesh areas had been seriously compromised, and immense losses, which had been coarsely patched with an improbable brown tone, were visible in raking light. Massive reconstructive restorations had also altered the hands and the modeling of the fingers. The pictorial film of the right hand had shattered into fragments that were severely consumed

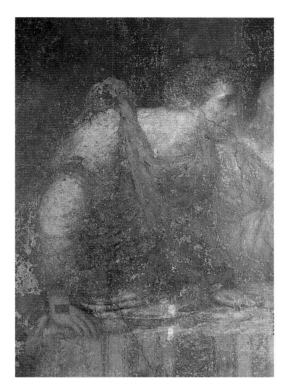

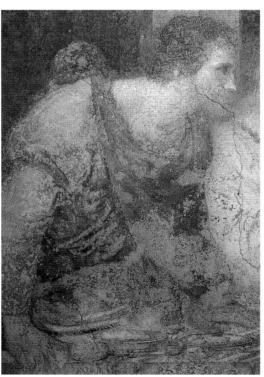

[upper]
162. *Detail: head of Bartholomew, before restoration.*

[lower]
163. *The same, after restoration.*

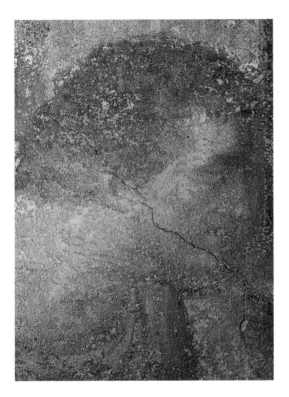

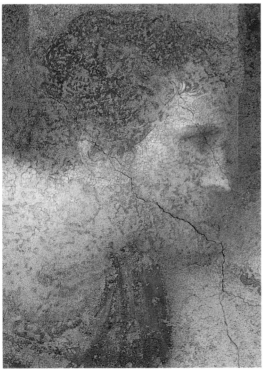

along the edges, and a dark area on the back of the hand left untreated by Pellicioli was clearly visible. The left hand was even less legible, and missing the last phalanges.

The mantle had been comprehensively and heavily repainted with a compact, oily material. Except for the area adjacent to the neck, where fragments of a light-blue pigment similar to that used in the tunic were identifiable, there were no discernible traces of the original color beneath the repaint. Lacunae believed to be extremely old were also scattered through the restored mantle, exposing the lead white imprimatura.

The light-blue tunic was in better condition, and the original color was still partially conserved on the sleeve. The rest of the garment was in poor condition. The flat applications of thick gray-brown repaint had obscured the modeling of the fabric, while the illuminated area had undergone a summary cleaning that had abraded the original light-blue flakes.

Four cracks traverse the pictorial surface: the first on the forehead, eye, and nose of the figure; the more apparent second one on the nape, cheek, and chin; the third crack descends from the shoulder to the chest; and the fourth goes from the elbow toward the table.

This cleaning operation was adjusted to the varying states of conservation. The repaint over the hair was lightened, revealing the original profile with its more reduced dimensions. It was possible to remove repaint from the flesh tones of the face and neck, while maintaining details of the eyes and lips. Two types of repaint were found in this area. One was a bright pink color located between flakes, which was difficult to remove. The other lighter, watercolor repaint was concentrated on the beard. Although fragmentary, the illuminated portion of the face was still rich in original details, such as the ear and the auburn locks of hair on the forehead and temple.

Along the neckline of the robe, heavy green repaint concealed the true contour of the garment, created with a light-blue border edged in gold with rapid brush strokes. The tenacity of the restoration material, anchored to Leonardo's delicate paint, made the cleaning a long and difficult process. Like the hair, the old repaint on the green mantle was partially maintained but freed of the layers of adhesive. In this phase of the work, original passages emerged that had previously been completely obscured by repaint.

Unexpected and noteworthy discoveries included the exact outline of the fabric draping the apostle's back, as well as a long piece of the mantle composed of light green folds, located near the tablecloth. The only original green color surviving in the entire painting, this luminous copper resinate pigment achieved brilliant, modeled tones. In the areas where original pictorial material was lacking, the two layers of repaint—a dark green over a black background coat—were preserved.

The light-blue robe exhibited a relatively good state of conservation, and the cleaning progressed after heavy layers of yellowed organic fixative had been removed. The operation revealed that the apostle's arm had been freed

[left]
164. Detail: Bartholomew's sleeve,
with a trial cleaning.

of some retouching during a previous cleaning, while layers of repaint were found in the shadow areas and below the elbow. The oldest repaint was blackish and overflowed into the areas of surrounding paint. Like the shoulder, some of the shallower lacunae had been filled with a thin layer of brown mortar to protect the edges.

The hands were partially freed of repaint that had restructured the fingers. Repeated restorations to the right hand had gradually modified the fingers' original position, which originally had been less contracted. Numerous dark gray flakes superimposed over the green mantle were recovered near the table, proving to be a napkin held be-

tween the apostle's fingers, also visible in the most reliable copies of the *Last Supper*.

The goal of the reintegration was to achieve better legibility for the figure's physiognomy. As a result of the detailed work, the robe's light-blue folds regained a sense of continuity in its movement, which had previously appeared

[upper]
166. The tablecloth, right-hand portion, partially cleaned. The area under the table is strongly darkened by repaints.

[lower]
167. The same, after restoration, showing recuperation of the apostles' feet.

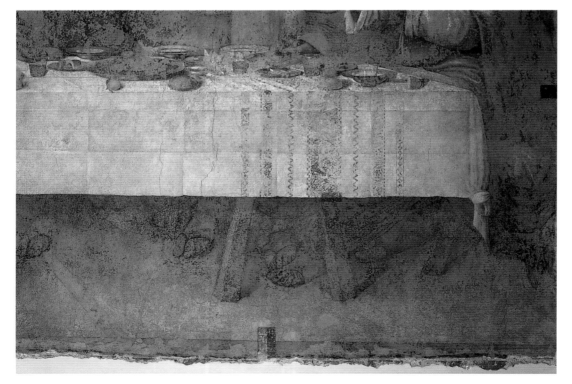

fragmentary and interrupted. It was more difficult, however, to put the original pieces of the green mantle back together with the preserved, different tones of old repaint. Despite the figure's initial precarious state, Bartholomew's imposing presence still shines through the numerous recovered passages.

The Tablecloth

The white tablecloth, decorated on each end with a motif of seven parallel, vertical light-blue bands, covers the table entirely. Creased horizontally and vertically, the cloth appears to have been freshly ironed. In fact, the image of the recently unfolded cloth, the soft puckering of its surface under a few glasses, and the two large, puffy knots at the corners convey a sense of great lightness.[47]

Because repaints had distorted the tablecloth's coloring and decorative motifs, after careful examination, we were obliged to formulate a hypothetical reconstruction of the tablecloth's decoration (see fig. 181, diagram 10). Its rhythmic regularity supports specialists' opinions that the tablecloth's decorative pattern is woven rather than embroidered.[48]

The primary elements of the pattern on the right were delineated with incisions and painted with light-blue color. On the left, however, the tonality of the fabric is grayer and cooler, and the artist first applied a layer of black pigment. The decoration was restored twice over the years. One greenish restoration partially reworked the design, while the other restoration in a violet-blue tone covered the decorative motif almost entirely.

Three large, shallow pewter serving dishes with wide rims are among the vessels arranged on the table. The one in front of Christ is empty, and the other two, in front of Matthew and Andrew, contain fish. Before each apostle is a small, rimmed bombé dish, perhaps a finger bowl, since the one in front of Simon contains water. Low plates hold leftover food, pieces of fish, and orange or lemon segments. Lemons and oranges still bearing little green leaves are strewn among the vessels. Soft, plump loaves of leavened bread, with delicate transitions from pale gold and gray to brown shadows, occupy the foreground.

Objects can be glimpsed through transparent glasses, which have convex bottoms and are half-filled with red wine (see fig. 182, diagram 11).[49] For each group of apostles, there is also a glass cruet filled with water. The table setting also includes knives and two pewter saltcellars, one in front of James Minor and one in front of Judas's arm. Only traces remain of the second cellar, which was in all likelihood originally depicted as being overturned in the heat of the dramatic moment.

As with the tablecloth, the tonal range of the well-laid table was completely obscured and altered by a layer of grime and organic adhesives; these had been applied in such quantities that the real chromatic values of the compositional elements were modified. Underneath, the paint surface seemed somewhat discontinuous. Fragmentary areas with lacunae alternated with well-conserved ones, such as the area near the figure of James Minor.

All the elements, now faithfully re-

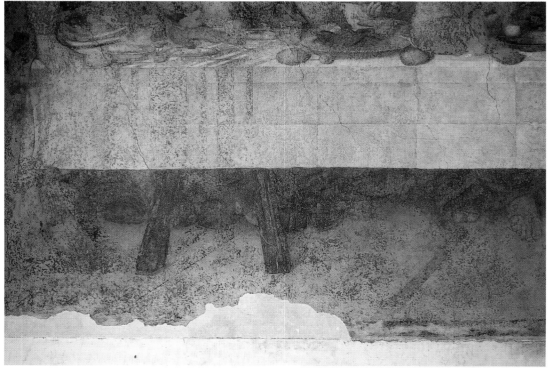

stored, seemed redrawn in an abbreviated fashion. The bread had been outlined in black, while repaint applied to the background progressed from pale gray to dark gray and black, emphasizing some of the foreground elements. Gray diagonal lines endeavored to conceal lacunae in the tablecloth's fabric. The dimensions of dishes and glasses had been altered, and serving dishes, such as the one in front of Matthew, had been arbitrarily filled with poorly drawn food. *Stuccature* plugged holes over the entire surface, mostly caused by the insertion of nails.

The preparation layer had suffered numerous losses. The most significant damage was concentrated in an immense gap between the corner of the tablecloth and Simon's sleeve, and in another area extending from the center of Thaddeus's glass to the decorated hem of the tablecloth. The preparation under the large dish in front of Matthew is almost completely gone, and unfortunately only a few traces of original color were found. The table area near James Major was very worn, and considerable abrasions had erased the darkest shadowed areas as well as the modeling of the bread and dishes. In this area and in the portion of the table near Christ, an unusual intervention stabilized the surface with wax. Then the area was toned to blend with the surrounding area, and detailed descriptive information completed the pictorial reconstruction of the figurative elements. Losses to the preparation layer are visible on the large dish in front of Christ, where scratches damage even the intonaco.

A preliminary examination of the

portion of the table between Christ and Bartholomew revealed that the objects and the tablecloth had been completely repainted. In this area, restoration had been much more comprehensive than in the area opposite, and both the lacunae and the adjacent original pigment had been summarily painted over, such as Andrew's glass and the food in the serving dish in front of him. Bartholomew's plate and the rim of Andrew's glass appear almost entirely fabricated. The objects on the table near the figure of Judas were severely compromised, and repaint concealed immense losses. The background color of the fruit in front of Andrew was seriously abraded, exposing the preparation layer.

In the portion of the painting below Bartholomew, from the cloth's decoration to the left edge of the table, we confirmed widespread microscopic flaking of the pictorial film, which proved both ancient and recent. The

losses to the geometric rhombus motif can be attributed to glues that caused traction between the paint surface and the preparatory layers, aggravating the problem rather than solving it.

After carefully examining the repaint, we proceeded to remove it. In some cases, such as some of the fruit in the foreground, it was only partially eliminated. Removing the wax was a particularly difficult and delicate operation, and solvents only partially managed to dissolve it. As a result, we resorted to mechanical means to wear down the wax and free the original material.

The thickness and tenacity of the overlying repaint on the light-blue decoration required serious attention and extreme caution, involving long hours to restore small portions of paint. Most difficult was the removal of the oldest, casein-based repaint applied to the entire tablecloth, and the shadowed areas where the double layer of original color under the repaint seemed very fragile.

Cleaning brought to light some of the best-conserved areas and effected some veritable recoveries, including, on the far right of the table, a knife, which had been transformed by an old restoration into a shadow cast by the amber-colored piece of bread. To the left, a pewter dish with light-blue reflections in the shadowed areas can now be glimpsed through a glass with transparent highlights. A loaf of bread next to the dish reacquired its original shadowing, which accentuates its roundness, and to its left, the transparent rim of a glass reappeared above a lacuna. Next to the glass, a highlighted plate containing segments of orange is now visible, along with a pewter bowl in delicate gray tones.

Objects that had been obscured by repaint have now reemerged in all their luminosity, such as the rounded saltcellar and the glass cruet filled with water in the foreground. Exceptionally

[cap., left; ill., upper left]
177. Detail: tablecloth decoration, before restoration.

[cap., middle; ill., upper right]
179. The same detail, after restoration.

[cap., right; ill., lower right]
180. Tablecloth, left-hand side. Where the tablecloth is in the shadow, the blue decoration is applied over a black base.

[cap., middle; ill., lower left]
178. Closer view of the same detail.

177. Detail: tablecloth decoration, before restoration.

179. The same detail, after restoration.

178. Closer view of the same detail.

180. Tablecloth, left-hand side. Where the tablecloth is in the shadow, the blue decoration is applied over a black base.

[upper]
181. Diagram 10. Reconstruction of the design of the tablecloth decoration.

[lower]
182. Diagram 11. Reconstruction of the layout of the objects set out on the table, seen as from above.

181. Diagram 10. Reconstruction of the design of the tablecloth decoration.

182. Diagram 11. Reconstruction of the layout of the objects set out on the table, seen as from above.

glues and oils proved to have so saturated the wall that it was impossible to eliminate them completely. Nevertheless, we managed to attenuate their effect, for the goal of the operation was to achieve the best perceptual recovery and legibility of the objects on the table. For the most part, the creases articulating the length of the tablecloth were clarified, and their chiaroscuro modulations slightly emphasized. These adjustments are visible at close range, but from a distance they reassemble the fabric's original harmony.

At the end of the restoration, the arrangement of vessels and food on the table revealed surprising passages. It proved essential to the rich and realistic play of light and color reflected in the tableware, explaining Leonardo's choice of pewter. The rims of the finger bowls assume different *sfumato* effects depending on the color of the apostles' clothing, and light inside the vessels bounces back and forth from the illuminated and shadowed parts to the water's surface. The highlights emphasize the heaviness of the plates and bowls, just as external and internal reflections define the glasses. Following the restoration, it comes as no surprise that the tablecloth of the *Last Supper* was greatly admired by Leonardo's contemporaries. Vasari was amazed at the "truth" of the details represented.

Even though many parts of the painting are irrevocably lost, the restoration brought to light significant traces of Leonardo's extraordinary painting, confirming the importance of the recovery. Mapping the tablecloth permitted it to be reconstructed graphically. Viewed

refined details, such as the reflection of a piece of orange in a pewter plate and the tones of the apostles' garments mirrored in the outer rims of dishes, can now be fully appreciated.

The cleaning also clarified the condition of the objects arranged on the left side of the table. Some were well conserved, like the bread and the serving dish containing fish, as well as the dishes in front of Judas and John. Oth-

ers, however, such as the glasses of wine and the oranges, often lacked brilliant reflections and proved mediocre.

The table was reintegrated according to the same principles applied to the rest of the painting. The considerable yellowed preparation layers complicated the unified recovery of the cool, slightly bluish tone of the fabric in the shadow areas. Despite repeated treatments, the old *beveroni* composed of

from above, the cruets appear much smaller than the glasses, saltcellars, serving dishes, and finger bowls, and the little plates next to the figures' hands seem slight and fragile. In composing the image, Leonardo appears to have thus relied more on the criteria of verisimilitude than on the rigors of perspective.

The extremities of the apostles' garments, their feet, the floor, and the table legs are represented in the area between the hem of the tablecloth and the lower edge of the painting. Leonardo envisioned the details somewhere between shadow and half-shadow, in dark tones and gradations that darken near the floor, cadenced by contrasting bands of color. At the lower edge, traces of a border conclude and frame the painting. Unfortunately, when the refectory's central door was enlarged, it destroyed part of the wall, as well as details of the lower parts of the figures, and it caused lesions above the door that are still visible.

It was difficult to distinguish details in this area, as it was totally blanketed by a uniform, dark pall. A close examination confirmed that its condition was seriously compromised. The layers of heavy restoration material had turned an arbitrary color, varying from brown to black at the extreme left. The repaint was covered by *beveroni* of animal glues that had clotted into a compact film, causing contractions and widespread microscopic flaking of color.

While the shape of the table legs could still just be discerned, everything else had been reduced to shapeless masses of indistinguishable color. The

floor had even been retouched where original pictorial material appears to have been intact. The heavy touch-ups gradually ended at the area circumscribing the door, leaving about fifty centimeters from the opening free of repaint, but nevertheless burdened by brownish-gray layers of glue.

The reconfiguration of the clothing was coarse and heavy, and the feet anatomically incorrect. Matthew's big toe on his left foot had actually been eliminated. The tone used to retouch the area was dull and arbitrary and, consequently, the luminosity of the few original flakes of color stood out distinctly.

On the lower left edge, a large lacuna had been filled with smooth plaster and matched to the surrounding color without the slightest mimetic intent. More flaking appeared in this area than in the rest of the painting, and losses to the pictorial film were greater on the left than in the corresponding right portion. The flaking must have occurred continuously over the centuries, and the particular morphology of the layers of preparation and color testify to energetic attempts to stabilize the area.

Lime is currently visible on the exposed preparation, left by fragments that flaked away from the pictorial film. This situation resulted from a method of stabilizing the surface with compression, executed at a moment when the preparation was saturated with condensed water and, therefore, soft. The pressure exerted to re-adhere the flakes was so strong that the fragments sank into the preparation layer, but they did not re-adhere. When the fragments suc-

cessively flaked off, an unusual reticular pattern remained in relief on the preparation.

The condition of each figurative element was carefully evaluated before cleaning this portion of the painting. Relative spatial arrangements, relationships between light and shade, chromatic correspondences with elements above the table (clothing, for example), and surviving original pictorial film all had to be taken into account. Copious amounts of fixative were removed, revealing two important restorations. Clearly the quality and quantity of the older repainting was higher and greater than the later one, which looked coarse in comparison, almost heedless of basic information. Greater legibility resulted from the elimination of this last restoration, and the shapes and real dimensions of mantles, feet, table legs, and Simon's stool were recovered.

In this phase of the restoration, abundant flakes of original color were found. We retained the oldest restoration in areas devoid of original material, but reduced the heaviest brushstrokes so as to have a base on which to work during the watercolor reintegration.

Because tests indicated that the original pictorial film was in reasonable condition, the repaint on the floor was also removed to the lower border of the painting, freeing the base layer, which emerged as a warm, decisive pink with brown shades for the shadow cast by the tablecloth. Leonardo superimposed a second heavy coat over this base layer, which graduated toward a light blue-gray tone. He then used a yellow ocher

to paint in the bands that articulate the floor pattern, but only a few fragments of the yellow ocher remain. The bands were delimited by a shallow incision. To the left there are traces of green pigment, which must have served as the background color.

Once the thick repaint on the lower portion of the figures had been reduced, the correct dimensions of the table legs and the stool were clarified. For example, the bizarre transformation of one of Bartholomew's feet into a chair leg was eliminated. Cleaning the area between the table and the right wall of the refectory revealed other details, such as oblique lines corresponding to the base of a pilaster, which delimited the painted environment. The background color of this architectural element was originally very pale, between white and beige. Part of Simon's purple mantle also reappeared, as did the shoe on Matthew's left foot, with traces of the turquoise decoration that embellished its emerald-green upper.

As *stuccature* were removed, they were dated according to their characteristics and composition. Most of them on the surface were attributed to Silvestri. More were removed, however, such as from the deep lacuna under the left table leg. There were composed of a light base of lime and sand, a very tenacious dark gray pigment, and a superficial layer of beige that had turned gray beneath glue and grime. The wall had also been damaged by a close-set series of nail holes of various sizes.

Though fragmented and fragile, the restored pictorial film allows Leonardo's virtuoso painting to emanate from the deepest shadows, obtained through the overlapping of delicate *sfumato* layers, whose intensity was built up with numerous layers of vermilion lake.

Plaster applied during the postwar restoration was also stripped away from the lower extremity of the painting, confirming that Leonardo finished the work by framing it with a monochromatic black border—now fragmentary—of about ten centimeters wide. He painted it directly on the finished floor and delimited its upper border, like the floor striations, with a shallow incision. The preparation layer only irregularly corresponds with the lower margin, suggesting that the color was applied directly to the intonaco. Furthermore, the lower edge of the intonaco was modeled as a protrusion, probably to simulate coherence with an underlying relief element. A brushstroke of sanguine red applied directly to the intonaco circumscribes the area occupied by the representation.

Achieving a cohesive vision of Leonardo's composition, with at least partial recomposition of the figural elements, was a long, complex process. The correct tonality was recovered for the clothing, which had been modified by prior restorations and, as a result, contrasted with the same garments above the table. Some details of the feet were corrected where legible traces remained, while in other areas the deterioration was too advanced to allow readjustment. Nevertheless, results of the treatment were extremely interesting. The correct relationships among figures in an immense area of the painting, which had seemed almost completely lost, were again legible and could be fully reintegrated into the *Last Supper*.

Lunettes[50]

Inexplicably, the earliest texts do not mention the lunettes. Later literature is justifiably silent, because the upper parts of the hall had, at some point, been whitewashed. Only Mazza, in his restoration of 1775, noted the decorations, which were perhaps visible because whitewash had flaked away.[51] The whitewash must have been applied at the same time that supports were added to suspend protective draperies over the *Last Supper* and hooks were installed to support the aristocratic arms that hung over the painted shields.[52] In 1722 the Richardsons recalled "the emperor's coat of arms" nailed so low it almost grazed Christ's hair, but they do not mention the decoration of the lunettes. Presumably they had already been whitewashed.[53]

Emilio Seletti notes that it was actually Stefano Barezzi who first eliminated the whitewash from the central wall's lunettes in 1853–55.[54] After this initial intervention, the restorer Knoller removed whitewash from the vault, the lateral lunettes and all of the refectory walls during the summer of 1858.[55] Knoller was also probably responsible for the heavy repainting that arbitrarily reworked the vault's decorative gilded lozenge design, encountered during the current restoration. Work must have progressed slowly, because the restoration was still being discussed in 1892.[56]

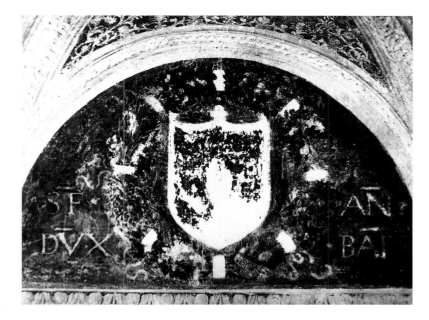

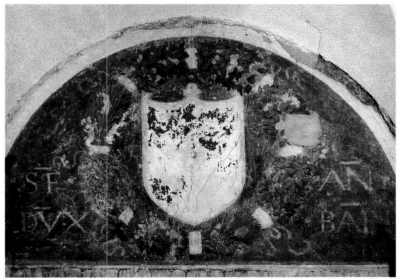

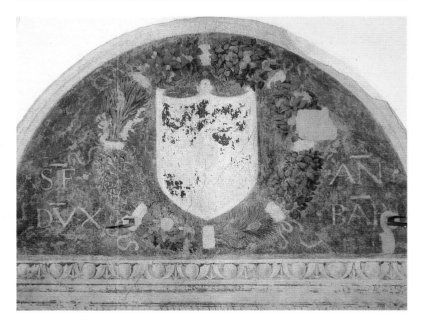

[upper] 183. Left-hand lunette in a photograph (1908) after the Cavenaghi restoration.

[middle] 184. The same lunette after the Pellicioli restoration (1954). The repainting has lightened the background, but it is clear that much of the original color inside the shield, remaining in 1908, had been lost.

[lower] 185. The same lunette, after restoration.

Barezzi died in 1859, and in 1895 the painter Mueller-Waelde[57] was called in to work on the lunettes. In 1908 Mueller-Waelde was succeeded by Cavenaghi, who declared, "I realized that the lunettes and the vault above the *Last Supper* needed to be restored, as even the color in various points had completely disappeared. The restoration revealed that the light-blue background of the vault sections was strewn with gold stars, while the admirable lunettes . . . proved to be the work of Leonardo."[58]

Our restoration thus confirmed that the nineteenth-century intervention arbitrarily interpreted the composition and coloring of the palmettes in the vault sections as well as the ultramarine blue of the background. Cavenaghi might have repainted the entire section in 1908, but some doubt remains concerning the chronology of the first restoration of the frontal lunettes and the different restoration of the vault and the walls. The most recent restoration dates to Pellicioli, who must have closed the crack caused by the bombing of 1943. Most likely, Pellicioli summarily cleaned the area without altering earlier restorations, limiting his task to integrating slightly the plastered areas.

The decorations of the lunettes were painted on a light-blue background, but today only the red ground remains. At the center of each lunette, the houses of the Sforza and the Estensi are glorified by coats of arms with silver- and gold-leafed backgrounds, surrounded by luxuriant festoons of fruit and leaves, knotted together by fluttering ribbons. (As we know, Leonardo's

[upper left]
186. Left-hand lunette: two layers of blue in different tones (from previous restorations) cover the reddish preparation.

[upper right]
187. Detail of the fruit in the garland. The fruit is modeled with a dense, smooth mixture placed over a layer visible below it (see arrow).

[lower right]
188. Stratigraphic photograph showing the two applications of green.

masterpiece was executed under the patronage of Ludovico il Moro and Beatrice d'Este.)

This restoration offered the opportunity to interpret more fully the botanical elements. Most of the various fronds composing the festoons were identified. In the three minor lunettes, the festoons include clusters of prunes, apricots, apples, pears, dates, oaks, and Scotch pine, variously arranged but repeated identically. The central lunette is embellished with other varieties of fruit, including blackberries, olives, and large quinces.[59]

Beside the festoons, inscriptions in capital Latin letters are flanked by ivy leaves. The letters were originally gilded, like the knotted ribbons (fig. 207, diagram 19). Independent of the queries posed by the recent restoration, questions remain concerning the dating

189. *Magnified detail showing the superposition of two layers of color. The red color underneath is more liquid and has been treated with more chiaroscuro (see arrow).*

of the beautiful repainting of the lunettes' festoons and coats of arms, presumably not much later than the original execution, and at any rate prior to the whitewashing. The refinement and quality of execution leave the identity of the artist—or artists[60] open to discussion.

Even though damaged by grime and dust, the lunettes' condition was profoundly different from that of the *Last Supper*. The colored surface, in fact, remained concealed for almost three centuries under whitewash, and was protected from damage caused by Bellotti and Mazza's eighteenth-century restorations.

Like the *Last Supper* itself, the lunettes exhibited a visible, profound disjunction along the right side, which had not been scarfed to the side wall. The intonaco had sustained minor damage in the form of thin cracks of various depths and irregular paths. Except for those surrounding the upper part of the lunettes—resulting from the bombing of 1943—the losses of intonaco had resulted from various interventions: for example, highly visible cracks had formed when fixtures were installed to support draperies and emblems or shields at the center of the coats of arms. The damage caused by the nail holes along the perimeter of the lunettes is relatively recent and probably due to the installation of draperies to protect the *Last Supper* during the reconstruction of the building after World War II. Along the edges of the cracks, in small areas the pictorial film had lifted and certain pigments had detached, especially on the shields.

In addition to the loss of color in the

intonaco, the light-blue background color that was applied over the first coat of reddish earth is completely missing. Only the most minute traces of gold decoration remain on the bands, the fluttering ribbons, the letters, and inside the shields. There are only fleeting traces of the shields. Abrasions were visible on the festoons, and the west wall's lunette was particularly damaged. Its background appeared to have been repainted at least twice. The oldest repaint altered the letters and the outlines of part of the foliage, while the most recent restoration, executed in dark but relatively transparent tones, extended over the largest part of the surface (fig. 186). The architectural decoration surrounding the lunettes also completely ignored the original coloring. Below the repaints, minute traces of lime were discovered; an attempt to remove it, executed with still-visible hammer strikes, did not appear complete. Shiny, waxy fixatives—and others that looked lumpy and opaque—were also discovered, concentrated in the blue and black portions of the shield's decoration.

The vault corresponding to the north wall's lunette was the only one that did not collapse following the bombing of 1943. Its condition merits separate comment. The vault displayed a close-set web of cracks, some of which were wide and deep, that had been plastered unevenly and sloppily. Along the cracks, the plaster had detached at numerous points. Traces of whitewash, poorly removed by hammering, were also discovered. The decorative aspects

had been repainted in bright tones, and the proportions and design of the architectural framing device had been modified.

The painted architrave under the lunettes was also traversed by thin cracks and exhibited adhesion problems between the color and the intonaco. Opaque repaint reinforcing the design was quite visible in the lower dark band that defined its depth.

Our restoration began with the vault, consolidating the areas around the cracks where intonaco had flaked away. This was a long and arduous process, and it required that we inject consolidation materials in existing cracks to prevent further damage to the pictorial surface. The paint layer was stabilized by saturating it with acrylic resin in solution after we had mechanically removed the residues of old whitewash (visible especially in the shields). Then the repaints from old restorations were gradually removed using solvents that had been rigorously studied in initial tests, and were applied to the surface with Japanese paper for controlled periods of time. In some areas—for example those involving the background and some leaf outlines—the repaint was not completely eliminated; instead, we halted before the image was compromised aesthetically. The decorative scheme that emerged at the end of the operation can only be resolved in the imagination, particularly when it comes to envisioning the clear, ringing harmonies of the light-blue background, the gold of the letters and ribbons, and the green of the fronds (see fig. 207).

While the recovered image does not convey the intensity of the original color, it is nevertheless quite powerful. We applied a glaze of color to the abraded walls, and conducted a partial integration of the lacunae *a neutro*.[61] When the restoration was completed, the three recovered frontal lunettes clearly proved to be important elements in Leonardo's original decorative plan. His intention seems to have been to surround the spacious, airy scene—vibrant with emotion and light—with subtle decorative detail, whose great variety of natural realism and rich observation could not be fully grasped at a distance.

Leonardo's Technique

By virtue of so much direct contact with the painting and exhaustive scientific research, we have tried to answer as many questions as we can concerning Leonardo's technique—always a matter of great interest. On the basis of careful observation, it was possible for us to "read" the work on a formal and technical level in its *details*; however, the painting's fragmentary condition did not permit a "larger" or more comprehensive rereading. We discovered that two different methods were used, one for the lunettes and one for the *Last Supper*. The well-known passage by Bandello[62] lends credence to the theory that the traditional *buon fresco* technique, which involves rapid execution in order to take advantage of the lime carbonatization process, was not compatible with the slow and meditative pace at which Leonardo worked on the *Last Supper*.

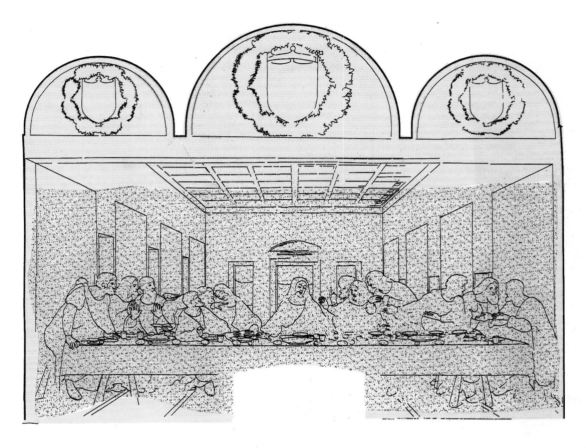

It is impossible to establish whether Leonardo simply could not achieve a normal *buon fresco* technique or whether he opted for greater technical freedom in order to return repeatedly to finished areas. In every way, Leonardo's working method confirms that he executed the mural according to the canons of panel painting. The results of the most recent restoration suggest that the lunettes were painted first, because the *Last Supper*'s preparation layer overlaps the upper area's intonaco layer.

Paint losses in the narrative scene revealed a preparation layer of varying thickness, as well as designs and incisions like those on the ceiling, which were reworked in order to improve the defined depth of certain objects and figures. The left part of the work demonstrates greater uncertainty in its handling, suggesting that Leonardo commenced the *Last Supper* on that side.

Support

The wall support is thin, is not scarfed to the right wall, and is composed of salvage materials bound with irregular mortar.[63] The support material was probably roughed out where necessary with mortar, visible along the crack in the corner of the east wall, where a fragment of the overlying intonaco flaked off. The intonaco appears to have been spread directly on the wall, presumably in a single application, and is characterized by a smooth, compact, and carefully finished surface. It is composed of a lime mixture: 30 percent of the inert component is local

sifted alluvial sand, and the rest is quartz. Its width varies from 1.5 to 2 centimeters.[64]

This type of plaster was used in the lunettes as a base for the application of color, in the upper area of the *Last Supper*, and in more or less regular strips along the sides and lower band of its frame (see fig. 190, diagram 129). Although the intonaco in the middle section has the same composition, its surface is rougher. As a result, the joint line is practically visible, especially in the upper part of the wall at about thirty centimeters from the trussing.

Probably Leonardo altered his initial plan when he realized that he could prepare a rougher surface that would provide greater adhesion for the overlying materials (figs. 191–93).

It is difficult to know if the wall had been completely prepared with an intonaco layer that was successively removed only within the *Last Supper* scene, or if it was different from the beginning. The intonaco stops in the lower band with a slight protrusion that indicates an overhanging frame was originally present and later removed (fig. 197).

[upper left] 191. Detail of the background of the smooth intonaco of the lunettes with remaining red preparation.

[middle left] 192. Detail of the upper edge framing of the Last Supper, showing where the smooth intonaco begins.

[bottom left] 193. Stratigraphic photograph of the intonaco of the lunettes: A, intonaco; B, white layer (calcium carbonate with traces of magnesium carbonate).

[upper middle] 194. Diagram 13. Reconstruction of the stratigraphy of the intonaco at the edge of the Last Supper: A, support; B, intonaco; C, preparation; D, imprimatura; E, layers of color.

[lower middle] 195. Stratigraphic photograph of the material at the edge of the Last Supper: A, intonaco incorporating stone fragments, some fairly large, in a matrix of carbonates; B, thick layer of light-yellow preparation made of calcium carbonate with traces of magnesium carbonate and quartz (–150/180?); C, thin and discontinuous layer of lead white (–20?).

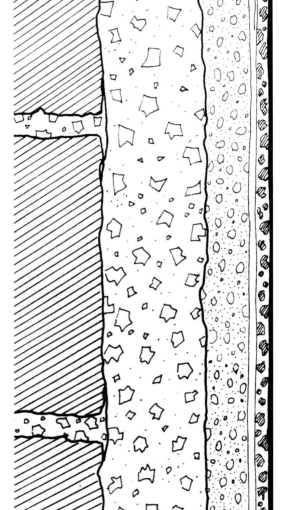

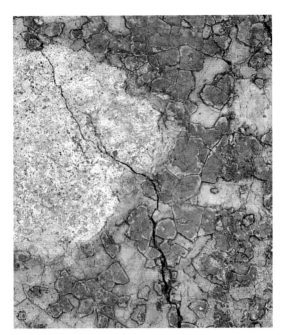

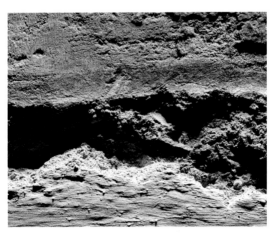

[upper right] 196. Detail showing light-colored granular intonaco underlying the preparation and the paint film at the edges of the Last Supper.

[lower right] 197. At the lower edge of the intonaco framing the picture, a slight indentation suggests the existence of a cornice (later removed).

410

198. Detail of fluid brush strokes
along the left-hand edge of the
painting; traces of a sinopia.

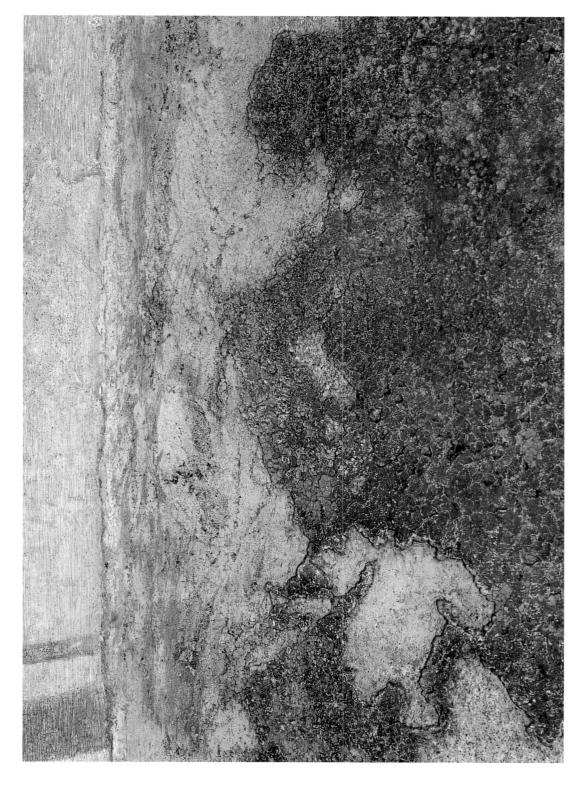

Sinopia

The discovery of extremely concise red
lines, executed freehand and with a
fluid brushstroke, is of particular in-
terest. They emerged only around the
Last Supper and were due to the loss
of preparation in the intonaco area
along the left and lower edges. A black
line defining the outlines of the paint-
ing was also found (fig. 198). In the
course of the restoration, minute traces
of red earth also appeared, which pre-
sumably belong to the actual composi-
tion. Leonardo probably sketched di-
rectly on the intonaco, perhaps to
define the masses for his composition,
before applying the rest of the prepa-
ration. It is impossible to know how
detailed this underdrawing was, but
the scenario is certainly plausible con-
sidering Leonardo's predilection for
translating his thoughts and ideas into
sketches.

Preparation

The application of the preparation layer
followed, its light color emerging after
the cleaning. Its slightly granular mix-
ture, with a thickness ranging from 100
to 200 microns, was composed of cal-
cium carbonate and magnesium. Chem-
ical analyses showed that the binder
was proteinaceous.[65] Leonardo must
have encountered certain difficulties in
his search for a material that corre-
sponded closely to the classical prepa-
ration of paintings on panel. He made
different choices in rendering the scene
of the *Last Supper* than he did for the
lunettes, altering the composition of
the material he used to one that proved
extremely sensitive to humidity.

The different areas could barely be distinguished by slight surface unevenness and junctions. A particularly obvious join is visible at the point where Christ's hair encounters his mantle; another in the hand of Judas; a third between Andrew's mantle and tunic (see fig. 199). The junctions partially correspond to the outlines of the figures, a method that suggests a *giornata*, or day's work, or simply the difficulty of immediately applying one uniform layer over the entire surface. In the left half of the painting, larger applications were noted near lacunae. Joins clearly appear, for example, in an area below the table near the robe of James Minor and on the figure of Bartholomew, where the preparation shows greater relief.

Imprimatura

In accordance with the principles of panel painting, imprimatura appears between the preparation layer and the pictorial film. It is composed of a thin layer (between 15 and 20 microns) of lead white, which, in addition to saturating any porosity of the underlying preparation, creates a homogeneous surface. It enhances the luminosity of the overlying color because of its white base.[66]

Incisions

As previously mentioned, we believe that Leonardo first worked on the central lunette. Leonardo's original idea, which he eventually altered, can be seen in the Windsor Castle sketch, whose black brushstrokes outline a coat of arms in the form of a polygonal shield, like a bucrane. It is decorated at the center by a circular design, but only a few suggestions remain. Color losses on the lunette revealed an early preparatory drawing rendered in extremely free brushstrokes.

An enigmatic series of diagonal lines, perhaps indicating a shadow and drawn from left to right on the right side of the early version of the lunette's shield, is crossed by the sinuous coil of a viper around a staff. In this lunette, as in the lateral ones, there were no traces of *spolvero,* the dotted outline that results from transferring a cartoon drawing to the painting surface. The consumed color revealed a light black drawing that denotes the fronds of the festoons and the knotted ribbons that bind them. In all three lunettes the incised double concentric circles delimiting the festoons and marking the shields' hooks are legible. Incisions detailing the fruit and dividing the shields are also visible. Precise incisions were also made in the preparation layer of the *Last Supper* and are easily visible through the paint. They almost exclusively involve the architectural scheme, and were identified, recorded, and reduced to a more appropriate scale to facilitate their reading by our team (see figs. 200–201; diagrams 14–15). The incisions are located mostly in the ceiling, in the blue decorative pattern of the tablecloth, and in the molding of the tympanum.

The incisions that outline the windows designate both the design of the molding and the doors, suggesting that they were executed when the color was applied. Furthermore, between Christ and James, at the height of the base of the window, an incision in the form of a cross delineates the edge of its lower outline. Another shallow incision defines part of Bartholomew's halo. The center line was then identified at the border of the architrave, delineated with small holes, and under the large serving dish in front of Christ, marked by a concise black line, which was found after cleaning an area lacking color.

On the right temple of Christ, a hole corresponds to the central vanishing point of the composition (see figs. 202–3). By stretching lines in the various directions, we tried to reread the entire spatial plan as traced in the geometric reconstruction. All the incisions and the resulting studies led to the discovery of an original sector of the ceiling, as previously discussed, and suggested a new perspective scheme for the painting. This is clearly apparent in the computer-generated model.

Pictorial Film

The chromatic surface of the lunettes was smooth and free of cracks. The technique used was different from normal *buon fresco*. The painter must have found a way to bind the pigment mixture with a medium that allowed it to adhere to the plaster and facilitate the smooth application of color. Chemical-physical analyses confirmed that the painting was accomplished *a secco* using a proteinaceous binder.

A red coat was identified that was limited to the light-blue background's preparation layer and did not occur in decorated areas. Examination of the festoons, in fact, confirms that they were painted with two layers of super-

imposed color. The underlying layer cannot be considered a preparation layer, however, because of its finished details and because of the results of fluorescent and UV analyses. Brown hatch marks are visible in some of the dates' details, indicating shadows on a first layer of lively, brilliant red, while an opaque, soft yellow layer covers it. The second layer is paler and duller (see fig. 189). This second layer could, however, be an old and skillful repaint. Given the results of Hermann Kühn's color analyses,[67] which identify the chemical composition of the pigments and binders in these two superimposed layers, if the material is repaint, then the artist must have been familiar with the original painting's technique.

Even though the most recent restoration has notably improved the legibility of the *Last Supper*, unfortunately the broad pictorial effect is marred by its condition, which does not allow us to readily perceive the vast gamut of original color passages. It was therefore difficult to reconstruct Leonardo's overall creative process. Still, his slow progress is confirmed by a few *pentimenti* and by the attentive refinement of important details. The figures do not show significant changes in shape or size or even of original intent so much as the occasional revision of an outline. Leonardo did, however, modify the position of Christ's fingers, which were more extended in the first version, and contracted in the final version. He made the same sort of alteration to Peter's fingers (see figs. 205–6; diagrams 17–18).

However, the two windows and the open door behind Christ were signifi-

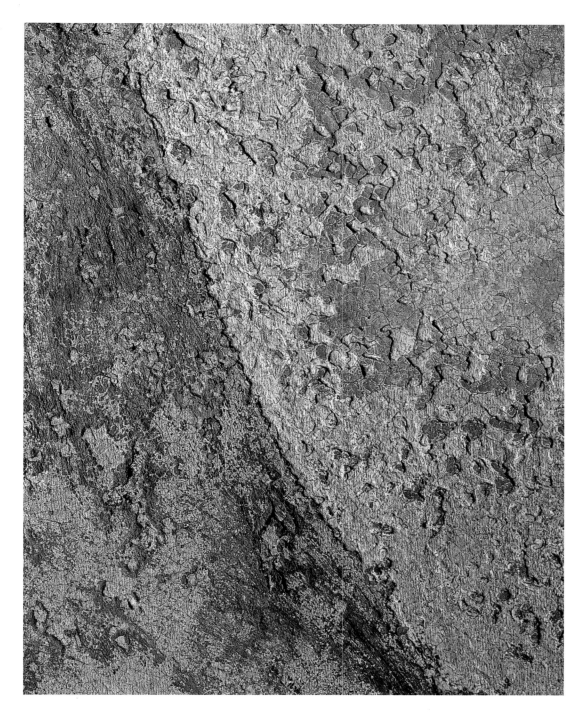

[upper]
200. Diagram 14. Taken from a graphic
plotting (1:1) of the incisions (shown in red).

[lower]
201. Diagram 15. Detail of the central lunette
showing incisions in red and outlines in gray.

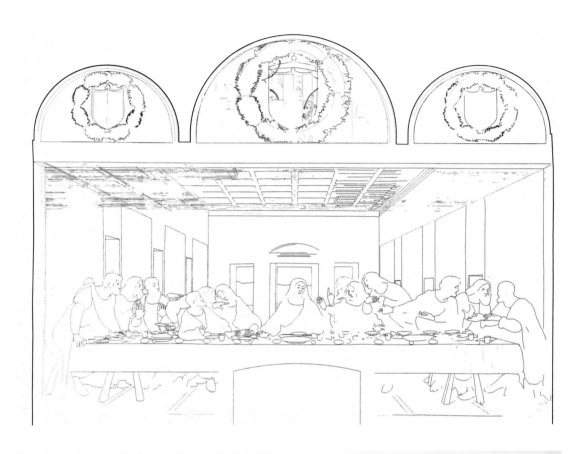

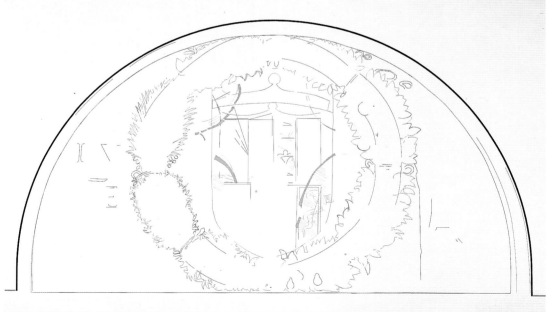

cantly reduced in the process of paint-ing. The light-blue background of the sky extends for about five centimeters under the surrounding gray molding of the frames (see fig. 208). Each figure and each object on the table show minor or significant revisions of out-lines, which stray into the adjacent col-ors, testifying to the fact that Leonardo allowed himself great freedom in re-turning more than once to a given motif. The figure of Thaddeus, for ex-ample, betrays two different interven-tions: one on the green mantle covered slightly by the sleeve cuff of nearby Simon's robe (only fragments of green survive, because it was covered), and a second on the fingers of Thaddeus's left hand, constructed in front of Matthew's blue mantle.

The arrangement of the bread loaves on the left half of the table shows that they were partially painted over the fabric of the tablecloth. Presumably Leonardo prepared the expanse of gray fabric leaving a small space unpainted for the bread, perhaps indicated by some sort of mark. No such trace, how-ever, was found beneath the pictorial film (see fig. 204, diagram 16). A con-tinuous black line, however, was found, made with a brush to define the out-lines of the hands with great freshness, before building them out with color in the final version (see fig. 209). Other distinct and delicate black and white lines reinforce outlines in shade and in light. For example, in the figure of Simon, the excellent condition permits this mode of pictorial execution to be clearly read (see figs. 210–11).

There is little information on Leonardo's technique. In 1954, Magde-

[upper]
202. *Preliminary reconstruction of the perspective scheme of the Last Supper: lines drawn from the vanishing point.*

[lower]
203. *Detail: hole in Christ's right temple that establishes the vanishing point.*

leine Hours extensively analyzed some paintings on panel by Leonardo in the Louvre, revealing that they were executed using significantly different methods from those employed for the *Last Supper*.[68] As the best-conserved passages came to light in our restoration, they revealed a coloring characterized by an extreme variety of tones—from green to red, and yellow to blue—on a surface that perhaps presupposed a "glazing" that no longer exists. The painting seems to have been executed passage by passage, each time recommencing after the pictorial film had dried in order to broaden, deepen, or define further the value of some of the tones, without introducing substantial modifications.

Leonardo's ability to render drapery is astonishing. On the figure of Simon, the soft fabric of the gray robe is practically tangible, as are the endless passages of the silky mantle, constructed with dark, intense lakes used both as a normal pictorial film and as a glaze to produce the rosy middle tones, all the way to the brightest, purest whites. The manner of achieving half shadows for the cuff of the same mantle—executed in silver gray and outlined with a violet stroke—is also superb. Clearly evident is that the same level of technical refinement was applied to each figure, even though they were often painted with different chromatic values.

Unfortunately most of the clothing has been irrevocably lost, but fragments of original paint discovered during the restoration help us understand the coloring. For example, a large fragment was recovered under the thick repaint of Bartholomew's green mantle (fig.

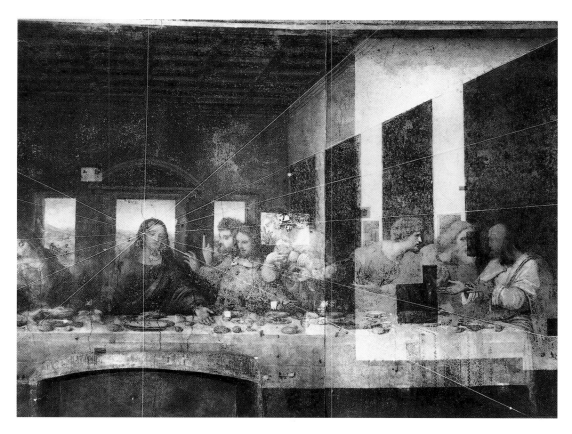

223), with highlights in luminous lead-tin yellow tones, or in the folds in the neckline of Philip's robe, executed in yellow, pink, and red tones. The intensity of the red hue was subdued with a green glaze in the dark portions of the lower area.

Interesting information was gathered on the precise structure of the pictorial film and on the composition of the pigments Leonardo employed.[69] Leonardo worked with masterful skill and extreme care, always using two or more thick layers to augment or reinforce the final chromatic tone, and in some cases even using a series of glazes for the final coat.[70]

The first layers painted are sometimes darker than the successive ones.

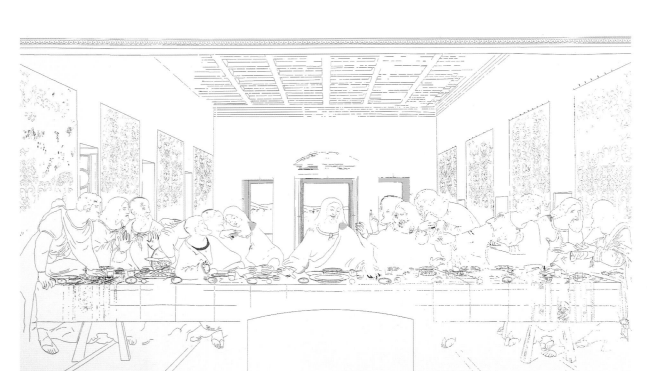

The double layering of color for the sky, for example, is very visible. On a base of intense turquoise, realized with azurite, the tone is defined and diversified on the surface with a lighter layer that decreases toward the horizon (see fig. 212). Another notable example can be seen on the floor, where a dense cool gray tone was laid over a pinkish base (see fig. 213). In the final layer, in almost imperceptible passages formed by soft brushstrokes, the colors achieve a mellow softness indispensable for the *sfumato* modeling.

The flesh tones were evaluated using an elaborate process, which revealed a mixture of several pigments and, in the few samples collected, a multiplicity of materials and layers. On the hand of the apostle Matthew, three distinct sequences of original material were noted, with similar tonal values, but with minor differences in the mixing of the pigments. A first application composed of lead white, vegetable black, and a little vermilion served as the base for two thin brushstrokes of lead white, yellow ocher, and vermilion. Philip's face is likewise constructed of thin layers composed of ocher, small quantities of vermilion, and vegetable black—the sequence followed for most of the flesh tones.

The characteristics of the flesh tones in shadow are particularly significant. Philip's straining neck showed four layers: the deepest layer is brown, the second is black, the third has a blue and lead white base, and the final layer is pinkish lead white, with traces of ocher (see figs. 214–15). All the layers work in combination to achieve desired effects of light and modeling. By overlapping these different tints, Leonardo achieved the particular gray-pink half tones present in certain figures, such as Philip and Christ.

The artist painted with an oil tempera, probably created by emulsifying thinning oils in egg. The binders are difficult to identify, however, as the pictorial film was saturated with various materials.[71] Leonardo's palette consisted of basic pigments in use at the time. Brief descriptions follow.[72]

Metal Leafing: Silver and Gold

Various fragments of gold were found that had been applied delicately with a brush according to traditional techniques. Residual small lines survive of

[upper]
207. Diagram 19. Hypothetical reconstruction of the original color of the left-hand lunette based on remaining traces of color.

[lower]
208. Detail of the horizontal upper edge of the window behind John: the gray background of the sky continues under the gray window molding that frames the view.

the rich decorations on the borders of garments, such as those worn by Judas and Bartholomew. Traces were also found in Bartholomew's halo.

The lunettes must have been highly embellished with gold and silver details. The capital letters next to the coats of arms were in gold, as were the ribbons that bind the festoons, the outlines of the shields, and the background of some of the fields in the coats of arms. In the central lunette, fragments of gold glazed with red lake border the squares bearing vipers and eagles. Gold glazed with green was used for the palm frond on the festoon. The remaining fragments document the attempt to use gold and silver as base colors on which to elaborate the decorative design (see figs. 218–20).

White: Lead White

Lead white seems to have been largely employed for the imprimatura but was also mixed to achieve the various chromatic ranges. In the painting's current state, "pure" white is found only in the most intense highlights in Simon's mantle; it was used to heighten the modeling and to reinforce the outlines with a delicate line. It also forcefully delineates reflections in the objects on the table (in the glasses, for example).

Vegetable Black

Black pigment was used frequently, both in its pure form and mixed with various tones. One of the most fragile pigments, it has been lost in substantial amounts in both the backgrounds and the ceiling. The ceiling's reconstruction, achieved through the application of different intensities of partially weakened

[upper]
209. Dark strokes define the outline of Philip's hand.

[lower left]
210. A white line profiles Simon's robe.

[lower right]
211. Simon's mantle: detail showing half-tones executed almost in gray.

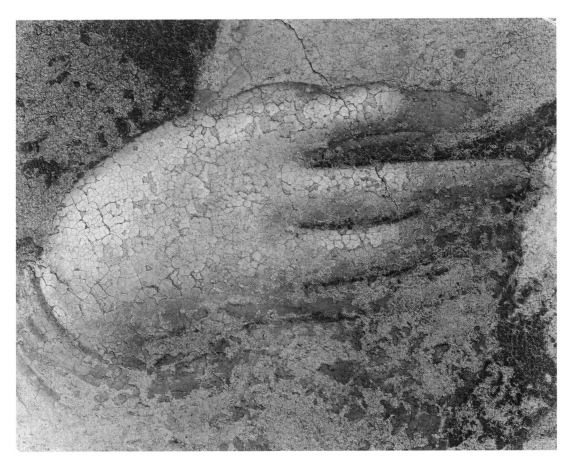

black, did not reach the deep, intense original black.

The shadows are almost transparent, becoming denser to the right of the objects, shading the outlines and gradually fading in subdued vibrations.

Red: Red Ocher, Vermilion, Red Lead, Red Lake

Leonardo's red palette is quite varied, and he used it to achieve a wide range of rich tones. Red ocher was added to other pigments, for example, to execute Thaddeus's robe. Vermilion was used over lead white as a background color for Christ's garment, and glazed with red lake in articulating the folds. The same lake was used for the iridescent colors in the silk fabric of Simon's mantle, both as a glaze and thickly applied in dark, deep tones. In this particular instance, an initial medium tone was achieved using lead white and lake, followed by a second, lighter layer in the illuminated parts, and successively glazed with lake. Red lake was used for John's mantle, for the wine in the glasses, and for some well-conserved areas such as the neckline of Matthew's robe, where minute, transparent brushstrokes form small pleats held by a gem. Red lead appears occasionally—for example, in James Minor's robe—mixed with lead white and glazed with lake in the shadows, and in Peter's mantle, where it was combined with lead-tin yellow to set off the folds of a bright, changeable color.

Yellow: Ocher, Lead-Tin Yellow

For the dull yellows, Leonardo employed yellow ocher, often added to

212. *Detail of the sky showing a first, darker, layer of bright blue.*

213. *Detail of the floor showing a layer of cool gray over a reddish base.*

other pigments. In this way, he obtained rather distinctive tonalities and chromatic passages such as those in the robes of Andrew and Thaddeus. In Thaddeus's robe, yellow and red ocher were detected as well as lead white and vegetable black. Lead-tin yellow was used for the strongest highlights of Bartholomew's green mantle and in some areas of James Minor's robe. Minute fragments were observed in all areas where green had been applied (mantles, robes). The few shreds conserved on Peter's mantle indicated a contrasting iridescent color for the fabric and for folds rendered in light, which darkened to a red-orange tone in shadow.

Green: Basic Copper Acetate

This color was widely used, especially in the apostles' mantles. Originally it must have been very intense, going from a deep, dark tone to a vibrant tone in a pale gamut. A very important fragment, which appeared when we removed the repaint on Bartholomew's mantle, shows a passage that varies in intensity from a medium green, with a successive application of darker green in the folds, to a yellow tone in the

216. Detail of Matthew's sleeve:
the modeled drapery is in nearly
imperceptible color gradations.

217. Detail of the landscape
showing fine execution of the blue
tones.

218. Central lunette: detail of a
palm branch executed in muted
gold with green lake.

219. Left-hand lunette: detail of
muted gold in red lake.

220. Edge of Judas's robe,
decorated with gold painted with a
brush.

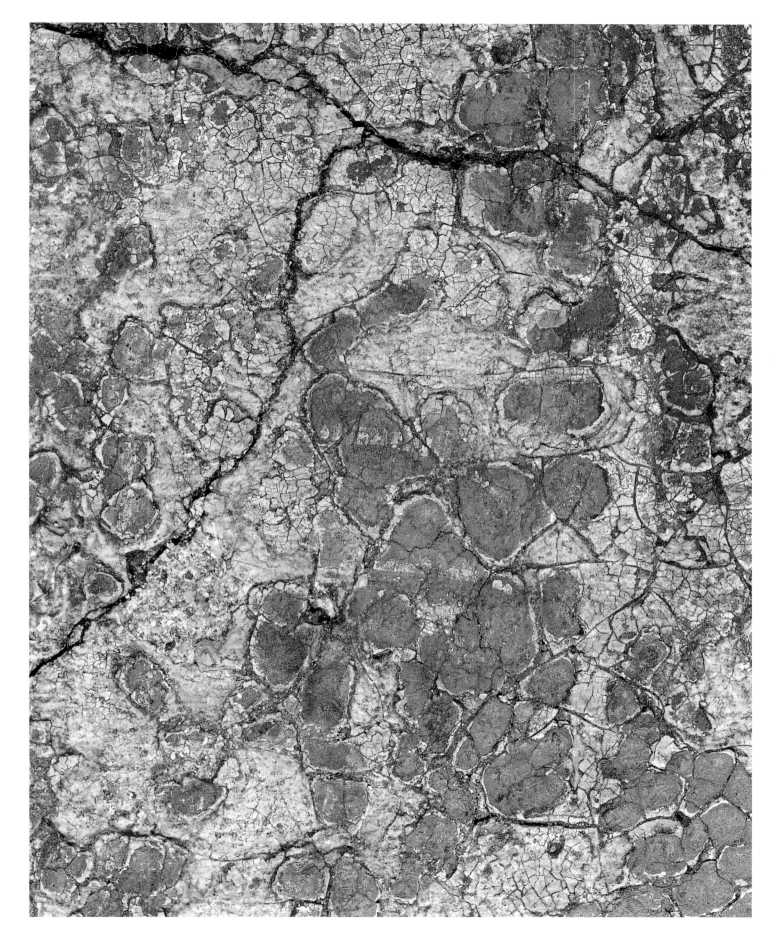

[left]
221. *Matthew's robe: detail showing red lake at the edging.*

[right]
222. *Simon's mantle, detail showing red lake shading.*

light. In the lunettes, the green color of the festoons, executed in two applications, proved to be composed of acetate of copper with yellow ocher.

Leonardo's method of applying green pigment was probably similar to his technique of painting light blues, which are better conserved and help us understand the material characteristics of the green color. Unfortunately the few remaining fragments of green do not allow a comparative analysis of the different figures. The restoration brought to light minute fragments on Andrew's mantle, examples of another tone of green that was cooler and more brilliant, composed of a resin pigment with particles of azurite.

Light Blue: Azurite, Lapis Lazuli

The entire composition is enhanced by the rich luminosity characteristic of azurite. Leonardo achieved intense modeling and chiaroscuro by toning down or toning up the color. He also created different effects by layering one color over another one with a different grain size, or by mixing different quantities of lead white and other pigments. Unlike all other applications of light blue, in Judas's mantle only one layer of azurite (80 microns) was used and added to traces of red lake. To achieve the light-blue background, Leonardo used a dense layer of azurite and lead white, to which he added a second layer of lapis lazuli and lead white, varying the mixture with small modifications and different granu-

lometries in order to differentiate the final tones.

The various light blues were evaluated according to their chromatic ranges. The cross-section of Christ's mantle shows that Leonardo first applied azurite and lead white, followed by a layer of particularly dense (135 microns), grainy lapis lazuli (see fig. 225). Peter's robe is chromatically similar. Large, sharp-edged granules of lapis were found, whose size serves to deepen the color tone. The blue of Bartholomew's sleeve is distinguished by the combination of red lake and azurite cast onto a base material of large round-edged particles (see fig. 226). The blue tone for the sleeve of Philip's robe was realized in a different way. A first dark-gray layer, ap-

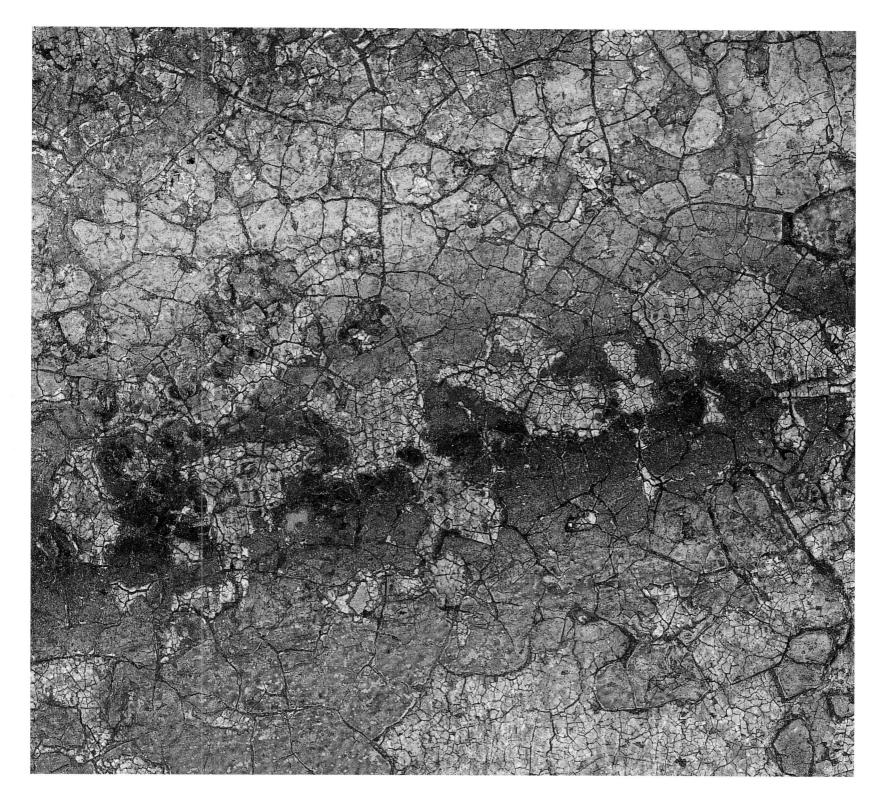

plied before the azurite, was combined with abundant lead white, all followed by very grainy lapis lazuli (see fig. 224).[73]

Variations in the same color used in garments result from light conditions, the subtle play of folds in the shadow areas, and the fact that they were applied at different moments in the creative process. The final result displays an astounding knowledge of the handling of pigments, applied to a composition that was crafted carefully over a great period of time, where nothing was haphazard or left to chance.

	AZURITE	LAPIS
	(average thickness in microns)	
Peter	34	100
Christ	54	135
Matthew	25	20
Bartholomew	25 (plus red lake)	34
Philip	45 (plus vegetable black)	25
Judas	80 (plus vegetable black and red lake)	

1. Codex Atlanticus, fol. 669r.

2. See Pinin Brambilla Barcilon, *Il Cenacolo in Santa Maria delle Grazie: Storia, condizioni, problemi,* Quaderni del restauro, 2 (Milan: Olivetti, 1984); Pinin Brambilla Barcilon, "Notizie e risultati delle indagini e degli interventi sulla volta e sulle lunette del Cenacolo," in Pinin Brambilla Barcilon and Pietro C. Marani, *Le lunette di Leonardo nel refettorio delle Grazie*, Quaderni del restauro, 7 (Milan: Olivetti, 1990).

3. See Alessandro Conti, *Storia del restauro e della conservazione delle opere d'arte* (Milan: Electra, 1988), 207; Pietro Petraroia, in *La restauration de la Cène de Léonard de Vinci et du Réfectoire de l'église Santa Maria delle Grazie de Milan*, Journée d'études, 1 October 1998, Lausanne, 1999.

4. For a survey of the literature on the various attempts to restore the *Last Supper,* see Brambilla Barcilon, *Il Cenacolo in Santa Maria delle Grazie* (1984).

5. Analysis by Antonietta Gallone of the Dipartimento di Fisica of the Istituto Politecnico, Milan (see Antonietta Gallone, "Analisi di campioni di intonaco e di colore dell'Ultima Cena e delle lunette soprastanti," in *Ricerche sulla conservazione e il restauro del Cenacolo di Leonardo,* ed. Istituto Centrale per il Restauro [forthcoming]. See J. M. M. Wainwright, J. M. Taylor, and R. D. Harley, "Lead Antimoniate Yellow," in *Artists' Pigments: A Handbook of Their History and Characteristics,* ed. Robert L. Feller, 2 vols. (Cambridge and New York: Cambridge University Press, 1986–93), vol. 1 (1986), 219: "On the basis of analyses, lead antimoniate yellow seems to appear in European painting only from the second quarter of the seventeenth century, when it began to replace lead-tin yellow, a pigment employed until then."

6. On Bellotti's restoration, see the accounts gathered in Brambilla Barcilon, *Il Cenacolo in Santa Maria della Grazie* (1984), 29–32.

7. This means that Mazza did not use thick applications of oil paint, as I suggested in ibid., 37. For accounts of this restoration, see ibid., 35–37.

8. The result of Barezzi's experimental removal of painted surface was, paradoxically, totally different from what had been expected: the glues spread to detach the paint turned out to be the best material for consolidating the surface of the painting when subsequently rolled under heavy pressure. The various stages of Barezzi's work emerge from the abundant papers documenting the enterprise. It is difficult to determine the extent to which this operation further damaged the painted surface: one inevitable consequence of the use of glue was that with high humidity some portions of the mural turned black and developed swellings (which Cavenaghi attempted to remedy). For the relevant literature, see ibid., 39–45.

9. In his report dated 14 March 1931, Oreste Silvestri, the restorer, stated that Cavenaghi used a "resin for varnishing paintings." For this and other reports, see ibid., 47–52. The texts tell us only that a gum mastic was used, diluted in suitable substances on which the hygrometric conditions would have the least possible effect. The documents furnish ample information, however, on the phenomena that occurred and the damages that were done at the beginning of the century.

10. The sizable number of gray *stuccature* spread around the edges of the colored portions treated can certainly be ascribed to this operation: one of them bears Silvestri's signature and the date 1924. Even if the restorer does not mention the removal of earlier restorations and speaks only of cleaning off the surface dirt, it seems clear that the use of a sponge wetted with a solvent (alcohol and ether) resulted in the removal of superficial repainting. For reports on this restoration attempt, see ibid., 54–59.

11. Pellicioli worked with the Istituto Centrale per il Restauro after the 1943 bombardment. He found the surface of the *Last Supper* blackened and its underlayers swollen with humidity. His first step was to stabilize the surface with wax-free shellac, diluted in ethyl alcohol and spread with a brush. Next he consolidated the intonaco with injections of casein. The shellac seems to have added consistency to the surface, regenerating and reinforcing the paint film and heightening the colors. It is difficult to determine how deeply it penetrated, but it seems to have dispersed to some depth through the broad cracks in the mural. Pellicioli documented his work with photographs taken before and after each step; he left untouched three whitish sample areas (which remain untouched in our recent operation as well) in order to show the previous condition of the painting.: see ibid., 60–66.

12. Giuseppe Bossi, *Del Cenacolo di Leonardo da Vinci Libri Quattro* (Milan, 1810), 197.

13. See Gisberto Martelli, "Il Refettorio di Santa Maria delle Grazie in Milano e il restauro di Luca Beltrami nell'ultimo decennio dell'Ottocento," *Bollettino d'arte* 8 (1980): 55–72; and Lionello Costanza Fattori, "Il Refettorio di S. Maria delle Grazie: Rimedi progettati per far fronte ai dessesti statici," *Arte Lombarda* 62 (1982): 5–10.

14. The documents show that this opening was enlarged to increase the flow of air in the room. This information comes from a report by Padre Maestro Monti, who states: "This most famous painting, as everyone knows, was almost forgotten a century after, and with the passing years it came to be so lost that perhaps without any hope of getting it back and no longer caring for such a treasure, they thought to heighten and broaden the door, which was very low and narrow." See Domenico Pino, *Storia genuina del Cenacolo, insigne dipinto di Leonardo da Vinci nel Refettorio de' Padri Domenicani di Santa Maria delle Grazie di Milano* (Milan, 1796), 38–39.

15. A letter of Antonio Traballesi dated 25 March 1780 confirms the existence of holes in the wall: see Brambilla Barcilon, *Il Cenacolo di Leonardo in Santa Maria delle Grazie* (1984), 78; and Emilio Motta, "Il restauro del Cenacolo nel secolo XVII e l'auto-difesa del pittore Mazza," *Raccolta Vinciana* 3 (1907): 127–38, esp. 131–32. Referring to Bellotti's restoration, Traballesi states that there must have been a number of framed paintings hung on top of the mural "as evidenced by the nail holes that were plastered up by that professor." Whether the holes were made to hang pictures, hang curtains, or for some other reason is an unresolved question.

16. For the older sources, see Brambilla Barcilon, *Il Cenacolo di Leonardo in Santa Maria della Grazie* (1984), 69–76.

17. In 1796, Domenico Pino wrote: "Because [the mural] is on a large wall in the entrance to the refectory, or because outside of [the refectory] there is a small atrium with a basin in which the Fathers washed their hands, or because the smoke from the kitchen, which comes out of an opening not far from there dampens, and thus discolors the painting; or because the wall itself, particularly to the right of Christ, may have begun to draw humidity from the bottom and slowly transmit it to the upper parts, there is no doubt that after not too much time, it began to suffer a noticeable deterioration. There is another reason for this misfortune: because the outside of the wall on which the Last Supper is painted faces to the north [*a tramontana,* to the north; to the north wind]; and because there are openings on both the cloister side and the kitchen side, as well as the door in the middle, and also because of the vast size of the refectory, which is on the ground floor, much moisture gathers on the painting, particularly when the *scirocco* blows [a warm, wet, southeast wind], which cannot help but harm it. Father Abbot Gallarati . . . has told me that . . . on certain days of a strong *scirocco* [the painting] was as wet as if it had been rained on, and you could not clearly see the facial features or the small details of the figures distinctly, which was why the surface had to be dried lightly with a sponge or a very fine cloth. Nor could the Last Supper be protected by the draperies that had been put up. If these were closed, on rainy days (especially on the part to the right of the Savior) so much moisture collected behind them that water even dripped down the wall in little rivulets, and if the picture were not given air, it would be covered with a thin whitish mildew that faded the colors and ruined the painting more and more. For this reason, the best expedient was to leave it uncovered, except for the short periods of time in which the refectory was swept." Pino, *Storia Genuina del Cenacolo* [1796], 31, 32, 33, 37, 52, 53.

18. Fernanda Wittgens, "Il restauro in corso del Cenacolo di Leonardo," in *Atti del Convegno di studi vinciani* (Florence: L. S. Olschki, 1954), 39–50.

19. For the results of Sergio Curri's analyses in 1973 and 1978, see Sergio B. Curri, "Aspetti di aggressione biologica al Cenacolo Leonardesco," *Arte Lombarda* 62 (1982): 47–50.

20. There is ample bibliography on the state of conservation of the *Last Supper* before the recent restoration: see Brambilla Barcilon, *Il Cenacolo di Leonardo in Santa Maria delle Grazie;* Carlo Bertellli, "Conservazione e restauro dopo Pellicioli," in Ludwig H. Heydenreich, *Invito a Leonardo: L'Ul-*

tima Cena, trans. Filippo Grandi (Milan: Rusconi, 1982), 127–56, esp. p. 127; Pietro Petraroia, in *La restauration de la Cène* (1999).

21. Pellicioli, working in collaboration with the Istituto Centrale per il Restauro, used wax-free shellac with diluted alcohol to stabilize the color.

22. The preliminary test cleaning was done by Paolo Mora of the Istituto Centrale per il Restauro.

23. Various tests carried out by Dr. Madeleine Masschlein-Kleiner of the Institut Royale du Patrimoine Artistique of Brussels led to the calibration of the mixtures used. Cleaning was accomplished by applying small patches of Japanese paper imbibed in a 50-50 solution of methyl alcohol and dichloroethane; a solution of dichloromethane, ethyl formate, and formic acid (49:49:2 by volume), or methyl ethyl ketone and water (24:75). All operations were repeated from two to four times—with intervals between treatments to allow the zone in question to dry—until all the superimposed materials had been removed.

24. Trials made with paraxylene did not give satisfactory results.

25. The photographs taken by Carlo Aschieri and, subsequently, by Jürgen Becker are now on deposit with the Soprintendenze per i Beni Artistici e Storici della Lombardia. The photographs taken after completion of the restoration give an inaccurate image of the lacunae because the watercolors used in the restoration are transparent and fade out under photographic lights.

26. The tracings prepared in this manner were planned and carried by the architect Fernando Delmastro, who first plotted the entire work, then developed renderings (together with Lidia Rissotto of the Istituto Centrale per il Restauro) and entered the data in the computer (in collaboration with Ugo De Riu of the firm Koinél). One result of this process was the creation of a database to facilitate consultation of the documentation by computer and comparison between the photographic images and the drawings. The methodology and the results of these operations will be reported in detail in a future publication.

27. Albert and Paul Philippot, "La dernière Cène de Tongerlo et sa restauration." *Het Laaste Avondmaal Tongerlo*, Brussels, n.d. Previously printed in *Bulletin* of the Koninklijk Instituut voor het Kunstpatrimonium, 10 (1967–68); Janice Shell, Pinin Brambilla Barcilon, and David Alan Brown, *Giampietrino e una copia cinquecentesca dell'Ultima Cena di Leonardo*, Quaderni del restauro, 4 (Ivrea: Olivetti, 1988).

28. Abbé Aimé Guillon speaks of Bellotti's restoration in *Le Cénacle de Léonard* (Milan, 1811): "The old copies, in particular that of Castellazzo, show us that he did not make his tapestry with arabesques like the ones in leather made in Venice (the invention of which comes from Spain), and even less in a sort of cut velvet that was not invented until the end of the seventeenth century, nor as natural leaves and flowers, with their real colors." Paola Frattaroli, from whom I borrowed the information on panels proposed here, has suggested some technical and iconographic deductions regarding the textile decoration. In her opinion, the pattern with a diamond-shaped design and oval connections recalls a series of textiles similar to these in design but different in decorative detail, which attest to Italian production and probably date from the middle or the end of the sixteenth century (but certainly no later than the early seventeenth century). The correspondence between the vertical axes of the pattern and the warp in comparable products further underlines the changes made. This means that the traces of fringes visible in the painting on the weft edge can be interpreted as trimming. From the viewpoint of the construction, taking into account both the colors and the "volumetric" character of the design, suggested by brush strokes, we can suppose that the cloth was a two-colored damascened silk or velvet known as *broccatello* or *velluto tagliato a un corpo*.

29. Frattaroli took a transfer on acetate directly from the Tongerlo copy (reproduced here). She states: "There are flowers lined up in parallel bundles, in which the variety of the patterns noted and the endless interplay of chromatic combinations make it impossible to define a relationship or a modular grid of a 'textile' sort. The only likely hypothesis is that it is a tapestry."

30. We can suppose that Leonardo took his inspiration from court tapestries, or that he was acquainted with the tapestries made by the manufactories that were already flourishing in Milan in Francesco Sforza's time. One of the oldest examples of painted cloth used as wall decoration occurs in a miniature by Cristoforo de Predis, *La preparazione della Sala del Cenacolo* (1474, in the Biblioteca Reale, Turin: see fig. 45). A similar painted cloth appears hanging on the wall in a picture in Bernardino Butinone's cycle, *Storia della Maddalena* at Ornago (fig. 47). The early sixteenth-century lectern cover from the Duomo at Monza shows French-Flemish characteristics in its decoration, which closely resemble the painted motifs in the Tongerlo and Oxford copies of the *Last Supper*, even though the chromatic range is limited to tones of red, green, yellow, and blue. In his will, drawn up in 1489, Ambrogio Griffi lists fifteen tapestries *a verdura o floribus*. See I. Riboli, G. Bascapè, and S. Rebora, *La generosità e la memoria* (Milan, 1995), 95. The will of Berganzo Botta, Maestro delle entrate ordinarie of the Duchy of Milan, hence a prominent personage in the court of Ludovico il Moro, includes many tapestries in its inventory of furnishings, such as a "spalere due foliaminibus cum cimero di Botis et Pusterlis": see R. Gorini in *Artes* 1 (1993): 107–10. Giovanni Bianchino, called Il Trullo, is reported to "have painted the small room of Her Excellency Madama in the Castelo Vechio, located in the tower of the Via Coperta, with bushes and greenery to resemble satins": see Thomas Tuohy, *Herculean Ferrara: Ercole d'Este, 1471–1505, and the Invention of a Ducal Capital* (Cambridge and New York: Cambridge University Press, 1996), 414. Examples from the same period documented in the manufactories of Tournai are thickly decorated with stylized flowers on a dark blue background, as are the better part of the tapestries of the time. My thanks to Nello Forti Grazzi for this and much more information.

31. It is interesting to note that the pilaster that closes off a room architecturally is sometimes considered "a pause" in pictorial renderings of the locality, often taking on a chromatic value different from the rest of the architectural construction: see Giulio Carotti, "Il restauro della Cena di Leonardo da Vinci," *L'Arte* 12, no. 2 (1909): 1–7, esp. p. 3.

32. Bossi, *Del Cenacolo* (1810), 115.

33. Motta, "Il restauro del Cenacolo" (1907), 133.

34. Carotti, "Il restauro della Cena" (1909), 4.

35. When Barezzi was charged with a test removal of paint under the figure of Bartholomew, he chose instead to conduct his test in a different location, working, as he tells us, "under a piece of toweling with one hand." There are traces of two sample removals located on Christ's hands. The one on the right hand, which is square (approx. 40 cm × 40 cm), shows signs of paint removal with a partial loss of color; the larger one, on the left hand (approx. 40 cm × 100 cm), also includes a part of the tablecloth. Barezzi incised the edges of the lacunae left by these trials, filled in the spaces with wax, and covered them with a layer of color. In a letter dated 29 May 1821, now in the dossier on Barezzi of the Raccolta Vinciana, he admits that he failed to remove these segments of the painting. See Brambilla Barcilon, *Il Cenacolo di Leonardo in Santa Maria delle Grazie* (1984), 39–40.

36. In her summary of the Pellicioli restoration, Fernanda Wittgens states that the repainting was completely removed, and she describes the "moving surprise . . . at uncovering the authentic tunic of Christ, masked by a muddy layer of restored color. The newly rediscovered zone flames with a vermillion that seems truly the symbolic color of sacrifice, and that renders even more fascinating the light-blue edge of the mantel where the scalpel has removed the restored layer that extinguished the vibration of Leonardo's color. Other suggestive details typical of Leonardo have been brought back to light, in particular, the swirl of pleats near Christ's right wrist that, by its movement, makes the contrast with the resigned abandonment of the divine hand on the table even more expressive": Wittgens, "Il restauro in corso" (1954), 48.

37. Brambilla Barcilon, *Il Cenacolo di Leonardo in Santa Maria delle Grazie* (1984), 43–49.

38. Wittgens, "Il restauro in corso" (1954).

39. Bossi, *Del Cenacolo* (1810), 112.

40. Ibid., 110.

41. Ibid.

42. Wittgens, "Il restauro in corso" (1954).

43. Bossi reports that Padre Gallarati "finished this apostle with two little fingers on the left hand": Bossi, *Del Cenacolo* (1810), 100.

44. Mauro Pellicioli partially re-

moved some plaster; a photograph taken during his restoration shows large, dark patches of *stuccatura*.

45. Bossi, *Del Cenacolo* (1810), 100, states: "Then attentively and closely observing the painting, one can see under the unspeakable retouchings some ancient crusts of flesh color, laid out so as to still indicate fairly clearly that there was a hand there, without which, as anyone can see, it would be difficult to envision the space occupied by the neighboring figure."

46. Wittgens, "Il restauro in corso" (1954), 49, states that in some drapery folds "up to five layers of superimposed stuccature have been found, beginning with a black sixteenth-century layer, perhaps owing to Lomazzo, and arriving at the red eighteenth-century stuccature on which Bellotti, Mazza, and the restorers who followed them skillfully repainted."

47. Judging from what is visible in the mural in its current state, the tablecloth does not appear to be damascened. Some copies (for example, Dutertre's watercolor in the Ashmoleon Museum, Oxford) do show damascened cloths.

48. Some patterns are repeated: pairs of face-to-face birds are shown with a flower (at times upside down) between them. Rather than representing a stylistic invention by the painter, this pattern is probably a well-known weave. High-quality woven pieces of the sort can be found in Umbria, the Marches, and Tuscany.

49. The schematic plan of the table setting in the *Last Supper* was created by Fernando Delmastro, working with the aid of a CAD program, based on an electronic scanning of the mural. Metal plates and bowls, knives, and saltcellars are indicated in dark gray; glasses and cruets are shown in lighter gray; the breads in yellow; pieces of fruit in red; the woven pattern of the tablecloth in blue. Vessels whose shapes are difficult to ascertain but can be guessed at from copies are shown with broken lines. Rolando Perino developed the original graphic.

50. The portion of this essay that addresses the lunettes was originally published as Brambilla Barcilon and Marani, *Le lunette di Leonardo* (1990).

51. See Motta, "Il restauro del Cenacolo" (1907), 130–38.

52. See Pino, *Storia genuina del Cenacolo* (1796), 32.

53. See Bossi, *Del Cenacolo* (1810), 61–62.

54. "Feeling those walls, almost as if aware of a hidden treasure, he managed to find in the three lunettes above the *Last Supper*, under four layers of plaster, coats of arms belonging to Ludovico il Moro and to Beatrice d'Este, his wife, richly festooned with leaves, fruits, and flowers—admirable works and recognized to be by Leonardo himself. To uncover them completely, these coats of arms will need more thoroughgoing work than our artist was able to dedicate to them, working for much time without recompense, either in payment or in praise": Emilio Seletti, *Commemorazione del pittore Stefano Barezzi da Busseto* (Milan, 1859), and Seletti, *Appendice documentata alla Commemorazione del pittore Stefano Barezzi da Busseto* (Milan, 1859), 16. One has the impression that the operation was carried out hastily: hammer marks are visible all around the coats of arms, and there are long spatula scratches in the portions of the lunettes that were originally gilded.

55. See Seletti, *Commemorazione* (1859), 16.

56. Diego Sant'Ambrogio, "Note epigrafiche ed artistiche intorno alla Sala del Cenacolo e al tempio di Santa Maria delle Grazie in Milano," *Archivio Storico Lombardo*, ser. 2, vol. 9, year 19 (1892): 414–22: "In the intention of arriving at a radical restoration of that hall, the walls were given a large-scale cleaning of their encrusted grime, thus newly displaying the ornamental bands with festoons of flowers and waving ribbons that decorate the upper portion. And, above all, in the three lunettes above the painting of the Last Supper, the Sforza coats of arms framed by laurel have unfortunately been lost. . . . All that can be seen in the middle lunette are scanty remaining traces of the shield, divided vertically in two with the Sforza and Este insignia on either side."

57. Communicated in Gaetano Moretti, "IV Relazione annuale dell'Ufficio Regionale per la conservazione dei Monumenti in Lombardia," *Archivio Storico Lombardo*, ser. 3, vol. 6, year 23 (1896): 390–91: "During the course of the year 1895/96, under the direction of Sig. Mueller-Waelde, work began, with happy results, to clean some of the lunettes above the *Last Supper* bearing highly interesting decorations of coats of arms and crowns."

58. Luca Beltrami, *Il Cenacolo di Leonardo: La relazione sul restauro Cavenaghi* (Milan: Allegretti, 1908), 51.

59. Examination of the outline of the branches that make up the garlands has determined that the composition of the bunches is repeated in each group of leaves, even though the leaves are disposed differently. One might hypothesize that one mold was used for each type of leaf.

60. For further contributions to the topic, see Carlo Bertelli, "Leonardo e l'Ultima Cena (ca. 1495–97)," in *Tecnica e stile: Esempi di pittura murale del Rinascimento italiano*, ed. Eve Borsook and Fiorella Superbi Gioffredi, Villa I Tatti Studies, 9 (Milan: Silvana, 1986), 1:31–42; Bertelli and Barbara Fabjan, "Il Cenacolo di Leonardo," *Brera: Notizie della Pinacoteca* (autumn and winter, 1981–82).

61. Gaps between the intonaco and the wall structure were corrected by injections of a vinyl resin solution and/or lime casein. In the vault, the preceding restorations' chalk and lime stuccature along the existing cracks was not redone, but where new breaks had appeared they were filled with a mixture of marble dust and Primal AC33. In the lunettes, the lacunae in the intonaco were filled in, at a level lower than the remaining surface, with a mixture including sand and marble dust. Small particles of color were anchored with applications of an acrylic resin and Primal AC33 emulsion in ethanol and water (5:95 by volume). Fatty surface dirt was removed with a paintbrush. Methyl ethyl ketone and water (25:75) were used to retouch the blue background, with isooctane and isopropanol (50:50) used for the garlands. A thin watercolor glaze was used for the abrasions, with hatching used for lacunae. Only stable pigments of Windsor and Newton colors were used.

62. "The excellent painter Lionardo Vinci, Florentine . . . had the habit—and I have many times seen and considered him—of climbing up on the scaffolding early in the morning, for the Last Supper is quite high off the ground. It was his habit (as I have said) from the early sun to twilight in the evening not ever to take the brush out of his hand, but to forget food and drink, and paint continually. Then it might be two, three, four days that he did not put his hand to it, yet he sometimes remained one or two hours a day doing nothing but contemplating, considering, and examining in his mind, judging his figures": Matteo Bandello, "Il Bandello a la molto illustre e vertuosa heroina, la S.a Ginevra Rangona Gonzaga," preface to novella 58, in Luca Beltrami, *Documenti e memorie riguardanti la vita e le opere di Leonardo da Vinci* (Milan: Fratelli Treves, 1919), 45–46.

63. "The entire monastery was built rather badly, and . . . one could see miserable and poorly worked columns, great arches mixed with little ones, uneven, sad-looking paving bricks, and all sorts of materials from old demolitions. On seeing such materials used in the outside places, the suspicion arises that out of poverty worse had been done in the internal walls, which should have been plastered with lime, and if the unfortunate wall of the Last Supper had been made of already nitrous old bricks, it may have absorbed humidity even more than the others": Bandello, "Il Bandello a . . . Ginevra Rangona Gonzaga," in Beltrami, *Documenti e memorie* (1919).

64. Bossi, *Del Cenacolo* (1810), 197. For some centimeters along the left-hand margin, the intonaco is superimposed on the side wall, which was frescoed with decorations in the fifteenth century. The intonaco was analyzed by Tiziano Mannoni of the Istituto di Petrografia of the Facoltà di Scienze of the Università di Genova and by Antonietta Gallone of the Istituto di Fisica of the Istituto Politecnico di Milano.

65. Laura and Paolo Mora and Paul Philippot note a similar preparation for a painting of St. Christopher in the cathedral of Erfurt: see Laura Mora, Paolo Mora, and Paul Philippot, *La conservation des peintures murales* (Bologna: Compositori, 1977). The stratigraphic and chemical analyses of the *Last Supper* were done by Mauro Matteini and Arcangelo Moles: see Mauro Matteini and Arcangelo Moles, "A Preliminary Investigation of the Unusual Technique of Leonardo's Mural 'The Last Supper,'" *Studies in Conservation* 24 (1979): 125–33; Enzo Fedeli, "Ricerche svolte su alcuni prelievi di materiale appartenente al Cenacolo," *Arte Lombarda* 62 (1982): 51–54; Hermann Kühn, "Naturwissenschaftliche Untersuchung von Leonardos *Abendmahl* in Santa Maria delle Grazie in Mailand," *Maltechnik Restauro* 111, no. 4 (1985): 24–51; Matteini and Moles, "Il Cenacolo di Leonardo: Considerazioni sulla tecnica pittorica e ulteri-

ori studi analitici sulla preparazione," *OPD Restauro*, Quaderni dell'Opificio delle Pietre Dure e Laboratori di Restauri di Firenze, 1 (1986): 34–41; Giuseppe Bossi, in *Le Vicende del Cenacolo di Leonardo da Vinci nel Secolo XIX* (Milan: Ufficio Regionale per la conservazione dei Monumenti della Lombardia, 1906), 39–40. One of the first analyses was done by Antonio Kramer, a professor of chemistry, on 10 May 1851. Kramer identifies the preparatory layer incorrectly: "The reactions that my research presented in this connection are so clear and decisive that I have the firm conviction that I am right. Here is the result. The yellowish intonaco, about one or two millimeters thick, which is becoming detached in small, irregularly formed flakes and on which the paint lies, is a mixture of wax and natural calcium carbonate, hence it contains little sand, clay, or iron. The material that was used to bind the colors of the painting is fatty in nature, but I could not discover whether it was oil or something else."

66. Leonardo writes: [191] "For those colors that you wish to be beautiful, first always prepare a very pure, white ground. This I say with regard to transparent colors, for a bright ground is not an advantage to those colors which are not transparent. The example of this can be learned from the colors of glass, which, when they are put between the eye and the luminous air, show themselves of excellent beauty, which they could not do, having behind them shadowy air or other obscurity": Lu 191, McC 191, original lost, ca. 1505–10: see Leonardo da Vinci, *Libro di Pittura*, ed. Carlo Pedretti and Carlo Vecce (Florence: Giunti, 1995), 223.

67. See Kühn, "Naturwissenschaftliche Untersuchung" (1985), 24–52.

68. Magdeleine Hours, "Étude analytique des tableaux de Léonard de Vinci au Laboratoire du Musée du Louvre," in *Leonardo: Saggi e ricerche,* ed. Achille Marazza (Rome: Istituto Poligrafico dello Stato, 1954), 13–26; Italian translation, 525–33.

69. Regarding the relative scientific investigations, see Antonietta Gallone, "Analisi di campioni di intonaco e di colore dell'Ultima Cena e delle lunette soprastanti," in *Ricerche sulla conservazione e il restauro del Cenacolo di Leonardo,* ed. Istituto Centrale per il Restauro (forthcoming); L. C. Pancella, "Contributo allo studio della policromia del Cenacolo," in *Rapporto 9/96* of the École Polytechnique Fédérale de Lausanne, Laboratoire de Conservation de la Pierre (1996).

70. Leonardo da Vinci: [190] "On accompanying the colors, one with the other, so that one gives grace to the other. If you want to have the vicinity of one color lend grace to the other color that stands next to it, use the rule that can be seen in the rays of the sun in the composition of the celestial arc, otherwise known as the iris [rainbow], whose colors are generated in the motion of the rain, because each drop is transmuted in [62v] its descent into each one of the colors of such an arc, as is demonstrated in its place. [190a] Now pay attention, for if you want to make an excellent obscurity, give it for comparison an excellent [whiteness], and thus the excellent whiteness you will make with the maximum obscurity; and the pale will make the red of a more firey red than it would seem in itself in comparison with purple; and this rule will be detailed further in its place. There remains to us a second rule, which is not aimed at making the colors in themselves of a more supreme beauty than they naturally are, but

rather that their company give grace one to the other, as does green to red, and red to green, each one of which in return gives grace to the other, and as green does with blue. And here we have a second rule for the generation of unfortunate company, such as blue with yellow, which turns whitish, or with white and its like, which will be said at its place." ([190] Lu 190, McM 183, Pedretti, *Commentary*, note to paragraph 287, ca.1505–10). Composition of the colors of the rainbow, with reference to a separate discussion ("come fia dimostrato al suo loco"). It is thus possible to place the date later: see 944. [190a] Lu 190a, McM 183, original lost, ca.1505–10. This forms one text with the preceding, as shown by the lack of a paragraph in the transcription. (Before the title, struck out): "Regole da far che le figure"; (Title corrected by VI): "Regole da far che le figure"; bianchezza / bellezza (V, corr. Ludwig), in Leonardo, *Libro della pittura*, ed. Pedretti (1995), 223.

71. Bruno Zanardi states: "The term *a secco* refers to the technique used to make powdered pigments adhere to any dry support: wood panel, canvas, intonaco, stone, leather, paper, etc. It seems obvious that in order to make powdered pigments adhere to a dry support, binders must be added, which can be divided into organic (oil, egg, wax, glue, etc.) and inorganic (lime, but from the mid-nineteenth century on, also silicates of various sorts). Glues in general, but also some inorganic binders are called 'temperas' because, like temperers for metals, they enable the pigments to harden. Hence the general (even generic) habit of ascribing to all 'tempera painting' *a secco* techniques": Zanardi, in Bruno Zanardi and Chiara Frugoni, intro. by Federico Zeri, *Il cantiere di*

Giotto: Le storie di San Francesco ad Assisi (Milan: Skira, 1996), 53. Filippo Baldinucci gives a precise definition of *pittura a tempera*: "Term of the Profession of the Painters, which applies to all liquids, glue, or egg white with which colors are liquified. From this comes the term *pittura a tempera*, or painting with tempera": Filippo Baldinucci, *Vocabolario toscano dell'arte del disegno* (1681), s.v. "tempera," facsimile edition, followed by a "Nota critica" by Severina Parodi (Florence: SPES 1975), 162. On protein binders, see *Corso sulla manutenzione dei dipinti murali, mosaici, stucchi: Tecniche d'esecuzione/Materiali costitutive* (Rome: Istituto Centrale per il Restauro, 1978), 2:4.

72. In this summary, I have tried to give a succinct description of the pigments used in the *Last Supper*, but I am well aware that the topic requires fuller treatment and constant updating. I thank Antonietta Gallone, who has been of particular help to me in this study.

73. For the granulometry, see Cennino Cennini, *Il Libro dell'arte* (1859), ed. Franco Brunello (Vicenza: N. Pozza, 1971), 65: "On the nature of, and mode of making, ultramarine blue: . . . Grind [the azurite] in a bronze mortar. . . . Keep in mind that the smaller you grind the pieces, the more subtle the blue becomes, but not of such a fine purple or really intense dark hue." On adding red lake to lapis lazuli blue he states: "If the blue does not become purplish, I shall teach you how to give it a little color. Take a little ground grain and a bit of *verzino* [a red coloring made from Pernambuco wood] and cook them, together with lye and a bit of rock alum. . . . Put a little of this grain and *verzino* [into the blue color] and mix everything well with your finger."

Bibliography
Edited by Pietro C. Marani

ARCHIVAL ABBREVIATIONS

ABM	Accademia di Brera, Milan
ACS	Archivio Centrale dello Stato, Rome
ASM	Archivio di Stato, Milan
RV	Raccolta Vinciana, Castello Sforzesco, Milan
SBBAA	Soprintendenza per i Beni Ambientali e Architettonici, Milan
SBBAS	Soprintendenza per i Beni Artistici e Storici, Milan

1493 Belinzone [Bellincioni], Bernardo. *Rime del arguto et faceto poeta Bernardo Belinzone fiorentino.* Milan (and Florence), 1493.

1509 Pacioli, Luca. *De divina proportione.* Venice, 1509. Reprint, Milan: n.p., 1956, Fontes ambrosiani, 31.

1520 Le Moyne, Pasquier. *Le couronnement du roy Francois Premier de ce nom voyage et conqueste de la duche de Millan . . .* Paris, 1520.

1546 Giovio, Paolo. "Leonardi Vincii Vita." In his *Elogia veris clarorum virorum imaginibus apposita quae in Musaeo Ioviano Comi spectantur.* Venice, 1546. Reprints: edited by Paola Barocchi, 1971–72; edited by Carlo Vecce, 1998; edited by S. Maffei, 1999.

1548 Pino, Paolo. *Dialogo di Pittura.* Milan, 1548. Reprint, Milan: Fratelli Magnani, 1945.

1550 Vasari, Giorgio. *Le Vite de' più eccellenti pittori scultori ed architetti.* Florence, 1550. (See also the editions listed under 1568.)

1554 Bandello, Matteo. *Le novelle.* Florence, 1554. Reprints: edited by Gioachino Brognoligo, Bari: Laterza, 1910; new ed. with notes and preface by Ettore Mazzali and an introduction by Luigi Russo, Milan: Rizzoli, 1990.

Castiglione, Sabba da. *Ricordi overo ammaestramenti . . .* Venice, 1554. Originally published Bologna, 1549.

1568 Vasari, Giorgio. *Le vite de' più eccellenti pittori scultori ed architettori.* Florence, 1568. Reprints: edited by Gaetano Milanesi, Florence, 1881; edited by Paola Barocchi and Rosanna Bettarini, Florence 1966–87; translated, with notes, by Julia Conaway Bondella and Peter Bondella under the title *The Lives of the Artists,* Oxford and New York: Oxford University Press, 1991; translated by Gaston du C. de Vere under the title *Lives of the Most Eminent Painters, Sculptors and Architects,* 10 vols., London: Macmillan and the Medici Society, 1912–14; and selections translated by George Bull under the title *Lives of the Artists,* 2 vols., London: Penguin, 1987.

1570 Bugati, Gasparo. *Historia universale.* Venice, 1570.

1572 Razzi, Serafino. *Diario di Viaggio di un Ricercatore.* Reprint, ed. Guglielmo Di Agresti, in *Memorie domenicane,* n.s., 2 (1971).

1584 Lomazzo, Giovan Paolo. *Trattato dell'arte della pittura.* Milan, 1584. Reprint, edited by Roberto Paolo Ciardi in Giovan Paolo Lomazzo, *Scritti sulle arti,* Florence: Marchi & Bertolli, 1973–74. See also the index in Barbara and Giovanni Agosti, eds., *Le tavole del Lomazzo (per i 70 anni di Paola Barocchi),* Brescia: L'Obliquo, 1997.

1587 Armenini, Giovanni Battisti. *De' veri precetti della pittura.* Ravenna, 1587. Reprints: Hildesheim and New York: G. Olms, 1971; edited and translated by Edward J. Olszewski under the title *On the True Precepts of the Art of Painting,* New York: B. Franklin, 1977.

1590 Lomazzo, Giovan Paolo. *Idea del Tempio della Pittura.* Milan, 1590. Reprints: edited by Roberto Paolo Ciardi in Giovan Paolo Lomazzo, *Scritti sulle arti,* Florence: Marchi & Bertolli, 1973–74; edited by Robert Klein, Florence: Istituto nazionale di studi sul Rinascimento, 1974.

1592 Morigia, Paolo. *Historia dell'antichità di Milano, Libri quattro.* Venice, 1592. Reprint, Bologna: Forni, 1967.

1625 Borromeo, Federico. *Musaeum.* Milan, 1625. Translated by Luigi Grasselli, with notes and preface by Luca Beltrami, under the title *Il Museo,* Milan: n.p., 1909.

1633 Carducho, Vincente. *Diálogos de la Pintura.* Madrid, 1633.

1651 Leonardo da Vinci. *Trattato della Pittura di Lionardo da Vinci nuovamento dato in luce, con la vita dell'istesso autore, scritta da Rafaelle Du Fresne.* Paris, 1651. Translated into French by Roland Fréart, sieur de Chambray under the title *Traité de la peinture de Léonard de Vinci,* Paris, 1651.

1657 Scannelli, Francesco. *Il Microcosmo della Pittura.* Cesena, 1657. Reprint, Bologna: Nuova alfa, 1953.

1671 Santagostino, Agostino. *L'immortalità e gloria del pennello ovvero Catalogo delle pitture insigni che stanno esposte al pubblico nella città di Milano.* Milan, 1671. Reprint, edited by Marco Bona Castellotti, Quaderni di Brera 4, Milan: Il Polifilo, 1980.

1672 Bosca, Pietro Paolo. *De origine et statu Bibliotecae Ambrosianae.* Milan, 1672.

1674 Torre, Carlo. *Il Ritratto di Milano.* Milan, 1674. Reprint (of the 1714 ed.), Bologna: Forni, 1973; 1996.

1699 Piles, Roger de. *Abrégé de la vie des Peintres.* Paris, 1699.

1722 Misson, François-Maximilien. *Voyage d'Italie.* 5th ed. Utrecht, 1722.

Richardson, Jonathan, the Elder, and Jonathan Richardson the Younger. *An Account of Some of the Statues, Bas-reliefs, Drawings and Pictures in Italy . . . with Remarks.* London, 1722. French translation, *Traité de la peinture et de la sculpture: Description de divers fameux tableaux . . . en Italie,* Amsterdam, 1728.

1738 Latuada, Serviliano. *Descrizione di Milano.* Milan, 1738. Reprint, Milan: La vita felice, 1995.

1739 Brosses, Charles de. *Lettres historiques et critiques sur l'Italie.* First published Paris, 1799.

1758 Cochin, Charles Nicolas. *Voyage d'Italie.* Paris, 1758.

1769 Lalande, Joseph-Jérôme Le Français de. *Voyage d'un françois en Italie dans les années 1765 et 1766.* Yverdon, 1769.

1775 Doissin, Louis. *Sculptura, Carmen.* Milan, 1775–77. Originally published Paris, 1753.

1776 Bartoli, Francesco. *Notizia delle pitture, sculture ed architetture . . . d'Italia.* Venice, 1776–77.

1784 Gerli, Carlo Giuseppe. Introductory essay by Carlo Amoretti. *Disegni di Leonardo da Vinci incisi e pubblicati . . . con un ragionamento intorno ai disegni di Leonardo da Vinci compresi un questo volume.* Milan, 1784.

1787 Bianconi, Carlo. *Nuova guida di Milano per gli amanti delle Belle Arti e delle sacre, e profane antichità milanesi.* Milan, 1787.

1789 Lanzi, Luigi. *Storia pittorica della Italia dal risorgimento delle Belle Arti, fin presso al fine del XVIII secolo.* 4th ed., edited by G. Fiorillo. Bassano, 1818. Translated by Thomas Roscoe under the title *The History of Painting in Italy from the Period of the Revival of the Fine Arts to the End of the Eighteenth Century,* rev. ed., London, 1852–54.

1796 Chamberlaine, John. *Imitations of Original Designs by Leonardo da Vinci.* London, 1796.

Pino, Domenico. *Storia genuina del Cenacolo, insigne dipinto di Leonardo da Vinci nel Refettorio de' Padri Domenicani di Santa Maria delle Grazie di Milano.* Milan, 1796.

1797 Venturi, J.B. (Giovanni Battista). *Essai sur les Ouvrages physico-mathématiques de Léonard de Vinci.* Paris, 1797.

1798 Mussi, Antonio. *Poesie pittoriche.* Pavia, 1798.

1804 Amoretti, Carlo. *Memorie storiche su la vita, gli studi et le opere di Leonardo da Vinci.* Milan, 1804.

1809 Cicognara, Leopoldo. *Dello stato delle Belle Arti nel Regno italico.* 1809. Reprinted in Paola Barocchi, *Dai neoclassici ai puristi 1780–1861,* vol. 2 of *Storia moderna dell'arte in Italia. Manifesti, polemiche, documenti.* Turin: Einaudi, 1998.

1810 Bossi, Giuseppe. *Del Cenacolo di Leonardo da Vinci Libri Quattro.* Milan, 1810.

1811 Fumagalli, Ignazio. *Scuola di Leonardo da Vinci in Lombardia.* Milan, 1811.

1812 Bossi, Giuseppe. *Postille alle Osservazioni sul volume intitolato Del Cenacolo di Leonardo da Vinci Libri Quattro.* Milan, 1812. New ed., 1912.
Chamberlaine, John. *Original Designs of the Most Celebrated Masters of the Bolognese, Roman, Florentine and Venetian Schools.* London, 1812.
Verri, Carlo. *Osservazioni sul volume intitolato Del Cenacolo di Leonardo da Vinci, Libri Quattro, di Giuseppe Bossi pittore, scritte per lume de' giovani studiosi del disegno e della pittura.* Milan, 1812.

1814 Verri, Carlo. *Saggio elementare sul disegno della figura umana.* Milan, 1814. Reprinted in Fernando Mazzocca, ed., *Scritti d'arte del primo Ottocento,* Milan and Naples: Ricciardi, 1998.

1817 Stendhal. *Histoire de la peinture en Italie.* Paris, 1817. Revised ed., Paris, 1892; reprint, Paris: Seuil, 1994.
Goethe, Johann Wolfgang von. "Joseph Bossi über Leonardos da Vinci Abendmahl zu Mailand." Weimar, 1817.

1828 Saunders, J. "A Critical Description of Leonardo da Vinci's Celebrated Picture of the Lord's Supper." In John William Brown, *The Life of Leonardo da Vinci with a critical Account of his Works.* London, 1828, 179–99.

1843–60 Ruskin, John. *Modern Painters.* London, 1843–60. Many subsequent editions, including London: J. M. Dent; New York: E. P. Dutton, 1906; and the Italian translation under the title *Pittori Moderni,* Turin: Einaudi, 1998.

1854 Selvatico, Pietro Estense, marchese. *Catalogo delle opere d'arte contenute nella Sala delle Sedute dell'Imperiale e Reale Accademia di Venezia.* Venice, 1854.

1855 Ridolfi, Michele. *Sul Cenacolo di Leonardo da Vinci.* Lucca, 1855.

1859 Seletti, Emilio. *Appendice documentata alla Commemorazione del pittore Stefano Barezzi da Busseto.* Milan, 1859.
———. *Commemorazione del pittore Stefano Barezzi da Busseto.* Milan, 1859.

1861 Mongeri, Giuseppe. "Sulla conservazione del Cenacolo di Leonardo da Vinci." *La Perseveranza* (1861): 15ff.

1872 Mongeri, Giuseppe. *L'Arte in Milano.* Milan, 1872.

1879 Cantù, Cesare. "Il Convento e la Chiesa delle Grazie e il Sant'Ufficio." *Archivio Storico Lombardo,* year 6 (1879): 233–49; 477–99.

1880 Atti della Commissione Conservatrice dei monumenti e oggetti d'arte e di antichità della Provincia di Milano. Pt. 1, Milan, 1880, in annex to Archivio Storico Lombardo, year 7 (1880).

1881 Vasari, Giorgio. *Le vite de' più eccellenti pittori scultori ed architettori . . . con nuove annotazioni di G. Milanesi.* Florence, 1881.

1883 Richter, Jean Paul, ed. *The Literary Works of Leonardo da Vinci.* 1883. 2d ed., rev., London and New York: Oxford University Press, 1939; 3d ed., London: Phaidon, 1970.

1890 Beltrami. Luca. "Notizie sconosciute sulle città di Pavia e Milano al principio del secolo XVI." *Archivio Storico Lombardo,* ser. 2, vol. 7, year 17 (1890): 408–24.
Frizzoni, Gustavo. "L'Affresco del cenacolo di Ponte Capriasca." *Archivio Storico dell'Arte* 3 (1890): 187–91.

1893 Beltrami, Luca. I Relazione annuale dell'Ufficio Regionale per la conservazione dei Monumenti in Lombardia. *Archivio Storico Lombardo,* ser. 2, vol. 10, year 20 (1893): 807–41.

1894 Beltrami, Luca. II Relazione annuale dell'Ufficio Regionale. *Archivio Storico Lombardo,* ser. 3, vol. 2, year 21 (1894): 207–11.

1895 Moretti, Gaetano. III Relazione annuale dell'Ufficio Regionale. *Archvio Storico Lombardo,* ser. 3, vol. 5, year 22 (1895): 186–88.

1896 Moretti, Gaetano. IV Relazione annuale dell'Ufficio Regionale. *Archivio Storico Lombardo,* ser. 3, vol. 6, year 23 (1896): 373–468.

1897 Taine, Hippolyte. *Voyage en Italie.* Paris, 1897.

1898 V Relazione annuale dell'Ufficio Regionale. *Archivio Storico Lombardo,* ser. 3, vol. 9, year 25 (1898): 121–206.

1899 Moretti, Gaetano. VI e VII Relazione annuale dell'Ufficio Regionale. *Archivio Storico Lombardo,* ser. 3, vol. 12, year 26 (1890): 168–278.
Müntz, Eugène. *Leonardo da Vinci: Artist, Thinker and Man of Science.* Boston, 1899. Originally published as *Léonard de Vinci: L'artiste, le penseur, le savant,* Paris, 1899.
Venturi, Adolfo. *La Galleria della R. Pinacoteca di Brera in Milano.* Florence, 1899.

1899–1900 Moretti, Gaetano. *VIII Relazione annuale dell'Ufficio Regionale. Archivio Storico Lombardo* (1899–1900), supplement.

1901 Beltrami, Luca. "A proposito dell'Ode per la morte di un capolavoro." *Rassegna d'arte* 1 (1901): 20–24.
D'Annunzio, Gabriele. "Per la morte di un capolavoro." *L'Illustrazione italiana* 28 (1901).

1902 Beltrami, Luca. "La Novella opera di Leonardo da Vinci." *Il Marzocco,* 11 May 1902.
Monti, Santo. *La Cena di Leonardo da Vinci nel Refettorio del Monastero delle Grazie.* Como, 1902.

1903 Berenson, Bernard. *The Drawings of the Florentine Painters.* London: Murray, 1903.
Loeser, Carlo. "Note intorno ai disegni conservati nella R. Accademia di Venezia." *Rassegna d'Arte* (December, 1903): 183.

1906 *Vicende del Cenacolo di Leonardo da Vinci nel secolo XIX.* Milan: Ufficio Regionale per la conservazione dei Monumenti della Lombardia, 1906.

1907 Hoerth, Otto. *Das Abendmahl des Leonardo da Vinci.* Leipzig: Hiersemann, 1907.
Motta, Emilio. "Il restauro del Cenacolo nel secolo XVII e l'auto-difesa del pittore Mazza." *Raccolta Vinciana* 3 (1907): 127–38.
Solmi, Edmondo. *Riccordi della Vita e delle Opere di Leonardo da Vinci raccolta degli scritti di Gio. Paolo Lomazzo.* Milan: 1907.

1908 Beltrami, Luca. "Relazione del Prof. Luigi Cavenaghi sul restauro del Cenacolo vinciano." In Luca Beltrami, Il *Cenacolo di Leonardo da Vinci, MCCCCXCV–MCMVIII.* Milan: Allegretti, 1908.
———. *Vicende del Cenacolo Vinciano dall'anno MCCCCXCV all'anno MCMVIII.* Milan: Allegretti, 1908.

Cavenaghi, Luigi. "Cenacolo Vinciano." *Bollettino d'arte* (1908): 321–23. Reprinted in Luigi Beltrami, "La relazione del prof. Luigi Cavenaghi sul consolidamento del Cenacolo e la medaglia d'oro a lui dedicata," *Raccolta Vinciana* 5 (1909): 95–103.

Moretti, Gaetano. *La Conservazione dei Monumenti della Lombardia dal 1 luglio 1900 al 31 dicembre 1906.* Milan: Allegretti, 1908.

1909 Berenson, Bernard. *The Florentine Painters of the Renaissance.* 1896. 3d ed., rev. and enl., New York: G. Putnam's Sons, 1909.

Borromeo, Federico. *Il Museo.* Edited by Luigi Grasselli, with a preface and notes by Luca Beltrami. Milan: n.p., 1909. Originally published as *Musaeum,* Milan, 1625.

Carotti, Giulio. "Il restauro della Cena di Leonardo da Vinci." *L'Arte* 12, no. 2 (1909): 1–7.

1910 Bandello, Matteo. *Le novelle.* 1554 Reprint, edited by Gioachino Brognoligo, Bari: Laterza, 1910.

1913–23 Malaguzzi-Valeri, Francesco. *La corte di Ludovico il Moro: La vita privata e l'arte a Milano nella seconda metà del Quattrocento.* 4 vols. Milan: Hoepli, 1913–23, esp. vol. 2, *Bramante e Leonardo* (1915).

1914 *Leonardo da Vinci: Das Abendmahl,* herausg. von Emil Schäffer, mit einer Einleitung von Goethe. Berlin: J. Bard, 1914.

Longhi, Roberto. "Le Due Lise." *La Voce* (January 1914). Reprinted in Roberto Longhi, *Opere complete di Roberto Longhi,* vol. 1: *Scritti giovanili, 1912–1922,* Florence: Sansoni, 1961.

1916 Berenson, Bernard. *The Study and Criticism of Italian Art.* London: G. Bell, 1916.

Sirén, Osvald. *Leonardo da Vinci: The Artist and the Man.* New Haven: Yale University Press, 1916.

1919 Beltrami, Luca, ed. *Documenti e memorie riguardanti la vita e le opere di Leonardo da Vinci.* Milan: Fratelli Treves, 1919.

Doréz, Léon. "Léonard de Vinci et Jean Perréal." *Nouvelle Revue d'Italie* (1919): 67–86.

Le Memorie su Leonardo da Vinci, di Don Ambrogio Mazenta ripubblicate ed illustrate da D. Luigi Gramatica. Milan: Alfieri & Lacroix, 1919.

Poggi, Giovanni. *Leonardo da Vinci: La vita di Georgio Vasari nuovamente commentata e illustrata.* Florence: Pampaloni, 1919.

Suida, Wilhelm. "Leonardo und seine Schule in Mailand." *Monatshefte für Kunstwissenschaft* 12 (1919).

Venturi, Lionello. *La critica e l'arte di Leonardo da Vinci.* Bologna: Zanichelli, 1919.

1924 Bucci, Vincenzo. "Per la salvezza di un capolavoro." *Corriere della Sera,* 19 August 1924.

Wölfflin, Heinrich. *Die Klassische Kunst.* Munich: Bruckmann, 1924. Reprint, Basel and Stuttgart: Schwabe, 1968. Translated by Peter and Linda Murray under the title *Classic Art: An Introduction to the Italian Renaissance,* 1952; London: Phaidon, 1994.

1925 Calvi, Gerolamo. *I manoscritti di Leonardo dal punto di vista cronologico, storico e biografico.* Bologna: Nicola Zanichelli, 1925. Reprint, edited by Gerolamo Calvi and Augusto Marinoni, Busto Arsizio: Bramante, 1982.

1927 Salmi, Mario. *Il "Cenacolo" di Leonardo da Vinci e la chiesa delle Grazie a Milano.* Parts 1 and 2. Milan: Fratelli Treves, 1927. Translated by Lily E. Marshall under the title *The "Last Supper" by Leonardo da Vinci and the Church of "Le Grazie" in Milan,* Milan: Fratelli Treves, 1928.

Secco Suardo, Giovanni. *Il restauratore dei dipinti.* 4th ed. Milan: Hoepli, 1927.

1928 Leonardo da Vinci. *Zeichnungen.* Edited by Anny E. Popp. Munich: Piper, 1928.

Sirén, Osvald. *Léonard de Vinci: L'artiste et l'homme.* Translated by Jean Buhot. Paris: G. Van Oest, 1928. Originally published as *Leonardo da Vinci: The Artist and the Man,* New Haven: Yale University Press, 1916.

1929 Suida, Wilhelm. *Leonardo und sein Kreis.* Munich: Bruckmann, 1929.

1930–34 Horst, Carl. "L'Ultima Cena di Leonardo nel riflesso delle copie e delle imitazioni." *Raccolta Vinciana* 14 (1930–34): 118–200.

1931 Bodmer, Heinrich. *Leonardo: Des Meisters Gemälde und Zeichnungen in 360 Abbildungen.* Stuttgart: Deutsche Verlags-Anstalt; New York: E. Weyhe, 1931.

1935 Clark, Kenneth. *A Catalogue of the Drawings of Leonardo da Vinci in the Collection of His Majesty The King at Windsor Castle.* Cambridge: Cambridge University Press; New York: Macmillan, 1935.

1938 Berenson, Bernard. *The Drawings of the Florentine Painters.* New ed., enl. Chicago: University of Chicago Press, 1938.

1939 Clark, Kenneth. *Leonardo da Vinci: An Account of His Development as an Artist.* Cambridge: Cambridge University Press, 1939. Reissued as *Leonardo da Vinci* in revised edition, edited, with an introduction, by Martin Kemp, London: Viking, 1988.

Mazzucchetti, Lavinia, ed. *Goethe e il Cenacolo di Leonardo.* Milan: U. Hoepli, 1939.

Pica, Agnoldomenico. *L'Opera di Leonardo al Convento delle Grazie in Milano.* Rome: Mediterranea, 1939.

Venturi, Adolfo, ed. *I manoscritti e i disegni di Leonardo da Vinci pubblicati dalla R. Commissione Vinciana.* Part 5, *I disegni.* Rome: Danesi, 1939.

1940 Borgomaneri. *Il Cenacolo del Fiammenghino (Refettorio di S. Michele alla Chiusa di Milano: Brevi cenni sul Cenacolo di Leonardo da Vinci).* Genoa, 1940.

1943 Heydenreich, Ludwig H. *Leonardo.* Berlin: Rembrandt-Verlag, 1943. 2d ed., 1944.

1945 Heydenreich, Ludwig H. *Arte e scienza in Leonardo.* Milan: Bestetti, 1945.

1946 Croce, Benedetto. *La Critica e la storia delle arti figurative: Questioni di metodo.* Bari: Laterza, 1934. 2d ed., enlarged, 1946.

Popham, Arthur Ewart. Introduction and notes to *The Drawings of Leonardo da Vinci.* London: Jonathan Cape, 1946. Rev. ed., with a new introductory essay by Martin Kemp, London: Pimlico, 1994.

1947 Benesch, Otto. *A Catalogue of Rembrandt's Selected Drawings.* New York: Oxford University Press; London: Phaidon, 1947.

Massari, G. "Un capolavoro malato." *Sapere,* 31 March 1947, 77, 78, 89.

Rocco, G. *Quel che è avvenuto al Cenacolo Vinciano.* Milan, 1947.

1949 Heydenreich, Ludwig H. *Leonardo da Vinci: An exhibition of His Scientific Achievements and a General Survey of His Art.* Los Angeles: Panold Masters, 1949.

Recchia, E. "Le vernici e la tecnica nel restauro del Cenacolo di Leonardo da Vinci." *L'industria della vernice* (December 1949): 300–9.

1950 Chierici, Gino. "Il refettorio delle Grazie." *Proporzioni* 3 (1950).

1952 Leonardo da Vinci. *Scritti scelti.* Edited by Anna Maria Brizio. Turin: UTET, 1952. New ed., 1968.

Longhi, Roberto. "Difficoltà di Leonardo." *Paragone,* 29 May 1952, 10–12. Reprinted in Roberto Longhi, *Cinquecento classico e Cinquecento manieristico (1951–1970),* vol. 8, pt. 2 of *Opere complete di Roberto Longhi,* Florence: Sansoni, 1976, 1–3.

Möller, Emil. *Das Abendmahl des Leonardo da Vinci.* Baden-Baden: Verlag für Kunst und Wissenschaft, 1952.

1953 Berenson, Bernard. "Il restauro del Cenacolo." *Proporzioni* (November 1953) and *Corriere della Sera,* 20 December 1953. Reprinted in Bernard Berenson, *Valutazioni 1945–1956,* ed. M. Loria, Milan: Electa, 1957, 81–87.

Pedretti, Carlo, ed. *Documenti e memorie riguardanti Leonardo da Vinci a Bologna e in Emilia.* Bologna: Fiammenghi, 1953.

1954 Arslan, Edoardo, and Cesare Brandi in *L'Europeo,* 448, 16 May 1954.

Brandi, Cesare. "Il restauro e l'interpretazione dell'opera d'arte." *Annali della Scuola Normale Superiore di Pisa,* ser. 2, vol. 23 (1954): 90–100.

Castelfranco, Giorgio. "Gli studi di Ladislao Reti sulla chimica di Leonardo." In *Leonardo: Saggi e ricerche.* Edited by Achille Marazza. Rome: Istituto Poligrafico dello Stato, 1954, 47–56.

———. "Momenti della recente critica vinciana." In *Leonardo: Saggi e ricerche.* 415–68.

Goethe, Johann Wolfgang von. *Schriften zur Kunst.* In volume 13 of Johann Wolfgang von Goethe, *Gedenkausgabe der Werke, Briefe und Gespräche,* ed. Ernst Beutler. Zurich: Artemis-Verlag, 1954.

Gombrich, Ernst H. "Leonardo's Grotesque Heads: Prolegomena to Their Study." In *Leonardo: Saggi e ricerche,* 197–220.

Hours, Magdeleine. "Étude analytique des tableaux de Léonard de Vinci au Laboratoire du Musée du Louvre." In *Leonardo: Saggi e ricerche,* 13–26.

La Joie, R. A. "The Great Restoration." *Home Messenger* (August 1954): 809.

———. "The Last Supper Survives." *Catholic Digest* (September, 1954): 39–42.

Leonardo: Saggi e ricerche. Edited by Achille Marazza. Rome: Istituto Poligrafico dello Stato, 1954.

Marinoni, Augusto. "I manoscritti di Leonardo da Vinci e le loro edizioni." In *Leonardo: Saggi e ricerche,* 187–274, esp. pp. 229–74.

"The True Last Supper." *Time,* 4 October 1954, 40.

Wittgens, Fernanda. "Il restauro in corso del Cenacolo di Leonardo." In *Atti del Convegno di studi vinciani.* Florence, L. S. Olschki, 1954, 39–50.

———. "Restauro del Cenacolo." In *Leonardo: Saggi e ricerche,* 1–12.

1957 Pedretti, Carlo. *Leonardo da Vinci: Fragments at Windsor Castle from the Codex Atlanticus.* London: Phaidon, 1957.

1958 Heydenreich, Ludwig H. *Leonardo da Vinci: Das Abendmahl.* Stuttgart: Reclam, 1958.

1960 Brizio, Anna Maria. "Lo studio degli Apostoli della Cena dell'Accademia di Venezia." *Raccolta Vinciana* 18 (1960): 45–52.

Steinitz, Kate Trauman. "Goethe and Leonardo's Treatise on Painting." *Raccolta Vinciana* 18 (1960): 104–11.

1961 Winckelmann, Johann Joachim. *Lettere italiane.* Edited by Giorgio Zampa. Milan: Feltrinelli, 1961.

1962 Shearman, John. "Leonardo's Colour and Chiaroscuro." *Zeitschrift für Kunstgeschichte* 25, no. 1 (1962): 13–47.

1964 Brizio, Anna Maria. Review of "Leonardo's Colour and Chiaroscuro," by John Shearman. *Raccolta Vinciana* 20 (1964): 412–14.

1965 Vertova, Luisa. *I Cenacoli fiorentini.* Turin: ERI, 1965.

1966–87 Vasari, Giorgio. *Le vite de' più eccellenti pittori, scultori e architettori.* Edited by Paola Barocchi and Rosanna Bettarini. 10 vols. Florence: Sansoni, 1966–87.

1967 *John Everett Millais.* Catalog of an exhibition. Liverpool, 1967.

L'opera completa di Leonardo pittore. Edited by Angela Ottino Della Chiesa. Milan: Rizzoli, 1967. Translated, with introduction, by L. D. Ettlinger, under the title *The Complete Paintings of Leonardo da Vinci,* New York: Harry N. Abrams, 1967.

1967–68 Philippot, Albert and Paul. "La dernière Cène de Tongerlo et sa restauration." In *Het Laatste Avondmaal Tongerlo.* Brussels, n.d. Previously printed in *Bulletin* of the Koninklijk Instituut voor het Kunstpatrimonium, 10 (1967–68).

1968 Berenson, Bernard. *Italian Pictures of the Renaissance . . . Central and North Italian Schools.* London: Phaidon, 1968.

Pedretti, Carlo. *Leonardo da Vinci inedito: Tre saggi.* Florence: Barbèra, 1968.

1968–69 Clark, Kenneth. *The Drawings of Leonardo da Vinci in the Collection of Her Majesty the Queen at Windsor Castle.* 2d ed., revised with the assistance of Carlo Pedretti. London: Phaidon, 1968–69.

1969 Gombrich, Ernst H. "The Form of Movement in Water and Air." In *Leonardo's Legacy: An International Symposium,* ed. Charles Donald O'Malley. Berkeley: University of California Press, 1969. Reprinted in Ernst H. Gombrich, *The Heritage of Apelles: Studies in the Art of the Renaissance,* Ithaca: Cornell University Press, 1976. Translated into Italian under the title "La forma del movimento nell'acqua e nell'aria," in Ernst H. Gombrich, *L'eredità di Apelle: Studi sull'arte del Rinascimento,* Turin: Einaudi, 1986.

1971 Brachert, Thomas. "A Musical Canon of Proportion in Leonardo da Vinci's Last Supper." *Art Bulletin* 53 (1971).

Cennini, Cennino. *Il Libro dell'arte.* 1437. Reprint, edited by Franco Brunello, Vicenza: N. Pozza, 1971.

1971–72 Barocchi, Paola, ed. *Scritti d'arte del Cinquecento.* 3 vols. Milan and Naples: Ricciardi, 1971–72.

1972 Pedretti, Carlo. *Leonardo da Vinci: The Royal Palace at Romorantin.* Cambridge: Belknap Press of Harvard University Press, 1972.

1973 Melzi d'Eril, Giulio. *La Galleria Melzi e il collezionismo milanese del tardo Settecento.* Milan: Virgilio, 1973.

Pedretti, Carlo. *Leonardo: A Study in Chronology and Style.* Berkeley: University of California Press, 1973.

———. "The Original Project for S. Maria delle Grazie." *Journal of the Society of Architectural Historians* 32 (1973): 30–42.

Steinberg, Leo. "Leonardo's Last Supper." *Art Quarterly* 36, no. 4 (1973): 297–410.

Torre, Carlo. *Il Ritratto di Milano.* Bologna, 1973. Originally published Milan, 1674.

1973–74 Lomazzo, Giovan Paolo. *Scritti sulle arti.* Edited by Roberto Paolo Ciardi. Florence: Marchi e Bertelli, 1973–74.

1974 Brizio, Anna Maria. "The Painter." In *The Unknown Leonardo,* ed. Ladislao Reti, 20–55. New York: McGraw-Hill, 1974. In Italian translation under the title "Leonardo pittore" in *Leonardo,* ed. Ladislao Reti, 20–55, Milan, 1974.

Brugnoli, Maria Vittoria. "Il Cavallo." In *The Unknown Leonardo,* 86–109. In Italian translation under the title "Il Monumento Sforza" in *Leonardo,* 86–109.

De Toni, Nando. "Giovan Battista Venturi e i manoscritti dell'Ambrosiana a Parigi nel 1797." Extract in *Commentari dell'Ateneo di Brescia per il 1974* (1974): 1–7.

Heydenreich, Ludwig H. *Leonardo: The Last Supper.* London: Allen Lane, 1974. Translated by Filippo Grandi under the title I*nvito a Leonardo: L'Ultima cena,* Milan: Rusconi, 1982.

Lomazzo, Giovan Paolo. *Idea del Tempio della Pittura.* Edited and translated by Robert Klein. Florence: Istituto nazionale di studi sul Rinascimento, 1974.

Gombrich, Ernst H. *La storia dell'arte raccontata da Ernst H. Gombrich.* Turin, 1974. Originally published as *The Story of Art,* New York: Phaidon, 1950; new ed. 1966; 16th ed., rev. and enl., London: Phaidon, 1995.

The Unknown Leonardo. Edited by Ladislao Reti. New York: McGraw-Hill, 1974. In Italian translation under the title *Leonardo,* 2d ed., Milan, 1975.

1975 Bora, Giulio. "Giuseppe Bossi segretario e professore di Brera." In *Mostra dei Maestri di Brera,* 31–35. Milan, 1975.

Brizio, Anna Maria. "L'Accademia di Brera nei suoi rapporti con la città di Milano, 1776–1814." In *Mostra dei Maestri di Brera.*

Freedberg, Sydney Joseph. *Painting in Italy: 1500 to 1600.* Baltimore: Penguin, 1975. Originally published Harmondsworth: Penguin, 1971.

Gould, Cecil Hilton Monk. *Leonardo: The Artist and the Non-Artist.* London: Wiedenfeld & Nicolson; Boston: New York Graphic Society, 1975.

Ost, Hans. *Das Leonardo-Porträt in der Kgl. Bibliothek Turin und andere Fälschungen des Giuseppe Bossi.* Berlin: Mann, 1975.

1976 Jeanson, C. Y., and S. B. Curri. "Microstructures minéralogiques et biologiques dans les matériaux du support d'une peinture murale de Leonardo da Vinci." XIII Congresso Mondiale della Società Internazionale per le Ricerche sui Grassi, Marseille, 31 August 1976.

Sciolla, Gianni Carlo. *Rembrandt: Disegni scelti e annotati.* Florence: Nuova Italia, 1976.

Scotti, Aurora. "La collezione De Pagave." In *La collezione De Pagave: Le stampe dell'Archivio di Stato di Novara,* by B. Gorni, A. Papale, and Aurora Scotti, 7–12. Novara, 1976.

1976–78 Varaldo, Carlo. "Un'opera leonardesca nella Liguria di Ponente: Il polittico di Marco d'Oggiono e Battista da Vaprio per il San Giovanni di Andora." *Rivista ingauna e intemelia* 31–33 (1976–78): 164–71.

1977 Brizio, Anna Maria. "Il Cenacolo." In *Leonardo: La pittura.* Florence: Giunti, 1977, 93–114.

Leonardo: La pittura. Florence: Giunti, 1977. 2d ed., 1985.

Mora, Laura, Paolo Mora, and Paul Philippot. *La conservation des peintures murales.* Bologna: Compositori, 1977. Translated under the title *Conservation of Wall Paintings,* London and Boston: Butterworths, 1984.

Pedretti, Carlo. *The Literary Works of Leonardo da Vinci Compiled and Edited from the Original Manuscripts by Jean Paul Richter.* Oxford: Phaidon, 1977.

———. "The Sforza Sepulchre." Part 1. *Gazette des Beaux-Arts* 119 (April 1977): 121–31.

Rosci, Marco. "La Sala delle Asse." In *Leonardo: La pittura* (1977), 115–25.

1978 Degl'Innocenti, Giovanni. In Carlo Pedretti, *Leonardo architetto,* 286–89. Milan: Electa, 1978. 2d ed., 1988. Translated by Sue Brill under the title "Perspective Reconstructions: Suggestions for a Method and Its Applications," in Carlo Pedretti, *Leonardo: Architect,* 274–89, New York: Rizzoli, 1985.

I disegni leonardeschi della Contessa De Béhague. Catalog by Alessandro Vezzosi. Florence, 1978. Translated under the title *The Countess de Béhague Collection: Leonardo, Poussin, Rubens: Leonardo's Return to Vinci,* New York: Johnson Reprints, 1981.

L'idea della magnificenza civile: Architettura a Milano 1770–1848. Milan: Electa, 1978.

Martelli, Gisberto. "Ricerche e precisazioni sull'ambiente del Cenacolo Vinciano nel complesso Monumentale Milanese di S. Maria delle Grazie." *Notiziario della Banca Popolare di Sondrio,* no. 18 (1978).

Mazzocca, Fernando. *Neoclassico e troubadour nelle miniature di Giambattista Gigola.* Florence: Centro Di, 1978.

Pedretti, Carlo. *The Codex Atlanticus of Leonardo da Vinci: A Catalogue of Its Newly Restored Sheets. Part One, Vols. I–VI.* New York: Johnson Reprint, Harcourt Brace Jovanovich, 1978.

———. "Leonardo's Studies for the Sforza Sepulchre." Part 2. *Gazette des Beaux-Arts* 120 (January 1978): 1–20.

———. *Leonardo architetto.* Milan: Electa, 1978. 2d ed., 1988. Translated by Sue Brill under the title *Leonardo, Architect,* New York: Rizzoli, 1985.

Rosci, Marco. *The Hidden Leonardo.* Oxford: 1978. Translated into Italian under the title *Leonardo,* Milan: Mondadori, 1979.

1979 Marani, Pietro C. "Stendhal e il Cenacolo di Leonardo." *L'Esopo* 3 (1979): 51–55.

Matteini, Mauro, and Arcangelo Moles. "A Preliminary Investigation of the Unusual Technique of Leonardo's Mural 'The Last Supper.'" *Studies in Conservation* 24 (1979): 125–33.

Naumann, Francis M. "The 'Costruzione legittima' in the Reconstruction of Leonardo da Vinci's 'Last Supper.'" *Arte Lombarda* 52 (1979): 63–89.

Pedretti, Carlo. *The Codex Atlanticus of Leonardo da Vinci: A Catalogue of Its Newly Restored Sheets. Part Two, Vols. VII–XII.* New York: Johnson Reprint; Harcourt Brace Jovanovich, 1979.

Rosenfeld, Emmy. "Goethe und der Mailänder Naturforscher Giuseppe de Cristoforis." *Literaturwissenschaftliches Jahrbuch,* n.s., 20 (1979): 107–38.

Samuels, Ernest. *Bernard Berenson: The Making of a Connoisseur.* Cambridge, Mass.: Belknap Press, 1979.

Scotti, Aurora. *Brera 1776–1815: Nascita e sviluppo di una istituzione culturale milanese.* Quaderni di Brera, 5. Florence: Centro Di, 1979.

———. "Carlo Bianconi, Luigi Dagoty e un tentativo di incisione a colori del Cenacolo Leonardesco." *Almanacco Italiano* 80 (1979): 148–57.

Snow-Smith, Joanne. "Pasquier Le Moyne's 1515 Account of Art and War in Northern Italy." *Studies in Iconography* 5 (1979): 173–234.

1980 Arese, Marichia, Aldo Bonomi, Claudio Cavalieri, and Claudio Fronza. "L'impostazione prospettica della 'Cena' di Leonardo da Vinci: Un'ipotesi interpretativa." In *La Prospettiva rinascimentale: Codificazioni e trasgressioni,* ed. Marisa Dalai Emiliani, 1:249–59, Florence: Centro Di, 1980.

Borsook, Eve. *The Mural Painters of Tuscany: From Cimabue to Andrea del Sarto.* 2d ed. rev. and enl., Oxford: Clarendon Press; New York: Oxford University Press, 1980.

Cogliati Arano, Luisa. *Leonardo: Disegni di Leonardo e della sua cerchia alle Gallerie dell'Accademia di Venezia.* Milan: Arcadia/Electa, 1980.

Marani, Pietro C. "Leonardo, Rubens e Poussin a confronto." *Almanacco Italiano* 81 (1980): 136–41.

Martelli, Gisberto. "Il Refettorio di Santa Maria delle Grazie a Milano e il restauro di Luca Beltrami nell'ultimo decennio dell'Ottocento." *Bollettino d'arte* 8 (1980): 55–72.

Pacioli, Luca. *De Divina Proportione.* Introduction by Augusto Marinoni. Vicenza, 1980. Originally published 1509.

Polzer, Joseph. "The Perspective of Leonardo Considered as a Painter." In *La Prospettiva rinascimentale: Codificazioni e trasgressioni,* 233–47.

La Prospettiva rinascimentale: Codificazioni e trasgressioni. Edited by Marisa Dalai Emiliani. Florence: Centro Di, 1980.

Santagostino, Agostino. *L'immortalità e gloria del pennello.* Edited by Marco Bona Castellotti. Quaderni di Brera, 4. Milan: Il Polifilo, 1980. Originally published 1671.

1981 Kemp, Martin. *Leonardo da Vinci: The Marvelous Works of Nature and Man.* London: Dent; Cambridge: Harvard University Press, 1981. Translated into Italian under the title *Leonardo da Vinci: Le mirabili operazioni della natura e dell'uomo,* Milan: Mondadori, 1982.

1981–82 Bertelli, Carlo, and Barbara Fabjan. "Il Cenacolo di Leonardo." *Brera: Notizie della Pinacoteca* (autumn and winter, 1981–82): 1–3.

1982 *Ben Willikens Abendmahl.* Catalog of an exhibition, Stuttgart, Münster, and Milan. Stuttgart, 1982.

Bertelli, Carlo. "Conservazione e Restauro dopo Pellicioli." *In Invito a Leonardo: L'Ultima Cena,* by Ludwig H. Heydenreich, 127–56. Milan: Rusconi, 1982.

———. "Verso il vero Leonardo." In *Leonardo e Milano,* ed. Gian Alberto Dell'Acqua, 83–88. Milan: Banco Popolare di Milano, 1982.

Costanza Fattori, Lionello. "Il Refettorio di S. Maria delle Grazie: Rimedi progettati per far fronte ai dessesti statici." *Arte Lombarda* 62 (1982): 5–10.

Curri, Sergio. "Aspetti di aggressione biologica al Cenacolo leonardesco." *Arte Lombarda* 62 (1982): 47–50.

De Vecchi, Pierluigi. "Stendhal e Leonardo: Il Cenacolo di Santa Maria delle Grazie." In *Stendhal e Milano.* Vol. 2. Florence: Leo S. Olschki, 1982, 729–37.

Fedeli, Enzo. "Ricerche svolte su alcuni prelievi di materiale appartenente al Cenacolo." *Arte Lombarda* 62 (1982): 51–54.

Heydenreich, Ludwig H. *Invito a Leonardo: L'Ultima Cena.* Translated by Filippo Grandi. Milan: Rusconi, 1982. Originally published as *Leonardo: The Last Supper* London: Allen Lane; New York: Viking, 1974.

Ianziti, Gary. "The *Commentaries* of Giovanni Simonetta: History and Propaganda in Sforza Milan (1450–1490)." In *Altro Polo: A Volume of Italian Renaissance Studies,* 79–98. Sydney: Frederick May Foundation for Italian Studies, University of Sydney, 1982.

———. "The First Edition of Giovanni Simonetta's *De rebus Gestis Francisci Sfortiae Commentarii:* Questions of Chronology and Interpretation." *Bibliothèque d'Humanisme et Renaissance* 44 (1982): 137–47.

Leonardo e Milano. Edited by Gian Alberto Dell'Acqua. Milan: Banca Popolare di Milano, 1982.

Martelli, Gisberto. "Il refettorio di S. Maria delle Grazie: Vicende degli ultimi novanta anni: L'individuazione dei dissesti statici." *Arte Lombarda* 62 (1982): 11–22.

———. "Ulteriori precisazioni sui lavori di restauro di Luca Beltrami nel refettorio di Santa Maria delle Grazie." *Raccolta Vinciana* 21 (1982): 161–75.

Natale, Mauro. In *Zenale e Leonardo: Tradizione e rinnovamento della pittura lombarda.* Milan: Electa, 1982.

Rossi, Marco. "Problemi di conservazione del Cenacolo nei secoli XVI e XVII." *Arte lombarda* 62 (1982): 58–65.

Testori, Giovanni. "Reliquiae Fugientes." In *Leonardo e Milano,* 11–15.

Wasserman, Jack. *Leonardo da Vinci.* Milan: Garzanti, 1982. Originally published in English as *Leonardo: Leonardo da Vinci,* New York: H. N. Abrams, 1975.

1983 Bertelli, Carlo. "Il Cenacolo vinciano." In *Santa Maria delle Grazie in Milano.* Milan: Banca Popolare di Milano, 1983, 188–95. Reprinted in *Leonardo: Studi per il Cenacolo dalla Biblioteca Reale nel Castello di Windsor,* 11–15 (catalog by Carlo Pedretti), Milan: Electa, 1983.

Brown, David Alan. *Leonardo's Last Supper: Precedents and Reflections.* Washington, D.C.: National Gallery of Art, 1983.

———. *Leonardo's Last Supper: The Restoration.* Washington, D.C.: National Gallery of Art, 1983.

Clark, Kenneth. Introduction to Carlo Pedretti, *Leonardo: Studi per il Cenacolo dalla Biblioteca Reale nel Castello di Windsor,* 17–22. Milan: Electa, 1983.

Cortelazzo, Manlio, and Paolo Zoli. *Dizionario etimologico della lingua italiana.* Vol. 3. Bologna: Zanichelli, 1983.

Fabjan, Barbara. *Leonardo a Milano: Fotografia del Cenacolo* Milan: Sicof Sezione Culturale, 1983.

Ludovico il Moro: La sua città e la sua corte (1480–1499). Catalog of an exhibit. Milan: Archivio di stato di Milano, 1983.

Pedretti, Carlo. *Leonardo: Studi per il Cenacolo dalla Biblioteca Reale nel Castello di Windsor.* Milan: Electa, 1983.

Travers Newton, H. "Leonardo da Vinci as Mural Painter: Some Observations on His Materials and Working Methods." *Arte Lombarda* 66 (1983): 71–88.

1984 Alberici, Clelia, and Mariateresa Chirico De Biasi. *Leonardo e l'incisione: Stampe derivate da Leonardo e Bramante dal XV al XIX secolo.* Milan: Electa, 1984.

Brambilla Barcilon, Pinin. *Il Cenacolo di Leonardo in Santa Maria delle Grazie: Storia, condizioni, problemi.* Quaderni del restauro, 2. Milan: Olivetti, 1984.

Rosci, Marco. "Leonardo 'filosofo': Lomazzo e Borghini 1584: Due linee di tradizione dei pensieri e precetti di Leonardo sull'arte." In *Fra Rinascimento, Manierismo e Realtà: Scritti di Storia dell'arte in memoria di Anna Maria Brizio,* ed. Pietro C. Marani, 53–78. Florence: Giunti Barbèra, 1984.

Scotti, Aurora. *Lo stato e la città: Architetture, istituzioni e funzionari nella Lombardia illuminista.* Milan: F. Angeli, 1984.

Trevisani, Filippo. *Restauri nel Polesine: Dipinti, documentazione e conservazione.* Catalog of an exhibit. Milan: Electa, 1984.

1985 Ciardi, Roberto Paolo. "Andrea Appiani commissario per le 'Arti Belle.'" *Prospettiva* 33–36 (1985): 376–80.

Fabjan, Barbara. "Il Cenacolo nuovamente restaurato." In *Leonardo: La pittura.* 2d ed., ed. Pietro C. Marani. Florence: Giunti-Martello, 1985.

Kühn, Hermann. "Naturwissenschaftliche Untersuchung von Leonardos Abendmahl in Santa Maria delle Grazie in Mailand." *Maltechnik Restauro* 111, no. 4 (1985): 24–51.

1986 Bertelli, Carlo. "Leonardo e l'Ultima Cena (ca. 1495–97)." In *Tecnica e stile: Esempi di pittura murale del Rinascimento italiano,* ed. Eve Borsook and Fiorella Superbi Gioffredi, 31–42. Villa I Tatti Studies, 9. Milan: Silvana, 1986.

Bona Castellotti, Marco, ed. *La pittura lombarda del Settecento.* Milan: Longanesi, 1986.

Cecchi, Roberto. "La chiesa e il convento di Santa Maria delle Grazie dalla fondazione all'intervento bramantesco." In *Il Cenacolo e Santa Maria delle Grazie,* by Pietro C. Marani, Roberto Cecchi, and Germano Mulazzani. Milan: Elemond, 1986. New ed. 1993. Translated into English as *The Last Supper and Santa Maria delle Grazie,* Milan: Electa, 1989.

De Vecchi, Pierluigi, and Aurora Scotti. "'Artefici di numi': Gli artisti e le istituzioni." In *I cannoni al Sempione: Milano e la 'Grande Nation' (1796–1814),* 103–212. Milan: Cassa di Risparmio delle provincie lombarde, 1986.

Disegni lombardi del Cinque e del Seicento della Pinacoteca di Brera e dell'Arcivescovado di Milano. Florence: Cantini, 1986.

Feller, Robert L., ed. *Artists' Pigments: A Handbook of Their History and Characteristics.* Cambridge: Cambridge University Press, 1986.

Leonardo da Vinci: I manoscritti dell'Institut de France: Il Manoscritto H. Diplomatic and critical transcription by Augusto Marinoni. Florence: Giunti, 1986.

Marani, Pietro C. In *Disegni lombardi del Cinque e del Seicento della Pinacoteca di Brera e dell'Arcivescovado di Milano,* 27–31.

———. *Il Cenacolo di Leonardo.* Milan: Electa, 1986. Translated into English under the title *Leonardo's Last Supper,* Milan: Electa, 1986.

Matteini, Mauro, and Arcangelo Moles. "Il Cenacolo di Leonardo: Considerazioni sulla tecnica pittorica e ulteriori studi analitici sulla preparazione." *Quaderni dell'Opificio delle Pietre Dure e Laboratori di Restauro di Firenze,* 1. OPD Restauro (1986): 34–41.

Pescarmona, Daniele, and Pietro C. Marani. In *Disegni lombardi del Cinque e del Seicento della Pinacoteca di Brera e dell'Arcivescovado di Milano,* 48–50.

Piva, Paolo. "Correggio e Bonsignori: La scoperta di un episodio di collaborazione artistica del primo Cinquecento." *Quaderni di Palazzo Te* 4 (January–June 1986): 37–59.

1987 Marani, Pietro C. In *Disegni e dipinti leonardeschi dalle collezioni milanesi.* Milan: Electa, 1987, 118–19.

———. *Leonardo e i leonardeschi a Brera.* Florence: Cantini, 1987.

———. "Una precisazione sulla provenienza del disegno leonardesco di Brera e un giudizio settecentesco sul Cenacolo 'restaurato.'" *Raccolta Vinciana* 22 (1987): 265–70.

1988 Binaghi Olivari, Maria Teresa. In *Pinacoteca di Brera: Scuole lombarda e piemontese 1300–1535,* ed. Federico Zeri and Carlo Pirovano, 268–76. Milan: Electa, 1988.

Conti, Alessandro. *Storia del restauro e della conservazione delle opere d'arte.* Milan: Electa, 1988.

Forti Grazzini, Nello. "Gli Arazzi." In *Monza: Il Duomo e i suoi tesori.* Milan: Electa; Credito Artigiano, 1988, 111–14.

Magnifico, Marco. In *Pinacoteca di Brera: Scuole lombarda e piemontese 1300–1535,* 144.

Rossi, Marco, and Alessandro Rovetta. *Il Cenacolo di Leonardo: Cultura domenicana, iconografia eucaristica e tradizione lombarda.* Quaderni del restauro, 5. Ivrea: Olivetti, 1988.

Rovetta, Alessandro. "La tradizione iconografica dell'Ultima Cena." In Marco Rossi and Alessandro Rovetta, *Il Cenacolo di Leonardo: Cultura domenicana, iconografia eucaristica e tradizione lombarda,* 28–48.

Shell, Janice, Pinin Brambilla Barcilon, and David Alan Brown. *Giampietrino e una copia cinquecentesca dell'Ultima Cena di Leonardo.* Quaderni del restauro, 4. Ivrea: Olivetti, 1988.

1989 Kemp, Martin. In *Leonardo da Vinci,* by Martin Kemp and Jane Roberts with Philip Steadman; introduction by E. H. Gombrich. New Haven: Yale University Press in association with the South Bank Centre, 1989.

Lucco, Mauro. *Le 'Tre età dell'uomo' della Galleria Palatina: Firenze, Palazzo Pitti.* Catalog of an exhibition. Florence: Centro Di, 1989.

Martelli, Gisberto. "Restauri al 'Cenacolo Vinciano' dal 1978: Richiamo di testimonianze vecchie e nuove." *Raccolta Vinciana* 23 (1989): 17–25.

Pepinashvili, Constantine C. "The 'Last Supper': A Cine-montage Breakdown." *Achademia Leonardi Vinci: Journal of Leonardo Studies and Bibliography of Vinciana* 2 (1989): 117–20.

Scotti, Aurora. *Il Foro Bonaparte: Un'utopia giacobina a Milano.* Introduction by Werner Oechslin. Milan: Ricci, 1989.

Shell, Janice, and Grazioso Sironi. "Documents for Copies of the Cenacolo and the Virgin of the Rocks by Bramantino, Marco d'Oggiono, Bernardino de' Conti and Cesare Magni." *Raccolta Vinciana* 23 (1989): 103–17.

———. "Giovanni Antonio Boltraffio and Marco d'Oggiono: The Berlin Resurrection of Christ with Sts Leonard and Lucy." *Raccolta Vinciana* 23 (1989): 119–54.

Tardito, Rosalba. "Il Cenacolo di Leonardo e il suo recente restauro." *Raccolta Vinciana* 23 (1989): 3–16.

1990 Agosti, Giovanni. *Bambaja e il classicismo lombardo.* Turin: Einaudi, 1990.

Bonsanti, Giorgio. "Il Cenacolo del Ghirlandaio." In *La chiesa e il convento di San Marco a Firenze.* Florence: Giunti, 1990.

Brambilla Barcilon, Pinin, and Pietro C. Marani. *Le lunette di Leonardo nel Refettorio delle Grazie.* Quaderni del restauro, 7. Milan: Olivetti, 1990.

De Maio, Romeo. *Michelangelo e la controriforma.* Florence: Sansoni, 1990.

Fiorio, Maria Teresa. *Bambaja: Catalogo completo.* Florence: Cantini, 1990.

Kemp, Martin. "Looking at Leonardo's Last Supper." In *Appearance, Opinion, Change: Evaluating the Look of Paintings.* London: United Kingdom Institute for Conservation, 1990.

———. *The Science of Art: Optical Themes in Western Art from Brunelleschi to Seurat.* New Haven and London: Yale University Press, 1990.

Marani, Pietro C. "Le alterazioni dell'immagine dell'Ultima Cena di Leonardo dopo le più recenti analisi." *Kérmes: Arte e tecnica del restauro,* year 3, no. 7 (1990): 64–67.

———. "Leonardo's Last Supper: Some Problems of the Restoration and New Light on Leonardo's Art." In *Nine Lectures on Leonardo da Vinci,* ed. Francis Ames-Lewis and Anka Bednarek, 45–52. London: Department of History of Art, Birkbeck College, University of London, 1990.

———. "Prospettiva, botanica e simbolo nelle ghirlande 'tonde a l'anticha' di Leonardo." In *Le lunette di Leonardo nel Refettorio delle Grazie,* by Pinin Brambilla Barcilon and Pietro C. Marani, 1–34.

Nine Lectures on Leonardo da Vinci. Edited by Francis Ames-Lewis and Anka Bednarek London: Department of History of Art, Birkbeck College, University of London, 1990.

Pedretti, Carlo. "A 'modello' for the 'Last Supper'?" *Achademia Leonardi Vinci: Journal of Leonardo Studies and Bibliography of Vinciana* 3 (1990): 148.

Rubin, P. "What Man Saw: Vasari's Life of Leonardo da Vinci and the Image of Renaissance Artists." In *Nine Lectures on Leonardo da Vinci,* 96–108.

Sicoli, Sandra. "La politica di tutela in Lombardia nel periodo napoleonico: La formazione della Pinacoteca di Brera: Il ruolo di Andrea Appiani e Giuseppe Bossi." *Ricerche di Storia dell'arte* 38 (1990): 71–90.

1991 Bandera Bistoletti, Sandrina. "Gian Lorenzo Bernini e la copia del Cenacolo di Leonardo a Saint-Germain l'Auxerrois." In *I leonardeschi a Milano: Fortuna e collezionismo,* ed. Maria Teresa Fiorio and Pietro C. Marani, 194–98. Milan: Electa, 1991.

Caroli, Flavio. *Leonardo: Studi di fisiognomica.* Milan: Leonardo, 1991.

Ferri Piccaluga, Gabriella. "Eugenio di Beauharnais collezionista e conoscitore di dipinti leonardeschi." In *I leonardeschi a Milano: Fortuna e collezionismo,* 221–23.

Kemp, Martin. "Authentically Dirty Pictures." *Times Literary Supplement,* 17 May 1991.

I leonardeschi a Milano: Fortuna e collezionismo. Edited by Maria Teresa Fiorio and Pietro C. Marani. Milan: Electa, 1991.

Mangili, Renzo. *Giuseppe Diotti nell'Accademia tra Neoclassicismo e Romanticismo storico.* Milan: Mazzotta, 1991.

Marani, Pietro C. "Fotografia e restauri del Cenacolo." In *Sviluppi non premeditati: La fotografia immediata fra tecnologia e arte.* Rome: Carte Segrete, 1991.

———. "Una 'Vergine delle rocce' dimenticata." In *I leonardeschi a Milano: Fortuna e collezionismo.*

Mazzocca, Fernando. "Il modello accademico e la pittura di storia." In *La pittura in Italia: L'Ottocento,* ed. Enrico Castelnuovo, 2:139–50. Milan: Electa, 1991.

Morandotti, Alessandro. "Il revival Leonardesco nell'età di Federico Borromeo." In *I leonardeschi a Milano: Fortuna e collezionismo,* 166–82.

Tardito, Rosalba. "Dipinti leonardeschi offerti alla Pinacoteca di Brera nell'Ottocento." In *I leonardeschi a Milano: Fortuna e collezionismo,* 253–54.

Wazbinski, Zygmunt. "Pieter Paul Rubens e il suo studio dell'Ultima Cena di Leonardo da Vinci: Un contributo alla storia del tenebrismo in Italia intorno al 1600." In *I leonardeschi a Milano: Fortuna e collezionismo,* 199–205.

1992 Alberici, Clelia. "Leonardo e l'incisione: Qualche aggiunta." *Raccolta Vinciana* 24 (1992): 9–54.

———. "La tavola apparecchiata: Considerazioni sul Cenacolo." *Raccolta Vinciana* 24 (1992): 3–8.

Bora, Giulio. "I leonardeschi a Venezia verso la 'maniera moderna.'" In *Leonardo & Venezia,* ed. Giovanna Nepi Sciré and Pietro C. Marani, 358. Milan: Bompiani, 1992.

Brown, David Alan. "Il Cenacolo a Venezia." In *Leonardo & Venezia,* 335–43.

———. "Il Cenacolo di Leonardo: La prima eco a Venezia." In *Leonardo & Venezia,* 85–96.

Clayton, Martin. "L'Ultima Cena." In *Leonardo & Venezia,* 228–29, 232–33.

Cogliati Arano, Luisa. "Leonardo Lascia Milano." In *Leonardo & Venezia,* 55–64, esp. pp. 56–57.

Fiorio, Maria Teresa. "Tra Milano e Venezia: Il ruolo della scultura." In *Leonardo & Venezia,* 137–52.

Humphrey, Peter. "Giovanni Agostino da Lodi." In *Leonardo & Venezia,* 358–59.

Leonardo da Vinci: I Codici Forster del Victoria and Albert Museum. Diplomatic and critical transcription by Augusto Marinoni. Florence: Giunti Barbèra, 1992.

Leonardo & Venezia. Edited by Giovanna Nepi Sciré and Pietro C. Marani. Milan: Bompiani, 1992.

Marani, Pietro C. "Leonardo e il Cristo portacroce." In *Leonardo & Venezia,* 344–47.

Nepi Sciré, Giovanna. "La Battaglia di Anghiari." In *Leonardo & Venezia,* 256–77, esp. pp. 258–62.

Shell, Janice. "Marco d'Oggiono a Venezia." In *Leonardo & Venezia,* 360–61.

1993 Ballarin, Alessandro, Luisa Attardi, and Alessandra Pattanaro. In *Le siècle de Titien: L'âge d'or de la peinture à Venise.* Catalog of an exhibit. Paris: Réunion des Musées nationaux, 1993.

Giordano, Luisa. "L'autolegittimazione di una dinastia: Gli Sforza e la politica dell'immagine." *Artes* 1 (1993): 7–33.

Goethe, Johann Wolfgang von. *La teoria dei colori.* Edited by Renato Troncon, introduction by Giulio Carlo Argan. Milan: Il Saggiatore, 1993.

Habert, Jean. In *Le siècle de Titien: L'âge d'or de la peinture à Venise,* 567–69.

Jones, Pamela M. *Federico Borromeo and the Ambrosiana: Art Patronage and Reform in Seventeenth-Century Milan.* Cambridge: Cambridge University Press, 1993. Translated into Italian under the title *Federico Borromeo e l'Ambrosiana: Arte e riforma cattolica nel XVII secolo a Milano,* Milan: Vita e Pensiero, 1997.

Lomazzo, Giovan Paolo. *G. P. Lomazzo e i Facchini della Val di Blenio: Rabisch.* Critical ed. with commentary by Dante Isella. Turin: Einaudi, 1993.

Marani, Pietro C. "Giovanni Testori e le reliquiae fugientes di Leonardo." *Raccolta Vinciana* 25 (1993): 455–61.

———. "Lettera a Martin Kemp (sul restauro del Cenacolo)." *Raccolta Vinciana* 25 (1993): 463–67.

Le siècle de Titien: L'âge d'or de la peinture à Venise. Catalog of an exhibit. Paris: Réunion des Musées nationaux, 1993.

1994 Ballarin, Alessandro. *Dosso Dossi: La pittura a Ferrara negli anni del ducato di Alfonso I.* Vol. 2. Cittadella: Bertoncello, 1994.

Bonatti, E. "Il Cenacolo Vinciano: I fatti e le opinioni (1979–1994)." *ANAΓKH: Cultura, storia e tecniche della conservazione* 6 (June 1994): 58–60.

Brown, David Alan. "Leonardo's 'Head of an Old Man' in Turin: Portrait or Self-Portrait?" In *Studi di Storia dell'arte in onore di Mina Gregori,* ed. Miklos Boskovits, 75–78. Milan: Silvana, 1994.

Hüttel, Richard. *Spiegelungen einer Ruine: Leonardos Abendmahl im 19. und 20. Jahrhundert.* Marburg: Jonas, 1994.

Kustodieva, Tatyana K. *The Hermitage Catalogue of Western European Painting: Italian Painting, Thirteenth to Sixteenth Centuries.* Florence: Giunti and Moscow, 1994.

Le Stanze del Cardinal Monti 1635–1650: La collezione ricomposta. Milan: Leonardo Arte, 1994.

Marani, Pietro C. *Leonardo.* Milan: Electa, 1994. Translated into Spanish, Madrid, 1995; translated into French, Paris, 1996.

Migliore, Sandra. *Tra Hermes e Prometeo: Il mito di Leonardo nel decadentismo europeo.* Florence: L. S. Olschki, 1994.

Musacchio, Matteo. *L'archivio della Direzione generale delle antichità e belle arti (1860–1890).* Pubblicazioni degli archivi di Stato, Strumenti 120. Rome: Ministero per i Beni Culturali e Ambientali, Ufficio Centrale per i Beni Archivistici, 1994.

Musiari, Antonio. In *Pinacoteca di Brera: Dipinti dell'Ottocento e del Novecento: Collezioni della Pinacoteca e dell'Accademia,* ed. Federico Zeri, 2:627–29. Milan: Elemond, 1994.

Pavoni, Rosanna. *Museo Bagatti Valsecchi a Milano.* Milan: Silvana, 1994.

Turner, Richard. *Inventing Leonardo.* Berkeley and Los Angeles: University of California Press, 1994.

1995 Antonelli, Rosalba. "Gli studi preparatori della copia del Cenacolo di Giuseppe Bossi allo Schlossmuseum di Weimar." *Raccolta Vinciana* 26 (1995): 287–327.

Bonsanti, Giorgio. "Aperto per restauri." *Il Giornale dell'arte* 134 (June 1995): 18.

La città di Brera: Due secoli di scultura. Milan: Fabbri, 1995.

Giordano, Luisa. In *"Ludovicus Dux,"* ed. Luisa Giordano, 94–117, 183–85. Vigevano: Diakronia, 1995.

Kemp, Martin. "Letter to Pietro Marani (on the restoration of the Last Supper)." *Raccolta Vinciana* 26 (1995): 359–66.

Leonardo da Vinci. *Libro di Pittura.* Edited by Carlo Pedretti and Carlo Vecce. Florence: Giunti, 1995.

Limentani Virdis, Caterina. In *Pinacoteca di Brera: Scuole straniere,* 69–72. Milan: Electa, 1995.

"Ludovicus Dux." Edited by Luisa Giordano. Vigevano: Diakronia, 1995.

Marani, Pietro C. "The 'Hammer Lecture' (1994): Tivoli, Hadrian and Antinous: New Evidence of Leonardo's Relation to the Antique." *Achademia Leonardi Vinci: Journal of Leonardo Studies and Bibliography of Vinciana* 7 (1995): 207–25.

———. "The Restoration of a Last Supper in 3-D." *Achademia Leonardi Vinci: Journal of Leonardo Studies and Bibliography of Vinciana* 8 (1995): 237–38.

———. "Una natura morta di Leonardo nella Milano di fine Cinquecento." In *La natura morta al tempo di Caravaggio,* ed. Alberto Cottino, 26–34. Naples: Electa Napoli, 1995. 2d ed., Naples, 1996.

Mulas, Pier Luigi. In *"Ludovicus Dux,"* 118–25.

Sannazzaro, Giovanni Battista. "Motivi leonardeschi nell'Appiani." *Raccolta Vinciana* 26 (1995): 255–85.

Testori, Giovanni. *La realtà della pittura: Scritti di storia e critica d'arte dal Quattrocento al Settecento,* ed. Pietro C. Marani, 124–28. Milan: Longanesi, 1995.

Welch, Evelyn S. *Art and Authority in Renaissance Milan.* New Haven: Yale University Press, 1995.

1996 Clayton, Martin. *Leonardo da Vinci: A Singular Vision: Drawings from the Collection of Her Majesty the Queen.* New York: Abrams, 1996.

Ferro, Filippo Maria. "Novità e precisazioni su Tanzio da Varallo." In *Il Seicento lombardo: Atti della Giornata di studi,* ed. Mina Gregori and Marco Rosci, 11–20. Milan: Artema, 1996.

Marani, Pietro C. "Nota su Tanzio da Varallo e su alcune sue possibili fonti lombarde." In *Il Seicento lombardo: Atti della Giornata di studi,* 5–10.

Morandotti, Alessandro. "Le stampe di traduzione come fonti per la storia del collezionismo: Il caso di Milano fra età napoleonica e restaurazione." In *Il Lombardo-Veneto 1814–1859: Storia e cultura,* ed. Nicoletta Dacrema, 193–217. Proceedings: Università degli studi di Pavia, Udine: Campanotto, 1996.

Mulazzani, Germano. "Giacomo Mellerio collezionista e mecenate." In *Palazzo Mellerio: Una dimora nobiliare nella Milano neoclassica,* 117–18. Cinisello Balsamo: Silvana, 1996.

Pancella, L. C. "Contributo allo studio della policromia del Cenacolo." In *Rapporto 9/96* of the École Polytechnique Fédérale de Lausanne, Laboratoire de Conservation de la Pierre, 1996.

Roy, Alain, and Paula Goldenberg. *Les peintures italiennes du Musée des Beaux-arts, XVIe, XVIIe et XVIIIe siècles.* Strasbourg: Éditions des Musées de la ville de Strasbourg, Musée des Beaux-Arts, 1996, 22–23.

Il Seicento lombardo: Atti della Giornata di studi. Edited by Mina Gregori and Marco Rosci. Milan: Artema, 1996.

Zanardi, Bruno, and Chiara Frugoni. Introduction by Federico Zeri. *Il cantiere di Giotto: Le storie di San Francesco ad Assisi.* Milan: Skira, 1996.

1997 Agosti, Barbara, and Giovanni Agosti, eds. *Le tavole del Lomazzo (per i 70 anni di Paola Barocchi).* Brescia: L'Obliquo, 1997.

Barbaduomo, M. "Gli affreschi del Cavenaghi in Santa Maria di Piazza a Busto Arsizio: Technica e restauro." In *Restauro e valorizzazione degli affreschi nella Provincia di Varese,* ed. Pietro C. Marani, 101–105. Varese, 1997.

Burnett, Andrew, and Richard Schofield. "The Medallions of the Basamento of the Certosa di Pavia: Sources and Influences." *Arte Lombarda* 120 (1997): 5–27.

Ciardi, Roberto Paolo. "Leonardo illustrato: Genio e morigeratezza." In *L'immagine di Leonardo: Testimonianze figurative dal XVI al XIX secolo.* Catalog of an exhibit at Vinci. Florence: Giunti, 1997, 17–60.

Dragstra, Rolf. "The Vitruvian Proportions for Leonardo's Construction of the 'Last Supper.'" *Raccolta Vinciana* 27 (1997): 83–101.

Fiorio, Maria Teresa. "Leonardo, Boltraffio e Jean Perréal." *Raccolta Vinciana* 27 (1997): 325–55.

Franck, Jacques. "The Last Supper, 1497–1997: The Moment of Truth." *Achademia Leonardi Vinci: Journal of Leonardo Studies and Bibliography of Vinciana* 10 (1997): 165–82.

Marani, Pietro C. "Pittura e decorazione dalle origini al 1534." In *Il Santuario della Beata Vergine dei Miracoli a Saronno,* ed. Maria Luisa Gatti Perer, 137–84. Monografie di Arte Lombarda, I Monumenti, 10. Milan: Istituto di Storia dell'Arte Lombarda, 1997.

Mazzocca, Fernando. "The Renaissance Repertoire in the History Painting of Nineteenth-Century Milan." In *Reviving the Renaissance: The Use and Abuse of the Past in Nineteenth-Century Italian Art and Decoration,* ed. Rosanna Pavoni, 239–67. Cambridge: Cambridge University Press, 1997.

Pedretti, Carlo. "Justissimus dolor." *Achademia Leonardi Vinci: Journal of Leonardo Studies and Bibliography of Vinciana* 10 (1997): 163–64.

Rossi, Marco. "Fra decorazione e teatralità: Andrea da Milano e Gaudenzio Ferrari e dintorni." In *Il Santuario della Beata Vergine dei Miracoli a Saronno,* 195–234.

1998 Agosti, Giovanni. "Scrittori che parlano di artisti, tra Quattro e Cinquecento in Lombardia." In *Quattro pezzi lombardi: Per Marie Teresa Binaghi,* by Barbara Agosti, Giovanni Agosti, Carl Brandon Strehlke, and Marco Tanzi, ed. Sandro Lombardi, 39–93. Brescia: L'Obliquo, 1998.

L'anima e il volto: Ritratto e fisiognomica da Leonardo a Bacon. Edited by Flavio Caroli. Catalog of an exhibit. Milan: Electa, 1998.

Barocchi, Paola. *Dai neoclassici ai puristi 1780–1861.* Vol. 1 of Paola Barocchi, *Storia moderna dell'arte in Italia: Manifesti, polemiche, documenti.* Turin: Einaudi, 1998.

———, ed. *Pittura e scultura nel Cinquecento: Benedetto Varchi, Vincenzo Borghini.* Livorno: Siballe, 1998.

Buganza, S. In *Pittura a Milano: Rinascimento e manierismo,* ed. Mina Gregori, 203–4.

Cassanelli, Roberto. *La cultura fotografica a Milano alla vigilia dell'Unità: Luigi Sacchi e L'Artista (1859).* Cinisello Balsamo: Silvana, 1998.

Eichholz, Georg. *Das Abendmahl Leonardo da Vincis: Eine systematische Bildmonographie.* Munich: Scaneg, 1998.

Geddo, Cristina. "Disegni leonardeschi dal Cenacolo: Un nuovo nome per le teste di Strasburgo." In *"Tutte queste opere non son per istancarmi": Raccolta di scritti per i settant'anni di Carlo Pedretti,* ed. Fabio Frosini, 159–88. Rome: Edizioni associate, 1998.

I leonardeschi: L'eredità di Leonardo in Lombardia. Milan: Skira, 1998. Translated into English under the title *The Legacy of Leonardo: Painters in Lombardy 1490–1530.* Milan: Skira; London: Thames and Hudson, 1999.

Leonardo: La dama con l'ermellino. Edited by Barbara Fabjan and Pietro C. Marani. Cinisello Balsamo: Silvana, 1998.

Marani, Pietro C. "Il problema della 'bottega' di Leonardo: La 'praticha' e la trasmissione delle idee di Leonardo sull'arte e la pittura." In *I leonardeschi: L'eredità di Leonardo in Lombardia,* 9–37.

———. "Il Cenacolo di Leonardo e i suoi restauri nella Milano fra il XV e il XX secolo fra arte e fede, propaganda politica e magnificenza civile." *I Tatti Studies: Essays in the Renaissance* 7 (1998): 191–230.

———. In *L'Ambrosiana e Leonardo,* 17–63.

Marani, Pietro C., Marco Rossi, and Alessandro Rovetta. *L'Ambrosiana e Leonardo.* Novara: Interlinea, 1998.

Mazzocca, Fernando. *Scritti d'arte del primo Ottocento.* Milan and Naples: Ricciardi, 1998.

Pedretti, Carlo. "Una 'cena' lucchese." In *Leonardo e la pulzella di Camaiore,* 41. Florence: Giunti, 1998.

Pittura a Milano: Rinascimento e manierismo. Edited by Mina Gregori. Milan: Cassa di Risparmio delle provincie lombarde, 1998.

Rabisch: Il grottesco nell'arte del Cinquecento: L'Accademia della Val di Blenio: Lomazzo e l'ambiente milanese. Catalog of an exhibition. Milan: Skira, 1998.

Righini Ponticelli, Sylvia. "La nascita del convento." In *Santa Maria delle Grazie,* 48–117. Milan: F. Motta 1998.

Rossi, Marco. In *L'Ambrosiana e Leonardo,* 67–99.

Rovetta, Alessandro. In *L'Ambrosiana e Leonardo,* 100–3.

Ruskin, John. *Pittori moderni.* Edited by G. Leoni, with the collaboration of A. Guazzi; introduction by Giuseppe Leonelli. 2 vols. Turin: Einaudi, 1998. (See also under 1843–60.)

Sicoli, Sandra. "I restauratori nella Regia Pinacoteca di Brera: Le origini di una professione della Milano napoleonica." In *Giovanni Secco Suardo: La cultura del restauro tra tutela e conservazione dell'opera d'arte.* Supplement to *Bollettino d'arte,* ser. 6, vol. 81, no. 98 (1998): 33–56.

Vecce, Carlo. *Leonardo.* Rome: Salerno, 1998.

1999 Bonsanti, Giorgio. "Diffamare gli italiani rende: Non rischi niente e si parla tanto di te." *Il Giornale dell'arte* 174 (February 1999): 63.

Colombo, A. "'Titolo nuovo di gallica accortezza': U. Foscolo e i restauri della Cena di Leonardo." In *Léonard de Vinci entre France et Italie: Miroir profond et sombre,* Actes du Colloque International de l'Université de Caen, 3–4 October 1996, ed. Silvia Fabrizio-Costa and Jean-Pierre Le Goff, 183–92. Caen: Presses Universitaires de Caen, 1999.

Giovio, Paolo. *Scritti d'arte: Lessico ed ecfrasi.* Edited by S. Maffei. Pisa, 1999.

Marani, Pietro C. *Leonardo: Una carriera di pittore.* Milan: Federico Motta, 1999.

Milano e Brera nella Repubblica Cisalpina. Atti del Convegno, Milan, Accademia di Brera, 4–5 February 1997. Edited by Roberto Cassanelli and Matteo Ceriana, with contributions from Fernando Mazzocca, Dario Trento, and Pietro C. Marani. Milan, 1999.

Pedretti, Carlo. "Le 'belle cose' di Leonardo a Milano in un 'sogno' di Benvenuto Cellini a Firenze." Paper read at the Convegno, "Attorno a Leonardo pittore," Florence, Palazzo Pitti, 20 January 1999. Published in part in *Il Sole 24 ore,* 31 January 1999, no. 30, p. 35.

Petraroia, Pietro. In *La Restauration de la Cène de Léonard de Vinci et du Réfectoire de l'église Santa Maria delle Grazie de Milan.* Journée d'études, Thursday, 1 October 1998. *Compte-rendu.* Lausanne, 1999.

Petraroia, Pietro, and Pietro C. Marani. In *TEMA: Tempo, materia, architettura* 4 (1998, but published in 1999).

Quatriglio, Giuseppe. "Divine rappresentazioni." *Arrivederci* 10, no. 107 (Bergamo: January 1999): 28–29.

Romano, Giovanni. Interview in *Il Giornale dell'arte,* supplement to no. 176 (April 1999): 1.

Villata, Edoardo. In Pietro C. Marani, *Leonardo: Una carriera di pittore.* Milan: Federico Motta, 1999.

Undated Cogliati Arano, Luisa. *Von Leonardo zu Goethe.* Milan, n.d.

Reference Photographs

Photography in Pinin Brambilla Barcilon's essay by Carlo Aschieri and Jürgen Becker.

The Royal Collection ©1999 Her Majesty Queen Elizabeth II.

Gabinetto dei Disegni dell' Accademia di Brera, Milan: Photographs by Paulo Manusardi, Milan.

Graphische Sammlung Albertina, Vienna.

Gallerie Dell' Accademia, Venice: photographs by Osvaldo Böhm, Venice.

Pinacoteca di Brera, Milan: Archivio Electa, Milan.